WITHDRAWN
No longer the property of the
Boston Public Library.
Sale of this material benefits the Library

S0-AES-466

Art & Queer Culture

Catherine Lord &
Richard Meyer

Art & Queer Culture

Phaidon Press Limited
Regent's Wharf, All Saints Street, London N1 9PA

Phaidon Press Inc.
180 Varick Street, New York, NY 10014

www.phaidon.com

First published 2013
© Phaidon Press Limited 2013

All works are © the artists or the estates
of the artists unless otherwise stated.

ISBN 978 0 7148 4935 5

A CIP catalogue record of this book is available from
the British Library. All rights reserved. No part of this
publication may be reproduced, stored in a retrieval system
or transmitted in any form or by any means, electronic,
mechanical, photocopying, recording or otherwise, without
the prior permission of Phaidon Press.

Commissioning Editor: Craig Garrett
Project Editor: Hettie Judah
Designer: A Practice for Everyday Life
Production Controller: Laurence Poos

Printed in Hong Kong

Section Illustrations:
p. 5: Fred W. McDarrah, *Outside the Stone Wall*, 1969
p. 8: Diana Davies, *Donna Gottschalk holds poster 'I am your worst fear I am your best fantasy' at Christopher Street Gay Liberation Day parade*, 1970
p. 13: Hal Fischer, *Gay Semiotics*, 1976
p. 15: Kay Tobin Lahusen, *Barbara Gittings Protesting at Independence Hall, Philadelphia, July 5, 1966*
p. 16: Pepe Espaliu, *Carrying Project, Barcelona*, 1991
p. 49: Brassaï, *Lesbian Couple at Le Monocle*, 1932
p. 51: Nancy Grossman, *No Name*, 1968
p. 52: Catherine Opie, *Self-Portrait/Nursing*, 2004
p. 253: Billy Name, *Andy Warhol under 'My Hustler' Marquee, New York City, 1965*
p. 255: Valerie Solanas's defaced cover of her book *S.C.U.M. Manifesto*, 1967
p. 256: Sharon Hayes, *In the Near Future*, 2005

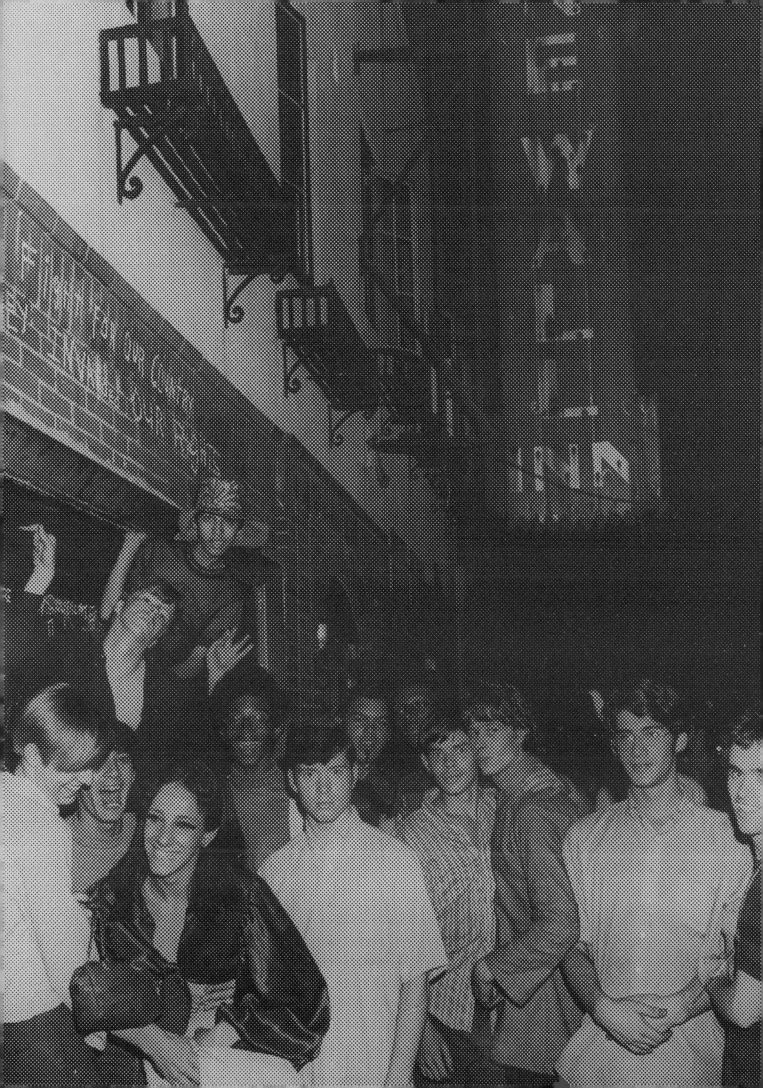

Preface

Survey

Works

Documents

Preface

'I am your worst fear. I am your best fantasy.'

So proclaims a gay liberation slogan of the early 1970s. The slogan positions homosexuality as a site of both anxiety and fascination. It foists fear and fantasy onto every non-gay-identified listener, including closeted homosexuals. No longer marginalized, the gay subject here claims knowledge of, even inhabits, the psyche of the 'straight' listener. Homosexuality is thus conceived not simply as an identity possessed by particular subjects but as a site of sexual meaning and symbolic investment under continual negotiation, both by those who name themselves as gay or lesbian and by those who do not.

This zone of negotiation lies at the heart of *Art and Queer Culture*. The pages that follow explore how particular artists have constructed, contested or otherwise responded to alternative forms of sexuality at pivotal moments in the last 125 years. Ours is not a book exclusively about artists who identified themselves as gay or lesbian, or artists who might have, or should have, or could have identified themselves as such. Rather than locating same-sex desire as a fixed category or consistent iconographic motif within modern art, we trace the push and pull of different historical moments and social contexts, the vehemence of proclamation and suppression, and the shifting possibilities and constraints of sexual identity. Throughout the book, we consider the ways in which the codes and cultures of homosexuality have provided a creative resource for visual artists.

Let us say at the outset that we recognize a number of challenges confronting our project, notably the unstable definitions of gay, lesbian and homosexual and the limits of identity politics as a framework for understanding modern and contemporary art. We believe we have developed an approach that will allow us to meet these challenges while providing a much-needed resource for scholars and students of art, art history, and gender and sexuality studies.

We have chosen the term 'queer' in the knowledge that no single word can accommodate the sheer expanse of cultural practices that oppose normative heterosexuality. In its shifting connotation from everyday parlance to phobic epithet to defiant self-identification, 'queer' offers more generous rewards than any

simple inventory of sexual practices or erotic object choices. It makes more sumptuous the space between best fantasy and worst fear.

Attempts to trouble the conventions of gender and sexuality, to highlight the performative aspects of identity, and to oppose the tyranny of 'the normal' are woven into the historical fabric of homosexuality and its representation. While the militant reclamation of the word 'queer' may be a product of the late 1980s and early 1990s (with the emergence of activist groups such as Queer Nation and the appearance of queer theory within academe), the anti-normative strategy behind that reclamation extends much farther back in time. From Oscar Wilde and *The Picture of Dorian Gray* to Susan Sontag and 'Notes on "Camp"', from the molly houses of eighteenth-century London to the Harlem drag balls of the 1920s, the flamboyant refusal of social and sexual norms has fueled the creation of queer art and life throughout the modern period.

Some sense of this flamboyance may be suggested by a two-part performance organized by the artist Sharon Hayes in 2008. In *Revolutionary Love 1 (I am your Worst Fear)* and *Revolutionary Love 2 (I am your Best Fantasy)*, Hayes assembled a diverse collective of performers to recite — in public and in unison — a text about sexual freedom inspired by the gay liberation movement of the early 1970s.[1] The artist put out the following call to recruit participants in the project:

> We are looking for lesbians, gay men, bisexuals, transmen, transwomen, queers, fags, dykes, muff divers, bull daggers, queens, drama queens, flaming queens, trannies, fairies, gym boys, boxing boys, boxing girls, pitchers, catchers, butches, bois, FtoMs, MtoFs, old maids, Miss Kittens, Dear Johns, inverts, perverts, girlfriends, drag kings, prom queens, happy people, alien sexualities or anything else you want to be or are and wish to bring out for the event![2]

The length of Hayes's list, and the fact that it is only one of many contemporary congeries of the queer, suggests the dimensions of what might be included in this book. Paradoxically, therefore, we have had to impose certain limits upon ourselves in order to convey the scope of queer culture. We have reproduced one and

only one work per artist, no matter their importance, no matter
the duration of their career. Despite the fact that this has allowed
us to include about 250 artists, we are well aware that we could
have included ten times more and that, as a result, we have left out
much of the dense web of back story, social context, deep gossip
and open secrets that structure both art and sexuality. We touch
only briefly, for example, on the contributions of filmmakers,
playwrights, poets and musicians. And while we have attempted to
suggest the global dimensions of both visual art and queer culture,
our intellectual training and resources have biased us towards the
Anglophone and the European.

　　Although this book proceeds in a chronological fashion,
it does not propose a progressive narrative in which homosexuals
become increasingly adept at negotiating the circumstances of
censorship and overcoming the terms of stigma and invisibility.
The dialogue between art and queer culture does not move towards
ever more affirmative images of equality and dignity. Rather than
countering homophobia with 'positive' images of assimilation,
many of the artists and photographers featured in this book draw
upon, and even draw out, the deviant force of homosexuality.

　　Art and Queer Culture is a curatorially promiscuous
endeavour. It includes pictures made and displayed under the
rubric of fine art as well as those intended for private, underground
or otherwise restricted audiences. Scrapbooks, amateur artworks,
cartoons, bar murals, anonymous photographs, activist posters —
all appear in the pages that follow, as do paintings, sculptures, art
photographs and mixed-media installations. Writing queer culture
into the history of art means redrawing the boundaries of what
counts as art as well as what counts as history. It means searching
for cracks in the partition that separates 'high' art from 'low' culture
and in the divide between public achievement and private life.

　　We aim to put the work of male and female artists into
dialogue with each other while simultaneously acknowledging
professional disparities and uneven social and material conditions.
We likewise try to put our own voices (as a gay art historian and
a lesbian artist/critic, respectively) into conversation without
flattening the distinction between them. Ultimately, we decided to
divide the survey essay into two, single-authored halves: the first
(by Meyer) covering the period from 1885 to 1980, the second
(by Lord) covering 1980 to the present. In part, we agreed on this

bipartite structure for practical reasons: half of the artworks in this book date from before 1980, half after. Which is to say, we discovered as much queer art and culture in the last thirty years as in the century preceding them.

But that is not the only reason for our division of labour. *Art and Queer Culture* is a book that neither of us could have conceived or completed alone. It does not, however, attempt to weave our distinct approaches and critical perspectives into a seamless whole. By way of acknowledging our discrete voices and points of view, we have specified individual authorship whenever possible. This book was forged through both dialogue and (occasional) disagreement. In keeping with the unruly history charted in these pages, *Art and Queer Culture* embraces the play of difference, debate and dispute.

— Richard Meyer

[1] *Revolutionary Love 1: I Am Your Worst Fear* took place on 27 August 2008 in conjunction with the Democratic National Convention in Denver, Colorado. *Revolutionary Love 2: I Am Your Best Fantasy* was performed on 1 September 2008 in conjunction with the Republican National Convention in Minneapolis/St Paul, Minnesota.

[2] Sharon Hayes, call for participation in *Revolutionary Love 1*, issued by the artist and Creative Time, 2008.

LEFT
AGGRESSIVE

RIGHT
PASSIVE

EARRING

HANDKERCHIEF

KEYS

SIGNIFIERS FOR A MALE RESPONSE

Survey

Inverted Histories: 1885 – 1979
by Richard Meyer

Inside the Body Politic: 1980 – present
by Catherine Lord

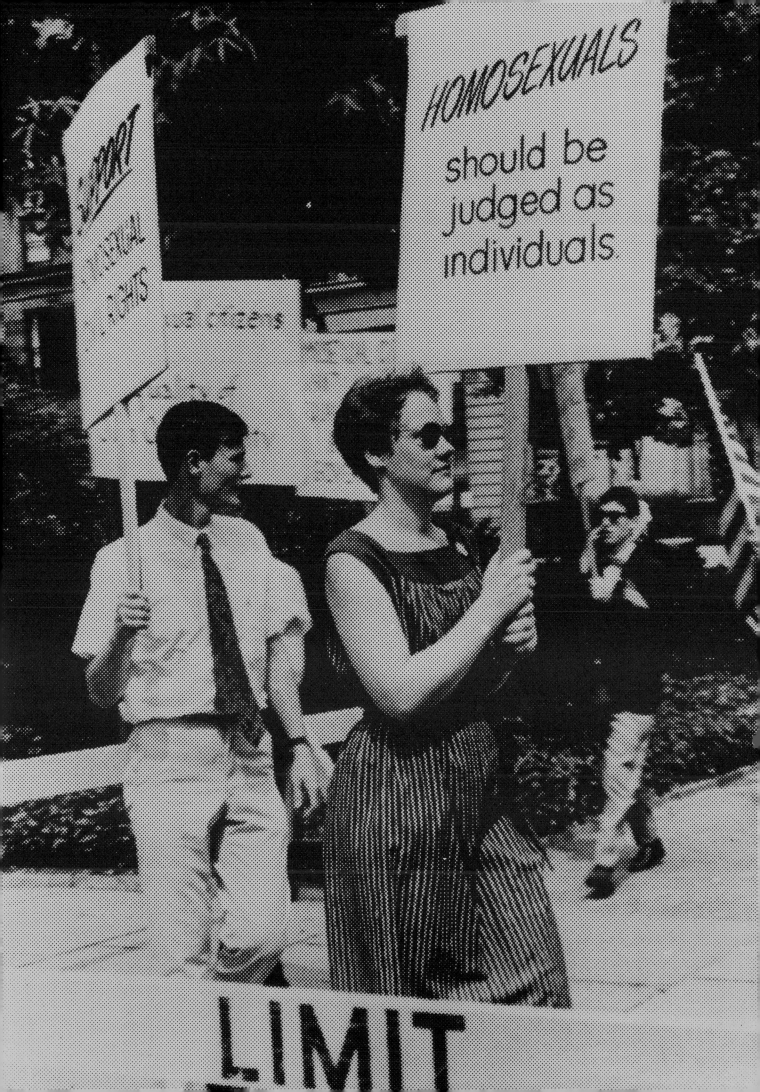

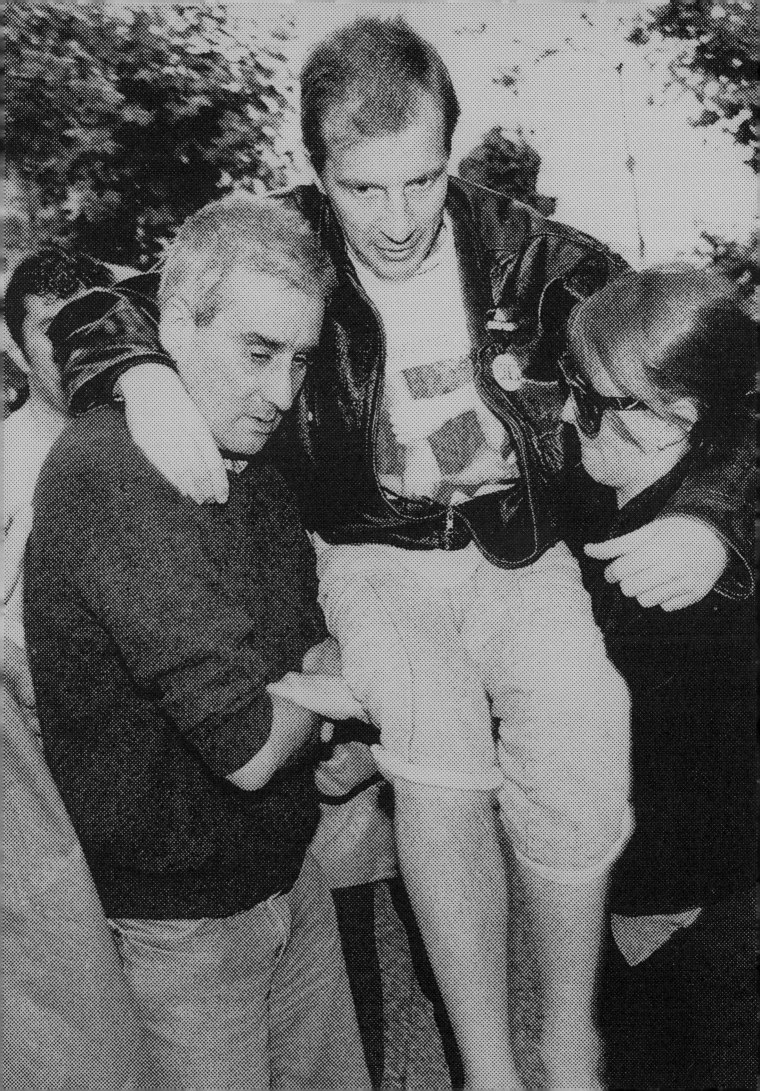

Inverted Histories: 1885 – 1979 by Richard Meyer

'The word homosexual was never used; they just said, "He's an artist".'[1] – Paul Cadmus, recalling 1930s New York

Insult / Affirmation

A painting by the artistic duo of David McDermott and Peter McGough offers a litany of homophobic taunts – 'Cocksucker', 'fairy', 'faggot', 'pansy', 'Nellie', 'Queen' and, of course, 'Queer'. Arrayed in green and red against a brilliant yellow backdrop, the insults dip and swirl in unexpected directions, sometimes crossing paths, sharing letters or veering off course. The letters that make up each word are charmingly inconsistent in size, font and capitalization. As painted by McDermott and McGough, the insults become markers of decorative flamboyance and eccentricity as well as, though now more distantly, insult and injury.

The painting's title, *A Friend of Dorothy, 1943*, references another code for male homosexuality. To be a 'friend of Dorothy' was to be an admirer of Judy Garland, one of whose signature roles was as Dorothy Gale in the 1939 film *The Wizard of Oz*. Garland's combination of emotional vulnerability and theatrical bravura resonated with particular intensity for homosexual audiences, and her later concerts were exceedingly popular among gay men.[2] Rather than an insult hurled by outsiders, 'friend of Dorothy' functioned as a code for those in the know.

Terms like 'friend of Dorothy' and 'Mary' (the one word painted in red on the canvas) speak in the parlance of homosexual camp, a parlance in which femininity may be assigned to and possessed by men as well as women. As Michael Bronski has argued,

> **What is sometimes referred to as 'camp talk' – especially gay men referring to one another with women's names or pronouns – evolved as a coded, protected way of speaking about one's personal or sexual life. If one man were to be overheard at a public dinner table saying to another, 'You'll never guess what Mary said on our date last night,' nothing would be thought of it.[3]**

The 'backdating' of *A Friend of Dorothy* – the painting was completed in 1986, but its title carries the date 1943 – suggests both nostalgia for and an imaginative recycling of homosexual history. McDermott and McGough refer back to a moment several decades before gay liberation (though just four years after *The Wizard of Oz*) when the coded use and practical necessity of 'camp talk' shaped exchanges among countless Marys and friends of Dorothy.

Like McDermott and McGough, many of the artists featured in this book have retrieved traces of the historical past, whether real or imagined. The German aristocrat Baron Wilhelm von Gloeden, for example, restaged classical homoeroticism in his photographs of toga-clad (and unclad) adolescent boys and young men in 1890s Sicily. Art historian Jason Goldman has eloquently described the dual appeal of the Baron's pictures: 'Alternately readable as ancient ephebi and anonymous local youths, playful fauns and agrarian laborers, von Gloeden's boyish subjects made overtures to an antique past but also implied the erotic pleasures currently on offer in Taormina.'[4] Von Gloeden's photographs – collected by the writer Oscar Wilde, the industrialist Friedrich Krupp and the sexologist Alfred Kinsey, among many others – reveal rather more about the homoerotic imagination of the late nineteenth century than about the sexual culture or customs of Greco-Roman antiquity.

Similarly, both the painter Marie Laurencin (working in Paris in 1908) and the artist Jeanne Mammen (in Berlin in 1931) created illustrations for *The Songs of Bilitis*, a series of erotic poems attributed in the late nineteenth century to 'Bilitis', an ancient Greek philosopher, a lover of Sappho and, as was eventually revealed, an entirely fictive person. Nevertheless, when the first lesbian rights group in the United States was founded in 1955, it took the name Daughters of Bilitis both to honour the Sapphic past (in ancient Greece as well as nineteenth-century Paris) and to elude the stigma of modern words such as 'homosexual', 'sex variant' and 'lesbian'. Like 'friend of Dorothy', 'Daughters of Bilitis' (or 'DOB' for short) was a term flexible enough to function as both sexual code and strategic closet. According to Del Martin and Phyllis Lyon, two of the founders of the Daughters of Bilitis, 'If anyone asked us, we could always say we belong to a poetry club.'[5]

Such tactical reclamations of the past resonate throughout the archive of art and queer culture assembled in this book, an archive by turns historical and fictive, inherited and invented, desired and disavowed. What follows is an illustrated tour of that archive and of some of the key issues and events that shaped it.

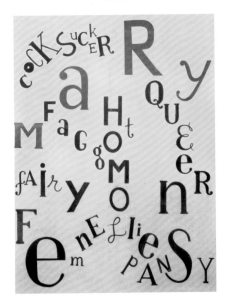

McDermott & McGough
A Friend of Dorothy, 1943
1986

Wilhelm von Gloeden
Untitled
c.1900

Inventing the Homosexual

The English word 'homosexuality' is a medical invention of the late nineteenth century.[6] This is not to say that same-sex activities between men or between women failed to exist prior to their clinical designation as such, but rather that individuals were generally not categorized according to their choice of sexual object.[7] The relatively recent coinage of 'homosexuality' (as well as its pendant term, 'heterosexuality') underscores its construction as an identity as opposed to a sexual act or sin in which anyone might participate. In the first volume of *The History of Sexuality*, Michel Foucault observes that

As defined by the ancient civil or canonical codes, sodomy was a category of forbidden acts; their perpetrator was nothing more than the juridical subject of them. The nineteenth-century homosexual became a personage, a past, a case history and a childhood, in addition to being a type of life, a life form and a morphology, with an indiscreet anatomy and possibly a mysterious physiology. [...] The sodomite had been a temporary aberration; the homosexual was now a species.[8]

Homosexuality emerged, in the latter half of the nineteenth century, as the defining characteristic of a newly deviant identity, one subject to the terms and technologies of medical science. Foucault's descriptive list ('a personage, a past, a case history, a childhood') draws out the multiple meanings that homosexuality was forced to carry once it entered into clinical, and then into more broadly social and cultural, discourse.

The 1895 trials of Oscar Wilde helped shape the emergent identity of the homosexual as both a criminal offender and a decadent artist. Wilde was accused and ultimately convicted of 'gross indecency', a crime introduced into English law a mere ten years earlier with the passage of the so-called Labouchere Amendment. According to the amendment,

Any male person who, in public or private, commits, or is a party to the commission of, or procures, or attempts to procure the commission by any male

person of, any act of gross indecency shall be guilty of misdemeanour, and being convicted shall be liable at the discretion of the Court to be imprisoned for any term not exceeding two years, with or without hard labour.[9]

Even as the law prohibited 'gross indecency', it veered away from explaining what, precisely, constituted such an act.

A similar refusal shaped the extensive press coverage of the trials. According to the literary critic Ed Cohen, Wilde's 'criminal activities were themselves never directly named in any newspaper account of the case but instead were designated by a virtually interchangeable series of euphemisms: '"certain misdemeanors", "indecencies", [...] "immoral relationships", "improper relations", "certain practices", "certain matters", [...] "disgraceful charges", "gross misconduct", "gross immorality", "grave offenses", "terrible offenses", "wicked acts" and "unmentionable acts".'[10] The newspapers could not, it would seem, resist mentioning the scandalously 'unmentionable' status of the acts of which Wilde was accused. Such elaborate forms of allusion and indirection run throughout the history and imagery of queer culture mapped in this book.

Critics and commentators likewise evoked Wilde's deviance without naming it outright. The writer's physical appearance, the gait of his walk, the 'perfumed rooms' in which he resided, his possessions and aesthetic preferences and, especially, his scandalous novel *The Picture of Dorian Gray* came to stand in for the unnatural crimes of which he was accused. *The Illustrated Police News*, for example, offered a front-page scene of the courtroom above a view of Wilde's effects, including a large oil painting in a gilded frame, being

Marie Laurencin
Chanson de Bilitis
1904

sold off to raise bail money. Two pendant views floating over the witness box contrast the author's recent circumstances – the first shows Wilde, in the full bloom of public visibility, lecturing in America in 1882; the second depicts his current situation 'as a prisoner' in the Bow Street police station. By depicting Wilde as both celebrated author and accused felon, both decadent aesthete and abject prisoner, the illustration effectively linked creative art to criminal vice.

In this sense, the *Illustrated Police News* was following the logic of the trial itself, as can be seen from the play of accusation and indirection in the cross-examination of Wilde by attorney Edward Carson during the first trial. After reciting a passage from Wilde's novel in which the character of a male painter professes his adoration for the beautiful Dorian, Carson pursued the following line of questioning:

Carson: The affection and love of the artist [for] Dorian Gray might lead an ordinary individual to believe that it might have a certain tendency?

Wilde: I have no knowledge of the views of ordinary individuals.

Carson: Now I ask you, Mr Wilde, do you consider that that description of the feeling of one man towards a youth just grown up was a proper or an improper feeling?

Wilde: I think it is the most perfect description of what an artist would feel on meeting a beautiful personality that was in some way necessary to his art and life.

Carson: You think that is a feeling a young man should have towards another?

Wilde: Yes, as an artist.[11]

Wilde elevates his desire (or 'feelings') for other men to the status of art while simultaneously defying Carson's framing of those feelings as improper or indecent. The category of art here serves as both a stand-in for love between men and an aesthetic justification for it. The association between art and homosexuality could cut both ways, however. Even as Wilde used a rhetoric of art and beauty to elude accusations of moral offence, Carson presented Wilde's fiction as evidence of unnatural proclivities.

On the night before his first trial, Wilde dined with the Post-Impressionist painter Henri de Toulouse-Lautrec. Though Lautrec wished to sketch Wilde that evening, the author was too distressed to sit for a portrait. Lautrec returned to his rooms and portrayed Wilde as he seemed to him that night – a mixture of fear, fatigue and flamboyance, of pursed red lips, vibrant dinner jacket, wrinkled face and jowls, downcast eyes and neatly combed hair.[12] Lautrec's inclusion of Big Ben in the background of the portrait would take on an additional layer of meaning when, during the trial, Wilde specified that a male brothel he occasionally visited was quite close to the House of Commons in Westminster Palace.

As Lautrec's portrait suggests, the dialogue between art and queer culture cannot be confined to homosexual artists. Shifting constructions of desire and deviance have shaped modern art in ways that extend beyond sexual biography or individual preference. Lautrec's portrait of Wilde (along with his earlier depictions of the writer, in happier days, visiting Paris) was forged across a shared sense of creative and sexual bohemianism rather than a strict association with homosexual acts or identities.

For all its vagueness around 'gross indecency', the English legal code specified quite clearly that the act could be perpetrated only by 'male persons'. Women could not commit the crime of gross indecency, much less be convicted of it. This legal loophole was produced by a failure to imagine the very possibility of lesbian sexuality. Similar refusals shaped the criminalization of homosexuality in Germany, the United States and Russia, among other nations, throughout the late nineteenth and twentieth centuries. As Judith Butler has argued,

Lesbianism is not specifically prohibited because it has not even made its way into the thinkable, the imaginable, that grid of cultural intelligibility that regulates the real and the nameable. [...] To be prohibited explicitly is to occupy a discursive site from which something like a reverse-discourse can be articulated; to be implicitly proscribed is not even to qualify as an object of prohibition.[13]

The trials of Oscar Wilde unfolded on the most public of stages – the Old Bailey courthouse and the pages of London's tabloid newspapers. Contemporaneous images of what might now be called lesbian culture, by contrast, were lodged within more private registers of representation. The life and work of the American photographer Alice Austen suggest the broader field of constraint and possibility that governed lesbian visibility in the late nineteenth century. An avid photographer as well as an accomplished athlete and New York socialite, Austen produced around eight

Henri de Toulouse-Lautrec
Portrait of Oscar Wilde
1895

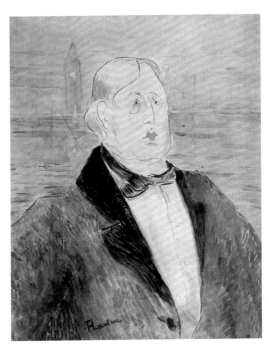

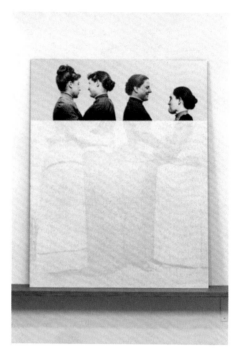

Nina Levitt
Submerged (for Alice Austen) (detail)
1895

thousand images in her lifetime, many of which depict the female friends who made up her intimate world. Beginning in the 1890s, Austen took private photographs of herself and her companions, sometimes cross-dressed in men's garb, sometimes wearing masks, often embracing or otherwise engaged in affectionate contact. These images stand on the threshold of queer visibility.

Austen befriended Gertrude Tate, a Brooklyn-born woman of some means, in 1899. The two became a couple and remained so for nearly fifty years, during most of which time they lived in Austen's home on Staten Island, an eighteenth-century farmhouse known as Clear Comfort. Rather little is known about Austen's domestic relationship with Tate other than that it was enduring and that the word 'lesbian' was not one used at the time to describe it. We also know, however, that Austen's life cannot be assimilated to dominant narratives of Victorian femininity – she never married or bore children and she lived with Tate until financial hardship forced them to separate late in life.

Clear Comfort has now been officially designated the Alice Austen House, a national historical landmark devoted to the photographer's 'life and times'. The House has let it be known, however, that researchers interested in linking Austen to lesbian history are not welcome.[14] Although the website for Alice Austen House includes a wealth of information about the photographer's life and work, the name of 'longtime friend' Gertrude Tate is mentioned once – and then only in passing.

In a 1991 work, the Canadian artist Nina Levitt reprinted but also partially erased an 1891 Austen photograph of two female couples embracing. The title of Austen's original photograph, *That Darned Club*, parrots the voice of an exasperated man excluded from the women's intimacy while alluding, however tongue-in-cheek, to the damnation of late nineteenth-century women who rejected the company of men.

Retrieving the photograph a century after its making, Levitt asks us to consider what appears within the visual record of lesbian life and what has been made to disappear from it; what has been submerged that might yet be excavated or allowed to emerge. Like Levitt's image, and like the relationship between Alice and Gertrude, the history of lesbian culture hovers between visibility and erasure, resolution and apparition.[15]

Art / Sex / Science

The visual history of homosexuality is inevitably a medical and scientific record of case studies and clinical research. While we have included a range of clinical photographs in the book (including an American photograph from 1914 of 'Patient No. 1', a 'married father of three' whose desire for 'complete womanhood' sometimes entailed the compulsive imitation of the poses of female figures in famous paintings), these images hardly exhaust the dialogue between medical science and queer culture.

Throughout the twentieth century, photographers and visual artists contributed sexual imagery (as well as, on occasion, their own case histories) to medical science. By highlighting two examples of such contributions – in Berlin in the late 1920s and early 1930s and in the United States in the 1950s – we can begin to see how the modern practices of art and sexology mutually shaped each other.

The Berlin-based physician Magnus Hirschfeld was one of the leading advocates for homosexual rights at the turn of the twentieth century. Distressed by what he saw as the injustice of the Wilde trials, he founded the Scientific Humanitarian Committee in 1897, the primary mission of which was to overturn Paragraph 175 of the Reich penal code, the German law that criminalized homosexuality. In his scientific studies, Hirschfeld proposed homosexuality as a third or intermediate sex 'between' heterosexual males and females. He argued for the 'third sex' as a natural variation of gender roles rather than as a pathology or dysfunction. Mannish women, effeminate men and cross-dressers of all stripes became the object of Hirschfeld's clinical study and political advocacy.

A student of both medicine and literature, Hirschfeld deeply respected the contribution of artists and writers to contemporary society. Later in life, he would remark,

My true inclination had always been, and still is, to spend my life in the society of journalists, writers, poets and artists. They are much closer to me than physicians and the whole hierarchy of medical science. The natural sciences have always left aside the most important aspect of life, which is love. It has always been left to the artist and writer. And I decided to make this theme the mainspring of my medical research.[16]

Hirschfeld's esteem for artists is suggested by the importance he accorded to visual images – hand-drawn illustrations, watercolour sketches, cartoons, postcards, prints – in his research and publications. His 1931 book, *Sittengeschichte der Nachkriegszeit* (Moral History of the Postwar Period) included nearly a thousand images of contemporary social

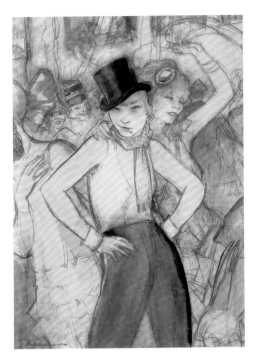

Jeanne Mammen
She Represents
c.1927–30

The dialogue between Berlin's lesbian nightlife and the broader reaches of popular culture was most famously embodied by the bisexual cabaret singer and movie star Marlene Dietrich. In her stage performances, films and publicity photographs, Dietrich projected a level of erotic sophistication and pansexual appeal that all but overwhelmed the homo/hetero divide.

The connection between lesbian subculture and chic cosmopolitanism extended well beyond the nightlife of 1920s Berlin. In Moscow, for example, a popular brand of cigarettes was marketed through the name and (updated) image of Sappho. With her red lipstick, (dyed) blonde hair and fashionable evening cape, the brazen 'new woman' pictured in the advertising poster would have officially qualified in 1925 as a counter-revolutionary figure of Western decadence. The femme fatale in the poster was nevertheless understood as a visual enticement to purchase a particular brand of cigarettes. In so far as she embodied sexual vice and capitalist luxury, this 'smoking' Sappho served as an effective counter-image to the official iconography of Soviet women as industrious workers and dutiful wives.

Mammen's pictures of lesbian Berlin circulated within a similarly double-edged discourse of immorality and pleasure. *She Represents*, for example, was first published in Curt Moreck's 1931 *Führer durch das 'lasterhafte' Berlin* (Guide to Immoral Berlin), a delightfully lurid handbook to the sundry, primarily nocturnal, diversions on offer in the metropolis. Mammen's picture appeared under the heading 'lesbian locales', in chapter six of the guidebook, a chapter that also featured sections on 'get together spots for homosexuals', 'night baths' and 'here are the transvestites'.[19] *Guide to Immoral Berlin* mapped the contemporary city according to the pleasures (and occasional dangers) it afforded.

Curt Moreck was the pen name of Konrad Haemmerling, a sexologist at the Institute for Scientific Sexual Knowledge

and sexual life, many of which were newly commissioned from Berlin artists. Appearing on almost every page of the book, the images survey an impressive spectrum of erotic activities and subcultures. Fetishism, cross-dressing, nudism, sex work and sadomasochism figure prominently, but by no means exclusively, throughout the tome.

Among the artists whom Hirschfeld sought out for this project was Jeanne Mammen, a painter and graphic designer whose imagery was closely associated with the thriving women's bars and lesbian nightclubs of Berlin at the time. Mammen contributed several watercolour sketches to *Moral History of the Postwar Period*, including *La Garçonne* (the 'bachelor girl' or, literally, 'female boy'), a picture of a stylish young woman with a short, bob haircut smoking a cigarette while reclining on a loveseat. Dressed only in her undergarments and high heels, the woman seems to have just returned from a night on the town. Herself a 'bachelor girl', Mammen was drawn to 'the cafes, the bars, the demimonde, the worlds of fashion and entertainment, the dives, joints, and red zones at the margins of [...] urban society'.[17]

Mammen's most famous picture, variously called *Masked Ball* and *She Represents*, offers a glamorous account of a lesbian nightclub with a butch/femme couple at its centre. According to the feminist scholar Marsha Meskimmon,

One of the key features which determined the atmosphere of the lesbian night-life of Berlin was the link it had with actresses and women singers, dancers and artists who may or may not have been defined as 'out' lesbians. It was more than just a sexual scene for women, it was a place where artistic and independent women could go to be out in public without the intrusion of men and a place where new, modish female identities could be played out through fashion and performance.[18]

Aleksandr Zelinski
Advertising poster for Sappho cigarettes
c.1925

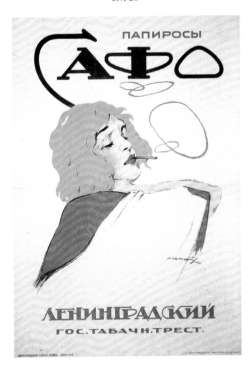

in Vienna. In the sections of his book devoted to women's bars and nightclubs, Moreck drew (in some cases, almost verbatim) on Ruth Roellig's slightly earlier guidebook *Berlins Lesbische Frauen* (The Lesbians of Berlin). Roellig, in turn, was promoted by Hirschfeld, who, writing under his own name, contributed a preface to her book. Berlin's lesbian scene of the late 1920s and early 1930s attracted the attention of artists and authors, doctors and demimondaines. Rather than seeing medical science and queer culture as mutually exclusive or oppositional discourses, we might look instead for their points of overlap and intersection.

Although Hirschfeld's library and archives were ransacked by the Nazis in 1933, his Institute of Sexology (the first such organization in the world) provided an important blueprint for post-war research on human sexuality, particularly that of the zoologist Alfred Kinsey and his staff at the Institute of Sex Research in Bloomington, Indiana. In his surprise best-sellers of 1948 (*Sexual Behavior in the Human Male*) and 1953 (*Sexual Behavior in the Human Female*), Kinsey demonstrated that homosexuality was far more prevalent within American culture than had previously been assumed. He proposed a continuum of sexual orientation on a scale from 0 (exclusively heterosexual) to 6 (exclusively homosexual), with most subjects falling somewhere in between.

In the introduction to *Sexual Behavior in the Human Male*, Kinsey pleads for scientific dispassion and the bracketing of moral judgements within the study of human sexuality:

No preconception of what is rare or what is common, what is moral or socially significant, or what is normal and what is abnormal has entered into the choice of the histories [gathered in this study] or into the selection of the items recorded on them. [...] Nothing has done more to block the free investigation of sexual behavior than the almost universal acceptance, even among scientists, of certain aspects of that behavior as normal, and of other aspects of that behavior as abnormal.[20]

For Kinsey, as for Hirschfeld before him, the visual contributions of artists and photographers helped challenge dominant images and traditional expectations of 'the normal'.

The figurative painters (and lovers) Paul Cadmus and Jared French were among the artists who donated work to Kinsey's visual archive. In French's case, he not only

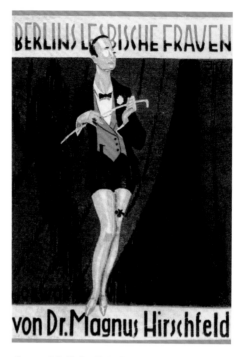

Cover of Ruth Roellig's *Berlins Lesbiche Frauen* (with a preface by Magnus Hirschfeld) 1929

contributed his own drawings and photographs but also helped Kinsey collect photographs from early historical moments. According to the art historian Mark Cole,

During the early 1950s, [French] was instrumental in acquiring for the archive a collection of more than 200 homoerotic albumen prints by turn-of-the-century photographer Wilhelm von Gloeden. The collection came to French's attention while he was traveling through Sicily, and he informed Kinsey of its availability. French subsequently arranged for its purchase and shipment to the Institute.[21]

French's purchase on Kinsey's behalf provides a vivid example of what we might call the traffic in images, the exchange, often covert, of homoerotic photographs, drawings, cartoons and journals across continents and cultures. Although both French and Kinsey worried that the von Gloeden pictures would be seized as contraband by US customs or postal officials, the photographs safely made the transatlantic passage from Italy to Indiana, where they continue to reside today.

The Traffic in Images

From the mid-1930s through the early 1950s, the portrait and fashion photographer George Platt Lynes shot several thousand photographs of the male nude, including couples and threesomes, and approximately one hundred photographs of the female nude, including some in pairs or trios. The men and women who posed for these pictures were some of the same models, dancers and artists who appeared, fully clothed, in the formal portraits that Lynes displayed in galleries and

Nazis plunder Magnus Hirschfeld's library, Berlin 10 May 1933

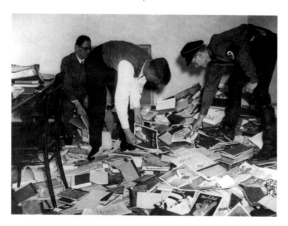

published in magazines such as *Vanity Fair*. Although Lynes never exhibited the nudes and destroyed many of them shortly before his death, he did agree to sell over a thousand prints to one collector – Dr Alfred Kinsey. While Lynes understood his nudes as a private form of artistic production, Kinsey valued them as scientific evidence of sexuality. In certain cases, Lynes seems to have thematized the clinical gaze of medical science within the very space of homoerotic fantasy, as in an unforgettable image of a female nurse soberly confronting the camera while two nude men – one some distance in front of her, the other some distance behind her – are framed from the rear.

Among the materials that Kinsey collected for the archives of his Institute were scores of physique magazines. Throughout the late 1940s, 1950s and 1960s, publications such as *Tomorrow's Man* (based in New York), *La Culture Physique* (Paris), *Physique Pictorial* (Los Angeles), *Body Beautiful: Studies in Masculine Art* (London) and *Grecian Guild Pictorial* (Washington, DC) employed the alibis of art, physical fitness, bodybuilding and classicism to picture erotically exposed male bodies while avoiding prosecution on charges of obscenity.[22] The pages of these magazines were populated by male models, sunbathers and bodybuilders naked save for a posing strap, a bathing suit or a decorative codpiece. By presenting physique photography and the academic tradition of life drawing as 'studies in masculine art', such magazines sought to justify their elaborate, endlessly repeatable stagings of the male body.

Even as Kinsey acquired physique magazines for his archives, some of those same magazines celebrated the Kinsey report as a means of liberalizing attitudes towards homosexuality. In a memorable cover of *Tomorrow's Man* from 1954, a hunk in zebra-patterned bathing trunks poses against a matching backdrop superimposed with an off-angle sign announcing '*Those* Kinsey Reports: Page 18'. The cover of *Tomorrow's Man* bespeaks the dialogue

between homoerotic spectacle and American sexology at mid-century. By factoring in the traffic in images mentioned above, we can extend this link beyond the national borders of the United States. The example of David Hockney provides an excellent case in point. In the late 1950s Hockney enrolled as a painting student at the Royal College of Art in London. While an undergraduate, he subscribed to *Physique Pictorial* magazine, each issue of which would arrive from Los Angeles wrapped in plain paper. At roughly the same moment, Bob Mizer, the publisher and chief photographer of *Physique Pictorial*, initiated a correspondence with Kinsey and contributed multiple issues of the physique magazine to the Institute's archives in Indiana. During his last semester at the Royal College, Hockney's practice of painting and his interest in physique photographs intersected. Here is the artist, circa 1976, recalling the circumstances that led to his 1962 work *Life Painting for a Diploma*:

> **At the Royal College of Art in those days, there was a stipulation that [...] in your diploma show you had to have at least three paintings done from life. I had a few quarrels with them over it because I said the models weren't attractive enough; and they said it shouldn't make any difference i.e. it's only a sphere, a cylinder and a cone. And I said, well, I think it does make a difference, you can't get away from it. [...] Any great painter of the nude has always painted nudes that he liked; Renoir paints rather pretty plumpy girls, because he obviously thought they were really wonderful. He was sexually attracted to them and thought they were beautiful, so he painted them; and if some thin little girl came along he'd probably have thought, 'lousy model'. Quite right. Michelangelo paints muscular marvelous young men; he thinks they're wonderful. In short, you get inspired. So I got a copy of one of those American physique magazines and copied the cover; and just to show them that even if the painting isn't anatomically correct I could do an anatomically correct thing, I stuck on one of my early drawings of the skeleton and I called it in a cheeky moment Life Painting for a Diploma. It's mocking their idea of being objective about a nude in front of you when really your feelings must be affected. I thought they were ignoring feeling, and they shouldn't. It was a way of telling them something.[23]**

In responding to the academic requirement for life painting, Hockney insists on the importance of the artist's desire for the naked body he depicts. Far from the dispassionate study of the human figure as an ensemble of volumetric forms ('it's only a sphere, a cylinder and a cone'), Hockney proposes a necessary link between artistic achievement and sexual attraction. Although Hockney does not describe Renoir as heterosexual or Michelangelo as homosexual, his examples nevertheless imply that an artist's sexual interests colour his attention to and appreciation of the model who poses for him.

In the next part of this extended recollection, Hockney goes on to complain, rather phobically, about the 'old fat women' that the Royal College was allegedly in the habit of hiring as life models at the time and the need for what he

George Platt Lynes
Untitled
1948

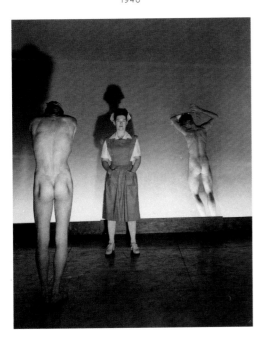

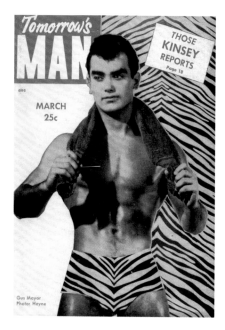

Cover of the March 1954 issue of
Tomorrow's Man magazine

calls 'some better models'. 'Better' turns out to mean young, male and muscular. According to the artist, he successfully lobbied the Royal College to hire one such model, a man named Mo McDermott, for its life classes, only to discover that 'nobody else at the college wanted to paint him; they didn't like painting male models, so I had him to myself.'

While Hockney may have had McDermott to himself, he showcased not McDermott's body in *Life Painting for a Diploma* but that of an American physique model. Hockney's inclusion of the word 'physique' in his work, or rather of the bottom two thirds of it, locates the male body as one that has already been photographed in a commercial magazine prior to its painted transcription by the artist, a body seen through photography and printed matter rather than through a direct study from life. It is also notable that the painting offers not the male nude but the male 'almost nude', the muscular body garbed in a posing strap. As though to draw out the links between painting, same-sex desire and medical science, Hockney juxtaposes the physique model with an anatomical drawing of a skeleton in profile.

Hockney's use of *Physique Pictorial* as a source material has long been acknowledged in the scholarly literature on his work. Yet the transcontinental traffic in physique images – from the Athletic Model Guild in Los Angeles to the artist in London (not to mention Dr Kinsey in Bloomington, Indiana, and many, many other customers in both the United States and abroad) – suggests a complex network of visual culture and sexual community that has remained almost entirely unexamined by historians.

While pictures of well-oiled and barely clad men proliferated in the physique magazines of the 1950s, lesbian pulp novels exploited an equally lavish imagery of 'strange sisters' and 'twilight girls'. Available for purchase in bus depots, drugstores and newsstands, the pulps linked lesbianism to a range of sensational vices including Satanism, drug use, prostitution, prison sex and, not least,

modern art. The most avowedly lesbian character in these novels (most often an older, predatory butch) was typically punished (abandoned, imprisoned or killed off) at the conclusion of the story as the younger femme discovered happy heterosexuality in the arms of a (real) man.[24] For many lesbian readers, however, it was not the moralizing ending that mattered but the extravagant staging of female lust and brazen homoeroticism that occurred along the way. The irresistibly lurid cover art for such pulps as *Women's Barracks*, *Strange Sisters*, *Her Raging Needs* and *Art Colony Perverts* ('They Lived Their Art in Depraved Orgies') portrayed lesbian life as unrepentantly sexy and deliciously wicked. At the height of their popularity during the 1950s and 1960s, lesbian pulps sold well into the millions of copies. And it was the cover art as much as the narrative itself that inspired lesbian and proto-lesbian readers. As pulp author Ann Bannon (*Odd Girl Out*, *Beebo Brinker*) would recall in 1999,

> **If there were two women on the cover, and they were touching each other, [...] even if they were just looking at each other, even if they were simply in proximity to one another, even if they were merely on the same cover together, it was reason to hope you had found a lesbian book. [...] The covers provided links among members of a wide-flung and incohesive community; a community that did not even think of itself as one and that, therefore, valued all the more any connection with others whose experience paralleled their own.[25]**

Though officially marketed to a male readership, the paperbacks were purchased by scores of women intrigued by (perhaps, even, aspiring to be) *Strange Sisters* or *The Girls in 3-B*. Even as these novels rejected the viability of lesbian love and life at the level of narrative, their flamboyant visibility helped to produce a sense of lesbian community.

David Hockney
Life Painting for a Diploma
1962

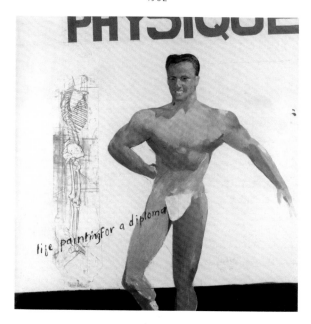

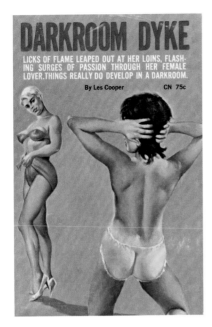

Cover of Les Cooper's novel
Darkroom Dyke
1965

Picturing Liberation

The Stonewall riots of late June 1969 are commonly taken to mark the birth of the modern gay and lesbian liberation movement. The story of the riots, in which patrons of a Greenwich Village bar spontaneously resisted arrest during a police raid and sparked three days of public uprisings, has been widely rehearsed, and the anniversary of the riots is now celebrated with Gay Pride parades and parties across the globe. There is little agreement, however, on precisely what happened at the Stonewall riots, how many people were involved, how long the stand-off lasted, how many members of the tactical police force were called to the scene and so forth. Adding to the event's unstable status within the historical record is the fact that no photographic images of the riots exist.

The pictures printed at the time and often reproduced in the years since were by Fred W. McDarrah, then chief photographer and picture editor at the *Village Voice*.[26] McDarrah's photographs, several of which feature a multiracial group of queer street kids posing, laughing and kissing each other outside the Stonewall bar, were taken just after the riots had ended.[27] The graffiti chalked on the exterior of the now boarded-up bar marks one response to the police raid and resulting violence of the preceding nights. Partially cut off by the left frame of the photograph, the graffiti's message read: '[THEY WANT US] TO FIGHT FOR OUR COUNTRY [BUT] THEY INVADED OUR RIGHTS.'

After photographing the scene outside the Stonewall, McDarrah entered the bar to shoot additional pictures. These interior shots feature not the bar patrons taunting, resisting or violently confronting police but rather the aftermath of those encounters: the remains of a battered bar stool, jukebox and cigarette vending machine alongside some trash cans. Taken after the clean-up process had begun, the photographs convey a sense of belatedness.

Given the spontaneity of the Stonewall riots, it may not seem surprising that no photographers were on hand to capture the scene. But if, as was reported at the time and supported by historians since, the riots spilled out onto Sheridan Square and ultimately involved hundreds, even thousands, of people over a three-day period, then the absence of photographic documentation becomes more striking.[28] This absence seems to have been regretted by gay and lesbian activists at the time, at least to judge from a 'plea to the community' printed in the 10 January 1970 edition of *Come Out*, the self-published newspaper of the New York city chapter of Gay Liberation Front, a radical activist group founded in the weeks just after the riots.[29] Printed beside the newspaper's masthead, the plea reads, 'Anyone owning or having access to photographs of the Christopher Street-Stonewall riots of last summer please call 477–4875 as soon as possible.'[30] *Come Out*'s 'plea' was made in the hope of running photographs of Stonewall in future issues of the paper. No such pictures appear in subsequent issues of the magazine, which ceased publication in 1972.

Given the absence of visual images of Stonewall, McDarrah's photographs of the bar's traumatized cigarette machine, shuttered exterior and empty street stand in for an event that could never be fully shown or known, even in its contemporary moment. Yet the photographs also speak to the importance of rendering that event visible, however belatedly. In lieu of the image of a wounded police officer or injured bar patron, a wounded jukebox would comprise a visual record of the uprising.[31] And in place of a photograph of rioting homosexuals, McDarrah would fashion a tableau of multiracial queer kids camping it up outside the bar. When it appeared in the *Village Voice*, the picture was captioned 'Outside the Stonewall'. But it could just as accurately have been described by the nearby headline: 'Gay Power Comes to Sheridan Square'.

Fred W. McDarrah
Photograph of crowd outside the Stonewall bar
shortly after riot, New York
1969

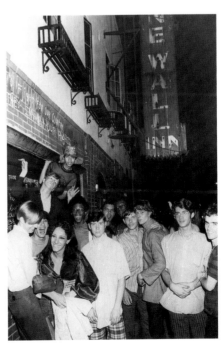

The *Village Voice* did not identify any of the people in McDarrah's photograph. However charismatic their appearance before the camera, the members of this queer collective were not granted the status of individuals by the newspaper in which they appeared in 1969. [32] One of those unnamed individuals – the young man on the far right in a striped T-shirt – was the artist Thomas Lanigan-Schmidt. A runaway from a working-class Catholic family and a self-described 'street rat', Lanigan-Schmidt worked odd jobs and occasionally sought public assistance while creating incongruously ornate art. In his otherwise undistinguished tenement flat, Lanigan-Schmidt created a high-camp fantasia of glitter, foil, gold leaf and detritus that he dubbed *The Summer Palace of Czarina Tatlina* (1969–70). Though virtually ignored by the established art world at the time, Lanigan-Schmidt was recognized as a kindred creative spirit by Jack Smith, the underground filmmaker, and Charles Ludlam, the founder and star of the Ridiculous Theater Company. Writing in the activist broadside *Gay Power*, Ludlam crafted 'A Fairy Tale' about Lanigan-Schmidt (whom he referred to as 'Mr T.') and the making of the *Summer Palace*:

> **If only he could combine his taste for botanicas, gypsy store fronts, and Puerto Rican boys with the grandeur that was Rome, [...] the grandeur that was St Petersburg. He prayed to St Catherine for a sign. And the sign came. He would build an Artorama, a genre more queer than Mexican folk art and a thousand times more detailed than Macy's Christmas windows. The Artorama would be the apotheosis of the Catholic religious holidays, Christmas and Easter rolled into one, an electric train, tin foil Wonder City where jewel encrusted rats in ecclesiastical garb murmur novenas in detailed replicas of Faberge Easter Eggs. [...] The things that Mr T. makes are not made to last. His is a transitory art that creates an illusion and then disappears. For this reason it might be called theatrical. The images dissolve before your eyes. Now it is an exquisite piece of jewelry or a relic of the true cross encased in a richness unmatched outside the Vatican. Then suddenly you realize it is made of Saran Wrap or Wondafoil. [...] The item appears worthless if seen from behind or from its 'bad' side. We turn it again and it becomes exquisite. This is Queen Art transformed by the genius of Mr T. into a metaphysical mockery.** [33]

Ludlam's 'Fairy Tale' was accompanied by a photograph of Lanigan-Schmidt brandishing a giant, gilded crucifix while standing in his Artorama. It can be thought of as a kind of pendant to the *Village Voice* photograph of the Stonewall kids from the summer before. Taken together, Lanigan-Schmidt's presence inside the *Summer Palace of Czarina Tatlina* and outside the Stonewall bar speak to the dialogue between camp and radical politics, the 'worthless' and the 'exquisite', the space of the streets and that of the artist's studio.

According to Lanigan-Schmidt, the only subjects who would agree to McDarrah's request for a group shot in front of the Stonewall bar were the 'street queens' (effeminate and flamboyant queers who hung out – and in some cases lived – on the streets) among whose number the artist counted himself. The 'husbands' (the more masculine, 'straight-

Thomas Lanigan–Schmidt
The Summer Palace of Czarina Tatlina
1969–70
(reconstruction at Holly Solomon Gallery, 1992)

acting' homosexuals) refused to be seen on camera for fear it would render them visible as, well, queer. [34]

The group that posed for McDarrah outside Stonewall included Sylvia Rivera – a Puerto-Rican-Venezuelan drag queen in a black satin top with handbag. Later that summer Rivera helped found the Gay Liberation Front, the first and most radical activist group to emerge in the aftermath of the Stonewall riots. In 1970, Rivera and her friend and fellow drag queen Marsha P. Johnson created STAR (Street Transvestite Action Revolutionaries), a group that provided short-term housing and financial assistance to hustlers and drag queens.

The framing of gay power as a defiance of conventional masculinity followed from the conviction that dominant models of gender, and especially of manliness, were themselves the core problem to be overcome. In the words of one gay-liberation manifesto, 'Gay revolution will see the overthrow of the straight male caste and the destruction of all systems of caste and class that are based in sexism.' [35] By way of visualizing this revolutionary goal, images of effeminacy, drag and genderfuck were featured extensively in gay-liberation publications. Warhol superstar Jackie Curtis (née John Holder, Jr) was a particular favourite of *Gay Power*, which devoted several features and one cover story to her life and work as a transgender poet, playwright and performer.

In this context, it is worth remembering that the liberationist use of the word 'gay' was intended to describe not only homosexual men – nor, for that matter, homosexual men and women – but to issue a broader call for political action and social transformation. In his 1971 manifesto, 'Out of the Closets', Allen Young wrote that 'gay, in its most far-reaching sense, means not homosexual, but sexually free. [...] This sexual freedom is not some kind of groovy life style with lots of sex, doing what feels good irrespective of others. It is sexual freedom premised upon the notion of pleasure through equality. [...] In a free society everyone will be gay.' [36]

Within a few years, however, the liberationist embrace of alternative gender roles and 'pleasure through equality' would be displaced by an increasingly vehement focus on homosexual manliness and the rise of a consumerist gay lifestyle severed from radical politics. While the earliest issues of *Gay Power* featured lesbian imagery and feminist graphics, such pictures

subsequently disappeared in the face of complaints from gay male readers who were 'turned off' by them.[37] By the time *Gay Power* became a wholly commercial venture in 1973, no women or transgender reporters, artists or photographers were among its contributors, and no coverage of radical gay activism ran in its pages. Following this shift, *Gay Power*'s tag-line was changed from 'New York's first homosexual newspaper' to 'the entertainment tabloid for today's gays'. The change was part of a wider repackaging of gay sexuality as a mode of urban pleasure (or form of entertainment) rather than as a means of political resistance and social critique.

In the late 1970s, the term 'clone' came to describe a highly codified style of gay self-presentation that appropriated the roles (cowboys, cops, construction workers) and attributes (moustaches, muscular bodies, laconic speech) of mythic American masculinity. The first published use of the term within a gay context has been attributed to a review in the *San Francisco Sentinel* (a local gay/lesbian newspaper) of an all-night disco event entitled 'Stars', which was held on an outdoor pier in the Spring of 1978. Written by Edward Guthmann, the review criticized the men attending 'Stars' for 'a new kind of mindless, wanton consumerism' and warned against the moment when 'we all turn into Castro Clones [...] buying the right levis and tee shirts, wearing the right bronzer, attending the right disco, sporting the right haircut'.[38] The review concluded with an earnest call for gay men to resist the clone lifestyle and recover their 'respect for individuality'.[39]

The gay clone, then, was criticized for embracing 'wanton consumerism' over expressive 'individuality' and superficial sameness over humanist depth. Through these very qualities, however, the clone revamped the dominant image of masculinity that he seemed merely to embody. Rather than presenting his butch act as an essential identity, the clone acknowledged the premeditation of his manly performance,

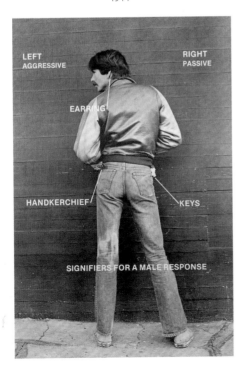

Photomontage for
Hal Fischer's book *Gay Semiotics*
1977

the homosexual labour of selecting the 'right bronzer', the 'right tee shirt' and the 'right haircut'. A 1982 essay in the *Advocate* argued for clone style as an avowed masquerade operating along the axes of both sexual orientation and class identity: 'We know the lumberjack cautiously eyeing the construction worker is really an accountant cruising a junior executive and that the cowboy and Marine who saunter down the street hand in hand are respectively computer programmer and college student. We know it's drag.'[40] The clone's performance of butchness as a kind of self-conscious dress-up, even a form of drag, distinguished his brand of machismo from its more earnest straight counterpart.

In 1977, the San Francisco-based photographer Hal Fischer created *Gay Semiotics*, a photo-text project that detailed the visual and sartorial codes of clone culture. Combining his interest in structuralist theories of communication (semiotics) with the vibrant gay scene in San Francisco, Fischer diagrammed the 'signifiers', 'fetishes', 'archetypical media images' and 'street fashions' popular among homosexual men at the time. Fischer's meticulous, quasi-scientific descriptions were often leavened with a line of deadpan humour, as, for example, in his account of the 'hanky code':

Handkerchiefs signify behavioral tendencies through both color and placement. A blue handkerchief placed in the right hip pocket serves notice that the wearer desires to play the passive role during sexual intercourse. Conversely, a blue handkerchief placed in the left hip pocket indicates that the wearer will assume the active or traditional male role during sexual contact. The blue handkerchief is commonly used in the treatment of nasal congestion and in some cases holds no meaning in regard to sexual preferences.[41]

Gay Semiotics documents the elaborate codes of gay sex culture in the 1970s while acknowledging the absurdity of its own seemingly dispassionate, strictly anthropological tone. Fischer wittily performs an ethnography on the sexual subculture of which he himself is a member.

As *Gay Semiotics* might suggest, the 1970s were marked by both an expansion of homosexual visibility and an increasingly sharp social and political division between gay men and lesbians, as well as between lesbians and heterosexual feminists. Tensions between male and female members of the Gay Liberation Front, for example, led a core group of women to leave GLF and found Radicalesbians, a separatist organization. Such divisions would become more ingrained as the decade progressed. The creation of lesbian-only spaces (communes, consciousness-raising groups, activist organizations, publications) responded in part to the sexism of gay men and to the homophobia of straight feminists but also, and more affirmatively, to the pleasures of erotic community. The Spring 1976 cover of *Dyke* magazine ('to be sold to and shared by women only!') offers a self-possessed trio of female friends as one such vision of community.

Inside the magazine, we learn that the trio on the cover ('Do, Linda and Pat') work at Bread and Roses, a lesbian-owned restaurant in Cambridge, Massachusetts, where, in lieu of leaving tips, diners were asked to make donations to local feminist causes.[42] In an interview published in this issue of *Dyke*, members of the Bread and Roses staff, including Pat,

address such issues as whether radical feminists can also be capitalist employers, the politics of serving meat (or, as one woman puts it, 'flesh') and the most effective ways to discourage men from dining in the restaurant.[43] The women who worked at Bread and Roses were part of a larger, lesbian-feminist community seeking to reconcile revolutionary goals with everyday realities.

The cover of *Dyke* plays off the well-known design of *Life* magazine (down to the white typeface set against red blocks of colour, the four-letter all-caps title and the black and white, virtually full-page photograph). Even as it rejects the mainstream visibility of a mass-distribution periodical, *Dyke* imagines a world in which three lesbians at their leisure might serve as a definitive image of 'life'. By claiming for its title an epithet often invoked to denigrate lesbians and other gender outlaws, *Dyke* defies the uses to which that word has been put in the past.

Lavender Menace

Phobic views of lesbians and gay men have issued not only from conservative leaders, government officials and orthodox religious organizations but also from individuals and groups otherwise committed to progressive politics. In 1969, for example, Betty Friedan, author of *The Feminine Mystique* and president of the National Organization for Women (NOW), declared lesbianism a 'lavender menace' that threatened to pervert the public image of feminism by associating it with deviant sexuality and unnaturally mannish (or worse, man-hating) women. Under Friedan's directive, NOW sought to distance itself from the most prominent lesbian rights group at the time – the Daughters of Bilitis.

In response, a group of lesbian activists planned a surprise protest (or 'zap') at the 2nd Annual Congress to Unite Women, a feminist assembly held in May 1970. The activists entered the opening session of the Congress and dutifully took their seats among the audience of about three hundred in the auditorium. As the first speaker was about to address the Congress, members of the insurgent group unplugged the microphone and switched off the lights. When the lights came back on a few moments later, the activists had stripped off their coats and long-sleeved shirts to reveal 'lavender menace' T-shirts underneath. The women identified themselves with – even flaunted – the phrase that Friedan had invoked as a threat to feminism. In so doing, they both declared the power of lesbian visibility and contested its phobic construction. The members of the Lavender Menace seized control of the meeting – of its agenda and discussion – so as to force the Congress to Unite Women to confront the issue of lesbianism head-on.[44]

Among the many remarkable aspects of this zap, the strategic presence of the photographer (and Gay Liberation Front member) Diana Davies should be stressed. Davies understood the task of visual documentation as a crucial

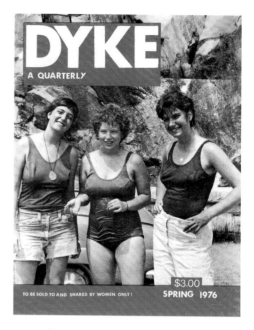

Cover of the Spring 1976 issue of *Dyke* magazine

component of the broader activist project in which she engaged. Although not visible in the photographs, she must be recognized as a central player both in the 1970 zap and in the symbolic power that it continues to carry as an image of lesbian resistance and visibility. Like the T-shirts worn by the protestors, Davies's photographs of the protest (not to mention those she took of numerous other demonstrations, marches and meetings) should be understood as performative images of homosexual activism rather than as snapshots of historical truth.

While visual rhetoric and sartorial style do not fully reveal the history of queer activism, neither can they be simply siphoned off as the cultural remainder or fashionable by-product of 'real' politics. The staging and circulation of visual images fuelled the activist goals of groups such as the Gay Liberation Front and Radicalesbians, no small part of which was attracting participation and affirming membership in the collective.

From the trials of Oscar Wilde to Betty Friedan's accusation of a 'lavender menace' and beyond, homosexual subjects have often been cast as the object of someone else's phobic representation. They have been framed as outlaws by the police, as sinners by the church, as perverts by the medical establishment, as security threats by the federal government. And yet, even as they have been subjected to the frequently violent force of these associations, sexual minorities have crafted ways to resist or exceed such definitions. In the process of becoming 'Dykes' and 'Flaming Faggots', of painting 'Friends of Dorothy' and photographing the 'Lavender Menace', they (which is to say we) have forged a living history of queer culture.

Inside the Body Politic: 1980—present
by Catherine Lord

'The discourse of the postmodern is the queer experience rewritten to describe the experience of the whole world.' — Nayland Blake [45]

Sontag as Metaphor

Had the artist Félix González-Torres not died of AIDS-related complications in 1996, he would doubtless have extended the inventories featured in his series of billboard timelines listing key events in queer culture. In addition to 'People With AIDS Coalition 1985 Police Harassment 1969 Oscar Wilde 1895 Supreme Court 1986 Harvey Milk 1988', his updated list would perhaps have read something like: 'Don't Ask Don't Tell 1993 Barnard 1982 *Gai Pied* 1981 Laramie 1998 Zero Patience 1993 Bristol 2008 Ellen 1997 Tinky Winky 1999 Susan 2004 Rachel 2009'.

Let us start with the penultimate entry, Susan – Sontag, that is, the novelist and essayist – using this figure to remind us that although the scope of this essay nominally begins in the 1980s, that decade was in fact well under way in the 1970s. In the late 1970s, AIDS was still masquerading as junkie pneumonia, and Sontag, having survived bucketfuls of chemotherapy for metastatic breast cancer, was at work on *Illness as Metapho*r, which she published in 1978 and in which she compared the dread diseases of two centuries. Tuberculosis, she said, was the disease of consuming passion, cancer the disease of repressed emotions. Like Ronald Reagan and his dear friend Maggie Thatcher, Sontag understood metaphor as a force of oppression, an opportunistic infection on the hunt for the soft tissue of cultural mystification, an arsenal created from the 'large insufficiencies' of our culture. [46] Illness, Sontag wrote, is not a metaphor but another country. The only way to get home is to fight metaphor to the death.

Ten years later, in 1989, she published *AIDS and Its Metaphors*. [47] In 2004, incredulous to the last breath, she died of blood cancer. By then she had been considerably bruised by identitarian attacks on her refusal to emigrate from (or, for that matter, repatriate herself to) yet another metaphor: the closet. Sontag dying and Sontag dead were intimately chronicled by photographer Annie Liebovitz. Neither *The New York Times* nor the *Los Angeles Times* noted Liebovitz as one of Sontag's lovers. Both papers remarked on Sontag's reticence to disclose personal information while nonetheless recounting as a matter of routine that she had once been married and that she had undergone a mastectomy. Gay and lesbian organizations and papers immediately protested this 'de-gaying'. A spokesman for *The New York Times* explained that since no 'authoritative source' would confirm any lesbian relationship, it had chosen not to use the phrase 'longtime companion' about Liebovitz because it would 'bear the unpleasant aroma of euphemism'. [48]

Sontag had never cared for euphemism. As Wayne Koestenbaum remarked after her death, in speaking, or not, about her practices, Sontag never found a closet that suited her. [49] Though her journals are being published only after her death – and reluctantly, it must be said, by her son David Rieff – it is evident that in the late 1940s, even as she worked through the vocabulary and practices of being gay, the young Sontag was not exactly timid in her adventures. Koestenbaum argues that she channelled the following statement – note the order of things – through one of the characters in her 1963 novel, *The Benefactor*: 'I am a homosexual and a writer.' Still later in the 1960s, but well before Stonewall, she eloquently defended two queers who had absolutely no desire to be domesticated as 'gay' – the writer Paul Goodman and the filmmaker Jack Smith. She outed herself in a *New Yorker* profile. Interviewed by *The Guardian* in 2000, she tallied her loves with amusement: 'Five women, four men.' [50] It is worth noting, one picture being worth a thousand open secrets, that both *The New York Times* and the *Los Angeles Times* accompanied their obituaries with one or another Liebovitz photograph of Sontag at her most seductive. In *The New York Times*, Sontag sprawls on a sofa in an oversized shirt, vibrant, apparently healthy, abandoned to her intellect and body. She is riveting.

Liebovitz's photographs of Sontag's illness and death were excoriated as 'carnival photographs of celebrity death' by her son. [51] 'She was the Butchest One of All', wrote former acolyte and literary critic Terry Castle, recalling her 'big mannish hair'. [52] Artist Paige Gratland, citing Sontag's roots in the gay aesthetic, fabricated in tribute a limited-edition feminist hairpiece called *The Sontag*. A silver-grey clip-on about an inch wide, it can be cut to any length and attached to whatever patch of hair the wearer fancies. 'Camp is the triumph of the epicene style', Sontag had opined in her most influential essay, noting the 'convertibility of "man" and "woman", "person" and "thing"' and acknowledging that the inventory she compiled to write 'Notes on "Camp"' was in and of itself a betrayal of her 'homosexual taste'. Perhaps, in their different ways, Rieff, Castle and Gratland were compiling their own notes on camp. '[T]o name a sensibility,' Sontag had written, 'to draw its contours and to recount its history,

Obituary for Susan Sontag in the 29 December 2004 issue of *The New York Times*, featuring a 1991 photograph of Sontag by Annie Liebovitz

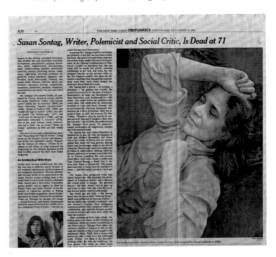

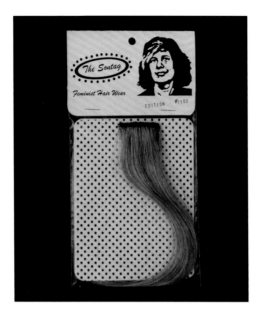

Paige Gratland
The Sontag: Feminist Hair Piece
2004–05

sexual practices are neither transcultural nor transhistorical. Meanings shift as sexual practices intersect with race, class and nationality – among other factors. To compound the difficulty, though the identities plausibly labelled 'queer' have multiplied with the flow of global capital and information, the word is not a transcultural signifier. An unwieldy piece of Anglophone baggage, 'queer' crops up in other languages as a loan word, stripped of the frisson of insult.

These reservations granted, let us also propose, borrowing from Paula Treichler, that the 1980s saw two epidemics of signification — that is to say, the 'exponential compounding of [the] meanings' of certain words (and pictures) through which the world is organized. [57] Both epidemics intensified the oscillation between metaphor and life. The first remains a global agony, the second continues to demarcate 'a horizon of possibility'. [58] One epidemic was called AIDS, and it raised the stakes of homosexual visuality to a matter of life and death. The other was the word 'queer'. It spread from closets to the streets, from sensationalized exposés to countercultural magazines, from bars to zines, from alternative galleries and to the occasional museum. Naturally, the concept insinuated itself into the academy. There, by the early 1990s, 'queer theory' posited productive critiques of various identity-based academic programmes of study, most notably those enterprises conducted under the rubric of 'gay and lesbian' or 'feminist'. Importantly, three enormously influential feminist theorists — Eve Sedgwick, Teresa de Lauretis and Judith Butler — took the first steps in deploying 'queer' as a concept that is 'less an identity than a critique of identity'. [59]

Redefining the Public

George Segal's *Gay Liberation* of 1980, installed across the street from the site of the old Stonewall Inn in Greenwich Village, consists of a bench and four life-size bronze figures. Two women sit. Two men stand. Everyone is young and apparently white. One woman looks butch, the other femme. Everyone is costumed in muscles that seem puny by today's

requires a deep sympathy modified by revulsion.' Her own death couldn't escape the artifice, the theatre, the hyperbole and the dexterity of the codes she herself had enumerated. [53]

How can one possibly untangle the nomenclature of Sontag's selves as she lived through several decades of historical change? Could she have been in the closet before the metaphor of 'the closet' came into play? Was she a feminist snob? A fag-hag of epic talents? A dyed-in-the-wool modernist with a weakness for Claire Morgan's pulp classic *The Price of Salt* [54] and any little morsel by Djuna Barnes? A bisexual polemicist? A single mom? A dyke caught between breast cancer, which she refused to see as either metaphor or punishment, and the so-called gay cancer, a metaphor inflicted as genocide? 'So we are out of the closet', writes Judith Butler,

but into what? what new unbounded spatiality? the room, the den, the attic, the basement, the house, the bar, the university [...] ? being 'out' must produce the closet again and again in order to maintain itself as 'out'. In this sense, outness can only produce a new opacity; and the closet produces the promise of a disclosure that can, by definition, never come. [55]

Acknowledging, once again, the insufficiency of language and the sway of insult, particularly in relation to sexual dissidence, let us call a queer a queer. It was one of the words with which Sontag described herself in the 1950s, [56] a word as subject to complacent historical erasure as the complexities of her life. At the same time, like the other words with which we test and by which we are tested, 'queer' comes loaded with meanings that are not entirely in our control. It surfaces – for instance in this volume – as a linguistic term for resistance to the norm. It signals the preposterous hope that one word might summarize the various subcultural permutations that function in opposition to a mainstream that is gendered as heterosexual and raced as white. But sex, sexuality and

George Segal
Gay Liberation
1979

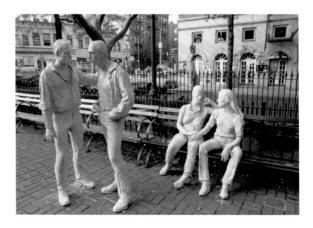

standards. Their jeans would now cost a fortune. Each couple engages in non-offensive touching and meaningful eye contact, making them, just as the sculpture's private funder stipulated, 'loving and caring'. Fucking in the nearby bushes has not crossed their young minds.

Segal made two versions of *Gay Liberation*, offering one to New York, the other to Los Angeles.[60] Los Angeles said no; New York said yes. After the neighbours complained, New York misplaced the funds to install the work until 1992. By then, 23,400 people had died of AIDS in the United States alone, giving the phrase 'loving and caring' an altogether different urgency. When *Gay Liberation* was finally unveiled, there were more complaints: not everyone had been consulted, all the figures were white, and a gay or lesbian artist should have received the commission. Others couldn't have cared less: gentrification had priced most queers out of Greenwich Village anyway; in the face of government indifference to AIDS deaths, gay communities everywhere had been obliged to educate themselves about safe sex and to bury their own; and the Gay Pride marches that had enabled *Gay Liberation* to be cast in bronze were under attack as sell-outs to corporate interests.

Gay Liberation was eminently legible in the category of what, by 1980, had been institutionalized by state agencies and mainstream art institutions as 'public' art. (Today of course, a webcam is trained upon Segal's sculpture, allowing anyone with access to the net to check out the sculpture as well as any cruising happening in the vicinity.) In 1980, however, 'public' signified audiences identified by race, class and ethnicity rather than sexuality. At the time, gays and lesbians were seldom named as either producers or consumers of their own public culture. In 1978, Robert Mapplethorpe's leather images, censored by a commercial gallery in San Francisco, had to be shown in an alternative space. He could not yet exhibit his 'faggot art' in what he called the 'legitimate art scene'.[61] At the end of the 1970s, lesbian artists 'existed almost entirely outside the boundaries of mainstream culture', as Terry Wolverton noted when looking back upon the 1978 'Great American Lesbian Art Show', organized in Los Angeles.[62] Consenting to invisibility was all too often the price of a lesbian's ticket to the commercial art market. Harmony Hammond, who curated a lesbian art show at 112 Greene Street, New York, in 1978, recounts that one prospective exhibitor's gallerist threatened to drop her if she participated. The intersection of feminism and the art market that allowed some women artists to thrive in the later 1980s was not yet in operation. The few successful women artists of the late 1970s had to make other choices. Louise Nevelson, for example, courted for the *Gay Liberation* commission, made the difficult but understandable decision to reinforce her closet. 'It is amazing', John Perreault observed in 1980, having himself recently come out into the pages of the art press, 'that the art world has been so little affected by gay liberation. [...] Everyone is "accepting" as long as you keep quiet and don't ask embarrassing questions.'[63] Sarah Schulman recalled – though hyperbolically, given that there were five gay art galleries in New York alone – of her wheat-pasting activities with the Gay Art Guerillas in 1982, '[T]here was nobody who was showing gay and lesbian art.'[64] Those who did want to do so were caught between cultures and generations.

Dan Cameron, reflecting upon 'Extended Sensibilities: The Homosexual Presence in Contemporary Art', the pioneering exhibition he organized in 1982 at the New Museum in New York, observed later that the gay art world professionals with whom he spoke warned him that curating such a show would end his career, while the 'guardians of gay art' in New York would help him only if he ceded control to them.[65]

Lacking the luxury of declining a commission like *Gay Liberation*, dissident artists of Schulman's generation began to make their own incursions into urban space. For a New York minute, between punk and the East Village, the scene was one of 'surprising generosity', in Nayland Blake's phrase.[66] Xerox flyers wheat-pasted onto hoardings, like Jenny Holzer's *Truisms*, rendered hollow the authority of public signage. David Wojnarowicz's spray-painted graffiti on the Chelsea piers occupied a heavily trafficked sex site almost invisible to a purportedly straight world. The sprawling 1980 'Times Square Show' tacked works on paper, for all practical purposes anonymous, upon the walls of a disused building. In the subways, Keith Haring waylaid the foundations of commerce, taking as a drawing surface the black paper panels awaiting advertising posters. In *Da Zi Baos* (1982), the collective Group Material took the facade of S. Klein's out-of-business department store as a 'democracy wall' and fabricated protest posters from various other political groups, among them the Committee in Solidarity with the People of El Salvador.[67]

In London, Jill Posener recorded (and no doubt produced) lesbian/feminist 'refacings' of the discursive space of billboards. 'We can improve your nightlife', read the text above an image of an almost naked woman on a mattress. 'JOIN LESBIANS UNITED' was the spray-painted retort. 'If it were a lady it would get its bottom pinched', opined the copy over a Fiat. 'IF THIS WOMAN WERE A CAR SHE'D RUN YOU DOWN', countered the women.[68] With their cheap, sly, hit-and-run tactics, such activists refused the mass-media definition of 'success', working their alterations on a precise and local level. The interventions nudged cultural politics out of the realm of hortatory visuality – that is, the positive imaging of identity – and turned subcultural representation into a matter of scanning between the lines and reading the writing on the wall. These tactics would be picked up by AIDS activists and, later, by web artists.

At the same time (the very end of the 1970s) – as Margaret Thatcher became prime minister in the UK (1979) and Ronald Reagan president of the USA (1980) – conservatives in both countries developed an agenda that used the idea of 'family' as a means of social control. Aided by nascent technologies of direct mail, they stripped back advances in reproductive and gay civil rights, worked to limit the public exchange of ideas and information, instituted the surveillance of library users, and honed their objections to free speech. In the USA, conservatives targeted state-funded 'political' (that is, progressive) culture, identifying culprits ranging from the behemoth of public television to struggling artist-run organizations and outspoken art critics. They objected to wasting taxpayers' money on 'bad' art, the most vivid example being Richard Serra's *Tilted Arc*, paid for with federal funds and installed in New York's Federal Plaza in 1981. Greeted as an inconvenience, an eyesore and possibly a menace to public safety, *Tilted Arc* was destroyed in 1989.

The campaign against wasting taxpayers' money segued into a campaign against the porn industry and from there to the suppression of artists' images deemed to be obscene. The battles over repression were promptly dubbed 'the culture wars'. While the newly empowered right perfected the technique of taking difficult images out of context and using them to mobilize its constituency, the arts community divided over the most effective response, generally emphasizing, as Richard Bolton points out, 'the right to free speech rather than the right to sexuality'.[69] Well-established organizations defended freedom of expression in general terms, but did little to defend smaller organizations or the rights of artists who made explicitly homoerotic work. There was no outcry among liberal groups when government restrictions eliminated funding for 'homoerotic' art. 'Even well-intentioned arts organizations leading the anti-censorship battle', Holly Hughes complained, 'are reluctant to speak up for us.'[70]

Nicholas Nixon
Tom Moran, East Braintree,
Massachusetts, November 1987
1987–88

AIDS, Sex and the Visual

No one but small groups of white urban gay men paid much attention to the announcement in 1981 that a puzzling new disease had erupted in San Francisco and Los Angeles – the gay flu, or Gay Related Immune Deficiency Syndrome. What in a year or so would come to be called AIDS intersected with the conservative cultural agenda that subjected to phobic moralism not only homosexuals but also intravenous drug users, Haitians and sex workers. In this constellation of deviances, struggles over cultural self-representation were redefined. 'It was frequently unclear', commented British theorist and activist Simon Watney, 'whether a new disease or a new social constituency, "homosexuals", had been discovered'.[71]

AIDS was initially pictured not in or on a body but through schematic medical diagrams and microphotographs of T cells besieged by what was then called the AIDS virus. In 1982, when the gay and lesbian press first began to cover the disease, it borrowed these scientific renderings. In 1983, after the *Journal of the American Medical Association* ventured that transmission might not be a punishment specifically visited upon homosexuals but a result of sexual practices also relished by heterosexuals, the mass media began to interest itself in the disease and its effect upon so-called 'innocent'

Lee Snider
Photograph of AIDS protest in Central Park, New York
1983

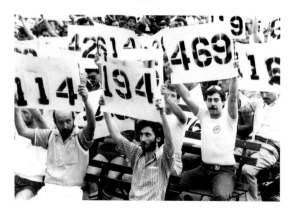

victims, meaning heterosexuals and children. The press sought to photograph people with AIDS – the more visibly ill the better – to scapegoat the supposed culprits in disease transmission.[72] In the face of escalating media panic, as well as persistent AIDS denial in various gay communities, activists fought to increase awareness of the crisis while resisting the picturing of people with AIDS (PWAs) as moribund, emaciated and wasted. Counter images were at first circulated in queer communities – family albums, for example, home movies and the snapshots used in the obituary columns of the gay press. Vigils, demonstrations and funerals were recorded by amateurs as well as by trained photographers such as Bettye Lane and Lee Snider,[73] whose 1983 photographs of demonstrators at a memorial service in New York's Central Park suggest a bemused yet empathetic collaboration between photographer and his subjects in the representation of resistance. The images suggest a wobble in genre, a presentation of illness to the camera that falls somewhere between the exuberance of those 1970s gay-lib marches and the robust rage that AIDS Coalition to Unleash Power (ACT UP) mustered to refute their status as victims. In Snider's photographs, police barricades keep onlookers at a safe distance from the demonstrators sitting upon benches, each witnessing with his body (only two or three women are visible in the photograph) and with the number stencilled upon his placard, one of the AIDS deaths that had by then occurred in New York.

The most astonishing thing about the photographs is that the highest number visible is 604. Debates about the relationship between picturing AIDS and picturing queers exploded in 1985 with the death of Rock Hudson. The celebrity performance that had defined heterosexuality was revealed to be just that – a performance. Ronald Reagan, silent for five interminable years on the virus, was forced to speak the word. In the mass media, AIDS was assigned a set of visual codes that became a locus of fascination, profit, reproach and contestation. In ways reminiscent of the 1950s panics about the commies and queers lurking beneath the facade of American patriotism, heterosexuality as a presumptive identity became suspect. Homosexuals could

Ross Bleckner
8,122+ as of January 1986
1986

be visually branded by equating them with the AIDS virus, and thus excised from the body politic. '[T]there is no way', argued Watney, 'in which a person with AIDS can hope to enter the public space of photographic representation save as a sign of mortality.'[74]

One challenge for queer artists and intellectuals, then, was to defy the ways in which they were framed by someone else's picture of illness. In 1988, the Museum of Modern Art in New York opened a well-publicized exhibition by the photographer Nicholas Nixon titled 'Pictures of People', one section of which was called 'Pictures of AIDS'. By this was meant not portraits of the diverse men, women and children then living defiantly *with* AIDS but, in the main, white homosexual men visibly on their way to dying *of* AIDS. (Jan Zita Grover reports that, in an informal discussion at the museum, Nixon admitted to turning away some PWAs who wanted to be photographed because they weren't sufficiently 'interesting'.[75]) 'Stop looking at us; start listening to us', read the ACT UP flyer distributed to museum visitors in protest against the Nixon exhibition. 'We demand the visibility of PWAs who are vibrant, angry, loving, sexy, beautiful, acting up and fighting back.'[76]

It is important to acknowledge, nonetheless, that most visual artists were slow to develop representational strategies that met these conditions. In the early days of the crisis, few of those working in the 'most commodified media', to use the phrase of critic and activist Robert Atkins, one of the organizers of a pivotal travelling exhibition on AIDS, rose to the challenge.[77] Ross Bleckner's paintings of flickering lights and coded numerical references to AIDS deaths are a remarkable exception. Mark Morrisroe's self-portraits after his diagnosis are an understated extension of the hundreds of Polaroid photographs with which he documented the quotidian details of his life – tricks, possessions, friends and his own hospital room. For the most part, though, video makers,

writers, performance artists and documentarians such as Ann Meredith and Gypsy Rose were the first to take on the responsibility for empathetic and positive representations.

Resexualizing the Queer Body

State and media response to the AIDS crisis equated disease transmission not with the exchange of bodily fluids but with the supposedly unspeakable and therefore endlessly fantasized 'lifestyle' of gay men. In consequence, rather than undertaking campaigns to inform everyone about safer sex, efforts were made to sanitize queer culture by eliminating the institutions fundamental to its formation – for example, bathhouses and cruising areas. Not only was the queer community obliged to undertake its own programme of education but it also had to insist that health-care issues did not foreclose the right to pleasure. In saving the gay body from those who would let it die or lock it up, the 'erotic', as Jan Grover noted, itself became 'a medium of information'.[78] *How to Have Sex in an Epidemic: One Approach* (1983) by Michael Callen and Richard Berkowitz was the first in a series of brochures, flyers and booklets produced by gay-health organizations to provide hot, accurate, funny representations of safer sex acts. In the same year, organizations of prostitutes in San Francisco and New York began to distribute information on safer sex practices, PWAs campaigned in Denver, and the group of artist/activists known as Metropolitan Health Association stickered New York City subways. 1985 saw similar didactic material distributed in bars and bathhouses by the Gay Men's Health Crisis in New York, the Sisters of Perpetual Indulgence in San Francisco, the Terrence Higgins Trust in the UK, and the West German AIDS-Hilfe. Information on safe sex for women – both lesbian and heterosexual – came from the veteran feminist press Firebrand, which commissioned Alison Bechdel to illustrate *Making It: A Woman's Guide to Safe Sex in the Age of AIDS* (1987) by Cindy Patton and Janis Kelley.

Video-makers working in a documentary tradition were the first to politicize both the pleasures of the gay body and the rhetoric used to contain it. John Lewis's *Chance of a Lifetime* (1983) used a smorgasbord of men to demonstrate safer

Mark Morrisroe
Untitled (Self-Portrait at home with Diane Arbus)
c.1984

Alison Bechdel
Illustration for Cindy Patton and Janis Kelly's *Making It:
A Woman's Guide to Safe Sex in the Age of AIDS*
1997

sex practices. Stuart Marshall's *Bright Eyes* (1984) linked the homophobia surrounding the AIDS crisis with the Nazi eugenics movement. 1987 saw three videos pivotal to the representation of people with AIDS. Stashu Kybartas's *Danny* eroticized a body covered with lesions. Isaac Julien's *This is Not an AIDS Advertisement* and John Greyson's *The ADS (Acquired Dread of Sex) Epidemic* both emphatically rejected the proposition that ending the crisis meant ending queer sex practices. Faced with considerable scepticism in high-art circles about the merits of either 'political' art or video art, the self-professed 'twenty-three-year-old faggot' Gregg Bordowitz argued passionately that documentaries about AIDS health workers and PWAs constituted in themselves an ethical artistic practice inseparable from community organizing. [79]

Linking health activism and sexual pleasure owed an enormous – if not widely acknowledged – debt to the feminist struggle for women to win control over their own bodies. Much of the historical research, cultural analysis and legal defence that laid the groundwork for a sex-positive queer culture during the AIDS crisis was instigated by the queer leather community and pro-porn lesbians and feminists. In San Francisco, Samois's *What Color is Your Handkerchief: A Lesbian S/M Sexuality Reader* sold out four printings after its publication in 1979. Pat (now Patrick) Califia's *Sapphistry: The Book of Lesbian Sexuality* (1980) brought the 1970s feminist strategy of self-education in health matters to the sadomasochistic (S/M) community. The book included anecdotes, fantasies, fiction, theory and history, as well as tips on techniques and retail outlets for accoutrements. *Sapphistry* featured several drawings by sex activist Tee Corinne in which she paid tribute to an earlier generation of lesbian erotic artists – among them that obscure Suzy Solidor fan Mariette Lydis. Samois's anthology *Coming to Power* (1981) provoked a furor by advocating practices and fantasies deemed by anti-porn feminists to be degrading to women. The anthology featured a visionary essay by Gayle Rubin, in which she outlined the concept of erotic communities based on sexual practices rather than the gender identities of sexual partners. [80] Pointing out that heterosexuals and homosexuals who practised S/M were equally ostracized as perverts, Rubin reasoned that divisions around sexuality were based not on a homosexual/heterosexual binary but on

a Dante-esque hierarchy that calculates damnation through the permutations of acts viewed as legitimate (reproductive, heterosexual, monogamous and infrequent) and acts viewed as deviant (recreational, homosexual, promiscuous and frequent).

Coming to Power also included a few pictures of lesbian S/M practitioners in full leather regalia by photographers such as Honey Lee Cottrell. 'Most of my work', she said later, 'is a point-for-point retaliation for the damages done to me.' [81] She did not exclude her lesbian sisters from the list of her oppressors. In the self-portrait *Bulldagger of the Month*, a spoof on the concerns about women's 'objectification' registered in feminist publications such as *Off Our Backs*, Cottrell's visibly aging body is half naked and wholly defiant. This butch sees nothing wrong with putting women to sexual use.

Bulldagger couldn't be further in intention, or in audience, from Cathy Cade's wholesome portraits of 'Ann'. To produce *Lesbian Photo Album: The Lives of Seven Lesbian Feminists* (1987) Cade photographed carefully selected women over a period of several years, then sequenced interviews and images to convey the somewhat sanitized complexities of her subjects' love and work lives. To resurrect a truism of the 1970s, in Cade's photographs, feminism is the theory and lesbianism the practice. In Cottrell's photographs, queer is the theory and pleasure the practice. Importantly for the articulation of 'queer' culture, though early documentation of the leather scene by artists such as Cottrell, Mark Chester and Claire Garoutte abided by gender apartheid, the scene and its structuring fantasies included encounters between men and women, biological or performative. 'I have sex with faggots,' proclaimed Pat Califia in 1983, 'and I'm a lesbian.' [82]

At the end of the 1980s, the arguments about the picturing of queers echoed the fissures within 1970s American and European feminist movements. Anti-porn groups such as Women Against Pornography (WAP) proclaimed that pictures

Honey Lee Cottrell
Bulldagger of the Month
1981

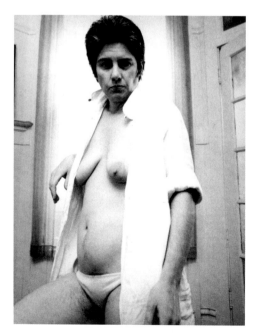

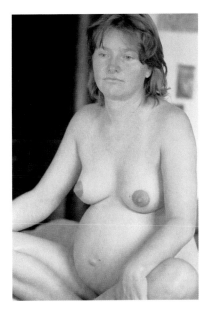

Cathy Cade
*I'm resting, not putting out,
letting the white girl smile drop*
1981

AS WELL.' So railed David Wojnarowicz in *Witnesses: Against Our Vanishing*, the 1988 catalogue of the exhibition that brought the wrath of US Senator Jesse Helms down upon a small nonprofit artist-run gallery in Manhattan.[85] Queer artists, therefore, had to complicate the picturing of their own bodies. More important, they had to re-territorialize the diseased society they had contracted, to infect that society with their dissent, their self-representation and their stubborn presence.

Blocks of design-savvy posters debuted in New York late in 1986, sniped on hoardings around lower Manhattan: 'SILENCE = DEATH', bold, white, all caps, Gill Sans on a black background underneath a pink triangle. The graphic migrated to T-shirts and buttons, becoming the first fundraising device of ACT UP, a loose direct action alliance of people of various sexualities, genders, races and classes. Though the insurgent energy of ACT UP faded in the early 1990s, to be replaced by groups such as Queer Nation, it would be difficult to overstate ACT UP's importance in securing resources to combat the AIDS epidemic and in the formation of queer identity. Some gays and lesbians, particularly those of earlier generations, were appalled by ACT UP's resurrection of the symbol used to mark the homosexuals shipped off to concentration camps, but in fact the triangle had already been reclaimed in the 1970s. It was used as a graphic by underground papers such as *Gay Sunshine* (San Francisco), the *Body Politic* (Toronto) and the Pink Triangle Press (London). SILENCE = DEATH, however, resignified the triangle for a new generation, refuting the equation HOMOSEXUALITY = AIDS = DEATH and aligning the genocidal indifference of American AIDS policy with a eugenics rationale that had swept off the map not only Jews but also communists, gypsies and homosexuals.

To be effective, ACT UP had to ensure a broad-based collaboration between scientists, visual artists, performers, community activists, cultural workers, health workers, street activists, scholars and theorists. (AIDS activism shaped many

of women in 'degrading' positions incited men, inherently aggressive, to violence. Other feminists argued that such fear-mongering tactics – whether deployed by feminists or family-values conservatives – made it difficult if not impossible for women to imagine and to seek their own sexual pleasure. In 1982, a group of feminists that included Califia, Kate Millett, Cherríe Moraga and Carole Vance – among other lesbians – planned and hosted a conference that was picketed by WAP and closed down by the Barnard College administration on the grounds that the organizers were promoting pornography. The debacle led to a pivotal series of small-press or academic anthologies that theorized the rewards of deviant sexuality, notably *Pleasure and Danger* (1984), *Powers of Desire* (1984), Gayle Rubin's essay 'Thinking Sex' (1984) and, a few years later, the pornography collection *Caught Looking* (1986).[83] In such projects, relations between visual artists and writers were both generative and strained. The phrase 'Her Tongue on My Theory' deftly summarizes the tensions. It titles a series of staged photographs of lesbian sex scenes by the Vancouver lesbian collective Drawing the Line that travelled widely between roughly 1988 and 1991. Drawing the Line mounted their photographs under Plexiglas so that the women in their audience could, literally, inscribe their conflicting readings over the images. (Men were asked to use a comment book placed to one side.) 'This is what the man who raped me said women like,' scrawled one woman. 'These pictures weren't made by the man who raped you,' read the reply. 'He's the one to be angry at, not these photos.'[84]

Reinfecting the Body Politic

'WHEN I WAS TOLD THAT I'D CONTRACTED THIS VIRUS IT DIDN'T TAKE ME LONG TO REALIZE THAT I'D CONTRACTED A DISEASED SOCIETY

ACT UP
SILENCE = DEATH
1987

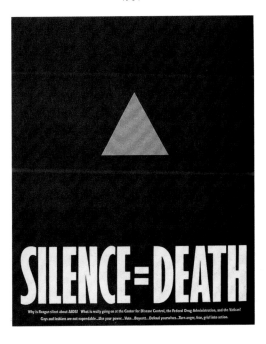

SILENCE=DEATH

Why is Reagan silent about AIDS? What is really going on at the Center for Disease Control, the Federal Drug Administration, and the Vatican? Gays and lesbians are not expendable...Use your power...Vote...Boycott...Defend yourselves...Turn anger, fear, grief into action.

academics who would produce foundational texts of queer theory: Douglas Crimp, Jan Zita Grover, David Halperin, Simon Watney and David Román among them. Their texts, in turn, shaped and provoked the work of queer artists and curators.) Though fully aware of 1980s postmodernist critiques of originality and authorship, the artists associated with ACT UP turned such ideas to less ironic use. No one claimed authorship of graphics and text bytes – precisely in order to render them copyright-free and easy to replicate. ACT UP produced signs – in every sense of the word – around which to rally, making gifts of the visual to a burgeoning movement. Translated into the appropriate languages, the graphics spread across the US and Europe, erupting as placards in protests and marches, as stickers placed in buses, taxis, subways, bathrooms and road signs, and upon bodies accessorized with buttons, baseball caps and T-shirts.

William Olander, senior curator at the New Museum of Contemporary Art in New York and a member of ACT UP, offered the collective of artists that evolved from the SILENCE = DEATH project their museum debut. Gran Fury's *Let the Record Show*, installed in 1987 in New York City at the New Museum's project space, featured a photo mural of the Nuremberg trials below a pink neon version of SILENCE = DEATH. The installation included photo silhouettes of six of the most vicious homophobes in the US, each paired with his own words, entombed in concrete. William Buckley, for example, famously advocated that PWAs should be tattooed on the buttocks, while Senator Jesse Helms favoured quarantine.

Gran Fury's early interventions had, when necessary, relied on bootlegged Xerox posters, but the group understood that invitations such as Olander's would allow them to fabricate and distribute their messages on a grander scale than they themselves could finance. They correctly predicted that their audience would increase in proportion with the media outrage that their works generated. Their billboard

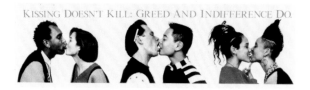

Gran Fury (with Aldo Fernandez)
Kissing Doesn't Kill: Greed and Indifference Do
1989

Kissing Doesn't Kill, commissioned by the American Foundation for AIDS Resources, took to the road on the sides of buses in 1989, winning press attention and attracting vandals in Chicago, Los Angeles and New York. The billboard depicted same-sex couples kissing, and the accompanying copy made it clear that this was no liberal plea for tolerance: 'Corporate greed, government inaction, and public indifference make AIDS a political crisis.' Invited to participate in the Venice Biennale of 1990, Gran Fury produced a triptych of panels that juxtaposed a photograph of the Pope, a screed against the Catholic church's 'preference for living saints and dead sinners', and, dead centre of an enlarged placard, an erect pink penis. The high-profile international fracas was predictable, charges of blasphemy and kitsch being countered with a spirited defence of artistic freedom.

The viral metaphor served as a generative tool for several groups, enabling production and inflecting distribution. A Toronto collective composed of the artists Jorge Zontal, Felix Partz and A A Bronson had collaborated since 1969 under the skirts of the drag avatar Miss General Idea, who first brought herself to public attention by hosting a pageant in her honour at the Art Gallery of Ontario. In 1987, at the height of the AIDS epidemic in North America, General Idea appropriated Robert Indiana's 1964 painting *LOVE*, by then a staple of international kitsch, and 'refaced' the image as a branding campaign to increase awareness of AIDS. In North America and Europe, General Idea's *AIDS* appeared on billboards, posters, hoardings, gallery walls and the cover of any magazine that would accommodate the project – among them *Ontario Dentist* and the *Journal of the American Medical Association*. General Idea's success spawned its own backlash. In 1988, Gran Fury used the AIDS logo to format the painting *RIOT*, and in that same year, Marlene McCarty used the format for a painting titled *FUCK*.

In San Francisco, then seen as something of an outpost of the international art market, another viral mutation began. Under the leadership of Cleve Jones, the collective energy that drove the annual vigils held to mark the assassinations of San Francisco Supervisor Harvey Milk and Mayor George Moscone were chanelled to address the AIDS crisis. In an era when funeral homes routinely declined to handle the bodies of those who had died of AIDS, and relatives (as many still do) routinely declined to recognize the surviving queer family, the *AIDS Memorial Quilt* gave a larger meaning to local rites of grief. As other cities and towns joined the project, the *AIDS Memorial Quilt* served as a formula for portable sculpture that built at once a web of mourners and a team of producers. At the *Quilt*'s first display

Gerard Julien
Photograph of ACT UP demonstration
at Place de la Concorde, Paris
1993

on the Washington Mall in October of 1987, 1,920 panels were displayed. By 1996, when it was last displayed in full, 44,000 panels blanketed the Washington Mall.

In Spain, artists and intellectuals were virtually silent about AIDS until the early 1990s, when performance artist and sculptor Pepe Espaliú organized friends and allies to support his wasted body in their arms and carry him through the streets of Madrid. *Carrying* theatricalized a relay of associations: not simply the vectors of the virus itself, but the transport of an infirm body and a collective transport of the soul. To carry the body of the artist was to incarnate all these meanings. Like the *AIDS Memorial Quilt*, Espaliú's project spawned offshoots inside and outside the art world. In San Sebastián, Carrying Society events involved the testimonies of a group of people with AIDS. In Barcelona, PWAs conducted carryings around a prison where many of the inmates had AIDS.[86]

Viruses run their course, however. Like Robert Indiana's *LOVE* and like General Idea's *AIDS*, the red ribbon that painter Frank Moore designed in 1991 was rapidly appropriated to feed an industry of kitsch accessories. The AIDS awareness ribbon was, in turn, annexed by enterprises surrounding other invisible epidemics – most notably, breast cancer. Elsewhere, as David Goldblatt's series of South African urban landscapes *in the time of AIDS* suggests, the ribbon has been buried in the landslide of multinational signage. Over the last decade, the Names Foundation has quietly laid off staff and warehoused most of the quilt panels. These are now attended by a few conservators and by younger artists interested in reanimating oppositional histories. Andrea Bowers, for example, whose meticulous drawings rework the graphics of early protest movements, has made laborious renderings from photographs of certain quilt panels. In this homage to invisible labour, what is lost in translation is a prerequisite for having a future.

Nasties and Dandies

The art world's putative multiculturalism of the 1980s existed in uneasy relation to gay and lesbian culture. Sandy Nairne's *State of the Art: Ideas and Images in the 1980s*,

General Idea
Infections
1994

a British survey of the decade, was a television programme followed by a book of the same title. Though based in identity politics, neither book nor programme mentioned homosexuality or AIDS. 'The Decade Show: Frameworks of Identity in the 1980s' was the blockbuster American equivalent, installed at three New York museums. Gay and lesbian issues were treated only under the rubric of AIDS, which in turn was presented as a subset of 'activism'.[87] During and after the 1980s, then, gays and lesbians struggled to distribute their presence in the intricate network of institutions called the art world. They organized film festivals, published anthologies, convened conferences and curated a steady stream of exhibitions addressing diverse issues of queer representation, printing catalogues whenever possible.[88] During the same period, certain gay artists were included in high-profile venues such as the Whitney Biennial – David Wojnarowicz in 1985, Robert Gober and the collaborative team of McDermott and McGough in 1987, Félix González-Torres and the collective Group Material in 1991. But as the superimposition of AIDS and homosexuality became ever more difficult to disentangle and the attacks on 'obscene' images ever more ardent, those interested in defining the terms of queer visibility inevitably had to confront the assumptions of identity politics. There were disputes about the conditions under which particular kinds of images ('positive'? 'negative'?) made by gays and lesbians could be shown, and arguments about whether gays and lesbians should be viewed together as an identity category. Such differences made more evident the divisions in a fictive community. Richard Hawkins and Dennis Cooper's 1988 exhibition 'Against Nature', held at Los Angeles Contemporary Exhibitions, is a case in point. While the subject was AIDS, the exhibition reinscribed a hotly contested stereotype by including only 'homosexual men', a fey anachronism used by the curators to take a jab at prescriptive ideals of 'multiculturalism'.[89]

Censorship campaigns in the US and the UK came to a head in the latter part of the 1980s. In 1987, the UK passed Section 28, which prohibited local councils from using government funds to 'promote homosexuality' or a 'pretended family relationship'.[90] In the same year, just as organizers ironed out the last details for unrolling the AIDS

Pepe Espaliú
Carrying Project, Barcelona
1991

The Names Project
AIDS Memorial Quilt Panels
1989

Quilt on the Mall for the first Gay and Lesbian March on Washington, Senator Jesse Helms was busy scandalizing his colleagues with photocopies of the Gay Men's Health Crisis safe-sex comics. Helms attached an amendment to a bill funding AIDS research and education that prohibited federal spending on '[AIDS] prevention materials or activities that promote, encourage, or condone homosexual activities or the intravenous use of illegal drugs'.[91] In May of 1989, on the floor of the US Senate, Alfonse D'Amato ripped up an exhibition catalogue containing Andres Serrano's photograph, *Piss Christ*. In June, the director of the Corcoran Gallery cancelled Robert Mapplethorpe's posthumous retrospective, 'The Perfect Moment'. In October, the US Congress passed a law forbidding federal funding of 'depictions of sadomasochism, homoeroticism, the sexual exploitation of children, or individuals engaged in sex acts and which, when taken as a whole, do not have serious literary, artistic, political, or scientific value'.[92] Later in the fall, the chairman of the National Endowment for the arts revoked funding to 'Witnesses: Against Our Vanishing', mainly because of David Wojnarowicz's 'strategically incendiary' essay.[93]

Such assaults rigidified the boundary between the public and private spheres, constraining any hope of reciprocity, or porousness, between the two. As Carole Vance eloquently argued at the time, 'diversity in images and expression in the public sector nurtures and sustains diversity in private life. When losses are suffered in public arenas, people for whom controversial or minority images are salient and affirming suffer a real defeat.'[94] Whether the suppression of images was forced or self-imposed, whether the arguments were conducted in courtrooms or voiced in the corridors of small nonprofits, the debates over censorship not only restricted what could be seen in public but had the effect of making 'the public' a club with limited membership.

Some artists insisted upon their right to place explicit sexual figuration in the public sphere. Others turned to strategies of code, embedding their references to queer culture in the languages of high art. In doing so they withheld from the radical right, not to mention jittery curators and arts administrators, the images that troubled them or that they fantasized to exist. González-Torres was perhaps the most influential proponent of this tactic, outwitting the censors by presenting not the offending homosexual body but conceptual translations of queer content. His minimalist 'pours', for example, offered for the taking hundreds of pounds of candy, arranged in corners or in rectangles upon the floor, as bait for an audience that might or might not have understood the viral referent. In one of these works, *"Untitled" (Portrait of Ross in LA)* (1991), González-Torres keyed the weight of the candy to the 'ideal' weight of his lover: 175 pounds. Those who ingested the Fruit Flashers had thus been seduced into swallowing queer intimacy. In other works – pairs of clocks, or chairs, or photographs of seagulls and the indentations left upon pillows – González-Torres insinuated coded references to queer coupledom into 'public' space. Similarly, Hunter Reynolds's drag incarnation, Patina du Prey, appeared over the years in a ball gown stencilled with lists of those dead from AIDS. A funereal and elegant black, with matching gloves, the gown is a costume that layers one cultural ritual upon another – the political funeral and the drag ball.

Mourning and Monuments

Culture is lived experience *and* historical memory. Excluded from, or misfiled in, the archives and institutions that consolidate a historical record, minoritized cultures generally lack access to the very materials that might structure their lived experience.

'As a woman, as a lesbian, as a Jew, I know that much of what I call history others will not. But answering that challenge of exclusion is the work of a lifetime.' So wrote Brooklyn's Lesbian Herstory Archives founder Joan Nestle in 1986.[95] Librarians are the archaeologists of queer culture, retrieving facts, gossip, names and images that would otherwise vanish, cruising and filtering to redistribute our presence in time and space, constructing counter memories through ink on paper and ephemera such as softball uniforms and matchbooks, salvaging what has been excised from the historical inventory. Jeannette Foster worked in some seventeen states to gain access to lesbian publications housed in public and private troves, including Alfred Kinsey's Institute for Sex Research, before she self-published, in 1956, the annotated

Andrea Bowers
*Still Life of The AIDS Memorial Quilt in Storage
(Blocks 4336–4340)*
2007

David Goldblatt
*The entrance to Lwandle, Strand, Western Cape
in the time of AIDS, 9 October 2005*
2005

bibliography *Sex Variant Women in Literature*. It is no coincidence that artist/lesbian/feminist/sex-radical/bibliographer Tee Corinne had a day job as a librarian in the 1970s and 1980s. Guy Hocquenghem's *Race d'Ep!: Un Siècle d'Images de l'Homosexualité* (1979) scavenged German and French archives to collate historical documents of homosexuality, including material drawn from Magnus Hirschfeld's photographs of androgynes and cross-dressers and interviews with surviving models of Wilhelm von Gloeden.[96]

In the transmission of queer culture, then, the archive is both mourning and monument, a site coloured by loss as well as a structure through which the future is inscribed and by which it can be imagined. The destruction of an archive central to a minoritized group is an act of cultural genocide. The Nazi incineration of the contents of Magnus Hirschfeld's Institute for Sexual Research is doubly an act of violence – first because of the destruction itself and second because the specific intent of the act has for the most part been minimized by descriptions of the conflagration as 'Nazi book-burning'. The very precariousness of queer archives unsettles the ways in which the conventional historical narrative opposes the 'public' and the 'private', sets history against gossip, pits stories against shards. Queer culture is necessarily collaged from fragments, animated by back story, mined from close readings and based upon an intelligence and intensity of gaze. 'Many of us', notes artist and writer Martha Fleming, 'must remember and recount at all costs – not in a flurry of induced abreaction, but rather because our realities and experiences are not inscribed in history, our identities and collectivities are fragile rumours composed of flicker and smoke.'[97]

Some queer artists have chosen to supply the archive with what should have been there in the first place. Zoe Leonard's installation *The Fae Richards Photo Archive* (1993–96) displays the forgeries she produced to anchor Cheryl Dunye's film *Watermelon Woman* (1996). In Dunye's mockumentary, Leonard's photographs are used to represent the treasure trove hidden in a private archive that proves the existence of a forgotten Hollywood 'mammy' – a lesbian, naturally. Similarly, Fred Wilson's installation *An Invisible Life: A View into the World of 120 Year Old Man* (1993) introduced a ghost

into the furnishings of a historic Nob Hill home in San Francisco. Through strategically placed artefacts such as paintings and books, Wilson invented one Baldwin Antinous Stein, an African-American compatriot of James and Gertrude, whose middle name just happens to be the young lover of the Roman emperor Hadrian. In *Monument to a Marriage* (2003) Patricia Cronin disrupts another archive, the cemetery. Installed 'for eternity' in New York's smartest necropolis, *Monument to a Marriage* makes pointed feminist reference to the funerary sculpture through which many nineteenth-century women artists supported themselves. Sculpted in white Carrera marble, Cronin and her partner lie entwined upon a modern mattress among the memorials to the partners in and products of state-sanctioned heterosexuality. By taking anticipatory revenge, Cronin out-manoeuvres the reality that she and her partner, Deborah Kass, could not be recognized as a family in the eyes of the American state at the time the work was made. 'If I can't have it in life,' says Cronin, 'I'm going to have it in death.'[98]

Other artists use the archive to dispute the sort of institutionalized memory that archives usually bolster. *The New York Daily News on the day that became the Stonewall Riot reproduced by hand from microfilm records* (1997), an installation by Mathew Jones, buries the record under graphite. By methodically tracing each microfiche page of the newspaper printed hours *before* the moment gay liberation is said to have commenced, Jones suggests that revolutions neither begin nor end but are invented – and thus, paradoxically, made usable – by documenting an arbitrary slice of time and space. Jones's magnificently ambivalent gesture of copying also reinscribes the backstage labour rendered invisible by fables of revolutionary moments. Gilbert & George's *In Bed with Lorca* alters both domestic space and a group exhibition organized in tribute to a major cultural figure not usually identified as gay. As their contribution to an exhibition installed at the summer house of Federico García Lorca, the artists had their picture taken while wedged side by side in Lorca's bed. Though this work is uncharacteristically modest, the couple wear their signature suits with their expressions set in their trademark deadpan. But despite the title of the work, Gilbert & George are

Patricia Cronin
Monument to a Marriage
(installed Woodlawn Cemetery, Bronx, NY)
2006

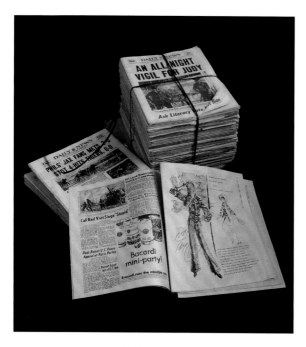

Mathew Jones
*The New York Daily News on the day that became the
Stonewall Riot reproduced by hand from microfilm records*
1997

I am a photographer, not a lesbian. Your assumptions have given me anguish, which at my age is surely not healthful. [...] If some of the photographs you mention are of 'interesting' women, it is because they were well known and therefore more often used. [...] I hope you realize that the assumption that strong women are lesbians (far from true) is one of the greatest smears for the entire 'women's liberation movement' especially now with a backlash rearing its ugly head. [99]

In the more recent *The Boy Mechanic* (1996–present), a project made in and for a very different era, Brooke approaches the issue of nomenclature with a more nuanced attention to the ambiguities of memory and evidence, as well as an explicit attention to histories rendered all the more compelling precisely because they cannot be reclaimed. Brooke's camera images of the facades of buildings that once housed lesbian bars seem at first glance to be an ironic comment on the mishaps of vernacular architecture. At a deeper level, however, they exude a site-specific melancholia for particular locales of lesbian pleasure. Each incarnation of *The Boy Mechanic* mutates with the conditions of the city in which it is researched and installed, thus reflecting the instability that is the real subject of Brooke's piece. Urbanity enables queer culture, but urbanity means change. A landlord's greed or a proprietor's illness can shutter one bar while somewhere else another opens. A politician's hunt for votes can empty one pleasure ground while nearby another gains customers.

pointedly not in bed *with* Lorca. The bed is too small. Instead, this photograph of the couple hangs as a slapstick apparition over Lorca's desk, disingenuously suggesting that Lorca's poetry and plays were written in a homosexual mental space.

Other artists have marked ephemeral sites to register histories of delight that lay claim to public space. Bars, clubs, cruising grounds and beds shift in status from private to public. In queer culture, they are not just addresses but characters. Imagined and policed as sites of resistant identity, they people the accounts of Magnus Hirschfeld and Christopher Isherwood, the case reports of police and doctors, the memoirs of Jean Cocteau and Colette, the photographs of Brassaï and Diane Arbus, the drawings of Reginald Marsh and the songs of Suzy Solidor, the pulp novels of Ann Bannon and the allegories of Dennis Cooper. Just as parks are a constant in the work of Jochen Klein, Donald Moffett and Elmgreen & Dragset, bars figure prominently in the work of Dean Sameshima, Kevin McCarty and Tom Burr, among others. (And, arguably, it is the resonance of a long history of gay bars that boosts Stonewall's cultural legibility. Earlier rebellions, like those at the Compton cafeteria in San Francisco and Dewey's cafeteria in Los Angeles, failed to convey the same romance.)

In her epic narratives, Kaucyila Brooke deploys several strategies of archival resurrection to bring into being a specifically lesbian visual history. An early effort to rescue a lesbian past by a kind of salvage ethnography backfired. Brooke's attempt to involve the photographer Berenice Abbott in a discussion of her role in 1920s lesbian Paris generated an exchange of letters that succinctly illustrates the risks of reading history through the perspective of the present. 'I am wondering what satisfaction it can give you to tarnish my name in such a flagrant and libelous fashion,' Abbott retorted:

Geonauts and Genderqueers

Didier Eribon has noted the mythology of 'a phantasmagoric "elsewhere" for gays, an "elsewhere" that offer[s] the possibility of realizing your hopes and dreams – one that seemed impossible for so many reasons, unthinkable even, in your land of origin'. Judith Butler has proposed that drag performance is not proof of failed heterosexuality but a tool that exposes gender itself as drag, 'a kind of imitation for which there is no original, [...] a kind of imitation that produces the very notion of the original as an effect'. [100] We might collapse these two theories to consider 'elsewhere'

Kaucyila Brooke
The Flame, San Diego
1994/1999

as a *performance* of place that produces the effect of a prior utopia, whether temporal or spatial, a performance now amplified by the exigencies and possibilities of globalism. Our history is replete with images of travel. We leave home. We travel first class. Or economy. Even standby. We take the bus. We go on road trips. We hitchhike. We are deported. We hunt the web. If we have to stay at home, we invent our own 'elsewhere'. In short, we cruise. Again and again we represent ourselves to ourselves in a state of diaspora: Djuna Barnes's *Ladies Almanack* (1928), the collages of H.D., Wilhelm von Gloeden's classicized Sicily, Charles Henri Ford's elaborate snapshot albums, Valentine Penrose's montages of the lesbian picaresque, David Hockney's dreams of a Los Angeles he had yet to visit, Bhupen Khakhar's uneasy return to India, and Gay Chan and Nandita Scharma's staged photographs of tourist destinations more appealing that the tourist destination through which they currently happen to be passing.

Seen in this light, Virginia Woolf's *Orlando: A Biography* (1928) is a masterpiece of gendered geography that flaunts her love for Vita Sackville-West without ever locating the relationship on the map of homosexual culture. Orlando's sex change and her/his frolics through the centuries are nothing compared to his voyages, the voyages of his ancestors, the voyages of the voyagers he meets, and the voyages of the voyagers they meet. When Woolf doubles back from these peregrinations to lavish admiration upon Orlando's ancestral seat, she delivers us not to a point of origin but to a hulk of corridors and turrets bursting with a vast accumulation of *stuff*, a concatenation so improbable that it could only have been made up as she went along. The building generates the architecture of a fable through which we move too quickly to touch the ground. Entirely like queer culture, our knowledge is provisional. The text of

Danh Vo
Cultural Boys, Saigon from the installation *Good Life*
2007

Orlando is more frequently discussed than its images, but the paintings and the photographs of Sackville-West that Woolf mischievously appropriated to punctuate *Orlando* constitute a performance of lesbian camp worthy of Jack Smith or John Waters – particularly when interpreted as a deliberate spoof on popular representations of the earnest, tailored, mannish modernity favoured by Romaine Brooks and Radclyffe Hall (whose *Well of Loneliness* was also published in 1928).

Danh Vo evokes another genre of geographical *mise en abyme*. He owes his Danish citizenship to a caprice of globalism, a result of nothing more than the registration of the ship that picked up his boatload of refugees from Vietnam. His works rigorously divest modern identity of its constitutive elements. In the episodic performance titled *Vo Rocasco Rasmussen* (2003–present), the artist marries those whom he deems important to him in order to divorce them, preserving the transactions in a gradually lengthening string of words that serves at once as legal surname and wry critique of gay marriage. In *A Good Life* (2007), Vo substitutes for the lost archive of his childhood the artefacts and snapshots of one Joe Carrier, a RAND Corporation employee who spent the better part of the 1960s in Vietnam. Carrier's images are installed in spotlighted vitrines set into a vaguely 'oriental' damask wallpaper. Each vitrine is titled with one of Carrier's captions. *Sleeping Boys*, *Swimming Boys* and *Cultural Boys* thus populate a fiction where 'homosexuality' is ubiquitous, not a country in which men can and do touch each other without assuming the identity of 'homosexuals'. Carrier's snapshots are surrogates for images that Vo never possessed of a country that never existed, given to him by a man with a metaphor for a name, who may – or may not, as the artist tells it – have cruised Vo one night in Los Angeles.

As gender too can map 'elsewhere' with such force that it reveals itself as a phantasm, producers of queer culture – be that 'high' or 'low', be they drag kings or theoreticians – have historicized gender while refusing it as the only imaginable site of dissidence.[101] 'Male and female it creates them,' wrote Gayle Rubin of gender in 1975, 'and it creates them heterosexual.'[102] Rubin's feminist critique of gender oppression forcefully made the point that traditional definitions of homosexuality (object choice of the same sex)

Duncan Grant and Vanessa Bell
Orlando, about the year 1840
1927

were the product of the institution of heterosexuality, which creates and permits two and only two genders. The liberation movements of the 1970s quickly foregrounded differences between various cultures explicitly concerned with issues *of* gender, sex, sexuality and sexism: lesbian, heterosexual feminist, gay male and transgender. Jill Johnston's sardonic paean to the short-lived group the Effeminists is one of many texts that speak to the feminist male heterosexual fears of homosexuality. The very existence of the 1977 lesbian issue of *Heresies* testifies to the blind spots lesbian artists perceived within the confines of a dominantly heterosexual feminist art movement, while groups such as Third World Gay Liberation and the lesbian-feminist anthologies developed by women of colour during the last years of the 1970s testify to other blind spots in both gay liberation and feminism.[103] Feminist vilification of male-to-female (MTF) Sandy Stone, who worked for the 'womyn's music company Olivia Records in the 1970s and was thus said to have invaded the space of real women, points to another source of friction. In the 1980s, however, during the worst of the AIDS epidemic, the need to insist on the right to sexual pleasure led genderqueer dissidents, trans people among them, to lampoon the insufficiencies of gay liberation and feminism through social spaces such as a thriving club scene and spin-off publications like G. B. Jones and Bruce LaBruce's short-lived zine *J.D.s*.[104] 'Queer' exploded into activist visibility at the 1990 New York Gay Pride march, when demonstrators wishing to take ACT UP's politics a step further distributed a flyer titled QUEERS READ THIS! 'It's not about the mainstream, profit-margins, patriotism, patriarchy or being assimilated,' wrote the anonymous authors. 'It's not about executive directors, privilege and elitism. [...] It's about gender-fuck and secrets, what's beneath the belt and deep inside the heart [...] We know that everyone of us, every body, every cunt, every heart and ass and dick is a world of pleasure waiting

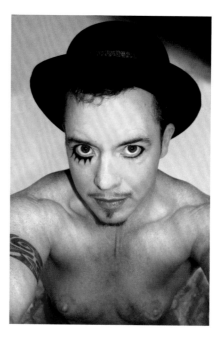

Del LaGrace Volcano
The Artist as a Young Herm, Paris
2004

to be explored.' The heated arguments that exploded in 1991 over the expulsion of transwomen from the Michigan Womyn's Music Festival[105] were part and parcel of the dykepunk movement, the eruption of local Queer Nation and transgender activist groups and, late in the decade, gay shame protests. The convergence of street activism, personal testimony, academic work and visual culture enabled the word 'queer' to assume the function of describing political and cultural alliances that only partly intersected with the categories of gay and lesbian, and offered rich provocations to earlier feminist critiques. In turn, this opened the way to performances of sex and sexuality that fractured the supposed links between embodiment and representation. 'Queer is by definition whatever is at odds with the normal, the legitimate, the dominant,' proclaimed David Halperin from the middle of the fray. '*There is nothing in particular to which it necessarily refers. It is an identity without an essence.*'[106]

'Femme Butch Tops' is the title of a song by Tribe 8, the San Francisco dyke punk feminist band whose name rescues the word 'tribad' from the archive of euphemism. Phyllis Christopher's photograph of the band's singer Lynn Breedlove both documents and contributes to the invention of a cult phenomenon that once headlined small San Francisco clubs and, in 1994, sparked protests at the Michigan Womyn's Festival for its rowdy enactments of blow jobs, castrations and scenes of S/M humiliation. In Christopher's image, a shirtless Breedlove mimes masturbation, wanking off with a hefty dildo that protrudes from her unzipped jeans. Though Tribe 8 has dissolved, Breedlove remains something of a cyberspace celebrity, using Myspace, Facebook and her own website to collate fan photographs, videos of her stand-up act and news about her latest gigs, constructing a gender dissident community in the ripples of virtual space. Del Volcano, once Del LaGrace, has been a self-described gender terrorist for more than thirty years. Known at the

Phyllis Christopher
Photograph of Lynn Breedlove from Tribe 8
1991

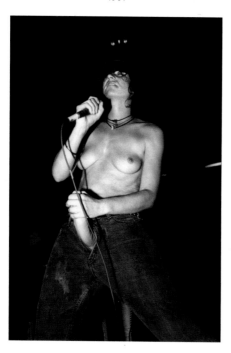

outset of her career as a sex-radical lesbian photographer, she circulated images of drag kings, ruff sex and S/M scenes among friends and in underground publications. Her primary audiences were at first the purchasers of the pro-porn lesbian magazine *On Our Backs* and the gay men who brought out her first book in 1991.[107] After staging, participating in and documenting numerous scenes of gender variance, Grace herself crossed a line, around 1998, to become 'an intentional mutation', both and neither male and female – a herm, a noun that wittily solves the pronoun problem. With facial hair and a deep voice, Volcano easily passes as a biological male. For convenience and safety, the herm that she has constructed allows the compromise. In the queer community, however, Volcano seeks visibility not as a transgendered ex-lesbian or as a performative drag king but as a multi-gendered hybrid. In her self-portrait *The Artist as a Young Herm, Paris* (2004), Volcano re-mixes the signifiers. Cosmetics are everywhere in evidence. One eye features huge lashes, the other a simple stroke of eyeliner. Lipstick, a moustache and a balding pate are hard to miss. Breasts have been removed. The bowler hat, a classic sign of androgyny, becomes not so much a reference to muddled gender as a comic anachronism.

Sharon Hayes is every bit as sceptical as Volcano and Breedlove about the baggage carried by the terms 'gay' and 'lesbian', but in questioning the nature of dissidence, and dissonance, her medium is quotation rather than embodiment, her method breaking the links between memory and history. Her projects have involved one-on-one street interviews in New York with subjects who fail to add up to an abstraction called 'public opinion', re-performances of docent interpretations of the historic homes of famous women, proclamations of love piped into locations from which she has absented herself, and the *Revolutionary Love* performances described in the Preface to these surveys. *I AM A MAN* is a detail from the ongoing series *In the Near Future*, in which Hayes travelled Manhattan as a one-woman movement, holding aloft placards of activism from previous decades: 'Ratify E.R.A. NOW!', for instance, referenced the sixty-year campaign to pass a constitutional amendment guaranteeing equal rights for women in the US.[108] *I AM A MAN* is the only Hayes performance, at least to date, to have attracted police attention. Held stubbornly

in the air, the placard offers a multivalent set of references. Hayes stands in front of St Patrick's Cathedral, the site of a massive ACT UP protest against Cardinal O'Connor, one of the homophobes who starred twenty years earlier in Gran Fury's *Let the Record Show*. Her placard quotes Glenn Ligon, a quoter from an earlier generation, some of whose black and white oil-stick stencil paintings are made from the disintegration of the words 'I Am a Man'. In turn, Ligon's painting quotes the placards held by striking sanitation workers in a 1968 image by Memphis civil rights photographer Ernest Withers. Hayes's solitary protest, then, invokes and destabilizes several struggles for agency – black, female and transgender. If anything, Hayes appears to be a mousy *flâneuse*, not a transgender or African-American activist. She asks her audience to contemplate the ways in which things do not line up, to untangle the alliances and identifications necessary to something as utopian in its possibilities as 'queer culture'. Could she be a terrorist? A tourist? A nerdy drag king? A female artist? A transman? An agile semiotician? A defender of compulsory interdisciplinarity?

Even to fantasize such a list, however, is to acknowledge that queer 'has been the victim of its own popularity, proliferating to the point of uselessness as a neologism for the transgression of any norm (queering history, or queering the sonnet). [...] If everyone is queer, no one is.'[109] The anthology in which the essay that I cite was published premised on the dilemma that queer academics now confront. An insurrection intended to destabilize culture – sparked in the intersection of the sex wars and the early days of AIDS –now has a past, and may well be passé. Some of the pioneers got tenure. A few have retired. Certain artists inspired by 'queer theory' have achieved canonical status. Fred Wilson represented the US at the Venice Biennale in 2003. Catherine Opie had a retrospective at the Guggenheim Museum in 2008, and Félix González-Torres in 2010. Glenn Ligon had a retrospective at the Whitney in 2011. Earlier artists such as Paul Thek and Kenneth Anger have been the subjects of renewed interest, with major exhibitions of Anger's work at MoMA PS1 in 2008 and Thek's work at the Whitney in 2010.

Predictably, then, the menus solicited by the word 'queer' have in themselves become for younger artists something of a subgenre – parodic, expansive and mischievously utopian. Consider these snippets (taken from a much longer list): 'Bakassi People, transwomen, queers, fags, Ainu people, dykes, the under privileged, the muff divers, Inuits, refugees, the shabby chic, bulldaggers, the leisure class, queens, men, Aymaras, drama queens, [...] Kabylians, cosmopolitans, bois, FtoMs, MtoFs, the middle class to working class, the working class to under class, East Indians, old maids, [...] wiggers, clandestinos, other genders, Palestinians, the undocumented, Afro-Latinos, nouveaux pauvres and global workers'.[110] Delivered as part of a lecture at a 2010 feminist symposium at the Moderna Museet in Stockholm, the deadpan inventory eviscerates meaning from the word 'queer' by refusing to make hierarchical distinctions between categories of sexuality ('bulldaggers'), gender ('men') and race ('wiggers') and those of nationality ('Palestinian') and furniture ('shabby chic').

This satirical jab at the museological apparatus stands in vivid contrast to the weighty controversy surrounding the Smithsonian Institution's decision in December of 2010 to remove an edited DVD version of David Wojnarowicz's

Sharon Hayes
In the Near Future (detail)
2009

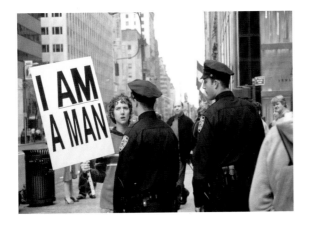

1987 film *A Fire in My Belly* from the exhibition 'Hide/
Seek: Difference and Desire in American Portraiture'
at the National Portrait Gallery. A well-funded, high-profile
scholarly exhibition, 'Hide/Seek' demonstrated that same-sex
desire was a constant in the canonical story of modern art
in America. The National Portrait Gallery is not an avant-
garde space, however. 'Hide/Seek' focused on traditional
media, and film was so marginal to the exhibition that
Wojnarowicz's work went unmentioned in the catalogue.
None the less, 'Hide/Seek' was the first major museum show
in America devoted to homosexuality (even if the word,
prudently, didn't appear in the exhibition's title). The Catholic
League and conservative American congressmen
publicized their objections to the film – specifically, to an
eleven-second sequence of ants crawling over a crucifix –
in order to manufacture a scandal about a supposed
attack on Christianity. Internet technology took the
affair viral. Not only were campaigns easier to organize,
but Wojnarowicz's work achieved wider distribution than it
had ever had before.

In actuality, however, the aspirations of the exhibition
and the magnificence of the venue magnified the event
to supply a spectacle of 'Wojnarowicz'. Those who objected
hadn't actually seen the work in the exhibition, relying
instead on a YouTube video of a performance by singer
Diamanda Galas that featured clips from Wojnarowicz's
film. The work that the art community subsequently moved
to defend, and promptly distributed via YouTube, was an
edit of *A Fire in My Belly* made for 'Hide/Seek' by curator
Jonathan Katz, who had felt it necessary to cut the film
to four minutes.[111] In other words, the work originally
censored was not in the exhibition, and the work defended
was a collaboration between an art historian passionately
committed to opening his field to queer culture and a
museum sensitive to the attention span of an audience.[112]

The protests against the Smithsonian, necessary though
they were, are cumbersome compared to the more intimate
tactics deployed by the artists and shifting collectives who
identify as genderqueer. Such artists see the support of art
institutions as incidental to the production and distribution
of their art, and collaboration to be as at least as important
as an individual practice. The attention recently paid to
histories of feminist art has served to provoke several such
groups, who have returned to second-wave feminism to

Andrea Geyer
Criminal Case 40/61: Reverb
2010

reinvent and improve it – sometimes satirically, sometimes
affectionately.[113] They offer, in their words, 'a new team
under an old threat'.[114] Working in London, Emma Hedditch
often chooses to provide the ground for the actions of others
rather than manufacture her own products. In 2004, for the
project 'A Political Feeling I Hope So' at Cubitt, she created
a short-lived feminist space, defined by a separatist curtain
made of duvets, and made it available for women to hold
meetings, play music, show films, and so on. In Sweden,
the YES! Association formed in response to the state-funded
exhibition 'Art Feminism: Strategies and effects in Sweden
from the 1970s up to the present day', which they viewed
as a superficial effort to disguise an institutional record
of gender discrimination rather than proof of institutional
change.[115] Their Moderna Museet performance, mentioned
earlier, was conceived as a critique of the one day that the
museum allotted to a symposium on feminism. The script
of the performance was filched from fragments of essays by
contemporary feminist writers, which the YES! Association
strung together to make a screed on anger. They then invited
actor Lea Robinson to rattle the symposium by lecturing
the audience – literally – in the role of transgender African-
American activist Lee H. Jones. In New York, a group called
LTTR solicited material for their 'collective song' through
a series of thematic open calls. They published five issues of
an eponymous journal between 2003 and 2006, making up
a new meaning for the acronym with each one, including
'Lesbians to the Rescue' and 'Listen Translate Translate Record'.
Something of a limited edition artists' book, *LTTR* welcomed
to its pages all sorts of artists and mediums, reanimating
second-wave feminism by orchestrating understandings
of gender and generation, race and nation under such rubrics
as 'positively nasty' and 'practice more failure'. The group
has since disbanded, rendering the journal, and its online
archive, the most tangible residue of their activities. It is,
however, a relatively small element in a performative social
practice that included curating exhibitions, throwing parties
and organizing workshops, including one on transgender
legal issues.[116]

In practices such as those of Hedditch, the YES!
Association and LTTR, transgender is a central concern,
not only as a descriptor of body and mind but also as
invitation, metaphor and theory. Indeed, as transgender
historian Susan Stryker writes, 'transgender' has come

The Yes! Association
We Will Open a New Front
2010

to suggest a crossing that may in fact have little to do with gender, much less homosexuality. 'It has come to mean *the movement across a socially imposed boundary away from an unchosen starting place* – rather than any particular destination or mode of transition.'[117] Andrea's Geyer's *Criminal Case 40/61: Reverb* (2010) puts transgender at the centre of the narrative without allowing the narrative to centre on a genderqueer figure. Geyer's work dissects historical trauma and the paralysis of memory through restaging elements of Adolf Eichmann's 1961 trial in Jerusalem. The main element of her piece is a circle of six LCD video screens. Each features one character, named only by his or her role: Accused, Defense, Judge, Prosecution, Reporter and Audience. Two are easy to recognize – Eichmann, the prototypical 1950s grey-suited bureaucrat, mumbles, while Hannah Arendt, the most celebrated journalist at the trial, opines animatedly through clouds of cigarette smoke. Each character performs sections of the trial transcript as well as passages from Arendt's writings. In Geyer's dispassionate analysis of an archive, which the viewer digests while sitting on a hard bench, the scene-stealer is the artist Wu Ingrid Tsang, who performs – bumpily, without the skill of a trained actor – each of the six characters. It is his, or her, undecidably gendered and ambiguously raced figure that both anchors and rocks Geyer's examination of history and memory, dislocating what would appear to be another story entirely – not from its margin but from its very centre.[118]

'Some works', writes LTTR's Emily Roysdon, 'speak pleasure to power. They shake their sensuous amputated left hand at the invisible naysayer and say, "Why not?".'[119]

1 Cited in Richard Goldstein, 'Culturati: Through the Peephole', *The Village Voice*, 18 May, 1999, p. 65.

2 See Richard Dyer, 'Judy Garland and Gay Men', *Heavenly Bodies: Film Stars and Society*, Routledge, London, 2004, pp. 137–91.

3 Michael Bronski, *Culture Clash: The Making of Gay Sensibility*, South End Press, Boston, 1984, p. 43.

4 Jason Goldman, 'The Golden Age of Gay Porn: Nostalgia and the Photography of Wilhelm von Gloeden', *GLQ: A Journal of Lesbian and Gay Studies*, vol. 12, no. 2, p. 242.

5 Phyllis Lyon and Del Martin, cited in Martin Meeker, *Contacts Desired: Gay and Lesbian Communications and Community, 1940s–1970s*, University of Chicago Press, 2006, p. 78.

6 See Michel Foucault, *The History of Sexuality, Volume I: An Introduction*, trans. Robert Hurley, Random House, New York, 1980; David Halperin, *One Hundred Years of Homosexuality: And Other Essays on Greek Love*, Routledge, London and New York, 1990; David F. Greenberg, *The Construction of Homosexuality*, University of Chicago Press, 1988; Jonathan Ned Katz, *The Invention of Heterosexuality*, Plume, New York, 1996; Jeffrey Weeks, *Against Nature: Essays on History, Sexuality, and Identity*, Rivers Oram Press, London, 1991.

7 As Steven Seidman has argued, it was not until the early twentieth century that 'the concepts of heterosexuality and homosexuality emerged as the master categories of a sexual regime that defined the individual's sexual and personal identity and normatively regulated intimate desire and behavior'. Steven Seidman, *Romantic Longings: Love In America, 1830–1980*, Routledge, London and New York, 1991, p. 209.

8 Foucault, op. cit., p. 43.

9 Cited in Jeffrey Weeks, *Coming Out: Homosexual Politics in Britain from the Nineteenth Century to the Present*, Quartet Books, London and New York, 1977 (revised 1990), p. 14. Since sodomy was already outlawed, the Labouchere Amendment prohibited all other sexual acts between men. The Labouchere Amendment would remain on the books until 1967.

10 Ed Cohen, *Talk on the Wilde Side*, Routledge, London and New York, 1993, p. 184.

11 These exchanges are excerpted from the transcripts of the 'Testimony of Oscar Wilde on Cross Examination', 3 April 1895, as posted on the 'Famous Trials' website by Professor Douglas Linder, University of Missouri-Kansas City School of Law.

12 In happier times, Lautrec had incorporated the figure of Wilde into his vibrant paintings of Parisian nightlife. Lautrec's vision of urban decadence, of the dancehalls and brothels of Montmartre, was thus already in dialogue with Wilde's public persona prior to the 1895 trials.

13 Judith Butler, 'Imitation and Gender Insubordination', in Diana Fuss (ed.), *Inside Out: Lesbian Theories, Gay Theories*, Routledge, London and New York, 1991, p. 20.

14 The museum's attempt to closet Austen's life and work inspired an on-site public protest by the Lesbian Avengers, an activist collective. Footage of the protest is included in Barbara Hammer's film *The Female Closet* (1998).

15 Levitt forces into view what the critic Laura Cottingham has called the 'disacknowledgment' of lesbian art and history. See Laura Cottingham, 'Notes on *lesbian*', *Seeing Through the Seventies*, Routledge, London and New York, 2000, pp. 175–7.

16 Magnus Hirschfeld, *Literarische*, 25 May 1928, cited and translated in Charlotte Wolff, *Magnus Hirschfeld: A Portrait of a Pioneer in Sociology*, Quartet Books, London and Melbourne, 1986, p. 27. I owe this reference to Thomas Waugh, *Hard to Imagine: Gay Male Eroticism in Photography and Film from their Beginnings to Stonewall*, Columbia University Press, New York, 1996.

17 Katharina von Ankum, *Women in the Metropolis: Gender and Modernity in Weimar Culture*, University of California Press, Berkeley and Los Angeles, 1997, p. 101.

18 Marsha Meskimmon, *We Weren't Modern Enough: Women Artists and the Limits of German Modernism*, University of California Press, Berkeley and Los Angeles, 1999, p. 207.

19 Information on (and translations of) Curt Moreck's *Guide to Immoral Berlin* was kindly provided by Suzanne N. Royal. On Mammen and Moreck, see Royal's doctoral thesis, 'Graphic Art in Weimar Berlin: The Case of Jeanne Mammen', PhD dissertation, Department of Art History, University of Southern California, 2007.

20 Alfred C. Kinsey, Wardell Pomeroy and Clyde E. Martin, *Sexual Behavior in the Human Male*, W. B. Saunders, Philadelphia, 1948, excerpted in Kathy Peiss, ed., *Major Problems in the History of American Sexuality*, Houghton Mifflin, Boston and New York, 2002, p. 369.

21 Mark Patrick Cole, 'Jared French (1905–1988)', PhD dissertation, Art History, University of Delaware, 1999, pp. 126–7.

22 As classicist Maria Wyke has pointed out, 'After the Second World War, a new form of physique magazine began to be produced for wide circulation among the gay community of the United States. During a period of growing demand for cultural legitimacy, it was nonetheless necessary to employ clever circumventions for any representations of homoeroticism if they were to remain above ground and be distributed through the legitimate market. For, during the 1950s and early 1960s, the so-called "beefcake" photographers were frequently prosecuted and convicted in the American courts if they were felt to have exceeded the strict requirements of state censorship. The rhetoric of classicism was then one of several such circumventions employed to safeguard mass-produced but privately consumed visualizations of gay desire.' Maria Wyke, 'Herculean Muscle!: The Classicizing Rhetoric of Bodybuilding', *Arion*, vol. 4, no. 3, 1997, pp. 59–60.

23 *David Hockney by David Hockney: My Early Years*, ed. Nikos Stangos, Thames & Hudson, London, 1988, p. 88.

24 The literary critic Terry Castle has drolly summarized the narrative arc of these novels: 'Just about all the classic lesbian pulps had the same formulaic plot: Abnormal Older Woman, beautiful and depraved, preys on Innocent Yet Susceptible Young Girl. Titillating scenes involving whips, red fingernail polish and Frederick's of Hollywood undergarments usually ensued. After a lot of boozing, erect nipples, and wriggling in and out of tight girdles, the IYSYG was inevitably saved from her life of perversion by a Real Man. The RM would awaken "normal feelings" in her just in time to carry her back to the Land of Heterosexuality. The AOW – freakish, unnatural, filthy-minded – typically disappeared or committed suicide. And a good time was had by all!' Terry Castle, 'Pulp Valentine: Patricia Highsmith's Erotic Lesbian Thriller', *Slate*, 23 May 2006.

25 Ann Bannon, foreword to Jaye Zimet, *Strange Sisters: The Art of Lesbian Pulp Fiction, 1949–1969*, Studio, New York, 1999, pp. 12–13. Like the male physique magazine, the lesbian pulp responded to and reworked the discourse of sexology for its own purposes. According to the Department of Special Collections at Duke University (which holds an extensive collection of lesbian pulps): '"Scientific research" was another popular premise around which to base these novels. Kinsey's *Sexual Behavior of the Human Female* came out in 1953, and William Howell Masters' and Virginia Eshelman Johnson's *Human Sexual Response* was published in 1966. Although these books were not intended to be prurient, the case studies apparently sparked the imaginations of pulp authors. Once again, pornography could be disguised as something socially acceptable, and the books had the added lure of being 'based on a true story'. Bea Campbell's *Orgy of the Dolls*, for example, claims to be comprised of 'actual case histories' and offers a bibliography. However, *Orgy of the Dolls* is not a particularly scientific title, and the 'case histories' are filled with an incredible amount of detail for something springing from a therapist's notes. One of the 'patients' even refers to Kinsey's book in regard to her 'condition' ('Lesbian Pulp Fiction Collection: An Introduction' on the website of the Duke University Library). Rather than seeing paperbacks such as *Orgy of the Dolls* as falsifications of serious scientific research, we might consider the ways in which the popularization of sexology in the 1950s and 1960s generated brazen new forms of lesbian visibility.

26 With two front-page stories (one reporting on the 'view from inside' the bar during the riots, the other on the 'view from outside'), the *Voice* carried the most detailed news coverage of Stonewall and was virtually the only publication to include photographic images. *The New York Times*, by contrast, published a one-column, unillustrated article on page 33 of its 29 June edition with a shorter follow-up, again without pictures, on June .

27 As historian Scott Bravmann has noted, 'Though obviously staged for the camera rather than a "live action" shot, the [...] photograph provides the closest approximation of an on-the-scene visual image of the riots, its campily posed subjects continuing to garner anonymous fame with recent republications of the picture.' Scott Bravmann, *Queer Fictions of the Past*, Cambridge University Press, Cambridge and New York, 1997, p. 76.

28 Robert Taylor, for instance, mentions 'two hundred or so patrons' of the Stonewall bar who helped initiate the riots and adds that 'soon their numbers doubled, then tripled. [...] The riots continued the following night, when about four hundred policemen ended up battling a crowd of more than two thousand.' *Gay Pride: Photographs from Stonewall to Today*, A Cappella books, Chicago, 1994, p. xxii. Lillian Faderman similarly estimates 'two hundred working-class patrons – drag queens, third world gay men, and a handful of butch lesbians – congregated in front of Stonewall and [...] commenced to stage a riot', in *Odd Girls and Twilight Lovers: A History of Lesbian Life in Twentieth-Century America*, Columbia University Press, New York, 1991, p. 194. Martin Duberman estimates 'two hundred or so people [...] were inside the Stonewall' when the police raid began. Many of these patrons joined the 'growing crowd and mounting anger' outside the bar, a crowd that ultimately 'swelled into a mob'. Martin Duberman, *Stonewall*, Dutton, New York, 1993, pp. 193, 197, 198.

29 GLF described itself as 'a militant coalition of radical and revolutionary homosexual men and women committed to fight the oppression of the homosexual as a minority group and to demand the right to the self-determination of our own bodies'. 'What is Gay Liberation Front?' flyer, spring 1970, as cited in Terrance Kissack, 'Freakin' Fag Revolutionaries: New York's Gay Liberation Front, 1969–1971', *Radical History Review*, no. 62, spring 1995, p. 107. On the history and significance

of GLF, see Kissack, pp. 104–34. The founding of gay liberation newspapers such as *Come Out*, *Gay Flames* and *Gay Power* (in New York City), *San Francisco Gay Free Press* and the *Berkeley Tribe* (in the Bay Area), *Fag Rag* (in Boston), *Killer Dyke* (in Chicago) and *Gay Liberator* (in Detroit) in the years between 1969–and 72 marked an unprecedented degree of visibility – and self-generated press coverage – for the radical gay movement.

30 *Come Out*, 10 January 1970, p. 2.

31 According to press reports, four police officers (and an unrecorded number of rioters) were injured on the first night of the confrontation. See '4 Policemen Hurt in "Village" Raid', *The New York Times*, 29 June 1969, p. 33.

32 This stands in sharp contrast, of course, to the named credit given to McDarrah as photographer.

33 Charles Ludlam, 'Mr T. or El Pato in the Gilded Summer Palace of Czarina-Tatlina (A Fairy Tale)', *Gay Power*, May 1970.

34 Thomas Lanigan-Schmidt, telephone interview with the author, 21 April 2008.

35 Gay Revolution Party Manifesto, in Karla Jay and Allen Young, *Out of the Closets*, p. 344.

36 Allen Young, 'Out of the Closet: A Gay Manifesto', (1971), p. 8; originally published in *Ramparts Magazine*, November 1971, reprinted as a pamphlet by New England Free Press.

37 A letter published in the sixth issue of *Gay Power*, for instance, noted that when 'the third issue [came] out, I was disappointed! What do you have on the cover of a gay male newspaper – Women!!! And what is one faced with on opening the newspaper. A naked cunt!!! Inside there is one picture of a very unattractive naked man. [...] Why not instead of campy women on your cover put a sexy guy? The male magazines have scores of them all hung like horses.'

38 Edward Guthmann, 'Stars', *San Francisco Sentinel*, 2 June 1978, p. 11.

39 Ibid.

40 Randy Alfred, 'Will the Real Clone Please Stand Up?', *The Advocate*, 18 March 1982, p. 22.

41 Hal Fischer, *Gay Semiotics: A Photographic Study of Visual Coding Among Homosexual Men*, NFS Press, San Francisco, 1977.

42 'Bread and Roses', *Dyke*, vol. 1, no. 2, spring 1976, p. 7.

43 Ibid, pp. 6–18.

44 According to the feminist historian Alice Echols, 'For two hours the protestors held the floor as they talked about what it is like to be a lesbian in a heterosexist culture. Drawing equally on their senses of humor and rage, the activists insisted that the Congress adopt the following four resolutions:
1. Women's Liberation is a lesbian plot.
2. Whenever the label lesbian is used against the movement collectively or against women individually, it is to be affirmed, not denied.
3. In all discussions of birth control, homosexuality must be included as a legitimate method of contraception.
4. All sex education must include lesbianism as a valid, legitimate form of sexual expression and love.' Alice Echols, *Daring to Be Bad: Radical Feminism in America, 1967-1975*, University of Minnesota Press, Minneapolis, 1990, p. 215.

45 Nayland Blake, 'Curating in a Different Light', in Nayland Blake, Lawrence Rinder and Amy

Scholder (eds.), *In A Different Light: Visual Culture Sexual Identity, Queer Practice*, City Lights, San Francisco, 1995, p. 12.

46 Susan Sontag, *Illness as Metaphor*, Farrar, Strauss and Giroux, New York, 1978, p. 67.

47 Also published by Farrar, Straus and Giroux. Anchor Press combined the two books in 1990 for a paperback edition.

48 Sontag obituary, *The New York Times* (28 December 2004). Patrick Moore's op. ed. piece, 'Susan Sontag and a Case of Curious Silence', *Los Angeles Times*, 4 January 2005, prompted the *New York Times* response, quoted in Dyana Bagby, 'Sontag "de-gayed" in obituaries', *Washington Blade*, 7 January 2005.

49 Wayne Koestenbaum, 'Perspicuous Consumption', *Artforum*, March 2005, p. 196.

50 See David Rieff, *Susan Sontag: Reborn, Journals and Notebooks, 1947–1963*, Farrar, Strauss and Giroux, New York, 1988; Joan Acocella, 'The Hunger Artist', *The New Yorker*, 6 March 2000, p. 74; and 'Finding Fact from Fiction', *The Guardian*, 27 May 2000.

51 David Rieff, *Swimming in a Sea of Death*, Simon and Schuster, New York, 2008, p. 150.

52 Terry Castle, 'Desperately Seeking Susan', *London Review of Books*, March 2005.

53 Sontag, 'Notes on Camp' (1964), notes 11 and 42, in *Against Interpretation and Other Essays*, Dell, New York, 1966. Ann Pellegrini's 'After Susan Sontag: Future Notes on Camp' is a definitive summary of Sontag's contested and contradictory opinions on the subject. See George E. Haggerty and Molly McGarry (eds.), *A Companion to Lesbian, Gay, Bisexual, Transgender and Queer Studies*, Blackwell, London, 2007.

54 Claire Morgan was the pen name of crime novelist Patricia Highsmith. When Naiad Press reissued the classic in 1984, Highsmith wrote an afterword in which she lamented the secrecy necessary in the 1950s, but nonetheless signed both afterword and book with her pen name. She did not acknowledge her authorship of *The Price of Salt* until the 1991 Naiad edition.

55 Judith Butler, 'Imitation and Gender Insubordination', in Diana Fuss (ed.), *Inside / Out*, Routledge, London and New York, 1991; reprinted in Henry Abelove, Michele Aina Barale and David M. Halperin (eds.), *The Lesbian and Gay Studies Reader*, Routledge, London and New York, 1993, p. 309.

56 See Rieff, op. cit, 2008.

57 Paula Treichler, 'AIDS, Homophobia and Biomedical Discourse: An Epidemic of Signification', *October*, no. 43, winter 1987, pp. 31–70.

58 David Halperin, *Saint Foucault: Towards a Gay Hagiography*, Oxford University Press, New York, 1995, p. 62.

59 The phrase is Annamarie Jagose's. See *Queer Theory*, University of Melbourne Press, Melbourne, 1996. In 1990, de Lauretis suggested 'queer' as a nonessentialist locution that would open multiple locations from which to resist institutional discourse. It is a sign of the instability of oppositional terms that three years later, feeling that the word had been co-opted, de Lauretis retracted the idea – not that anyone paid attention.

60 That version was shortly thereafter installed at Stanford University, only to be vandalized, reinstalled and once again vandalized.

61 Quoted in Richard Meyer, *Outlaw Representation: Censorship and Homosexuality in Twentieth-Century*

American Art, Oxford University Press, Oxford and New York, 2002, p. 204.

62 For an account of GALAS, see Terry Wolverton, 'The Great American Lesbian Art Show', in Nayland Blake et al. (eds.), *In a Different Light: Visual Culture, Sexual Identity, Queer Practice*, City Lights, San Francisco, 1995, pp. 50–1.

63 John Perrault, 'I'm Asking – Does It Exist? What Is It? Whom Is It For?', *Artforum*, November 1980.

64 Stephen Kent Juscick, 'Gay Art Guerrillas: Interview with Jim Hubbard and Sarah Schulman', in Mattilda Bernstein Sycamore (ed.), *That's Revolting! Queer Strategies for Resisting Assimilation*, Soft Skull Press, Brooklyn, 2004, p. 71.

65 Dan Cameron, 'Extended Sensibilities', *A Different Light*, op. cit., p. 53.

66 Nayland Blake, 'Curating in a Different Light', in ibid., p. 23.

67 See David Deitcher, 'Taking Control: Art and Activism', in Nilda Peraza, et al. (eds.), *The Decade Show: Frameworks of Identity in the 1980s*, New Museum of Contemporary Art, New York, 1990, pp. 180–96.

68 Susie Bright and Jill Poserner (eds.), *Nothing But the Girl: The Blatant Lesbian Image*, Freedom Editions, London, 1996, p. 134. Poserner's postcard of the Fiat image has sold over half a million copies, making it an astonishingly durable morsel of lesbian feminism.

69 See Carole Vance, 'The War on Culture', *Art in America*, vol. 77, no. 1, September 1989, pp. 39–45; Richard Bolton (ed.), *Culture Wars: Documents for the Recent Controversies in the Arts*, the New Press, New York, 1992, p. 23.

70 *The New York Times*, 28 July 1990, reprinted in Bolton, ibid.

71 Simon Watney, 'The Possibilities of Permutation', in James Miller (ed.), *Fluid Exchanges: Artists and Critics in the AIDS Crisis*, University of Toronto Press, Toronto, 1992, p. 337.

72 I rely on Jan Zita Grover's closely analysed history of the visual representation of AIDS during the 1980s. See her 'Visible Lesions: Images of the PWA in America', in James Miller, op. cit., pp. 23–52.

73 For accounts of community rituals, see David Roman, *Acts of Intervention: Performance, Gay Culture and AIDS*, Indiana University Press, Bloomington, 1998.

74 Simon Watney, 'Photography and AIDS', *Ten.8*, no. 26, 1987, reprinted in Simon Watney, *Practices of Freedom: Selected Writings on HIV/AIDS*, Rivers Oram Press, London, 1994, pp. 67–8.

75 Grover, op. cit., p. 51.

76 Quoted in Douglas Crimp, 'Portraits of People with AIDS', *Melancholia and Moralism: Essays on AIDS and Queer Politics*, MIT Press, Cambridge, MA, 2002, p. 87.

77 The phrase is Atkins's. See Robert Atkins and Thomas W. Sokolowski, *From Media to Metaphor: Art About AIDS*, Independent Curators, New York, 1992.

78 Grover, op. cit., p. 37.

79 Gregg Bordowitz, 'Picture a Coalition', *October*, no. 43, winter 1987.

80 Pat Califia, *Sapphistry*, Naiad Press, Tallahassee, 1988; Gayle Rubin, 'The Leather Menace: Comments on Politics and S/M', in SAMOIS (eds.), *Coming to Power: Writings and Graphics on Lesbian S/M*, Alison Publications, Boston, 1982, pp. 192–227.

81 Susie Bright and Jill Posener, op. cit., p. 110.

82 Pat Califia, 'Gay Men, Lesbians, and Sex: Doing It Together' (1983), in *Public Sex: The Culture of Radical Sex*, Cleis Press, Pittsburgh, 1994, p. 183.

83 Carole Vance (ed.), *Pleasure and Danger: Exploring Female Sexuality*, Harper Collins, New York, 1993; Ann Snitow, et al. (eds.), *Powers of Desire*, Monthly Review Press, New York City, 1983; Gayle Rubin, 'Thinking Sex: Notes for a Radical Theory of the Politics of Sexuality' (1984), reprinted in *Lesbian and Gay Studies Reader*, op. cit.; Nan D. Hunter, et al., *Caught Looking: Feminism, Pornography & Censorship*, Caught Looking, Inc., New York, 1986.

84 The Drawing the Line collective was comprised of Lizard Jones, Susan Stewart and Persimmon Blackbridge. Quoted in Susan Stewart, et al., *Drawing the Line: Lesbian Sexual Politics on the Wall*, Press Gang Publishers, Vancouver, 1991, n.p.

85 David Wojnarowicz, 'Postcards from America: X Rays from Hell', originally printed in *Witnesses: Against Our Vanishing*, Artists' Space, New York, 1988; reprinted in *Close to the Knives: A Memoir of Disintegration*, Vintage Books, New York, 1991, p. 114.

86 Juan Vicente Aliaga, 'A Land of Silence: Political, Cultural and Artistic Responses to AIDS in Spain', in Joshua Oppenheimer and Helena Reckitt (eds.), *Acting on AIDS: Sex, Drugs and Politics*, Serpent's Tail, New York and London, 1997, pp. 346–59.

87 See Sandy Nairne, *State of the Art: Ideas and Images in the 1980s*, Chatto and Windus, London, 1987, and *The Decade Show*, op. cit. The latter was organized and exhibited in New York at the New Museum, the Studio Museum in Harlem and the Museum of Contemporary Hispanic Art.

88 The exhibitions include 'Sight Specific: Lesbians and Representation', A Space, Toronto, 1987; 'Erotophobia', Baskerville & Watson, New York, 1989; 'Situation', New Langton Arts, San Francisco, 1991; 'Oh Boy, It's a Girl!', Kunstverein Munich, 1994; 'A Different Light', Berkeley Art Museum, 1995; 'Gender, Fucked', Center for Contemporary Art, Seattle, 1996; 'Beau Comme Un Camion', Paris, 1997.

89 And the 'homosexual men', as John Grayson remarked in a catalogue essay, were further subdivided into 'dandy' or 'activist', each position being equally 'inflexible, didactic, exclusionary, defensive'. John Greyson, 'Parma Violets: A Video Script', in *Against Nature: A Group Show of Work by Homosexual Men*, Los Angeles Contemporary Exhibitions, Los Angeles, 1988. In 2008, Christopher Russell took another look at the debates engendered by 'Against Nature' in an exhibition titled 'Against the Grain'. Russell curated a group of artists, women among them, in order to suggest contemporary reinterpretations of decadence.

90 Section 28 is quoted in full in Watney, op. cit. pp. 41–2.

91 Quoted in Douglas Crimp, *Melancholia and Moralism: Essays on AIDS and Queer Politics*, MIT Press, Cambridge, MA, 2002, p. 70. The language approved by the Senate was later modified: 'None of the funds made available under this act to the Centers for Disease Control shall be used to provide AIDS education, information, or prevention materials and activities that promote or encourage, directly or indirectly, homosexual sexual activities.'

92 Bolton, op. cit., p. 5.

93 See R. Meyer, *Outlaw Representation*, op. cit., p. 245.

94 Vance, op. cit., p. 4.

95 Joan Nestle, 'Preface', *A Restricted Country*, Firebrand Books, New York, 1987.

96 Guy Hocquenghem, *Race d'Ep!: Un Siècle d'Images de l'Homosexualité*, Hallier, Paris, 1979.

97 Martha Fleming, *Studiolo: The Collaborative Work of Martha Fleming and Lyne Lapointe*, Artextes Editions and the Art Gallery of Windsor, 1997, p. 22.

98 After the New York state legislature voted to allow same-sex partners to marry, Cronin and Kass took the step on 22 July 2011 at the Marriage Bureau in New York City. In the USA, however, marriage confers civil rights only on the state level, not the federal.

99 Kaucyila Brooke, 'Roundabout' in Deborah Bright (ed.), *The Passionate Camera: Photography and Bodies of Desire*, Routledge, London and New York, 1998, pp. 129–31.

100 Didier Eribon, *Insult and the Making of the Gay Self*, Michael Lucey (trans.), Duke University Press, Durham and London, 2004, p. 20; Judith Butler, 'Imitation and Gender Insubordination', in Henry Abelove, Michele Aina Barale and David M. Halperin (eds.), *The Lesbian and Gay Studies Reader*, Routledge, London and New York, 1993, p. 313.

101 Queer culture is a moveable feast, both an invitation to and the tension between other movements, a sign capable of visual coding and recoding. This may explain in part the fascination with representations that read as queer by artists who do not identify as 'homosexual': for example, Nikki S. Lee's *Lesbian Project*, Anita Steckel's reclamations of Tom of Finland, and Charles Ray's *Oh! Charley, Charley, Charley*.

102 Gayle Rubin, 'The Traffic in Women: Notes on a "Political Economy" of Sex', Rayna R. Reiter (ed.), *Toward an Anthropology of Women*, Monthly Review Press, New York and London, 1975, p. 180.

103 See, for example, Cherrie Moraga and Gloria Anzaldua (eds.), *This Bridge Called My Back: Writings by Radical Women of Color*, Persphone Press, Watertown, 1981, and Barbara Smith (ed.), *Home Girls: A Black Feminist Anthology*, Kitchen Table, New York, 1983.

104 Eight issues were published in Toronto between 1985 and 1991.

105 See the text of Sandy Stone's 'The Empire Strikes Back', presented at an academic conference at University of California, Santa Cruz, in 1988. Kristina Straub and Julia Epstein (eds.), *Body Guards: The Cultural Politics of Gender Ambiguity*, Routledge, New York, 1991. Relations between transgender and intersex people have been a constant presence in what are described as 'gay and lesbian' histories. The tangled history of 'sex reassignment' begins at least as far back as Dora Richter, whose transition from male to female was facilitated by Magnus Hirschfeld in 1931. It includes the surgeries performed upon infants and adults with ambiguous genitalia, as well as those chosen by people who wanted to alter their gender presentation, and the hormone treatments widely used after the late 1940s.

106 David M. Halperin, *Saint Foucault: Towards a Gay Hagiography*, Oxford University Press, New York, 1995.

107 *Love Bites*, Gay Men's Press, London, 1991.

108 The Equal Rights Amendment, first proposed in 1923, was defeated in 1982 because the requisite number of states failed to ratify it.

109 Sharon Marcus, 'Queer Theory for Everyone: A Review Essay', *Signs*, vol. 31, no. 1, autumn 2005, p. 196, quoted in the introduction to Janet Halley and Andrew Parker (eds.), *After Sex? On Writing Since Queer Theory*, Duke University Press, Durham, 2011, p. 7.

110 The YES! Association, *We Will Open a New Front: Lecture by Lee H. Jones* (2010), first performed by Lea Robinson at the Moderna Museet in Stockholm as part 'One-Day Seminar of Feminist Strategies and Methods' on 23 October 2010.

111 Katz is quoted in an interview with Tyler Green: 'Well, we edited in terms of length, not to remove content. We felt the imperative to represent David Wojnarowicz's work as he designed it. We included every scene that's in the video, we just truncated the length.' *Art INFO*, 8 December 2010.

112 The Smithsonian blunder sounds like an exact replay of the 1989 Artists' Space affair, when Wojnarowicz's collages and writing eventually resulted in the dramatic reduction of federal support for the arts. Some progress had been made, however, in the intervening years. To paraphrase a sardonic remark by Jonathan Katz, one of the curators of 'Hide/Seek', in 1989 homosexuality was sufficient justification for censorship. In 2010 sacrilege also had to be invoked. Katz was interviewed in the programme 'Gay U.S.A.' on 14 December 2010.

113 These exhibitions include 'WACK!: Art and the Feminist Revolution' (Museum of Contemporary Art, Los Angeles, 2007, and tour), 'Global Feminisms' (Brooklyn Museum of Art, 2007) and 'elles@centrepompidou' (Centre Pompidou, Paris, 2009–11).

114 Emily Roysdon, K8 Hardy, and Ginger Brooks Takahashi, Editorial, *LTTR*, no. 1, 2002.

115 The YES! Association was founded by Line S. Karlström, Johanna Gustavsson, Malin Arnell, Anna Linder and Fia-Stina Sandlund, who suspected that the Riksutställningar, Dunkers Kulturhus and Liljevalchs Konsthall aimed to ameliorate a reputation for gender discrimination rather than institute real change. The group's first action was to request that the institutions involved in the exhibition sign an 'equality agreement' implementing discrimination remedies. The institutions declined.

116 The journal as well as documentation of related activities are archived online at www.lttr.org.

117 See Susan Stryker, *Transgender History*, Seal Press, Berkeley, 2008, p. 31.

118 Tsang achieves an equally unsettling recontextualization in the short video *SRS*, in which Tsang re-enacts the words of autism-rights activist Amanda Baggs, a performance distributed via YouTube 2007. Baggs's performance centres on language and isolation. Her words are compelling enough in the original performance; Tsang's re-reading shifts the meaning entirely.

119 Emily Roysdon, 'Ecstatic Resistance' exhibition brochure, Grand Arts, Kansas City, Missouri, November 2009. Available online at www.emilyroysdon.com.

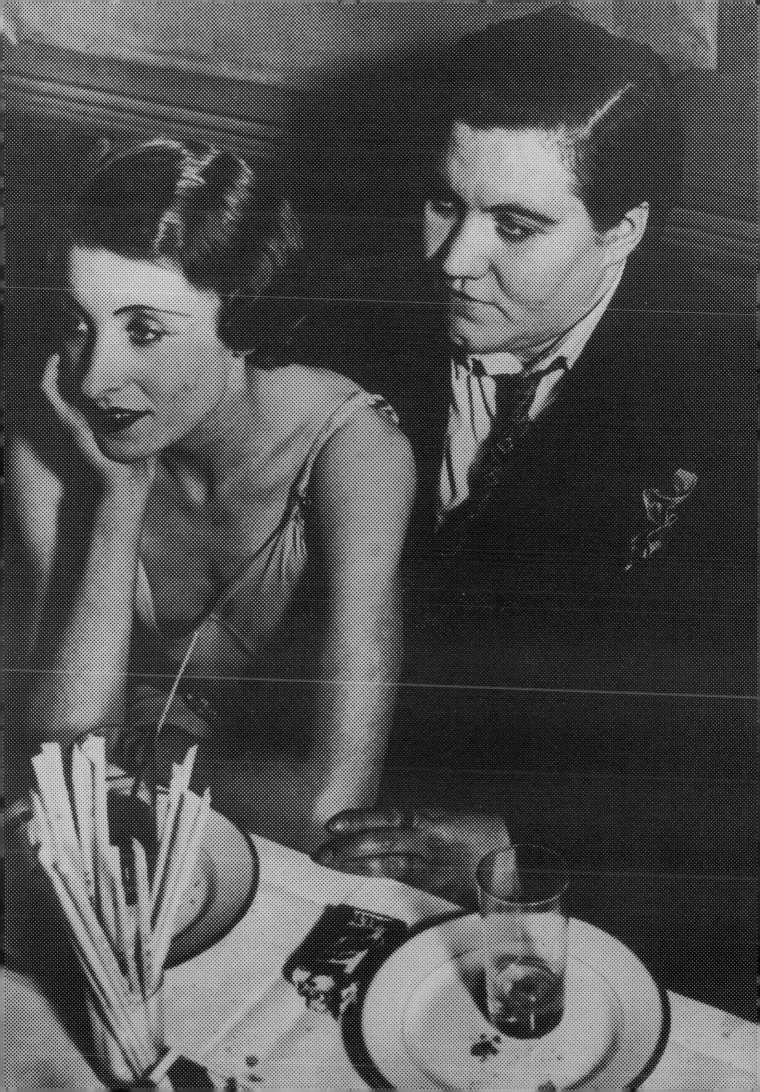

Works

A —
Thresholds
(1885—1909)

E —
Into the Streets
(1965—79)

B —
Stepping Out
(1910—29)

F —
Sex Wars
(1980—94)

C —
Case Studies
(1930—49)

G —
Queer Worlds
(1995—present)

D —
Closet
Organizers
(1950—64)

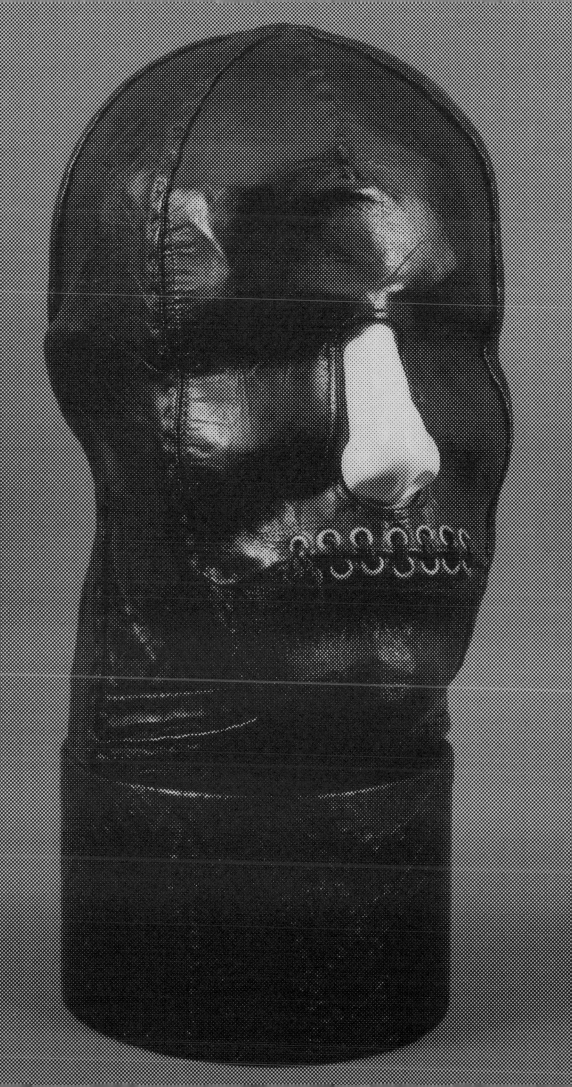

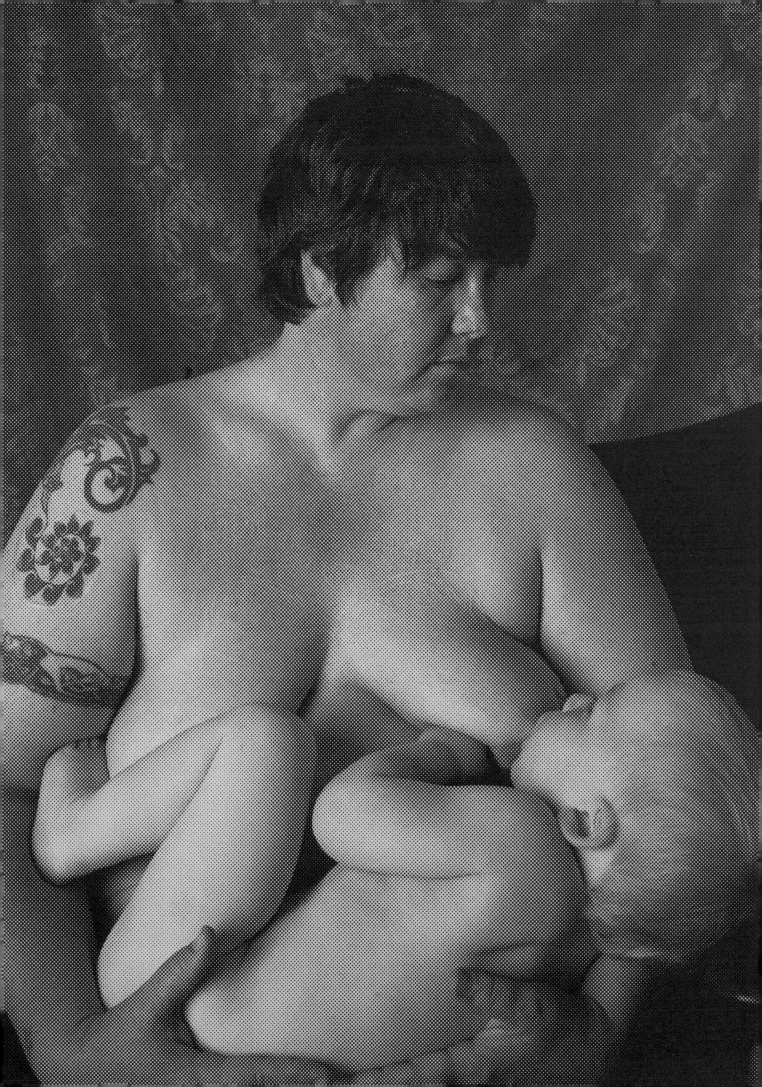

A —
Thresholds
(1885—1909)

At the turn of the twentieth century, artists and photographers began to conceive of the homosexual as an identity (a kind of person) rather than as a discrete act, sin or crime that anyone might potentially commit. The English word 'homosexuality', a medical invention of the late nineteenth century, remained restricted to clinical discourse until the mid-1920s. Popular language referred instead to 'inverts' and 'perverts', as well as to a multiplicity of other roles — 'mannish woman', 'fairy', 'uranian', 'dandy' — that do not align with the subsequent construction of a homosexual/heterosexual binary.

 This chapter explores how artists deployed visual codes to signal sexual difference. It considers the relationship of homosexuality to the other deviant identities in urban European and American contexts, and suggests the ways in which such identities were made visual. The works included here reflect the impact of the developing science of sexology on visual representation, as well as the intersection of early feminism and the camera's increasing presence within the domestic sphere. Certain themes recur: cross-dressing, desire across divisions of race and class, and the intimacies afforded by social settings such as the private home, the artist's studio and the swimming hole.

THOMAS EAKINS
Swimming, 1883–85
Oil on canvas
69 x 92 cm
Collection, Amon Carter Museum of Art,
Fort Worth, Texas

Thomas Eakins' career was beset by scandal and
accusations about his moral standards, in part because of
his practice of exposing his female students to nude male
models. *Swimming*, based on a series of photographs that
Eakins made of students in the flooded field of a copper
mill, forced the painter's resignation from the Pennsylvania
Academy. Eakins generally favoured the male nude over
the female. 'She is', he famously wrote, referring to the
naked woman, 'the most beautiful thing there is – except a
naked man.' This is not to say that Eakins was gay,
in the contemporary sense of the word, but that interpreting
his explorations of the naked human body is a matter of
controversy. Eakins' paintings and photographs have been
used to bolster claims for his importance as a realistic painter
of heterosexual American masculinity *and* to argue for
his significance as a pioneer in a male homoerotic tradition
of visual art. [CL]

ALICE AUSTEN
*Julia Martin, Julia Bredt and Self dressed up
as men, 4:40 p.m., Thurs., Oct. 15th, 1891*
Black and white photograph
Collection, Staten Island Historical Society, New York

Many amateur and professional photographs from the end
of the nineteenth century depict middle-class women wearing
men's clothes, or conventionally dressed women flaunting
the public signifiers of masculinity: alcohol, facial hair, a
cigarette, a cigar or openly crossed legs. New York socialite
Alice Austen's image of herself and two close friends in
male garb – as well as her depictions of young women
masquerading as banjo players, gymnasts and bicyclists –
should be understood in the context of these performances
of masculinity. When Austen staged this photograph, she had
not yet met Gertrude Tate, with whom she would share a life
for thirty years on Staten Island, New York. In 1950 Austen's
work was 'discovered' when she was forced to move, without
Tate, to the poor house, and from time to time feminist art
historians and lesbian artists have turned their attention to
it. But even as her photographs embody an emergent queer
visibility, they do so within Austen's private sphere of female
friendship and gender masquerade. [CL]

F. HOLLAND DAY
Ebony and Ivory, 1897
Black and white photograph
Collection, Metropolitan Museum of Art, New York

GIOVANNI BOLDINI
Portrait of Robert de Montesquiou, 1891–92
116 × 83 cm
Collection, Musée d'Orsay, Paris

F. Holland Day was once as influential a practitioner of pictorialist photography as Alfred Stieglitz. Reproduced in Stieglitz's *Camera Notes* in 1898, this photograph depicts J. Alexandre Skeete, an artists' model and aspiring artist whom Day used in many images of his Nubian series. The project ennobled, albeit at a steep colonial price, an African-American man, thus anticipating some of the arguments that would surround the use of black models by Robert Mapplethorpe and Carl Van Vechten. Affiliated with the Decadents of the 1890s, Day was also a dabbler in the occult, an orientalist, an aficionado of the Hellenic as well as the 'exotic' (he produced series of Chinese men and women in 'Moorish' costume) and a publisher of fine books. Day and his business partner, Herbert Copeland, introduced William Morris to America and published Oscar Wilde and Stephen Crane. They also brought out Aubrey Beardsley's scandal-provoking *The Yellow Book*, with the penis of the Herm of Pan expurgated for the Boston audience. In an attempt to demonstrate that photography could be an art through its reclamation of 'timeless' themes, Day would go on to photograph reenactments of the Crucifixion, in which he starred as Christ. His images of persecuted, almost nude male figures allowed gay male critics and historians of the 1990s to suggest, simplistically, that Day identified with Christ because the artist felt oppressed as a homosexual. [CL]

Giovanni Boldini's portrait is only one instance of the extraordinary attention lavished upon Robert de Montesquiou-Fezensac (1855–1921) by painters, photographers and novelists in the late nineteenth and early twentieth centuries. De Montesquiou was a dandy. He presented himself as an archetype of the aesthete and the man of breeding, elegant in his dress and faultless in his deportment. His image shaped contemporary representations of the dandy – he was the man upon whom Karl Huysmans based the central character in his novel *À Rebours* (Against the Grain or Against Nature, 1884). He is also said to have served Oscar Wilde as a model for the eponymous character in *The Picture of Dorian Gray* (1891) and Marcel Proust for Baron de Charlus in *Remembrance of Things Past* (1913–27). The popular press could not resist caricaturing de Montesquiou. Adorning a male figure with the inventory of de Montesquiou's accessories – cane, gloves, cape, pocket hankerchief, cravat, waistcoat, form-fitting cutaway jacket and elegantly trimmed goatee and moustache – made that figure instantly legible as a dandy, a man who cruised other men as he strolled his metropolis. As Boldini's painting suggests, de Montesquiou was not troubled by his own narcissism. He constantly had himself photographed – in one memorable image, as John the Baptist. Boldoni renders de Montesquiou in shades of grey and black. His subject twists his seated body to achieve a flattering profile and a slender waist. The picture hinges on two diagonals that intersect suggestively between de Montesquiou's legs: the cane that he holds across his body in his right hand and the line of his gloved left hand. [CL]

AUBREY BEARDSLEY
Illustration for the title page of
Oscar Wilde's play *Salome*, 1896
Ink on paper

Aubrey Beardsley's short career as an artist and illustrator
(he died at the age of twenty-five) was laced with scandal
and innuendo. His extensive knowledge of the erotic arts of
Japan, ancient Greece and eighteenth-century France
shaped both his commercial artwork and his more explicit
private drawings, many of which were suppressed during his
lifetime. Beardsley intended this drawing, featuring a stylized
hermaphrodite with female breasts and male genitals, for
the title page of Oscar Wilde's *Salome*. The image could not
be used in its original form, however, by Wilde's American
publishers, and a version that concealed the figure's genitals
was chosen instead. [CL]

FRANCES BENJAMIN JOHNSTON
Self-Portrait with Cigarette, 1896
Black and white photograph
Collection, Library of Congress, Washington, DC

ANONYMOUS
Two women engaged in oral sex, c.1895
Black and white photograph
Collection, Kinsey Institute Archives,
Bloomington, Indiana

With the invention of the daguerreotype in 1839, photography
was enlisted in the production of pornography. By the 1880s,
when developments in photographic technology brought
cameras into the middle-class home, amateurs could produce
not only their own portraits and snapshots but also the means
of their own arousal. This pocket-sized photograph is one of
some 50,000 erotic images – professional and amateur –
that pioneer sexologist Dr Alfred Kinsey began to collect in
the late 1930s, working with difficulty around obscenity laws
and codes of 'public' morality. Taken not in a conventional
studio but in a homey Victorian bedroom, this representation
of cunnilingus was probably intended for illicit heterosexual
male consumption, though one hopes that at least a few
women managed to put it to good use. The woman sitting
demurely on the bed wears an apron, indicating that male
fantasies about the sexual availability of domestic servants
were operative in the production of the image. Unlike in
most erotic photographs of the period, the face of the sitting
woman has been crudely blacked out. [CL]

Frances Benjamin Johnston worked as a professional
photographer for fifty years. Raised in Washington, DC,
by affluent and somewhat unconventional parents, Johnston
developed the connections to allow her access to official
Washington circles, enabling her to make a name for herself
by producing portraits that were at once intimate and
classical. She also frequented artistic circles in Washington
and, ignoring the limitations imposed on the middle-class
Victorian female, encouraged other women to take up
various genres of photography. Indeed, Johnston is notable
not only for her portrait work but also for her documentary
photographs of schools and colleges for African-American
and Native American students: Washington, Hampton,
Carlisle and Tuskeegee. Between 1913 and the late 1920s,
Johnston and her partner, Mattie Edwards Hewitt, ran a
New York studio that specialized in photographs of gardens
and architecture. Hewitt's letters to Johnston survive as
documents of feminist enterprise and sensual delight. 'I slept
in your place and on your pillow,' she wrote to Hewitt,
'it was most as good as the cigarette you lit and gave me all
gooey – not quite, for we had you and the sweet taste too.'
Johnston's self portrait – legs crossed with masculine ease,
boy's cap on her head, skirt pulled up to bare her ankles,
beer stein in one hand, cigarette in the other – displays
the arsenal of symbolic weapons that women could deploy in
the revolt against Victorian gender conventions. [CL]

ALBERT WEISBERGER
Illustration of the 'New Prussian Coat of Arms'
for the magazine *Jugend*, 1907
Ink on paper

ROSA BONHEUR
*Untitled (Anna Klumpke at work in the Bonheur
studio painting Portrait of Rosa Bonheur)*, 1898
Black and white photograph

In this photograph, nineteenth-century animal painter
Rosa Bonheur records her partner – and for all practical
purposes, second wife – Anna Klumpke at work on the 1898
Portrait of Rosa Bonheur. The best-known woman painter of
the nineteenth century, Bonheur was celebrated equally
for her depictions of animals and her life-long cross-dressing,
which she is said to have done only to gain the access to
the slaughterhouses and livestock markets that she needed
to study her subjects. Nonetheless, in an account that
Bonheur provided to Berlin sexologist Magnus Hirschfeld,
she described herself as a member of the 'third sex'. Bonheur
photographs her much younger partner, dressed in a long
skirt and ruffled white blouse, painting Bonheur – brush in
hand, hair scandalously short – who is also painting, at work
on an equestrian canvas. [CL]

The Eulenberg affair of 1906–07 was as much of a scandal
in Germany as Oscar Wilde's trial of 1895 was in England.
Both made visible a stereotype of the male homosexual,
rigidifying cultural prejudices. The Eulenberg affair revolved
around accusations by the journalist Maximilian Harden
about the homosexuality of the circle of advisers that
surrounded Kaiser Wilhem II. An affair between General
Kuno Graf von Moltke and Phillip, Prince of Eulenberg,
was at the centre of the case. (Documents suggesting the
proclivities of the Kaiser apparently existed but were not
used by the press.) Harden's accusations unleashed a flood
of newspaper caricatures and reports, as well as a series
of trials that traded charges of homosexuality – outlawed
by Germany's Paragraph 175 from 1871 until 1994 –
and charges of libel. Both Magnus Hirschfeld and Moltke's
ex-wife, none other than the transsexual Lili Elbe, testified
to Moltke's homosexuality. Moltke was found guilty.
This caricature of 1908 replaces the virile Prussian warriors
represented on the Kaiser's seal with two pudgy 'romantic
friends'. The Prussian motto has been replaced with pillow
talk: 'My heart. […] My own little bear.' [RM]

JOHN SINGER SARGENT
Figure Study, 1900
48 × 56 cm
Watercolour and pencil on paper
Collection, National Museums and Galleries of Wales

Born to American expatriate parents living in Italy, Sargent
studied painting in Florence and Paris. After settling in
London (with frequent trips to the Continent and the United
States), he enjoyed great success as a portraitist of the upper
classes. In private, Sargent also produced an extensive body
of homoerotic drawings and watercolours, including this
erotically charged painting of a lightly draped male model.
Whatever Sargent's own sexuality (he never married, and his
family destroyed his personal papers upon his death), his
sketches and watercolours all but caressed the male nude. [RM]

LEON BAKST
Portrait of Zinaida Gippius, 1906
Sanguine, black and white chalk on paper
38 × 30 cm

Though it portrays one person, this painting brings together
a queer trio of creative subjects. Its sitter, Zinaida Gippius,
was a symbolist poet and novelist exiled from Russia after
the Revolution. In Paris, she became as famous for her
androgynous style and rumoured lesbianism as for her writing.
The painter of the portrait, Leon Bakst, was best known as
the creator of scenic design and costumes for the Ballet Russes,
including the exotic, daringly erotic costumes worn by lead
dancer Vaslav Nijinksy. Finally, Oscar Wilde, the witty and
scandalously homosexual writer, provided the inspiration for
Gippius's cross-dressed attire and dandified pose. [RM]

EUGENE JANSSON
Self-Portrait, 1910
Oil on canvas
34 × 25 cm
Collection, Örebro Konsthall, Sweden

A lifelong resident of Sweden, Eugene Jansson was celebrated
for his Symbolist landscapes and marine paintings, often set
at night or twilight. After achieving both popular and critical
success in the 1890s, Jansson turned in 1904 almost exclusively
to the subject of the male nude. He painted his lover Knut
Nyman, as well as scores of other strapping young men, within
the context of Sweden's 'open air' vitalist movement. Jansson
set up a makeshift studio on the island of Skeppsholmen,
near a cold-water bathhouse utilized by sailors in the Swedish
Navy. Here the artist found a ready supply of naked men
swimming in the outdoor baths, lifting weights and performing
calisthenics. Jansson's first exhibition of male nudes in 1907
was bitterly rejected by the same critics who had embraced
the artist's early landscapes and Symbolist nocturnes. [RM]

PABLO PICASSO
Portrait of Gertrude Stein, 1906
Oil on canvas
100 × 82 cm
Collection, Metropolitan Museum of Art, New York

Writer, patron and impresario of modernism Gertrude Stein
donated this painting to the Metropolitan Museum of Art in
New York. She thus ensured that an iconic image of a butch
lesbian would flourish in the halls of high culture. Picasso
renders Stein with the techniques of abstraction, influenced
by African art, that he would articulate in his Cubist period.
And even though the portrait was painted two decades before
Stein adopted her celebrated crew cut, he renders her as an
'hommesse' – a mannish woman, legs apart, hands on knees,
leaning forward into pictorial space. [CL]

B —
Stepping Out
(1910 – 29)

'Stepping Out' traces the increasing visibility of distinct gay and lesbian subcultures in urban centres in the early twentieth century. Illustrations and photographs from Paris in the 1920s serve to document the freedoms claimed by the well-heeled American and British expatriate community, as well as the key French artists they shared the city with, while New York in the 1910s and 1920s brings into play the black and bohemian cultural scenes of Harlem and Greenwich Village. In each of these locations, gay and bisexual figures were seen, to varying extents, as the very embodiments of fashionable modernity and free love. Female masculinity, while it often involved explicitly lesbian practices, was bound up with the broader representation of the 'modern woman' in art, advertising and literature. A sense of this increased visibility is suggested by the fact that the word 'homosexuality' first appeared in *The New York Times* in 1926.

GEORGE PLANK
Illustration of 'Aunt Georgie' for E. F.
Benson's novel *The Freaks of Mayfair*, 1916
Ink on paper

In this illustration for E. F. Benson's 1906 novel *The Freaks of Mayfair*, the character of Aunt Georgie has been aligned with the interior space of his own domesticity, the space of tassels and polka dots, of needlepoint and pinky rings. Rather than suggesting the possibility of sexual coupling with another man, Georgie's image conveys the solitary status of the bachelor uncle or spinster aunt (or, perhaps, the bachelor uncle become the spinster aunt) who devotes his time to embroidering shawls and pillowcases or to getting gussied up in his smoking jacket and tie while having little, if any, place to go. The stereotype of the homosexual 'aunty' stranded in his own effeminacy points to the ways in which queer forms of desire were represented through the crossing and confusion of gender roles. [RM]

Aunt Georgie

ELISAR VON KUPFFER
Tre Anime: antiquita, oriente e tempi moderni, 1913
Tempera on canvas
161 × 102 cm
Collection, Museo Elisarion, Minusio, Switzerland

In *Tre Anime*, Elisar von Kupffer brings together three
curvaceous, slightly simpering boys (and one large peacock)
to create an unlikely allegory of antiquity, the 'Orient'
and modernity. An Estonian-born aristocrat, poet, artist
and literary translator, von Kupffer edited one of the first
and most influential anthologies of homosexual poetry.
Published in 1900 and partially inspired by what he saw as
the unjust imprisonment of Oscar Wilde, *Lieblingminne und
Freundesliebe in der Weltliteratur* (loosely, Love Between Friends
in World Literature) gathered poems from contemporary
(late nineteenth-century) Germany, Renaissance Italy,
and ancient Greece, Rome and Egypt, among other cultures
and periods. With his lover, the scholar Eduard von Mayer,
von Kupffer established the Sancturaiam Artis Eliasarion,
a sanctuary dedicated to the couple's art collection, much of
which featured floridly homoerotic paintings by 'Eliasarion'
(AKA von Kupffer), such as *Tre Anime*. [RM]

ANONYMOUS
Untitled, 1913
Black and white photograph
Collection, Schwules Museum, Berlin

Though the Eulenberg affair of 1907–08 turned
homosexuality in the military into a scandal, the First World
War put men in close quarters in a same-sex environment;
as in all other wars, eroticized friendships were inevitable, as
were nominally illegal homosexual acts. Drag acts flourished,
as they did in the Second World War. We would have no way
of even beginning to decipher this image without recourse
to the notations on the back of the photograph. From these
we can infer that the men are conscripts performing a drag
marriage in the Grabowsee forest. On the left is the groom,
in the middle the bride and on the right the mother-in-law.
A 'volunteer' is plunked on the ground before them. To ridicule
military hierarchy, the soldiers have invented fake titles and
battalions for themselves; the groom, for example, is 'Knight
of the Order of the Elephant, Seventh Class'. [CL]

MARSDEN HARTLEY
Portrait of a German Officer, 1914–15
Oil on canvas
174 × 105 cm
Collection, Metropolitan Museum of Art, New York

RICHARD FAYERWEATH BABCOCK
Join the Navy, 1917
Lithgograph on paper
106 × 72 cm

The American painter Marsden Hartley arrived in Berlin in 1913 and was immediately awestruck by what he saw as the 'masculine ruggedness and vitality' of the city, particularly as embodied by German soldiers in uniform. 'The whole scene', Hartley would later recall, 'was fairly bursting with organized energy, and the tension was terrific and somehow most voluptuous in the feeling of power – a sexual immensity even in it, when passion rises to the full and something must happen to quiet it.' Hartley translated his attraction to German soldiers in general – and to one in particular, Karl von Freyburg, with whom he fell in love – into a series of vibrant abstract paintings that include fragments of military insignia, flags and medals such as the Iron Cross. [RM]

This startling First World War recruiting poster stations the sailor astride an oversized torpedo. This is the bluejacket as bronco-buster or cowboy, one whose horse has become a sleekly phallic means of mobility and attack. The figure is presented in three-quarter profile so that attention is called to the force that shoots through his spread legs. For all his conventional manliness, the sailor is remarkably receptive to that massive thrust. While the poster attempts to imbue the figure with some control over the torpedo through the introduction of reins and a riding crop, the skimpy length of the crop and the near illegibility of the reins suggest the half-heartedness of the attempt. In *Join the Navy*, it is the torpedo that drives the sailor, not the other way around. [RM]

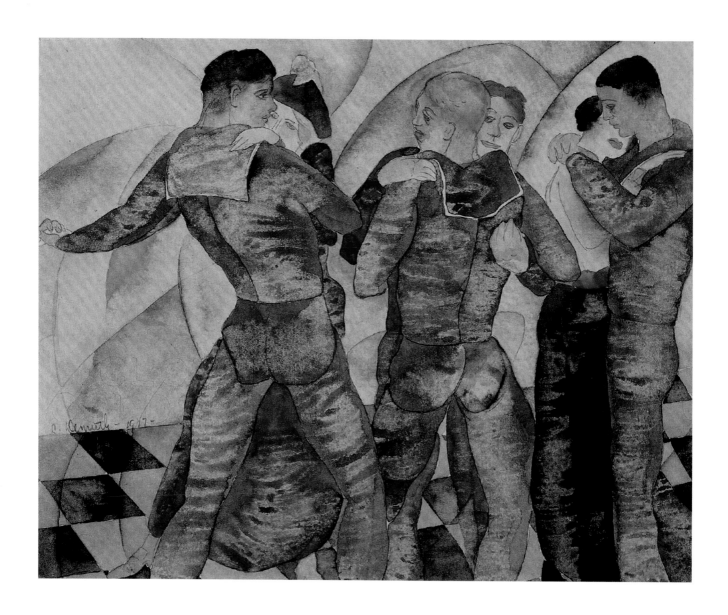

CHARLES DEMUTH
Dancing Sailors, 1917
Watercolour and pencil on paper
20.5 x 25.5 cm
Collection, Cleveland Museum of Art

The modernist painter Charles Demuth is best known for
his cubist-inspired compositions, brilliant colourism and
crisp geometries. In private, he also produced scores of erotic
watercolours, many featuring sailors in various states of
dress and undress. In *Dancing Sailors*, three couples are seen
in close proximity on a checkerboard dance floor. The middle
couple is comprised of two sailors, one of whom eyes not his
partner but the bluejacket dancing with a blonde woman
to his immediate left. That sailor, meanwhile, seems more
interested in the company of other men than in the woman
he holds in his arms. [RM]

GOSTA ADRIAN-NILSSON (GAN)
Dancing Sailors, 1923—25
Collage
32 × 25 cm
Collection, Kulturen, Lund, Sweden

A Swedish artist who travelled repeatedly to Berlin, Gosta
Adrian-Nilsson (otherwise known as GAN) incorporated
elements of Cubism and Futurism into his work. He played
a key role in introducing modernist painting to Sweden
and was, by 1919, creating entirely abstract compositions.
In the 1920s and 1930s, GAN returned to figuration in
a number of photomontages of Swedish sailors variously
posing for the camera, dancing with one another and
standing in military formation. As in this work, GAN's
pictorial accumulation of sailors was often punctuated by
stencilled words and numbers suggesting both commercial
signage and cubist collage. [RM]

FLORINE STETTHEIMER
Portrait of Marcel Duchamp, 1923
Oil on canvas with painted frame
76 × 58 cm

Florine Stettheimer, an eccentric socialite who lived
with her two sisters and mother for much of her adult life,
was also a painter delighting in elongated, androgynous
and otherwise gender-bending figuration. In this work,
Stettheimer wittily presents her close friend and fellow artist
Marcel Duchamp in two guises: as the artist seated in an
armchair and as his flamboyant drag alter ego, Rrose
Selavy. He elevates her as she perches, in rose-colored
lounging pyjamas, on a mechanized stool. Rather than
making a strong divide between masculinity and femininity,
the portrait presents both Duchamps as broad-shouldered,
narrow-waisted, long-limbed androgynes. [RM]

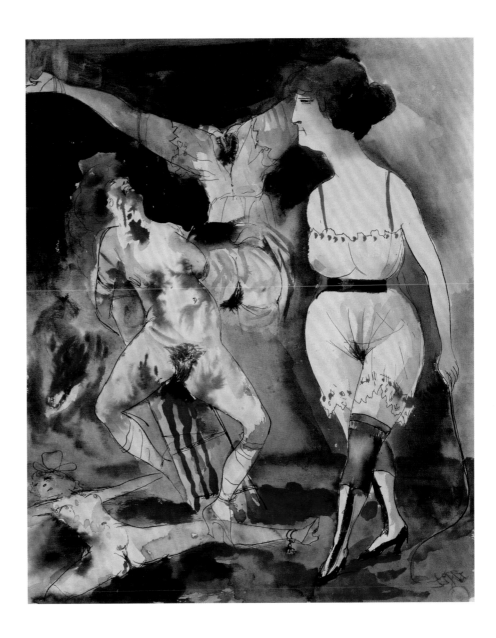

OTTO DIX
The Dream of the Sadist I, 1922
Watercolour and ink on paper
48 x 39 cm

After surviving the First World War, Otto Dix became a
central figure in avant-garde German culture, along with
fellow painters George Grosz, Christian Schad and Max
Beckman. Dix's work was ruthless in its criticism of the
decadence and greed of the Weimar Republic. He focused
on central tropes of German metropolitan life of the 1920s:
fat financiers, rich women, disfigured war veterans,
prostitutes, 'new women', transvestites, drag queens,
homosexuals, artists, writers and entertainers. Dix generally
used an admixture of such icons, but he also took as
material the thriving Berlin gay and lesbian bar scene,
a world-famous tourist attraction that also provided
interracial, same-sex spaces for queers in the know. Unlike
Jeanne Mammen, but like Brassaï, Dix was an onlooker,
not, as far as we know, a participant. This fantastical,
and gory, watercolour of a lesbian S/M orgy might represent
something Dix had heard about, something he had actually
witnessed, or something he wished he had. [CL]

HILDA DOOLITTLE (HD), ANNIE WINIFRED ELLERMAN
(BRYHER) AND KENNETH MCPHERSON
Untitled, c.1920–30
Collaged photographs on scrapbook page
28 x 38 cm
Collection, Beniecke Library at Yale University,
New Haven, Connecticut

The photographs mounted on this scrapbook page were
a collaboration between two lovers. One was HD, or Hilda
Doolittle, imagist poet and Sigmund Freud analysand.
The other was Bryher, or Annie Winifred Ellerman, shipping
heiress and art patron. They were the loves of each other's
long lives. They lived independently, negotiated several
ménages-a-trois and travelled as cousins. In these, as in many
other snapshots that the couple made in the Greek isles
during the early 1920s, HD presents herself to Bryher's
camera as a goddess. The occasion appears to be a romantic
summer outing, the photographs campy improvisations.
What has come to be known as HD's scrapbook, however,
was in fact assembled by homosexual painter and filmmaker
Kenneth McPherson from HD's accumulation of postcards,
film stills and snapshots. The scrapbook itself, then, is a
collaboration between HD, Bryher and McPherson, who
also happened to be Bryher's second husband. McPherson
included himself on some pages. On the others he arranged
fragments of statuary, architectural details and snapshots
that Bryer had made of HD displaying herself as a Greek
goddess. The scrapbook reflects the intricate layers of
romantic and erotic relationships between three people. [CL]

ROMAINE BROOKS
Portrait of Una, Lady Troubridge, 1924
Oil on canvas
127 x 77 cm
Collection, Smithsonian Museum of
American Art, Washington, DC

This almost entirely monochromatic portrait is one of
three iconic depictions of mannish women that Romaine
Brooks produced in the 1920s, the other two being her *Self-
Portrait* (1923) and *Peter, a Young English Girl* (1923–24).
Una, Lady Troubridge, wears striped trousers, a waistcoat,
monocle, cravat and pocket watch. She stands behind two
dachshunds that were a gift from Radclyffe Hall, her lover
of twenty-eight years. Hall's novel *The Well of Loneliness*,
for better or worse the foundational epic of lesbian culture,
is a maundering account of the travails of an aristocratic
male 'invert' trapped in a woman's body. Published in 1928
and promptly tried for obscenity, the novel, and Hall's
resulting visibility, had not yet cemented the connection
between the 'mannish' woman and the female homosexual.
Portrait of Una, then, a collaboration in representation
between sitter and painter, represents not a lesbian
recognized by her predilection for cross-dressing but a woman
of means costumed in extremely expensive female clothing –
an emancipated, modern, well-dressed, and plausibly
heterosexual woman of the period. The well-heeled coterie
to which Troubridge, Hall and Brooks belonged could,
of course, recognize the signifiers of homosexuality, but
Brooks's portrait indicates a more complex manipulation,
by painter and subject, of the codes of female masculinity
and high fashion. [CL]

AGNES GOODSIR
The Parisienne, c.1924
Oil on canvas
61 x 50 cm

The painter Agnes Goodsir, born in the conservative British
colony of Australia in 1864, left for London and Paris around
the turn of the century, where she frequented the lesbian
circles of the epoch. Though Goodsir produced streetscapes
and genre studies, her most powerful work consists of oil
portraits, particularly of women. The independent woman
depicted in *La Parisienne* is American expatriate Rachel
Dunn, who divorced her husband to live with Goodsir in
Paris – as it happens, in the same Latin Quarter apartment
block as Sylvia Beach and Adrienne Monnier. As she did
in several other portraits, Goodsir portrays her 'longtime
companion' as a 'new woman', an independent being with
cloche hat, bobbed hair, tailored blouse and a cigarette
dangling from one elegantly manicured hand – all signifiers
that made Dunn legible as a lesbian to the circles within
which she travelled. Dunn returned a significant number of
works to Australia after Goodsir's death in 1939. [CL]

JAMES VAN DER ZEE
Beau of the Ball, 1926
Black and white photograph

RICHARD BRUCE NUGENT
Cover illustration for the March issue
of *Opportunity* magazine, 1926
Ink on paper

Born in Lenox, Massachusetts, in 1886, James Van Der Zee moved to Harlem in 1910 and became the most noted photographer of African-American life between the two World Wars. Van Der Zee recorded weddings, funerals, parties, workplaces, community events and basketball teams. His 1925 studio portrait captures a fetching man on his way to one of Harlem's famed drag balls, decked out in high heels and an outfit of Eastern European embroidery trimmed with fur. Although now seen as definitive images of the Harlem Renaissance, Van Der Zee's portraits were largely unheralded prior to their 'rediscovery' by New York's Metropolitan Museum of Art as part of its controversial 'Harlem on My Mind' exhibition in 1969. [CL]

Painter and writer Richard Bruce Nugent was an intimate of Harlem Renaissance luminaries such as Countee Cullen, Zora Neal Hurston and Langston Hughes. The group represented a younger generation of African-Americans who broke from a previous imperative to improve the race through respectability. (For a time, Nugent lived with Wallace Thurman and others in a house in Harlem notoriously dubbed the 'Niggeratti Mansion'. Nugent was one of the people who contributed to erotic murals that adorned the interior of the building.) He made no secret of his considerable interest in men. He was, in fact, the first African-American writer to write about his homosexuality, albeit mildly and under a pseudonym. 'Smoke, Lilies and Jade' (1926), published in the sadly short-lived journal *Fire!!!*, caused a sensation. The poem is in the voice of Alex/Nugent, who idles about New York, reflecting upon Oscar Wilde and the beauty of men as well as women. 'Alex wondered why he always thought of that passage from Wilde's *Salome* ... when he looked at Beauty's lips ... I would kiss your lips.' Nugent frequently contributed brush-and-ink illustrations to *Opportunity*, the magazine of the National Urban League. This cover illustration employs the profile view that Nugent favoured. His stylized subject, given the signs of heroic status, as well as African origin, turns back to look at an unidentifiable but temptingly phallic object. [CL]

OPPORTUNITY

JOURNAL OF NEGRO LIFE

15¢

MARCH
1926

FEDERICO GARCÍA LORCA
The Kiss, 1927
Ink, pencil and gouache on board
30 × 22.5 cm
Collection, Museo Casa de los Tiros, Granada

For the poet and playwright Federico García Lorca, the act of drawing was as important a means of thinking as that of writing. In his earliest sketches, Lorca theatricalized the pain of women who desired men. He moved on to melancholic, tender drawings of elongated clowns, sailors and bullfighters. In this representation of a kiss, Lorca plays with doubling, even tripling, as a means to create both distance and intimacy. The superimposition of the two heads in this painting align to delineate a kiss, while a third perhaps suggests a shadow or the presence of an onlooker. Following a tempestuous affair with Salvador Dalí in the 1920s, Lorca was executed by Franco's troops outside Granada in 1936, not only for his politics but also for his homosexuality. [CL]

BERENICE ABBOTT
Janet Flanner in Paris, 1927
Black and white photograph
Collection, Library of Congress, Washington, DC

Berenice Abbott made many portraits of Parisian artists of
the 1920s, among them Eugene Atget (whose archive of
glass-plate negatives she helped to rescue from oblivion) and
Man Ray. She also photographed gay and lesbian artists
active in or connected to the Left Bank scene, including Jean
Cocteau, Andre Gide, Sylvia Beach, Adrienne Monnier,
Eileen Gray, Betty Parsons, Gluck and Djuna Barnes. 'To be
"done" by Man Ray or Berenice Abbott', said Sylvia Beach,
'meant you rated as somebody.' Here Abbott photographs
Janet Flanner, an habitué of Nathalie Barney's salon and
The New Yorker correspondent who dispatched her thoroughly
queer 'Letters from Paris' under the pen name Genet. Cross-
dressed for a carnival ball, Flanner wears a top hat on which
are attached two masks. [CL]

MAN RAY
Barbette Applying Makeup, 1928
Black and white photograph
Collection, Getty Museum, Los Angeles

JANET FLANNER
Poem Written for Mercedes d'Acosta, c.1928
Ink on paper
31 × 22 cm
Collection, Rosenbach Museum and Library, Philadelphia

Fully engaged in the drama of backstage preparation, Man Ray catches the trapeze artist Barbette in the midst of applying mascara to her already highly made-up face. Born Vander Clyde (or, by other accounts, Vander Clyde Broadway) in Round Rock, Texas, the boy who would become Barbette trained himself as an aerialist by walking along his mother's clothesline. After joining the circus at the age of fourteen, he refashioned himself Barbette and performed a high-wire act in full drag, revealing himself as a man only at the conclusion of his performance. After making his Paris debut in 1923, Barbette was embraced by popular audiences, as well as by avant-garde artists, particularly the writer Jean Cocteau and the Surrealist photographer Man Ray. Cocteau, who later cast Barbette in an experimental film, expressed his adulation of the performer in a letter to a Belgian friend: 'Next week in Brussels, you'll see a music-hall act called "Barbette" that has been keeping me enthralled for a fortnight. The young American who does this wire and trapeze act is a great actor, an angel, and he has become the friend to all of us. Go and see him […] and tell everybody that he is no mere acrobat in women's clothes, nor just a graceful daredevil, but one of the most beautiful things in the theatre. Stravinsky, Auric, poets, painters and I myself have seen no comparable display of artistry on the stage since Nijinsky. [RM]

This water-stained piece of paper is a love letter. Drawn by Janet Flanner, Paris correspondent for *The New Yorker*, it is addressed to the champion seductress and unsuccessful Hollywood screenwriter Mercedes d'Acosta. 'Say what you want about Mercedes,' Alice B. Toklas famously observed, 'she's had the three greatest women of the twentieth century.' (Greta Garbo and Marlene Dietrich were certainly on Toklas's shortlist, but no one knows the identity of the third woman.) Flanner uses words to render images of flowers – in this case, a tulip. 'She ate daintily,' Flanner wrote to draw the edge of a leaf, 'consuming a sweetened crumb like a sinner taking a high note. She ate flesh talking of flowers and flesh.' The love letter is but one scrap in the mounds of paper generated by the army of lovers that populated expatriate lesbian Paris. Ink on paper was the women's route to visibility. They ran bookstores (Sylvia Beach and Adrienne Monnier), they helped each other out by producing interdisciplinary work (Nathalie Barney's soirees), wrote gossip columns about their gay lives (Flanner's letters in *The New Yorker*), and fired off sexy poems (Gertrude Stein's 'Tender Buttons'). They also painted (Romaine Brookes), photographed (Berenice Abbott) and drew each other (Djuna Barnes). [CL]

CLAUDE CAHUN AND MARCEL MOORE
Untitled from the series *Cancelled Confessions*, 1928–29
Photomontage
22 × 17 cm

Claude Cahun (Lucie Schwob) and Marcel Moore (Suzanne Malherbe) began their *amour fou* as stepsisters and teenagers in 1909. They remained in creative and romantic partnership for more than thirty years, creating photographs, illustrated books, fashion plates and stage sets. Having fled Paris for the Isle of Jersey early in the Second World War, they launched an anti-Nazi propaganda campaign that nearly resulted in their execution. In *Aveux non avenues* (Cancelled Confessions) Moore weaves photomontages with scraps of Cahun's self portraits, themselves theatrical collaborations with Moore that offer a masquerade of queer tropes, staged collisions of gender signifiers and, most important, a contestation of female narcissism. The collages serve as chapter headings to Cahun's patchwork of texts, this one leading off a section on sex. 'Surely you are not claiming to be more homosexual than I?', reads Cahun's epigraph. In this image, various views of Cahun's shaved head are aligned to place her in a lover's relationship with herself. [CL]

C —
Case Studies
(1930 — 49)

Queer culture in the 1930s and 1940s could be characterized by
three kinds of case studies: the medical classification of the
homosexual as an object of clinical attention, the legal status of
the homosexual as a criminal, and the development of substantial
bodies of work by artists and photographers that represented or
resisted these definitions. The works in this chapter consider the
prohibitions imposed upon artists who depicted homoeroticism,
the visual framing of homosexuality as a sickness or crime, and
the use of allegorical and symbolic codes in painting to represent
homosexuality. Weegee's photographs of transvestites, Brassaï's
pictures of 'Secret Paris' and Paul Cadmus's paintings of carousing
sailors and 'fairies' all speak to the scandal — as well as the
pleasures — attached to alternative genders and sexualities. Worth
noting is the absence of lesbians as producers of visual images,
coupled with their presence as subjects in photographs, paintings
and various popular culture images.

SERGEI EISENSTEIN
Untitled (Au cours de Verlaine et de Rimbaud), 1930
Ink on paper

The Russian revolutionary filmmaker Sergei Eisenstein
created some of the most influential films of the early
twentieth century, including *Battleship Potemkin* (1925) and
October (1927). His homoerotic drawings, however, remained
unpublished and all but unknown to anyone outside his
immediate circle throughout his life. Ranging in tone from
the lightly humorous to the hotly explicit, the drawings
variously report on *Greek Philosophy* (a comely youth
embraces his bearded mentor outside a Greek temple),
L'Amour qui n'ose pas dire son nom (one man places his hand
between the legs of another) and *Sodomy*, which, true to
its title, offers a Jean Cocteau-like sailor penetrating his
partner from behind. [RM]

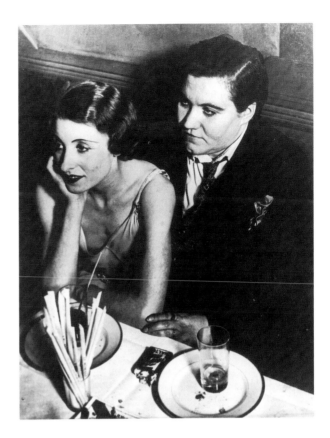

BRASSAÏ (GYULA HALASZ)
Lesbian Couple at Le Monocle, 1932
Black and white photograph
Collection, Cleveland Museum of Art;
The Museum of Modern Art, New York

CARL VAN VECHTEN
Gladys Bentley, February 27, 1932, 1932
Black and white photograph

After leaving Cedar Rapids, Iowa – where he was born and where, according to biographer Bruce Kellner, he was known for having the tightest trousers in town – Carl Van Vechten settled in New York City, where he began to work as a critic, novelist and a passionate supporter of the Harlem Renaissance. Black critics reacted to his 1926 novel *Nigger Heaven* as the worst of white voyeurism; white audiences generally found it realistic. In 1932, Van Vechten took up photography. By the time he died, in 1964, he had produced some 15,000 portraits of musicians, actors, writers, poets and painters. In this portrait, he captures the femme incarnation of Gladys Bentley, Harlem's celebrated cross-dressing bulldagger crooner, legendary for wreaking salacious havoc on contemporary lyrics and putting the moves on women in her audiences at Harry Hansberrry's Clam House and the Ubangi Club. In the 1940s, Bentley entertained as the Brown Bomber at San Francisco's Club 440. [CL]

Brassaï's images of the Paris demimonde of the 1920s and 1930s ('faggots, cruisers, chickens, old queens, famous antique dealers', as he put it) record in abundant detail a social world in which his subjects are the dominant group and the photographer himself is in the minority. Recollecting his lesbian subjects in his 1976 book *The Secret Paris*, he expressed his fascination but was hardly nonjudgemental: 'Obsessed by their unattainable goals to be men, they wore the most somber uniforms: black tuxedos, as though in mourning for their ideal masculinity. [...] And of course their hair.'

Taken at a lesbian bar in Montparnasse, this photograph appears to be a candid shot, but in fact Brassaï's sitters would have known that they were being photographed. At the right moment, he would have signalled an assistant to set off the magnesium flash so that he could expose his negative. The strategy was not subtle: Picasso dubbed Brassaï 'the Terrorist' because of his use of flash. Nonetheless, the photographer captures a beautifully ambiguous moment. A butch/femme couple sit close together on one side of a cocktail table, looking with interest at the scene unfolding beyond the frame of the photograph. The butch was the French weightlifter, shot-put athlete and sometime cabaret singer Violette Morris. She underwent a double mastectomy in order to fit more comfortably behind the wheel of a racing car. Lest she be romanticized for her manly outfit and gentlemanly demeanor, it should be said that she went on to become a Nazi collaborator, known as 'the hyena of the Gestapo'. She was assassinated by the French Resistance in 1944. [CL]

CHARLES HENRI FORD
Untitled (Bastidores), 1934
Collage on scrapbook page
19 × 27 cm

The Mississippi-born poet and editor Charles Henri Ford
travelled to Spain in 1934 with his friends, film critic Parker
Tyler and photographer Cecil Beaton. During the trip, Ford
kept a scrapbook into which he pasted a series of collages,
including this scene, in which the three men pose within the
courtyard of a Spanish ranch house, on the roof of which
presides a giant bull and matador. The high-waisted jacket
and utter self-possession of Beaton (on the far left) mirrors
the theatrical self-presentation of the matador, while Tyler
(in the centre) and Ford (seated on the right) discreetly
turn their bodies (but not their gazes) towards each other.
In 1933, Tyler and Ford's co-authored novel *The Young and
the Evil* was published in Paris. Often considered to be the
first gay novel, the book was banned in England and the
United States for several decades after its publication. It is
loosely based on the experiences of Tyler and Ford in early
1930s New York and includes scenes set in Greenwich Village
saloons, poetry salons and Harlem drag balls. Ford would
go on to edit the influential Surrealist magazine *View* and
to become the lover and life partner of the Russian-émigré
painter Pavel Tchelitchew. [RM]

MONTE PUNSHON
Untitled, c.1932
News clippings on scrapbook pages
First scrapbook 23 x 31 cm
Second scrapbook 28.5 x 22 cm

An Australian school teacher, amateur theatrical performer and member of the Women's Army Service during the Second World War, Monte (née Ethel May) Punshon kept scrapbooks of selected newspaper clippings from the 1920s and 1930s. An inordinate number of the clippings feature photographs of short-haired, chicly man-tailored young women, the look that Punshon herself adopted at the time. Now housed in the Australian Lesbian and Gay archives, the scrapbooks also contain 'stories about theatrical cross-dressing, male impersonators, women passing as men [...] and a review of Radyclffe Hall's 1928 lesbian novel *The Well of Loneliness*', according to the 2002 guide *Who's Who in Contemporary Gay and Lesbian History*. Punshon's scrapbooks testify to the visibility of butch women, boyish flappers, drag queens and other gender variants in the early twentieth-century illustrated press, and to the delight of certain readers in seeing and saving such images. [RM]

MARIETTE LYDIS
Suzy Solidor, 1934
Pencil and gouache on paper
24 x 31 cm

Mariette Lydis was a painter and illustrator in Paris before the Second World War until she fled with her lover, eventually settling in Buenos Aires. Her engravings, often of lesbian erotica, were used in luxury editions of works by Charles Baudelaire and Paul Verlaine, as well as that almost mythic 'lesbian' text *Les Chansons de Bilitis* (1894) by Pierre Louÿs. This figure study depicts Suzy Solidor, the lesbian chanteuse whose cabaret, La Vie Parisienne, made her a celebrity, though she moved in circles other than lesberati like Gertrude Stein and Djuna Barnes. In making this drawing, Lydis joined the group of some 250 artists, including other queers such as Foujita and Tamara de Lempicka, whom Solidor commissioned or allowed or encouraged to paint her. Solidor covered the walls of her cabaret with these portraits – some reverential, some satirical and some frankly erotic. Lydis's drawing is a hyberbolic embodiment of the Solidor lyrics to *Ouvre* that still serve as a camp lesbian theme song: 'Open your trembling knees, open your thighs.' [CL]

PAUL CADMUS
The Fleet's In!, 1934
Oil on canvas
76 x 152 cm
Collection, Navy Art Collection, Washington, DC

In 1934, shortly before Paul Cadmus's painting *The Fleet's In!* was to be displayed at the Corcoran Gallery of Art in Washington, DC, it was confiscated by an outraged Rear Admiral and publicly denounced as a 'disgraceful, sordid, disreputable, drunken brawl'. The suppression of Cadmus's painting provoked a media sensation, with scores of newspapers and several national magazines running articles and editorials on the episode, many accompanied by reproductions of the work. As the artist himself would recall, 'I owe the start of my career, really, to the Admiral who tried to suppress it.' [RM]

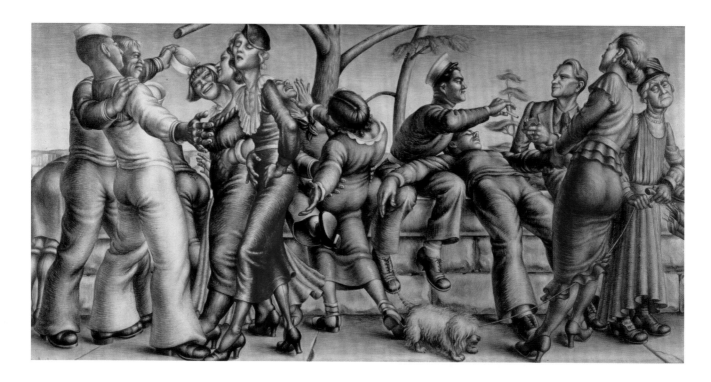

RICHMOND BARTHÉ
Feral Benga, 1935
Bronze
48 × 12.5 × 12.5 cm

Born and raised in the American South, James Richmond Barthé moved to Harlem in 1928 to explore the vibrant artistic, social and sexual worlds on offer there. Though not as overtly political as some of his peers, Barthé was audacious in his frank eroticization of the black male nude. In works such as *Feral Benga*, he drew together his interests in classical sculpture, African culture and the male nude. The sculpture is based on a performance Barthé attended in Paris of the Senegalese cabaret dancer François Benga, also known as Feral Benga. As his stage name might suggest, Benga's style of performance was wildly theatrical and self-consciously primitivizing. [RM]

PAVEL TCHELITCHEW
Bathers, 1935
Gouache on paper
68 × 48 cm

Variously known as a Surrealist, a Magic Realist, and a Neo-Romantic, Pavel Tchelitchew created what may well qualify as some of the weirdest figurative paintings of the mid-twentieth century. Born in Russia and based in Paris during the 1920s – where he became part of Gertrude Stein's social circle and, like Leon Bakst, created stage designs for the Ballets Russes – Tchelitchew fell in love with the American writer Charles Henri Ford and followed him back to New York in 1934. Although modernist critics were dismissive of his work (Clement Greenberg wrote that his 'shrill saccharine colour and gelatinous symbolism set a new high in vulgarity'), Tchelitchew was the subject of a retrospective at the Museum of Modern Art in 1942 and was widely considered a leading painter of his day. In *Bathers*, a large gouache from 1935, he isolates six figures against a horizonless expanse of sand and oatmeal-coloured sea. He employs a range of formal techniques – foreshortening, unexpected contrasts of colour, and the silhouetting of two figures on the screen-like surface of their upraised towels – to create a dialogue between personal exposure and concealment, between physical presence and psycho-sexual retreat. [RM]

JARED FRENCH
Stuart's Raiders at the Swollen Ford, 1939
Painted mural
Parcel Post Building, Richmond, Virginia

BEAUFORD DELANEY
Dark Rapture, 1941
Oil on canvas
87 × 71 cm

In 1937, Jared French was awarded a commission by the Treasury Section of Fine Arts to paint a mural for the Parcel Post Building of Richmond, Virgina. For his theme, French selected a moment in the American Civil War during which Confederate (Southern) Cavalrymen, led by Major General J. E. B. Stuart, had to cross a rain-engorged, seemingly impassible stream. French's original design for the mural included six men, all nude, wading in and posing beside the stream. None of them seemed to be in any hurry to cross to the other side. At the Section's insistence, French's work was substantively revised so as to downplay (and partially cover over) the male nude. The letter from the Superintendent of the Treasury Section to French put the point bluntly: 'It is necessary for me to ask you in case you wish to use the subject matter of Stuart's Raiders to have them clothed. [...] You have painted enough nudes in your life so that the painting of several more or less should not matter in your artistic career. It is too obviously flying in the face of the public.' [RM]

Beauford Delaney arrived in Greenwich Village from Tennessee in 1929. He quickly made a reputation painting city scenes, occasionally peopled by pairs of sailors or ambiguously gendered couples. He also painted portraits of leading black figures such as W. E. B. Du Bois, Countee Cullen and Louis Armstrong. The writer and civil-rights activist James Baldwin met Delaney in the early 1940s and came to consider him a surrogate father. Delaney painted numerous portraits of Baldwin over the years, including this early nude, made when Baldwin was sixteen. After the Second World War, Delaney followed Baldwin to Paris, where barriers of race and sexuality were less crippling than in McCarthyist America, and where he moved decisively from figuration to abstraction. 'I left New York for Paris in 1953,' recollected Delaney, 'and I have painted with greater freedom ever since.' [CL]

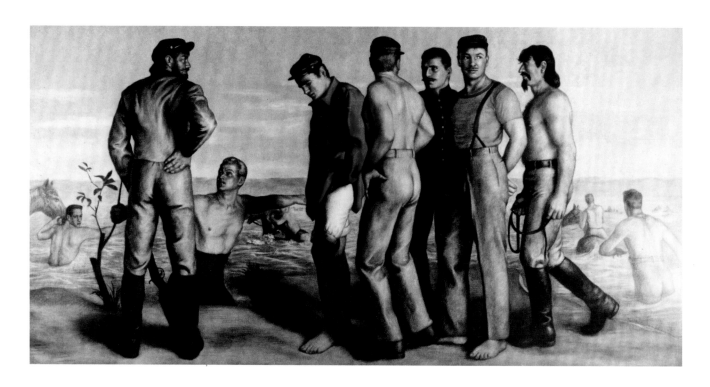

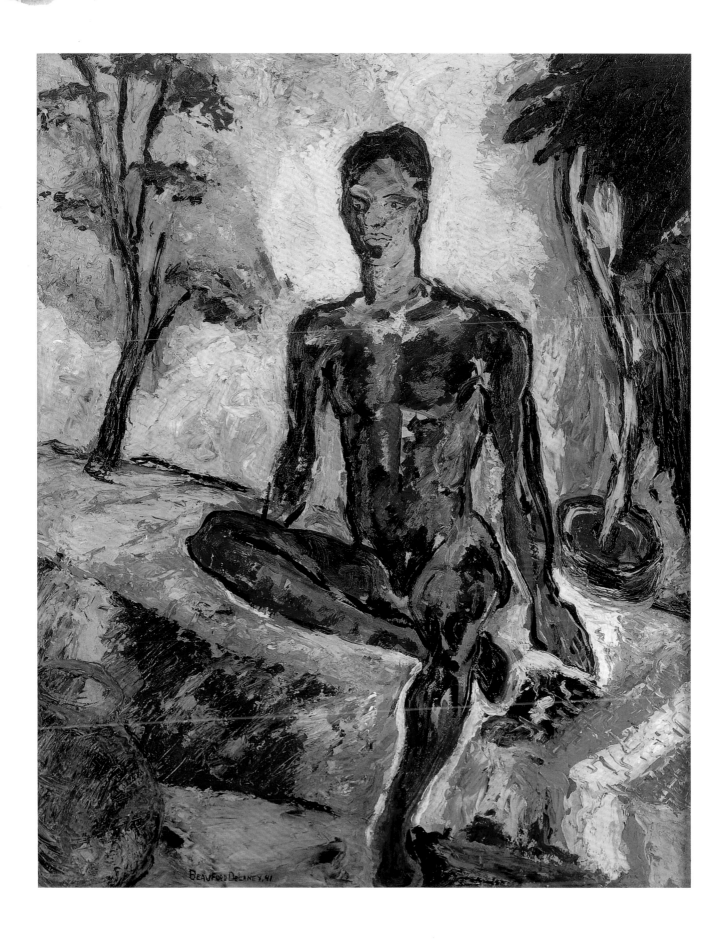

BETTY PARSONS
The Circle, 1947
Gouache on paper
41 × 51 cm

Painter, gallerist and social butterfly Betty Parsons spent
the 1930s ducking marriage proposals, as well as the stigma
of being labelled a homosexual. Lesbianism was not part of
the very public persona she presented, though she travelled –
literally, sexually and emotionally – in a well-heeled lesbian
circle that included Greta Garbo, Jo Carstairs and Tallulah
Bankhead. Parsons opened her own gallery in New York
in 1946. For the next five years, she was clearly ahead of the
field in promoting modernist art. The most important men in
her stable, however – including Jackson Pollock, Clyfford Still,
Barnett Newman and Mark Rothko – defected to competitors
when Parsons declined to sacrifice her own ambitions as a
painter or to drop those artists whom the giants judged
second-rate. Not coincidentally, among those in disfavour
were some flamboyantly queer or openly gay artists –
Theodoros Stamos, Sonia Sekula, Forrest Bess and Alfonso
Ossorio among them. The gallery never regained its
reputation. Perhaps made during Parsons's summer travels,
this still life appears to be a detail of her studio. In no way
coded as lesbian (indeed, it probably owes more to her studies
with Alexander Archipenko than to any other influence),
The Circle prefigures what would later be said of artists such
as Joe Brainard, Ana Caballo and Helena Carceller: that their
abstractions do not rely on a gay 'sensibility' or queer subject
matter but concentrate on the act of painting itself. [CL]

FOREST BESS
Untitled (The Dicks), 1946
Oil on canvas
36 × 41 cm
Collection, Nora Eccles Harrison Museum
at Utah State University, Logan

Though he showed his small abstract paintings at the
influential Betty Parsons Gallery throughout the 1950s and
1960s, Forest Bess eschewed New York City for the Gulf
Coast Texas town where he was born. Often referred to as
a visionary painter, Bess insisted that his works were the
transcription, more or less automatic, of forms and patterns
that appeared to him in the dark. In *Untitled (The Dicks)*,
those forms assume frankly phallic (as well as frankfurter-
like) associations. Bess's open struggle to come to terms
with his sexuality seems to have been heightened when he
visited New York. Writing to the art historian Meyer Schapiro
in 1950, he noted, 'I have always had strong homosexual
leanings which I have tried to understand. [...] I have
intentionally blocked the sexual outlet until I have a solution
for it – however this does not keep me from going from to
bar to bar in New York when I am there looking.' [RM]

GLUCK
Medallion, 1936
Oil on canvas
29 × 34 cm

Gluck, born Hannah Gluckstein, insisted upon 'no prefix, suffix or quotes' around her gender-neutral name. She also refused to exhibit her works alongside those of any other artist. Her paintings of flowers, landscapes, numerous portraits of women, and several self-portraits were displayed in the tiered frames she designed, which made them appear to be part of the exhibition space. Unlike Romaine Brooks, Una Troubridge and Radclyffe Hall, who wore man-tailored female garb, Gluck transgressed the conventions of the boyish modern woman by wearing recognizably male clothing, fastidiously tailored, that made legible her homosexuality. *Medallion*, a dual portrait, depicts Gluck and her lover Nesta Obermer, their splendid profiles mirroring each other as they began what both considered to be a marriage. Importantly, the painting's focus on their heads not only romanticizes the merging of two like spirits but also restricts the field of signifiers of lesbian visuality. They are still made legible, however, by the Eton-cropped hair, combed back close against the scalp, the hint of man-tailored shirts and, in a prefiguring of a trope of 1950s pulp novels, a difference in hair colour; Gluck is brunette, Obermer blonde. [CL]

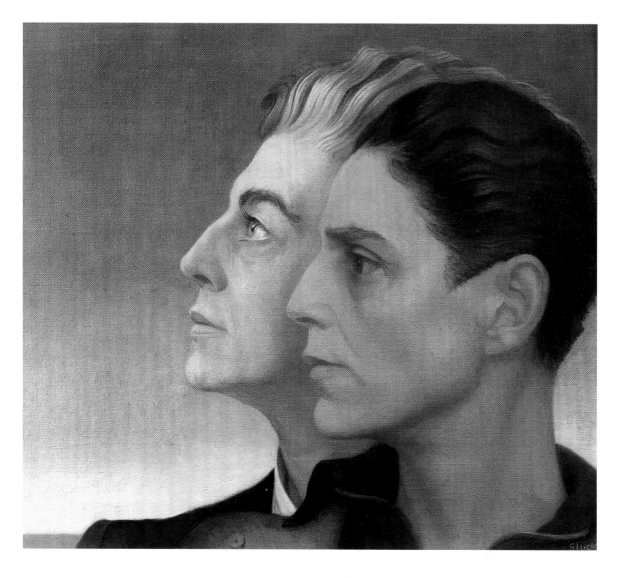

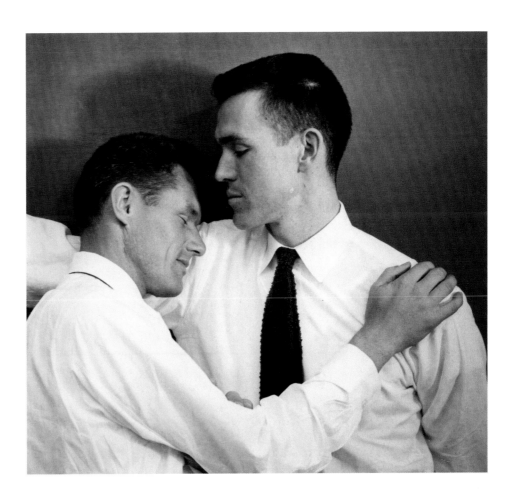

MINOR WHITE
Ernest Stones and Robert Bright, 1949
Black and white photograph
Collection, Princeton University, New Jersey

Minor White never attempted to exhibit this photograph
of a fully clothed male couple in an embrace of stylized
tenderness. Made the year after the publication of the Kinsey
Report, it is the only unambiguous image of homosexual
intimacy involving identifiable models in White's entire
oeuvre. A photographer, educator and editor (he was one
of the founders of *Aperture* in 1953), White devoted his life
to two causes. First, he crusaded to win recognition for the
medium of photography as a fine art. Second, he undertook
various spiritual quests, such as Zen Buddhism and the
philosophy of Gurdjieff, that would allow him to transcend
the material needs of the body. As a photographer, White
used the theories of Alfred Stieglitz not only to lay out
strategies for building meaning through precisely arranged
sequences of images but also to suggest homoerotic content
through juxtaposition, suggestive abstraction and the
presentation of nude male bodies in fragments or with their
faces cropped out. In 1947 one such project, *Amputations*,
was censored at the Palace of the Legion of Honor in San
Francisco. This portrait of Ernest Stones and Walter Bright,
as journalist Ingrid Sischy has pointed out, was not private
but secret: 'Privacy is a choice; it's about living your life the
way you want to. Secrecy is usually a form of protection,
but the safety it affords has the same relationship to freedom
as being locked in an isolation chamber.' [CL]

THOMAS PAINTER
Untitled, 1948
Black and white photograph

Over the course of more than twenty years, beginning in the early 1940s, Thomas Painter documented his sexual life in New York City for Alfred Kinsey. Painter was particularly interested in male prostitution (about which he wrote two unpublished books) and the practice of 'rough trade' (gay sex with straight-identified hustlers, sailors and street toughs). This photograph atypically includes the figure of Painter himself – fully clothed and holding his camera – alongside a naked, and probably rented, young companion. [RM]

CECIL BEATON
Brides, Bodybuilders, and Ladies in Edwardian Dress,
and a Gentleman in the Apartment of Monsieur Charles
de Beistegui, c.1939
Photomontage in scrapbook
42 × 31 cm
Collection, Victoria & Albert Museum, London

In this collage, the fashion and society portrait photographer Cecil Beaton represents and reinvents the interior of Charles de Beistegui's Paris apartment. An Edwardian couple and two brides have been inserted on the spiral staircase, and a glistening muscleman surrounded by mirrors, candelabra and gilded furniture, in the drawing room. As Beaton was well aware, the apartment was originally designed by the modernist architect Le Corbusier and extravagantly decorated by Beistegui. Given Corbusier's antipathy towards what he called 'the abominable little perversion' of ornate decoration, both de Beistegui's baroque interiors and Beaton's homoerotic elaboration of them within the collage take on a pointedly anti-modernist charge. [RM]

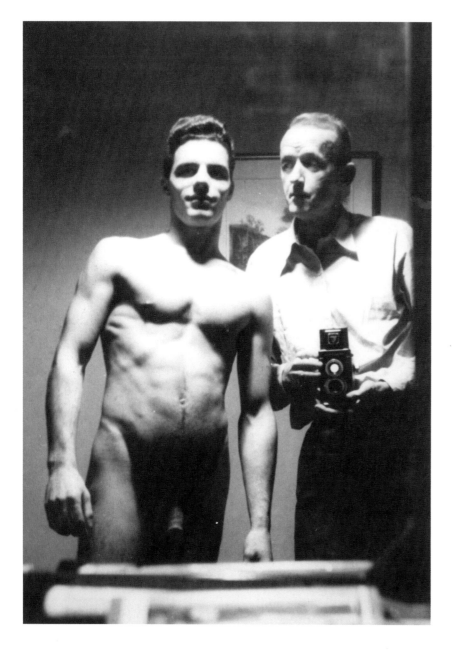

WEEGEE (ARTHUR FELLIG)
The Gay Deceiver, 1940
Black and white photograph
Collection, International Center for Photography,
New York

In 1939, the tabloid photographer Weegee (also known
as Arthur Fellig) captured a drag queen – or 'gay deceiver',
as the picture's title put it – emerging from a paddy wagon.
The subject showcases his own theatrical flair and drag
glamour, even – or especially – at the scene of his public arrest.
Throughout the 1930s and early 1940s, Weegee shot many
photographs of people (usually but not always men) in paddy
wagons and police stations. In most of these photographs
the subjects shield their face from the camera in order to
frustrate his attempt to render them visible in their moment
of police detention. The subject of *The Gay Deceiver*,
by contrast, appears to welcome the attentions of the camera.
The drag queen stages his emergence from the paddy wagon
as an occasion for self-display rather than public disgrace,
as a moment of posing rather than punishment. [RM]

D –
Closet Organizers
(1950–64)

The 1950s are generally considered the most politically conservative and expressly homophobic decade of the twentieth century. The repercussions of being identified as a homosexual at mid-century were considerable, involving social humiliation, criminal punishment, charges of mental illness and possible loss of employment and legal custody of children. The works in this section touch upon the ways in which anxieties about both communism and homosexuality prompted severely repressive measures (legislative investigations, blacklisting, criminal arrests), as well as decisive steps to resist those measures. Queer cultural producers, including visual artists and photographers, began to organize and represent themselves around and through questions of sexual secrecy, exposure, privacy and public knowledge. Key homophile groups — the Mattachine Society, Daughters of Bilitis, Arcadie — used mythic references or historical arcana to camouflage themselves to outsiders. Presenting a dignified image of assimilation while distancing themselves from the specifically sexual connotations of homosexuality, these groups laid the groundwork for a networked culture of gays and lesbians that fought to ensure employment rights, reform the penal code and affect medical research protocols. They should not be underestimated as a force for liberation and visibility. Neither should visual artists and photographers such as Jess, Andy Warhol, Valentine Penrose and Ruth Bernhard, all of whom produced alternative visions of sexuality and desire in the 1950s and early 1960s while negotiating the closets and constraints of their moment.

Cover of the novel *The Price of Salt*, written by Patricia Highsmith under the pseudonym Claire Morgan, 1953

The contents and covers of the lesbian pulp novels published between the late 1940s and the mid-1960s relied on certain tried-and-true formulas. The plot punished the deviant while at the same time providing thrilling descriptions of the mores and locations of gay life. The cover art had its own requirements. Two or more women should be in physical contact, preferably on a sofa or bed. If the women stand, one should be behind the other. They should look troubled. At least one should read as femme, and the hair of one should be darker than the other's. A distressed male voyeur should be included, when possible, while words like 'twilight', 'unnatural' or 'twisted' should appear in the jacket copy. Such were the formulas to which writers such as Ann Bannon, Ann Aldrich and Valerie Taylor adhered. Though the cover of Claire Morgan's one and only pulp novel, first published in 1951, is typical, the contents are not. The novel was at first rejected because it did not fit the prescribed formulas. Not only does the text move from tortured love story to a political critique of homophobia, but the lesbian couple in the story have a chance of living happily ever after. Claire Morgan is the pen name of the mystery novelist Patricia Highsmith, who 'came out' only in 1984 by publishing *The Price of Salt* under her real name. [CL]

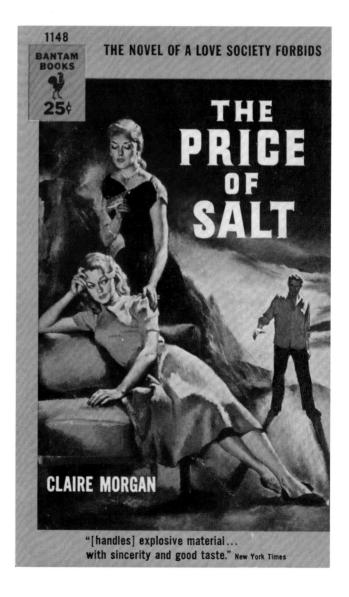

1148
BANTAM BOOKS
25¢

THE NOVEL OF A LOVE SOCIETY FORBIDS

THE PRICE OF SALT

CLAIRE MORGAN

"[handles] explosive material... with sincerity and good taste." New York Times

O Rubia! ce goût que nous avons connu de l'heureuse façon vivante
Cette mort abondante cette nuit sommée
A trop d'étendue à présent pour moi seule.

----- ✦ -----

O Rubia! This thirst we have known for the happy living way
This abundant death this obedient night
Is now far too great for me alone.

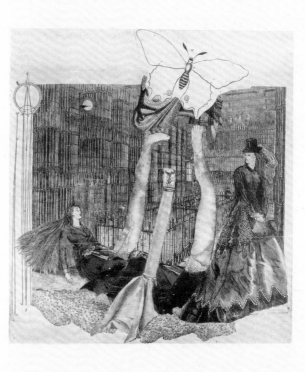

VALENTINE PENROSE
Dons de Féminines, 1951
Book
34.5 x 26.5 cm
2 of 57 pages

The surrealist Valentine Penrose used the techniques of
disjunctive collage in her writings but did not translate her
skills to visual art until the late 1940s. She began the book
work *Dons de Féminines* in 1951, after she had left her
husband, Roland Penrose, to go to an ashram in India.
Rather in the manner of Max Ernst, Penrose invented dense
collages of mythical creatures, bearded women, Victorian
balloon adventurers and damsels disporting themselves
amidst tropical foliage. *Dons des Féminines* recounts the
travels of two Victorian heroines, Rubia and Emily, whose
corporeal explorations are surprisingly explicit. The text
opposite one image, for example, reads, 'At the curtain of
your hips where I am now kneeling I beg as none has ever
begged / To let me sleep and melt into the ages.' [CL]

LARRY RIVERS
O'Hara Nude with Boots, 1954
Oil on canvas
246 × 135 cm

FRANCIS BACON
Two Figures, 1953
Oil on canvas
153 × 117 cm

In what must qualify as one of the sexiest portraits of the 1950s, Larry Rivers painted his one-time lover, poet/curator Frank O'Hara, frontally nude save for a pair of leather combat boots. The larger-than-life portrait (almost two and a half metres high) presents O'Hara standing with his arms over his head, one leg on the floor and the other on a breeze block. In the lower left of the painting, just beside the spot where boot gives way to flesh, Rivers has written the name of the poet. In the same year that Rivers completed this portrait, O'Hara wrote a poem titled 'Homosexuality', which opens with the following lines: 'So we are taking off our masks, are we, and keeping/our mouths shut? as if we'd been pierced by a glance!' Mask off and mouth shut, *O'Hara Nude with Boots* seems to command – rather than be pierced by – our attention. [RM]

A figure painter of intense, even brutal expressionism, Francis Bacon received virtually no formal training as an artist. Though he frequently based his paintings on specific photographic images, those sources were all but unrecognizable in the finished works. *Two Figures* was inspired by a late nineteenth-century photograph by Eadweard Muybridge of two men wrestling. Bacon transposed the figures onto a bed and fiercely stylized their forms so as to suggest a scene of sexual struggle bordering, perhaps, on violation. [RM]

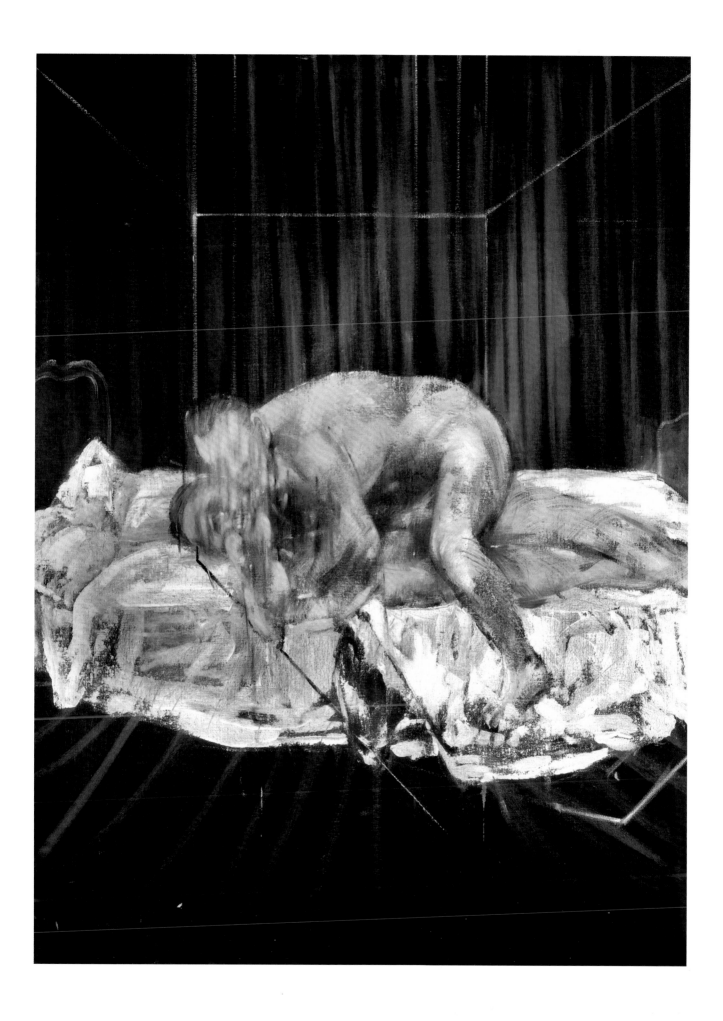

RUTH BERNHARD
Two Forms, 1963
Black and white photograph
Collection, Minneapolis Museum of Art

JOHN KOCH
The Sculptor, 1964
Oil on canvas
203 x 152 cm
Collection, Brooklyn Museum of Art

John Koch's large-scale realist painting *The Sculptor* brings together two highly charged encounters – one mythic, the other contemporary. A bronze sculpture on the left depicts the Greek hero Hercules rescuing the titan Prometheus, who, bound to a rock as punishment for stealing fire from the gods, has been daily tormented by an eagle. In the foreground we see the sculptor who has made the bronze, and the nude male model who, we may presume, posed for it, lighting his cigarette.

Art historian Kenneth Silver has provided a (suitably) close reading of the interaction between artist and model: 'The picture's sexual charge is located not only in the superb body of the model brought up so close to the picture plane, the string of the tiniest of posing straps just caressing the top of his buttocks, but also in Koch's self-portrayal: he tilts his head toward the model, each lens of his eyeglasses glowing with the flame he is offered (a doubled glow, in effect), while, in his right hand, he holds a sculptor's caliper, presumably used to measure the nearly ideal proportions of the beautiful male body now in such close proximity.' Although his painterly delectation in the male body was unmistakable, Koch was by all accounts happily married to a piano teacher (the former Dora Zavlasky) for forty-five years, until his death in 1978. *The Sculptor* offers an especially vivid example, then, of the non-alignment of artist, artwork and sexual self-definition. [RM]

Born in Berlin in 1905, Ruth Bernhard followed her artist father to New York in 1927, where she apprenticed as an advertising photographer. Before leaving for America, she had had a brief affair with a much older man, and at the age of sixty-two began a lasting relationship with another man, but in between she came out as a lesbian through a passionate but unconsummated crush on a woman in New York. Bernhard found her way to bars such as Childs in Times Square, where lesbian 'tea dances' were held in the afternoon. 'There', she said, 'the space was always filled, with everyone in snappy clothes, dressed up, even sophisticated.' She was introduced to Berenice Abbott, with whom she went nightclubbing in Greenwich Village and Harlem. In the 1930s Bernhard moved to California, where she formed a passionate friendship with Edward Weston, adopting his modernist techniques and formalist commitments while refraining from a physical relationship. Bernhard took a series of female lovers from the 1930s on, none of whom she used for her nude studies. 'I could not photograph a person for whom I had desire,' she wrote, 'because personal feeling gets in the way of expression.'

This impromptu photograph was taken when a nurse who occasionally sat for Bernhard dropped by with a friend. Until the feminist movement of the 1970s, her supporters never discussed her photographs as representations of lesbian desire. Bernhard's images, however, revel in the texture and contours of the female body. She saw her nudes as a means to redeem women's bodies from degradation in the mass media, and in this and other photographs offered images of interracial female desire. [CL]

SONIA SEKULA
Les Amies, 1963
Oil on paper
35 × 56 cm

One of the few women in Betty Parsons' stable, Sonia
Sekula occupied the uncertain ground between Surrealism
and Abstract Expressionism from the 1940s until her suicide
in 1963. That year, she made two small figurative paintings,
Lesbienne II and *Amies*, both depicting a pair of naked
women in a sexual embrace. In her earlier work Sekula had
responded with intense and intricate abstraction to the work
of her contemporaries, particularly Roberto Matta and Betty
Parsons herself. Unlike most women of the period, Sekula
made scarcely less a secret of her lesbianism than of her
bouts of depression and mental illness. 'Let homosexuality
be forgiven,' she wrote in her journal in 1960, 'let us hope
that she will be welcome in Greek mythology and protected
by pagan nature gods, for most often she did not sin against
nature but tried to be true to a law of her own.' [CL]

ROBERT RAUSCHENBERG
Erased de Kooning Drawing, 1953
Traces of ink and crayon on paper with
hand-lettered ink label in gilt frame
64 × 56 cm
Collection, San Francisco Museum of Modern Art

JASPER JOHNS
Target with Plaster Casts, 1955
Encaustic and collage on canvas
with plaster cast objects
130 × 112 cm

Robert Rauschenberg and Willem de Kooning represented two poles of the New York art world in the 1950s. De Kooning was the older man, just coming to visibility as a painter and determined to continue the practice of oil on canvas. He was also staunchly heterosexual. The young Rauschenberg was the bad boy of the art world. Married once, he was later involved with Jasper Johns for about six years, until 1961. At Rauschenberg's request, de Kooning gave him a drawing to erase, consciously choosing one that would make it hard on both of them: a drawing that he would miss and that Rauschenberg would have to work to remove. Though Rauschenberg's motives have been interpreted as violently Oedipal, the labour of erasure would have been slow and delicate. The undertaking is eccentric. We don't know what Rauschenberg was erasing. One of De Kooning's *Women*? A self-portrait? At any rate, the title of the piece, which appears in a small window mat below the ghost of the drawing, was provided by Johns, who did the lettering.

Johns and Rauschenberg were circumspect about their relationship – neither secretive nor 'out' in a post-Stonewall sense – and the importance of their relationship has been a contested topic in art-historical circles. 'I remember once', said Johns to critic Calvin Tompkins, 'I was reading Gertrude Stein's *Autobiography of Alice B. Toklas* to him, reading it aloud in the studio, and Bob turned and said, "One day they'll be writing about us like that."' [CL]

Alfred Barr wanted to buy this work for the Museum of Modern Art when he spotted it at Jasper Johns's first one-person show at the Leo Castelli Gallery in New York. Sceptical about getting the trustees to approve a work that included the plaster cast of a penis, Barr asked Castelli to enquire whether Johns would be willing to keep the lid covering the penis permanently closed. Johns wasn't willing. Instead, Barr recommended the penis-free *Target with Four Faces* to his trustees, along with *Flag*. Castelli himself bought *Target with Plaster Casts*. The anxiety around purchasing a painting that could have been read as unpatriotic in the McCarthy era has been discussed by art historians; the decision not to purchase a painting because one tiny fraction contains a penis has received attention only from queer art historians. In the 1950s, the one critic to make mention of the painting's actual content was Robert Rosenblum. *Target with Plaster Casts*, he observed in 1958, offers 'a peep show which even imposes a moral decision upon the viewer'. [CL]

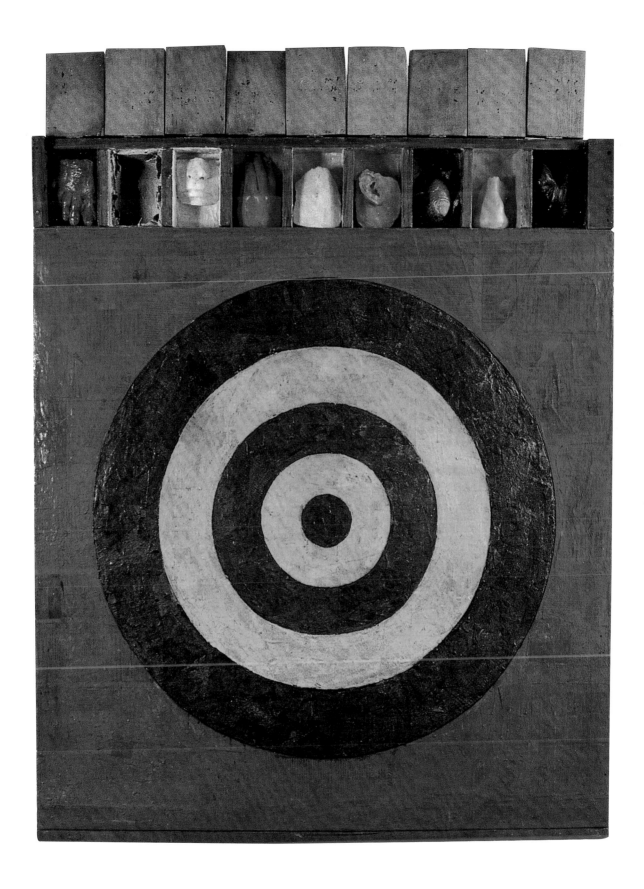

ALLEN GINSBERG
Bill Burroughs at bookshelf window on
fire escape 206 East 7th Street, Fall 1953, 1953
Black and white photograph

In 1953, Beat poet Allen Ginsberg began 'fooling around'
with a Kodak Retina, photographing friends such as Jack
Kerouac, Neal Cassady and William Burroughs. 'We slept
in the rear,' Ginsberg noted, referring to his East Village
apartment, where he took this intimate snapshot depicting
the usually reserved Burroughs, one of his lovers at the time.
'We took it for granted the world was a little crazy if it saw
our friendship and sense of sacramental respect for each
other to be neurotic, sick, weird or strange.' Ginsberg was
helping Burroughs edit the manuscript of *Queer*. Peopled by
a crowd of American expatriates in post-war Mexico City,
the novel describes one man's pursuit of another through
an underworld of homosexuals and hustlers. *Queer* would not
be published until 1985. [CL]

JESS
Boob #1, 1952
Collage
50 × 62 cm
Collection, University at Buffalo,
State University of New York

In 1951, Burgess Collins dropped his last name, abbreviated
his first to Jess, and began a period of intense art-making,
concentrating on intricate collages that sometimes took years
to complete. Jess's life partner and creative collaborator,
the poet Robert Duncan, was involved in many of these densely
referential, multi-layered, bookish works. Duncan supplied
the text and image fragments from which Jess composed
Boob #1, a collage intended for reproduction as a broadside.
Like Carl Van Vechten's more or less contemporaneous
scrapbooks, Jess's collages rely on juxtaposition and double
entendre to insinuate homoerotic meaning. [CL]

DUNCAN GRANT
Russell Chantry, Lincoln Cathedral, c.1958
Oil on panel
West wall 416 × 390 cm
East wall 382 × 366 cm
North wall 370 × 520 cm

Commissioned in the late 1950s for the Russell Chantry of
the cathedral in Lincoln, the historical center of England's
wool industry, Duncan Grant's panel nominally centres on
St Blaise, the patron saint of wool-combers. Grant had painted
both carefully homoerotic and explicitly sexual scenes all his
life. He used the cathedral's invitation as an opportunity
to continue the Omega Workshop's commitment to the idea
of art in everyday life. He placed his wife, the painter Vanessa
Bell, on the left side of the panel. On the right, directly in the
line of sight of Christ on the cross (for whom Grant used his
lover, poet and translator Paul Roche, as model), delectably
underdressed young men load bales of wool onto ships.
Perhaps as a result of Grant's sly implication, the Chantry
came to be used as one of the cathedral's storerooms in the
1960s, to be restored only in the late 1980s. [CL]

FLAVIO DE CARVALHO
*New Look: Summer Fashion for
a New Man of the Tropics*, 1956
Action, São Paolo

Painter, sculptor, architect, writer and performance artist
Flavio de Carvalho was a pioneering force in mid-century
Brazilian modernism. Six years after representing Brazil at
the 1950 Venice Biennale, de Carvalho created a sensation
by walking through the streets of Rio de Janeiro in his *New
Look: Summer Fashion for a New Man of the Tropics*, a self-
designed ensemble consisting of a striped blouse, a short
skirt and a pair of sandals. Carvalho's *New Look* sought to
challenge the constraints of normative gender, especially
as they were enforced in the public sphere. Though most
critics and commentators ridiculed the performance at the
time, a columnist for *A Gazeta* newspaper endorsed it as
'a conscious festival of revolt against conventions that need
to be overcome'. [RM]

Cover of the July 1962 issue of *Mattachine Review*

This *Mattachine Review* cover features a nineteenth-century photograph of two men, one resting his head upon the other's chest. The older man affectionately places his hands on the younger man's body. According to a note on page 2, 'This month's cover may be the earliest known gay photo extant. It was submitted by a friend in Maine who found it but knows nothing of its background. The original is a small 2-inch square daguerreotype in a thin brass oval frame. Shown are two young men, both sporting chin whiskers of the period, in a pose of a father and sleeping son which can be described as "campy" at the very least. It has no bearing on anything; we just thought it to be of interest to *Review* readers.' Together, the cover image and the explanatory note speak of the inventive recycling of found images for queer (or 'campy') purposes by new viewers and audiences.

Mattachine Review was the publication of the Mattachine Society, an early homosexual rights group. The word the group used to describe itself, however, was not 'homosexual' but 'homophile', a term selected precisely for its non-sexual associations. The name Mattachine (a medieval society of masked men) similarly camouflaged the group's homosexuality. As the historian Martin Meeker has pointed out, Mattachine's emphasis on respectability (members were asked 'to try to observe the generally accepted social rules of dignity and propriety at all times [...] in conduct, attire and speech') itself masked the group's audacity in terms of sex reform, education and anti-censorship activism in the 1950s and 1960s. [RM]

MATSON JONES
(ROBERT RAUSCHENBERG AND JASPER JOHNS)
Window display for Bonwit Teller department store, New York, 1957

In the mid-to-late 1950s, Robert Rauschenberg and Jasper Johns collaborated on commercial designs and window displays for Bonwit Teller Department Store and Tiffany's. So as to protect their 'serious' art from the taint of commercialism, the pair worked for hire under the pseudonym of Matson Jones. (Matson was Rauschenberg's grandmother's maiden name and Jones a surrogate for Johns.) 'Our ideas are beginning to meet the insipid needs of the business [so] that our shame has forced us to assume the name of Matson Jones – Custom Display', they wrote in a letter to Rachel Rosenthal. Though it sounds like the name of one man, Matson Jones stands in for a shared endeavour whose output was both explicitly public (the windows of Fifth Avenue) and obscurely pseudonymous. In this sense, it might be understood as a metaphor or parallel to the intimate partnership of the two artists at the time. [RM]

Cover of the July 1962 issue of *Mattachine Review*

mattachine
REVIEW

JULY 1962 FIFTY CENTS

ALBERT ELLIS
Art and Sex

MOLLY MALONE COOK
Singing (Lorraine Hansberry), c.1957–58
Black and white photograph

Molly Malone Cook – photographer, sometime gallerist and owner of a well-known bookstore in Provincetown, Massachusetts – was the longtime partner of Pulitzer Prize-winning American poet Mary Oliver. While learning her medium and working for the new underground newspaper *The Village Voice*, Cook made this portrait of Lorraine Hansberry, a member of the Daughters of Bilitis and an early contributor (identified only as LH) to pioneering lesbian magazine *The Ladder*. Hansberry was a rising star in black American culture whose play *A Raisin the Sun* debuted on Broadway in 1959. Cook's portraits of the famous and the unknown catch her subjects in fleeting moments of sentiment. Here, she captures her intimate and prodigiously talented friend giving voice to her emotions. The hint of an audience appears in the background. Hansberry is ever so slightly butch in her garb: tousled hair and a loose, rumpled white shirt with unevenly rolled sleeves. In one of her letters to *The Ladder* from 1957, Hansberry compared common reactions to seeing a 'badly dressed Negro' on the street to seeing a butch. Noting that it had been a long time since she had been made uncomfortable by the sight of the former, she expressed her hope that someday 'the discreet lesbian will not turn her head on the streets at the sight of the "butch" strolling hand in hand with her friend in their trousers and definitive haircuts'. [CL]

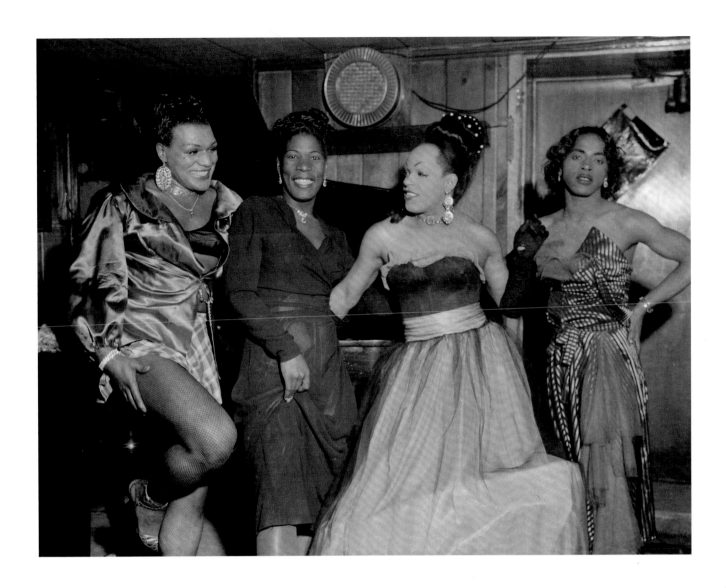

CHARLES 'TEENIE' HARRIS
Group portrait of four cross-dressers posing in
a club or a bar in front of a piano, including
Michael 'Bronze Adonis' Fields, on left, and possibly
'Beulah' on right, 1955
Black and white photograph
Collection, Carnegie Museum of Art, Pittsburgh

The photojournalist Charles 'Teenie' Harris once estimated
that he had shot more than eighty thousand photographs
over the course of his career. From 1936 to 1975, Harris
worked for the *Pittsburgh Courier*, one of the oldest black
newspapers in the United States. He became known as
'one-shot' Harris for his ability to capture the desired picture
on his first take. Now housed at the Carnegie Museum of
Art, Harris's photographs provide a comprehensive account
of black working-class life in mid-century Pittsburgh,
including church events, political rallies, local sports leagues,
neighbourhood gatherings and sundry other social occasions.
When he photographed drag queens in local bars and
nightclubs, he presented them not as criminals or degenerates
but as friends enjoying a night out on the town. This picture
all but invites us to join these high-stepping, cross-dressing
chorines in front of the piano. [RM]

HAROLD STEVENSON
The New Adam, 1962
Oil on linen
9 parts
Overall 2.5 × 12 m

Painted in 1962 for an exhibition of early Pop art at the
Guggenheim Museum in New York, Harold Stevenson's
The New Adam pumps up a reclining male nude to startlingly
monumental scale. Spread across nine panels, the painting
extends two and a half metres in height and over ten metres
in width. Living in Paris at the time, Stevenson hired the
actor Sal Mineo (whom the artist did not previously know
but thought 'beautifully proportioned') to model for the
painting. The Guggenheim's curator refused to display
The New Adam on the grounds that it would 'distract from
the thesis of the show'. Ultimately the exhibition – titled
Six Painters and the Object – included works by Rauschenberg,
Johns and Warhol, but none by Stevenson. He placed
The New Adam in storage, where it remained until 1992,
when the New York gallerist Mitchell Algus convinced him
to display the work. In 2005, the painting was acquired by
the very institution that had rejected it forty years earlier.
According to the Guggenheim's website, 'the museum
is honored to have this landmark of art history join its
permanent collection.' [RM]

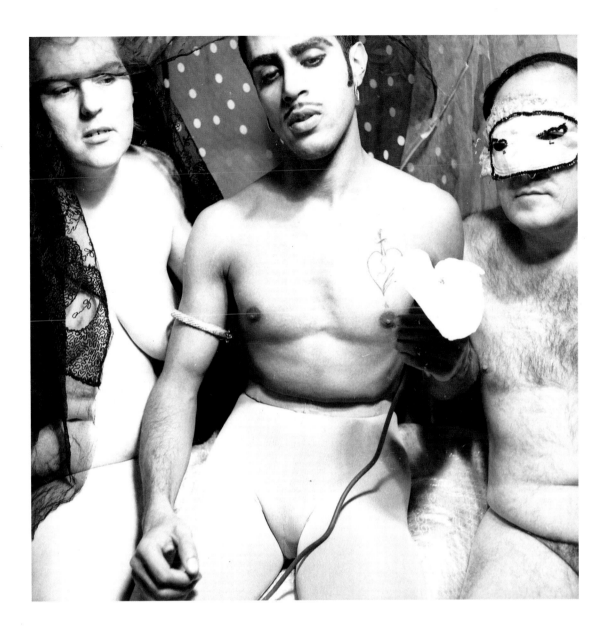

JACK SMITH, MARIO MONTEZ AND
FRANKIE FRANCINE (FRANK DI GIOVANNI)
Black and white shooting session
from the series *The Beautiful Book*, 1962
Black and white photograph

Best known as the director of the polymorphously perverse
film *Flaming Creatures* (1963), Jack Smith was also an actor,
photographer, performance artist and champion of camp,
trash, drag and (not least) Maria Montez, the 'hot-blooded'
Hollywood movie goddess of the 1940s. In 1962 Smith
published *The Beautiful Book*, an album of photographs derived
from film shoots in his Lower East Side apartment. Priced at
'4 dollars or 16 nouveau francs or 24 shillings', the book
was likened in a promotional blurb to 'draperies and silks'
unfurling across the surface of the page 'like some long lost
mysterious fume from byzantium'. Featured prominently
throughout *The Beautiful Book* was Mario Montez,
the Puerto Rican drag performer who became a fixture of the
downtown scene. [RM]

BOB MIZER
Gary Conway, 1964
Black and white photograph
Atheletic Model Guild photograph published in
Physique Pictorial, vol 14, no. 2, October 1964

ATHLETIC MODEL GUILD
Handwritten chart for *Physique Pictorial*, c.1965

In 1945, Bob Mizer founded the Athletic Model Guild, a physique photography studio and 'talent agency' that operated out of the house he shared with his mother near downtown Los Angeles. Mizer found a ready supply of models to photograph among the aspiring actors in Hollywood and the bodybuilders on Venice Beach. In 1951 he launched *Physique Pictorial*, a magazine populated by pictures of oiled, muscular and nearly naked young men, sometimes outfitted as Roman gladiators, prison inmates or sailor buddies. Though *Physique Pictorial* featured the work of multiple artists and photographers (including Tom of Finland and Bruce of Los Angeles), Mizer shot most of the photographs himself. In many instances, including this picture of Gary Conway from the October 1964 issue, Mizer conjured abstract, iridescent backdrops by projecting light through goblets, serving bowls or other pieces of his mother's Fostoria glass collection. In addition to lending her crystal, Mrs Mizer knitted some of the posing pouches worn by the physique models. [RM]

Beginning with the October 1964 issue of *Physique Pictorial*, small markings – circles with arrows, squiggles, squares, plus and minus signs – began to appear, without explanation, beside or beneath the male bodies on display. The June 1965 issue announced, 'We at last have available a key to subject character analysis symbols used on many of the models' photos appearing in *Physique Pictorial*.' Available free of charge to those who sent in a self-addressed envelope, the typewritten key translated each hieroglyph into a personality trait, from 'ambitious and enterprising, wants to get ahead' to 'very affable' to 'aesthetic – may tend to be mother-oriented'. For longtime patrons of the magazine deemed trustworthy, publisher Bob Mizer would furnish an additional, hand-written key that translated the signs into explicitly sexual meanings. The circle crowned by an upraised arrow (equated with 'agreeable personality' in the Subjective Character Analysis chart) was deciphered in the hand-written key as 'can be sucked' while the circle with an arrow pointing down ('Likes to dominate (forceful personality)') was further defined as 'will fuck'. The hand-written chart is testimony to the desire of *Physique Pictorial* readers to move beyond the surface image and official description of each model to questions of sexual disposition and availability. The circle with a diagonal arrow next to model Gary Conway signals that he is a 'typical man', an attribute that the hand-written chart further translates, not altogether surprisingly, as 'likes girls'. [RM]

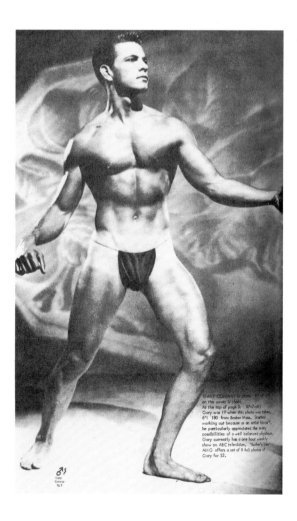

SUBJECTIVE CHARACTER ANALYSIS

TYPICAL MAN

AGREEABLE PERSONAL-
(socially oriented) ITY

LIKES TO DOMINATE
(forceful personality)

Humourous, Likes var-
iety. Prefers tongue-in-
cheek type of humour

Receptive to suggestion
(either symbol alone)

Vacillating personality
(can't make up his mind)

Ambitious & enterprising
Wants to get ahead.

Difficult personality
Tends to be "problem
child"

Physically dangerous

Phlegmatic, somewhat
lacking in enthusiasm

Aggressive.
Enthusiastic

Very affable.

Aesthetic
may tend to be mother-
oriented

Our knowlege of sub-
ject's personal traits
is very limited.

Self controlled

Conformist

Closed mind

Early riser

Late riser

Vagueness of purpose

Well-balanced
personality

Devotion to duty
and work

Ergophobiac
(intense dislike for
work).

Introverted

Extroverted

Hypocondriac

Intellectual. Avoids the
trivial and emphasizes
lofty goals

Tends to form lasting
friendships

Pathological liar

Deceitful

Petty thief

Criminally inclined

Strongly religious

Ingratious

Obsequious

Vain

Boastful & arrogant

+= Intensifies characteris-
tic described

−= Detracts from charac-
teristic described

Secretive

Glutton
Insatiable appetites

Hostility Tends to
have "chip on shoulder"

ANDY WARHOL
Thirteen Most Wanted Men, 1964
(destroyed 1964)
Mural
New York State Pavilion at the World's Fair,
Queens, New York

Philip Johnson, the architect of the New York Pavilion at the 1964 World's Fair, invited ten Pop artists to create murals for the building's circular facade. Warhol opted to make a silk-screen grid of mug shots and candid photographs of 'most wanted men', many of Italian descent, pursued by the New York City police as criminal offenders. At the Fair's insistence, the mural was painted over prior to the official opening of the grounds, ostensibly because the Italian-American community might object to the suggestion that its members were criminals. In this work, Warhol may well have been punning on the idea of 'wanting men' as a form of criminality and thus signalling – albeit in coded form – his own outlaw desires. [RM]

E –
Into the Streets
(1965–79)

In the years immediately preceding the Stonewall riots of June 1969, a queer art and activist culture emerged, with links forming between the radical social movements of the period – the anti-war movement, women's liberation, black power – and the emergent gay rights movement (including, for example, the first public demonstration for homosexual rights at the White House in 1965). Founded in the immediate aftermath of the Stonewall riots, the Gay Liberation Front (GLF) proposed gay identity as a revolutionary form of social and sexual life, one that would ultimately reinvent traditional systems of sex and gender and, by extension, society itself. As a first step towards achieving this vision of sexual freedom, lesbians and gay men were exhorted to come out of their 'closets' of secrecy and denial – that is, to declare their homosexuality to family, friends, colleagues and to the larger public world. Gay power quickly became an international movement. A chapter of the GLF was founded in London in 1970, and, in response to the homophobia of the French political Left, Front Homosexual d'Action Revolutionaire (FHAR) launched in Paris the following year.

Tensions between male and female members of the GLF led a core group of women to leave the group and found Radicalesbians, a separatist organization. Such divisions would become common as the decade progressed. The creation of lesbian-only spaces (communes, conscious-raising groups, activist organizations, publications) responded in part to the sexism of gay men and to the homophobia of straight feminists but also, and more affirmatively, to the pleasures of erotic community.

TIM WOOD
Frontispiece of *The San Francisco*
We Know and Love, c.1965
Collage in scrapbook
26.5 × 38 cm

Tim Wood, a retail salesman for the Sears department store, created a remarkable series of sexually explicit scrapbooks in the late 1950s and early 1960s. In the course of amassing his extensive collection of male physique photographs, nudes and 'action' shots, Wood visited gay beaches, cruising grounds and private parties in and around San Francisco, often accompanied by a friend who was also an amateur photographer. A number of the resulting pictures (and many others that Wood purchased or privately exchanged with fellow collectors) were organized in thematically specific scrapbooks. For the frontispiece of the gay beach scrapbook, Wood pasted a golden map of the Westernmost parts of San Francisco beneath a constellation of five circular images – or peep-holes – revealing the pleasures on offer at specific sites along the coast. Captioned 'The San Francisco We Know and Love', Wood's frontispiece remaps the city as a dazzling space of homoerotic possibility. [RM]

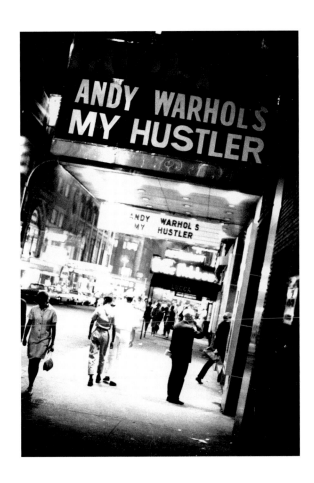

FLORIDA LEGISLATIVE INVESTIGATION COMMITTEE
A homosexual act being performed
in a public restroom, 1964
Black and white photograph

First published by the Florida Legislative Investigation
Committee in 1964, this photograph shows a man patronizing
a 'glory hole' (a hole drilled through the partition between
toilet stalls so as to enable sexual contact between the men
on either side). In the accompanying caption, the Committee
noted with alarm that 'such occurrences take place every
day in virtually every city in every state. It is significant that
the removal of the toilet stall doors to facilitate photography
did not deter these and numerous others from practicing
homosexuality.' Were the removal of the toilet-stall door to
have deterred the practice of sexual activity altogether, there
would have been nothing for the police to photograph, and
no picture for the Florida legislative Investigation Committee
to publish. Like the police camera itself, the removal of the
toilet-stall door anticipates – and helps to produce – the visible
image of illicit homosexuality. Following its state-wide
distribution by the Florida Legislative Investigation
Committee in 1964, 'Homosexuality and Citizenship in
Florida' was reprinted in 1965 by the Guild Press, a publisher
of male physique magazines such as *Grecian Guild Pictorial*,
as well as gay pulp novels and other homoerotic materials.
The barring (both literal and figurative) of homosexuality by
the Florida State Legislative Committee thus became a means
of pleasurable counter-identification for the very audience
positioned as criminal by the State. [RM]

BILLY NAME
Andy Warhol under 'My Hustler' Marquee,
New York City, 1965
Black and white photograph

At the request of his friend Andy Warhol, Billy Name became
the unofficial 'house photographer' for the Factory, Warhol's
industrial-scale studio in midtown Manhattan. From 1963 to
1967, Name shot stills of Warhol's films and the 'Superstars'
who appeared in them, from Edie Sedgwick and Paul America
to Mario Montez and Ondine. Warhol described *My Hustler*
as 'the story of an old fag who brings a butch blond hustler
out to Fire Island for the weekend. and his neighbors all try
to lure the hustler away'. The film enjoyed a commercial run
at the Hudson Theater in the summer of 1967. One night
during the run, Name captured Warhol walking beneath the
marquee of the theatre. As though to signal the eccentricity
of Warhol's cinematic vision (or perhaps to recall the
copious amounts of LSD reputedly consumed on the set of
My Hustler), Name tilts the composition sharply so as to set
the city – and the artist – askew. [RM]

NANCY GROSSMAN
No Name, 1968
Leather, wood, epoxy
38 × 18 × 25 cm

PAUL THEK
Untitled (Meat Piece with Flies)
from the series *Technological Reliquaries*, 1965
Wood, melamine laminate, meal, wax, paint, hair, Plexiglas
48 × 31 × 21.5 cm
Collection, Los Angeles County Museum of Art

Nancy Grossman started making leather-encased sculptural heads in 1968 and first exhibited them the following year. Unmistakable in their reference to leather fetishism and sadomasochism, the masks were produced through a painstaking process in which the sculptures were carved in wood, built up with layers of paint, covered with a red under-mask and then, finally, sheathed in black leather, with cord, zippers and sometimes horns. The sculptures suppress identity (we never see individuated faces beneath the masks) even as they propose a queer world of sexual domination and subordination. [CL]

In the series *Technological Reliquaries*, Paul Thek indulged himself in culture-jamming by juxtaposing references to high culture with reminders of fleshy materiality, at once sensual and surrealist. Thek's remark to Andy Warhol that his *Brillo Boxes* lacked only flesh may be apocryphal, but in this representation of a glistening, malodorous, liquefying haunch of meat, cool Warholian cynicism meets hot tactility. [CL]

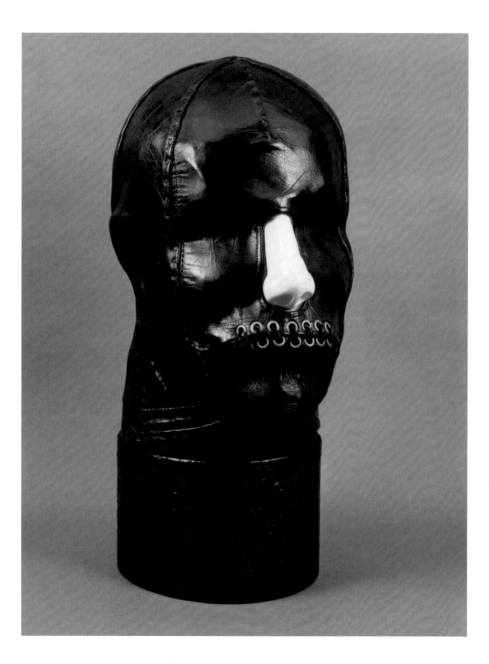

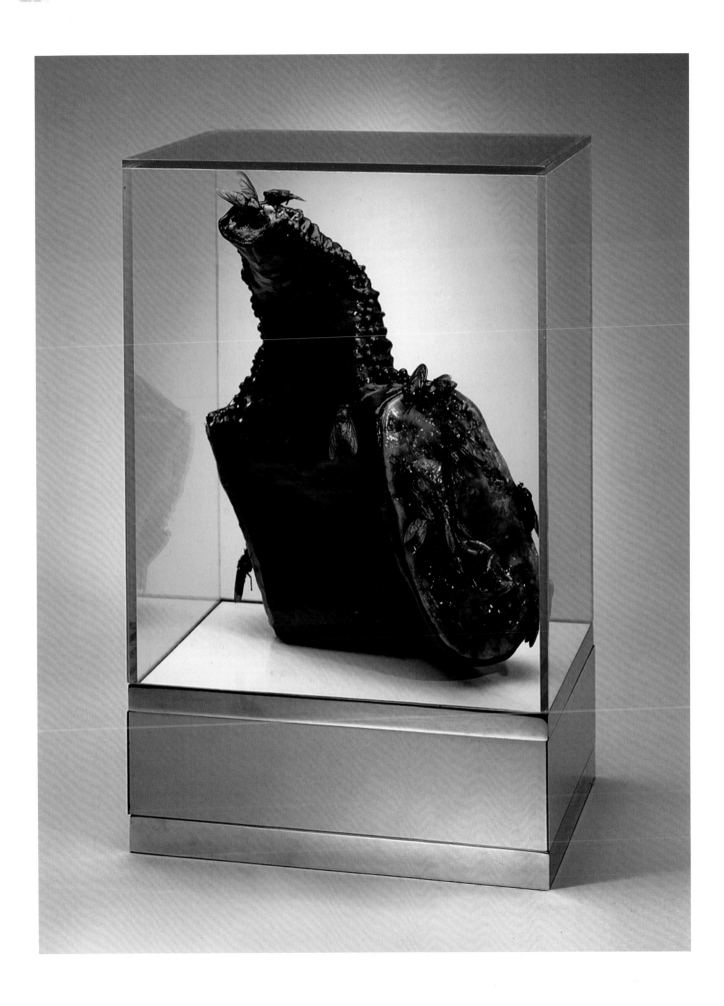

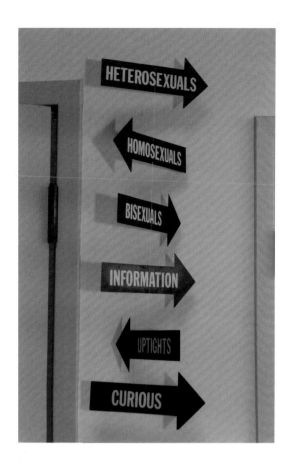

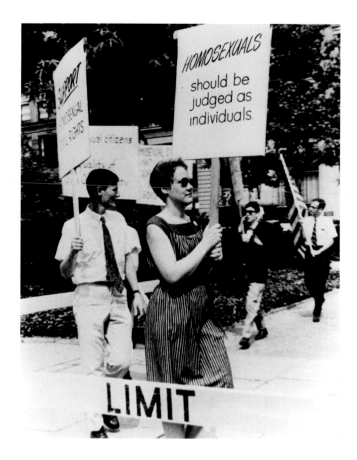

PHYLLIS LYON AND DEL MARTIN
Sex Terms Mobile, c.1965
Lettering on board, string
Collection, GLBT History Society, San Francisco

KAY TOBIN LAHUSEN
Barbara Gittings Protesting at Independence Hall,
Philadelphia, PA, July 4, 1966
Black and white photograph

Each of the mobile's six arrows is printed with two different terms on either side: 'HETEROSEXUALS'/'SATYRS', 'HOMOSEXUALS'/'HERMAPHRODITES', 'BISEXUALS'/ 'APHRODISIACS', 'TRANSEXUALS'/'INFORMATION', 'UPTIGHTS'/'VIRGINS', 'CURIOUS'/'UNDECIDED'. As the arrows turn, they reveal first one word and then the other, constantly changing the larger configuration of words and directional markings. Like a roulette wheel, it is impossible to determine in advance how the mobile will read when it stops rotating. Since none of the 'pairs' constitutes familiar opposites ('HETEROSEXUALS', for example, shares its arrow not with 'HOMOSEXUALS' but with 'SATYRS'), the mobile enacts a kind of exchangeability, rather than a clinical demarcation, of its various sexual terms. Homo-, hetero-, bi- and trans-sexuality (not to mention undecided and curious) are situated as potentially complementary rather than mutually exclusive categories. According to the gay archivist Willie Walker, this sex-terms mobile dates from the mid-1960s: 'Originally owned by Phyllis Lyon & Del Martin [longtime lesbian activists], this mobile came out of the budding effort to increase people's knowledge of sexuality, and develop sex education classes for youth. The mobile itself reflects the idea that sexuality is variegated and complex, challenging the monolithic model then in place that heterosexuality was the normal and ideal form of sex and the resultant labeling of all other sexual interest as perverse and degenerate. This was, in effect, an early expression of queerness.' [RM]

Writer and photographer Kay Tobin Lahusen was the life partner of Barbara Gittings, the woman marching at the head of this Philadelphia protest against the exclusion of homosexuals from the US Armed Forces. Their love relationship was inseparable from their lives as gay activists. Lahusen photographed thousands of gay events during the 1960s and 1970s. She also made cover photographs for *The Ladder*, the pioneer lesbian magazine that Gittings edited between 1963 and 1966. Lahusen and Gittings were partially successful in replacing the rather insipid line drawings used on the cover with black and white photographs of lesbians, though they were at first shown from behind, or in shadow. In fact, it took Lahusen until 1966 to find a woman who would pose for a full-frontal head shot. Gittings founded the East Coast branch of the Daughters of Bilitis in 1955 and was also instrumental in the campaign to remove homosexuality from the American Psychiatric Association's list of mental diseases. Lahusen's photograph of the Philadelphia event illustrates two conscious strategies that activists used to make their protests more effective. First, the demonstrators themselves dress conservatively and in gender-appropriate garb: no drag, no women in trousers, no effeminate men. Second, in one of her favourite moves, Lahusen composed the image so that four people suggest a much longer line of dissidents. Lahusen and Gittings were determined to see to it that the record of their activism was as widely accessible as possible. The women's papers now reside in the New York Public Library. [CL]

JOE BRAINARD
Untitled (Garden), c.1967
Collage
94 × 70 cm

Openly gay in the pre-Stonewall years, and very much a
part of the New York art scene, Joe Brainard was nonetheless
an artist more protean than Pop. In his assemblages and
paintings, he trawled high and low culture to amass
the material for works that constrain intricate details of his
appropriations within a unified visual field. Brainard's flower
paintings and collages of the late 1960s and early 1970s
not only flaunt the obvious readings of 'pansy' but revel in
a Burpee seed-packet cornucopia of violets, nasturtiums and
daisies. The botanical realism of each individual blossom
destabilizes the meticulously constructed visual field of
the entire painting. Brainard's garden works thus place the
viewer in an uncertain space between foreground and
background, a method of queer representation that decisively
confronts without in the least appearing to provoke. [CL]

KATE MILLETT
Food for Thought
from Metaphysical Plate Series, 1967
Ceramic plate, wood, enamel
Diameter 23 cm

PIERRE MOLINIER
Mixture of Dildos and Legs, 1967
Photomontage
14.5 × 11.5 cm

Married to sculptor Fumio Yoshimura at the time she made *Food for Thought*, Millett was also working on her doctoral dissertation. Published in 1970 under what now seems the harmless title *Sexual Politics*, the 500-page text put Millett on the cover of *Time* magazine and at the forefront of the feminist movement as an activist and a spokesperson. Millett was reluctantly outed as a lesbian during a lecture at Columbia University in December of 1970. The revelation crowned a year in which the National Organization for Women had purged lesbians from its ranks and in which Betty Friedan's remark that lesbians were a 'lavender menace' to the feminist cause had sparked a celebrated action at the Second Congress to Unite Women in New York. As a sculptor, Millett participated in exhibitions protesting against the Vietnam War in the 1970s, as well as in feminist exhibitions. *Food for Thought* suggests two dildos, spaced just the right distance apart to suggest that one is for the anus and the other for the vagina. The plate, however, renders the dildos useless, and vice versa. The deft implosion of domesticity and (supposedly) underground sexual practices evokes a vision of 'queer' that would disappear in the heterosexually inflected feminism of the next decade. [CL]

The Bordeaux artist Pierre Molinier made kitschy post-Surrealist paintings and drawings for most of his life, exploring themes of androgyny, transvestism, fragmented and multiplied bodies, as well as his fetishes: stockings, dildos, veils and high heels. André Breton, who became interested in Molinier in the mid-1950s, ceased to publish him ten years later when Molinier proposed a painting of Christ with a dildo up his arse. Molinier then turned to photography. Produced with the aid of a mirror – the same mirror in front of which he shot himself in 1976 – his photomontages were made with his own body for his own delectation and future arousal, giving a whole new meaning to the idea of the autoportrait. Molinier's symmetrical, impossibly configured bodies confound binaries such as male/female or homo/heterosexual by celebrating autoerotic transgression. [CL]

The back cover of the October 1966 issue of *Vector*, a newsletter-cum-magazine dedicated to the 'homophile community', features an ad for the Detour bar in San Francisco's Tenderloin district. The ad's creator, Mike Caffee, employed trippy, op-art patterns to suggest the bar's freewheeling attitude and hallucinogenic appeal. After dubbing the Detour 'a side trip', the text notes the bar's various attractions, including 'psychedelic décor' and Monday night 'Prizes for Best Mod Costumes'. Both abstract art and the hippie counter-culture were drawn into the Detour's groovy orbit.

Caffee moved to San Francisco in the early 1960s after having been discharged from the military for 'dishonorable conduct' – that is to say, homosexuality. Though the public record of his discharge made it difficult for him to find employment, Caffee was ultimately hired to tend bar at the Tool Box and was among those who appeared in a famous 1964 photograph of the bar's patrons in *Life* magazine. [RM]

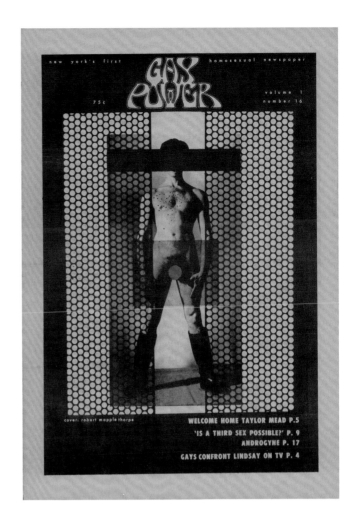

RAY JOHNSON
Shirley Temple I, 1967
Collage
61 × 38 cm

Cover of *Gay Power* magazine, vol. I, no. 16, 1970

The artist Ray Johnson was a gleaner, scavenging images from popular culture, advertisements and newspaper clippings, adding to the mix the silhouettes of friends and scraps of handwriting or plain paper, and then converting the lot into postcards and photocopier art. Favorite images and characters were recycled, again and again, for different contexts and compositions. Photocopies of a publicity photograph of the child star Shirley Temple wearing a belted leather jacket, aviator's cap and tap shoes, for example, appear in several of the artist's collages of the late 1960s and early 1970s. In *Shirley Temple 1* the diminutive star forms the base of a vertical composition that unfolds in a casually off-kilter fashion. The photograph of Temple at the bottom of the picture is countered at top by Johnson's rendering of a condom-like form in black ink. In many other works by the artist, these condom-like forms are doubled into rabbit ears which stand in for an (otherwise) bodiless bunny which, in turn, stands in for Johnson. Full of puns and in-jokes, Johnson's postcards and collages were sent to a network of correspondents and participants who were often asked to add to what they received and return the results to him. [CL/RM]

In the fall of 1970, Robert Mapplethorpe's photomontage *Bulls-Eye* appeared on the cover of *Gay Power*, a liberation broadside that billed itself as 'New York's first Homosexual Newspaper'. *Gay Power* carried news of gay liberation politics, both locally and nationally, as well as book reviews, advice columns, personal ads, graphic art and topical cartoons. *Bulls-Eye* appropriates the pornographic image of a naked man wearing knee-high rubber boots and sets it within a larger field of cut-out circles, bars and rectangles. A black bar obscures the man's eyes, as though shielding his identity from the viewer, and a square of yellow spray paint covers his midsection. A red circle bounded by a larger white ring, the bulls-eye of the work's title, overlays the figure's genitals. Mapplethorpe presents the naked male body as both target of prohibition and a source of pleasure, as both an example of censorship and a defiance of it. While he figured the effects of censorship and constraint in his early work, that work was itself severely constrained in terms of its public visibility. Apart from their display in a 'friend's hotel room' at the Chelsea Hotel and the reproduction of *Bulls-Eye* on the cover of *Gay Power*, Mapplethorpe's early collages were neither exhibited nor published during the early 1970s. [RM]

DUANE MICHALS
Chance Meeting, 1970
6 Black and white photographs

In the first four images, two men pass each other in a
narrow, litter-strewn New York alley. In the fifth, one man
stops to look at the retreating back of the other. That man,
feeling the weight of the other's gaze, turns to see whether
a meeting might interest him. In the sixth and final image,
he is the only figure in the frame. If chance indeed led to
an encounter, it happened out of our sight. Duane Michals
seldom relies on the sort of meaning that can be generated
by a single photograph. Rather, he works in delicately
staged sequences of images that suggest narratives
that almost – but never – resolve themselves into certainty.
Though the dilapidated New York of 1970 offered numerous
sites for anonymous cruising, Michals chose not to
record sexual acts but to stage something more difficult:
the fleeting pull of desire in a quintessentially urban,
anonymous setting. [CL]

CHANCE MEETING

ALVIN BALTROP
Untitled, 1970
Black and white photograph

Between 1975 and 1986, Vietnam veteran and African-
American artist Alvin Baltrop worked – that is to say,
both cruised and photographed – the abandoned piers of
Manhattan. The ruins were a major site for gay male sex
as well as for art-world projects, including a dance by
Joan Jonas, a pioneering exhibition curated by Willoughby
Sharp, and Gordon Matta-Clark's architectural 'cut' *Day's
End* (1975). This picture reveals Matta-Clark's attempt to
fence off Pier 52 from queer incursions as a thorough failure.
The cut of *Day's End*, and the bright spot of light cast by
the afternoon sun, forms nothing more than a backdrop for
two men on the prowl. Baltrop had little success exhibiting
his photographs during his lifetime, even in the emerging
gay (male) New York gallery scene of the early 1980s. [CL]

JUAN HIDALGO
Sad Baroque and *Happy Baroque*, 1969
2 black and white photographs

HÉLIO OITICICA
Parangole Cape 25, 1972
Performance, costume

In 1964, Juan Hidalgo and his fellow artists founded the Spanish Fluxus group Zaj, a collaborative of Dadaesque troublemakers intent upon disturbing the moral codes of the Franco dictatorship. A cultural revolutionary and sex radical, Hidalgo insists upon sexuality as a index of democratic freedom. His conceptual approach – in performance, music and visual art – uses explicit representations of sex to question the pathologizing of certain practices. This diptych, *Sad Baroque* and *Happy Baroque*, transforms a flaccid penis and an erect penis into stamens protruding from the petals of a flower, a trope of Baroque art so common as to be virtually invisible. By eroticizing the sexual organs of the flower, Hildalgo hides what is nominally forbidden at the centre of innocent beauty. [CL]

A Brazilian artist who sought to dismantle the divide between art and life, Hélio Oiticica produced sculpture, films, writing, installation, painting, photography, slide shows and performances. He is perhaps best known for his *parangoles* – stylized Brazilian capes that he created for dancers from the *favelas* (slums) of Rio to wear in Samba competitions. The *parangoles* embody Oitcica's desire to draw together the material realities of everyday life with the glamour and appeal of theatrical performance. Oiticia left Brazil in 1970, in part because of the difficulty of living as an out gay man in Rio at the time. In New York he quickly discovered the queer social and creative worlds of Jack Smith and Andy Warhol. His 'quasi-cinema' and audio/slide works from this period, including *Helena inventa Angela Maria* (1975) and *Neyrotika* (1973), combine Brazilian Tropicalia, underground film and the cultures of drag and drugs, particularly cocaine, which Oiticica often used as an ornamental element in his work. [RM]

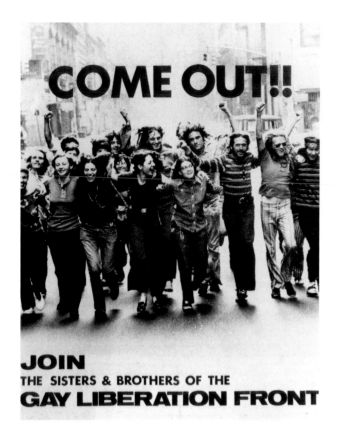

MICHEL JOURNIAC
The Purchase, 1974
Photographic documentation from the performance
Life of an Ordinary Woman

Journiac's early body art works, which spectacularly mocked
the macho pretensions of the French art establishment,
were produced in the days of radical French organizing for
the rights of women and gays. He participated in the Comité
d'Action Pédérastique, the pre-Stonewall French militant
group whose posters were removed from the walls by the
organizers of the Sorbonne occupation in May of 1968.
He was also a member of the Front Homosexuel d'Action
Revolutionaire (FHAR), a group of lesbians and gay men
who united in protest against the heterosexual presumptions
of both feminism and the French left. To make *24 Hours*,
Journiac had himself documented by a professional
photographer (Marcelle Fantel) in drag as a lower middle-
class French woman conducting her quotidian chores (laundry,
grocery shopping, serving dinner, etc.) and performing
her quotidian fantasies (striptease dancer, prostitute, etc.).
Journiac uses transvestism to produce a withering satire
of bourgeois French life, exposing the suffocation of woman
by both banal labor and impossible fantasies. In this image,
Journiac's housewife, dressed in a white suit accessorized
with white gloves and white pearls, discreetly slips into her
white handbag the Tampax she has purchased in the pharmacy
behind her – an ordinary gesture in the ordinary day of
an ordinary woman. [CL]

PETER HUJAR
COME OUT!, 1970
Black and white poster

In the early summer of 1970, the New York chapter of the
Gay Liberation Front (GLF) created a poster to mark the
upcoming anniversary of the Stonewall riots. The poster's
textual message is amplified by the image of seventeen
men and women, the 'sisters and brothers' of GLF, walking
and running, arm in arm down an otherwise deserted city
street. Peter Hujar, a studio and fashion photographer, shot
the image. Although not a member of the Gay Liberation
Front, at the time he was the boyfriend of one of the group's
founders, Jim Fourratt, the figure in sunglasses and striped
trousers (second from right). [RM]

JOHN BUTTON AND MARIO DUBSKY
Agit-Prop, 1971 (destroyed 1974)
2.5 × 12 m
Photomontage on wall
The Firehouse, New York

A collaboration between John Button and Mario Dubsky,
Agit-Prop was a twelve-metre photomural created for the
Firehouse, the headquarters of the Gay Activists Alliance in
New York City in the early 1970s. While focused on the
struggle for gay and lesbian liberation, the mural linked
that struggle to other historical moments and political
movements. Just down the wall from Fred McDarrah's
photograph of Stonewall, for example, was a portrait of
Black Panther leader Huey Newton. Likenesses of Plato
and Walt Whitman were juxtaposed with anti-war marches
and same-sex dances, among other scenes of protest
and pleasure. *Agit-Prop* was destroyed in 1974 when the
Firehouse burned down. Photographs of fragments of the
mural are all that survive. [RM]

LOUISE FISHMAN
Angry Jill, 1973
Acrylic, charcoal and pencil on paper
66 × 102 cm

The abstract painter Louise Fishman was one of the few out
lesbians in the women's art movement of the early 1970s.
Angry Jill is a pivotal painting in her return to abstraction
from the anti-painting imperatives of the women's art
movement – namely, the charge that painting represents
a male tradition, male culture and a male language.
Each painting in the *Angry Women* series is composed
of the first name of a woman. There are about thirty in all,
including Gertrude (Stein), Yvonne (Rainer) and Djuna
(Barnes). Around, under and over the name, Fishman
painted a calligraphic representation of what she visualized
as that woman's specific rage. By making this extended
series, Fishman created a fictive network of women united
in feminist protest. Most of these women are lesbian, of
course. *Angry Jill* refers to Jill Johnston, a writer for the
Village Voice who forged a tumbling, dissonant, hilarious,
personal and thoroughly experimental language of lesbian
cultural criticism. [CL]

ASCO
(HARRY GAMBOA JR, GRONK (GLUGIO NICANDRO),
WILLIE HERRON III AND PATSSI VALDEZ)
Walking Mural, 1972
Action, East Los Angeles

The collective Asco (Spanish for 'nausea') orchestrated
various satirical performances and 'mural' pieces around Los
Angeles, including the anti-war street protest *Stations of the
Cross* and *Project Pie in De/Face*, for which the group spray-
painted their names on the wall of the Los Angeles County
Museum of Art. The group developed not from the art-school
milieu, however, nor from the Chicano mural movement of
the 1970s, but from anti-war protests of the late 1960s and,
slightly later, the punk scene of East Los Angeles. Asco's
performance antics contested the propositions that high
art and social realism had a monopoly on possibilities for
social change.

In this mural, Patssi Valdez, Willie Herron III and
Gronk parade down Whittier Boulevard in East Los Angeles.
Though not all members of Asco identified as gay, Gronk's
flamboyant presence helped to form the gay culture of
East Los Angeles. In this piece, Gronk swishes along as an
ornamented chiffon Christmas tree. Valdez, in black, plays
the Virgin of Guadeloupe, while Herron sports a headdress
of ghouls. [CL]

TOM OF FINLAND
(TOUKO LAAKSONEN)
Untitled, 1975
Graphite on paper
21.5 × 28 cm

Tom of Finland (born Touko Laaksonen) is best known for
his sexually explicit drawings of strapping lumberjacks,
lifeguards, sailors, truckers, policemen and, in this
(unforgettable) case, circus aerialists. First published in
American physique magazines of the late 1950s, Tom's work
went on to become, arguably, the most popular homoerotic
illustrations of the later twentieth century. Indeed, his
drawings of bulgingly muscular, impossibly well-endowed
men have sometimes been credited with popularizing the
frankly macho style of post-Stonewall gay culture. In 1982,
The Advocate described Tom of Finland as 'the Scandinavian
folk artist whose drawings have probably done more
to shape the leather image than any other single force'.
The magazine then quoted a San Francisco gallery owner
named Peter Hartman who claimed that 'it is the first time
in the history of art that an actual imagery has produced
a subculture'. Hartman's claim, while overblown, suggests
the indebtedness of post-Stonewall gay culture to the openly
homoerotic images of the male body that preceded it.
In 2004 the Museum of Modern Art acquired drawings by
Tom of Finland for its permanent collection, thus marking
the entry of his work – and its unapologetic cultivation of
gay sexual fantasy – into an elite art-historical canon. [RM]

KOHEI YOSHIYUKI
Untitled (Sex in the Park), c.1975
Black and white photograph

Using infrared film and filtered flash, Yoshiyuki
photographed clandestine sex in the public parks of Tokyo
during the 1970s. In some of the most startling images,
we see not only a sexually engaged couple but also a group
of male onlookers who crawl or edge towards the scene
as though to participate physically or perhaps just to get
a better view. The photographs capture a complex
choreography of secrecy, sexuality and voyeurism in which
the photographer's presence on the scene mirrors those of
the encroaching onlookers. When first displayed in Tokyo in
the late 1970s, the photographs were shown in a darkened
gallery. Each visitor was given a flashlight with which to
discover, as if under cover of night, Yoshiyuki's life-size scenes
of sexuality and spectatorship. [RM]

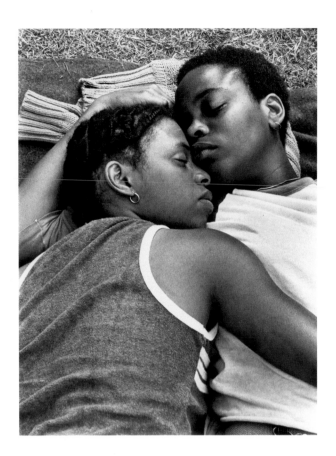

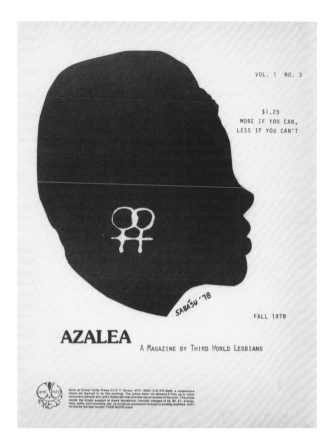

JEB (JOAN E. BIREN)
Pricilla and Regina, Brooklyn, NY, 1979
Black and white photograph

JEB was a documentary photographer of the 1970s women's movement, based primarily in Washington, DC. In this portrait, two young African-American women, lying on a blanket on the grass, rest in each other's arms. The photo reflects JEB's view that 'personal photography' was a key component in public visibility and political liberation. 'I had never seen a picture of two women kissing, and I wanted to see it,' she explained in an early interview. 'I borrowed a camera.' JEB distributed her work through feminist journals as well as through the alternative-press bestseller, *Eye to Eye*, published in 1979, and distributed through a thriving feminist press network. [CL]

IRARE SABASU
Cover illustration for *Azalea:
A Magazine by Third World Lesbians*, 1978

Irare Sabasu, with Ntozake Shange and Aida Mansuer, was one of the founders of NAPS, the first black lesbian performing-arts group. She here illustrates the cover of the quarterly *Azalea: A Magazine by Third World Lesbians*. One of the various publications and presses founded to combat the blind spots of white lesbian/feminism, *Azalea* was published by Third World Wimmin Inc. between 1977 and 1983. Among its other contributors were Sapphire and Audre Lorde. Irare's illustration, designed to accommodate financial exigencies by using one-colour printing, depicts in profile the silhouette of a black woman. In this red field, in place of an earring, Irare superimposed that ubiquitous 1970s sign for lesbian/feminists: the overlapping symbol for women. [CL]

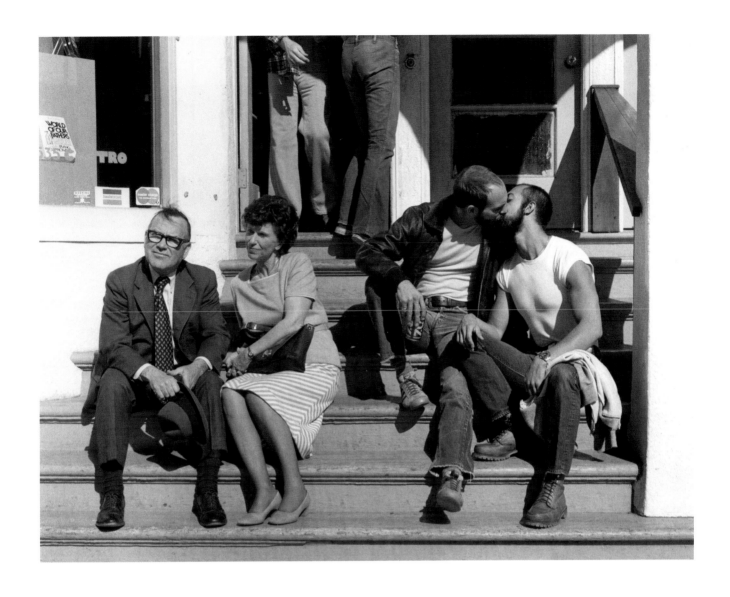

CRAWFORD BARTON
A Castro Street Scene, 1977
Black and white photograph

Crawford Barton's juxtaposition of couples on the steps
of a storefront in the Castro area of San Francisco came to
symbolize the public visibility of urban gay culture in the
1970s. On the left, a soberly dressed man and woman engage
in a tense face-off; on the right, two bearded men in jeans
and T-shirts enjoy a deep kiss. Behind the straight couple,
the title of a book on display in a shop window declares *World
of Our Fathers*. Although the photograph was later revealed
to be staged, its status as a sign of the changing times was
already assured. As Barton said, 'I wanted to feed back an
image of a positive, likeable lifestyle, to offer pleasure as well
as pride.' [RM]

DANIEL NICOLETTA
White Night Riots, San Francisco, 1979
Black and white photograph

MIKE KELLEY
Tool Box Mural in Ruins, 1975
Black and white photograph

When Harvey Milk, a camera-store owner in the Castro, was elected to the San Francisco Board of Supervisors in 1977, he became the first openly gay man to hold public office in the United States. Less than a year later, he and San Francisco's Mayor, George Moscone, were assassinated at city hall by Dan White, a conservative politician increasingly enraged by Milk's visibility. White received an absurdly light sentence for 'voluntary manslaughter' (rather than double murder). The rage of the gay and lesbian community fuelled the so-called White Night Riots, in which police cars were torched and City Hall was trashed. Milk's friend and former employee Daniel Nicoletta was on hand as both a protestor and a photographer. This memorable shot captures a group of protestors silhouetted against the backdrop of city hall on the night of the riots. [RM]

In 1975, San Francisco photographer Mike Kelley documented the site of the former Tool Box bar in the city's South of Market neighbourhood. An early gay leather and biker bar, the Tool Box was immortalized in *Life* magazine's 1964 report on 'Homosexuality in America'. *Life*'s lead photograph for the article, spread across two pages, showed Tool Box patrons standing beneath a mural of men in black jackets against a stark white backdrop. Painted by Tool Box bartender Chuck Arnett in 1963, the mural would remain miraculously (if fleetingly) intact amidst the rubble of the demolished bar more than a decade later. Kelley captures a moment of urban transition in which the present and the queer past intersect. Today, the site of the former Tool Box bar houses a branch of the upscale supermarket Whole Foods. [RM]

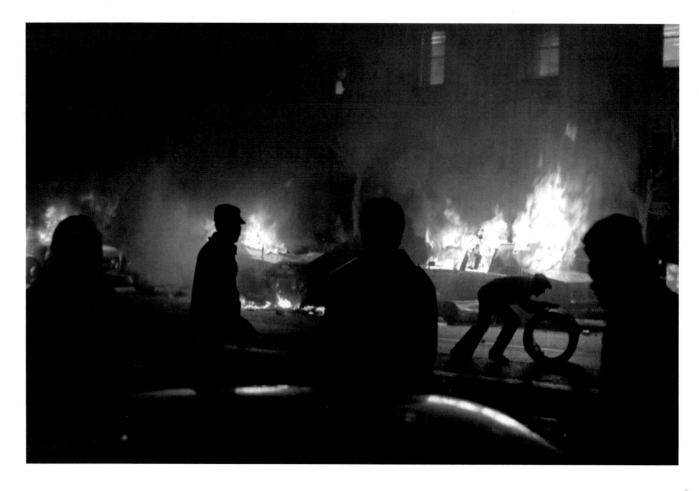

HARMONY HAMMOND
Hug, 1978
Cloth, wood, acrylic
163 × 74 × 36 cm

Harmony Hammond was a founding member of the
women's gallery collective AIR in 1972, and of the magazine
Heresies in 1976. Though she identified herself as being
'in love with "the lesbian brain"' well before she came out in
1973, not until the late 1970s did the conceptual underpinnings
of her work become legibly lesbian. In *Hug*, two ladders,
slightly smaller than the size of the average woman, lean
against the wall. Constructed from layers of fabric wound
around a wooden armature, their volume is chunky, their
surfaces painterly. The taller ladder, the color of white skin,
supports the smaller, a black so richly dark it suggests
leather rather than flesh. This is a lesbian couple, literally off
the wall, smuggled into the field of Minimal art. [CL]

F —
Sex Wars
(1980 – 94)

A series of public controversies and cultural battles erupted in the 1980s and early 1990s around the politics of sexuality, illness and representation. The term 'sex wars' was most often linked to the debates within second-wave feminism regarding concerns about sexual violence and female objectification on the one hand and women's pleasure and sexual freedom on the other. Political and ethical conflicts between feminists surfaced within the context of the federal government's increased law enforcement and legislation against pornography as well as the limited success of radical feminists in legalizing bans on sexually explicit imagery.

In 1982, the United States Centers for Disease Control published the first report on the 'gay cancer' that would later be identified as Acquired Immune Deficiency Syndrome (AIDS). In the absence of any effective response from the American government, AIDS became a national crisis and, ultimately, a global pandemic. Gay men in urban centres, along with intravenous drug users and prostitutes, were the populations hardest hit in the USA in the first decade of the epidemic. Queer artists and activists — many of whom were themselves HIV-positive or the friends or lovers of those who were — responded with particular ferocity to the AIDS crisis through the production of art, agitprop, guerilla street theatre and a direct-action protest movement in the form of the AIDS Coalition to Unleash Power (ACT UP).

In the United Kingdom, fears about homosexual 'recruiting' led to the 1988 passage of Section 28, a conservative political measure that prohibited 'teaching [...] in any school of the acceptability of homosexuality as a pretended family relationship'. Section 28 effectively allowed the Thatcher administration to scapegoat gays and lesbians for government budget cuts to schools, housing and child care. While the effects of Section 28 were unfolding in the UK, the United States witnessed the eruption of its own 'culture wars' over freedom of expression and federal funding to the arts. Works in this section include those by a range of queer artists whose images were censored or defunded as a result of allegedly obscenity. The 1993 imposition of a decency clause (which remains in effect to this day) on the National Endowment for the Arts suggests the continuing effects of the culture wars on the creation, funding and distribution of contemporary art.

ULRIKE OTTINGER
Freak Orlando, 1981
35 mm film
126 min.

Ulrike Ottinger is best known for some fifteen feminist and queer feature films, including *Dorian Gray in the Mirror of the Yellow Press* (1983), *Johanna d'Arc of Mongolia* (1988) and *Shanghai* (1997). Her body of work, however, is more varied in media than her fame as a filmmaker would suggest. She was active as a performance artist and as a painter in Paris during the 1960s, and throughout her career she has made photographs. Whether visual notes, portraits, staged film stills or travel records, Ottinger's photographs lead a double life; not only do they often become components in her films but they also exist as autonomous images. An extravaganza of sets, costumes and oddities, *Freak Orlando* is one of Ottinger's most important films. With a nod to Tod Browning (*Freaks*) and Virginia Woolf (*Orlando*), the film carries the gender shifting Mr and Mrs Orlando, Orlando Capricho and Orlando Orlanda, through worlds of freaks, giants, little people, women without bodies, chickens with the heads of human infants, and Siamese twins. In the end, the freaks turn out to be the normal ones. In this staged photograph, two uncertainly sexed figures in black evening gowns pull each other's grey beards. [CL]

NAHUM B. ZENIL
The Visit, 1984
Mixed media on paper
50 × 35 cm

Drawing on the legacy of Mexican surrealism and, more
especially, on the self-portraits of Frida Kahlo, Nahum
B. Zenil typically casts himself as a protagonist in the
otherworldly scenes he paints. Whether flying half-naked
over New York City with a winged male companion or
surfacing as the bride, groom and every other member of a
seven-person wedding party, the figure of the artist magically
defies the laws of gravity. Sometimes characterized as
updated (and radically re-imagined) *retablo* paintings,
Zenil's pictures tend to be modestly scaled and intricately
detailed. A longtime advocate for gay civil rights, Zenil was
one of the founders of *Semana Cultural Lesbica-Gay*, a weekly
paper devoted to gay culture and awareness. [RM]

ROTIMI FANI-KAYODE
Ebo Orison from the series
Black Male White Male, c.1982
Black and white photograph

Born in Nigeria to a Yoruba family of considerable religious
and political status, the photographer Rotimi Fani-Kayode
fled Nigeria for the United Kingdom as a boy in 1966.
He lived thereafter in the United States, as well as in London.
During his short career (he died of AIDS in 1989, aged
thirty-four) Fani-Kayode saw the world 'transformed by
the emergence of the postmodern and the postcolonial'.
In keeping with the two influential black British cultural
collectives of the late 1980s to which he belonged – the Black
Audio Film Collective and Autograph – Fani-Kayode made
racial, national, spiritual and queer identities visible to
and inextricable from each other. 'It is photography – Black,
African, homosexual photography – which I must use not just
as an instrument, but as a weapon if I am to resist attacks
on my integrity and, indeed, my existence on my own terms.'
In collaboration with young men such as his lover Alex
Hirst (died 1994) and the poet Essex Hemphill (died 1995),
Fani-Kayode transformed his anger and his intelligence into
beautifully staged tableaux that proclaimed the complexities
of positioning the self between different cultures.

In this photograph, we see the back of a beautifully
muscled man, his hair in dreadlocks. He leans forward, holding
in front of him, upside-down, a Yoruba head, slightly larger
than human scale. The eyes are closed. The mask, a tired
metaphor for the closeted Western homosexual, is upended into
a proclamation of queer diasporic modernity. [CL]

NAN GOLDIN
Cookie at Tin Pan Alley from the series
The Ballad of Sexual Dependency, 1983
Colour photograph

Photographer Nan Goldin worked at Tin Pan Alley, near
Times Square, during the first half of the 1980s. 'There was
never another bar like that in New York,' Goldin said in
a 2003 interview, 'a mix of the streets, the sex trade, artists,
bands like the Clash on tour, and hip Japanese tourists.'
Cookie Mueller – the underground actress, writer and
'mother of the tribe' that included David Wojnarowicz and
Greer Lankton – presided over Tin Pan Alley. She would die
of AIDS in 1989, the same day that the legendary exhibition
'Witnesses: Against Our Vanishing', curated by Goldin,
opened at Artists' Space. It was after she put together the
photographs that documented her friendship with Mueller,
Goldin recalls, that she 'realized photographing couldn't
keep people alive'. [CL]

NICHOLAS MOUFARREGE
Banana Pudding, 1983
Needlepoint, glitter, jewellery
30 × 38 cm

JUAN DAVILA
Art I$ Homosexual, 1983
Oil on canvas
274 × 274 cm

Nicolas Moufarrege was best known as a critic, curator and champion of the East Village art scene in the early 1980s. The author of the influential essay 'Lavender: On Homosexuality and Art', he was also, until his AIDS-related death in 1985, an inventive visual artist. Fashioned from needlepoint, glitter and bits of costume jewellery, *Banana Pudding* delights in the disjunction between word and image, between the hand-stitched title phrase at centre stage and the sparkly man in a blue toga who dances behind the letters. Here, as in many of his needlepoint paintings, Moufarrege wove together references to high and low culture – to classicism and banana pudding – without prioritizing one over the other. [RM]

Born in Chile, Juan Davila began living in Australia in the late 1970s. At about the same time, he started to apply the techniques by which the body is represented in pornography to the venerable art-historical tradition of the female nude. His aim, said Davila, was to show 'what has never been represented and to [debase] the idea of high art by bringing popular materials to it'. By montaging porn, references to art history and popular culture, Davila levels the distinction between these separate cultural worlds, placing whatever he uses within a non-hierarchical field of language and knowledge. *Art I$ Homosexual* can be read on various levels. Davila sees art as homosexual because it is feminine, nonlinear, fragmented and non-rational. In addition, he views both art and homosexuality as a counter to social regulation. As Chilean critic Nelly Richard writes, 'On the one hand, art squanders signifiers and perverts a utilitarian economy and the instrumentalism of language. […] Homosexuality, on the other, subverts masculine and feminine categories, it refuses to conform to the model of familial and reproductive sexuality.' In this painting, Davila makes gay representation collide with the art market. Two men who are about to kiss inhabit a frame of disjunctive visual references. We see the images that Davila used as sources painted in black and white on the right side of the frame. The men are repeated and enlarged in the centre of the painting. One is cubist, with a Roy Lichtenstein head; the other has more than a touch of Philip Guston. Off to the left, under a map of Australia, is a Keith Haring drawing of a man having sex with a dog – available, it would seem, for a mere $234. [CL]

PATRICK ANGUS
Boys Do Fall in Love, 1984
Oil on canvas
122 × 168 cm

Inspired by the example of David Hockney, Patrick Angus
moved to Hollywood in 1975 to launch his career as a
painter. In contrast to Hockney, however, Angus frequently
depicted the commercial sites of gay sex – the bathhouses,
porn theatres, hustler bars and strip joints of Los Angeles
and, later, New York. Rejected by both the commercial art
world and 'mainstream' gay culture, Angus eventually moved
to a welfare hotel in New York and gave up trying to exhibit
his work publicly. Although in the 1980s Hockney purchased
five of his paintings and he was celebrated by the gay
magazine *Christopher Street*, Angus remained impoverished
and largely ignored by the art world throughout his life.
He died as a result of AIDS in 1992. Since that time,
his paintings have been increasingly recognized as audacious
representations of gay sexual culture in the midst of
epidemic loss. [RM]

BHUPEN KHAKHAR
You Can't Please All, 1981
Oil on canvas
176 × 176 cm

A critic of Indian nationalism in the 1960s and 1970s,
Khakhar was fascinated by indigenous Indian popular
painting as well as by Ambrogio Lorenzetti and other Italian
primitives. This painting, which Khakhar made to declare
his homosexuality, bears the marks of these influences.
A naked, solitary male figure stands calmly on his balcony
regarding scenes of work in the village below. His act of
voyeurism records the intricacies of public life in which he
feels at ease. He leans on the edge of the balcony, making his
buttocks more prominent and rendering both actual viewer
and pictorial neighbour complicit in desire. The painting,
writes critic Geeta Kapur, 'is a space for this artist's affective
existence – for his sexual vagrancy lodged comfortably in
a householder's environment without wife and children, his
amoral provocations interleaved with a self-designation,
by no means insincere, of a peaceable member of a middle-
class society, well adjusted within public life.' [CL]

MARTIN WONG
The Annunciation According to Mikey Pinero
(Cupcake and Paco), 1984
Acrylic on canvas
122 × 183 cm

MARTHA FLEMING AND LYNE LAPOINTE
The Tiger Tamer from *La Donna Delinquenta*, 1987
Mixed media installation
The Corona theatre, Montreal

Mikey Pinero, a poet and performer in New York's Lower East Side, was a close friend and collaborator of the painter Martin Wong, who chronicled the neighbourhood. Though Wong had already used text in his work in the 1970s, his friendship with Pinero provoked a more visual incorporation of words to parallel the shifts and turns of Pinero's voice. In this painting, Wong takes a scene from one of Pinero's plays and relocates it within the pictorial conventions of Christianity. In Wong's version, the annunciation is a transaction between two prisoners. Paco, kneeling, tries to seduce the newly arrived Cupcake, who replies, 'Leave me alone! I'm not a fag.' Pinero's writings tended to be harsh on queers, but Wong has resituated his source material to convey an ambiguous and intensely homoerotic prison scene, paying explicit homage to Jean Genet, author of *Miracle of the Rose* (1946), by adding the graffiti of a rose on the wall of the prison cell. [CL]

Between 1982 and 1987, Martha Fleming and Lyne Lapointe began a romantic and creative collaboration during which they produced insurrectional site-specific installations in abandoned buildings in Montreal. *La Donna Delinquenta* was created in the Corona, a derelict vaudeville theatre in a working-class district of the city. The title refers to Cesare Lombroso's 1893 book *The Female Offender*, a foundational criminological text that linked the categories of prostitute, immigrant, pauper and pervert in order to police urban populations and to identify future thieves and murderers. (Lesbians, though never named as such, were also snared in the capacious net of Lombroso's suspicions.)

With a hired production team, Fleming and Lapointe began the project in the dead of Montreal winter. They ripped up piss-soaked carpets and shovelled dirt to weave together the material space of a public theatre and the psychic space of memory. The artists were particularly interested in offering an intimate arena for longing and for fantasy, echoing the original role of the Corona. Their subtle interventions into the site, a hybrid of theatre and the visual arts, involved the creation of nineteenth-century special effects and large-scale backdrop paintings. They returned vaudeville and spectacle to the Corona, offering spontaneous performances on the stage and in front of the paintings. Here, amidst rotting walls, hangs a floor-to-ceiling painting of two circus staples, a woman and a tiger, wrestling in an uneasy, oddly erotic embrace. The image refers to both circus and theatre as havens for deviants and spaces of freedom. [CL]

KISS AND TELL
(SUSAN STEWART, PERSIMMON BLACKBRIDGE,
LIZARD JONES)
Drawing the Line (detail), 1988
Interactive photograph installation
Dimensions variable

Shown sixteen times in fifteen cities between 1988 and 1994,
'Drawing the Line' consisted of a group of sexually
explicit photographs that progressed from the tender to the
hardcore, from kissing and nibbling to whipping, bondage
and simulated rape. The same two women served as models
for all the fantasies depicted in the photographs. Kiss and
Tell, the lesbian collective that created the piece, invited
female viewers to write their reactions directly on the walls
and over the photographs, which were protected by glass.
Men were encouraged to use a 'men's book'. The scrawled
comments revealed that viewers often interpreted the work
as realistic, ignoring the fact that the fantasies depicted
were contradictory and that the images were transparently
staged. Some women were clearly aroused; others were
furious. *Drawing the Line* comprised both the original
photographs and the viewers' commentaries, a conceptual
strategy that made the divided and emotional response
to images part of the process of developing explicit sexual
representation made by and for lesbians. [CL]

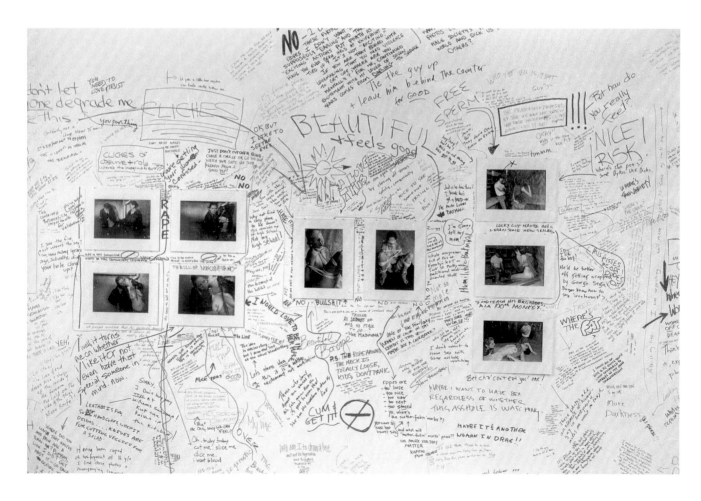

YASUMASA MORIMURA
Double Marcel, 1988
Colour photograph

Yasumasa Morimura restages aspects of the Western visual
tradition by photographing himself posing as figures in
iconic works. In this picture, he appropriates Man Ray's
portrait of Marcel Duchamp as his female alter-ego Rrose
Selavy. In this way, Morimura underscores Duchamp's
curious centrality as a seductive, gender-ambiguous, dandy-
esque figure in the European avant-garde. By including
both a pair of female hands, as in the pose of the original
Rrose, and his own darker hands, Morimura undercuts the
belief that drag is a simple gender reversal, that Rrose/
eros represents desire between the sexes, and that whiteness
is an unmarked racial category. [CL]

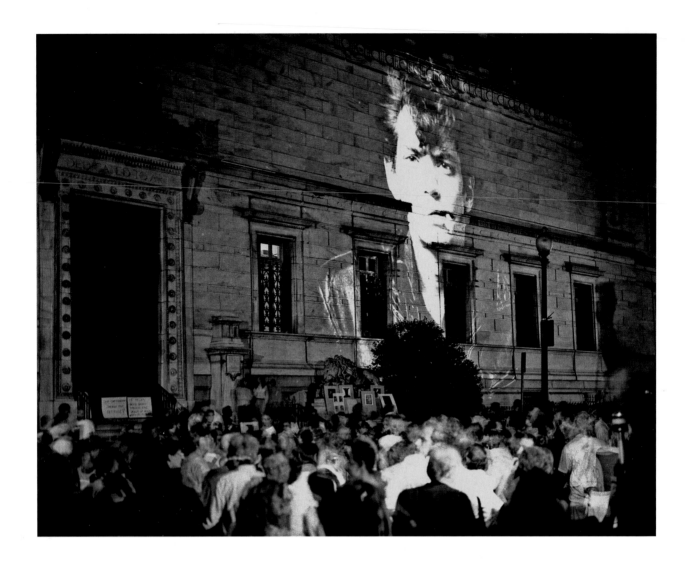

FRANK 'TICO' HERRERA
Protest against the cancellation of a Robert
Mapplethorpe exhibition at Corcoran Gallery of Art,
Washington, DC, 1989
Black and white photgraph

In June of 1989, the Corcoran Gallery of Art cancelled
'The Perfect Moment', a full-scale retrospective of Robert
Mapplethorpe's photographs that was due to open less than
three weeks later. The public controversy that ensued fuelled
the 'culture wars' over federal funding, homoerotic art and
the limits of creative freedom. A protest rally held outside the
museum on the evening of 30 June 1989 (the night before
'The Perfect Moment' was to have opened) marked a key
moment in the political reclamation of Mapplethorpe and
his work. During the protest, several Mapplethorpe pictures,
including a 1979 photograph of a threadbare American flag
and a 1980 *Self-Portrait*, were projected onto the building.
Mapplethorpe's work thus appeared, in radically oversized
format, on the exterior of the very institution to which it had
been denied access. To draw out the irony, the photographs
were projected near the main entrance to the Corcoran,
whose stone lintel bears the inscription 'DEDICATED TO
ART'. The protestors indicted the Corcoran's decision to
cancel 'The Perfect Moment' by ironically simulating the
museum's official function – the public display of art. [RM]

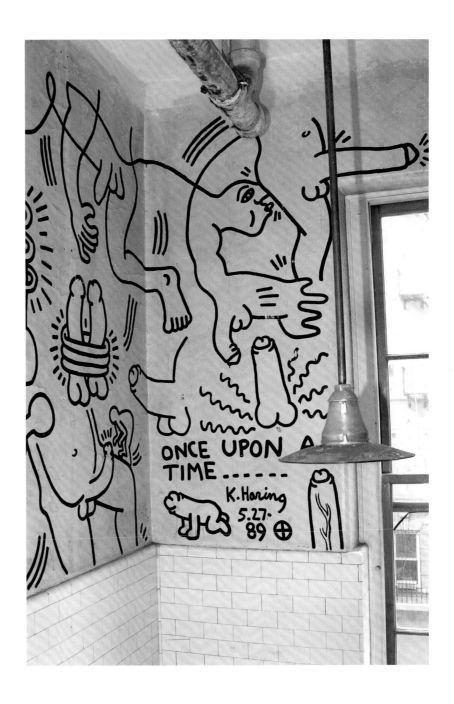

KEITH HARING
Once Upon a Time, 1989
Enamel on wall
350 x 250 x 750 cm

Beginning in 1980, Keith Haring made illicit chalk drawings
on the blank panels of unsold advertising space in New York
City subway stations. His signature style – silhouetted figures
of barking dogs, radiant babies and exuberant characters –
soon became familiar to New York City commuters. By the
middle of the 1980s, he had been discovered by the art world,
opened his Pop Shop in Soho and become one of the most
famous – and well remunerated – 'graffiti' artists of his day.
To commemorate the twentieth anniversary of the Stonewall
riots in 1989, Haring created an orgiastic mural for the men's
room of the Lesbian and Gay Community Services Center.
A popular attraction to the Center, the men's room has since
been repurposed as a meeting room for use by community
members of all genders. [RM]

JEROME CAJA
The Birth of Venus in Cleveland, 1988
Nail polish on plastic tip tray
15 × 10 × 1.5 cm

MARK CHESTER
ROBERT (ks lesions with hard dick and superman spandex)
from the series *Diary of a Thought Criminal*, 1989–90
6 black and white photographs

Jerome Caja was a performance artist and a producer of small-scale paintings and assemblages. Though hardly documentary in nature, his work deals with a number of aspects from contemporary queer life, often with wit and cutting humour. Much of his art employs scrappy materials and untraditional pigments, such as mascara, to achieve a roughly hewn, campy aesthetic. *Venus in Cleveland*, which shows the titular goddess as a stoic suburban transsexual, was made with nail polish and correction fluid. [RM]

From the early 1980s, Mark Chester participated in and documented the San Francisco leather scene, working in the legendary South of Market district until it was gentrified into oblivion. Most of Chester's photographs are stark, deeply shadowed black and white, classical in their arrangements of harnesses, boots, whips and leather masks and, of course, bodies. His photographs, Chester points out, are not just sex photos but 'pools at midnight reflecting waves made up of the moments of my life overflowing with unbearable quantities of love, sex and grief'. The fetishes in *ROBERT (ks lesions with hard dick and superman spandex)* do not, however, include leather and bondage equipment, but rather the eroticized signs of a man displaying and resisting his status as a person with AIDS. Robert Chesley's penis hangs out of his spandex Superman pants, and as he dons the top of his outfit, we can see that his torso is covered with Kaposi's Sarcoma lesions. Chesley regularly modelled for his friend and would die in 1990. [CL]

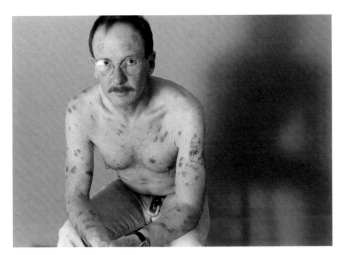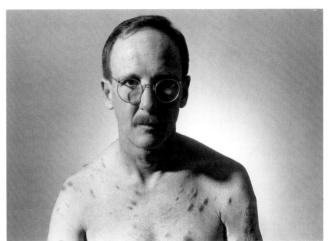

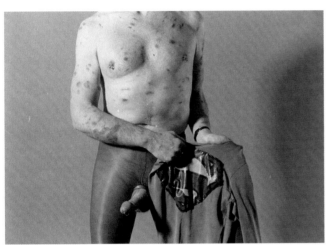

DAVID WOJNAROWICZ
Untitled from the series *Sex Series*
(for Marion Scemama), 1988–89
Photomontage
79 × 87 cm

From 1988 to 1989 David Wojnarowicz created a set of eight
photomontages that he called the *Sex Series*. In each work,
pornographic images printed in negative are set within larger
photographic fields, also in negative. While the porn shots
present couples in close-up detail, the background images
offer expansive sweeps of land, sea and sky. Inset images
are commonly used in road maps or anatomical diagrams
to magnify otherwise illegible or insufficiently detailed
fragments of the larger field. Perhaps the circular insets in
Wojnarowicz's series fulfil a similar function, serving as
apertures that magnify an otherwise unseen or submerged
erotics taking place within the city. In these photomontages,
the force of sexuality disorients both the viewer and the
visual field, erupting into and undoing our relation to the
larger environment. The primary mappings never set us
securely on the ground; we are descending from the skies or
in the midst of the sea, high over the Brooklyn Bridge or half
a storey above the earth. Perhaps the inset porn shots figure
another – more symbolic – sort of falling or groundlessness:
a loss, in the face of desire, of the spatial and psychic
guideposts that might otherwise situate us. [RM]

MONICA MAJOLI
Untitled, 1990
Oil on board
366 × 366 cm

Monica Majoli, whose meticulous paintings reconstruct the
luminous glow of Renaissance devotional icons, composed
this tableau from the account of an S/M scene given by
a gay male friend, an event in which she could never have
participated. She delights in a sense of the taboo, through the
filter of her own masochistic lesbian desires. By softening the
skin and musculature of these 'male' bodies, Majoli places
herself, across gender, in alliance with the central figure. [CL]

ANN MEREDITH
AIDS JUDGMENT HAS COME
(billboard, Slidell, Louisiana), 1989
Black and white photograph

Over her thirty-year career as a video-maker and documentary
photographer, Ann Meredith documented incarnations
of and changes in lesbian/feminist/queer identity and
the status of women. Her subjects include women in non-
traditional jobs, such as rodeo girls, drag kings and military
women, as well as lesbians and their dogs, homeless women
and women with HIV/AIDS. Through the representation
of marginalized or invisible groups, she offers sympathetic,
informed, respectful images of women's survival and
strength. At the same time, Meredith could not meet her
artistic commitments without confronting the forces that
marginalize those groups. The tattered but vicious billboard
in this photograph is an indelible record of the zealous
homophobia of the Christian right that was a fact of life for
people with AIDS in the late 1980s and after, particularly
in America's Bible Belt. [CL]

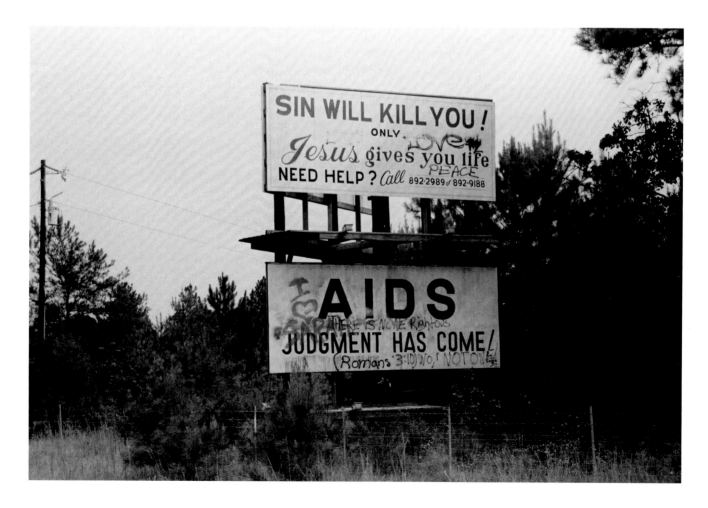

ANN MEREDITH
AIDS JUDGMENT HAS COME
(billboard, Slidell, Louisiana), 1989
Black and white photograph

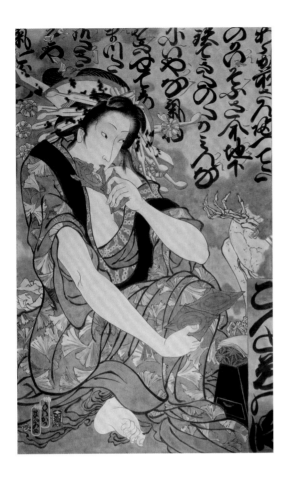

MASAMI TERAOKA
Tale of a Thousand Condoms/Geisha and Skeleton, 1989
Watercolour on canvas
334 × 210 cm

Masami Teraoka moved to Los Angeles from Japan in 1961 to study visual art. His paintings of the late 1960s and 1970s pivoted on the collision of Japanese and American cultures. Using watercolour to translate the flat pigments of late-Edo woodblock imagery, he produced parodic paintings such as *McDonald's Hamburgers Invading Japan/Self-Portrait* (1974) and *Flavors Invading Japan/French Vanilla IV* (1979). Teraoka was one of the first heterosexual, HIV-negative artists to represent AIDS as a global pandemic that would affect everyone. 'I thought it was important to remind people that gender, race and sexual preference are not the issue,' he said. 'AIDS is a health issue, and everyone deserves to be treated equally as a patient.' The paintings in Teraoka's *AIDS* series weave condoms into the texture of the composition, representing the transmission of AIDS as a matter of unprotected sexual acts rather than the outcome of sexual identity. The geisha in this dramatically scaled watercolour wears a traditional kimono and opens a packet of condoms. She converses with a skeleton who evidently used to be one of her customers. 'I felt bad on the train because everybody was afraid of me,' says the skeleton. 'You must have felt so awkward,' she replies. [CL]

JOHN DUGDALE
Life's Evening Hour, 1993
Cyanotype photograph

For John Dugdale, the early history of photography provides a renewable resource for creative practice. In the early 1990s, in the midst of a successful career as a commercial photographer, Dugdale lost almost all of his vision as a result of an AIDS-related disorder called CMV retinitis. He determined to continue making photographs, though with necessarily different means and intentions. Using a vintage large-format camera and a nineteenth-century method of photographic printing requiring iron salts and natural sunlight as a developing agent, Dugdale produced cyanotype prints of still lifes, nudes and landscapes. In this self-portrait, the artist appears before the gravestone of one of the inventors of photography, William Henry Fox Talbot. The photograph acknowledges mortality while asserting ongoing creative activity. It reaches back into the historical past to suffuse the present in a different light: a queer key of blue. [RM]

SUNIL GUPTA
Untitled 4 from the series
'Pretended' Family Relationships, 1989
Colour photograph, text on paper,
Black and white photograph
91 x 61 cm

Artist, writer, activist and curator Sunil Gupta has lived in
northern India, London, Montreal and the eastern United
States. His work generally juxtaposes incommensurate
elements in diptychs or triptychs, suggesting his nomadic
dislocation as well as his process of making work from an
accumulation of disparate images. The series *'Pretended'*
Family Relationships was made in response to Britain's
passing of Section 28 in 1988. The law explicitly forbade
government funding of affirmative queer relations, describing
them as 'pretended families'. Each instance of a 'pretended'
relationship consists of a portrait of a couple (some
interracial, some casual partners), a short, poetic text panel,
and a black and white image of one of the widespread
protests against Section 28. [CL]

Seeing you, seeing
me, it all becomes

so clear

GROUP MATERIAL
AIDS Timeline, 1989
Installation with various printed materials
Dimensions variable
Collection, Berkeley Art Museum at the University
of California, Berkeley

AIDS Timeline, a mixed-media installation by the artist collective Group Material, reconstructs the history of AIDS as embedded within a web of cultural and political relations, primary among them the federal government's response to the syndrome. The collective called upon a variety of art objects, as well as cultural artefacts, including images and texts from the popular media, the government and grassroots political activists, to create a chronology of the syndrome. Using this breadth of representational materials, the timeline suggests that AIDS was constructed through a bio-medical discourse of infection, incubation and transmission, as well as through a cultural vocabulary of innocence and guilt, dominance and deviance, threat and threatened, self and other. [RM]

CANDYASS (CARY LEIBOWITZ)
Carnival, 1991
Installation with various materials
Dimensions variable

FÉLIX GONZÁLEZ-TORRES
"Untitled" (Billboard), 1992
Photograph on Billboard
Dimensions variable

Whiner, satirist, self-loathing Jew, neurotic homosexual, über-gadfly, queen of the deadpan quip: Cary Liebowitz does not accommodate himself to the crass pretensions of the art world. He is, rather, a connoisseur of schlock and the outsourced multiple: mugs, caps, cushions, pennants and trash cans. As in his choice of nicknames, Leibowitz/Candyass opts for a nonchalantly queer and hilariously self-deprecating tone. 'I am a selfish and miserable person,' reads one painting scrawled in loopy blue calligraphy on an unfortunate shade of pink and hanging in the centre of this installation – a room that looks like the salon of a friendless, sissy boy. The 'depression pennants' read 'Life Sucks', 'Go Losers' and 'Drop Dead'. But Candyass's sentiments are often trenchantly pragmatic: 'There are two things I need to watch for the rest of my life', reads the rug on the floor: 'my weight and my racism.' [CL]

Commissioned by the Museum of Modern Art, New York, for its exhibition 'Projects 34: Felix González-Torres', the artist's bed billboards depict a space of comfort – but also of bodily absence and longing – within the commercial sphere. The near monochrome image, entirely devoid of text, offers a bed that bears the impression but not the physical presence of two reclining bodies. González-Torres placed the billboard at twenty-five sites throughout Manhattan, Brooklyn, Queens and the Bronx, only one of which (the Projects gallery at MoMA) was indoors.

In MoMA's exhibition brochure we read that González-Torres lost his lover, Ross Laycock, to AIDS in 1991 and that this project might therefore be seen as a kind of individual memorial or tribute to an absent partner. Once offered, this biographical information becomes inextricable from any experience of the work's meaning. Yet in its wilful ambiguity and open appeal to fantasy, the billboard cannot be confined to a specific message about the epidemic or to any single act of memorialization. Rather than reconstituting an individual lover (or, for that matter, the self) as the pictorial subject of commemoration and pathos, these billboards figure the trace of bodies that have, as it were, disappeared before our very eyes. [RM]

DEBORAH KASS
Double Double Yentl (My Elvis), 1992
Silk-screen ink and acrylic on canvas
2 parts
Each 183 × 183 cm

Double Double Yentl (My Elvis) is one of the first works from
Deborah Kass's *Warhol Project*, a two-decade attempt to
reconcile her admiration for and pleasure in Warhol's work
with her distinctly feminist, Jewish, lesbian critique of his
omissions. Kass sources her works in what she describes as
Warhol's 'preloaded' imagery, painstakingly reconstructing
particular paintings in order to insert figures that expose
Warhol's assumptions about celebrity, femininity, gender and
ethnicity. Barbra Streisand, the self-made singer-actress who
became not merely the most powerful woman in Hollywood
but also a compelling political activist, is Kass's answer to
Warhol's obsession with Jackie Onassis. This image from
Kass's *Jewish Jackie* series re-imagines Warhol's *Double Elvis*
as two nearly but not quite identical Barbras in Yeshiva
boy drag. The repetition not only suggests the possibility
of desire between the two figures but represents an early
queer reading of Warhol's 'original' by recognizing his erotic
desire for his celebrity males. [CL]

CARRIE MOYER
The Pussy Eater, 1994
Acrylic on wood panel
30 × 23 cm

NICOLA TYSON
Song, 1995
Oil on linen
142 × 127 cm

When Carrie Moyer moved from abstract painting to 'lesbian activist propaganda' around 1989, the United States was in the thick of the 'gay gene' debate. Amused that emphasis was being placed on locating the origins of homosexuality rather than just accepting it, Moyer revisited childhood to parody the heterosexual's worst nightmare – the queer child. Moyer often uses the figure of a little lesbian predator, instructed in deviancy by her mother, a precocious 'man-hater'. In *The Pussy Eater*, a little white girl stares bleary-eyed from the painting, her mouth smeared with, presumably, the menstrual blood of an older woman. When straight people saw Moyer's work, however, they would ask her whether she had been an incest victim, abandoning any knowledge of painting as a fiction to read the work autobiographically. Perhaps because of such misinterpretations, Moyer eventually moved on to more coded abstractions. [CL]

Trial Balloon, meaning information sent out to observe the reaction of an audience, applies not only to the name of the women-only gallery that Tyson founded and directed for three years in lower Manhattan in the early 1990s but also to her own work as a painter. Tyson's nominally cheerful surrealist paintings, composed of flat fields of colour, subject the human form to a series of biological transformations. At the centre of this painting is an orifice (a vagina? an anus?). The figure backed into a perspectival corner is surrounded by two others. Or perhaps it is just one androgynous, ageless, distorted figure. From its mouth issue two tongues, or penises, or jets of vomit. The unstable border between abstraction and figuration in Tyson's paintings produces a representation of giddy sexualization. [CL]

FRED WILSON
*An Invisible Life: A View into the World
of a 120 Year Old Man*, 1993
Installation with various materials
Dimensions variable

Since the late 1980s, Fred Wilson has, as the title of one
of his best-known works put it, 'mined the museum' to
explore the links between aesthetics and politics. He recovers
objects buried in archives and storage facilities to rattle the
stability of neutral cultural presentation. This San Francisco
installation was set within a historic Victorian house on
upscale Nob Hill. Within the domestic interior, the artist
placed artefacts that suggested the inhabitant was an upper-
class African-American man of distinct homosexual leanings.
Portraits of James Baldwin, Gertrude Stein and Antinous
(the lover of the emperor Hadrian) are among the objects
that populate this 'invisible life'. [CL]

DANIEL GOLDSTEIN
Icarian II, 1993
Leather, sweat, wood, copper, felt, Plexiglas
73 x 37 x 6 cm

At once a relic, a shroud and a skin, Daniel Goldstein's
Icarian (Decline) embodies the gay past in a unique fashion.
The leather surface of the sculpture was formerly the cover
for a bench press at the Muscle System, a popular,
predominantly gay gym in San Francisco during the 1980s
and 1990s. When the gym refurbished its work-out equipment
in the early 1990s, Goldstein asked if he could have the
time-worn bench covers that were about to be thrown away.
For each leather hide, the artist constructed a reliquary
case of wood, copper, felt and Plexiglas. By preserving these
sweat-stained surfaces, Goldstein memorializes a community
of gym patrons and work-out buddies that was nearly wiped
out by the AIDS crisis. The mythological title of the series,
Icarian, is also the name of the manufacturer that produced
the weight-lifting equipment. [RM]

BOB FLANAGAN
Bob on Scaffold, 1989
Performance

'Because it's in my nature; because it's against nature;
because it's nasty; because it's fun; because it flies in the face
of all that's normal.' So wrote poet and performance artist
Bob Flanagan in 'Why', his defiant manifesto on his career
as a 'super masochist'. Flanagan was a central figure in
Los Angeles's S/M and underground club scene of the
1980s. In this event at the Threshold Club in Los Angeles,
he demonstrates a DIY contraption for pain and pleasure
made of two-by-four timber, gym equipment and rope. Within
the frame of this scaffold, Flanagan lies bound, his nipples,
penis and scrotum covered with metal clamps and clothes
pegs. Like all Flanagan's collaborations with his partner and
dominatrix Sheree Rose, this performance was accompanied
by his banter: practical, improvisational, forthright and
hilarious. The audience included not only artists but also
a cross section of S/M aficionados from various occupations
and classes. [CL]

ZOE LEONARD
Untitled, 1992
Installation with photographs
Neu Galerie, Documenta 9, Kassel, Germany

An out lesbian whose work was included in a premier
exhibition of contemporary art, Zoe Leonard chose to use
four rooms at the Neue Galerie in Kassel, Germany,
for her contribution to Documenta 9 in 1992. In an eloquent
but simple gesture, she pinned unframed, crudely printed
black and white beaver shots roughly equidistant between
seventeenth- and eighteenth-century portraits of women.
If such paintings are arguably renderings of the property of
men, Leonard crudely, and hilariously, exposes the vagina
as currency. At the same time, the beavers belong to
Leonard's friends, and the photographs represent her own
desire. 'They're totally erotic images for me,' Leonard
has said, 'as well as a real mirror […] of what the viewer's
relationship is to female genitals.' [CL]

HUNTER REYNOLDS
Patina du Prey's Love Dress, 1993
Ink on fabric
150 × 150 × 200 cm

Hunter Reynolds's mythopoetic drag persona, Patina du Prey,
stands on a rotating platform wearing her love dress, a ball
gown designed specifically for Reynolds' male and resolutely
hairy body. Written across the fabric are thousands of the
artist's own diary texts and love stories. There have been
eight Patina du Prey dresses, beginning with the *Memorial
Dress* (1993–2007), which featured the names of twenty-five
thousand people who had died of AIDS. While wearing it,
Reynolds invited viewers to write in a guest book the names
of those they wished added to the next edition of the work.
Patina du Prey is a living, breathing *memento mori*, a healer
of grief. When performing in the gallery, she opens the space
to the potential for catharsis. When she strolls the streets, she
is an eloquent reproach to those who consider drag either
frivolous or anti-feminist. [CL]

In a 1995 Charles Ray reflected that he was 'in search of
a sensation located somewhere between the genitals and the
head, [...] juvenile but also sublime'. *Oh! Charley, Charley,
Charley...* is comprised of eight very pink, entirely naked,
life-size mannequins of the artist, arranged in a circle
so as to suggest an orgy. The 'other' that feeds the artist
in the narcissism of his own desire is the artist himself.
Thus Ray's literalization of the glories of his masturbatory
fantasies takes heterosexual autoeroticism and queers it.
If homosexuality is conventionally pathologized as a
sexuality that refuses to grow up and enter the adult world
of sexual difference, *Oh! Charley, Charley, Charley...* is a
hilarious rebuttal of that theory. [CL]

JOSÉ LEONILSON
34 with Scars, 1991
Synthetic polymer paint, embroidery thread
and plastic tacks on voile
41 × 31 cm
Collection, the Museum of Modern Art, New York

In *34 with Scars*, the Brazilian artist José Leonilson fashioned
a self-portrait on the threshold of invisibility. Using black
thread, he embroidered the edges of a rectangular piece
of white cotton voile. Inside this black and white border
appear only three small forms: two stitched and painted
'scars' and the number 34, the age of the artist at the time.
Already ailing as a result of AIDS, Leonilson died less than
two years later. One of the artist's last completed works,
34 with Scars has come to be seen, perhaps inevitably, as a
response to mortality. According to Colombian critic José
Roca, 'Leonilson's work, which had always been precarious
in character, became even more stripped down, ethereal and
dematerialized, a metaphor for his own condition.' [RM]

ROBERT GOBER
Untitled, 1991
Beeswax, pigment, human hair
61 × 40 × 31 cm

In whatever medium he chooses to use, Robert Gober
restores sentiment to minimalist art. The sinks, urinals,
doors and torsos that he has repeated, with variations, again
and again, are quietly elegiac. This untitled torso – legless,
armless and headless – sits propped in a corner. The weight
it does not possess appears to have caused it to melt into
the floor upon which it sits. As a human torso, the object is
life-sized. As a paper bag, which the work suggests through
its colour and the crumpling of its surface, it is dramatically
over-scaled. A space of uncertainty frames and complicates
the gender split that divides the torso vertically: hairless
skin, a breast and a prominent nipple on the left side; hair,
a hint of more muscle and a flat chest on the right. In this
work, as in Gober's larger series of body-part sculptures,
all of which call attention to the architecture in which they
are positioned, the artist manages to eroticize and to make
vulnerable the human body. [CL]

DEBORAH BRIGHT
Dream Girls, 1989–90
Photomontage
41 × 51 cm

Made at the height of the 'culture wars' – high-profile
political battles over creative freedom in the United States –
Deborah Bright's *Dream Girls* reclaims the classic Hollywood
cinema that feminist theory had condemned as synonymous
with the heterosexual 'male gaze'. Using film stills purchased
at a second-hand shop, Bright photomontaged her butch
persona into selected Hollywood demonstrations of (hetero)
sexual difference. At once impish and intellectually rigorous,
Bright's interventions not only overturn normative economies
of heterosexual desire with the erotic charge of butch/femme
gendering but also expose representations of heterosexual
gendering as in and of themselves a form of high camp.
In this example, Bright whips out a lighter to ignite Audrey
Hepburn's cigarette in *Breakfast at Tiffany's*, skilfully beating
the male suitor to the punch. [CL]

HILLARY LEONE AND JENNIFER MACDONALD
Double Foolscap, 1994
Installation with various materials
Dimensions variable

In *Double Foolscap*, hundreds of sheets of textured paper wrap
around the walls of the gallery to form a monumental grid
of contrasting monochromes. Over the course of a year,
the artists – Hillary Leone and Jennifer MacDonald –
shredded, boiled, soaked, pulped and pressed their wardrobes
into sheets of paper. The clothing that once belonged to
each woman has been refashioned into a collaborative
artwork. At the time the work was made, the artists shared
more than their clothing: they were lovers and life partners.
Double Foolscap literally opens the artists' private 'closet'
to public view while also suggesting that secret stories and
half-hidden forms of visibility are part of the very fabric of
intimate partnership. [RM]

ROBERT BLANCHON
Untitled (Benjamin Franklin), 1992–94
Framed black and white photograph
36 × 32 cm

Robert Blanchon was a conceptual artist whose work
absorbed and redeployed tropes of gay life such as hankies,
stains, want ads and sympathy cards for those who had died
of AIDS (as Blanchon himself would in 1999). He turned
a merciless eye upon the ways in which public space both
represses and solicits a homosexual imaginary. In a series
of images that queer public monuments, Blanchon eroticizes
apparently innocuous monumental sculptures by focusing
on certain details – an intersection of torso and bicep outside
the Federal Reserve Building in New York, or the capacious
butt of the rhinoceros outside the New York customs house.
In this image, Blanchon positioned himself directly below
American icon Benjamin Franklin to zoom in, under the skirt
of his eighteenth-century jacket, upon a bulging crotch. [CL]

Mother knew

VIRGIL MARTI
For Oscar Wilde, 1995
Installation with live sunflowers, ceramic plaque,
silk lilies, hand-printed wallpapers, cotton velveteen,
wood mouldings, iron bed
Eastern State Penitentiary, Philadelphia
Cell 269 x 244 x 549 cm

The Philadelphia-based artist Virgil Marti creates sculptural objects and installations that question the boundaries between art and interior decoration as well as the hierarchies of taste, class and gender that organize both private and public space. In 1995, he created a site-specific work at the Eastern State Penitentiary, a former prison now preserved as a historical monument in Philadelphia. Titled *For Oscar Wilde*, the installation is dedicated to the flamboyant late nineteenth-century writer and marks, more specifically, the hundredth anniversary of Wilde's imprisonment on charges of 'gross indecency'. The hand-printed wallpaper that Marti used for decorating the interior of the cell is based on William Morris's designs, which would have been more or less contemporaneous with Wilde's imprisonment. Wilde was sentenced to two years of hard labour at Pentonville, a prison whose architectural design (with five wings radiating from a central surveillance station) was based in part on the model of Eastern State Penitentiary. [RM]

GLENN LIGON
A Feast of Scraps (detail), 1994
Photographs and collage in photo albums
Dimensions variable

In *A Feast of Scraps*, Ligon inserts pornographic photographs of black men, complete with self-invented captions ('Mother knew', 'I fell out', 'It's a process') into albums of family snapshots, some of which depict Ligon's own family. In these albums, unbidden erotic fantasies and sexual stereotypes of black men suddenly, and spectacularly, take their place beside vacation snapshots, graduation photographs, wedding showers, birthday celebrations and church baptisms.

A Feast of Scraps renders visible that which must be kept hidden, left unspoken, or otherwise repressed within traditional records of domestic and familial life. As Ligon wrote in 1995, 'The 1970s were the decade when I discovered that I was sexually attracted to men. I had albums full of family pictures from that period, pictures of male cousins and me as adolescents. These pictures record our unkempt afros, flowery polyester shirts, and pressed blue jeans, but they do not record my desire for my cousins. The photos of black men in Gay Treasures [a porn shop in Greenwich Village] are the photos left out of my family albums, and when I look at them I see my cousins' faces and bodies and I remember my desire.' [RM]

LSD
Es-cultura Lesbiana, 1994
Black and white photograph

LSD and Radical Gay, both formed in 1993, were the first
queer activist/artists groups in post-Franco Spain. LSD
usually stood for *Lesbianas Sin Duda* (Lesbians Without a
Doubt). It also, if the occasion demanded, meant *Lesbianas
Sudando Deseo* (Lesbians Sweating Desire), *Lesbianas Sin
Desodorante* (Lesbians Without Deodorant) and many other
permutations. Based mainly in the working-class Lavapies
quarter of Madrid, LSD was a loose collective of lesbian
artists, writers and activists who played with the idea of
lesbian culture, historical and contemporary. The group
published three issues of the zine *Non Grata* – in 1994, 1995
and 1997 – and mounted exhibitions in alternative galleries
and bars. This photograph, the title of which plays with
various meanings – 'Is Culture Lesbian?' and 'Lesbian
Sculpture' – was part of *Non Grata*'s most controversial issue.
LSD made such images in order to represent themselves
rather than submitting themselves to being represented
by others. [CL]

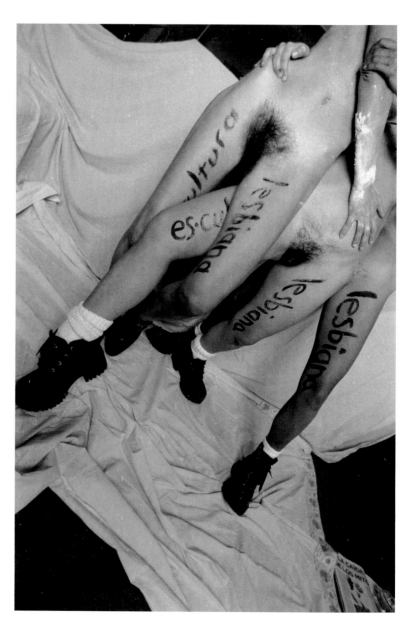

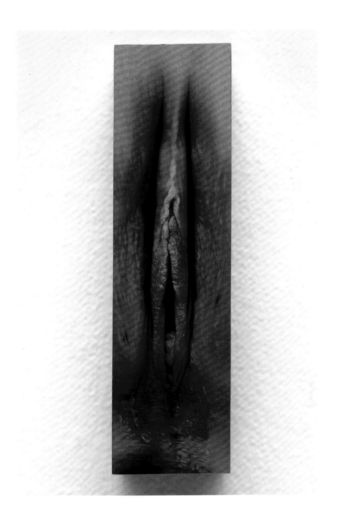

I AM A
lezzie
butch
pervert
girlfriend
bulldagger
sister
dyke
AND PROUD!

FIERCE PUSSY
*I AM A lezzie butch pervert girlfriend bulldagger
sister dyke AND PROUD!*, 1994/2008
Photocopy on paper

JUDIE BAMBER
Untitled I, 1994
Oil on wood
16.5 x 5 cm

During the late 1980s, Judie Bamber's minutely detailed realist paintings depicted small objects sitting abjectly in the middle of large fields of colour. Shortly before coming out as a lesbian, Bamber made three small paintings based on photographs of the genitalia of her friends. Bamber is hardly the first lesbian artist to choose this subject matter, but these paintings are important in their witty positioning of the vaginal opening and labia to suggest a phallus and, even more importantly, in their lascivious, micro-realist use of paint to represent a membrane of desire. [CL]

Wheat-pasted to a wall outside the artist's-book emporium Printed Matter in New York City in 2008, this image reprises an early 1990s explosion of dyke activism, when a shifting cadre of quick-thinking young queers posted their comments around the city. Active between 1991 and 1995, the collective fierce pussy brought a defiantly lesbian presence to the queer resistance sparked by the AIDS epidemic. They capitalized upon the zine aesthetic of the 1990s, churning out down-and-dirty, low-tech, trenchant and infinitely reproducible posters. (Indeed, the fact that the photograph in this book has been captured from a Flickr photostream demonstrates fierce pussy's success at viral distribution.) Fierce pussy's graphics made the ACT UP posters developed in the 1980s look positively commercial in comparison. 'You're too fucking straight to walk these streets,' one poster baited. [CL]

PIERRE ET GILLES
(PIERRE COMMOY AND GILLES BLANCHARD)
Casanova (Enzo Junior), 1995
Colour photograph

Pierre et Gilles became romantic and creative partners in
1977, beginning their prolific celebrity careers with advertising
illustrations as well as photography for publications such
as *Gai Pied* and *Aktivist*. Their division of labour remains
constant: Pierre photographs, Gilles reworks the image
with paint. In their portraits – characterized by delirious
ornamentation and hyperbolic fluff – porn stars, transvestites,
drag queens, actors, musicians and celebrities are
mythologized through excessive hairstyles, makeup and
costumes. Other sitters enact familiar tropes of gay culture:
sailors, the brawny gardener, Saint Sebastian, and David
and Jonathan. Celebrities such as Nina Hagen and Franck
portray Jesus and Mary, while the artist Christian Boltanski
poses as Saint Vincent de Paul, and Naomi Campbell plays
the goddess Diana. In this image, the thief of female virtue
whose name is synonymous with illicit pleasures stands
naked. He admires his equipment in the mirror amidst the
doubled glitter of beaded drapery and candlelight. Women are
unnecessary to his homosocial universe; Casanova renounces
them in order to seduce himself. [CL]

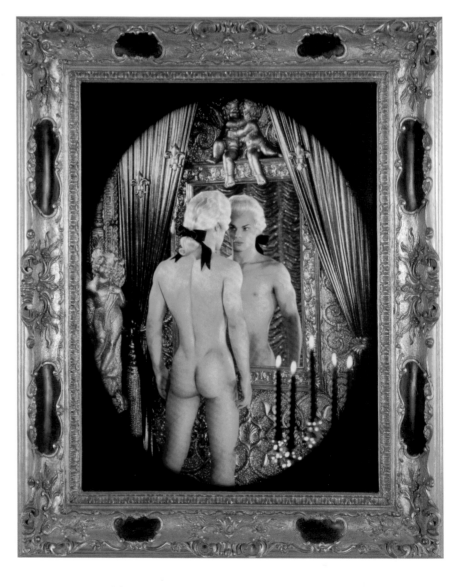

G –
Queer Worlds
(1995 – present)

Within the art world recent years have witnessed a complex dialogue between the affirmation of difference on the one hand and the disavowal of identity-based categories on the other. This dialogue has informed a number of influential art exhibitions, including 'Oh Girl, It's a Boy' at the Kunstverein München (1994), 'In a Different Light' at the Berkeley Art Museum (1995), 'Rrose is a Rrose is a Rrose: Gender Performance in Photography' at the Guggenheim Museum in New York (1997), 'The Eighth Square' at Museum Ludwig in Cologne (2006) and 'Just Different' at the Cobra Museum in Amstelveen (2008). The very title of a 2006 New York gallery exhibition, 'The Name of This Show Is Not Gay Art Now', bespeaks the ongoing tensions between sexual affirmation and refusal within the production and display of contemporary art.

Many sexually dissident artists hesitate to identify as gay, lesbian or queer for fear that it might limit the visibility of their work or the progress of their careers. Others have taken up queer as a subject position more expansive than either gay or lesbian, one that can accommodate heterosexual artists dealing with radical sexual perversity, for example, or transgender and bisexual artists, or those who are sexually questioning, undecided or experimenting with alternate genders. Still others have embraced 'queer' in the process of opening up virtual networks of expression and exhibition and formulating new cultural and aesthetic alliances.

The politics of sexuality in cross-cultural contexts has become increasingly generative for artists and writers. Depending upon the context, queer can be either an accepted identity that underlies artistic production or a route to protest against the increasing normalization of gay and lesbian culture by, for example, the struggle for marriage rights.

AA BRONSON
Felix, June 5, 1994, 1994—99
Lacquer on vinyl
305 x 610 cm

AA Bronson, Felix Partz and Jorge Zontal (born Michael Tims, George Saia and Ronald Gabe) began to collaborate under the rubric General Idea in 1969. First based in Toronto, they moved to New York in the 1980s. Partz and Zontal died of AIDS in 1995. In this mural-sized portrait made a few hours after the Partz's death, Bronson confronts not only the passing of a beloved friend but also the genre of the death-bed likeness.

This is not a sober death. Partz's eyes have not been closed for the comfort of the viewer. Television remote still within reach, his body forms a rather small part of a defiant composition of brightly coloured bedclothes and patterned fabric. The exuberance of the display is reminiscent of the tactics General Idea used for twenty-five years to mimic and critique commodity culture. Remarkably prolific in their output, the group applied punk, drag-queen finery, advertising savvy and superbly bad taste to whatever artistic medium suited their consistently subversive message, including prints, boutique shops, publications, sculpture, video, performance and painting. [CL]

LAURA AGUILAR
Nature Self-Portrait #7, 1996
Black and white photograph

Since the early 1990s, photographer Laura Aguilar has
worked to create her own version of 'queer raza' by unsettling
smugly positive depictions of both the Chicano and gay
Los Angeles communities. In the series of nudes from which
this photograph is taken, Aguilar adds to her representational
challenges the resplendently overweight female body.
In this photograph, woman occupies the space of nature with
a body that is the polar opposite of the cultural ideal.
The raking sun theatricalizes her flesh, producing a deeply
shadowed indentation in the small of her back and a
dramatic cleft between her buttocks. Aguilar both references
and unsettles seventies lesbian-feminist goddess worship.
The weight of her form echoes the weight of the boulders in
the foreground, and they, in turn, tell us that the nature in
which she sits is a road track in the desert partially blocked
by boulders. [CL]

FRANK MOORE
Release, 1999
Oil on canvas mounted on wood panel
57 × 241 cm

Frank Moore's *Release* focuses on a fragment of the body:
a single arm, outstretched and monumentally elongated.
Here and there, small pools of blood cut into the surface of
the skin, out of which sprout verdant blades of grass and
variegated weeds. A mix-and-match swarm of brilliantly
coloured butterflies flutter around the arm, gathering density
on the painting's left edge, just beside the open hand.
With its distended veins, bluish cast and blood-filled puddles,
the arm pictured by Moore cannot but suggest sickness,
decomposition and imminent (or perhaps recent) death.
And yet human death here gives way to other forms of
natural life, to a veritable habitat of flora and fauna. For
all their beauty, these butterflies and dandelions are also
parasites, feeding on (and perhaps hastening the demise of)
the body they surround and colonize.

Moore signed *Release* not with his own signature but
with the computerized bar code that identified him on health-
insurance forms. As a person living with AIDS, his access
to medical treatment, and thus his very survival, was tied to
this most impersonal of identifications. The inclusion of the
bar code echoes some of the central tensions of his late work:
between survival and dependence, self and other, health
and death. [RM]

GREER LANKTON
It's all about ME, not you, 1996
Installation with various materials
Dimensions variable

At the age of twenty-one, Greg Lankton underwent
sex-reassignment surgery and became known as Greer.
A participant in the East Village art scene of the early 1980s,
Lankton created vibrantly detailed, often life-size dolls that
challenged the conventions of gender, sexuality and social
acceptance. Nan Goldin (who photographed Langton on
multiple occasions) recalls that the artist 'constantly worked
and reworked her dolls, changing their genders, identities,
sizes and clothes. They were beautifully rendered, with complex
substructures and movable joints.' Lankton's last work,
a 1996 installation at the Mattress Factory in Pittsburgh,
recreated the interior of her studio apartment, complete with
shrines to Patti Smith, Candy Darling and Jesus, as well as
numerous dolls, photographs, empty pill bottles and drug
paraphernalia. A month after the opening, Lankton died
of a cocaine overdose. [RM]

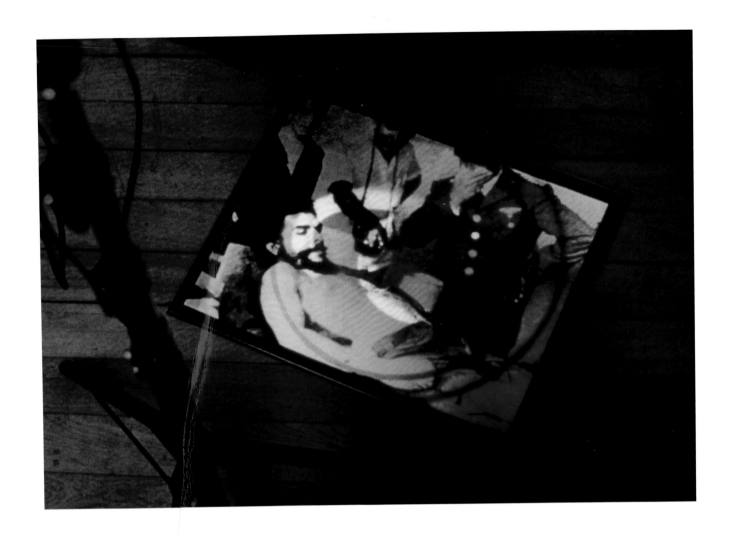

DOUG ISCHAR
Cul de Sac, 1996
Installation with video, photographs
and various materials
Dimensions variable

Experiencing Doug Ischar's installations of the 1990s
entailed traversing in virtual darkness an obstacle course
made up of precariously stacked electronic equipment –
small film projectors, video monitors, tripods, decks and
wires. The photographs or projected images were almost
always small – the size of a hand, or a mouth. While offering
some of the pleasures of the porn theatre, Ischar taunted
his viewers, who had to grope in the dark for the queer body
they expected, and wanted. Fascinated by the liberation
politics of the 1960s, Ischar annexed figures who would seem
inseparable from the bedrock of heterosexual masculine
history: Fidel Castro, Mao Zedong, John F. Kennedy and,
in the image shown here, Che Guevara. The revolutionary
hero lies dead on a table, bare-chested, belt unbuckled,
fly unbuttoned. His head has been propped up to offer
a better view for the camera. Looking down upon him are
a photographer who points at Che's fly, a handsome young
sailor who stands with his mouth agape, and an army officer
who holds a handkerchief to his nose. Ischar suggests
not that Che or the men surrounding him were homosexual
but that the mechanism of creating heroes entails an erotic
charge that can only partially be repressed. Queer desire,
then, will inevitably be part of the equation. [CL]

GEORGE STOLL
Untitled (wall mounted Scott, green puddling), 1997
Painted wood, silk chiffon, acrylic paint
67 × 60 × 46 cm

George Stoll remakes everyday objects of domestic life –
cups, sponges, Tupperware containers – in unlikely materials
such as beeswax, silk and burned balsa wood. In *Untitled
(wall mounted Scott, green puddling)*, a sheet of flamboyant teal
chiffon unspools from a toilet-paper holder housed within
a niche in the wall. In an earlier, closely related work, Stoll
hand-quilted miniature roses onto a roll of unfurled white
chiffon. In bestowing this meticulous craftsmanship on toilet
paper (and Tupperware), Stoll demonstrates the ongoing
allure of camp. 'To be camp', wrote Mark Booth in 1983,
'is to present oneself as being committed to the marginal
with a commitment greater than the marginal merits.' [RM]

MARIA ELENA GONZÁLEZ
Self Service, 1996
Tiles, mirrors, chrome handles, rawhide
Dimensions variable

You step into a shower-like stall that is tiled, mirrored and
equipped with a drain on the floor and two large chrome
handles on the wall. There is no shower, sink or bathtub,
however – indeed, no water at all. Instead, a rawhide phallus
juts out from the wall between the chrome handles. Wittily
titled *Self Service*, this installation by the Cuban-born sculptor
Maria Elena González conjures a scenario of autoerotic
penetration. At the same time, *Self Service* never specifies the
gender or sexual identity of the self in question. Each viewer
of the work is invited to imagine her or his own relation to
the special plumbing that González has installed. [RM]

CABELLO/CARCELLER
(HELENA CABELLO AND ANA CARCELLER)
Promise, 1998
Installation with photographs and various materials
La Gallera, Valencia

Dissatisfied with the stagnation of feminist studies in Madrid
in the early 1990s, Helena Cabello and Ana Carceller
embarked on their own investigation of gender and sexuality.
They created the working partnership Cabello/Carceller
to impose a strategic ambiguity around the issue of gender
and to shine any morbid curiosity about the topic back upon
the viewer. Their defiance extended to refusing to supply
a conventional biography for the *Promesa* (Promise) catalog.
Instead, they substituted a series of short texts supposedly
penned by a frustrated studio assistant named Nora and
purporting to be letters to critics and others anxious to
extract the usual biographical information on the artists.
'They tell me that they prefer to live in the future than to
drag up the past.' *Promise*, installed in a building in Valencia
designed to host cockfights, was created after the artists had
returned from a year in San Francisco. They were drawn
there by the turquoise fantasies of David Hockney and tales
of lesbian bars. Naturally, the reality did not live up to these
fantasies. Instead, the artists photographed empty, dirty,
abandoned sites of pleasure. *Promesa* is the result and record
of some of these excursions. The photographs that circle the
gallery above focus on swimming pools, which the artists see
as a metaphor for desire and the unconscious. The project
is also an oblique homage to the (unmarried) Californian
architect Julia Morgan, whose magnificent swimming pools
the artists chose to consider spaces of lesbian desire. [CL]

JOCHEN KLEIN
Untitled, 1996
Oil on canvas
76 × 101 cm

Jochen Klein's paintings of the late 1990s depict photographically derived young bodies, male and female, in pastoral landscapes rendered in brushy fragments. Bodies and nature are both obvious quotations. With this perfect young man, shirtless and tucked into a perfect landscape, Klein appears to deploy a fantasy of childhood innocence to provoke the viewer's erotic desire. This scene is part of a larger examination of utopia in public space that included texts and installations about cruising in public spaces. Before his death, Klein and his close collaborator Thomas Eggerer became members of Group Material. Though this may seem an unlikely injection of apolitical oil painters into a team of activist practitioners, Klein was of pivotal importance to the group. He expanded its idea of critique to include the understanding that to recognize the force of intimate desire in public space accords us the transformative power of imagining a different future. [CL]

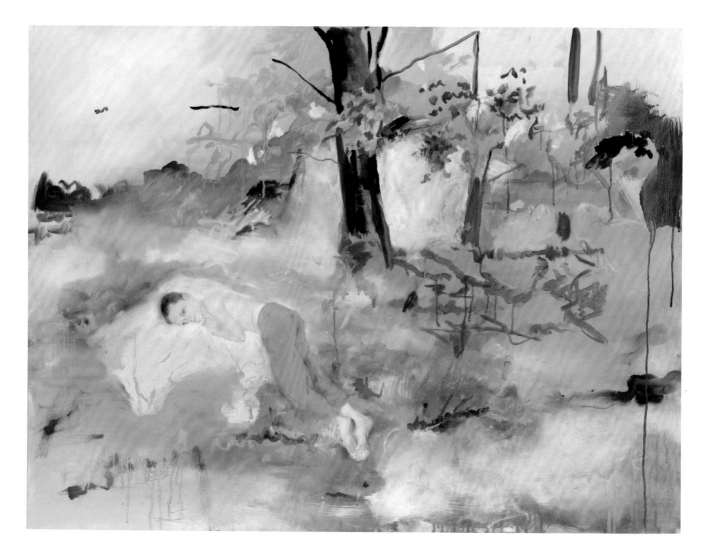

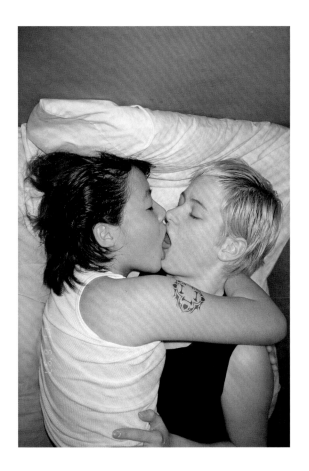

TAMMY RAE CARLAND
Ransom Letter, Alice B. Toklas from the series
Random Letters to Ransom Girls, 1998
Collage on paper
21.5 × 28 cm

NIKKI S. LEE
The Lesbian Project, 1997
1 of 14 colour photographs

Lee makes groups of photographs in which she assumes
the identity of specific social groups – for example, seniors,
tourists, young Japanese in the East Village, yuppies and
lesbians. She costumes herself to blend into any given
subculture, passing her camera to a member of the group to
make the actual photograph. Her camouflage is so expert,
in fact, that her presence is visible only by recognizing her
from other photographs. Here, she is costumed as a lesbian,
which is to say, with nose piercing, a tattoo, short hair,
and tank top. The kiss would appear to be the identity
clincher, but it is, of course, the most unstable sign of all.
The terms of the collaboration represented by the kiss
are as unknowable – and, ultimately, irrelevant – as the
terms of Lee's collaboration with, say, male swingers. [CL]

A zine pioneer *(I [heart] Amy Carter*, 1992–96), videomaker
(Lady Outlaws and Faggot Wannabes, 1995) and independent
music entrepreneur and distributor (Mr Lady Records),
Tammy Rae Carland is also a visual artist who works in
collage and photography. She has photographed herself
in 1950s period costume as her gay father. She has
photographed 'lesbian beds' from above, the results being
little more than composed abstractions. She has mined the
inscriptions on the backs of photographs for hints of queer
content. In the sprightly collages that make up *Random
Letters to Ransom Girls*, Carland cuts letters from glossy
magazines to mimic the methods of a kidnapper. Each
communication is accompanied by an envelope that reveals
the implied recipient of the letter: the lesser-known, even
overshadowed partner of an artist. But rather than exacting
payment, this kidnapper confesses. Novelist Willa Cather,
for example, writes the following to her partner Edith Lewis:
'She dared not speak her name in books or public. 40 years
of love & silence.' In this image, Gertrude Stein writes to
Alice B. Toklas, 'Dear Alice, A wifely rose will not wilt. Tilt,
maybe. We are adorably we. A rose & a rose. Yes yes yes.' [CL]

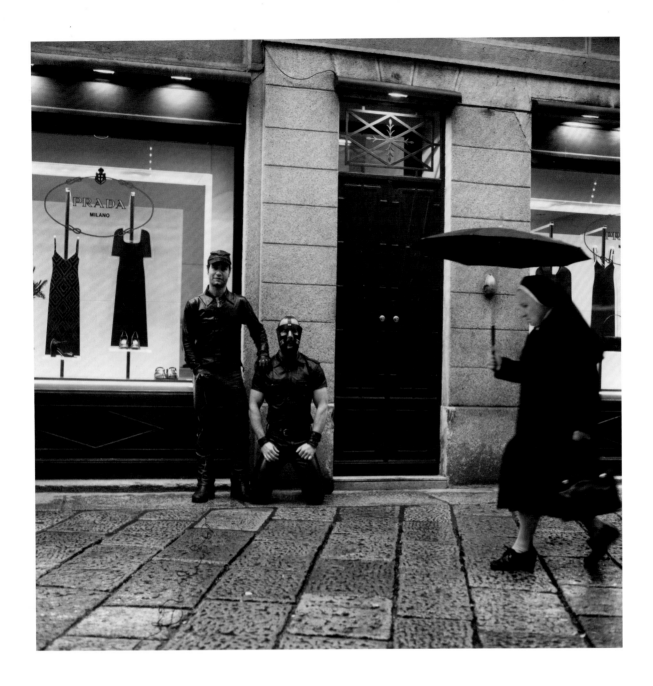

JOHN LOVETT AND ALESSANDRO CODAGNONE
Prada, Via della Spiga, Milano, 1997
Colour photograph

What if gay subculture were no longer 'sub-'? What if the
queer pleasures of leather, kink and S/M spilled out, in plain
view, into (so-called) mainstream society? This proposition
animates the work of John Lovett and Alessandro Codagnone,
a collaborative duo who frequently insinuate gay sexuality
into unexpected public, commercial and residential contexts.
In *Prada, Via della Spiga, Milano*, Lovett and Codagnone
present an unlikely trio of variations on dressing in black.
Outfitted in full-leather (including, in the case of the kneeling
half of the duo, a bondage mask), the men appear on the
street beside a Prada shop window in which two chic black
dresses are on display. Entering the scene from the right edge
of the composition is a nun holding an umbrella. With her
gaze fixed firmly downwards, she admits neither to the lure of
the gay leathermen nor to that of the couture dresses. [RM]

COLLIER SCHORR
Two Shirts, 1998
Colour photograph

'How come you don't take pictures of girls?', someone once asked Collier Schorr. 'I do,' she said, 'I just use boys to do them.' Obsessed with both masculinity and the spaces that form masculinity, Schorr's photographs and collages of adolescents and young men often disturb the surface of gender through a series of aliases: for example, having a German boy pose as Andrew Wyeth's model Helga; presenting – as in this photograph – depictions in which conventional gender is unclear; slipping her own image into a series of portraits of young men; and through intimate explorations of the vulnerability of male bodies in male spaces, such as the military or sports. Schorr's work unsettles hetero-normative representational expectations by focusing in extreme close-up on the details of normative masculine behaviour. Masculinity, neither an attribute nor a prerogative of the male body, is a performance. [CL]

YINKA SHONIBARE MBE
Gay Victorians, 1999
Wax-printed cotton textile
Height 165 cm

In his tableaux, Yinka Shonibare uses brightly colored
'African' textiles, appropriated as a sign of Nigerian
nationalism in the 1960s, to rework canonical motifs in
European culture. The wax-resist batiks are in fact
contemporary fabrics, purchased in London, modelled on
Indonesian-influenced textiles produced in the Netherlands
for sale in Africa during the nineteenth century. These
two ladies, their modesty defended by layers of flashy
colonial fabrication, make evident the hypocrisy of
middle-class Victorian prudery, all the more so because
'gay Victorian' is usually a euphemism used to avoid
discussion of male homosexuality of the period. Shonibare's
headless mannequins also sport Victorian bustles, possibly
an appropriation of the European cultural obsession
with Saartjie Baartman, the 'Hottentot Venus' exhibited
throughout Britain in the early nineteenth century because
of her genitalia and large buttocks. [CL]

ALMA LOPEZ
Our Lady, 1999
Iris print on canvas
26 x 43 cm

Our Lady, Alma Lopez's creative reworking of the Virgin
of Guadalupe, set off a public furore when it was included
in *Cyber Arte: Tradition meets Technology*, a 2001 exhibition
at the Museum of International Folk Art in Santa Fe, New
Mexico. Shortly after the opening of the show, Lopez was
denounced by the Catholic Church, the exhibition's curator
received death threats, and state lawmakers threatened to
pull funding from the museum unless the offending work was
removed from view.

In place of the traditionally demure Virgin with downcast
head, Lopez offered a physically confident and partially
exposed Latina whose hands are planted defiantly on her
waist. All but lost in the controversy over the 'Madonna in
a bikini' and the 'Madonna as a tart or call girl' (as the
collage was characterized by its opponents) was the presence
of a bare-breasted woman beneath the Virgin, whom Lopez
inserted in place of the clothed male angel of traditional
iconography. Although the female homoeroticism implied
by *Our Lady* is made explicit in Lopez's related digital
collages, it remained virtually unspoken during the conflict
in Santa Fe. [RM]

ERNESTO PUJOL
Levitation from the series *Hagiography*, 1999
3 colour photographs

Shortly after graduating from college, Ernesto Pujol entered
a Roman-Catholic abbey, where he spent the next four
years as a cloistered monk studying monastic and mystical
texts. After receiving a dispensation from his vows from the
Vatican in 1984, Pujol left the abbey for New York, where,
he recalls, 'I knew nothing and no one.' The work he has
created in the years since often returns, with a queer twist,
to the history and regalia of Catholicism. In one part of his
1999 series titled *Hagiography*, Pujol embodies the character
of a nun levitating in ecstasy. According to the artist, 'These
photographs subvert gender and religious propriety, but
they are also careful visual essays in which I am consciously
trying to preserve a certain sense of dignity, like the captain
in a sinking ship.' [RM]

TOM BURR
Deep Purple, 2000
Wood, paint
2.5 × 250 m
Installation view at Kunstverein Braunschweig, Germany

Like many artists of the 1990s, sculptor Tom Burr
deconstructs the architecture of public space, making objects
and installations that reference or relocate sites of queer
identity such as parks, porn theatres and bars. The apparent
neutrality of Burke's minimalist works is the result of a
process of architectural subtraction that reduces queer
locales to a set of constituent elements. Like the works of
Donald Moffett or Elmgreen & Dragset, Burr's sculptures
hover in the space between lived memory and mediated relic.
Deep Purple is both a homage to Richard Serra's site-specific
Tilted Arc (1981) and a playful subversion of its Cor-ten
machismo. (Commissioned for the Federal Plaza in New
York, *Tilted Arc* was greeted with a frenzy of criticism. It was
eventually destroyed in 1989.) *Deep Purple*, mischievously
citing the name of a heavy metal group, treats Serra's
behemoth as a found object, re-gendering it by clothing it in
drag-queen colours, transforming it into a stage rather than
an obstruction. [CL]

ALEX DONIS
Abdullah and Sergeant Adams, 2001
Ink and gouache on board
41 x 70 cm

Alex Donis specializes in unlikely, even impossible, pairings: an American marine performing a ballet with an Iraqi soldier, a Los Angeles police officer disco-dancing with a member of a South Central street gang, the Hindu god Rama kissing Jesus Christ on the lips. Donis places each of his couples against an undifferentiated white background, as though to suspend them in a space outside of historical context and political conflict. His dancers and kissers appear before us like lucid, Technicolor fragments from an otherwise indecipherable dream. In pictures such as *Abdullah and Sergeant Adams,* Donis takes adversarial relationships marked by hatred and violence and restages them as dances of joy and mutual pleasure. He forces deep-seated animosities to give way, however temporarily or tongue-in-cheek, to affection. [RM]

NAYLAND BLAKE
Starting Over, 2000
Video projection with various materials
23 min.

JEAN-MICHEL OTHONIEL
Kiosk of the Night-Walkers, 2000
Aluminium posts and rings, glass beads
560 × 600 × 200 cm
Metro Palais-Royal Musée de Louvre, Paris

Nayland Blake describes the objects that he annexes to his performances and sculptures as 'props', meaning that they have both function and symbolic meaning. In this case, the bunny costume is something to wear and something that sparks associations ranging from childhood toys to drag to non-stop sex. When Blake dons one of these suits, the associations multiply further. In *Starting Over*, the bunny anchors Blake's search for a visual embodiment of, in his words, the 'cooperation, conflict, […] push and pull' of his relationship with Phillip Horvitz. The enormous white suit is filled with beans equal in weight to Horvitz's body. In the live performance, and in the video that forms part of the subsequent installation, we hear Horvitz off-camera teaching his partner and collaborator the steps of a dance that he has choreographed. The complexities of the relationship are literally enacted. Blake dances until he collapses. [CL]

Commissioned by the Paris Metro system, Jean Michel Othoniel's *Le Kiosque des Noctambules* (Kiosk of the Night-Walkers, or *Impertinence* in its early stages) adorns the Place Colette entrance of the Palais Royal Metro, near to the Comedie Française and the Ministry of Culture. Crowned by interlinked cupolas of Murano glass beads, from which rise the figures of two men, *Kiosk* suggests a double reading of cruising: the passage from one place to another and the passage from one life to another. Othoniel not only references the Parisian nightlife once recorded by Brassaï but also celebrates the contemporary meetings of those seeking sex in gardens and in clubs, on particular streets and on the banks of the Seine – conveniently, not far from the Place Colette. The small rings that Othoniel welded together to form a railing suggest cock rings, the thousands of glass beads a flamboyantly baroque performance of drag – the French word for which, *drague*, also means cruising. Othoniel's work has often used the markers and materials of high European culture – Murano glass, embroidery, luxury fabrics – to declare and conceal queer readings. 'Glass', he wrote, 'has a memory. If a glass ball is damaged by an incision while it is being made, the glass heals but when it cools the cut reappears.' [CL]

TIMOTHY HORN
Spunk (Boy Germs), 2002
Lead crystal, nickel-plated bronze,
Easter egg foil, mirrored blown glass
138 × 50 × 20 cm

Drawing freely on Surrealism, Pop art and French rococo
jewellery design, Australian artist Timothy Horn creates
sculptures in which precious-looking gems expand to
fantastical proportions. Horn's oversized baubles are at once
fabulously seductive and unapologetically vulgar. As though
to draw out the latter tendency, the artist often gives his
work sexually suggestive titles such as *Golden Showers*, *Bump
'n Grind*, *Spunk (Boy Germs)* and its companion *Difficult to
Swallow (Boy Germs)*. From blown glass and nickel-plated
bronze to Easter-egg foil and crystallized rock sugar, Horn's
sculptural materials engage in a similarly shameless mixing
of high and low. [RM]

LYLE ASHTON HARRIS
Billie #25, 2002
Polaroid photograph
51 x 61 cm

The sheer size and complexity of a 20 × 24 inch Polaroid
camera obliges both photographer and sitter to bring intense
attention to the performance that will be offered to the lens.
Since Lyle Ashton Harris played both roles to make this
photograph, the demands are doubly intense. The series
of sepia-toned images in which he performs Billie Holiday
is paralleled by another series in which he plays an almost
naked boxer. Both series attempt the impossible: a visual
representation of sound – and not just any sound but the
controlled voicing of states of rage and loss. With the *Billie*
series, the body that belts out Holiday's lyrics – 'Strange
Fruit' being her most haunting song – is not only in female
drag but also in handcuffs. The reference is cunningly
indeterminate; the icon of oppression is also a sex toy. [CL]

Amy Adler treads a precarious yet deadpan line between photography and drawing. She starts with photographs that she finds or makes. She produces a drawing based on the photograph she has selected, re-photographs the results, then destroys both the original drawing and the photographic negative. The result is a unique image on photographic paper that gives the unsettling impression of a photograph that has been so heavily retouched that it seems to have been re-photographed. Adler's final image both displays and conceals her labour. Here she lays claim to the young Leonardo DiCaprio – rather like James Dean, a famously powerful object of desire for men and women. Celebrity is produced by the multiplication of recognizable images. Adler's working process reverses this, effectively taking the actor out of circulation by funnelling the image into a single unique object upon which she can focus her own lesbian desire. Her work suggests that desire is the result of intricate manipulation, and that gender is irrelevant to the process. [CL]

Sadie Benning was a member and co-founder of the American feminist queer punk bank Le Tigre. Between 1998 and 2001, she made drawings that were projected as slides during the band's gigs. In the paintings that evolved from this period, she evokes the transitory moments in which a queer negotiates the loneliness of a world where identification is never a simple matter. Like her videos, which often use crude animation to reveal a provisional drawing process, Benning's paintings are placidly awkward in their cut-and-paste zine aesthetic. She is as influenced by the self-fashioning of Andy Warhol and Cindy Sherman as she is by outsider art and anonymous graffiti. The gender of her monumental figures, positioned in garish fields of colour, is either unclear or irrelevant. Generally their gaze is slightly off-centre, making the viewer both complicit in and irrelevant to the complex performances depicted. [CL]

WOLFGANG TILLMANS
Exhibition view of 'View from Above'
at Castello di Rivoli, Italy, 2002

A man pissing on a green office chair, a young couple
outside a bar, a pair of jeans drying on a radiator, and a
sniffing contest between a sheep and a small dog. The
hallmark of Wolfgang Tillmans' photographic installations
is the mixture of all kinds of pictures: black and white,
colour, abstractions, portraits, photocopies, still lifes and
staged scenes. His subjects also sprawl: fellow artists, gay
scenes, youth culture, aeroplanes, garbage, food. Tillmans'
installations are specific to the gallery or museum in which
he is exhibiting; his arrangements enlist the particular
architectural attributes of a space. Almost always, photographs
of different scales, framed and unframed, are dotted about
on the wall from floor to ceiling. Tillmans links points in a
web of non-hierarchical, intimate moments. The connections
are pansexual rather than gay. In Tillmans' words, 'Things
are not necessarily what they seem.' [CL]

DANICA PHELPS
Making Love with D., January 9, 2003, 2003
Pencil, ink and watercolour on paper mounted on wood
46 × 61 cm

Danica Phelps has incorporated her erotic activities into the
elaborate drawings and notations that reveal – hour by
hour, day by day, week by week – the time and cost of every
detail of her daily life. Subway fares, reading materials,
groceries, cheap dinners, phone bills, video rentals, exercise,
art sales and sex with 'Debi' are all methodically recorded.
Green represents income from artwork sales, red indicates
expenses, and grey stands for credit-card charges. Phelps
'comes out' not from a closet of sexual shame but from
the shame associated with money in relation to the lives
of artists. The piece multiplies and inscribes its own income-
earning potential; the drawing of the two women having
sex is copied whenever a buyer wishes it, and that
transaction recorded. [CL]

JACK PIERSON
Self-Portrait #4, 2003
Colour photograph
Collection, Hammer Museum, Los Angeles

KAROLINA BREGULA
Let Them See Us, 2003
Photograph on billboard
Dimensions variable

Something is being branded here – not a product but an identity constructed by Jack Pierson, an image that would sell as easily in a gallery as it would in a fashion magazine. The softly illuminated, quietly erotic picture of the naked torso of a young man is one in an ongoing series of images of unidentified men who are not Jack Pierson but are photographed by the artist to represent the narrative that is his identity. [CL]

In 2003, photographer Karolina Bregula launched the first public-awareness campaign for gay and lesbian visibility in Poland. The campaign sponsored billboards in which photographs of same-sex couples holding hands were stamped with the slogan 'NIECH NAS ZOBACZA' (Let them see us). The slogan's plea was not, however, to be granted. Denounced by the Catholic Church, the billboards were torn down or painted over within days of their installation.

Lest we assume that the Catholic Church enjoys an exclusive claim on such intolerance, or that it is confined to Poland, consider what happened to Bregula's project three years later. In 2006, Real Art Ways, a not-for-profit art centre, collaborated with the artist to bring her billboards (minus the Polish-language slogans) to Hartford, Connecticut. Citing the possibility of public controversy and vandalism, however, the local billboard company, Lamar Outdoor Advertising, refused to allow the work to be seen. [RM]

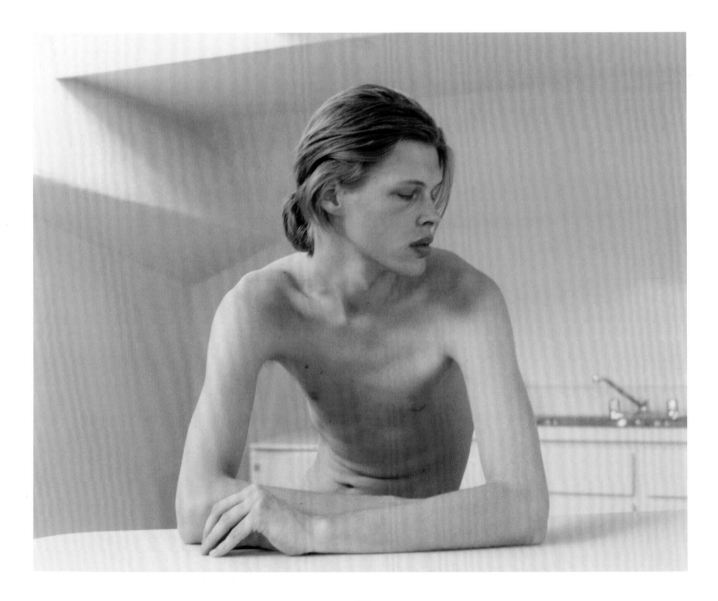

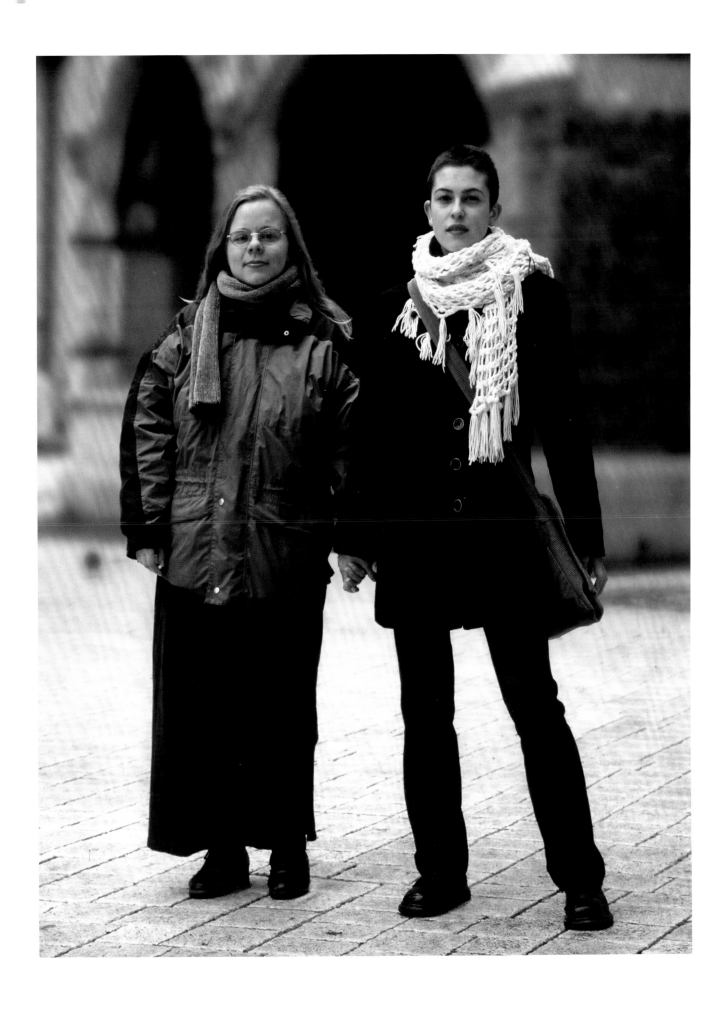

DEAN SAMESHIMA
Untitled (...Are Not Welcome), 2004
Colour photograph

The art of Dean Sameshima attends to the signs, spaces and
archival history of gay desire. *Untitled (...Are Not Welcome)*
of 2003 focuses on a hand-written sign posted outside the
entrance to Cuffs, a leather bar in Los Angeles that has
since closed. The sign identifies the establishment, however
euphemistically ('This is an Alternative Lifestyle Business'),
issues a warning to homophobes ('If You Might Be Offended
... DO NOT ENTER'), and sternly instructs patrons as to
a governing law of the bar ('Excessive Colognes Are Not
Welcome You May Be Asked to Leave'). The prohibition on
cologne was meant to preserve the scent of leather, sweat and
beer that wafted through the bar's modestly sized, darkly lit,
frequently well-populated rooms. *Untitled (...Are Not Welcome)*
asks us to consider how such prohibitions simultaneously
enable and police the pursuit of pleasure. [RM]

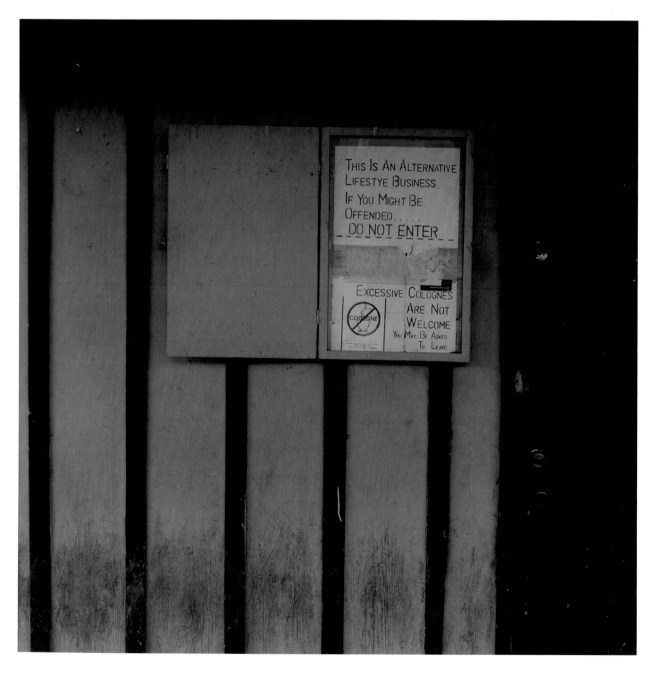

STEPHEN ANDREWS
*Untitled (US forces make Iraqis strip
and walk though public park)*, 2003
Crayon on parchment
48 × 61 cm

The Toronto-based artist Stephen Andrews scrambles the
codes and conditions of visual information, forcing us to
question the veracity of what we thought we knew. Since
2002, he has been making crayon drawings on parchment
based on pictures of the war in Iraq retrieved from the
internet. In *Untitled (US forces make Iraqis strip
though public park)*, Andrews's blurry translation of the scene
both distances and compels our attention. We strain to see
more even as we recognize (thanks especially to Abu Ghraib)
the spectacle of sexualized humiliation from this 'theatre of
war'. In reference to Andrews's artistic strategies, critic Ara
Merjian notes how these 'hazy impressions [...] evince a
certain impotence of vision. There is something ultimately
unrepresentable about the ideology with which and through
which this war is being conducted, something more fleeting
and fugitive than even Andrews's gossamer images.' [RM]

DONALD MOFFET
Gold Landscape #2 from *The Extravagant Vein*, 2003
Video projection, oil and enamel on linen
1 of 8 parts
137 × 244 cm

For *The Extravagant Vein*, Donald Moffett covered eight
paintings with drips and splotches reminiscent of Jackson
Pollock and hung them in a darkened gallery. Projected on
these canvases, exactly aligned with the edges, is footage of
the Rambles, a gay cruising area in New York's Central Park.
Some of the projections depict the movement of branches; in
others, a duck moves across a pond, or a shadowy male
figure crosses the frame. Moffett layers twin worlds of pleasure:
the artifice involved in the construction of a painting and
the search for sexual partners in the 'natural' world. [CL]

CATHERINE OPIE
Self-Portrait / Nursing, 2004
Colour photograph
102 × 76 cm

A woman breastfeeds a child. Were it not for the fact that
the body of the mother reveals not just age but also the
scars and tattoos of an S/M history, the image would be
a competent cliché. The mother is photographer Catherine
Opie, however, and upon her body we can read her own
queer history. On her chest we can discern the ghost
of an earlier self-portrait in which she displayed the word
'PERVERT' cut into her skin. Her intense gaze into the
eyes of her son recognizes the physical pleasure obtained
at the moment of the portrait's making. An image that
might suggest 'progress' in her work towards propriety
is thus undercut by the traces of another history that she
does not exclude from her representation of her own family.
Opie treats herself as she has always treated members of
the communities she photographs, not only by encouraging
them to inhabit their own costumes but also by applying
her technical sophistication and her knowledge of European
painting to the portrait. [CL]

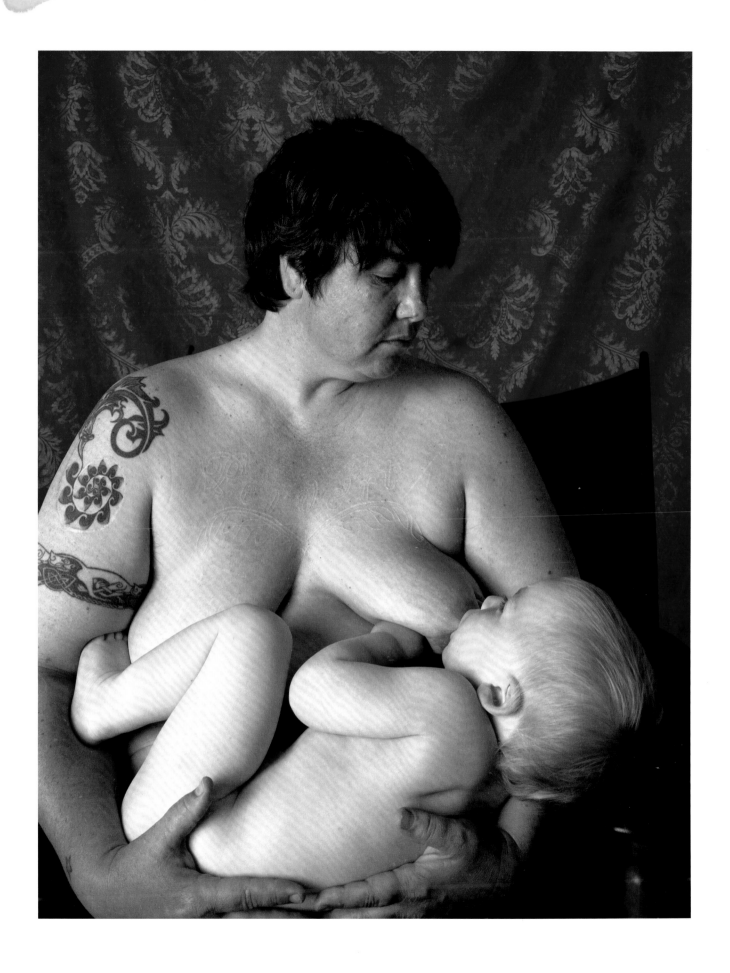

FRANCESCO VEZZOLI
Trailer for a remake of Gore Vidal's Caligula, 2005
35 mm film transferred to video
Colour, sound
5 min.

In *Trailer for the Remake of Gore Vidal's Caligula*, Italian artist
Francesco Vezzoli publicizes an extravagant (if non-existent)
remake of the sexually explicit 1979 film *Caligula*. With a
stentorian introduction by Gore Vidal, fabulous togas
designed by Donatella Versace, and cameo appearances by
an international roster of stars ranging from Helen Mirren
and Benicio del Toro to Milla Jovovich and Catherine
Deneuve, the five-and-a-half minute trailer sparked a
sensation at the Venice Biennale in 2005 and at the Whitney
Biennial in New York the following year. 'For me', Vezzoli
told *The New York Times*, 'the art world has become a place
that has turned itself, willingly or not, into some sort of
entertainment industry.' With this work, the artist wallows in
the very spectacle (of publicity, celebrity and soft-core porn)
that he so expertly satirizes. [CL]

FRANCESCO VEZZOLI
Trailer for a remake of Gore Vidal's Caligula, 2005
35 mm film transferred to video
Colour, sound
5 min.

MARY ELLEN STROM
Nude #5, Eleanor Dubinsky and Melanie Maar, 2005
Video projection
201 x 135 cm

Mary Ellen Strom's meticulous restaging of Gustave
Courbet's *The Sleepers* (1866), a classic depiction of lesbian
sexuality for the benefit of the heterosexual male viewer,
is projected at the size of the original painting. Strom's
intent is to re-embody, literally, a territory that was not
only the location of male desire but also the prerogative
of male artistic production. Strom's models are her peers –
contemporary women artists. Her nudes have names.
They collaborate with Strom in making lesbian pleasures
available to lesbians, among other viewers. [CL]

CIRILO DOMINE
Boy of Night, 2005
Tattoo ink on rubber leaf
mounted on paper and framed
41 x 51 cm

In a series of exquisitely fragile small sculptures, Filipino-born artist Cirilo Domine uses ink to tattoo short texts onto the leaves of tropical plants. The capillary action of the veins pulls the ink further into the structure of the leaf. In this piece, Domine has tattooed into a rubber-plant leaf usernames drawn from an internet chat room ('nofear805', 'boyofthenight'). The digital technology that has redefined 'queer' as both virtual and global is here imprinted into a living, analogue body, evoking the signifier of the tattoo in queer culture while suggesting the mortality of the bodies that carry these signifiers. The implications of Domine's series unfold at the intersection of sex, anonymity, digital technology and the natural world. [CL]

AMY CONGER
Queer Reader Mandorla, 2004
Collage
102 × 102 cm

EVE FOWLER
Untitled, 2005
Colour photograph

Eve Fowler's photograph of friend and performance artist K8 Hardy immediately calls to mind the celebrated publicity photograph for *Action Pants: Genital Panic*, a 1969 work by Austrian feminist VALIE EXPORT in which the artist paraded through an art-house cinema wearing jeans with the crotch cut away. VALIE EXPORT was critiquing male hypocrisy; the men in the audience didn't actually have the courage to touch what they said they wanted. Her grainy, full-frontal, high-contrast publicity shot evokes porn. In contrast, Fowler presents Hardy as a working artist in her studio. Her steady, tender gaze compels the eye – almost but not quite drawing attention away from her crotch. Other elements of Fowler's portrait engage a queer seduction: the technical skill, controlled lighting, saturated colour and the careful insinuation of props such as a rainbow mug and an inside-out T-shirt that inverts the letters of the word 'BUZZ'. Fowler's work was produced at the moment when the international art world was said either to have brought feminism into the present or condemned it to the past by mounting shows such as 'WACK! Art and the Feminist Revolution'. Fowler's photograph presents a counter-narrative that carries the erotic anger of feminism into the present – not as an art object but as a means of social change. [CL]

Early in 2001, librarians at the main branch of the San Francisco Public Library began to discover that numerous books on lesbian and gay culture, AIDS and women's health issues had been slashed and then shoved beneath the shelving units in the stacks. Over six hundred books would be destroyed before the vandal was identified by an off-duty librarian and apprehended by the police. Rather than allowing the episode to end there, however, the library put out a public call inviting artists and community groups to create new works of art from the remains of the slashed books. Each artist or group was randomly assigned a single title.

San Francisco-based artist Amy Conger, for example, was given a slashed copy of *A Queer Reader*, the cover of which features a photograph by Pierre and Gilles of a sailor in lipstick posing before a flowery blue backdrop. The vandal had gouged out the sailor's eyes and then sheared through the pages of the book. Conger responded by slicing off the book's binding and cutting the now freestanding pages into triangular and petal-shaped fragments, many of which she then dyed in high-contrast colours and reassembled into a large, intricately layered collage. The shape of Conger's collage echoes the vandal's elliptical cut into the cover of the book. Although Conger's work includes literally thousands of fragmented pages from the original book, only one word is clearly legible from a distance. That word, 'queer', has been inserted into the gash where the eyes of the sailorboy once were. The off-kilter fashion in which 'queer' has been restored both remembers and refuses the violence of the vandalism that preceded it. [RM]

Assume vivid astro focus (AVAF), a collective whose name
amalgamates those of the band Ultra Vivid Scene with
Throbbing Gristle's album *Assume Power Focus*, was started
by Brazilian-born Eli Sudbrack. Sudbrack and AVAF's
shifting teams of collaborators create a sensual overload
of imagery from an inventory of magnificent cultural
flotsam: Buddhism, 1960s psychedelia, Francis Picabia,
Brazilian carnival, Aubrey Beardsley, anime, digital pattern
and decoration, video projections and drag. AVAF's aim
is to build an immersive environment that remains dense
yet flexible, mutating with time and place. This museum
installation, made with the help of artists Christophe
Hamaide-Pierson, Anna Sew Hoy, Giles Round and
Paloma Mentirosa (otherwise known as Alfredo Piola), pays
homage to the nightclubs of the 1970s and 1980s that AVAF
views as 'the birthplace of gay politics'. The disco floor is
on the ceiling. A colossal plastic statue of a naked porn star,
one head male, the other female, arches in a back bend.
Images of George Bush and Tom Cruise are buried in the
wallpaper pattern, while Pope Benedict can be decoded
in a chain curtain. The soundtrack consists of the mix of
'acid electro house, cosmic disco and neo-Italo-disco' played
on opening night. [CL]

JONATHAN HOROWITZ
Three Rainbow American Flags for Jasper
in the Style of the Artist's Boyfriend, 2005
Oil and glitter on linen
79 × 116 × 13 cm

Glitter and glamour make up the surface of Jonathan
Horowitz's re-mix of Jasper Johns's 1958 icon *Three Flags*.
In the Johns painting, the culmination of a body of work
in which the artist investigated common objects such as
numbers and paint cans, each flag is smaller than the one
behind it. In a reversal of the laws of perspective, however,
the flags do not recede but rather move forward off the
picture plane. The work also turns a symbol (the flag) into
an object, making it impossible to decide whether the
painting is a representation or an abstraction. Horowitz's
version, in keeping with the politics of gay pride, replaces
the red, white and blue of the original with the colours of
the rainbow flag but maintains this visual ambiguity and
reversibility. Horowitz's title is also deliberately ambiguous.
Since his boyfriend, Rob Pruitt, often used glitter in
his sculpture, the 'boyfriend' in question could be his own.
But it could just as well be Johns's. In this way, Johns is
mischievously outed, both visually and verbally. [CL]

KALUP LINZY
Conversations wit de Churen IV:
Play wit de Churen, 2005
Video
Colour, sound
4 min. 9 sec.

Though Kalup Linzy's performative videos have been
screened in various art institutions, his spoofs on soap operas
receive their widest distribution through YouTube, from where
they have ricocheted around cyberspace. *Conversations wit
de Churen IV: Play wit de Churen* (2005), for example, received
almost 22,000 hits in the first year it was posted. In the
Churen series, Linzy invents and plays all the members of
the Braswell family (the grandmother, the sisters, the cross-
dressing brother) by staging improvised conversations,
inevitably on the telephone, between the artist and the
character whom he plays. Linzy's doubling and redoubling
of characters laces a black storytelling tradition with queer
subject matter, while turning the white world of daytime
soaps upside down. [CL]

KEHINDE WILEY
St Sebastian, 2005
Oil and enamel on canvas
152 × 183 cm

Kehinde Wiley locates his depictions of black masculinity within the European canon of Old Master painting, a history in which he is as complicit as he is critical. He finds his male models, ghetto-fabulous and young, on the street and asks them to imitate a figure in a painting that they choose themselves. He then photographs them posing as the saints and angels of Renaissance painting, or the male figures in historical allegories by Tiepolo, Velásquez, Rubens and Gainsborough, among others. The resulting paintings balance two delicately constructed masculinities: urban hip hop and white European aristocracy. This Saint Sebastian, a slightly bigger than life-size incarnation of the arrow-riddled staple of homoerotic art, wears a white tank top and jeans. He stands ready to inflict damage on himself. The background of the original painting has been replaced with Wiley's characteristic decorative patterns, stripping away the original allegory and restoring the saint to his previous historical context as a form of interior decoration. [CL]

CHI PENG
I Fuck Me – Telephone Booth, 2005
Colour photograph

Putting Photoshop to good use, Chinese artist Chi Peng depicts a series of public and private encounters in which he appears to be having sex with himself. The artist imagines what it might look like if, as his title concisely puts it, 'I fuck me' in the shower, in a telephone booth, under a desk at the office, in a public restroom, and so on. Within the fictive space of these self-portraits, Peng is at once sexually active and passive, 'top' and 'bottom'. *I Fuck Me* humorously plays on the association between homosexuality and narcissism by casting sex between men as the very image of self-mirroring – as an endless pursuit of more of the same. [RM]

GAYE CHAN AND NANDITA SHARMA
Victoria, Canada from the series *There There*, 2005
Internet project

'There is no there there,' Gertrude Stein famously, and
snobbishly, remarked of her home town, Oakland, California.
If Stein's acerbic comment laments the lack of a proper
backdrop for her self-invention, Hawaii-based collaborators
Gaye Chan and Nandita Sharma have taken this several
steps further in a critique of what colonialism refuses to
include within the frame. Many of their previous projects
offered an activist critique of notions of 'public' in relation
to property and land use in Hawaii, but as the artists travel
throughout the world, they hire photographers to depict
them in front of a series of artificial backdrops that inevitably
depict a better place – a place that is not there. In Toronto,
Chan and Sharma are photographed in front of 'Italy';
in Delhi they are photographed in front of 'New York'.
Wherever they may be, the artists incorporate into the image
a trace of the studio or the photographer photographing
them. In this colour image, Chan and Sharma consider
the portrait photographer's black and white digital image,
displayed on a monitor, that shows the pair garbed in
cowboy outfits and posed in front of a backdrop depicting
a nineteenth-century Western saloon. [CL]

MARK BRADFORD
Niagara, 2005
Video
3 min. 17 sec.

Mark Bradford's three-minute video *Niagara* takes its name
from a 1953 Hollywood film in which the camera lingers
on a view of Marilyn Monroe seen from behind as she
walks away. In Bradford's updated version, the camera is
trained on a young, African-American man with a certain
bounce in his step as he saunters, alone, down a dilapidated
stretch of South Central Los Angeles. According to Bradford
he was inspired by the walker, who is well-known in the
neighbourhood, for his fearless embodiment of flamboyance
within an especially tough public sphere. [RM]

ANITA STECKEL
Anita of New York Meets Tom of Finland, 2004–05
Mixed media on book pages
36 × 25.5 cm

A veteran feminist artist and anti-censorship activist,
Steckel has explored female sexual expression since the 1960s,
including and especially in terms of the eroticized male body.
In a 2004 series of mixed-media collages entitled *Anita of
New York Meets Tom of Finland*, she engages with explicitly
homosexual images. The pairing of Tom's strapping men
and Anita's even larger female nudes (a reference to her
Giant Woman series of the late 1960s and early 1970s) is
incommensurate, even irreconcilable. For that very reason,
however, the series suggests how art exceeds the particular
identities and desires of its makers and thereby opens onto
unforeseen possibilities and pleasures. Within the space of her
own collage, a straight feminist artist can freely work over
homosexual imagery of phallic muscularity. [RM]

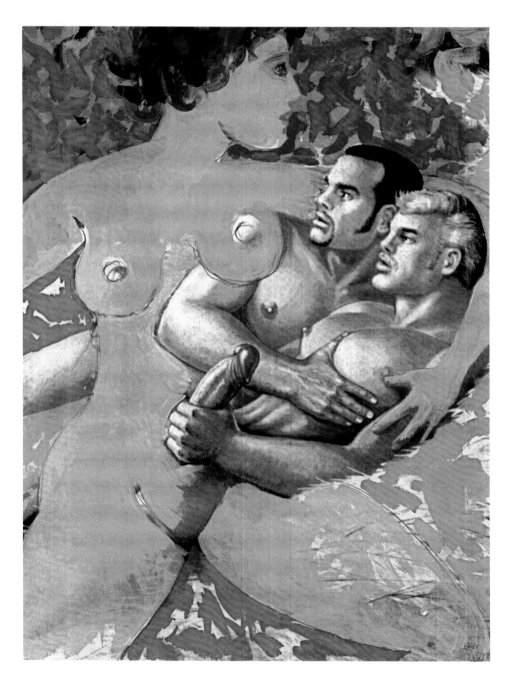

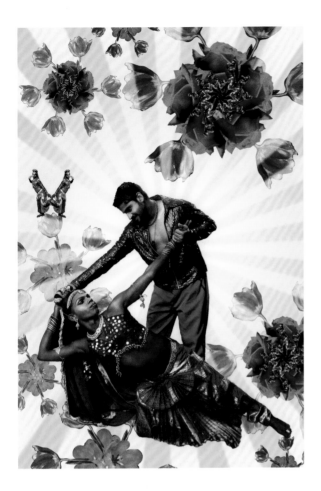

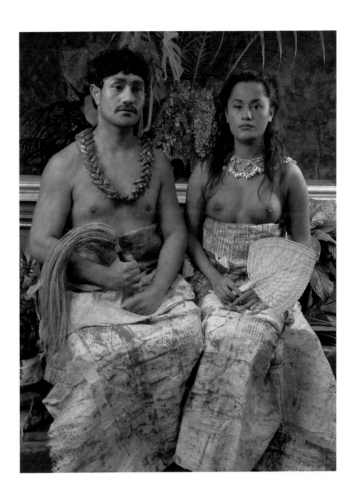

SHIGEYUKE KIHARA
Samoan Couple, 2004—05
Colour photograph

TEJAL SHAH
Southern Siren: Maheshwari, 2006
Colour photograph

A photographer, video maker and installation artist, Tejal Shah often focuses on the crossing of genders, sexualities and cultures within a contemporary South Asian context. In *Southern Siren: Maheshwari*, Shah creates a vibrant fantasia of colour and pattern emanating from a central couple performing an intricate dance move in matching electric-blue costumes. The photograph was inspired by the female figure it showcases – Maheshewari, a *hijira* (transgender) identified woman whom the artist met while working with the MTF (male to female) community in Mumbai. In this photograph, Shah stages Maheshwari's fantasy of Bollywood stardom, complete with a dashing leading man, a technicolour set and, if one looks closely at the purple centre of the largest roses, an endless array of miniature Maheshwaris dancing in formation. [RM]

Shigeyuke Kihara, of Japanese and Samoan descent, lives as a *fa'a fafine*, a status best described not as transgender but as third gender. Kihara recreates, in order to parody mercilessly, nineteenth-century colonial images made by white photographers in which Pacific Islanders are depicted as exotic and the women as all too happy to be seduced. Posing in front of a studio backdrop of tropical foliage, Kihara presents herself as both man and woman. To fabricate the 'man', she photographs herself in a wig and moustache, then digitally attaches her face to a man's body. In so doing she slyly undercuts ethnographic projects about heterosexuality as a cultural universal and dislocates assumptions about what marriage could possibly mean when the same person performs both halves of the equation. Kihara's work has been compared to that of Yasumasa Morimura and Cindy Sherman, but the artist is quick to point out that her status as third gender is not a performance that she abandons when she leaves the studio. [CL]

LUKAS DUWENHÖGGER
*The Celestial Teapot (Proposal for a memorial site
for the persecuted homosexual victims of National
Socialism in Berlin)*, 2006
Gouache, pencil and pen on paper
29.5 × 42 cm

ELMGREEN & DRAGSET
(MICHAEL ELMGREEN AND INGAR DRAGSET)
*Memorial for the Homosexual Victims of the
Nazi Regime*, 2008
Concrete, glass, film projection
366 × 190 × 491 cm
Tiergarten, Berlin

This painting incarnates Lukas Duwenhögger's proposal for a competition for a public monument in Berlin to commemorate homosexual victims of the Nazi regime. In a grove of trees, perhaps a cruising ground for public sex, a swishy, limp-wristed teapot sits on something that looks like a guard tower. Duwenhögger's work is full of codes and literary references. The teapot, dressed in fetching green, one arm akimbo, wears a dashing cravat of the sort favoured by Berlin's fashionable gay set of the 1920s and 1930s. Though Duwenhögger's monument suggests a tenacious insistence upon the social spaces that made a gay culture possible in the Weimar Republic, it was purportedly rejected because, among other reasons, it was viewed as too frivolous. It may also have been interpreted as a stereotypical, even derogatory, representation. Duwenhögger lost the competition to the duo Elmgreen & Dragset but exhibited a copper model of *Teapot* in 2007 at Documenta 12. [CL]

Masters of irony, Michael Elmgreen and Ingar Dragset describe themselves as 'fags from the suburbs' who entered the art scene by an alternative route. One trained as a mime; the other, in the tradition of Jasper Johns and Robert Rauschenberg, worked as a florist's window dresser. Their extended series of *Powerless Structures* uses the intersection of architecture, art and design to scoff at the icons of queer culture. Their strategies are astutely urban, attentive to unravelling the possibilities of behavioural experiments in public consumption that are often slyly queer. Their proposal for a Holocaust memorial points to Berlin's Tiergarten as a longstanding location for public sex and refers to previous works that use cruising as an embodiment of Michel Foucault's understanding of power as something everywhere present and everywhere subject to subversion. It also draws attention to homosexual victims of the Nazis. In the park the artists have placed a massive, seventy-five-tonne cement stele with a window through which the curious can watch a small video projection depicting two men kissing. Every two years the projection will be replaced by a new video of a same-sex encounter, each made by a different artist, ensuring the work's reading as a living memorial and allowing for the inclusion of imagery of and by lesbians – another group who were victims of the Nazis. The memorial opened in 2008 and was vandalized within months. [CL]

LUKAS DUWENHÖGGER
*The Celestial Teapot (Proposal for a memorial site
for the persecuted homosexual victims of National
Socialism in Berlin)*, 2006

MICKALENE THOMAS
Feel Like Makin' Love from the series
Brawlin' Spitfire, 2006
Enamel, rhinestone and acrylic on panel
213 x 244 cm

Resplendent in rhinestones and animal-skin leotards,
Mickalene Thomas's women wrestlers roll in tangles over
furniture and around the fake-wood panelled house. The
reference is to blaxploitation of the 1970s, Thomas's formative
decade. Her figures are composed from montages of
photographs taken from popular-cultural images, album
covers and the art-historical canon. In this dramatic painting,
two women spitfires, one in yellow and black tiger print, the
other in black and white zebra print, tumble on a red bedspread,
becoming an indecipherable muddle of pattern. As in all the
Brawlin' Spitfire paintings, only one woman's face is visible.
With erotic gusto she sucks, or bites, on a body part that is
even more erotically difficult to decipher. Underneath the glitz,
or perhaps because of it, these women are fierce. They are
fully in control of their sexuality and entirely comfortable in
the domestic settings in which they enact their pleasures. [CL]

MICKALENE THOMAS
Feel Like Makin' Love from the series
Brawlin' Spitfire, 2006
Enamel, rhinestone and acrylic on panel
213 x 244 cm

"PUT IT ON"

An exhibition of new works by
THUKRAL AND TAGRA

THUKRAL AND TAGRA
(JITEN THUKRAL AND SUMIR TAGRA)
Put It On, 2007
Announcement card for the installation *Put It On*

The collaborative duo of Jiten Thukral and Sumir Tagra create work in multiple mediums and contexts: painting, installation, graphic design, video, websites, music and fashion. In 2007, they devoted a gallery exhibition in New York to the theme of safer sex. Among the works on display were custom-designed underwear with slogans such as 'I like my man covered' and 'Condoms are sexy', as well as flip-flops imprinted with instructions for putting on a condom. Based in New Delhi, Thukral and Tagra have been especially concerned with the steep rise in HIV infection rates in India during the last decade. [RM]

SUZANNE WRIGHT
Rainbow Highway, 2007
Colour pencil on paper
366 × 213 cm

In the 1990s, artist Suzanne Wright was a member of
several activist collectives: ACT UP, DIVA TV (Damned
Interfering Video Activists Television) and fierce pussy.
She also made the photographs for lesbian safe-sex
brochures. In her later *tour-de-force* drawings, at once
beautiful and comic, she superimposes the architecture
of man-made industrial structures upon the man-made
imaginary that subjugates the female body. Wright places
these disparate subjects on a collision course, so that the
scale of the drawing monumentalizes both the female
body and the built environment, creating intricate overlays
of biomorphic and inanimate architecture. The thrust,
so to speak, of the architecture, is placed in such a way
as to further masturbation fantasies, rendered in Hallmark-
card pastels. The result is a provocative juxtaposition
of being and having: lesbian identification with the male
gaze and lesbian desire to possess the object of the
male gaze. [CL]

SHEILA PEPE
Mr. Slit, 2007
Shoelaces, industrial rubber bands, yarn, hardware
305 × 467 × 91 cm

Sheila Pepe's installations feminize high modernism with craft, permeate the materials of industrial fabrication with the secrets of domesticity, and tame the scale of architecture with the intimacies of the human body. Generally she works on a large scale, redefining interior space with the most economical of means, stretching and hanging lines of various sorts to make three-dimensional drawings that invite as much as they repel. Made from crocheted and knotted shoelaces, industrial rubber and scraps of hardware, *Mr. Slit* not only follows a trajectory of resistance and complicity but also sets two signifiers of gender at odds, rendering a giant vagina with heroic masculinity. In balancing irony with seduction, Pepe redefines 'butch' in sculptural terms. [CL]

RYAN TRECARTIN
(WITH BRYAN MCKELLIGOTT)
Vicky Veterinarian, 2006
Various materials
112 × 97 × 64 cm

Ryan Trecartin's sprawling videos, the result of collaborative efforts of a shifting group of friends, are cult destinations on YouTube and Vimeo. His multimedia installations, made by a similar communal process, include videos, various props and, occasionally, figurative sculptures that raise the stakes for the cunning use of coded stereotypes: fat men, gay dads and earth mothers coated with fruit. Goofy puns are not only welcome but hypertheatricalized. In this work, at once tasteless and cunning, a veterinarian clad in dorky scrubs – the very stereotype of a white lesbian of a certain age – grins in bewildered resignation as she is penetrated by a pussy. [CL]

235

BORIS TORRES
Buttons, Locked, Chair, 2007
Oil pastel on paper
3 of 16 seamless drawings from an accordion-style book
Each 25.5 × 18 cm

A suite of pastel paintings fills the pages of a Japanese
accordion book. Each page offers a view of a particular
object: a door handle, a plastic chair, a control panel with
buttons pointing up and down, a towel, a key with a
numbered tag, a wall with an oval-shaped hole, a dimly lit
room with a single bed. Patrons of adult bookstores and
gay bathhouses in particular are likely to recognize
these objects and the uses for which they are intended.
The pictorial attention lavished on them by the Ecuadorian-
born, New York-based painter Boris Torres, however, comes
as something of a surprise. No one goes to a bathhouse,
after all, to capture the play of light filtering across the
floorboards or visits a peep show to consider the precise
shade of pink in which the plastic chairs have been
fabricated. By focusing on these details, Torres encourages
us to linger in the space of sexual cruising and possibility.
He focuses not on anonymous sexual acts but on the places
and props that enable them. The buttons pointing up and
down, for example, are taken from the control panel of a
'buddy booth'. If patrons in neighbouring booths both press
the 'up' button, an opaque divider is raised, and a shared
Plexiglas window becomes transparent. Torres portrays
no 'buddy', however, in the pages of this illuminated book.
As anyone who has ever paced the halls of a bathhouse or
waited in vain for a handsome stranger to appear in an
adjacent booth can attest, these sites of sexual exchange are
also spaces of isolation, expectation and self-reckoning. [RM]

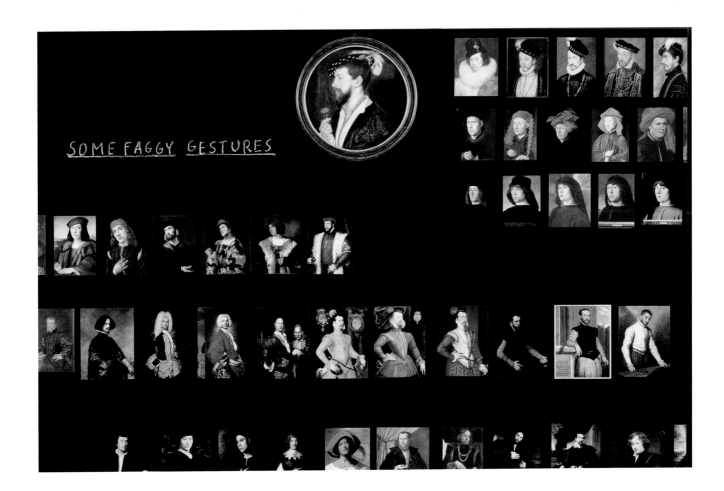

HENRIK OLESEN
Some Faggy Gestures, 2007—08
Installation with various materials
Dimensions variable
Book
29.5 × 20.5 cm
192 pages

Drawing on a vast range of Western art and photography
from the early Renaissance to the late nineteenth century,
Danish artist Henrik Olesen has created a dazzling
visual archive of homosexuality and its criminalization.
At once a pictorial treasure trove of same-sex desire and a
queer send-up of art-historical method, the archive has
taken various forms, including an exhibition at the Migros
Museum in Zurich and an artist's book published the
following year. Both the book and the exhibition are organized
around thematic groupings, such as 'The Appearance of
Sodomites in Visual Culture', 'American Dykes in Rome'
and 'Sex in America', which consist of multiple pictorial
examples. 'Some Faggy Gestures', the iconographic category
from the show that gives the book its title, consists of, in
Olesen's words, 'a series of picture of noblemen in particular
postures and in certain getups which today would be
regarded as stereotypically gay. [...] Men's legs can be
seen in stockings, they wear dandified headgear, and their
hands perform delicate gestures while other figures with
dreamy expressions gaze off into the distance.' By claiming
portraits of Renaissance noblemen as 'faggy', Olesen
insists on the pleasures of art-historical cruising and
wilful anachronism. [RM]

JEANNIE SIMMS
Pigy, Erendz, Angie and friend, Hong Kong
from the series *Readymaids: Here or Where*, 2007
Colour photograph

GABRIEL MARTINEZ
Self-Portraits by Heterosexual Men, 2007
100 colour photographs

Readymaids: Here or Where is an extended series of photographs documenting the self-representations of some of the thousands of domestic workers in Hong Kong. The women have come to the city from Indonesia, the Philippines, Thailand, Sri Lanka and Malaysia to work as live-in maids for about $500 per month. On Sundays, they gather in Victoria Park near the photo vendors who use backdrops of scenes such as St Petersburg, Tiananmen Square and the Sydney Opera House. Many of the lesbian workers get their pictures taken with their girlfriends in front of the backdrops, and this photograph captures the moment of hipster performative fantasy. [CL]

To create *Self-Portraits by Heterosexual Men*, the Philadelphia-based artist Gabriel Martinez enlisted one hundred straight men (some friends or acquaintances, others contacted through internet postings) to photograph their legs and feet at the moment of self-induced orgasm. The artist furnished each man with a cable-release digital camera and instructed him to snap multiple shots (using his free hand) at the appropriately climactic moment. Martinez then selected one picture for each man (identified by first names only in the finished work), printed them at nearly life-size, and composed the aggregate into a giant grid of self-gratification. Created by an openly gay artist, *Self-Portraits by Heterosexual Men* unfolds at the border between private pleasure and public exposure, between the individual straight guys ('Eric', 'Benjamin', 'Brent', 'Dave', et al.) and the homoerotic spectacle to which they contribute. [RM]

MARLENE MCCARTY
*Group 2 (Norman, Oklahoma, 1964–1977. Baboon Island,
the Gambia, Africa, 1977–1987)*, 2007
Graphite and ballpoint pen on paper
284 × 508 cm

Marlene McCarty's colossal drawings of primates – meaning
groups of apes and humans – accommodate the rich
diversity of her interests: gender, sex, language, childhood,
zealotry, comedy and violence. In a series of works based on
specific chimps and gorillas who were subjected to atrocities
of primatology, McCarty proposes scientific accounts of
evolution as a sanitized fraud. This drawing derives from the
story of a chimp named Lucy Temerlin, who was placed in
a human family to test her ability to learn language, and
then 'rehabilitated' to the Gambia when the family decided,
thirteen years later, they had had enough. Lucy was
eventually killed by poachers. The primate interaction
depicted here is an orgy, at once hilarious and disturbing.
Hands wander, penises multiply, nipples lie on skin like
jewellery, fingers clasp, fur grows on the backs of infants,
men kiss apes and apes kiss women, a woman suckles an
infant chimp while giving birth to another. Without such
antics, McCarty suggests, 'man' would not exist. Evolution
means sex across boundaries. [CL]

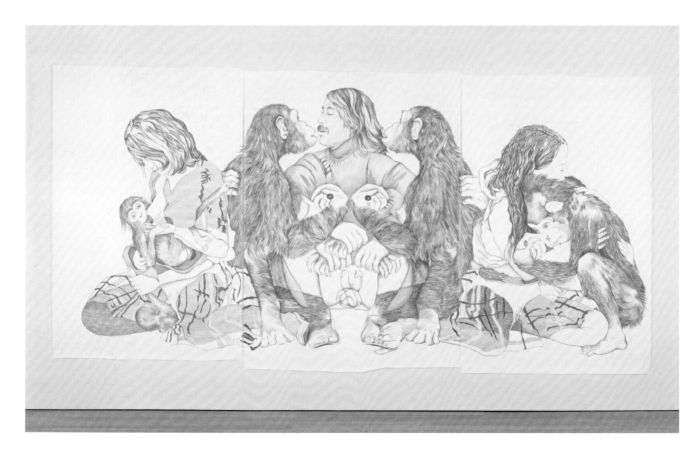

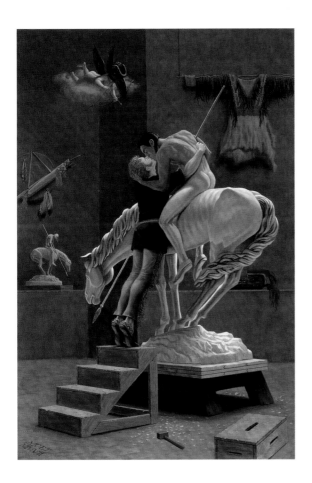

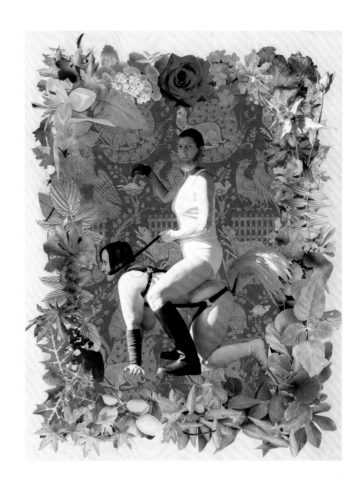

KENT MONKMAN
Si je t'aime, prends garde à toi, 2007
Acrylic on canvas
274 × 213 cm

INES DOUJAK
Victory Gardens, 2007
Installation with flower bed on 146 sticks with
69 seed packets, Documenta 12, Kassel, Germany
1 × 16 × 1 m
Carrier bag
45 × 35 cm

Kent Monkman's work not only reinstalls indigenous peoples within the narratives of European history but also makes certain that his revisions insinuate a campy queer presence in the myths of the frontier American West. In this imposing painting, Monkman reinterprets *The End of the Trail* (1915), the kitsch, colonialist bronze of an American Indian by James Earle Fraser. Here, a kiss from a fetching redheaded white youth, clad in a short tunic, causes the marble Indian to come to life. Or perhaps it is the Indian who will turn the youth into marble. At any rate, the youth, presumably, is the sculptor, who collects and takes inspiration from the Native American artefacts pinned to the wall. Either way, *Si je t'aime, prends garde à toi* (literally, 'If I love you, watch out'), a quote from Bizet's opera *Carmen*, suggests the romantic havoc wrought by the seductions of the heroine. Carmen, after all, works in a Spanish factory making cigarettes from the tobacco that American Indians introduced to European culture. [CL]

In an elegantly vengeful metaphor, this plastic carrier bag enlisted the cognoscenti who gorged on glossy picture books at the Documenta 12 shop to help disperse the spores of Ines Doujak's installation *Siegesgärten* (Victory Gardens) around the world. A sixteen-metre seed bed on stilts, dotted with dozens of seed packets, *Siegesgärten* protested the theft of natural resources by transnational corporations. This modern form of colonialism depends upon staking claim to the reproductive processes of plants through genetic modification and claiming ownership of the 'natural'. Doujak exposes this greed as 'unnatural' by fabricating an assortment of queer frolics in gardens of plants culled from global trafficking. The image on this carrier bag has a nineteenth-century-style background design of garden flowers and a picket fence. In the midst of this confection, a bearded figure, perhaps male, perhaps female, rides a woman wearing nothing more than a black leather harness and a plumed tail. 'Patents Instead of Bombs', reads the yellow banner, referring to the techniques of biopiracy. [CL]

ANWAR SAEED
A Book of Imaginary Companions, 2008
Drawings and collage on paper
Each 2I × I4 cm

SPENCER FINCH
Sunlight in an Empty Room (Passing Cloud for
Emily Dickinson, Amherst, MA, August 28, 2004), 2008
I00 fluorescent lights, filters, clothes pegs
Dimensions variable

In *A Book of Imaginary Companions*, the Pakistani artist Anwar Saeed paints onto and over the pages of his own copy of a book titled *I Pierre Seel, Deported Homosexual*. The 1994 memoir of a French survivor of a Nazi concentration camp, the book becomes the unexpected site for the artist's erotic renderings of Pakistani men. According to Saeed, 'It was a book about pain and torture, so I thought I should make images of pleasure.' *A Book of Imaginary Companions* defies both the historical persecution of homosexuals and the ongoing suppression of queer desire and imagery, not least in Pakistan, where, according to the artist, this work of art could not be shown because of the stigma attached to homosexuality. [RM]

Spencer Finch is an artist of memory, of history and of light. He focuses on particular historical sites (the spot on the consulting-room ceiling at which Sigmund Freud's patients stared, for example) and memory (the colour of Jackie Kennedy's hat on the day JFK was assassinated) and then produces, in different mediums, renderings of the light at that site. Sometimes the renderings take the form of framed watercolours, sometimes stained glass, sometimes photographs. This lavender cloud represents the residue of Finch's visit to Amherst, Massachusetts, where the poet Emily Dickinson lived. Dickinson, who never married, enjoyed a passionate friendship with her sister-in-law, Susan Gilbert. 'If you were here – and Oh that you were, my Susie,' Dickinson wrote in an 1852 letter, 'we need not talk at all, our eyes would whisper for us, and your hand fast in mine, we would not ask for language.' The sentiments Dickinson expressed cannot be interpreted to declare her a lesbian, in the contemporary sense of the label, but Finch's cloud is the record of an afternoon spent measuring the light in Dickinson's back yard as clouds passed overhead. This tribute, held together with clothes pegs, is a whirl of lavender, blue and violet filters lit by a bank of flourescent tubes whose colour temperatures exactly match Finch's painstaking measurements on that summer day. [CL]

ISAAC JULIEN
Still Life Studies Series, No. 1, 2008
Colour photograph in light box
120 x 140 cm

Isaac Julien's photograph appears to be an innocuous
representation of a cottage fronted by an eccentric garden.
It is, rather, *a memento mori,* a gift, a morsel of a posthumous
collage, a moment in the record of a mosaic of friendships.
The cottage belonged to filmmaker Derek Jarman; the garden
was one of his most celebrated works. Particularly after
Jarman's AIDS diagnosis in 1986, and certainly after his
death in 1994, Prospect Cottage in Dungeness, England,
and particularly its garden, became something of a
pilgrimage site for queers wishing to pay tribute to the life
of a groundbreaking figure not only in the struggle for gay
liberation but also in the many intersecting creative worlds
of the 1970s, 1980s and 1990s: art, fashion, independent
film, theatre and music. Jarman was an old friend of Julien's,
whose work parallels his own: independent film and video,
activism, photography and installation. [CL]

LIZ COLLINS
Knitting Nation Phase 4: Pride, 2008
Action and site-specific installation

Knitting Nation, founded in 2005, is the project of fashion
designer and textile artist Liz Collins, who deploys knitting
machines, site-specific installation, performance and a
small army of collaborators to manufacture comments on
the interaction of humans and machines. On the fortieth
anniversary of the Stonewall riots, Collins and her workers
reconstructed the Gay Pride flag designed in 1978 by Gilbert
Baker. The original rainbow flag, intended to represent
the diversity of the gay community, featured eight colours
representing ideals such as healing, nature, spirit and life.
Among the original colours were hot pink and turquoise,
representing sex and art. As the rainbow flag evolved into a
marketing opportunity, sex and art were somehow deleted
from the rainbow. *Knitting Nation Phase 4: Pride* restores
these ideals to queer consciousness, theatricalizing their
disappearance from community ideals and proclaiming the
necessity of their presence. [CL]

GINGER BROOKS TAKAHASHI AND
DANA BISHOP-ROOT
*A graphic of the Island of Lesbos with icons
depicting different sites and tourist activities
from the series Herstory Inventory, 2009–12*
Ink on paper
41 × 61 cm

In remapping the Greek island of Lesbos, Ginger Brooks
Takahashi and Dana Bishop-Root whimsically chart an
all-female migration rooted in both collective fantasy and
subcultural history. As the island itself takes on a vaguely
human form, complete with a pair of legs, three streams
of female swimmers approach from different sides. But not
all the women seek a destination on shore. According to
the text that dips below the swimmers on the upper right,
'Each has chosen a direction according to the climate she
prefers. There are also wondering tribes. Several groups
of companion lovers have decided to live on the sea and
become fishers. Other have set out in search of islands.
Some of them are still searching.' In rendering Lesbos as
a map inscribed with multiple fables, Takahashi and
Bishop-Root pay light-hearted tribute to women who have
searched out alternative tribes and ways of loving and
living together. [RM]

ELLIOTT HUNDLEY
Ryan as Polyxena, 2009
Inkjet print in light box
52 x 75 cm

ZANELE MUHOLI
Puleng Mahlati, Embekweni, Paarl
from the series *Faces and Phases*, 2009
Black and white photograph

'The reality', says Zanele Muholi, 'is that black lesbians are targeted with brutal oppression in the South African townships and surrounding areas.' In *Faces and Phases*, the extended series that includes this image, Muholi uses portraiture to create an archive of resistance to hate crimes such as 'curative rape'. She set out to make positive images of black South Africans – lesbians, women and transmen – in order to register a queer presence in the visual record and to honour the victims of hate crimes. (Indeed, some of her subjects died of anti-queer violence before the photographs were exhibited.) The individuals photographed represent various occupations and hail from various townships. They also trouble stereotypes of lesbian and female appearance. Muholi's subject here – Puleng Mahlati – could be biologically female or a transman. We see only wide shoulders, a jacket usually worn by men, a stunning head and an utterly self-possessed gaze aimed directly at the viewer. [CL]

The mixed-media artist Elliott Hundley reworks classical Greek myth and Euripidean theatre through a decidedly contemporary lens. He periodically invites friends and family members to don costumes in his studio and mime mythical characters for the camera. In some cases, such as *Ryan as Polyxena*, the portraits that result from these sessions are editioned as photographs; in others, the portraits are incorporated into massive assemblages featuring thousands of individually cut-out pictures that have been carefully pinned or pasted onto the work.

The title of this portrait refers to both the contemporary person posing in the studio (Ryan) and to the Classical role (Polyxena, the ill-fated Trojan princess with whom Achilles fell in love) he steps into. It is as though Ryan were pausing before resuming his or her performance as Polyxena – except that the pause and pose for Hundley's camera *are* the performance. Costumes, lighting and décor are likewise savoured not for their verisimilitude but for their artifice. Ryan makes no effort whatsoever to stuff the bodice of his evening gown to simulate a woman's bust line. And he grabs his fluffy helmet by the crown, as though to whip it off momentarily and change costume again. [RM]

ELIZABETH STEPHENS AND ANNIE M. SPRINKLE
The Love Art Laboratory (detail, *Blue Wedding to the Sea —
an Ecosexual Performance Art Wedding* 2009), 2005–11
Action

Beth Stephens and Annie M. Sprinkle describe themselves
as 'an artist couple committed to doing projects that explore,
generate, and celebrate love'. They use a wide range of
media – including visual art, theatre, lectures, printed matter
and activism. Stephens and Sprinkle initiated the project
The Love Art Laboratory in 2005 in response to the beginning
of the war in Iraq, as well as to the California Supreme
Court's prohibition of gay marriage in California. They vowed
to stage a commitment to their relationship each year for
(at least) seven years as a way to 'look hatred in the eye',
and to involve a queer community in an annual marriage
ceremony. A changing roster of queer artists and sex activists
officiates at each event. [CL]

A. L. STEINER
Angry, Articulate, Inevitable, 2010
Installation with colour photographs and photocopies
Dimensions variable

These walls of photographs – some modestly sized,
some dramatic enlargements – are A. L. Steiner's archive of
sex as a radical political practice. The participants are
members of Steiner's community of queers – a term which,
in Steiner's case, does not mean mostly male. Her emphasis
is on women, even 'womyn', understood here as a condition
of desire rather than a biological imperative. In *Angry,
Articulate, Inevitable*, huge photographs of bruised butts and
bare pussies are interspersed with scenes in which naked
bodies of all sorts cavort in spaces both public and private.
Steiner expands our ideas on what acts of 'sex' might be,
producing for the benefit of her community images that are
inclusive, comedic, irreverent, sexy. [CL]

A. L. STEINER
Angry, Articulate, Inevitable, 2010

RICHARD HAWKINS
Edogawa Rampo #2, 2010
Acrylic, pencil and collage on paper
46 × 58 cm

The similarity between the names of Japanese master of crime fiction Edogawa Rampo and American master of the macabre Edgar Allan Poe is no coincidence. Cross-cultural intersections, erudite as well as low, are central to Richard Hawkins's practice of collage. In this series, he floats the heads of pretty Japanese hairstyle models clipped from magazines in the blackened rooms of haunted, almost gothic houses that evoke the decimated settings of Anglo-European Romanticism. Such scavengings are merely two categories in the image archive he has amassed over two decades, which is dominated by objects of desire culled from classical sculpture as well as heavy metal, fashion and Hollywood. In his labyrinthine table constructions, Hawkins disassembles and recrafts doll's houses in order to cut up the architecture of memory, desire and narrative. In the *Edogawa Rampo* collages, it is as if we have been allowed to enter these constructions. [RM]

HEATHER CASSILS AND ROBIN BLACK
Advertisement (Homage to Benglis), 2011
from the series *Cuts: A Traditional Sculpture*
Colour photograph

Fascinated by Lynda Benglis's notorious 1974 double-headed dildo advertisement in *Artforum*, Heather Cassils decided to turn her own body into the phallus rather than holding a phallus in front of her body. To sculpt the body photographed here, Cassils altered her diet to add twenty-three pounds (5.4 kg) of muscle in as many weeks, took regular doses of steroids, and worked out relentlessly. In so doing, she not only paid homage to Benglis but also reversed the narrative trajectory of Eleanor Antin's 1972 conceptual piece *Carved: A Traditional Sculpture*, in which Antin recorded herself daily as she starved in order to chisel a thinner, more fashionable body. In *Advertisement (Homage to Benglis)*, Cassils transforms a woman's body into a riveting transgender spectacle of white hypermasculine androgyny, a confounding image that Cassils and Black then circulated by means of a zine, *LadyFace/ManBody*, which in turn moved through the internet on various transgender and gay blogs. [CL]

INS A KROMMINGA
Das Defensive Organ, 2010
Colour pencil and ink on paper
38 × 41 cm

From the point of view of intersex artist and activist Ins A Kromminga, the binary system of sex and gender is punitive as well as preposterous. Why is sex determined by genitalia and the reproductive organs? What about chromosomes? What about hormone levels? Kromminga's works are powerful comments on the pathologizing of gender ambiguity, especially by 'sex reassignment' – surgical castration followed by hormone 'therapy'. Understanding that normative culture – heterosexual as well as homosexual – defines itself by creating its 'other' in order to exclude it, Kromminga's drawings and installations unabashedly celebrate the beauty of the monstrous. [CL]

WU TSANG
Green Room, 2012
Installation with wood, linoleum, carpet, furniture,
light fixtures, rope light, fabric, mirrors, Mylar
600 × 500 × 300 cm
Whitney Museum of American Art, New York

The room in this photograph was designed and furnished
by Wu Tsang to offer a dressing room for the dancers, actors
and musicians participating in the 2012 Whitney Biennial.
When not needed for this purpose, *Green Room* is open to
museum visitors, who can watch Tsang's two-channel video,
Que Paso Con Los Martes? (What Happened to Tuesdays?).
Que Paso revolves around a transgender Honduran woman
who finds a haven in Los Angeles at a dominantly transgender
Latino bar called the Silver Platter. Talking-head shots and
interviews are intercut with footage of the Silver Platter,
which became for a period a site in which Tsang organized
for transgender rights for people of colour. *Green Room*,
just like the Silver Platter and other gay bars, blurs the line
between public and private space. [CL]

Documents

A —
Thresholds
(1885—1909)

E —
Into the Streets
(1965—79)

B —
Stepping Out
(1910—29)

F —
Sex Wars
(1980—94)

C —
Case Studies
(1930—49)

G —
Queer Worlds
(1995—present)

D —
Closet
Organizers
(1950—64)

S.C.U.M.

(Society for Cutting Up Men) MANIFESTO

Valerie Solanas

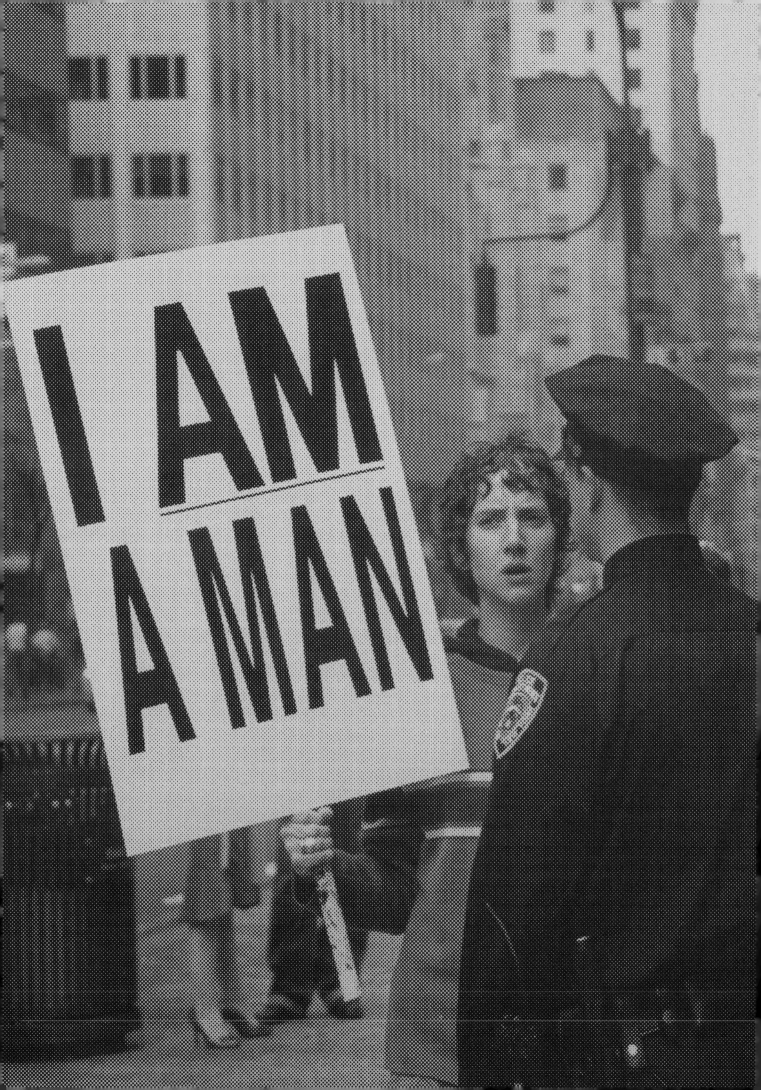

A —
Thresholds
(1885–1909)

While homosexuality was alluded to and occasionally explicitly pictured by artists and photographers of the time, it was still very much in formation as a cultural and psychological category. Though the late nineteenth century does not mark the definitive point of origin from which modern gay and lesbian visibility flows, the period gave rise to artistic and cultural projects that suggested alternative forms of sexual life and possibility. Contemporary discussions of deviant identities were sometimes highly coded, sometimes surprisingly explicit. The recovery of such material has led to re-readings pivotal to the formation of contemporary queer cultures.

Oscar Wilde
'Testimony on Cross Examination, 3 April' (1895)

[*Queensberry's defence attorney*]
Edward Carson: This is in your introduction to *Dorian Gray*: 'There is no such thing as a moral or an immoral book. Books are well written, or badly written.' That expresses your view?

Wilde: My view on art, yes.

Carson: Then, I take it, that no matter how immoral a book may be, if it is well written, it is, in your opinion, a good book?

Wilde: Yes, if it were well written so as to produce a sense of beauty, which is the highest sense of which a human being can be capable. If it were badly written, it would produce a sense of disgust.

Carson: Then a well-written book putting forward perverted moral views may be a good book?

Wilde: No work of art ever puts forward views. Views belong to people who are not artists.

Carson: A perverted novel might be a good book?

Wilde: I don't know what you mean by a 'perverted' novel.

Carson: Then I will suggest *Dorian Gray* as open to the interpretation of being such a novel?

Wilde: That could only be to brutes and illiterates. The views of Philistines on art are incalculably stupid.

Carson: An illiterate person reading *Dorian Gray* might consider it such a novel?

Wilde: The views of illiterates on art are unaccountable. I am concerned only with my view of art. I don't care twopence what other people think of it.

Carson: The majority of persons would come under your definition of Philistines and illiterates?

Wilde: I have found wonderful exceptions.

Carson: Do you think that the majority of people live up to the position you are giving us?

Wilde: I am afraid they are not cultivated enough.

Carson: Not cultivated enough to draw the distinction between a good book and a bad book?

Wilde: Certainly not.

Carson: The affection and love of the artist of *Dorian Gray* might lead an ordinary individual to believe that it might have a certain tendency?

Wilde: I have no knowledge of the views of ordinary individuals.

Carson: You did not prevent the ordinary individual from buying your book?

Wilde: I have never discouraged him. [...]

Carson: [*reading a passage from* The Picture of Dorian Gray *in which the artist Basil Hallward confesses his passion for Dorian*]: 'Let us sit down, Dorian,' said Hallward, looking pale and pained. 'Let us sit down. I will sit in the shadow, and you shall sit in the sunlight. Our lives are like that. Just answer me one question. Have you noticed in the picture something that you did not like? — something that probably at first did not strike you, but that revealed itself to you suddenly?'
'Basil!' cried the lad, clutching the arms of his chair with trembling hands, and gazing at him with wild, startled eyes.
'I see you did. Don't speak. Wait till you hear what I have to say. It is quite true that I have worshipped you with far more romance of feeling than a man usually gives to a friend. Somehow, I have never loved a woman. I suppose I never had time. Perhaps, as Harry says, a really '*grande passion*' is the privilege of those who have nothing to do, and that is the use of the idle classes in a country. Well, from the moment I met you, your personality had the most extraordinary influence over me. I quite admit that I adored you madly, extravagantly, absurdly. I was jealous of every one to whom you spoke. I wanted to have you all to myself. I was only happy when I was with you. When I was away from you, you were still present in my art. [...]'

Carson: Do you mean to say that that passage describes the natural feeling of one man towards another?

Wilde: It would be the influence produced by a beautiful personality.

Carson: A beautiful person?

Wilde: I said a 'beautiful personality.' You can describe it as you like. Dorian Gray's was a most remarkable personality.

Carson: May I take it that you, as an artist, have never known the feeling described here?

Wilde: I have never allowed any personality to dominate my art.

Carson: Then you have never known the feeling you described?

Wilde: No. It is a work of fiction.

Carson: So far as you are concerned you have no experience as to its being a natural feeling?

Wilde: I think it is perfectly natural for any artist to admire intensely and love a young man. It is an incident in the life of almost every artist.

Carson: But let us go over it phrase by phrase. 'I quite admit that I adored you madly.' What do you say to that? Have you ever adored a young man madly?

Wilde: No, not madly; I prefer love that is a higher form.

Carson: Never mind about that. Let us keep down to the level we are at now?

Wilde: I have never given adoration to anybody except myself.

[*Loud laughter.*]

Carson: I suppose you think that a very smart thing?

Wilde: Not at all.

Carson: Then you have never had that feeling?

Wilde: No. The whole idea was borrowed from Shakespeare, I regret to say — yes, from Shakespeare's sonnets.

Carson: I believe you have written an article to show that Shakespeare's sonnets were suggestive of unnatural vice?

Wilde: On the contrary I have written an article to show that they are not. I objected to such a perversion being put upon Shakespeare.

Carson: 'I have adored you extravagantly.' Do you mean financially?

Wilde: Oh, yes, financially!

Carson: Do you think we are talking about finance?

Wilde: I don't know what you are talking about.

Carson: Don't you? Well, I hope I shall make myself very plain before I have done. 'I was jealous of every one to whom you spoke.' Have you ever been jealous of a young man?

Wilde: Never in my life.

Carson: 'I wanted to have you all to myself.' Did you ever have that feeling?

Wilde: No; I should consider it an intense nuisance, an intense bore.

Carson: 'I grew afraid that the world would know of my idolatry.' Why should he grow afraid that the world should know of it?

Wilde: Because there are people in the world who cannot understand the intense devotion, affection, and admiration that an artist can feel for a wonderful and beautiful personality. These are the conditions under which we live. I regret them.

Carson: These unfortunate people, that have not the high understanding that you have, might put it down to something wrong?

Wilde: Undoubtedly; to any point they chose. I am not concerned with the ignorance of others. [...]

Testimony of Police Chief William S. Devery and George P. Hammond (1899)

In testimony on April 10, 1899, Police Chief Devery mentioned that the resort commonly called 'Paresis Hall' was officially named Columbia Hall, adding: 'It is rumored that the gentlemen [degenerates] ... frequent there once in a while, as they do many other hotels in the city.'

On November 3, 1899 an officer of the City Vigilance League, George P. Hammond, was asked by the committee about places that are well known as being resorts for male prostitutes. Has that unmentionable crime, so far as it is open to the people been on the increase?

A. It has increased wonderfully within the last six months.

Paresis Hall was mentioned, and Hammond was asked:

Q. Is it not a fact that there is not any of these resorts [...] for dissolute classes, which has not its male degenerates? [...] How many of those places do you know of that are open from the street, where boys go in freely, and where they have attached to it as a feature of the place, a male degenerate?

A. On the Bowery alone there is to my knowledge certainly six places. There are other places where they have them.

Q. Do these poor, miserable creatures make themselves public? Do they show themselves?

A. They do. They exhibit themselves and solicit. I have seen them solicit openly, and they have solicited me.

Q. Do you remember an occasion recently when one of those persons, after exhibiting himself, walk[ed] through the audience and offered his photograph for sale?

A. Yes, sir. He just got through singing a song. I should not say he, I should say 'it'. 'It' just got through singing a song [...] there were three or four gentlemen sitting there, he offered the photographs. Those are the photographs sold by him at that place that night. (Showing photographs.) I bought these from that party. That was a place called 'Little Buck,' at the Bowery; [...] it is diagonally opposite from Paresis Hall. It is an off-shoot of that. It is the place [...] where they used to give what they called 'the circus.' He was not the only man of that kind that was present [...] there were either three or four of them. There were two of them sang; sang a duet. There were men and women in that place. There was immoral solicitation and immoral conduct. They danced the rag time there. By the rag time I mean a decidedly immoral dance. That is one of the evils of this thing. You will find the word 'rag time' used in high social circles. The people do not know what it means. They do not know where it emanated from. If they did they would blush for shame. It sometimes makes me boil over with indignation when I hear that phrase used.

– Testimony of Police Chief William S. Devery and George P. Hammond, reprinted in Jonathan Ned Katz, *Gay/Lesbian Almanac* [Carroll and Graf, New York, 1994] 297–9

Richard Whelan 'Thomas Eakins: The Enigma of the Nude' (1979)

Our experience of any work of art involves a balance between the artist's intentions as expressed in the work and the proclivities and preoccupations that we ourselves bring to the experience. Thomas Eakins's male nudes are a case in point. Whether or not Eakins actually had any conscious homosexual feelings, his scenes of naked men swimming or wrestling can be enjoyed as some of the most beautiful homoerotic works by an American artist. [...]

Eakins felt that the human body was the most beautiful thing in nature, a sentiment opposed to the prudery that dominated American art and society in the nineteenth century.

Consequently, in 1866, after five years at the Pennsylvania Academy, Eakins went to Paris to study at the Ecole des Beaux-Arts, where the emphasis was on drawing nude models. He chose as his teacher Jean Leon Gerome, a prominent academic artist who specialized in historical and exotic scenes painted in an almost photographic style. But Eakins absorbed little of Gerome's style, or of anyone else's, for he was more interested in developing his personal vision than in looking at other people's art. He seems to have thrived in the rambunctious atmosphere of the school, where students would often strip for an impromptu boxing or wrestling match. Eakins was a powerfully built man who had always loved sports, including rowing, wrestling, skating, hunting, and sailing. Among the most frequent entries in his Parisian account books are expenses for visits to a gymnasium where he wrestled.

While in Paris, Eakins wrote a letter to his family in which he said, '[A naked woman] is the most beautiful thing there is – except a naked man, but I never yet saw a study of one exhibited. It would be a godsend to see a fine man painted in a studio with bare walls [...]' The nude was to remain the basis of Eakins's own teaching. [...]

In 1876, Eakins began to give classes at the Pennsylvania Academy, and revolutionized American art education by bringing live models into classes that consisted of both male and female students. He also established a dissecting room in the school and made anatomy a required part of the curriculum. The students responded with enthusiasm and loyalty.

It was undoubtedly this desire to seize the essence of reality that led Eakins, around 1880, to buy a camera and to begin photographing his family, studio scenes, and alfresco nudes. Photography was then regarded with great suspicion and hostility by most artists, especially portrait painters like Eakins, whose livelihood was threatened by the popularity of daguerreotypes and tintypes. But Eakins, with his scientific and mechanical turn of mind, was naturally drawn to the camera as a recording device and tool for making preliminary studies for paintings. Indeed, both of Eakins's paintings with male nudes, *The Swimming Hole* and *Arcadia*, are based on photographs. [...]

Lloyd Goodrich, Eakins's biographer and the organizer of the major Eakins show at the Whitney in 1970, has written, '[Eakins] had unusually close relations with his students, some of whom remained his friends throughout his life [...]They went on outdoor excursions with him. Eakins was always entirely natural about nudity, and preferred bathing without benefit of bathing suits.'

The Swimming Hole is one of Eakins's most classically balanced compositions, in which the movements of four of the men form a marvellously fluid pyramid, leading the eye from the figure in the water on the left, through the arms of the figure kneeling on the jetty, culminating in the magnificent standing figure, and following through in the figure diving into the pond. The latent eroticism of the painting is heightened by the fact that the inescapable foci of the composition are the buttocks of the standing figure — the most brightly highlighted part of his body and the point of convergence of almost all the gestural lines in the painting. *Arcadia* (and its related photographs of naked boys wrestling, reclining, and playing Pan's pipes in idyllic landscapes) reveals an unexpected 'pagan' strain in Eakins's otherwise staunchly rationalistic personality.

Both *Arcadia* and *The Swimming Hole* date from 1883, when Eakins was at the height of his career, becoming so comfortable with nude models that he began to live out some of his fantasies of ancient Greek innocence and idealism — to the extent of having himself photographed nude playing Pan's pipes. [...]

In 1886, during a lecture in the women's life drawing class at the Philadelphia Academy, Eakins removed the loincloth of the male model in order to demonstrate the workings of the pelvic muscles. A scandal resulted; Eakins was forced to resign. Many of his students (mostly men) left the Academy with him and founded the Art Students' League of Philadelphia under Eakins's direction. After this episode, Eakins was largely excluded from Philadelphia society. But he had never received many commissions for portraits anyway as his sitters generally resented his scrupulous realism and his refusal to flatter them. Fortunately, his inherited income freed him from the need to earn a living through painting and enabled him to paint subjects of his own choosing in his own manner — mostly portraits of men and women with whom Eakins felt some deep sympathy and who agreed to sit for him. [...]

One of the greatest joys of Eakins's later life was his friendship with Samuel Murray, a handsome and muscular young Irish stonecutter who himself became a prominent sculptor. Murray was sixteen and Eakins forty-two when they met in 1886, in the cemetery where Murray worked. Murray soon enrolled in Eakins's classes at the Art Students' League and became the artist's favourite student. Eakins, who had no children, practically adopted Murray as a son. The two men shared a studio and became constant companions (a relationship much like that of Eakins with his own father). Murray, who was athletic and religious, introduced

Eakins to two widely disparate worlds that were important in his later paintings: the world of boxing and the world of the Roman Catholic clergy. Soon after Eakins and Murray began attending prizefights at the Philadelphia Arena in 1898, Eakins started a series of boxing and wrestling paintings that were his last studies of the semi-nude male figure. Like the rowing pictures, these paintings are portraits of specific athletes; but the mood of the boxing paintings, in contrast to the rowing scenes, is distinctly sombre and tragic.

Eakins often said that the only three writers he had ever read with pleasure were Dante, Rabelais, and Walt Whitman (who lived across the river from Philadelphia in Camden, New Jersey). In 1887, Eakins finally had an opportunity to meet the poet who sang so eloquently of the beauty of the human body. The two men who most brilliantly and honestly celebrated the energy of everyday life in nineteenth-century America felt an immediate affinity for each other. Whitman, summing up Eakins's passionate affirmation of ordinary reality, his moral commitment to painting as a way of reaching scientific and philosophical truth, and his great compassion for men and women of intelligence and sensitivity, declared, 'Eakins is not a painter, he is a force.'

— Richard Whelan, 'Thomas Eakins: The Enigma Of The Nude', *Christopher Street Magazine*, vol. 3, no. 9 [April 1979] 15–18

Jonathan Ned Katz 'The Invention of Heterosexuality' (1995)

In the twentieth century, creatures called heterosexuals emerged from the dark shadows of the nineteenth-century medical world to become common types acknowledged in the bright light of the modern day.

Heterosexuality began this century defensively, as the publicly unsanctioned private practice of the respectable middle class, and as the publicly put-down pleasure-affirming practice of urban working-class youths, southern blacks, and Greenwich Village bohemians. But by the end of the 1920s, heterosexuality had triumphed as dominant, sanctified culture.' In the first quarter of the twentieth century the heterosexual came out, a public, self-affirming debut the homosexual would duplicate near the century's end.

The discourse on heterosexuality had a protracted coming out, not completed in American popular culture until the 1920s. Only slowly was

heterosexuality established as a stable sign of normal sex.

The association of heterosexuality with perversion continued as well into the twentieth century[...]

In the first years of the twentieth century *heterosexual* and *homosexual* were still obscure medical terms, not yet standard English. In the first 1901 edition of the 'H' volume of the comprehensive *Oxford English Dictionary*, *heterosexual* and *homosexual* had not yet made it.

Neither had heterosexuality yet attained the status of normal. In 1901, *Dorland's Medical Dictionary*, published in Philadelphia, continued to define 'Heterosexuality' as 'Abnormal or perverted appetite toward the opposite sex.' Dorland's heterosexuality, a new 'appetite,' was clearly identified with an 'opposite sex' hunger. But that craving was still aberrant. Dorland's calling heterosexuality 'abnormal or perverted' is, according to the *Oxford English Dictionary*'s first Supplement (1933), a 'misapplied' definition. But contrary to the *OED*, Dorland's is a perfectly legitimate understanding of heterosexuality according to a procreative norm.

The twentieth century witnessed the decreasing legitimacy of that procreative imperative, and the increasing public acceptance of a new hetero pleasure principle. Gradually, heterosexuality came to refer to a normal other-sex sensuality free of any essential tie to procreation. But only in the mid-1960s would heteroeroticism be distinguished completely from reproduction, and male-female pleasure sex justified for itself. [...]

In 1923, 'heterosexuality' made its debut in Merriam Webster's authoritative *New International Dictionary*. 'Homosexuality' had, surprisingly, made its debut fourteen years earlier, in 1909, defined as a medical term meaning 'morbid sexual passion for one of the same sex.' The advertising of a diseased homosexuality preceded the publicizing of a sick heterosexuality. For in 1923 *Webster*'s defined 'heterosexuality' as a 'Med.' term meaning 'morbid sexual passion for one of the opposite sex.' Only in 1934 does 'heterosexuality' first appear in *Webster*'s hefty Second Edition Unabridged defined in what is still the dominant modern mode. There, heterosexuality is finally a 'manifestation of sexual passion for one of the opposite sex; normal sexuality.' Heterosexuality had finally attained the status of norm.

In the same 1934 *Webster*'s 'homosexuality' had changed as well. It's simply 'eroticism for one of the same sex.' Both terms' medical origins are no longer cited. Heterosexuality and homosexuality had settled into standard American. In 1924, in *The New York Times*, heterosexuality first became a love that dared to speak its name.

On September 7 of that year the word 'hetero-sexual' made its first known appearance in *The New York Times Book Review* significantly, in a comment on Sigmund Freud. There, in a long, turgid review of Freud's *Group Psychology and the Analysis of the Ego* one Mary Keyt Isham spoke of 'repressed hetero-sexuality' and 'hetero-sexual love'. [...]

By December 1940, when the risque musical 'Pal Joey' opened on Broadway, a tune titled 'Zip' satirized the striptease artist Gypsy Rose Lee, by way of a character who, unzipping, sang of her dislike for a deep-voiced woman or high-pitched man and proclaimed her heterosexuality. That lyric registered the emergence in popular culture of a heterosexual identity.

By 1941, the glossary of a book about 'sex variants' said that 'straight' is being employed by homosexuals as meaning not homosexual. *To go straight is to cease homosexual practices and to indulge — usually to reindulge — in heterosexuality.*

The 'not homosexual,' a new creature, defined by what he or she isn't, had emerged among the cast of erotic characters on the twentieth-century stage. Here, 'straight' is a condition toward which one may venture or not, depending on one's 'practices' (feeling is not the issue). Now, the sex variants are doing the defining — categorizing is a game that two preferences can play.

The 'cult of domesticity' following World War II — the re-association of women with the home, motherhood, and child care, men with fatherhood and wage-work outside the home — was an era in which the predominance of the hetero norm went almost unchallenged. In the late 1940s and the 1950s, conservative mental-health professionals reasserted the old link between heterosexuality and procreation. In opposition, sex-liberals strove to expand the heterosexual ideal to include within the boundaries of the normal a wider-than-ever range of gender ideals and nonprocreative, premarital, and extramarital behavior. But that sex-liberal reform actually helped to secure the dominance of the heterosexual idea, as we shall see when we get to Kinsey. [...]

This sex scientist [Kinsey] popularized the idea of a 'continuum' of activity and feeling between hetero and homo poles:

Only the human mind invents categories and tries to force facts into separated pigeon-holes. The living world is a continuum.

His recasting of the hetero / homo polarity did suggest that there are degrees of heterosexual and homosexual behavior and emotion. But that famous continuum also emphatically reaffirmed the idea of a sexuality divided between the hetero and homo.

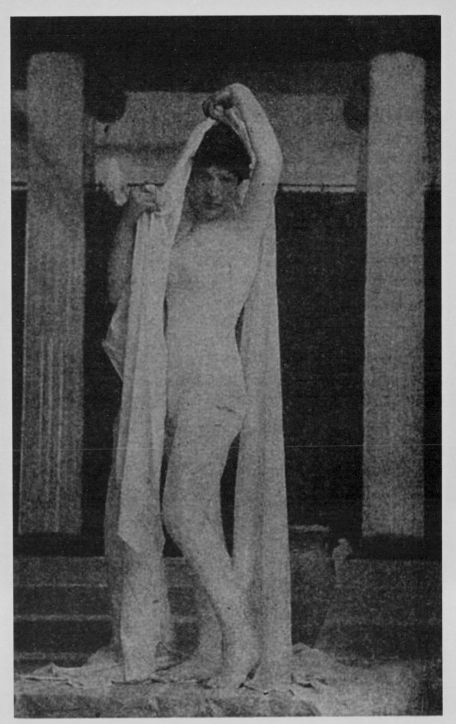

'A characteristic symptom of patient no.1, posing in imitation of a celebrated painting' from Dr. Bernard S. Talmey's *Transvestitism*, 1895

Kinsey's 'heterosexual–homosexual rating scale,' from zero to six, sounded precise, quantitative, and scientific, fixing the het / homo binary in the public mind with new certainty. His science-dressed, influential sex-liberalism thus upheld the hetero / homo division, giving it new life and legitimacy.

Kinsey also explicitly contested the idea of an absolute either / or antithesis between hetero and homo *persons*. Stressing the variations

between exclusive heterosexual and exclusive homosexual behavior and feeling, he denied that human beings 'represent two discrete populations, heterosexual and homosexual'. The world's population, he ordered, 'is not to be divided into sheep and goats'. (That revealing Biblical metaphor positions heterosexuals as sheep, coupled with conformity, and homosexuals as goats, linked with licentiousness).

The hetero / homo division of persons is not nature's doing, Kinsey

stresses, but society's. As sex-liberal reformer, he challenged the social and historical division of people into heterosexuals and homosexuals because he saw this person-labeling used to denigrate homosexuals. Motivated by a reformist impulse, he rejected the social reality and profound subjective force of a historically constructed tradition which, since the early twentieth century in the U.S., had cut the sexual population in two — and helped to establish the social and personal reality of a heterosexual and homosexual identity. [...]

Between the 1890s and the 1960s the terms *heterosexual* and *homosexual* moved into American popular culture, constructing in time a sexual solid citizen and a perverted unstable alien, a sensual insider and a lascivious outlaw, a hetero center and a homo margin, a hetero majority and a homo minority. The new, strict boundaries made the new gendered, erotic world less polymorphous. The term heterosexual manufactured a new sex-differentiated ideal of the erotically correct, a norm that worked to affirm the superiority of men over women and heterosexuals over homosexuals. Feminists questioned those gender and pleasure hierarchies.

— Jonathan Ned Katz, *The Invention of Heterosexuality* [Dutton Books, New York, 1995] 83–112

Jason Goldman
'The Golden Age of Gay Porn: Nostalgia and the Photography of Wilhelm von Gloeden' (2006)

'My memoirs are not for historians. They can be of interest only to voluptuaries and artists.'
— Roger Peyrefitte,
Les amours singuliers

When the French novelist Roger Peyrefitte wrote these words in 1949, he was not referring to his own memoirs, but those he had invented for the largely forgotten nineteenth-century photographer Wilhelm von Gloeden (1856—1931). Pieced together from what little evidence was available and moving between factual account and poetic embellishment, Peyrefitte's text describes von Gloeden as a libertine artist who deeply admires his boyish models and thrills at providing homoerotic pictures to a lustful clientele.

While much has been written about von Gloeden in the intervening sixty years, Peyrefitte's interlacing of historical fact and nostalgic fantasy has proved hard to shake. Even a casual survey of the von Gloeden literature reveals the tendency of certain details to vary greatly from one account to the next, the desire to give the photographer a vivid psychological interiority for which there is little archival basis, the prominence of speculation and inference in ascertaining certain lost portions of his oeuvre, and a broad sense of nostalgia for the time and

'Fidus' (Hugo Höppner), Cover/poster for *Der Eigene* magazine, 1906

place in which he lived and the kind of pederastic eroticism he was able to pursue. While von Gloeden's pictures are important cultural artefacts in their own right, the nostalgic historical packaging that surrounds the photographer is equally deserving of critical scrutiny.

Wilhelm von Gloeden, or Baron von Gloeden, as he is sometimes known, was a minor but wealthy Prussian aristocrat who immigrated to Taormina, Sicily, in 1878. Living off an allowance from his family, von Gloeden led a leisurely life in Taormina and took up residence in a villa where he hosted friends from abroad. In addition to Taormina's coastline and many classical ruins, some of von Gloeden's male guests came for another local attraction: after nightfall and much wine, so the story goes, von Gloeden and his visitors would often partake in wild orgies with the local youths. According to one account, the baron's houseboy served as liaison to the other teenagers, 'help[ing to] organize the scandalous revels whose secret fame had reached as far away as St. Petersburg in Russia and New York in the new world.'

Von Gloeden dabbled in photography, but it was not until 1888 that he acquired his own camera and began to operate a commercial studio. Although he worked in a number of genres, von Gloeden was best known for his Arcadian scenes, pictures that evoked Taormina's Greek and Roman heritage and figured his young companions as living embodiments of the ancient past. By World War I, von Gloeden had attained an international reputation, and his prints and photographic postcards were widely collected. Although he worked in relative isolation in remote Taormina, von Gloeden was attached to the pictorialists, a generation of photographers who claimed the status of artists (as opposed to technicians) and sought to develop the medium's artistic possibilities. While von Gloeden never embraced the hazy soft focus that many pictorialists favored, his adaptation of classical motifs to the language of photography, as well as his penchant for working en plein air, made him highly relevant to the movement.

A sense of place was essential to von Gloeden's Arcadian fiction, and many of his photographs make prominent use of Taormina's landscape and architectural ruins. To complete the illusion, von Gloeden stripped his models of their contemporary garb, dressing them in skimpy tunics or nothing at all, and made heavy use of animal skins, pottery, panpipes, and other ancient-seeming props. Despite their artifice, the Arcadian pictures were meant to imply the perfect ease with which the ancient past could resurface in modern Sicily.

Von Gloeden seems, on occasion, to have recognized the limits of his nostalgic project. In one of his few extant writings, he comments:

I tried to resurrect ancient Greek life in these images. But how the desire surpasses the means! Fortunately, I did not choose professional models, so I did not have to fight against academic poses and practiced positions. My models were peasants, shepherds, fishermen. I had to be intimate with them for a long time in order to be able to observe them later in scanty garments, to select among them, and to stimulate them spiritually with stories from Homer's sagas.

The passage reveals that antiquity offered the artist much more than an expeditious alibi for photographing nude and scantily clad boys. It is true that for von Gloeden's highbrow clientele and pictorialist colleagues the allusions to antiquity were a matter of artistry, erudition, and good taste. But these were not the only audiences von Gloeden had in mind, as the baron reserved a special line of more risqué pictures for special clients. Whereas the general offerings avoided frontal nudity, }the under-the-counter photographs did away with the loincloths and tunics. Many of von Gloeden's special clients, such as Oscar Wilde and Friedrich Krupp, were elite men who possessed the means of traveling to the baron's far-off studio, where they could acquire the photographs in person. However, von Gloeden's nudes are thought to have circulated in a clandestine market that extended from Sicily to continental Europe, Britain, and the United States, to the extent that von Gloeden's identity as an artist is often eclipsed by his identity as an early pornographer. Much of von Gloeden's illicit work retained strong references to antiquity and thus promoted an extended fantasy of the ancient Mediterranean in which nude and docile boys were seemingly around every corner. At the same time, the photographs could not but index von Gloeden's own material world and modern historical moment. Alternately readable as ancient ephebi and anonymous locals, von Gloeden's boyish subjects made overtures to an antique past, but also implied the homoerotic pleasures currently on offer in Taormina.

While von Gloeden seems to have avoided censure or scandal during his lifetime, his photographs became the target of obscenity charges shortly after his death. During a series of raids that are variously dated to 1933, 1936, and 1940, the Italian Fascist police destroyed or confiscated several thousand of von Gloeden's delicate glass-plate negatives.

Von Gloeden's executor was ultimately acquitted, but the raids had already done their damage, making it virtually impossible for historians to fully assess von Gloeden's oeuvre and, in turn, mobilizing speculation and fantasy as a means of describing the lost pictures. In a 1951 letter to sexologist Alfred Kinsey, the American painter Jared French reported the following: 'It seems that ten or twelve years ago the Fascist government got after [von Gloeden] and seized and destroyed some 7,000 plates. I suspect many of these were "action" pictures.'

It is unclear whether von Gloeden made such 'action pictures,' but for Kinsey and other postwar viewers, the homoerotic and pornographic bent of von Gloeden's work was nonetheless apparent. Indeed, beginning in the 1960s, von Gloeden's pictures began to circulate in the United States and elsewhere through a smattering of physique magazines and other fringe publications that exploited the pornographic utility of the baron's work. One 1966 booklet tilted *Sicilian Boys*, for example, resembles other physique magazines of the day except it consists entirely of von Gloeden photographs, some fifty-one uncensored nudes in all. But since the booklet attributes the pictures to 'the well-known French photographer JACQUES, who is represented by our firm,' readers of *Sicilian Boys* might have had little sense of what they were actually looking at.

In the summer of 1969, *Queen's Quarterly: The Magazine for Gay Guys Who Have No Hangups* paid homage to von Gloeden with a feature article, an accompanying portfolio, and a von Gloeden photograph on the cover that, superimposed with a ring of flamboyant pansies, seemed aptly updated for the summer of Stonewall. But while *Queen's Quarterly* certainly situated von Gloeden and his pictures in the historical past, it drew few distinctions between the photographer and contemporary gay life: 'visitors to Taormina are advised to carry their cameras well displayed as they stroll the side streets and mountain paths […] they are sure to be approached with friendly and conspiratorial smiles by this generation's crop of Sicilian models!' This advice, though playful, reveals a serious belief in the continued plausibility of von Gloeden's experience and the ongoing availability of his 'Sicilian models.' By contrast, Charles Leslie's deferential monograph of 1977 framed von Gloeden as an icon of ancestral gay pride, as a man who 'had to live in dangerous defiance of an age and a Christian society which regularly crucified men of his kind' and as 'one of those figures who to this day stand as models for people who dare to live the truth of what they are.' While Leslie warns that 'so little

was written about Wilhelm von Gloeden in his own lifetime that the story is perforce sketchy at times,' his book is rife with enticing details and heady prose:

> Wilhelm remembered his early years in Sicily as a long, starry-nighted ecstasy, a delirium of carnal and spiritual rapture. On the day of his arrival in Taormina, the son of a burro driver, a youth of sixteen or seventeen, was given to him to act as a guide. Wilhelm kept the boy with him for most of the night. Stretched out together on the uppermost tier of the Greek Theatre, they watched the brilliant Mediterranean stars for hours. Later, they lay together in the warm meadows of Monte Ziretto with the sound of summer cicadas singing in the cool dawn.

Nostalgia, narrative embellishment, and vicarious pleasure loom large in Leslie's monograph and other accounts from the period — not as digressions from von Gloeden's history, but as ways of making that history speak. More than mere sentimentality, these nostalgic tendencies point to the difficulties of assimilating von Gloeden's sexual and photographic practices within an overarching notion of gay history. Although von Gloeden, from the vantage point of the late 1970s, seemed to embody gay desire, his identity as a nineteenth-century aristocratic pederast simultaneously placed a gulf of historical difference between him and contemporary U.S. gay male subjectivity. Meanwhile, the photographs themselves now circulated under a different set of disciplinary forces and von Gloeden's models began to signify as 'underage.' However anachronistic, this designation introduced a powerful taboo and worked to anchor the baron's pictures to a historically distinct and seemingly less constrained time and place. The sparse documentation of von Gloeden's life, the lost pictures, the troubling power differential between the aristocratic baron and his impoverished models, the disparities between von Gloeden's subjectivity and post-Stonewall gay identity — all of this was readily ameliorated by a nostalgic rendition of von Gloeden's life and photographic practice, a rendition that could embellish, fill in, and smooth over the fragmentary historical record. If von Gloeden intended his photographs to provoke a desire for antiquity in the minds and libidos of his period viewers, the photographs have become, in their ongoing afterlife, equally prone to nostalgic desire for von Gloeden's own historical condition and erotic practice.

Although vintage von Gloeden prints and postcards are now collected by some art museums, von Gloeden remains a marginal figure in most academic histories of photography and his pictures continue to straddle high and low, as their recent appearance on the commercial pornographic web site 'The Golden Age of Gay Porn' makes clear. Itself a nostalgic tribute to bygone grandeur, the web site presents von Gloeden's pictures, without attribution, as examples of 'early porn.' Instead of linking the pictures to von Gloeden's individual history, the site detaches them from any one life or any one set of known circumstances while still encouraging the viewer to approach the pictures as an encounter with history. Framed only in relation to the construct of a golden age of gay porn, von Gloeden's photographs assume the status of tantalizing artefacts whose history is unclear but whose historical intrigue is certain.

— Jason Goldman, 'The Golden Age of Gay Porn: Nostalgia and the Photography of Wilhelm von Gloeden', *GLQ: A Journal of Lesbian and Gay Studies*, vol. 12, no. 2 [February 2006, revised 2011] 237–58.

B —
Stepping Out
(1910 – 29)

The founding by Magnus Hirschfeld of the Institute for Sexology in Berlin in 1919 provides the backdrop against which German artists and photographers of the day (as well as foreign-born artists, such as Marsden Hartley, working in Berlin) proposed alternative forms of gender and sexuality as signs of cosmopolitism. The later 1920s saw the publication of classics of gay literature, such as Jean Cocteau's anonymously published *The White Book*, Colette's *Pure and Impure*, Virginia Woolf's *Orlando* and Radclyffe Hall's *The Well of Loneliness*, the latter banned in the United Kingdom. This chapter also addresses the significance of butch-femme roles, codes and costumes within lesbian culture, as well as gay male practices of drag and camp.

Magnus Hirschfeld 'The Homosexuality of Men and Women' (1913)

(I) Object Choice
(Residence and Clothing)

Just as in their lifestyle, people's originality is also externally projected in those things with which they surround themselves, which they choose according to their inclinations, in their orientation of taste, whereby we have to distinguish between what they like about themselves and about others. That which they like about themselves gives them the stamp of individuality; that which attracts them to others gives them the stamp of sexuality. To go into details about the connection between both these direction of taste, as much as we would like to, is too far-reaching to do here. In this case, we intend only to examine how Uranians form the background of their surroundings and accoutrements, especially their residence and clothing. We have already given details above about the extent to which eroticism consciously or unconsciously plays an important role in the case of furnishing one's abode. Apart from that, in the objects used by homosexuals we will repeatedly encounter that original mixture of masculine and feminine tendencies, and how they characterize a psyche. People who want to evaluate the special individuality of homosexuals should remember to visit them at home. We often certainly will not perceive many typical things; however, just as often you will find many worthwhile points of departure for the uniqueness of the resident. The saying, 'Tell me with whom you associate, and I will tell you who you are' could also go, 'Tell me with what you surround yourself, and I will tell you who you are.'

If we enter the residence of an Urnind, the heavy pieces of furniture, the leather easy chair, the gigantic desk, and the serious colors often enough call to mind gentlemen's rooms, while just as frequently the rooms of an Urning remind you of a lady's boudoir, with their decorated chairs, tables, mirrors, and side-tables; their colourful curtains, wallpaper, and pillow cases; their knickknacks, little pictures, and bows. In the bedrooms of Urnings we often meet with a four-poster bed with silk covers, in that of the Urnind an iron camp bed. In the case of Urninds, there is often a cloud of smoke streaming toward you, in that of Urnings fine perfume and potpourri.

Just to what extent this tendency can go can be illustrated by the following report to us by a Uranian from the upper echelons of the aristocracy. The data are completed in a remarkable way by the reports about his female 'counter-part,' a Uranian singer. After he tells about the death of his mother and sister, he continues about his lifestyle since becoming an adult. 'My rooms up to that time had been too masculine for me, so, in some of the rooms, which had belonged to my mother and sister, I fixed up an apartment with all the luxuries of an elegant, fashionable lady. I redecorated the bedroom in white, the boudoir in blue, the toilet in pink, one of the salons in yellow, and the other in red damask, the kitchen in white and gold. Marianne and her daughter, Julie, the two maids, had nothing to do after my mother's and sister's death. Both maids were very attached to the house, and, since they knew everything about my passion, suited me very much. Julie immediately became my personal maid. Now the chests were filled with the best women's undergarments, vests, plus-fours of the finest cambric and likewise decorated with lace, silk stockings, hats, and shoes, especially the most beautiful evening gowns of every kind.

'There were many of them, those for young women and those for older ones, formal gowns with and without trains, evening party dresses, all kinds of street and house dresses, deshabillées, coats, jackets, also costumes for masked balls: I'll mention only those for a milk maid, a Spanish lady, a baby, a (paper) flower girl, a shepherd girl *á la* Watteau, a rococo lady, Mary Stuart, and turn-of-the-century costumes. As far as my daily routine is concerned, after breakfast, at ten o'clock I took a perfumed bath; afterward, Julie dressed me in a morning or house dress, something with lace. Before noon, I spent time knitting or crocheting, playing piano, and reading. After lunch, which was served at one o'clock, I sometimes still had to dress as a man, but that occurred only rarely, because I had retreated more and more from my former circle. Men's clothing bothered me a great deal; I mostly stayed a lady, even if I went out for a walk or a drive. No one discovered my transvestism; I was just made to fit into a skirt. Marianne had been dressed up as a female companion. At seven o'clock dinner was served. In the evening, I used to go the theater. For this, I dressed myself as a young woman or as an older one. Marianne chaperoned me and looked very droll in her place of honor. I specially liked to go to the *opera comique*, whose star, a singer by the name of Lea, appeared almost exclusively in men's roles. She was as if made for this genre, built tall and slender, pretty face, but with sharp lines and masculine features, and with a voice remarkable for its deep timber. When she appeared as a man, she was totally a man. She walked and

moved as such. Everything womanly had vanished in her case. She wore her hair short, and went home always dressed as a man. I also heard that she was unhappy about being a woman. I felt the urge to meet her. In a letter to her, I described myself and told her about my feelings and thoughts. I told her it was my greatest wish to introduce myself to her. I immediately received a letter in which she agreed to see me.

'She invited me to meet her the following day, after the performance, with the provision that we would be alone. I carefully prepared for the occasion. I put my hair up in Greek knots surrounded with diamonds. I left the house for Lea's in a silk-lined coat. She was waiting for me in a chic frock-coat and gave the impression of being a fine, young man. When I entered, she approached me in a state of surprise. We just stood there a moment as if kindred spirits, and we had found each other. What a remarkable metamorphosis — she, the woman, stood there as an elegant man, and I, the man, as a shy young woman. Finally, Lea kissed my hand gallantly and complimented me on my appearance and on my dress. We immediately became friends. We busily set about trying to understand each other. Sitting and drinking our tea, we spoke for a long, long time about our feelings and thoughts. Only when it was late in the evening did I return home. We saw each other almost daily. At her place, I also met a prince from a royal house, who in everyday life is a lieutenant in the cavalry, wearing a charming, little gossamer dress made of white dewdrop tulle with lilies of the valley. He often complained about his situation. He would have liked to exchange his uniform for women's clothing, his saber for a fan, the poor fellow. Up to then, I was totally innocent. Lea opened my eye. I was thoroughly amazed, but the natural drive is more powerful than the law.'

— Magnus Hirschfeld,
The Homosexuality of Men and Women [1913, reprinted by Prometheus Books, New York, 2000] 206–9

Anonymous 'On Being Queer' (1921)

ON BEING QUEER

Christopher Columbus was queer. He had queer ideas about the earth being round. He thought India could be reached by sailing westward when everybody knew that it lay to the east. He was a freak, an oddity to be shunned by everyone.

Benjamin Franklin was queer. He stood out in the rain on dark nights and flew kites. He had strange ideas about education and government.

Walt Whitman was queer. He would stand for hours on a street corner and gaze abstractedly at the passing throng. He consorted with bus drivers, Broadway hoodlums, and others outside the pale of respectable society.

THE DIAL

is queer – to all lovers of the commonplace. It contains queer pictures, odd verse, bizarre stories, subtle essays, erudite book reviews, and exasperating criticism of art, music, and the theatre. It doesn't like what everybody likes simply because everybody likes it – which is why discerning people like it. 'The vivid and various Dial,' as the *New York Evening Post* describes it, is queer – in the same way that all things of distinction are queer.

Queer things do differ from the divine average of mediocrity.

– Magazine advertisement for
 The Dial magazine [1921]

Alastair
'The Metamorphosis of the Dandy' (1923)

[…] A dandy is not the outcome of choice but an accident of birth; his status cannot be achieved through effort but only through fate.

[…] From the pyramids of dancing Egypt, where even the tiniest expression of life was devoted to sacred and meaningful systems, the dandy emerged. He knew that there were insoluble enigmas and that peaceful harmony determined the course of life and death, even in its phantom rebirth. The dandy could be found among the death-defying heroes, the fighters for freedom in Greece, with a jest on his lips as golden Nike lifted him from blood and death to join the immortals on wings of laurel. Crowned with a wreath of distinction he relaxed nonchalantly at the feet of philosophers at a banquet; he was as well known in places of learning and of civilization as in the echoing marble surroundings of the theatre. The dandy sat at porphyry tables as the aloof partner in perfidious games with irate emperors to whom Rome and the world knelt in the dust. Emerging from the bath immaculately clad he omitted to pay homage to effigies of the insane potentates, even if those very colossi passed by in their shaky litters dripping with pearls. In Chinese bell-

encrusted pagodas the dandy wrote verses perfumed with irises, remaining unembarrassed when hysterical princesses on tinkling porcelain bridges posed health-damaging questions. The Samourai dandy sacrificed his life in wisteria bowers for his fierce ideals, sure in the safety of tradition; with not the slightest desire to share his thoughts, he smiled in the face of the most jagged fate so that through his superiority the demons would never be certain of victory […]. He tossed yellow carnations onto the stakes of the Spanish Inquisition and stood in the shadows of the complex intrigues of the Italian Renaissance while papal courtesans played to him on the harp. The dandy slept dreamlessly through the terrors of St. Bartholomew's night and rescued black and white in the religious wars; he waved fans with dragonfly iridescence in the torchlit sarabands in the gardens of St. Cloud and manipulated foil and poison in the northern courts. He exchanged letters in French with the ill-treated heirs to the Prussian throne, handed over his treasure of diamonds to fashionable alchemists and embarrassed notorious actresses on the river Thames. In the darkness of revolutionary dungeons the dandy tapped minuettes and gavottes with his dying red heels and, when the tumbrel to the guillotine called, he went on distributing with perfect manners to powderless

duchesses the cards of an interrupted game. Nor did he fail to beg the executioner's pardon should he accidently knock his elbow. He drifted around Napoleonic battles and waited outside a famous singer's house for years in a chequered carriage. He put on cardinals' hats and Czarist crowns, fools' caps and anemone wreaths. He… but enough! The dandy has appeared throughout history with the smooth, nonchalant movements characteristic of his name.[…]

– Alastair, 'Die Verwandlungen des Dandy', *Styl*, vol.5, no.6 [Berlin, 1923], excerpted and translated in Victor Arwas, *Alastair: Illustrator of Decadence* [Thames and Hudson, New York, 1979]

Djuna Barnes
'May Hath 31 Days' (1928)

[…] 'Tell me about it!' said Nip, for she was at best a little curious, being hard pressed by Journalism, and could not let a Morsel go, though she knew well that it could be printed nowhere and in no Country, for Life is represented in no City by a Journal dedicated to the Undercurrents, or for that matter to any real Fact whatsoever.

'In my day', said Dame Musset, and at once the look of the Pope, which

Djuna Barnes, *May Hath 31 Days* (from *Ladies Almanack*), c.1932

she carried about with her as a Habit, waned a little, and there was seen to shine forth the Cunning of a Monk in Holy Orders, in some Country too old for Tradition, 'in my day I was a Pioneer and a Menace, it was not then as it is now, *chic* and pointless to a degree, but as daring as a Crusade, for where now it leaves a woman talkative, so that we have not a Secret among us, then it left her in Tears and Trepidation. Then one had to lure them to the Breast, and now,' she said, 'you have to smack them, back and front to ween them at all! What joy has the missionary,' she added, her Eyes narrowing and her long Ears moving with Disappointment, 'when all the Heathen greet her with Glory Halleluja ! before she opens her Mouth, and with an Amen ! before she shuts it ! I would,' she said, 'that there were one Woman somewhere that one could take to task for Lethargy. Ah !' she sighed, 'there were many such when I was a Girl, and in particular I recall one dear old Countess who was not to be convinced until I fervid with Truth, had finally so floored her in every capacious Room of that dear ancestral Home, that I knew to a Button, how every Ticking was made ! And what a lack of Art there is in the Upholstery Trade, for that they do not finish off the under Parts of Sofas and Chairs with anything like the Elegance showered upon that Portion which comes to the Eye ! There should,' she added, with a touch of that committee strain which flowed in a deep wide Stream in her Sister, 'be Trade for Contacts, guarding that on which the Lesbian Eye must, in its March through Life, rest itself. I would not, however,' she said, 'have it understood that I yearn with any very great Vastness for the early eighties; then Girls were as mute as a Sampler, and as importunate as a War, and would have me lay on, charge and retreat the night through, as if,' she finished, 'a Woman, be she ever so good of Intention and a Martyr, could wind herself upon one Convert, and still find Strength in the Nape of her Neck for the next. Still,' she remarked, sipping a little hot tea, 'they were dear Creatures, and they have paced me to a contented and knowing fifty. I am well pleased. Upon my Sword there is no Rust, and upon my Escutcheon so many Stains that I have, in this manner, created my own Banner and my own Badge. I have learned on the Bodies of all Women, all Customs, and from their Minds have all Nations given up their Secrets. I know that the Orientals are cold to the Waist, and from there flame with a mighty and quick crackling Fire. I have learned that Anglo Saxons thaw slowly but that they thaw from Head to Heel, and so it is with their Minds. The Asiatic is warm and willing, and goes out like a Firecracker; the

Northerner is cool and cautious, but burns and burns, until,' she said reminiscently, 'you see that Candle lit by you in youth, burning about your Bier in Death. It is time now that I find me a Nightlight, and just what Fusion of Bloods it be, I have not as yet determined, but — I think I have found it.'

'Where!' exclaimed Nip, looking about her with a touch of kindly Apprehension. [...]

— Djuna Barnes, 'May Hath 31 Days', *Ladies Almanack* [1928, reprinted by Dalkey Archive Press, 1992] 30—8

Louis Aragon, Jacques Baron, Jacques-A. Boiffard, André Breton, Marcel Duhamel, Max Morise, Pierre Naville, Benjamin Péret, Jacques Prévert, Raymond Queneau, Man Ray, Georges Sadoul, Yves Tanguy, Pierre Unik 'Research into Sexuality / The Place of Objectivity, Individual Determinants, Degree of Consciousness' (1928)

First Session, 27 January 1927, André Breton, Max Morise, Pierre Naville, Benjamin Péret, Jacques Prévert, Raymond Queneau, Yves Tanguy, Pierre Unik

[...]
BENJAMIN PÉRET Queneau, how do you imagine love between women?

ANDRÉ BRETON Physical love?

BENJAMIN PÉRET Of course.

RAYMOND QUENEAU I imagine that one woman plays the part of the man and the other that of the woman — sixty-nine.

BENJAMIN PÉRET Do you have any direct information on this subject?

RAYMOND QUENEAU No. What I'm saying is drawn from literature and imagination. I have never interviewed a lesbian.

BENJAMIN PÉRET What do you think of homosexuality?

RAYMOND QUENEAU From what point of view? Moral?

BENJAMIN PÉRET If you like.

RAYMOND QUENEAU If two men love each other, I have no moral objections to make to their physical relations.

Protests from Breton, Péret and Unik.

PIERRE UNIK From a physical point of view, I find homosexuality as disgusting as excrement, and from a moral point of view I condemn it.

JACQUES PRÉVERT I agree with Queneau.

RAYMOND QUENEAU It is evident to me that there is an extraordinary prejudice against homosexuality among the surrealists.

ANDRÉ BRETON I accuse homosexuals of confronting human tolerance with a mental and moral deficiency which tends to turn itself into a system and to paralyse every enterprise I respect. I make exceptions thought — among them one for the unparalleled case of Sade, and another, more surprising to me, for Lorrain.

PIERRE NAVILLE How do you justify these exceptions?

ANDRÉ BRETON By definition, everything is permitted to a man like the Marquis de Sade, for whom freedom of morals was a matter of life and death. As for Jean Lorrain, I appreciate the remarkable courage he showed in defending what was, for him, a true conviction.

MAX MORISE Why not priests?

ANDRÉ BRETON It is priests who are most opposed to the establishment of this freedom of morals.

BENJAMIN PÉRET What does Tanguy think of homosexuality?

YVES TANGUY I accept it but have no interest in it.

BENJAMIN PÉRET How do you imagine two men making love and what feelings does this arouse in you?

YVES TANGUY I can imagine it in every possible way. I feel total indifference.

PIERRE NAVILLE Prévert, what do you think of onanism?

JACQUES PRÉVERT I don't think anything about it any more. I used to think about it a lot, once, when I practised it. [...]

Second Session, 31 January 1928, Louis Aragon, Jacques Baron, Jacques-A. Boiffard, André Breton, Marcel Duhamel, Marcel Noll, Benjamin Péret, Jacques Prévert, Raymond

Queneau, Man Ray, Georges Sadoul,
Yves Tanguy, Pierre Unik

[...]
JACQUES BARON Noll, what do you
think of homosexuality?

MARCEL NOLL I can only talk about
homosexuals. I feel nothing but a
deep, visceral antipathy to such people.
There is no similarity whatsoever
between their values and mine.

JACQUES BARON Man Ray?

MAN RAY I don't see any great
physical distinction between the love
of a man for a woman and
homosexuality. It is the emotional
ideas of homosexuals which have
always separated me from them:
emotional relations between men have
always seemed to me worse than
between men and women.

RAYMOND QUENEAU I find these
emotional relations equally acceptable
in both cases.

ANDRÉ BRETON Are you a
homosexual, Queneau?

RAYMOND QUENEAU No. Can we hear
Aragon's view of homosexuality?

LOUIS ARAGON Homosexuality seems
to me to be a sexual inclination
like any other. I don't see it as a
matter for any kind of moral
condemnation, and, although I might
criticise particular homosexuals for
the same reasons I'd criticise 'ladies'
men', I don't think this is the place
to do so.

JACQUES BARON I share that opinion.

MARCEL DUHAMEL I do not believe
that moral viewpoints have any place
in this question. I'm generally
annoyed by the external affectations
and feminine mannerisms of
homosexuals. Nonetheless I've been
able to imagine without revulsion —
for a short space of time — going to
bed with some young man whom I found
particularly beautiful.

JACQUES-A. BOIFFARD Not all
homosexuals indulge in such
affectations. The mannerisms of some
women are more ridiculous, more
annoying, than those of some
homosexuals. I absolutely do not
condemn homosexuality from a moral
point of view. I too have imagined
going to bed with a man without
any revulsion. Though I haven't
done it.

ANDRÉ BRETON I am absolutely
opposed to continuing the discussion
of this subject. If this promotion of
homosexuality carries on, I will leave
this meeting forthwith.

Jean Cocteau, *Le Livre Blanc*, 1928—29

LOUIS ARAGON It has never been a
question of promoting homosexuality.
This discussion is becoming reactive.
My own response, which I would like to
elaborate upon, isn't to homosexuality
so much as to the fact that it has
become an issue for us. I want to talk
about all sexual inclinations.

ANDRÉ BRETON Do people want me
to abandon this discussion? I am quite
happy to demonstrate my
obscurantism on this subject.

RAYMOND QUENEAU Do you condemn
everything that is called sexual
perversion, Breton?

ANDRÉ BRETON In no way.

RAYMOND QUENEAU Which perversions
don't you condemn?

ANDRÉ BRETON All apart from
the one we have been discussing for
too long. [...]

— 'Research into Sexuality / The Place of
Objectivity, Individual Determinants,
Degree of Consciousness',
La Révolution Surréaliste, no. 11
[15 March 1928], reprinted in
*Investigating Sex: Surrealist
Discussions, 1928—32*, ed. José
Pierre [Verso, London, 1992] 4—29

Jean Cocteau
'The White Book' (1928)

[...] Sickened by emotional adventures,
incapable of reaction, I dragged
my feet and my soul. I sought the

consolation of a more secretive atmosphere. I found it in a working-class *établissement de bains*. It was reminiscent of the *Satyricon* with its little cells, its central courtyard and its low room decorated with Turkish divans where young men sat playing cards. At a sign from the proprietor they would get up and stand in a row along the wall. The owner would feel their biceps, squeeze their thighs, uncover their intimate charms and offer them as a salesman offers his wares.

The clients were sure of their tastes, quick and discreet. I must have been a problem for these young men who were accustomed to precise demands. They looked at me without understanding; for I prefer talk to action.

My heart and instinct combine in such a way that I find it difficult to commit either without the other following. This is what leads me to cross the boundaries of friendship and makes me wary of casual contacts in which I risk catching the malady of love. In the end I envied those who do not suffer vaguely from beauty, know what they want, bring a vice to the point of perfection, pay, and satisfy it.

One man wanted to be insulted, another weighed down with chains, another (a moralist) could only find enjoyment in the spectacle of a Hercules killing a rat with a red-hot needle. How many sensible people I saw, who knew the exact recipe for their pleasure and whose existence was simplified because they bought themselves, on a fixed day, at a fixed price, an honest, bourgeois complication! Most of them were rich industrialists who came from the north to satisfy their needs and then rejoined their wives and children.

In the end I spaced out my visits. My presence was beginning to look suspicious. The French find it difficult to tolerate a character that is not true to type. The miser must always be miserly, the jealous man jealous. This explains the success of Molière. The proprietor thought I was attached to the police. He gave me to understand that one was either buyer or seller. One couldn't be both.

This warning jolted me out of my laziness and forced me to break with unworthy habits, to which was added the memory of Alfred perpetually floating over the faces of young bakers, butchers, cyclists, telegraph boys, zouaves, sailors, acrobats and other professional masks.

One of my few regrets was the two-way mirror. You went into a dark cabin and opened a shutter. This shutter revealed a metallic canvas through which the eye could see a small bathroom. On the other side of the canvas was a mirror that reflected so well from such a smooth surface that it was impossible to guess that it was full of eyes.

Due to financial reasons I happened to spend a Sunday there. Out of the twelve mirrors in the twelve bathrooms it was the only one of this sort. The owner had acquired it for a very high price and had had it brought from Germany. His staff were unaware of the observatory. The young working-class men supplied the show.

They all followed the same routine. They undressed and hung up their new suits carefully. Once they were out of their Sunday best their delightful professional deformities made it possible to guess their jobs. Standing up in the bath, they would look at themselves (and me) and begin by a Parisian grimace that bares the gums. Then they would rub one shoulder, pick up the soap and make it lather. The soaping turned into a caress. Suddenly their eyes left the world, their head would fall back and their body spit like a furious animal.

Some of them sank down exhausted into the streaming water, while others began the same procedure all over again; the youngest ones were distinguishable because they climbed out of the bath and wiped from the tiles the sap that their blind stems had hurled distantly, madly, towards love. Once, a Narcissus who was pleasuring himself, brought his mouth up to the mirror, glued it to the glass and completed the adventure with himself. Invisible as a Greek god, I pressed my lips against his and imitated his gestures. He never knew that the mirror, instead of reflecting, was participating, that it was alive and loved him.

— Jean Cocteau, *Le Livre Blanc*, first published anonymously [Editions des Quatre Chemins, Paris, 1928], reprinted as *The White Book*, trans. Margaret Crosland [Peter Owen, London, 1969] 48–55

Colette
'The Pure and
The Impure' (1941)

[...] How timid I was, at that period when I was trying to look like a boy, and how feminine I was beneath my disguise of cropped hair. 'Who would take us to be women? Why, women.' They alone were not fooled. With such distinguishing marks as pleated shirt front, hard collar, sometimes a waistcoat, and always a silk pocket handkerchief, I frequented a society perishing on the margin of all societies. Although morals, good and bad, have not changed during the past twenty-five or thirty years, class consciousness, in destroying itself, has gradually undermined and

debilitated the clique I am referring to, which tried, trembling with fear, to live without hypocrisy, the breathable air of society. This clique, or sect, claimed the right of 'personal freedom' and equality with homosexuality, that imperturbable establishment. And they scoffed, if in whispers, at 'Papa' Lépine, the Prefect of Police, who never could take lightly the question of women in men's clothes. The adherents of this clique of women exacted secrecy for their parties, where they appeared dressed in long trousers and dinner jackets and behaved with unsurpassed propriety. They tried to reserve for themselves certain bars and restaurants and to enjoy there the guilty pleasures of backgammon and bezique. Then they gave up the struggle, and the sect's most stubborn proselytes never crossed the street or left their carriage without putting on, heart pounding, a long plain cloak which gave them an excessively respectable look and effectively concealed their masculine attire.

At the home of the best-known woman among them — the best known and the most misunderstood — fine wines, long cigars, photographs of a smartly turned-out horseman, one or two languorous portraits of very pretty women, bespoke the sensual and rakish life of a bachelor. But the lady of the house, in dark masculine attire, belied any idea of gaiety or bravado. Pale, without blemish or blush, pal like certain antique Roman marbles that seem steeped in light, the sound of her voice muffled and sweet, she had all the ease and good manners of a man, the restrained gestures, the virile poise of a man. Her married name, when I knew her, was still disturbing. Her friends, as well as her enemies, never referred to her except by her title and a charming Christian name, title and name alike clashing with her stocky masculine physique and reserved, almost shy manner. From the highest strata of society, La Chevaliére, as we shall call her, was having her fling, sowing her wild oats like a prince. And like a prince, she had her counterparts. Napoleon III gave us Georges Ville, who survived him for a long time. La Chevaliére could not prevent this man-woman, deathly pale, powdered, self-assertive, from exhibiting herself and signing the same initials as her model.

Where could I find, nowadays, messmates like those who, gathered around La Chevaliére, emptied her wine cellar and her purse? Baronesses of the Empire, canonesses, lady cousins of Czars, illegitimate daughters of grand-dukes, exquisites of the Parisian bourgeoisie, and also some aged horsewomen of the Austrian aristocracy, hand and eye of steel [...]Some of these ladies fondly

kept in their protective and jealous shadow women younger than they, clever young actresses, the next to the last authentic demimondaine of the epoch, a music-hall stair…You heard them in whispered conversation. […]

— Colette, *The Pure and The Impure* [1941], reprinted in *New York Review of Books* [2000] 70—72

BRASSAÏ
'Sodom and
Gomorrah' (1946)

Le Monocle

Although Paris in the thirties had a few intimate bars where women could meet among themselves, the sumptuous, specialized night clubs of the Champs-Elysées, Montmartre, or Montparnasse — like Frida, Quolibet, 'weaker' sex — did not exist in those days. The Monocle, on the Boulevard Edgar-Quinet, was one of the first temples of Sapphic love, as famous in its day as its neighbour, the fashionable Montparnasse bordello known as Le Sphinx.

I was introduced to this capital of Gomorrah one evening by Fat Claude, who was an habituée of such places. From the owner, known as Lulu de Montparnasse, to the barmaid, from the waitresses to the hat-check girl, all the women were dressed as men, and so totally masculine in appearance that at first glance one though they were men. A tornado of virility had gusted through the place and blown away all the finery, all the tricks of feminine coquetry, changing women into boys, gangsters, policemen. Gone the trinkets, veils, ruffles! Pleasant colors, frills! Obsessed by their unattainable goal to be men, they wore the most sombre uniforms: back tuxedos, as though in mourning for their ideal masculinity … And of course their hair — woman's crowning glory, abundant, waved, sweet-smelling, curled — had also been sacrificed on Sappho's altar. The customers of Le Monocle wore their hair in the style of a Roman emperor or Joan of Arc. Even their perfumes — frowned on here — had been replaced by Lord knows what weird scents, more like amber or incense than roses and violets.

As I watched these women dancing slowly together, pressed close against each other, their breasts touching, I thought of Marcel Proust, of his jealousy, his sick curiosity about the foreign pleasures of Gomorrah. The fact that Albertine had been unfaithful to the narrator with a woman bothered him far less than the kind of pleasures she had experienced with

her partner. 'What can they really be feeling?' he continually wondered.

Sometimes a few outsiders would try to get into the fold. Some girls for whom lesbianism seemed less of a risk than an affair with a man would disguise themselves as tomboys in order to earn a little money. However, the masculine female clientele looked at these fake lesbians, sized them up, judged them, and unmasked them with a glance. For that matter, one-night stands didn't interest them. These women, their passions slower to ignite, generally looked for more devotion and fidelity in their love affairs than do pederasts, most of whom cruise a lot and are often content with a quick trick. In the female bars, there was also more discretion and probity than in male gathering places. Evenings at Le Monocle never got as frenetic as those at the Carrousel or Madame Artur's, the capitals of Sodom in those days.

Lulu de Montparnasse, the owner of Le Monocle, was a masterful woman with a husky build, whose stentorian voice filled the room. She left Montparnasse a few years later for Monmartre, and raised the standard of Sapphism in the Rue Pegalle.

The Ball at 'Magic City'

In 1933, I attended a strange ball: the last of the big homosexual balls at Magic City. The cream of Parisian inverts was to meet there, without distinction as to class, race, or age. And every type came, faggots, cruisers, chickens, old queens, famous antique dealers and young butcherboys, hairdressers and elevator boys, well-known dress designers and drag queens, the Duchess Zoé, the Peruvian, Memosa and Peaches, Mignon and Divine, the Blonde and Notre-Dame-des-Fleurs, the Baron de Charlus and the tailor Jupien, every Albert and André — metamorphosed for this great night into Andrée and Albertine […]

They arrived in small groups, after having emptied the closets of the fairer sex: dresses and corsets, hats, lingerie, wigs, jewelry, necklaces, mascara, creams and perfumes […] Everyone wore silk flowers, garlands, ropes of pearls, feathers, trinkets […] Of course most of them were in dressmaking, lacemaking, furs, hairdressing — creators of hats, ribbons, embroidery, fabrics, laces […] Almost all of them had devoted their lives to dressing, beautifying, deifying women, making them seductive and attractive for others to love — for they certainly didn't.

Every entrance and every costume gave rise to shrieks of surprise, cries of astonishment, of joy. They embraced, they showered each other with compliments, they admired and kissed. They camped and teased

each other with squeals of delight. An immense, warm, impulsive fraternity. There were monstrous couples, grotesque couples, some were surprising and even heart-warming. Two young men wrapped in each other's arms had — to demonstrate the perfect union of their souls, their bodies — dressed in a single suit: one was wearing the jacket, with his legs and buttocks naked; the other wore the pants, his torso and feet bare, since he had given his boyfriend the only pair of shoes.

Most of the couples were less well matched, however. Mature men accompanied by youths in drag were the rule. With hair by Antoine, clothes by Lanvin or Madeleine Vionnet, the great couturiers of the period, some of these ephebes on the arms of their rich protectors were extremely beautiful and elegant. They had figures like fashion models. And I saw many enigmatic, unidentifiable creatures, floating between the poorly drawn barrier between the sexes in a sort of no man's land. There were long, fragile necks, smooth doll-like faces, peaches and cream complexions, platinum hair set off by a camellia or a red carnation. And what about the low necklines that often revealed the swelling of breasts? In those days, they were already making them out of rubber, built into a brassiere. Or were they real breasts, hermaphrodite breasts? Hormone treatments hadn't yet been invented, nor had operations to alter sex surgically […] These creatures who lent such an ambiguous tone to the evening were obviously the forerunners of the Coccinelles and the Bambis — the great contemporary Parisian drag queens — today's celebrated stars of Parisian night life, appearing in so many all-male night clubs.

With humour, with self-mockery, many 'old aunties' dressed the part. In fact, noisy and picturesque, they gave life to the evening. With their gem-laden fingers, they would lift their ruffled skirts and petticoats like French cancan dancers, revealing their feminine undergarments: silk slips, lace panties, embroidered jockstraps, garters around their muscular, hairy calves. And the curls, the blond wigs that hid balding heads! Pigtails, curls falling into mascaraed eyes, the pupils dilated with belladonna. Here and there were heads crowned with huge old-fashioned bonnets loaded with feathers or ribbons, or the enormous cartwheel hats of the Gay Nineties. And these middle-aged nellies in their finery and their glad-rags would utter piercing shrieks, join hands, and dance wildly together. There were no indiscreet onlookers here to make them uneasy. No threatening opprobrium from 'normal' men, no humiliating female disdain, no

inquisitorial vice squad surveillance looking for outrages to public decency. On that night, the 'love that dares not speak its name' said it loud and clear, shouted it from the rooftops [...]

— Brassaï, 'Sodom and Gomorrah', *The Secret Paris of the 30's* [Editions Gallimard, Paris, 1976], trans. Richard Miller [Thames & Hudson, Lodon, 1976] unpaginated

Kermit Champa
'Charlie Was Like That' (1974)

In my painting of Orchids which Charlie did – the one called *Pink Lady Slippers* [1918] he was interested in the similarity between the forms of the flowers and the phallic symbol, the male genitals. Charlie was like that.
— William Carlos Williams, quoted in Emily Farnham, Charles Demuth, *Behind A Laughing Mask*

Charles Demuth's greatest American contemporary, John Marin, was unique in passing through the first third of the century in America with serene, almost sublime, sensuous and pictorial self-confidence, working in a boldly conceived — yet highly unique landscape style derived somewhat randomly from Fauvism, Cubism, and Futurism. But Marin was a-typically strong personally and artistically. Others were equally strong and confident personally, but artistically inconsequential. Only Demuth approached Marin on the level of artistic quality (both actual and potential). But lacking innate sensuous confidence, he had to fabricate a substitute.

Fabricating a substitute meant for him the grafting of modernism to a uniquely personal and at the same time dependable imagistic base, and in Demuth's case that base was achieved in rarefied cerebral emblems of sexuality perceived by him to be unnatural. Once these were established he could proceed with a sense of self-reliance and originality in the domain of imagery and direct his efforts toward estheticizing, or more properly, 'spiritualizing' that imagery into something pure and unphysical.

Out of the process of refining the overt quirkishness of his imagery by a selective overlay of surface effects carefully gleaned from French and German modernism and from more than a few Old Masters, Demuth ultimately made his art an esthetically significant confessional of spiritualized personal (and national) immaturity.

Necessarily rejecting Marin's pictorial bluster, Demuth turned epicurean. For him, this meant simultaneously savoring the flagrant and cultivated sexual inclinations which he viewed as personal weaknesses, and making those weaknesses the most dependable sources of his creative strength.

It appears to this writer at least that some attempt must be made straightaway to give an account of Demuth's sexuality — across the board, so to speak — in order to proceed from the comparatively straightforward externals of his life and his work to a more basic comprehension of its true pulse and, by extension, its meanings and the sources of its distinct qualities. Sexuality, its varieties and its importance, are difficult enough to discuss with conviction in the work of any primarily visual artist. With Demuth whose skill at personal disguise was both consistent and nearly all-encompassing, the difficulty of discussion (and the potential for error) is overwhelming. Yet an attempt must be made; the paintings in their provocativeness seem to demand it. There is, finally, more potential for error in avoiding the issue of cultivated sexuality in Demuth than in phrasing it wrongly. To avoid it means to overlook so much contained in so many images that there remains too little left to see, and Demuth wanted his pictures seen above all.

Generically speaking, the sexuality which is, in varying degrees of explicitness, present in Demuth's work (particularly after 1915), quite self-consciously bespeaks unnaturalness or 'corruption', to use the language of Henry James' *Turn of The Screw*, one of Demuth's favorite tales and the theme of a series of illustrations done in 1917–18. Presumably Demuth's particular 'corruption' was ultimately homosexual — to judge from the most overt visual documents which remain. Yet to call the playful and troubling sexual suggestiveness of his work from the teens strictly homosexual is to miss the mark — randomly sexual, yes, distinctly homosexual, no. From this comparatively early and productive period in Demuth's life, sexual innuendos, whether represented by actual figures or indirectly by flowers or other plant life are ambiguous and pictorially supportive. Later on in the 1920s, as industrial and still-life paintings become increasingly programmed to elicit the shapes of genitalia, usually male, overt sexual imagery emerges and appears dominantly homosexual; and much later in the early 1930s when this imagery becomes flagrantly, almost defensively, explicit, the result is pictorial disaster.

The longer one looks over the whole of Demuth's work, the more it is apparent that his achievement of

quality seems to have depended more often than not upon the imagistic tension, resistance, or perhaps perverse security of sexual imagery, although it was the tension of concealment rather than the overt statement of that imagery that was important. Overtness in Demuth collapses tension and with it quality. The real content of sexual tension in Demuth's best work is not much more or less than the kind of adolescent feeling of naughtiness so stimulating to a child of puritan upbringing at even the mention of a mildly dirty word. This tension exists for as long as a person's interpersonal physical sexuality remains unexplored. For this reason, one tends to doubt the fact of much real sexual experience of any sort for Demuth prior to his ultimate surrender to homosexuality rather late in life. One suspects that sexuality was for him far more mental than physical throughout his life, and for that reason it informed his art in very special ways.

In a highly self-conscious, yet esthetically productive way, homosexual feelings succeeded on a regular basis in stimulating the puritan raw material of guilt (combined with fascination) in Demuth and in sublimating that force into painting. The direct physical sensations of nature alone were never comparable in their creative effect on Demuth to the filtering of those sensations through a screen of guilt, sponsored by what he saw as unnatural sexual associations. Demuth was, of course, hardly alone in cultivating sexual guilt to produce a consciously perverse style. By the turn of the century, elaborate codes of sexual self-presentation had become relatively commonplace and had already proven their potential as a positive stylistic force. This esthetic potential of homosexual sensation clearly evident in the writings of men as otherwise separate as Oscar Wilde and Robert McAlmon, provided Demuth with the encouragement he needed to translate the substance of his confused sexuality, whether genuine or feigned at its source, into a kind of sickly — sometimes pretty, sometimes heavy and downright morbid – decorousness in his mature art. Whether in figures, flowers, factories, or still lifes of fruit, the drive to submerge decorously but without total concealment naughty and frequently chaotic sexual suggestions seems to establish a goal, or completion point, in the conversion of a motif into a painting.

With totally abstract art still too new and too threatening, and with forthrightly sensuous realism so clearly at odds with the substructure of Demuth's whole personality, the discovery and cultivation of emblems denoting complex if unclear sexual feeling were critical to the

achievement first, of dependable pictorial quality and second, of an ongoing method whereby that quality could be obtained with some semblance of routine beyond that already provided by literary sequence in his illustrations.

The curiously inverted and declared 'unnaturalness' of Demuth's artistic personality, while original in detail, location, period, accomplishment, and general purpose, was hardly unique in type. Very little insight is required to posit the source, which was English and of an earlier date – roughly 1895. Both the manner and the substance of the London world of Oscar Wilde and Aubrey Beardsley cast an unbroken spell over Demuth's entire life. The Whistler-cum-Huysmans brew of English 'decadence' seemed as psychologically true to Demuth as Picasso's and Matisse's paintings ultimately seemed esthetically true. The fact that Wilde and Beardsley regularly used their own homosexuality to incontrovertible esthetic advantage firmly supported Demuth's half-studied, half-compulsive inclinations in the same direction. Like them, Demuth followed Whistler's example of how an artist should act, what he should say, and how he should say it. Like them, too, he read and reread the handbook of fantasy, Huysmans' À Rebours, to learn what unnatural sensations might be had and how one might have them. The title of Huysmans' work, suggesting the direction of the sensibility it portrayed, translates into 'against the grain' or 'against nature'.

Huysmans' book is one of the comparatively few things which Demuth is known to have read with enthusiasm and which he recommended to friends. Reading À Rebours with Demuth in mind is an even more revealing exercise than one might suspect. It seems hard to fathom, at least initially, why this book even more than its more fashionable and refined successor (of Demuth's own day), Proust's Remembrances, impressed itself so firmly on Demuth's mind. But while Proust provided so much sensation that Demuth found Remembrances heavy and overextended, Huysmans provided just enough individual sensations, all of the right sort, with no one sensation pushed descriptively beyond the bounds of clinical curiosity and seemingly rational analysis.

À Rebours appears to have provided the code which first initiated various forms of Demuth's nonliterary imagery and which ultimately keyed its overall meaning. Coming at the critical, if not the historical end of the tradition of the realist novel in France, À Rebours represents a sensibility utterly satiated to the point of sexual impotence with the real sensations of nature. In order to continue existing at all, Duc Jean des Esseintes, the central character, is driven to construct new sources of sensation from indirect or artificial means. Living in a virtually windowless house, existing more by night than by day, and cut off from all contact with the outside world, des Esseintes first creates and then experiences oral and olfactory 'symphonies' of liquors and rare perfumes. He uses the most rarefied and refined of books to experience vicariously travel, religion, and whatever he deems worthwhile in the world outside. The paintings of Gustave Moreau, particularly his *Salomé*, and later the grotesque (almost necrophilic) blossoms and leafage of exotic plants provide des Esseintes with means of stimulating his mind to erotic reverie. When his memories turn directly, if inadvertently, to the female body, he sets them to rest by recalling from earlier days his even greater sexual excitement at the sight of the two great man-made ladies – new locomotives recently put into service by the French national railways. The voluptuous sensation of specific machines thus recalled, des Esseintes' impulse to recall the physical source of real sexuality is obviated. However, he does toward the end of the narrative entertain the specific memory of one experience of the body which remains exciting in its imagined fictions, if not in what des Esseintes saw as its squalid facts.

Once having visited the circus, des Esseintes was struck by a female acrobat – an American girl named Miss Urania, 'with a supple figure, sinewy legs, muscles of steel and arms of iron.' Huysmans describes the progress of des Esseintes' reaction to the girl as follows:

'Little by little as he watched her, curious fancies took shape in his mind. The more he admired her subtleness and strength, the more he thought he saw an artificial change of sex operating in her; her mincing movements and feminine affectations became ever less obtrusive, and in their place there developed the agile, vigorous charms of a male. In short, after being a woman to begin with, then hesitating in a condition verging on the androgynous, she seemed to have made up her mind and become an integral unmistakable man.

In that case, [des Esseintes said to himself] just as a great strapping fellow often falls for a slip of a girl, this hefty young woman should be instinctively attracted to a feeble, broken down, short-winded creature like myself.'

By dint of considering his own physique and arguing from analogy, he got to the point of imagining that he for his part was turning female; [...] this exchange of sex between Miss Urania and himself had excited him tremendously. The two of them, so he said, were made for each; and added to this sudden admiration for brute strength, a thing he hitherto detested, there was also that extravagant delight in self-abasement which a common prostitute shows in paying dearly for the loutish caresses of a pimp.

Meanwhile, before deciding to seek the acrobat and see if his dreams could be made reality, he sought confirmation of those dreams in the facial expressions she unconsciously assumed, reading his own desires into the fixed, unchanging smile she wore on her lips as she swung on the trapeze

Having seduced the acrobat, des Esseintes discovered that she offered 'no justification for the cerebral curiosity she had aroused,' and that she was unfortunately 'not subject, as he had for the moment hoped she might be, to sexual fluctuation.' Yet the cerebral excitement she had caused remained in des Esseintes' mind justifying itself despite the absence of physical confirmation.

While it is unlikely that any European reader of À Rebours 20 or 30 years after its publication in 1884 could have experienced afresh its rapier like incidents of sensation, particularly its eroticism, an American like Demuth could have and probably did. For an American of Demuth's generation Zola's *Nana* and Huysmans' À Rebours were, in spite of their age and their differences of perspective, morally if not officially proscribed texts. They could be read only at the risk of moral corruption, but that fact alone made them continuously attractive for any American seeking to become cosmopolitan. Significantly, *Nana*, the most formidable realist presentation of the life-passage of a modern *femme fatale*, became the text for Demuth's first series of watercolor illustrations, while À Rebours established the sexual coding – whether elaborated or not – of his flowers, his acrobats, and later his machines.

What was perhaps most valuable for Demuth in Huysmans' code was its comprehensiveness. Its range of sexual transmutations both in general scope and precise effect was exceptionally broad. Nearly everything which Demuth wanted to paint was preeroticized by Huysmans, but the options of stress or nonstress were left marvelously open. The choice of how definitely or indefinitely his own emblems should be formed rested fortuitously on Demuth's inclinations of the particular moment – inclinations either of a stylistic or of a programmatic sort. What was also extremely supportive about À Rebours was the fact that it was a book. Its codes were literary in origin, if not in development, and as such safer and more available to Demuth in their

predefined sensuousness than any comparable codes he might have gleaned from nature or from painting.

Yet for all the stimulations and license of Huysmans, and of Beardsley and Wilde as well, it seems doubtful whether the 1890s quality of Demuth's attitude could have been productive after 1910 even in America were it not for the fact of the reinforcement of that attitude by more contemporary ideas and events. One of these was the near mania for amateur Freudian analysis that existed in New York during the war years. Besides being directed at people, the fad extended — as it has ever since — to the earnest and playful search for phallic and vaginal symbolism in seemingly neutral objects. This particular aspect of Freudianism coupled with an elementary comprehension of phobias, fantasies, complexes, and sublimations could quite easily have led anyone with Demuth's sensibility to experience 'decadence,' not only with the delight of initial discovery, but also with a sense — probably an intellectually false sense — of ultimate comprehension. With Freud as a means of clarification, the sensuous mysteries of 'decadence' became at once deeper, yet less puzzling, and, finally, capable of even greater refinement than 'decadence' itself had ever achieved.

'I Remember, Of Course, Marcel Duchamp'

Combined with the reinforcement to 'decadence' of Freudianism were the contemporary uses to which Freudian association had already been put in the context of the most contemporary and available European art of the day. Marcel Duchamp and Francis Picabia arrived in New York in 1915, shortly after the outbreak of war in Europe. Both men had quite recently parted with Cubism over the issue of definiteness, preferring to cultivate an art of precise — or seemingly precise — cross-reference between human and machine forms. As a contrast to the loose and objectively unpressing studio imagery of Cubism, Duchamp and Picabia chose to develop a richness of mental associations culled from the complicated modern world around them.

Of the two painters, Duchamp made the more exciting artistic and public moves. Picabia, for the most part, just painting, producing a sequence of images which either combined fairly literal mechanistic forms in such a way as to imply anatomical associations (frequently sexual in nature), or which simply renamed mechanical images so as to invoke some appropriate sort of human presence or activity. Duchamp, on the other hand, developed elaborate artistic strategies. Some of them required a lot of handwork to

achieve and some simply involved the finding and 'titling' of a readymade object. Probably the most famous of Duchamp's Readymades and the one which impressed his contemporaries most forcefully was his *Fountain*, an object nothing more or less than a mass-produced urinal. Having separated the urinal from its normal context and having given it an artistic yet rather rational title, Duchamp succeeded in making the object press those viewing it to recognize, with a mixture of humor and discomfort, its rather outlandish eroticism — an eroticism bred by the object itself but heightened enormously by its removal from the men's room and its introduction into the art gallery. Whatever the viewer's reaction to the urinal, the artist, Duchamp, could not be held fully responsible, a state of personal removal which increasingly appealed to Demuth as his work progressed. As many associations, as much or as little meaning could be imposed by the viewer while all the artist had done was to select the object and to alter its setting — or at least so it was thought. But was Duchamp's selection all that pure and simple? Certainly a urinal was common and readymade, but it was a urinal. As such, its potential for stirring in a situation of unaccustomed isolation, erotic as well as scatological associations was predictable both before and after the fact, and Duchamp pretty clearly took that potential into account in making his selection of this particular Readymade. What the *Fountain* finally constituted more than anything else was the brilliant discovery within the world of the Readymade and the everyday of the perfect Freudian symbol, flagrantly obvious and stimulating once it was discovered, but utterly untranslatable and, as a result, perversely pure. Phallic? Vaginal? It was a man-made female object for exclusive male functions. Yet, who could characterize it precisely? Other Duchamp Readymades approached the Freudian perfection of the *Fountain*, but none ever successfully equaled it.

There is a fundamental resonance between the Freudianism of Duchamp's New York Dada and the much more open-ended elaborations of sexual association and transmutation in the tradition of 'decadence'. While this resonance was generated most consistently by Duchamp, it seems to have been understood most profoundly by his friend Demuth. Demuth admired Duchamp, and spent much time in his company both in New York and later in 1921 in Paris. He even wrote and published a poem 'For Richard Mutt' to the manufacturer and hence the signer of Duchamp's urinal. The first two lines of his poem suggest that he understood Duchamp's accomplishment, as outlined above, completely.

One must say everything — then no one will know

To know nothing is to say a great deal.

Along with the *Fountain* another of Duchamp's works — a handmade rather than a readymade — seems to have attracted Demuth perhaps even more and over a much longer period. This was The *Bride Stripped Bare by Her Bachelors, Even*, the large construction on glass, worked on from 1915–23. Demuth thought it a very great achievement. He recalled and emphasized its greatness in a letter to Stieglitz of February 5, 1929. 'The big glass thing, I think, is the great picture of our time.' Great was not a word Demuth used lightly, but rather one which he reserved for use in his most special blessings. In another letter to Stieglitz, one from a slightly earlier date (November 14, 1926), he had, however, applied the word to the accomplishments of two other men '[…]Aubrey who with Oscar I still find to be great.'

At the risk of forcing a point, it is possible to suggest that Duchamp's *Bride Stripped Bare by Her Bachelors, Even* and Demuth's true understanding of it provides the quintessential clue to Demuth's basic sense both of meaning and of quality in art — a sense which his own work tried itself to contain. Few people could have brought to this or any other of Duchamp's works the particular kind of responsiveness that Demuth had simultaneously to 'decadence,' Freudianism, and New York Dada. Even fewer would have probed the relationship between Duchamp's apparently after-the-fact title, the imagery of his great glass painting, and its probable feedback not only to earlier points in Duchamp's own work, but also to a most memorable 'event' in the endless and frequently bizarre wartime party circuit in New York — a circuit traveled regularly by Duchamp, Demuth, Arensberg, and William Carlos Williams, among many others. Just how frequently this event happened cannot be determined very precisely, but it was sufficiently remarkable for Williams to record it in detail in his *Autobiography*, for Duchamp ultimately to translate it into the purity of mechanical forms on glass, and for Demuth to nod his head slightly in comprehension and approval. The following is Williams' written record of his experience.

I was a bit late and the small room was already crowded — by Frenchmen mostly. I remember, of course, Marcel Duchamp. At the end of the room was a French girl, of say eighteen or less, attended by some older woman. She lay reclining upon a divan, her legs straight out before her, surrounded

by young men who had each a portion of her body in his possession which he caressed attentively, apparently unconscious of any rival. Two or three addressed themselves to her shoulders on either side to her elbows, her wrists, hands, to each finger perhaps, I cannot recall — the same for her legs. She was in a black lace gown fully at ease. It was something I had not seen before. Her feet were being kissed, her shins, her knees, and even above the knees, though as far as I could tell there was a gentlemen's agreement that she was to not be undressed there.

This 'phenomenon' itself constituted a kind of Readymade, introducing into America a profound and uniquely real event of European 'decadence' — an event sufficiently disturbing in its comprehensive unnatural eroticism to have stamped itself clearly on Williams' mind. As a doctor and as a well-traveled man of the world, Williams was hardly a stranger to visions and events of the flesh, but this 'appearance' was *sui generis*, and he never forgot it. The combination of absolute reality and rampant 'decadent' symbolism was sufficient to make even the most purple passages of imaginary 'decadence,' whether written or painted, seem pale by comparison. Here was a kind of mythic bride simultaneously regaled and defiled by her bachelor attendants. Here was France passively, almost mechanically, distributing her favors willingly or unwillingly to the world, even while herself in exile. Here was sordidness for which no pure or conceivable redemptive explanation could possible by given. And, yet, Duchamp seems to have sensed, whether for reasons of nationalism, subtlety, or sheer perverseness, a need to conceive the inconceivable — to redress and purify the 'appearance' in machine forms on glass and to produce in that state a didactic stained-glass window for the chapel of a new religion whose theology remained to be determined. Of that theology one could only say that its prophets were sexually active Dada machines, its prophesies and behavioral ethics as 'against the grain,' if as apparently pure, as the voices enunciating them.

Demuth understood the religion Duchamp had glimpsed in the revelation of the unnatural bride. A convert before the fact, Demuth was soon to experience for himself both the fascination and the fickleness of the new gods of the machine, just as he had already experienced the related, equally potent, but not so new gods of 'decadence' as well. Like Duchamp, Demuth was ultimately out to spiritualize their flagrantly unspiritual declarations and appearances by making them appear esthetically

pure, if by definition unnatural and threatening when approached in any other way.

— Kermit Champa 'Charlie Was Like That', *Artforum*, no. 12 [March 1974] 5—59

Laura Doan
'Fashioning Saphism: The Origins of a Modern English Lesbian Culture' (2001)

[...] What we have become accustomed to reading as distinctively lesbian, I would argue, might represent something else, perhaps something Modern. And if this is the case, all of the ostensibly determinant signifiers of lesbianism — smoking, trousers, monocle — suggested any number of interpretive possibilities in the 1920s. [...]

Women such as Hall, Troubridge, and Gluck are today easy for us to identify as lesbians, but it is important to remember that they appeared quite differently to the press and the public in the 1920s. For example, on August 22, 1928, two days before the banning of *The Well of Loneliness*, the *Newcastle Daily Journal and North Star*, commented that Hall was 'a most arresting personality, she may frequently be seen at West End theatres dressed in what is, save for a tight skirt, a gentleman's evening dress suit, with white waistcoat complete. She wears her Titian hair in a close Eton crop, and looks the strong silent woman to the life. With her notably fine forehead and beautiful hands, her whole aura is high-brow modernism'. [...][1]

Hall's version of the masculine, mode in the mid-1920's signalled not a loss of femininity but, rather, its redefinition within modernity. Certainly an observer most qualified to comment authoritatively on Hall's appearance would be the sexologist responsible for setting the record straight, Havelock Ellis. Upon meeting Hall in April of 1928, he observed that she was 'terribly Modern & shingled & monocled'.[2]

Hall and Troubridge shopped prodigiously, and Troubridge kept a meticulous record of the shops they patronized, the particular items they purchased, and when they returned for fittings and refitting. Tracking this shopping record over the decade reveals that the couple's sartorial progress was not only on the forefront of fashion but was also on an upward spiral, from respectable middle-class shops, such as Gamages and Barkers, in the early twenties on to more elite and expensive shops by the middle of the decade. Harrods,

for instance, recurs frequently in the diary from 1926 onward, as does Weatherill's. The couple's wardrobe was noticed by journalists because it was distinctively splendid — the clothing put them among the in crowd. In February 1924 Hall appeared in a photograph in the *People* in a tailor-made suit.[3] In the same month the *Tatler* reported: 'A few weeks ago and women were looking askance at the tailor-made [suit] — today it is on the crest of the wave[...] [Some] coats are cut on the lines of a man's dinner-jacket, and they are accompanied with fitted waistcoats of piqué or crêpe de chine enriched with embroidery[...]. Capes take the place of the coat in some of the tailor-mades.[4] When cape coats were fashionable, Hall wore cape coats; when the Spanish hat came into vogue, Hall could be seen in one — again both items were not part of the mainstream but aligned Hall with the far edge of a style favoured by the most daring or artistic. Even so, a 1926 Harrods advertisement featured a 'dashing military cape,' an item characterized by another fashion observer as 'absolutely indispensable to the woman of fashion today.'[5] The cape and Spanish bolero together became a popular combination in 1926: 'The bolero in some form or other is as often present on race frocks as it is on evening gowns, and is frequently reinforced with a cape.'[6] Hall was seen in this hat at the obscenity trial and thus in many newspapers at the time, but a random sampling of newspapers and magazine from the autumn of 1928 indicates that the hat would have been regarded as striking but not unusual. A photograph of the artist Laura Knight in the Spanish hat, for instance, suggests that the headwear was the choice of the artistic.[7]

Far from being perceived as the inventor and embodiment of a deviant mannish lesbian style, Hall was seen as a thoroughly modern woman. [...] Observers repeatedly drew attention to Hall's striking 'shingle,' dubbed the best in London. Although her shingle may look masculine to us, in the 1920s it was considered the most feminine of short haircuts (the Eton crop being the most severely masculine). Hall's hair was cut and styled at Harrods, not at a barber shop, and her curls added a highly feminine touch to her famous shingle rather than being 'an exotic imitation' of masculine 'sideburns'.[...]

One final example of how biographers who do not understand fashions of the twenties misread their subjects is evident in Richard Ormrod's analysis of the famous portrait of Troubridge by Brooks: 'Why Una chose to pose in such a very masculine 'get-up (black jacket, white starched shirt, monocle) is debatable, and it certainly leaves the viewer in little doubt as to her proclivities.

Perhaps that was the point, a public statement of commitment to a cause'.[8] Baker too describes the outfit as a 'long dark severely cut jacket and pinstripe skirt over a white shirt with stiff wing collar and stock' and continues, 'Whatever her original intentions Romaine finished by creating a brilliant caricature of Una, one that caught both her eccentricity and that element of class arrogance.'[9] Brooks's biographer calls the portrait a 'tour de force of ironic commentary.'[10] Such readings are only partially accurate: the element of class is undeniable (Troubridge adopted the title of 'Lady' even though her marriage with Admiral Troubridge had broken up), but the myth that Troubridge was Brooks's naïve dupe is far-fetched and untenable if one reads the sitter's garb from the perspective of high fashion. Far from being the object of ridicule or the butt of a joke, Troubridge exerted considerable control over her own self-fashioning. The portrait is saturated with codes of Troubridge's devising, for she had a keen fashion sense and an eye for sartorial detail. In April 1924, a month before this portrait was painted, the *Daily Express* announced the 'Masculine Note in Fashion' for women: 'The most interesting feature of the new spring suits is the return to the ultra-masculine [in cut and fabric][…]. The waistcoat […] the collar, the cuff, the pockets, and the stock of sporting proclivities are all there in the region of the latest tailor-made.'[11] The piece mentions that 'masculine close-cropped' hair cuts 'came, conquered, and stayed,' and it concludes: 'Nothing at the moment is smarter wear than a varnished coat in black satin, loose and three-quarter length, with no trimming beyond either rows of heavy stitchery or a narrow band of military braid.' A month earlier (March 25, 1924) the same newspaper had celebrated the 'mannish high white collar of stiff but exquisitely fine white linen [as] the latest candidate for honors in the spring collar range. It is shaped in the pattern of a man's double collar.'[12] The *Tatler* notes 'that fobs, once the prerogative of mere man, have been commandeered by women, and the various forms that they have assumed is quite amusing.'[13] Careful scrutiny of the portrait shows that Troubridge has not neglected this playful detail either. She arrived for the sitting not in a 'get-up,' as Brooks put it, but in clothing that captures the very latest fashion trend: high, stiff collar, tailored jacket, which appears to be of black satin, fob, and monocle — the very picture of 'exclusive smartness,' to quote the advertisement of a London firm that specializes in the 'severely masculine mode' of women's fashion.[14] Troubridge was among the first to adopt the bob and the

Late December 55

THE SMALL NEAT COIFFURE IS THE FAVOURITE OF THE MODE

'Small neat coiffure is the favourite of the mode' from the December 1923 issue of British *Vogue*

monocle as signs of the 'emancipated woman,' signs also simultaneously the distinctive marks of a certain social set connoting at once class status and Modern chic. In the spring of 1924 Hall and Troubridge socialized almost exclusively with a group of lesbians in the theatre and the arts. Presumably this smart set would have recognized and appreciated the way in which Troubridge manipulated and controlled the masculine mode to pass as a woman in the height of fashion, and at the same time 'provided a visual code by which middle- and upper-class lesbians […]could recognize each other.'[15]

Hall and Troubridge courted the public gaze at first nights and other public events dressed, as the society pages suggest, as women with the utmost fashion sense. The artist Gluck's self-presentation, on the other hand, may at first suggest the mannish lesbian, especially since she pushed female masculinity even further than Hall by wearing trousers in public. One of the earliest press commentaries points out that the 'new and much-discussed artist […] wears her hair brushed back from her forehead just like a boy, and when in Cornwall goes about in shorts. At her show […] she had a long black cloak covering a masculine attire.'[16] Dressed in men's rather than masculine clothing — never to pass but to violate the rules of fashion as well as social etiquette — Gluck's unique appearance precipitated sharp media dissent concerning her motivations for dressing the way she did, for changing her name from Hannah Gluckstein, and for flaunting her smoking habits. The *Westminster*

Gazette refrained from the title 'Miss', not in deference to Gluck's own wishes but because 'one could hardly call a slim young creature in plus fours, overcoat, and man's shirt and collar Miss Gluck.'[17] The *Tatler* bluntly dismissed Gluck as a 'young woman who affects pipes and plus-fours and scorns prefixes,' while the *Daily Graphic* saw her appearance as a 'guess the gender game,' reporting that 'the young artist [...] might be a boy or a girl.'[18] The paper positioned Gluck within the acceptable framework of 1920s boyishness, yet her appearance came dangerously close to violating the cardinal rule of the boyish female who always avoided crossing the line from acting to passing.

Gluck's daring tactic of using her own clothing to emblematize the theme of her 1926 'one-man' show, 'Stage and Country,' left her vulnerable to more snide remarks. The *Sketch*, for one, commented ironically on Gluck's 'performance' by inserting a photograph and a brief mention of her exhibit on the golf page: 'Miss Gluck [who] [...] has been rousing a good deal of interest, is very unconventional in regard to dress, and usually wears' plus-fours.' [...] She is, of course, Eton-cropped.'[19] Press attention fixated on Gluck's unquestionably outrageous dresschoice, which doubly violated gendered clothing and social protocol; plus-fours, 'long wide *men's* knickerbockers [...] so named because the overhang at the knee requires an extra four inches of material,' are by their very definition 'usu[ally] worn for golf etc.' [...]

Gluck's own plain-spoken explanation about 'why she feels better in men's clothes' defuses any suspicions about female homosexuality: 'I just don't like women's clothes. I don't object to them on other women [...] but for myself, I won't have them [...] I've experienced the freedom of men's attire, and now it would be impossible for me to live in skirts.' For this woman artist, male clothing feels more comfortable and, more crucially, 'Gluck's manly equipment did not disguise her sex.' In the context of twenties fashion, the viewer sees Gluck as a woman in men's clothing – never a woman passing as a man, even though she 'has all her clothes made by man's tailors, wears men's shirts, cravats and hats, [and] carries a cane just like a man.' Gluck took exceptional offense to the fact that some of the double takes she received on the street came from so-called Modern Girls – the artist believed that because she did not object to their short skirts, they should not object to her outfit; she saw her own project as continuous with that of the Modern Girls. Gluck's style did seem to enhance rather than inhibit media interest: for an 'artist' it is permissible, if not preferable, to capitalize – or cash in – on eccentricity. [...]

Notes

[1] *Newcastle Daily Journal and North Star*, August 22, 1928, p. 8. Incidentally, Hall would not have worn an Eton crop in 1928. By then that style was 'not nearly so popular' and was displaced by the 'long shingle vogue.' See *Daily Express*, August 16, 1928, p.5 and August 23, 1928, p.3.

[2] Baker, *Our Three Selves*, p.203.

[3] Ibid., p.164.

[4] *Tatler*, February 27, 1924, p.402.

[5] Ibid., June 2, 1926, p. aa (advertising supplement) and March 15, 1922, p. 386. Another *Tatler* article stated: 'Capes will be accepted for evening wear [including] [...] those of black satin lined with wonderful brocades.' January 25, 1922, p.136.

[6] Capes were still going strong two years later: 'And, of course, the cape... is another popular feature of the present fashions.' See *Eve: The Lady's Pictorial*, June 11, 1924, p.356.

[7] *Tatler*, June 23, 1926, p. 468. The photograph of Knight appeared in *Eve: The Lady's Pictorial*, September 19, 1928, p.577.

[8] A photo of an unidentified woman in a Spanish hat, looking extremely feminine, can be seen in the September 9, 1928, edition of the very paper that led to the obscenity trial, the *Sunday Express*.

[9] Baker, *Our Three Selves*, p.132.

[10] Cline also compares Hall's 'exotic kiss curl' to 'sideburns.' See *Radclyffe Hall*, p.148. Incidentally, to have one's hair shingled at Harrods was an expensive proposition, costing about four guineas. Alan Jenkin's, *The Twenties* (London: Book Club Associates, 1947), p. 56. Richard Ormrod, *Una Troubridge: The Friend of Radclyffe Hall* (New York: Carroll and Graf, 1985), p.153. Baker, *Our Three Selves*, p. 166. Meryle Secrest, *Between Me and Life: A Biography of Romaine Brooks* (London: Macdonald and Jane's, 1976), p.199.

[11] *Daily Express*, April 8, 1924, p.5.

[12] Ibid., March 25, 1924, p.7.

[13] *Tatler*, February 27, 1924, p.402.

[14] A 'severely masculine woman' is virtually synonymous for contemporary readers with lesbian. We should remember that in fashion terms, however, as defined by the *Oxford English Dictionary*, 'severe' refers to a style 'sober, restrained, austerely simple or plain.' See *Oxford English Dictionary* (Oxford: Oxford University Press, 1971).

[15] Bridget Elliott and Jo-Ann Wallace, *Women Artists and Writers: Modernist (Im) Positionings* (New York: Routledge, 1994), p.51.

[16] *Daily Mirror*, October 18, 1924. Newspaper cutting from the private papers in the collection of Roy Gluckstein, London. (Hereafter referred to as Gluckstein.) *Westminster Gazette*, undated newspaper cutting, Gluckstein.

[17] *Tatler*, April 21, 1926; *Daily Graphic*, October 14, 1924, Gluckstein.

[18] *Sketch*, April 21, 1926, p.146. *The Concise Oxford Dictionary of Current English* (Oxford: Clarendon Press, 1995), p. 1052. Emphasis mine. 'Why She Feels Better in Men's Clothes,' undated and unidentified newspaper cutting, Gluckstein. This sentiment echoes a comment Barker made about trousers: 'I know that dressed as a man I did not, as I do now that I am wearing skirts again, feel hopeless and helpless.' See *Sunday Dispatch*, March 31, 1929, p.18.

[19] *Morning Post*, April 12, 1926, Gluckstein. 'Why She Feels Better in Men's Clothes,' Gluckstein.

— Laura Doan, *Fashioning Saphism: the Origins of a Modern English Lesbian Culture* [Columbia University Press, New York, 2001] 110–19, 235–8

Tirza True Latimer 'Entre Nous: Between Claude Cahun and Marcel Moore' (2003)

In the mid-1990s, images of the surrealist Claude Cahun crossed the Atlantic from France to the United States, where her edgy portraiture captured the imagination of new audiences. Theatrical images such as *I'm in Training, Don't Kiss Me* (ca. 1928) seemed to parallel today's postmodern, feminist, and queer theories of gender and embodiment. Costumed in boxer shorts, wrist guards, and a leotard inscribed with hearts and the admonition 'I'm in Training, Don't Kiss Me,' Cahun balances a dumbbell endorsed by a team of comic heroes (the boy scout Totor and his sidekick Popol) in her lap, crosses her legs incongruously (exposing a smudged knee), and preens for the camera in a manner that accentuates signs of hyperfemininity: two paste-on nipples,

two painted lips, two lacquered-down spit curls, two bright hearts to redden her cheeks.[1] 'Training for what?' she prompts the viewer to ask. To become a twosome? To unbecome a woman? The earliest theories emphasizing the role of social conditioning in the production of gender issued from the same decade this photograph was taken. For example, the English psychiatrist Joan Riviere published her paper 'Womanliness as a Masquerade' in 1929, and the abortion rights activist Madeleine Pelletier claimed in her pamphlet *L'amour et la maternité* (1923) that the chasm separating the sexes was largely the work of society.[2]

Since the 1995 retrospective 'Claude Cahun, Photographe' at the Musée d'Art Moderne de la Ville de Paris, Cahun's striking *mise-en-scenes* have appeared in major exhibitions exploring intersections of gender play, surrealism, and photography.[3] The recent publication of Cahun's collected writings, edited by her biographer François Leperlier, has lent new impetus to scholarship on both sides of the Atlantic.[4] This essay departs from the territory explored by Leperlier and the other surrealist-focused scholars who followed in his wake.[5] The study of original photographic negatives, letters, and unpublished manuscripts unavailable to Leperlier in the 1980s during his preliminary research has led me to draw some new conclusions. Most significant, in the light of this archival material, I have come to view the oeuvre attributed to Cahun as the product of a collaboration in which she imagined, composed, performed, and her partner Marcel Moore envisioned, visualized, imaged.[6]

Hardly anyone would deny that the photographs typically described as 'autographs' result from some sort of collaboration, since Cahun could not possibly have realized the majority of them alone, even with the aid of a timer or cable release. This observation alone suffices to compromise the word *self* in the generally accepted formulation 'self-portraiture.' Yet the categorical designation has provided scholars, curators, and other contemporary viewers with what seems a viable term of convenience.[7] Framing the collaborative work done by Cahun and Moore as self-portraiture has both conceptual and ethical implications because Cahun's collaborator was also her lover. What social norms and artistic hierarchies does the erasure of Moore accommodate and to what extent did the two artists attempt to forestall (or, in effect, foreordain) this erasure? Certainly, the overvaluation of the individual artist by Western cultural institutions and markets has colored reception of Cahun's work. Yet Moore's

characteristic reluctance to step into the limelight has, by default, also focused critical attention on Cahun.[8]

The Jersey Heritage Trust collection — held on the island where the two sought refuge in 1937 and then remained — preserves material that makes both the fact and the thematic of this collaboration apparent. When Cahun describes the photographs as 'our photography' or 'our amateur efforts' in letters to friends, her use of the first-person plural possessive acknowledges Moore's involvement.[9] Negatives, whose film sleeves as often bear the name of Moore as of Cahun, preserve images to both taken in the same settings, indicating Moore's involvement in the production of photographs of Cahun and the reverse. The vast majority represent Cahun, who, as a result, claims to view herself as Moore's fabrication ('Je suis l'oeuvre de ta vie').[10] Art historians have rightly considered the devices of doubling that emerge as a signature feature of this oeuvre as exemplary of surrealism's debt to psychoanalysis.[11] While Sigmund Freud's theories of the uncanny and Otto Rank's notion of the doppelganger certainly informed work produced by Cahun and Moore's surrealist circle, I suggest that doubling in this couple's work could also be interpreted as a reference to their partnership. The photographer's shadow that regularly intrudes on the space of the photograph, the double exposures and mirror imaging, may be viewed as both uncanny and as intimations of an unseen collaborator, the 'other me.'

Thus the suggestion that the photographic oeuvre attributed to Cahun has been jointly produced changes our perception of the work. Although traditional portraiture has served to valorize the notion of singularity (with respect to both the artists and the sitter), it provided an arena of experimentation for Cahun and Moore to improvise alternate scenarios of both intimacy and creativity. 'Our two heads (hair intermingling inextricably) inclined over a photograph. Portrait of one or of the other, our two narcissisms drowning together there, it was the impossible realized in a magic mirror. Exchange, superimposition, the fusion of desires. The unity of the image achieved through the close intimacy of two bodies.'[12] Cahun wrote to Moore in a letter dated 1920. The passage, excerpted and published in the 'anti-autobiography' *Aveux non avenus (Disavowed Confession)* ten years later, trains the reader's focus on what transpires between Cahun and Moore, in the places that are not proper to either but serve to connect them: the photograph the mirror image, the imagination.

'I am one. You are the other. Or the contrary,' Cahun (or it could have been Moore) continued, as if the identification between them were a revolving door.[13] I hesitate to use the word *lesbian* to describe their ménage because I doubt that either Cahun or Moore would have accepted this or any other such label. And if they *had* employed the term, *faute de mieux*, they would likely have used it to describe a disposition — 'noncooperation with God,' Cahun called it — rather than a categorical identity.[14] Nevertheless, *lesbian* is a placeholder for the non-normative relational alternative imagined by Cahun and Moore and other women in their Paris environment. […]

In 'Les jeux uraniens' ('Uranian Games'), an unpublished manuscript archived in Jersey, Cahun integrates the words of select male ancestors (English and French, by and large) into the own script to open a transhistorical forum on the subject of same-sex desire and friendship. In the form of an interior dialogue between lover and same-sex beloved, this text plays with and off a set of references shared by educated European homosexuals of Cahun and Moore's era.[27] The title, for instance, makes reference to Karl Ulrichs, the German homophile activist who in turn had appropriated the Platonic term *uranian* to designate members of the 'third' or 'intermediate' sex.[28] The utterances of Shakespeare, Verlain, Rimbaud, Whitman, Douglas, Gide, and Wilde punctuate the manuscript. These quotations, set off as handwritten headers on the typewritten pages, appear to serve a generative function. They literally provide the pretexts for the narrator's reflections. It is tempting to speculate that Moore, who compiled a personal dictionary of quotations, selected the epigraphs and laid them down like challenges for her lover to take up, or arrows for her to follow. A 'no trespassing' signpost planted on the manuscript's coversheet marks kilometre zero of the author's odyssey and warns off those for whom the homophile points of reference would have no meaning.

Early writings such as 'L'idée-maîtresse' and 'Les jeux uraniens' indicate that Cahun and Moore commanded a comprehensive bibliography representing the 'love that dare not speak its name.' During their high-school years in Nantes-when Cahun and Moore shared quarters in the Schwob family strong-hold and spent days on end reading in the publisher's library — this homocentric set of references formed the constellation within which they first imagined themselves and their relationship. Golda M. Goldman, a correspondent for the *Chicago Tribune* whose column 'Who's Who

Abroad' catalogued rising stars on the European cultural horizon, devoted two separate articles to these 'radical daughters' of bourgeois families in the late 1920s.[29] By this time, writings by Cahun and drawings by Moore had appeared in Nantes publications, and Cahun had begun to make a name for herself in Paris literary circles (her work had appeared in *Philosophies*, *Le disque vert*, and *Le journal littéraire*, as well as the prestigious *Mercure de France*, which was cofounded by her uncle Marcel Schwob, the author of *Vies imaginaires*).[30] The couple's address book from the interwar period reads like a register of vanguard Paris and situates them at the hub, not the margins, of the capital's cultural life.[31]

Yet their collaborative work, if familiar to an intimate circle of friends and colleagues, remained relatively private. Goldman probably learned of Cahun and Moore's artistic partnership from Sylvia Beach, whom she also interviewed and who displayed photographs by Cahun and Moore in her store.[32] Goldman's piece on Moore refers to the couple's first joint publication, *Vues et visions*.[33] (The book's modest print run of 460 copies suggests that the authors or publisher viewed this as an 'artist's book' and did not envision mass or even moderate circulation.) The book consists of twenty-five paired verses by Cahun embedded in what Goldman describes as 'very clever black and white illustrations' rendered in Moore's Beardsleyesque style. The title *Vues et visions* describes a two-pronged initiative in which picture and text elevate the worldly 'view' to an otherworldly register by placing the mundane here and now in dialogue with an ideal of the past.

The iconographic and poetic thrust of these 'visions' situated Cahun and Moore within a homophile revival of antiquity under way since the previous century. [...] [34]

Cahun and Moore were working on their second collaborative publication, *Aveux non avenus*, whose duplicitous title both reclaims and disclaims the project of autobiography. The camera, instrument of evidence as well as fabrication, played a significant role in this project, which intersperses citations from Cahun's own citation-laden journals with collages composed by Moore from the couple's 'monstrous dictionary' of images. The camera's ability to reframe artistic and relational transactions yielded photographs like the well-known portrait of Cahun cheek to cheek with her mirror image. [...] This doubled (or mirrored) image could be viewed as an allusion to Cahun's unsingular status as an artist and author. At odds with the vanity conventions it evokes — indeed the

face and its mirror image are at odds with each other — the mirror image here resists interpretation as a closed, narcissistic system. Instead, the mirror — triangulated by the external regard of the collaborator, Moore, and mediated by the photographic picture plane, appears to open the field of representation to possibilities of transformation as well as exchange. The oblique angle of the *prise de vue* (approximately forty-five degrees off the plane of the mirror) results in what appears to be an 'unnatural' relationship between Cahun and her reflection, an effect of estrangement enhanced by the blanking out of all real-world points of reference in the field behind Cahun's reflected image. The mirror's effect of doubling visibly invites more than one point of view into the representational field, while the atypical vantage point compels the external viewer to consider the cliché from a new angle. [...]

Notes

[1] Totor and Popol were created by the Belgian cartoonist Hergé (Georges Rémi), the author of the popular Tintin series.

[2] Joan Riviere, 'Womanliness as a Masquerade,' originally published in *The International Journal of Psychoanalysis* 10 (1929); Madeleine Pelletier, *L'amour et la maternité*, originally published by the Group for Propaganda by Pamphlet (1923).

[3] In addition to the 1995 exhibition that François Leperlier organized at the Musée d'Art Moderne de la Ville de Paris, exhibitions showcasing images of Cahun include Juan Vicente Aliaga's 'Claude Cahun' (Insitut Valencì d'Art Modern, 2002); David Bate's 'Mise-en-Scène: Claude Cahun, Tacita Dean, Virgnia Nimarkoh' (Institute of Contemporary Arts, London, 1994); Jennifer Blessing's 'A Rrose Is a Rrose is a Rrose: Gender Performance in Photography' (Guggenheim Museum, New York, 1997); Henri-Claude Cousseau's 'Le rêve d'une ville: Nantes et le surrealism' (Musée de Beaux-Arts de Nantes, 1994); Whitney Chadwick's 'Mirror Images: Women Surrealism, and Self-Representation' (SFMOMA), San Francisco, 1993); and Shelley Rice's 'Inverted Odysseys: Claude Cahun, Maya Deren, Cindy Sherman' (Grey Gallery, New York University, 1999).

[4] Leperlier's 1992 biography, *Claude Cahun: L'écart et la metamorphose* (Paris Jean-Michel Place, 1992), and the high-profile retrospective that followed helped bring this artist, a well-known Paris vanguard figure in her day, to the attention of contemporary audiences. Leperlier's

collection, *Claude Cahun: Ecrits* (Paris: Jean-Michel Place, 2002), fills in the literary dimension of an oeuvre that today's public has viewed as primarily photographic. 'De Marcel Schwob à Claude Cahun,' a colloquium held in Cerisy, France, in August 2005, was organized in part to provide a forum for exchange between scholars on the literary and visual context that generated this oeuvre: the goal of the 'Creative Partnership' symposium at the University of California, Berkeley, in April 2005 was similar.

[5] Jennifer Blessing, Katharine Conley, Steven Harris, Katy Kline, Therese Lichtenstein, Laurie Monahan, and Abigail Solomon-Godeau, for example, have all drawn on Leperlier's work to rethink Cahun's position in relation to surrealism.

[6] The Jersey Museum, a local history museum in St. Helier on the Channel Isle of Jersey, houses an important collection from the estate of Cahun and Moore. These resources were not held in a public collection or archived until 1995 and, with the exception of about a quarter of the total number of photographic images currently conserved by the Jersey Heritage Trust, the material was not available to Leperlier when he was researching his book or organizing his exhibition. Subsequently, logistical problems prevented all but a few scholars from drawing on this archive. The photographic holdings are now available for consultation online.

[7] The term *self-portraiture* has been problematized by several scholars, me included. See also Catherine Gonnard and Elisabeth Lebovici, 'How Could They Say I? in *Claude Cahun* (Valencia: Institut Valencià d'Art Modern, 2001); Jennifer Shaw, 'Singular Plural: Collaborative Self-Images in Claude Cahun's *Aveux non avenus*,' in *The Modern Women Revisited: Paris between the Wars*, ed. Whitney Chadwick and Tirza True Latimer (New Brunswick, NJ: Rutgers University Press, 2003); and Abigail Solomon-Godeau, 'The Equivocal 'I': Claude Cahun as Lesbian Subject,' in *Inverted Odysseys: Claude Cahun, Maya Deren, Cindy Sherman*, ed. Shelley Rice (Cambridge, MA: MIT Press, 1999).

[8] Of the over four hundred negatives and prints preserved by the Jersey Heritage Trust, only a few dozen capture the image of Moore. 'Very few people have had the opportunity of viewing Mlle. Moore's work,' one reported observed, 'as she is one of those rare people who hide their light under a bushel' Golda M. Goldman, 'Who's Who Abroad: Suzanne Moore,' *Chicago Tribune*, European edition, December 18, 1929).

[9] Claude Cahun to Charles—Henri Barbier, September 21, 1952: 'Il nous reste d'avant-guerre […] d'assez belles photographies. Belles? Si j'en puis juger par la diversité des gens qui les ont admires […] des inconnus lorsqu'elles furent exposées chez des libraries […] et par l'appréciation de quelques-uns qui les virent chez nous. Parmi ceux-ci, des gens les moins esthètes à des professionnels tells que Man Ray. D'autre part, récemment, un jeune anglais, professionnel aussi […], nous posant des questions sur 'innovation' (!) technique (!) […] à propos de nos essai d'amateurs datant des plus d'un quart de sièle.' In French, *amateur* has no negative connotation but simply denotes (1) a devotee or 'lover' and (2) a non-commercial practitioner.

[10] Claude Cahun, 'Les jeux uraniens,' unpublished manuscript (ca. 1914), 34, Jersey Heritage Trust archives.

[11] See, for example, Katy Deepwell's important essay 'Uncanny Resemblances,' which appeared in *Women's Art Magazine* 62 (January—February 1995): 17—19; and Jennifer Shaw's 'Cahun's Narcissus' (presented at the College Art Association conference, Los Angeles, in 1999 and as a Beatrice Bain lecture at the University of California, Berkeley, the same year).

[12] Letter dated September 20, 1920, cited in Claude Cahun and Marcel Moore, *Aveux non avenus* (Paris: Carrefour, 1930), 13: 'Nos deux têtes (ah! que nos cheveux s'emmêlent indébrouillablement) se penchèrent sur une photographie. Portrait de l'un ou de l'autre, non deux narcissisms s'y noyant, c'était l'impossible realise en un miroir magique. L'échange, la superposition, la fusion des désirs. L'unité de l'image obtenu par l'amitié étroiet des deux corps — au besoins qu'ils envoient leurs âmes au diable!'

[13] 'Je suis l'un, tu es l'autre. Ou le contraire. Nos désirs se rencontrent' (Cahun and Moore, *Aveux non avenus*, 118).

[14] Cahun and Moore, *Aveux non avenus*, 39.

[15] Cahun's 'Les jeux uraniens' (ca. 1914) assumes the literary form of an epistle to a 'friend' and presents a poetic defense of the same-sex love. There are certain parallels between 'Les jeux uraniens' and Gide's *Corydon* (also largely composed before the 1914 war but not published until 1924). In both cases, the direct form of address, for instance, collapses the distinction between the utterances of the narrator and those of the author. Cahun and Moore kept abreast of Gide's publications, as records from Monnier's bookstore indicate. The inclusion of Gide's portrait likeness in a series by Moore of 1920s cultural pioneers suggests that his work met with their approval.

[16] Ulrichs's defense of the 'third sex' provided a basis of reflection for influential members of homophile communities in Germany, France, and England — the German homosexual rights movement leader Magnus Hirschfield, André Raffalovitch (author of *Uranisme et unisexualité*), and Edward Carpenter — authors numbering among those with whom Cahun and Moore claimed spiritual kinship.

[17] Golda M. Goldman, 'Who's Who Abroad: Lucie Schwob,' *Chicago Tribune*, European edition, December 18, 1929. The *Chicago Tribune* clipping, among other personal papers in Moore's possession when she died in 1974, is archived in Jersey.

[18] Cahun's Paris publications from the 1920s include 'Cahnson Sauvage,' *Mercure de France*, March 1921; 'Héroïnes,' *Mercure de France*, February 1925; 'Héroïnes,' *La journal littéraire*, February 1925; 'Méditation de mademoiselle Lucie Schwob,' *Philosophies*, March 1925; 'Récits de rêve,; *Le disque vert*, 1925; and 'Ephémérides,' *Mercure de France*, January 1927. Moore had trained at the Académie des Beaux Arts in Nantes. (Goldman, in 'Who's Who Abroad: Suzanne Moore,' reports

that she 'entered the art school of Nantes…as a means of escape from what she found to be the unsympathetic restrictions of French bourgeois life.') Moore furnished *Le phare de la Loire* and *La gerbe* with fashion illustrations until she and Cahun moved to Paris. There she exercised her talents in the domain of theatrical design in addition to collaborating in the production of books with Cahun.

[19] The address book records the names Aragon, Barney, Bataille, Beach, Birot, Breton, Caillois, Cocteau, Crevel, Dali, Desnos, Eluard, Ernst, Giacometti, Heap, Huxley, Lacan, Man Ray, Michaux, Monnier, Orloff, Pitoëff, Stein, Tanguy, and Tzara, among others.

[20] The Princeton University Library conserved two portraits of Sylvia Beach taken in her shop in the early 1920s. One bears an inscription in Beach's hand attributing the photo to 'Lucie Schwob and Suzanne Malerbe.'

[21] Claude Cahun and Marcel Moore, *Vues et visions* (Paris: Crès, 1919).

[22] The adoption of antiquity as a point of reference, while redolent of mainstream high culture, would have resonated within Paris's subculture, where influential women and men of letters contributed to homophile reconstructions of antiquity from the turn of the century until the Second World War. See, e.g., John Addington Symonds, *Studies of Greek Poets* (1873) and 'A Problem in Greek Ethics' (1897); Walter Pater, *Greek Studies: A Series of Essays* and *Plato and Platonism: A Series of Lectures* (1910); and Edward Carpenter, *Intermediate Types among Primitive Folks* (1919).

[23] Cahun and Moore, *Vues et visions*, 78,79.

— Tirza True Latimer, 'Entre Nous: Between Claude Cahun and Marcel Moore', *GLQ: A Journal of Lesbian and Gay Studies*, vol. 12 no. 2 [February 2006] 197—216

C —
Case Studies
(1930 – 49)

Though references to gay and lesbian life were still coded in the 1930s and 1940s, writers such as James Baldwin and Robert Duncan began to shape cogent, elegant defences of homosexuality as an identity, while activist Lisa Ben (an anagram for 'lesbian') launched *Vice Versa*, the first American lesbian periodical. In 1935 Freud wrote to an American mother arguing against homosexuality as a pathology. In 1948 the Kinsey Report revealed that two-thirds of American men had at some point engaged in homosexual behaviour. Even as these documents testify to the liberalization of scientific attitudes towards homosexuality, other texts from the same period bespeak the ongoing public anxiety aroused by the idea and image of same-sex love.

Dr La Forest Potter
'Dr La Forest Potter Describes a Drag Ball' (1933)

It is stated on the authority of one who has frequently attended the 'Mardi Gras' festival at New Orleans, and the 'Rose Pageant' held in Pasadena, California, that, not infrequently, the most beautifully decorated floats, the most gorgeous costumes, the loveliest gowns are worn by urnings (homosexuals) of the effeminate type.

At all the festivals I have mentioned the 'bars are down'. All restrictions concerning the wearing of women's clothes by men or the wearing of men's clothes by women are withdrawn. In fact, there is the greatest possible tolerance shown for almost anything — short of murder — just as during the old Greek Bacchanalia or the Roman Lupercalia and Saturnalia.

Under ordinary circumstances, in most American cities, the 'fairy' — with plucked eyebrows, rouged lips, powdered face, and marcelled, blondined hair — who attempts to walk the streets, attired in woman's costume is practically certain of arrest and severe punishment […]

In addition to the pageants, however, there are still other festivities at which the ban against *transvestism* — or the wearing of the clothes and 'make up' of the opposite sex — is permiss(i)ble.

These are the famous 'Drag Balls' held in many of our principal cities, on the average of once a year. The men, dressed in the clothes of women, are called 'drags'.

In New York City there are at least two outstanding Drag Balls yearly — one held at Webster Hall, in Greenwich Village, the other in the Manhattan Casino, up in Harlem. Of late years this place has had 'the run'.

The Drag Ball is really a great masquerade party, at which many of the men who attend wear the fancy dress costumes of women. Substantial prizes are offered for the most striking and original costumes. And it may here be said that many costumes worn by the men are really superb creations.

These balls offer a meeting place for the 'drags' at which those of the intermediate world may dance with one another to their heart's content, while thousands of normal men and women, seeking a novel thrill, look on and applaud.

Among those who come to stimulate jaded senses are society people, lights of the literary and theatrical world, prize-fight promoters, 'racket' chiefs and their 'gun molls', clubmen, show-girls and financiers, gangsters and hoodlums. They fill the balconies to the bursting point, and peer down

upon the motley throng that surges and sways to the blood-boiling rhythm of a Negro band.

Hundreds and hundreds of Negroes also — of every shade of black and brown — from the octoroon, hardly to be distinguished from a strikingly lovely brunette Caucasian girl, to the burly blackamoor, of pure Ethiopian type — are crowded, cheek by jowl, into sense-maddening proximity. For the Harlem Drag Ball is a 'mixed' affair, attended by whites and blacks alike.

On the floor of the hall, in every conceivable sort of fancy dress, men quaver and palpitate in each other's embrace. Many of the 'effeminates' are elaborately coiffured, in the powdered head dresses of the period of Madam Pompadour. They wear the billowy, ballooning skirt of that picturesque pre-guillotine era.

Others affect the platinum blond hair, made popular by one of our motion picture actresses a few years ago. Still others wear the long, tight-fitting gowns which were a recent vogue, and which fit the figure like a seal skin coat fits the seal that owns it.

Still others wear the long, trailing skirts and the constricting corsets of the 1880's — yards of elaborately furbelowed material, frou-frouing behind them, when space permits. At other times, they carry the impending contraption draped over their left arm.

The grace and the assuredness with which the men wear these costumes proclaim long weeks of practice in the art and science of handling what must always seem to normal men strange and often burdensome draperies.

Nevertheless, the homosexuals, in some instances, seem to have out-womened the women themselves in these sex-twisted efforts […]

The crowds, who come to 'get a kick' out of all of this, fill the boxes, pack the aisles, jam the stairways — perhaps violating fundamental Fire Department rulings, just as the 'pansies' in their one-night-a-year freedom under police protection, violate the stupid Penal Code of the State of New York.

Finally the dancing floor is cleared by the police for the chief event of the evening. It is the big 'kick' for which most of the spectators have come — the 'parade of the fairies' with a prize of two hundred dollars to be awarded to the 'fairy' who displays the loveliest and most artistic costume.

A long elevated platform is erected in the center of the hall. Everyone who has not already secured a point of vantage surges to the narrow aisle between the solid banks of human flesh — an aisle kept open by the muscular minions of the law themselves.

The 'fairies' now come forward in Indian file. They mount the platform

and walk slowly across to the other side — as 'bathing beauties' and 'style manikins' walk in the news reels.

The 'pansies' halt every few steps in their slow course to strike a pose, twirl a fan, kick a train, or perform some other incredibly feminine action.

— 'Dr La Forest Potter describes a Drag Ball', *Strange Loves: A Study in Sexual Abnormalities* [Robert Dodsley, New York, 1933], excerpted in *Major Problems in the History of American Sexuality*, ed. Kathy Peis [Houghton Mifflin, New York, 2001] 346–8

Thomas Craven
'Effeminacy?' (1935)

Thomas Craven, writing in the New York American, *has turned his vitriol against the widely-used descriptive phrase, 'he has delicate, shapely hands, the sensitive hands of the artist', and has declared a 'moratorium on that word sensitive'. It is an obvious fallacy, Mr Craven says, to assume that the successful practice of the art of painting depends 'not on the size of a man's intelligence but on the size of his hands'. The idea 'that shapely, slender hands denote the sensitive artist is part of the modern cult of effeminacy'.*

I do not know when or where this superstition originated, but it was probably the invention of some light-fingered knave with pretty hands and imperceptible artistic ability; and it has been kept alive by neurotics, lily-painters, she-artists, tea drunkards, and credulous writers with no respect for hard facts.

Some painters have well formed hands; the majority do not; and one of the most distinguished of living painters has the hands of a stone-mason — massive, powerful hands that have been bruised and knocked out of joint by the hardest kinds of manual labor.

If small hands and tapering fingers were the accompaniments of the artistic faculty, then the Hindus would be a race of artists, and the Japanese superior to the Americans, which they emphatically are not. They may be more wily and more sensitive — sensitive, that is, to criticism — but their art, at present, is the cheapest form of badly colored prints and flimsy knick-knacks manufactured for the five-and-ten cent stores. And I need not mention the women. They have never figured in the history of the fine arts, and their best work in weaving, pottery and handicraft was produced in primitive societies where there was neither soap nor leisure, neither beauty doctors not aesthetes.

The idea that shapely, slender hands denote the sensitive artist is part of the modern cult of effeminacy. In former times when art was a thriving, legitimate industry the painter was content to be an honest and sober workman; today, more often than not, he is a shiftless epicene pretending to, or actually possessing, abnormal sensitivity. Thus, it has happened that the public, for the last twenty years, has been invited to admire and accept mysterious technical machinery instead of pictures; and when the public has refused to be gulled, the angry artists have cried, 'You are not sensitive! You cannot understand us!'.

Thus it has happened that art has produced Picasso, a painter of the ghosts of Frankensteins, a diabolically sensitive artist — but sensitive only to trifling ingenuities and deformed litter which his previous admirers hold up as reflections of their own sensitive souls — and maybe they are. And thus it has happened that the word artist has come to signify a refined weakling with exorbitant nervous irritability; that the playboy Picasso is esteemed as more artistic than the great Hogarth; that the minute and inconsequential agonies of the veronal-guzzling Proust are more artistic than the incomparably lucid and masculine imagination of Mark Twain.

It is time to declare a moratorium on that word sensitive. It used to be a good word before the maniac painters and addled psychologists began to fool with it, but, according to current usage, its implications are morbid and disreputable. It is about the worst thing that can be said of an artist.

— Thomas Craven, 'Effeminacy', *The Art Digest* [October 1935]

Sigmund Freud 'Letter to an American Mother' (1935)

Dear Mrs...

I gather from your letter that your son is a homosexual. I am most impressed by the fact that you do not mention this term yourself in your information about him. May I question you, why you avoid it? Homosexuality is assuredly no advantage, but it is nothing to be ashamed of, no vice, no degradation, it cannot be classified as an illness; we consider it to be a variation of the sexual function produced by a certain arrest of sexual development. Many highly respectable individuals of ancient and modern times have been homosexuals, several

of the greatest among them (Plato, Michelangelo, Leonardo da Vinci etc). It is a great injustice to persecute homosexuality as a crime, and cruelty too. If you do not believe me, read the books of Havelock Ellis.

By asking me if I can help, you mean, I suppose, if I can abolish homosexuality and make normal heterosexuality take its place. The answer is, in a general way, we cannot promise to achieve it. In a certain number of cases we succeed in developing the blighted germs of heterosexual tendencies which are present in every homosexual, in the majority of cases it is no more possible. It is a question of the quality and the age of the individual. The result of treatment cannot be predicted.

What analysis can do for your son runs in a different line. If he is unhappy, neurotic, torn by conflicts, inhibited in his social life, analysis may bring him harmony, peace of mind, full efficiency whether he remains a homosexual or gets changed...

Sincerely yours with kind wishes. Freud

— Sigmund Freud, 'Letter to an American Mother' [1935], reprinted in *The American Journal of Psychiatry*, no. 107 [1951] 787

Robert Duncan 'The Homosexual in Society' (1944)

[...] Although in private conversation, at every table, at every editorial board, one *knows* that a great body of modern art is created by what almost amounts to a homosexual cult; although hostile critics have opened fire in a constant attack as rabid as the attack of Southern senators upon 'niggers'; critics who might possibly view the homosexual with a more humane eye seem agreed that it is better that nothing be said. Pressed to the point, they may either, as in the case of such an undeniable homosexual as Hart Crane, contend that they are great despite their 'perversion' — much as my mother used to say how much better a poet Poe would have been had he not taken dope; or where it is possible they have attempted to deny the role of the homosexual in modern art, the usual reply to unprincipled critics like Craven and Benton in painting being to asset that modern artists have not been homosexual. [...]

But one cannot, in face of the approach taken to their own problem by homosexuals, place any weight of criticism upon the liberal body of critics. For there are Negroes who have joined openly in the struggle for

human freedom, made articulate that their struggle against racial prejudice is part of the struggle for all; while there are Jews who have sought no special privilege of recognition for themselves as Jews but have fought for *human* recognition and rights. But there is in the modern scene no homosexual who has been willing to take in his own persecution a battlefront toward human freedom. Almost co-incident with the first declarations for homosexual rights was the growth of a cult of homosexual superiority to the human race; the cultivation of a secret language, the *camp*, a tone and a vocabulary that is loaded with contempt for the human. They have gone beyond, let us say, Christianity in excluding the pagan world.

Outside the ghetto the word 'goy' disappears, wavers and dwindles in the Jew's vocabulary. But in what one would believe the most radical, the most enlightened 'queer' circles the word 'jam' remains, designating all who are not homosexual, filled with an unwavering hostility and fear, gathering an incredible force of exclusion and blindness. It is hard (for all the sympathy which I can bring to bear) to say that this cult plays any other than an evil role in society.

But names cannot be named. I cannot [...] name the nasty little midgets, the entrepreneurs of this vicious market, the pimps of this special product. There are critics whose cynical, back-biting joke upon their audience is no other than this secret special superiority; there are poets whose nostalgic picture of special worth in suffering, sensitivity and magical quality is no other than this intermediate 'sixth sense'; there are new cult leaders whose special divinity, whose supernatural and visionary claim is no other than this mystery of sex. The law has declared homosexuality secret, non-human, unnatural (and why not then supernatural?). The law itself sees in it a crime, not in the sense that murder, thievery, seduction of children or rape is seen as a crime — but in an occult sense. [...]

Like early witches, the homosexual propagandists have rejected any struggle toward recognition in social equality and, far from seeking to undermine the popular superstition, have accepted the charge of Demonism. Sensing the fear in society that is generated in ignorance of their nature, they have sought not to bring about an understanding, to assert their quality and their common aims with mankind, but they have sought to profit by that fear and ignorance, to become witchdoctors in the modern chaos.

To go about this they have had to cover with mystery, to obscure the work of all these who have viewed

homosexuality as but one of the many facets, one of the many eyes through which the human being may see and who, admitting through which eye they saw, have had primarily in mind as they wrote (as Melville, Proust or Crane had) mankind and its liberation. For these great early artists their humanity was the source, the sole source, of their work. Thus in *Remembrance of Things Past* Charlus is not seen as the special disintegration of a homosexual but as a human being in disintegration, and the forces that lead to that disintegration, the forces of pride, self-humiliation in love, jealousy, are not special forces but common to all mean and women. Thus in Melville, though in *Billy Budd* it is clear that the conflict is homosexual, the forces that make for that conflict, the guilt in passion, the hostility rising from subconscious sources, and the sudden recognition of these forces as it comes to Vere in that story, these are forces which are universal, which rise in other contexts, which in Melville's work have risen in other contexts.

It is, however, the body of Crane that has been most ravaged by these modern ghouls, and, once ravaged, stuck up cult-wise in the mystic light of their special cemetery literature. The live body of Crane is there, inviolate; but in the window display of modern poetry, of so many special critics and devotees, it a painted mummy, deep sea green. One may tiptoe by, as the visitors of Lenin's tomb tiptoe by and, once outside, find themselves in a world in his name that has celebrated the defeat of all that he was devoted to. One need only point out in all the homosexual imagery of Crane, in the longing and vision of love, the absence, for instance, of the 'English' speciality, the private world of boys' schools and isolate sufferings that has been converted into the poet's intangible 'nobility' into the private sensibility that colors so much of modern writing. Where the Zionists of homosexuality have laid claim to a Palestine of their own, asserting in their miseries their nationality; Crane's suffering, his rebellion, and his love are sources of poetry for him not because they are what make him different from, superior to, mankind, but because he saw in them his link with mankind; he saw in them his sharing in universal human experience.

What can one do in the face of this, both those critics and artists, not homosexuals, who, however, are primarily concerned with all inhumanities, all forces of convention and law that impose a tyranny upon man, and those critics and artists who, as homosexuals, must face in their

own lives both the hostility of society in that they are 'queer' and the hostility of the homosexual cult of superiority in that they are human?

For the first group the starting point is clear, that they must recognize homosexuals as equals and as equals allow them neither more nor less than can be allowed any human being. For the second group the starting point is more difficult; the problem is more treacherous.

In the face of the hostility of society which I risk in making even acknowledgement explicit in this statement, in the face of the 'crime' of my own feelings, in the past I publicized those feelings as private and made no stand for their recognition but tried to sell them disguised, for instance, as conflicts rising from mystical sources. I colored and perverted simple and direct emotions and realizations into a mysterious realm, a mysterious relation to society. Faced by the inhumanities of society I did not seek a solution in humanity but turned to a second out-cast society as inhumane as the first. I joined those who, while they allowed for my sexual nature, allowed for so little of the moral, the sensible and creative direction which all of living should reflect. They offered a family, outrageous as it was, a community in which one was not condemned for one's homosexuality, but it was necessary there for one to desert one's humanity for which one would be suspect 'out of key'. In drawing rooms and in little magazines I celebrated the cult with a sense of sanctuary such as a Medieval Jew must have found in the ghetto. [...]

After an evening at one of those salons where the whole atmosphere was one of suggestion and celebration, I returned recently experiencing again the after-shock, the desolate feeling of wrongness, remembering in my own voice and gestures the rehearsal of unfeeling. Alone, not only I, but, I felt, the others who had appeared as I do so mocking, so superior to feeling, had known, knew still, those troubled emotions, the deep and integral longings that we as human beings feel, holding us from violate action by the powerful sense of humanity that is their source, longings that lead us to love, to envision a creative life. [...]

Among those who should understand those emotions which society condemned, one found that the group language did not allow for any feeling at all other than this self-ridicule, this gaiety (it is significant that the homosexual's word for his own kind is 'gay'), a wave surging forward, breaking into laughter and then receding, leaving a wake of disillusionment, a disbelief that extended to oneself, to life itself.

What then, disowning this career, can one turn to?

What I think can be asserted as a starting point is that only one devotion can be held by a human being seeking a creative life and expression, and that is a devotion to human freedom, toward the liberation of human love, human conflicts, human aspirations. To do this one must disown *all* the special groups (nations, religions, sexes, races) that would claim allegiance. To hold this devotion every written word, every spoken word, every action, every purpose must be examined and considered. The old fears, the old specialities will be there, mocking and tempting; the old protective associations will be there, offering for a surrender of one's humanity congratulations upon one's special nature and value. It must be always recognized that the others, those who have surrendered their humanity, are not less than oneself. It must be always remembered that one's own honesty, one's battle against the inhumanity of his own group (be it against patriotism, against bigotry, against, in this specific case, the homosexual cult) is a battle that cannot be won in the immediate scene. The forces of inhumanity are overwhelming, but only one's continued opposition can make any other order possible, will give an added strength for all those who desire freedom and equality to break at least those fetters that seem now so unbreakable. [...]

– Robert Duncan, 'The Homosexual In Society' [1944], reprinted in Ekbert Fass, *Young Robert Duncan: Portrait of the Poet as Homosexual in Society* [Black Sparrow Press, Santa Barbara, 1983]

Lisa Ben
'Here To Stay' (1947)

Whether the unsympathetic majority approves or not, it looks as though the third sex is here to stay. With the advancement of psychiatry and related subjects, the world is becoming more and more aware that there are those in our midst who feel no attraction for the opposite sex.

It is not an uncommon sight to observe mannishly attired women or even those dressed in more feminine garb strolling along the street hand-in-hand or even arm-in-arm, in an attitude which certainly would seem to indicate far more than mere friendliness. And bright colored shirts, chain bracelets, loud socks, and ornate sandals are increasingly in evidence on many of the fellows passing by. The war had a great deal to do with influencing the male to wear jewelry, I believe, with the

introduction of dog tags, identification bracelets etc. Whether the war by automatically causing segregation of men from female company for long periods of time has influenced fellows to become more aware of their own kind is a moot question. It is interesting to note, however, that for quite some time the majority of teenage girls seem to prefer jeans and boy's shirts to neat, feminine attire. It is doubtful that this has any vast social significance, yet might not the masculine garb influence them toward adopting boyish mannerisms more than if they had adhered to typical girlish fashions?

Nightclubs featuring male and female impersonators are becoming increasingly prevalent. Even cafes and drive-ins intended for the average customer, when repeatedly patronized by inverts, tend to reflect a gay atmosphere. Such places are ever the center of attraction for a 'gay crown' and become known as a likely rendezvous in which to meet those of similar inclinations.

Books such as *Dianna* and *The Well of Loneliness* are available in expensive editions at book marts and even the corner drugstores. With such knowledge being disseminated through fact and fiction to the public in general, homosexuality is becoming less and less a taboo subject, and although still considered by the general public as contemptible or treated with derision. I venture to predict that there will be a time in future when gay folk will be accepted as part of regular society.

Just as certain subjects once considered unfit for discussion now are used as themes in many of our motion pictures, I believe that the time will come when, say, Stephen Gordon will step unrestrained from the pages of Radclyffe Hall's admirable novel, *The Well of Loneliness*, onto the silver screen. And once precedent has been broken by one such motion picture, others will be sure to follow.

Perhaps even *Vice Versa* might be the fore-runner of better magazines dedicated to the third sex, which in some future time might take their rightful place on the newsstands beside other publications, to be available openly and without restriction to those who wish to read them.

Currently appearing in many popular magazines are comprehensive articles on psychological differences between the two sexes, which are enlightening many women as to the unbridgeable gaps between the opposite sexes and why most of them in this rapidly changing world are unable to come to terms with each other on a mental and emotional basis.

In days gone by, when woman's domain was restricted to the fireside, marriage and a family was her only prospect, the home was the little

Illustration of the gynecology of lesbians in Dr George W Henry's *Sex Variants*, 1941

world around which life revolved, and in which, unless wives were fortunate enough to have help, they had to perform innumerable household chores besides assuming the responsibility of bearing children. But in these days of frozen foods, motion pictures palaces, compact apartments, modern innovations, and female independence, there is no reason why a woman should have to look to a man for food and shelter in return for raising his children and keeping his house in order unless she really wants to.

Today, a woman may live independently from man if she so chooses and carve out her own career. Never before have circumstances and conditions been so suitable for those of lesbian tendencies.

— Lisa Ben, 'Here To Stay',
Vice Versa, vol. I, no. 4
[September 1947]

Jack Lait and Lee Mortimer 'Where Women Wear Lace Lingerie' (1948)

Not all who call their flats in Greenwich Village 'studios' are queer. Not all New York's queer (or, as they say it, 'gay') people live in Greenwich Village.

But most of those who advertise their oddities, the long-haired men, the short-haired women, those not sure exactly what they are, gravitate to the Village.

There are really two Greenwich Villages — the one the sightseer glimpses and the less appetizing one inhabited by psychopaths dimly conscious of reality, whose hopes, dreams and expressions are as tortuous as the crazy curves in the old streets.

'Artistic' sections are a magnet in all cities for tourists and for those who would live *la vie bohème*.

Greenwich Village got an extra shove during Prohibition. The factors which put Harlem on the night-life map also worked out for the Village. It was off the beaten track. Its streets were dark and narrow. Its buildings were old and dingy. A perfect set-up for speakeasies. [...]

There are floor shows in which most entertainers are fairies, men playing the female roles.

Many of these are in Third Street, though on Eighth Street, a few feet from the women's prison, is the city's most publicized 'queer' joint.

Most female homos' hangouts are in Third Street and here, in a small, smoky and raucous saloon every Friday night is held a 'Lesbian soiree,' at which young girls, eager to become converts, meet the initiates.

These parties are presided over by an old and disgusting excuse for a woman, who is responsible for inducing thousands of innocent girls to lead unnatural lives.

It is a law violation for entertainers to appear in 'drag' (clothes of the opposite sex). By means of broad burlesque, the regulation is skirted. The swish in wig and dress is okay if the trousers hang down under the gown.

Technically, homos must not gather on licensed premises or be exploited in a floor show.

Until a decade ago, many midtown night clubs presented such shows and catered to the twisted trade. When the cops cracked down, the pouting queens and Lesbians took to Greenwich Village.

There they are not molested by police if they remain in the district and don't both others, on the theory that you can't do away with them, and as long as they're with us, it's better to segregate them in one section, where an eye can be kept on them. But the most notorious Lesbian night club in New York is on Second Avenue, south of 14th Street, on the lower East Side.

Here, too, the police are comparatively lax about enforcing the law against female entertainers of hostesses mingling with guests. One reason for this 'tolerance' in the Village undoubtedly is due to the fact that there are so many small joints in its narrow streets, it would take a regiment for enforcement.

Another is that in many of the smaller dives it's difficult to tell who is an entertainer and who a customer. All manner of exhibitionists, frustrated hams and undiscovered artists gather in these places. In many, the floor show is almost always impromptu, with most of the entertainment provided free by the guests, especially the 'gay' ones. [...]

— Jack Lait and Lee Mortimer,
'Where Men Wear Lace Lingerie',
New York: Confidential!
[Ziff–Davis Publishing Company,
Chicago, 1948] 72–5

James Crump 'Iconography of Desire: George Platt Lynes and Gay Male Culture in Post War New York' (1993)

George Platt Lynes was a prodigious source of erotic imagery of the male nude, from the early 1930's through the decade that followed the Second World War. From a late-twentieth-century vantage point, Lynes was a pioneer in this genre.

Those who have considered Lynes's male nudes have been grappling with the photographer's intentions. More than one observer has commented on Lynes's reluctance to bring this work to the fore, lest he tarnish his professional image. Indeed, the personal nudes, we are told, were never meant to be viewed outside of Lynes's close circle of confidants. These views overlook the full import of facts that suggest Lynes's deeply felt interest in exhibiting and publishing this material.

Ascertaining Lynes's personal regard for this work and identifying his great repugnance to its attendant restrictions has been hindered, in part, by the insufficient documentation that has entered the discourse. In none of the few documents previously published does Lynes broach the subject of the male nude or his motivations in creating this work. Missing from the discussion is Lynes's own outspoken and often opinionated demeanour, which is revealed in numerous extant letters from this period. It is hard to imagine that Lynes *did not* have an opinion about the work that he considered his 'best'. In fact, in numerous letters written to Dr. Alfred C Kinsey dating from 1949 to 1955, Lynes wrote at length about the male nude. Lynes's correspondence with Kinsey plays an important role in forging an understanding of this time and its moralizing sentiment affecting gay artists.

'It is most excellent' Kinsey declared to Lynes in 1950. 'Certainly, it is the best nude photography that we have in our collection, and it is of definite moment to us in the study of our particular interests'. Kinsey's 'particular interests' included of course, gay sexual practices, and Lynes's photographs became a significant addition to Kinsey's taxonomically ordered archive of photography. Before meeting Lynes in 1949, Kinsey's landmark publication, *Sexual Behavior in the Human Male*, revealed to America that homosexuality was, indeed, more prevalent in society than previously believed.

It was a time of rising discrimination against gay citizens, and Kinsey's research offered scientific data from which the subculture could find support and a means to elevate the collective morale. The great respect Lynes and his circle held for Dr Kinsey is apparent in a letter from Lynes to his mother in 1949. Lynes wrote, 'The big interest of the moment is Dr Kinsey — in all our lives. He is on a new "kick" now and is interviewing and collecting data on artists [...]. I had a three hour interview with him last Sunday... discussing artists, the erotic in art, and suchlike [...] He is quite wonderful and Bill [Bishop] is going to be busy for weeks making prints for him, for that famous collection of his. It's an extraordinary job he is doing'.

While the preponderance of Lynes's male nudes were aesthetically derived from the tradition of the subject in Western painting and earlier photography, explicit sexual acts were not beyond the realm of Lynes's creativity. Yet Lynes's ambivalence toward explicit imagery, revealed in several letters, suggests his concern that this work would eventually undermine his refined images of the male nude, which he someday hoped to share with larger audiences. Responding to his friend Bernard Perlin in March 1952 Lynes wrote 'You're not the only one who has wanted me to make pornography, even Kinsey has (by implication), but for me personal and professional sexiness are, have always been, mutually exclusive. Besides I've always been too timid to go all out'. Lynes also revealed to Kinsey his displeasure with the free usage of the word 'pornographic' and his own resistance to classifying his male nudes as either 'esthetic' or 'erotic'. Writing to Kinsey in 1954 he said, 'I wonder if you will not classify as erotic or confidential a number of my photographs which seem to me neither. Please let me have your definition, in this connection, to the word "erotic". Later that year Lynes confused the issue by declaring that 'while ["erotic"] would serve well enough for nine-tenths of negatives I proposed to send, it would not serve at all for the other tenth, the best of the lot, which I cannot agree to have buried forever'. It becomes clear that Lynes was very concerned about the limited ways he had to reveal this work. And it is certain that Lynes wished to preserve this important aspect of his oeuvre notwithstanding the legal and social pressures to suppress it. In an earlier letter, he wrote to Kinsey, 'I don't want [the male nudes] buried in some archive. I do want them available to anybody who may want them. They are not, as you know, "pornographic"'.

When he indulged in creating explicit photographs himself, Lynes approached the male body aesthetically, utilizing the very same techniques of lighting and staging found in his fashion and commercial photographs. There is little distinction that can be made between the construction of Lyne's anesthetized — one night say more 'legitimate' — male nude images and the interaction of men having sex together. This is readily detected in the series that Lynes made of two black men embracing before commencing the sex act. Here, the viewer is presented with the sinuous and glistening texture of the men's bodies as they perform for Lynes's camera. In a number of instances Lynes also used a cartouche to photograph and aestheticize the sex of his model, not unlike the visual treatment found in the work of more recent photographers.

It may be argued that Lynes objectified his models, presenting their sexuality for his own voyeuristic pleasure. And this is borne out in a number of extant letters. Yet, Lynes proffered himself as a nude model for several artists, albeit in academic fashion. The drawing of Lynes by Paul Cadmus, executed in 1937, illustrates the photographer's willingness to share his eroticized body for gay male consumption. We see Lynes lying supine on a bed, head toward the viewer. As the model, Lynes lies vulnerable to the viewer's gaze — his genitalia marking the centre point from which the composition emanates. Lynes had explored his own sexuality with the camera as early as the late 1920's. There is extant a so-called self-portrait of Lynes executed around 1929 in which he presents his erect penis to the lens of his camera. Objectification, then, scarcely explicates the fascination with sexuality that imbued Lynes's explicit and eroticized male nudes throughout his career.

Although Lynes had a particular interest in aestheticizing the male nude, his letters demonstrate that this work went beyond simply creating a beautiful image. Concealed beneath Lynes's opinions about his male nudes are clues that indicate the momentous self-reflection of this work which transcends its classification as either erotic or aesthetic. Many of the male nudes are inscribed with Lynes's active participation in the burgeoning gay subculture in New York. By name and physical description Lynes often defined a host of men who not only posed, but later became part of his personal and intimate life. In a letter from October 1952, Lynes wrote, 'Tomorrow I've a date with D, that "wonderful gentle good-looking (superb body!) Negro" I have inherited'. Speaking of the same model a few days later Lynes wrote, 'The brown boy I inherited [...] is HEAVEN — affectionate and good, beautiful in the lean long muscular way, chocolate and ashes-of-roses, and (you guess where and how) fantastic, wonderful'. This was no extraordinary exercise in description, as Lynes was a fastidious letter writer, employing no small amount of candor. This type of description appeared in another letter, again from October 1952: 'There's a new Bob, the biggest little man in the world, muscular midget, handsome if rather mean-looking [...] And there are still Jen and Romain and David and Doug. And I've just photographed Michael — not one of us, I'm told, though in the photographs anyway he'll be an honorary member — whom I find wonderfully attractive'. The fact that these photographs were so personal, however, did not preclude Lyne's genuine desire for publication and exhibition. That Lynes was

reluctant to show this work poignantly suggests both the explicit and implicit forces against which the homoerotic photograph had to contend during this period.

If Lynes's images of the male nude were influenced by the prohibitions fostered by the changing moral structure of American society, how does one begin analyzing them as such? With little documentation, the tendency has been to portray Lynes as a closeted victim of his sexuality.

Here Lynes's photographs of the male nude offer a paradoxical situation. As a determinant of Lynes's mode of vision, the male nudes work adversely to a theory of victimization. That is, the images communicate Lynes's celebration and frankness about his own sexuality. They show Lynes at ease in a legitimate endeavour to aestheticize his own personal experiences. It has been said of Robert Mapplethorpe that he achieved a higher degree of sexual suggestiveness than his forebears through the distance he placed between the model and himself. By employing the glance of the model or directly returning the view's gaze, Mapplethorpe, it has been argued, achieved greater connotation of homosexuality in his photographs. Rather than subdue the male genitalia, Mapplethorpe drew attention to them in many instances, framing them as the primary component of the composition. It may now be argued that Mapplethorpe's vision owes a great deal more to Lynes than heretofore recognized, as Lynes employed similar devices in both his 'action' photos and the more refined images where frontal nudity was employed. Lynes, too, was very frank about this elemental framing and the voyeuristic nature of the photographic experience. He mentioned these interests in a number of letters from the 1950's. In 1953, revealing his physical snobbishness, Lynes wrote 'G was a disappointment, in looks at any rate...A no account body — I did nude him...but took only eight pictures, small fraction of what I take when I'm interested; only his genitalia was impressive'. Of another model he photographed in 1952 Lynes wrote, 'Instead of making love, (I) made a lot of nudes with crotch-emphasis. They'll be pretty but not to be entrusted to the mail'. Of the now famous series of a black man juxtaposed against the body of a white man Lynes conflates his photographic activity with his voyeuristic pleasure in simply viewing his subjects. He wrote, 'I asked B if he'd be willing to pose with D. A little to my surprise he said yes, so I asked D to come along. He did. I photographed...them together in all sorts of close-contact suggestive sentimental sensuous poses — but no (what dear Dr K would call) action pictures. D would have

been willing, but I thought B wouldn't...
But then...everything did happen...and
the sight of that black boy screwing
that super-naked little white bundle
of brawn was one of the finest I've
ever seen'.

We may learn more about the
evolving homoerotic aesthetic by
analyzing the consumption of gay male
photography in the postwar period.
The devices of shame, guilt,
embarrassment, prejudice and
alienation, used often to characterize
Lynes's work, are more readily
detectable in the modes of viewing
than what is typically manifest in
the work itself. It is plausible that

considering the sociopolitical climate
of New York at this time, the viewer
of such images would have discerned
his own marginalization or 'otherness'.
This 'otherness' is categorically
related to the restricted viewing
forced upon homoerotic expression.
Thomas Waugh has previously
argued that until the 1960's the
'external perpetrator of the look
of desire' was indeed the viewer
of the homoerotic still image or
photograph'. This 'perpetrator', as it
were, from the turn of century
through the 1950's was given no
alternative but to project his own
feelings, insecurities, and sensibilities

onto the homoerotic image. In this
sense, those sharing the visual image
with Lynes bring themselves into
the realm of fantasy and desire.
Simultaneously this viewer was forced
to respond to the stress of his
'otherness' and to the implied bearers
of heterosexual power as defined in
the postwar period.

— James Crump, 'Iconography of
 Desire: George Platt Lynes and
 Gay Male Culture in Post War
 New York', *George Platt Lynes:
 Photographs from the Kinsey
 Institute* [Bulfinch Press / Little
 Brown & Co, New York, 1993]

D –
Closet Organizers
(1950 – 64)

The increasing visibility of gay and lesbian subcultures in the early 1960s was marked by popular news coverage (e.g. *Life* magazine's 'Homosexuality in America,'), by avant-garde essays such as Susan Sontag's 'Notes on Camp,' and by key episodes of censorship, such as the confiscation of Jack Smith's underground film *Flaming Creatures* and the over-painting of Warhol's *Thirteen Most Wanted Men* at the New York World's Fair in 1964. These tensions were reflected in debates over the supposed contagion of homosexuality in the cultural world.

Thomas Hart Benton 'What's Holding Back American Art?' (1951)

EDITOR'S NOTE: *One of the most distinctive characteristics for American art during the decade of the Thirties was the vogue of 'Regionalism' — the expression of the idea that our painters should concern themselves with indigenous American subjects and esthetic standards. Of the three chief exponents of Regionalism, Grant Wood, John Steuart Curry and Thomas Hart Benton, only Benton still lives. [...]*

In the accompanying essay Mr Benton expresses his views, while in another article beginning on Page II James Thrall Soby, conductor of SRL's monthly column on the fine arts, comments critically on them.

[...] It was the country-wide concentration, more probably than any of our artistic efforts, which raised Wood, Curry, and me to prominence in the national scene. We symbolized esthetically what the majority of Americans had in mind — America itself. Our success was a popular success. Even where some American citizens did not agree with the nature of our images, instanced in the objections to my state-sponsored murals in Indiana and Missouri, they understood them. What ideological battles we had were in American terms and were generally comprehensible to Americans as a whole. This was exactly what we wanted. [...]

As soon as World War II began substituting in the public mind a world concern for the specifically American concerns which had prevailed during our rise, Wood, Curry, and I found the bottom knocked out from under us. In a day when the problems of America were mainly exterior, our interior images lost public significance. Losing that, they lost the only thing which could sustain them, because the critical world of art had, by and large, as little use for our group front as it had for me as an individual.

The coteries of high-brows, of critics, college art professors, and museum boys, the taste of which had been thoroughly conditioned by the new esthetics of twentieth-century Paris, had sustained themselves in various subsidized ivory towers and kept their grip on the journals of esthetic opinion all during the Americanist period. These coteries, highly verbal but not always notably intelligent or able to see through momentarily fashionable thought patterns, could never accommodate our populist leaning. They had, as a matter of fact, a vested interest in esthetic obscurity, in highfalutin'

symbolisms, and devious and indistinct meanings. The entertainment of these obscurities, giving it an appearance of superior discernment and extraordinary understanding, enabled it to milk the wealthy ladies who sent in for art and the college and museum trustees of the country for the means of support. Immediately after it was recognized that Wood, Curry and I were bringing American art out into a field where its meanings had to be socially intelligible to justify themselves and where esthetic accomplishment would depend on an effective representation of cultural ideas, which were themselves generally comprehensible, the ivory tower boys and girls saw the danger to their presumptions and their protected position. They rose with their supporting groups of artists and high-browish disciples to destroy our menace. [...]

When we were left to the mercies of the art journals, the professors, and the museum boys, we began immediately to lose influence among the newly budding artists and the young students. The band wagon practitioners — and most artists unhappily are such — left our regionalist banner like rats from a sinking ship and allied themselves with the now dominant internationalisms of the high-brow esthetes. The fact that these internationalisms were for the most part as local as the forms they deserted never once occurred to any of our band wagon fugitives. [...]

— Thomas Hart Benton, 'What's Holding Back American Art?', *Saturday Review of Literature* [15 December 1951] 9–11, 38

James Thrall Soby 'A Reply to Mr Benton' (1951)

Thomas Hart Benton frankly concedes the collapse of the Regionalist movement in American art. There was nothing else he could do. One hears the same story from jurors on exhibitions of contemporary art all over the country: there is no longer anywhere a vigorous, identifiable painting of region; the younger artists of, say, Illinois, Missouri, or Idaho for the most part follow the same direction as their colleagues in New York — abstraction, abstract expressionism, and so on. [...]

And here, I think, we come on a basic weakness of the Regionalist movement of the 1930's, spearheaded by Benton, Wood and Curry, rationalized in terms of defensive vituperation by a skilled journalist, Thomas Craven.

These men — especially Benton and Craven — were not content to assert the virtues of their own aims and belief. Their pronouncements consisted

in great part of violent attacks on 'modern' art, particularly in its Parisian or Paris-inspired varieties. Their onslaughts, of which Mr Benton's article constitutes a fairly complete battleplan, included frequent references to a mysterious conspiracy working in support of progressive painting and sculpture. The villains of the cabal, to quote Mr Benson, were 'high-brows ...critics, college art professors, and museum boys, the tastes of which had been thoroughly conditioned by the new esthetics of twentieth-century Paris...' Toward museums and their personnel the Regionalists were exceptionally bitter. 'The Museum of Modern Art...' writes Mr Benton, 'and other similar culturally rootless artistic centers, run often by the most neurotic of ladies, came rapidly, as we moved through the war years, to positions of predominant influence over the artistic life in our country'.

There and in the preceding quotation we have the full range of the Regionalists' Philistine abuse of professionals in the art field. Museum curators if male are homosexual — the clear inference of Mr Benton's persistent use of the word 'boys'; if female they are 'most neurotic'. That there have been a few homosexuals on the staffs of American museums no one can fairly deny. But they have been and are vastly outnumbered by normal men. Indeed, I can't think of a single major art museum in this country whose director's sex life is open to Mr Benton's innuendo. As to the charge that neurotic ladies run our institutions, it is patently absurd. Extremely few of our museums have any women, jittery or placid, on their boards of trustees; the power in most of these museums, on the contrary, is vested in conservative, not to say reactionary, businessmen who recoil in horror at the thought of female infiltration of their territory of executive and cultural decision.

But quite apart from the human equation, which Mr Benton weighs so oddly in oddity's favour, what have our institutions as such done about American art, other than 'modern' during the recent period of which he speaks? If his memory were not so recalcitrant he would know they have done a great deal. [...]

One of Mr Bentons chief grievances against contemporary art is that it is too intelligent. He says: 'Effective esthetic production depends on something beyond thought. The intellectual aspects of art are not, nor does a comprehension of them enable art to be made'. But who claims that art can be created only through the intellect? Certainly not the defenders of 'modern' painting and sculpture, the 'high-brows, ... critics, college art professors, and

museum boys', who Mr Benton despises. On the contrary, it is such people who in our own century, for the first time, have admitted untrained, instinctive artists to a peerage with their more erudite colleagues. The Douanier Rousseau did not evolve his magic sense of proportion from a study of Euclid; the tribal artists of Africa and the South Pacific are not known to have held symposia on the Golden Section. Our era's drastic reappraisal of esthetic values in the fine arts has included, as a cardinal factor, the recognition of the validity of emotion as distinct from knowledge, of instinct as opposed to *a priori* rationalization. Mr Benton is aware of this as well as any one; in his eagerness to make an irresponsible point he just plain forgets. [...]

— James Thrall Soby, 'A Reply to Mr Benton', *Saturday Review of Literature* [15 December 1951] 11—14

The Editors of One Magazine 'One Is Not Grateful' (1953)

Your August issue was late because the postal authorities in Washington and Los Angeles had it under a microscope. They studied it carefully from the 2nd until the 18th September and finally decided that there was nothing obscene, lewd or lascivious in it. They allowed it to continue on its way. We have been found suitable for mailing.

This official decision changes our status considerably. Incredible as it may seem to everyone else but us, we have been pronounced respectable The Post Office found that ONE is obscene in no way, incites no one to anything but thought and doesn't want to overthrow the government. This decision will also indicate to the timorous deviate that we are a safer bet than once assumed. Many who were contented to be told what to read, will now reconsider the matter of their own dignity and human rights. Subscriptions will mount astronomically. We are prepared.

But one point must be made very clear. ONE is not grateful. ONE thanks no one for this reluctant acceptance. It is true that this decision is historic. Never before has a governmental agency of this size admitted that homosexuals not only have legal rights but might have respectable motives as well. The admission is welcome, but it's tardy and far from enough. As we sit around quietly like nice little ladies and gentlemen gradually educating the public and the courts at our leisure, thousands of homosexuals are being unjustly arrested, blackmailed, fined, jailed, intimidated, beaten, ruined

and murdered. ONE's victory might seem big and historic as you read of it in the comfort of your home (locked in the bathroom? Hidden under a stack of other magazines? Sealed first class?). But the deviate hearing of our late August issue through jail bars will not be overly impressed.

There's still a bit to be done. Want to help?

— The Editors of *One Magazine*, 'One Is Not Grateful', front and back cover of *One Magazine* [October 1953]

André Baudry 'Extracts from Arcadie' (1954)

Arcardie, a new scientific and literary journal, claims to bring peace of soul and of the heart to this world of suffering. [...] At long last we want to be included and to be considered objectively. We stand side by side with others, just like others. [...] We are paving the way. Our columns are open to all those willing to loyally examine what continues to cause, even after so many millennia, *concern for humanity*. [...] *Arcadie* will address anxiety and worry and indirectly provide a better life for everybody and also, therefore, for society. These are our projects and our aspirations. [...] [A few years ago] I hardly knew any homophiles. I knew almost nothing of their lives. [...] I knew nothing of the world of homosexuality and I didn't attempt to penetrate it. Having never refused my true nature, I faced up to my own personal destiny — free regardless. [...] Like thousands of others I haven't done anything to be marked by this destiny, and yet day by day I had to

come to terms with it. [...] Were others like me? Who were they? Did they accept themselves? Were they suffering? Were they maintaining their human dignity? How many were there? How many passed away silent and smothered? (And that's why *Arcadie* was founded.) Oh I know some will sneer, but I assure you it's an apostolate, a vocation. [...] *Arcadie* is like no other 'journal'. No, because it dares to speak out about this human problem, because it's a *presence*, a consolation, for thousands of creatures. [...] Arcadie does not defend vice, nor does it defend debauchery; it only claims to save men, and to help them assume their destinies. [...] *Arcadie* wants to provide every sincere homophile — and they exist — with security, a methodology for life and friendship.

— *Arcadie*, no. 1 [January 1954] and no. 3 [March 1954]

Norman Mailer 'The Homosexual Villain' (1955)

Those readers of ONE who are familiar with my work may be somewhat surprised to find me writing for this magazine. After all, I have been as guilty as any contemporary novelist in attributing unpleasant, ridiculous, or sinister connotations to the homosexual (or more accurately, bisexual) characters in my novels. Part of the effectiveness of General Cummings in *The Naked and The Dead* — at least for those people who thought him well-conceived as a character — rested on homosexuality I was obviously suggesting as the

Advice card from the Los Angeles Mattachine Society, c.1950

core of much of his motivation. Again, in *Barbary Shore*, the 'villain' was a secret police agent named Leroy Hollingsworth whose sadism and slyness were essentially combined with his sexual deviation.

The irony is that I did not know a single homosexual during all those years. I had met homosexuals of course, I had recognised a few as homosexual, I had 'suspected' others, I was to realize years later that one or two close friends were homosexual, but I had never known one in the human sense of knowing, which is to look at your friend's feelings through his eyes and not your own. I did not *know* any homosexual because obviously I did not want to. It was enough for me to recognize someone as homosexual, and I would cease to consider him seriously as a person. He might be intelligent or courageous or kind or witty or virtuous or tortured — no matter. I always saw him as at best ludicrous and at worst — the word again — sinister. (I think it is by the way significant that just as many homosexuals feel forced and are forced to throw up protective camouflage, even boasting if necessary of women they have had, not to mention the thousand smaller subtleties, so heterosexuals are often eager to be so deceived for it enables them to continue friendships which otherwise their prejudices or occasionally their fears might force them to terminate).

Now, of course, I exaggerate to a certain degree. I was never a roaring bigot, I did not go in for homosexual-baiting, at least not face to face, and I never could stomach the relish with which soldiers would describe how they have stomped some faggot in a bar. I had, in short, the equivalent of a 'gentleman's anti-Semitism'.

The only thing remarkable about all this is that I was hardly living in a small town. New York, whatever its pleasures and discontents, is not the most uncivilized milieu, and while one would go too far to say that its attitude toward homosexuals bears correspondence to the pain of the liberal or radical at hearing someone utter a word like 'nigger' or 'kike', there is nonetheless considerable tolerance and considerable propinquity. The hard and fast separations of homosexual and heterosexual society are often quite blurred. Over the past seven or eight years I had had more than enough opportunity to learn something about homosexuals if I had wanted to and obviously did not.

It is a pity I do not understand the psychological roots of my change of attitude for something valuable might be learned from it. Unfortunately, I do not. The process has seemed a rational one to me, rational in that the impetus apparently came from reading and not from any important personal experiences. The only hint of my bias mellowing was that my wife and I had gradually become friendly with a homosexual painter who lived next door. He was pleasant, he was thoughtful, he was a good neighbor, and we came to depend on him in various small ways. It was tacitly understood that he was a homosexual, but we never talked about it. However, since so much of personal life was not discussable between us, the friendship was limited. I accepted him the way a small-town banker fifty years ago might have accepted a 'good' Jew.

About this time I received a free copy of ONE which was sent out by the editors to a great many writers. I remember looking at the magazine with some interest and some amusement. Parts of it impressed me unfavourably. I thought the quality of writing generally poor (most people I've talked to agree that it has since improved), and I questioned the wisdom of accepting suggestive ads in a purportedly serious magazine. (Indeed, I still feel this way no matter what the problems of revenue might be.) But there was a certain militancy and honesty to the editorial tone, and while I was not sympathetic, I think I can say that for the first time in my life I was not unsympathetic. Most important of all, my curiosity was piqued. A few weeks later I asked my painter friend if I could borrow his copy of Donald Webster Cory's *The Homosexual in America*.

Reading it was an important exercise. Mr Cory strikes me as being a modest man, and I think he would be the first to admit that while his book is very good, closely reasoned, quietly argued, it is hardly a great book. Nonetheless, I can think of few books which cut so radically at my prejudices and altered my ideas so profoundly. I resisted it, I argued its points as I read, I was often annoyed, but what I could not overcome was my growing depression that I had been acting as a bigot in this matter, and 'bigot' was one word I did not enjoy applying to myself. With that, came the realization I had been closing myself off from understanding a very large part of life. This though is always disturbing to a writer. A writer has his talent, and for all one knows, he is born with it, but whether his talent develops is to some degree responsive to his use of it. He can grow as a person or he can shrink, and by this I don't intend any facile parallels between moral and artistic growth. The writer can become a bigger hoodlum if need be, but his alertness, his curiosity, his reaction to life must not diminish. The fatal thing is to shrink, to be interested in less, sympathetic to less, desiccating to the point where life itself loses its flavour and one's passion for human understanding changes to weariness and distaste.

So, as I read Mr Cory's book, I found myself thinking in effect, '*My God, homosexuals are people too.*' Undoubtedly, this will seem incredibly naïve to the homosexual readers of ONE who have been all too painfully aware that they are indeed people, but prejudice is wed to naivete, and even the sloughing of prejudice, particularly when it is abrupt, partakes of the naïve. I had not tried to conceal that note. As I reread this article I find its tone ingenuous, but there is no point in trying to alter it. One does not become sophisticated overnight about a subject one has closed from oneself.

At any rate I began to face up to my homosexual bias. I had been a libertarian socialist for some years, and implicit in all my beliefs had been the idea that society must allow every individual his own road to discovering himself. Libertarian socialism (the first word is as important as the second) implies inevitably that one have respect for the varieties of human experience. Very basic to everything I had thought was that sexual relations, above everything else, demand their liberty, even if such liberty should amount to no more than compulsion or necessity. For, in the reverse, history has certainly offered enough examples of the link between sexual repression and political repression. (A fascinating thesis on this subject is *The Sexual Revolution* by Wilhelm Reich.) I suppose I can say that for the first time I understood homosexual persecution to be a political act and a reactionary act, and I was properly ashamed of myself. […]

— Norman Mailer, 'The Homosexual Villain', *One Magazine*, vol. 3, no. I [January 1955]

Lorraine Hansberry 'Letter to the Ladder Magazine' (1957)

'Please find enclosed a money order for $2.00. I should like to receive as many of your back issues as that amount will cover. In the event $2.00 is in excess of the cost of six issues — well, fine. Those few cents may stand as a mere downpayment toward sizeable (for me, that is) donations I know already that I shall be sending to you.

'I hope you are somewhat interested in off-the-top-of-the-head reactions from across the country because I would like to offer a few by way of the following:

'(I) I'm glad as heck that you exist. You are obviously serious people and

I feel that women, without wishing to foster any strict *separatist* notions, homo or hetero, indeed have a need for their own publications and organizations. Our problems, our experiences as women are profoundly unique as compared to the other half of the human race. Women, like other oppressed groups of one kind or another, have particularly had to pay a price for the intellectual impoverishment that the second class status imposed on us for centuries created and sustained. Thus, I feel that THE LADDER is a fine, elementary step in a rewarding direction.

'(2) Rightly or wrongly (in view of some of the thought provoking suggestions I have seen elsewhere in a homosexual publication) I could not help but be encouraged and relieved by one of the almost subsidiary points under Point I of your declaration of purpose, '(to advocate) a mode of behaviour and dress acceptable to society'. As one raised in a cultural experience (I am a Negro) where those within were and are forever lecturing to their fellows about how to appear acceptable to the dominant social group, I know something about the shallowness of such a view as an end in itself.

'The most splendid argument is simple and to the point, Ralph Bunche, with all his clean fingernails, degrees, and, of course, undeniable service to the human race, could still be insulted, denied a hotel room or meal in many parts of the country. (Not to mention the possibility of being lynched on a lonely Georgia road for perhaps having demanded a glass of water in the wrong place.)

'What ought to be clear is that one is oppressed or discriminated against because one is different, not "wrong" or "bad" somehow. This is perhaps the bitterest of the entire pill. HOWEVER, as a matter of facility, of expediency, one has to take a critical view of the revolutionary attitudes which in spite of the BASIC truth I have mentioned above, may tend to aggravate the problems of a group.

'I have long since passed that period when I felt personal discomfort at the sight of an ill-dressed or illiterate Negro. Social awareness has taught me where to lay the blame. Someday, I expect, the "discreet" Lesbian will not turn her head on the streets at the sight of the "butch" strolling hand in hand with her friend in their trousers and definitive haircuts. But for the moment, it still disturbs. It creates an impossible area for discussion with one's most enlightened (to use a hopeful term) heterosexual friends. Thus, I agree with the inclusion of that point in your declaration to the degree of wanting to comment on it.

'(3) I am impressed by the general tone of your articles. The most

Cover of the April 1959 issue of *The Ladder*

serious fault being at this juncture that there is simply too little.

'(4) Would it be presumptuous or far-fetched to suggest that you try for some overseas communications? One hears so much of publications and organizations devoted to homosexuality and homosexuals in Europe; but as far as I can gather these seem to lean heavily toward male questions and interests.'

'Just a little afterthought: considering Mattachine; Bilitis, ONE;

all seem to be cropping up on the West Coast rather than here where a vigorous and active gay set almost bump one another off the streets – what is it in the air out there? Pioneers still? Or a tougher circumstance which inspires battle? Would like to hear speculation, light-hearted or otherwise.'

L.H.N., New York, N.Y.

– Lorraine Hansberry, letter to *The Ladder*, vol. I, no. 8 [May 1957]

Minor White
'Letter to a photographer, November 1, 1962, Rochester' (1962)

At long last there was the appropriate time last evening to study your prints. So for several hours I looked at them, thought, and finally selected what seemed to me to be your biography[...]

These prints outline for me a rather tragic story of a man's life. I do not actually know whether it is your story or not. Yet the prints sort of crystallized out of the whole 200, crystallized or precipitated whatever the right word is. The story is familiar to many people in our society: childhood home, for some reason the sex wires get crossed, confusion, self pity, anger, guilt all arise in various combinations. The remarkable psychological image of the nude with the tools is the most direct expression of the hidden desire to transform the male into the female that I have ever seen. Thereafter come the twisting caused by the psychological blocks, the anger and the disintegration, the denying principle in the human being becomes stronger and stronger. Seen as fear, self pity, vanity and a host of posturing. And there is no end to it, the inner conflict is neither resolved by solution nor by death.

Not a pleasant story. Nevertheless it is a story that IF YOU WISH and IF YOU CAN SEE THE STORY you can universalize and then offer to people as a mirror of themselves. Your photographs are still mirrors of yourself. In other words your images are raw, the emotions naked. To present these to others they need appropriate clothes. These are private images not public ones. They are 'expressive' meaning a direct mirror of yourself rather than 'creative' meaning so converted as to affect others as mirrors of themselves. I wish that you would read *Acting: The First Six Lessons* by Richard Boleslavsky. In one of the chapters he discusses this clothing of the naked emotions that is necessary to art.

I found tears coming down my eyes as I went thru these photographs, the whole thing is pathetic, ill, the inwards turning of one who became confused many years ago, retreated from the world, and eats his own heart out (Because it tastes so good?) This reaction was for psychological reasons. On the craftsmanship side, the printing is generally dreadful, and frequently you do not know where the pictorial or image edge of the prints are. That you have no knowledge of editing is of little consequence, tho I hold, light to be sure, that a man who claims to be a photographer rightfully can visually edit his own images. In the same day I was able to compare your photographs with those of Frederick Sommer. He uses subject matter that would make even you squirm (chicken guts). But he looks at his photographs on the walls of his home for months before he permits them to be seen by others. He can edit. And his images are, when they work at all, mirrors of the man looking at them as well as being mirror images of himself — in brief universality, appropriately dressed emotions and inner psychological events.

I deeply appreciate having this large collection to study because there is enough material to confirm findings, rather than suggest. I have met you, seen you, and feel moved to suggest that you try to understand your work. It is very real. And further suggest out of a welling heart that you try to universalize your private images and make them for the love of other people.

— Minor White, 'Letter to a photographer, November 1, 1962, Rochester', reprinted in Peter C. Bunnell, *Minor White: The Eye That Shapes* [Princeton University Art Museum, 1989]

Susan Sontag
'Notes on "Camp"' (1964)

Many things in the world have not been named; and many things, even if they have been named, have never been described. One of these is the sensibility — unmistakably modern, a variant of sophistication but hardly identical with it — that goes by the cult name of 'Camp'.

A sensibility (as distinct from an idea) is one of the hardest things to talk about; but there are special reasons why Camp, in particular, has never been discussed. It is not a natural mode of sensibility, if there be any such. Indeed the essence of Camp is its love of the unnatural: of artifice and exaggeration. The Camp is esoteric — something of a private code, a badge of identity, even, among small urban cliques. Apart from a lazy two-page sketch in Christopher Isherwood's novel *The World in the Evening* (1954) it has hardly broken into print. To talk about Camp is therefore to betray it. If the betrayal can be defended, it will be for the edification it provides, or the dignity of the conflict it resolves. For myself, I plead the goal of self-edification and the goad of a sharp conflict in my own sensibility. I am strongly drawn to Camp, and almost as strongly offended by it. That is why I want to talk about it, and why I can. For no one who wholeheartedly shares in a given sensibility can analyze it; he can only, whatever his intention, exhibit it. To name a sensibility, to draw its contours and to recount its history, requires a deep sympathy modified by revulsion.

Though I am speaking about sensibility only — and about a sensibility that, among other things, converts the serious into the frivolous — these are grave matters. Most people think of sensibility or taste as the realm of purely subjective preferences, those mysterious attractions, mainly sensual, that have not been brought under the sovereignty of reason. They *allow* that considerations of taste play a part in their reactions to people and to works of art. But this attitude is naïve. And even worse. To patronize the faculty of taste is to patronize oneself. For taste governs every free — as opposed to rote — human response. Nothing is more decisive. There is taste in people, visual taste, taste in emotion — and there is taste in acts, taste in morality. Intelligence, as well, is really a kind of taste: taste in ideas. (One of the facts to be reckoned with is that taste tends to develop very unevenly). It's rare that the same person has good visual taste and good taste in people *and* taste in ideas.)

Taste has no system and no proofs. But there is something like logic of taste: the consistent sensibility which underlies and gives rise to a certain taste. A sensibility is almost, but not quite, ineffable. Any sensibility which can be crammed into the mold of a system, or handled with the rough tools of proof, is no longer a sensibility at all. It has hardened into an idea [...]

To snare a sensibility in words, especially one that is alive and powerful, one must be tentative and nimble. The form of jottings, rather than an essay (with its claim to a linear, consecutive argument), seemed more appropriate for getting down something of this particular fugitive sensibility. It's embarrassing to be solemn and treatise-like about Camp. One runs the risk of having, oneself, produced a very inferior piece of Camp.

These notes are for Oscar Wilde.

'One should either be a work of art, or wear a work of art' — *Phrases & Philosophies for the Use of the Young*

1. To start very generally: Camp is a certain mode of aestheticism. It is one way of seeing the world as an aesthetic phenomenon. That way, the way of Camp, is not in terms of beauty, but in terms of the degree of artifice, of stylization.

2. To emphasize style is to slight content, or to introduce an attitude which is neutral with respect to content. It goes without saying that the Camp sensibility is disengaged, depoliticized — or at least apolitical.[…]

6. There is a sense in which it is correct to say: 'It's too good to be Camp'. Or 'too important', not marginal enough. (More on this later.) Thus, the personality and many of the works of Jean Cocteau are Camp, but those of André Gide; the operas of Richard Strauss, but not those of Wagner; concoctions of Tin Pan Alley and Liverpool, but not jazz. Many examples of Camp are things which, from a 'serious' point of view, are either bad art or kitsch. Not all, though. Not only is Camp not necessarily bad art, but some art which can be approached as Camp (example: the major films of Louis Feuillade) merits the most serious admiration and study.

'The more we study Art, the less we care for Nature' — *The Decay of Lying* […]

8. Camp is a vision of the world in terms of style — but a particular kind of style. It is the love of the exaggerated, the 'off', of things-being-what-they-are-not. The best example is in Art Nouveau, the most typical and fully developed Camp style. Art Nouveau objects, typically, convert one thing into something else: the lighting fixtures in the form of flowering plants, the living room which is really a grotto. A remarkable example: the Paris Métro entrances designed by Hector Guimard in the late 1890's in the shape of cast-iron orchid stalks.

9. As a taste in persons, Camp responds particularly to the markedly attenuated and to the strongly exaggerated. The androgyne is certainly one of the great images of Camp sensibility. Examples: the swooning, slim, sinuous figures of pre-Raphaelite painting and poetry; the thin, flowing, sexless bodies in Art Nouveau prints and posters, presented in relief on lamps and ashtrays; the haunting androgynous vacancy behind the perfect beauty of Greta Garbo. Here, Camp taste draws on a mostly unacknowledged trust of taste: the most refined form of sexual attractiveness (as well as the most refined form of sexual pleasure) consists in going against the grain of one's sex. What is most beautiful in virile men is something feminine; what is most beautiful in feminine women is something masculine […]

Allied to the Camp taste for the androgynous is something that seems quite different but isn't: a relish for the exaggeration of sexual characteristics and personality mannerisms. For obvious reasons, the best examples that can be cited are movie stars. The corny flamboyant female-ness of Jayne Mansfield, Gina Lollobrigida, Jane Russell, Virginia Mayo; the exaggerated he-man-ness of Steve Reeves, Victor Mature. The great stylists of temperament and mannerism, like Bette Davis, Barbara Stanwyck, Tallulah Bankhead, Edwige Feuilliére.

10. Camp sees everything in quotation marks. It's not a lamp, but a 'lamp'; not a woman, but a 'woman'. To perceive Camp in objects and persons is to understand Being-as-Playing-a-Role. It is the farthest extension, in sensibility, of the metaphor of life as theater. […]

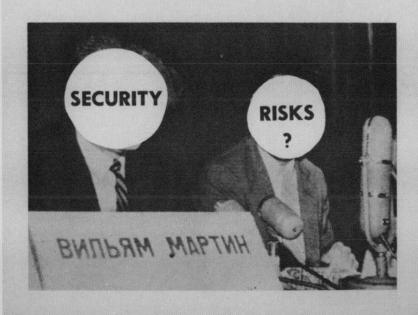

Cover of the October 1960 issue of *One* magazine

38. Camp is the consistently aesthetic experience of the world. It incarnates a victory of 'style' over 'content', 'aesthetics' over 'morality' or irony over tragedy. [...]

41. The whole point of Camp is to dethrone the serious. Camp is playful, anti-serious. More precisely, Camp involves a new, more complex reaction to 'the serious'. One can be serious about the frivolous, frivolous about the serious.

42. One is drawn to Camp when one realizes that 'sincerity' is not enough. Sincerity can be simple philistinism, intellectual narrowness. [...]

47. Wilde himself is a transitional figure. The man who, when he first came to London, sported a velvet beret, lace shirts, velveteen knee-breeches and black silk stockings, could never depart too far in his life from the pleasures of the old-style dandy; this conservatism is reflected in *The Picture of Dorian Gray*. But many of his attitudes suggest something more modern. It was Wilde who formulated an important element of the Camp sensibility – the equivalence of all objects – when he announced his intention of 'living up' to his blue-and-white china, or declared that a doorknob could be as admirable as a painting. When he proclaimed the importance of the necktie, the boutonniere, the chair, Wilde was anticipating the democratic *esprit* of Camp.

48. The old-style dandy hated vulgarity. The new-style dandy, the lover of Camp, appreciates vulgarity. Where the dandy would be continually offended or bored, the connoisseur of Camp is continually amused, delighted. The dandy held a perfumed handkerchief to his nostrils and was liable to swoon; the connoisseur of Camp sniffs the stink and prides himself on his strong nerves. [...]

50. Aristocracy is a position vis-à-vis culture (as well as vis-à-vis power), and the history of Camp taste is part of the history of snob taste. But since no authentic aristocrats in the old sense exist today to sponsor special tastes, who is the bearer of this taste? Answer: an improvised self-elected class, mainly homosexuals, who constitute themselves as aristocrats of taste.

51. The peculiar relation between Camp taste and homosexuality has to be explained. While it's not true that Camp taste is homosexual taste, there is no doubt a peculiar affinity and overlap. Not all liberals are Jews, but Jews have shown a peculiar affinity for liberal and reformist causes. So, not all homosexuals have Camp taste. But homosexuals, by and large, constitute the vanguard – and the most articulate audience – of Camp. (The analogy is not frivolously chosen. Jews and homosexuals are the outstanding creative minorities in contemporary urban culture. Creative, that is, in the truest sense: they are creators of sensibilities. The two pioneering forces of modern sensibility are Jewish moral seriousness and homosexual aestheticism and irony.) [...]

53. Nevertheless, even though homosexuals have been its vanguard, Camp taste is much more than homosexual taste. Obviously, a metaphor of life as theater is peculiarly suited as a justification and projection of a certain aspect of the situation of homosexuals. (The Camp insistence on not being 'serious', on playing, also connects with the homosexual's desire to remain youthful.) Yet one feels that if homosexuals hadn't more or less invented Camp, someone else would. For the aristocratic posture with relation to culture cannot die, though it may persist only in increasingly arbitrary and ingenious ways. Camp is (to repeat) the relation to style in a time in which the adoption of style – as such – has become altogether questionable. (In the modern era, each new style, unless frankly anachronistic, has come on the scene as an anti-style).

'One must have a heart of stone to read the death of Little Nell without laughing' – *In conversation*.

54. The experiences of Camp are based on the great discovery that the sensibility of high culture has no monopoly upon refinement. Camp asserts that good taste is not simply good taste; that there exists, indeed, a good taste of bad taste. (Genet talks about this in *Our Lady of the Flowers*.) The discovery of the good taste of bad taste can be very liberating. The man who insists on high and serious pleasures is depriving himself of pleasure; he continually restricts what he can enjoy; in the constant exercise of his good taste he will eventually price himself out of the market, so to speak. Here Camp taste supervenes upon good taste as a daring and witty hedonism. It makes the man of good taste cheerful, where before he ran the risk of being chronically frustrated. It is good for the digestion.

55. Camp taste is, above all, a mode of enjoyment, of appreciation – not judgement. Camp is generous. It wants to enjoy. It only seems like malice, cynicism. (Or, if it is cynicism, it's not a ruthless but a sweet cynicism.) Camp taste doesn't propose that it is in bad taste to be serious; it doesn't sneer at someone who succeeds in being seriously dramatic. What it does is to find the success in certain passionate failures.

56. Camp taste is a kind of love, love for human nature. It relishes, rather than judges, the little triumphs and awkward intensities of 'character' [...] Camp taste identifies with what it is enjoying. People who share this sensibility are not laughing at the thing they label as 'a camp', they're enjoying it. Camp is a tender feeling. [...]

– Susan Sontag, 'Notes on "Camp"', *Partisan Review*, no. 31 [Fall 1964] 515–530, reprinted in *Against Interpretation and other essays* [Farrar, Straus & Giroux, 1966]

Thomas Waugh
'A Fag-Spotter's Guide to Eisenstein' (1977)

[...] In *Introduction to Film History 200* they tell you Sergei Mikhailovich Eisenstein was the leading figure of the heroic first decades of Soviet cinema and one of the most influential filmmakers ever. They never tell you he was a homosexual.

He had to do a pretty good job of keeping in the closet during his life – whenever he entered a period of disfavor with the bureaucrats, the whispering always started. Straight art historians, who will tell you they think that an artist's sexuality has nothing to do with his or her art, have done an even better job of keeping him in the closet after his death.

An artist who was always very cerebral and impersonal in his approach to his films, Eisenstein is a particularly tantalizing subject for modern-day gay cultural historians, or fag-spotters (as a former roommate used to call me).

You really have to root around his films to find Eisenstein the homosexual. But he's undeniably there. The value

of finding him is not simply the adding another feather in our cap but in adding to our knowledge of the history and the nature of our oppression, our sexuality, and our culture.

The stills I've assembled here are among the most useful from the few that are available, but as any survivor of *Intro 200* can attest, a still can do no more than suggest the definition and power of the moving image.

Our Old Friend St. Sebastian

You never have any doubt that there is a lot of erotic energy in Eisenstein's fascination with images of suffering, victimization, and martyrdom. It's not surprising that gay artists living within a homophobic society should often express themselves with such images, whether it's the gay Renaissance painters who continually overdid it with St. Sebastian at the stake or Mart Crowley reveling in the misery of his Greenwich Village faggots in *Boys in the Band*. With Eisenstein the martyrdom of his revolutionary heroes is always a pretext for an exaggerated, aestheticized indulgence in the ritual agony of the fallen.

During Eisenstein's stay in Mexico (1930—1932), the image of the martyr became a central preoccupation for the director, fired by the blinding sunlight, the death-obsessed Mexican Catholicism, and the poverty he saw all around him. At one point a fantasy of a martyr under the lash sparked a notebook meditation on the purely aesthetic properties of the image — but the jargon needn't fool anybody; it vibrates with sexual intensity.

For me the delineation seems to stem from the image of the ropes constraining the bodies of the martyrs, from the lashes of the whip on the body's white expanse, from the swish of the sword before it makes contact with the condemned neck. Thus the naked line shatters the illusion of space, thus the line makes its way through color, thus the law of harmony splits open the varied chaos of form [...] the whips swish no more. The searing pain has given way to a state of warm numbness. The marks of the blows have lacerated the surface of the body, the wounds have opened up like so many poppies and the ruby blood has begun to flow.

The image reappears as a motif in the footage for the film that was never to be finished. Another variation of it was the ritual of the *corrida*, the bull-fight: a whole cycle of his sketches intercut the image of the martyred bull with the image of our old friend St. Sebastian. But for the socialist, as for the Christian, martyrdom of the hero is only a temporary setback, in fact, an advance in terms of the long struggle:

Vakulinchuk's death in *The Battleship Potemkin* sets off a beautiful elegiac sequence of gliding ships and hushed procession of mourners, with a final outburst of revolutionary anger among the mourners, which culminates in victory.

Mexican Sojourn

Eisenstein was a timid but jovial intellectual who could never be a public homosexual in Soviet society the way his contemporaries, like Jean Cocteau or Gertrude Stein, could be, protected as they were by the polite tolerance of the artistic avant-garde. Even his biographers will deal with his gayness only in whispers and innuendoes. One of them has reportedly suggested (off the record, of course) that it was Eisenstein's embarrassing sexual predisposition as much as his political intransigence that led to his periodic bouts of disfavor with the Stalinist bureaucrats. Even as a world-famous artist he didn't fare any better during his brief foray into the West at the end of the twenties.

After a few aborted projects in Hollywood, he attempted a Mexican film, backed by liberal American money and support. This was eventually withdrawn before the film was finished but not before the Mexican light, the Latin/Indian male beauty, and Eisenstein's perception of the Mexican struggle had inspired some of the most breathtaking unedited footage in existence.

It's also said that he brought back with him a trunkload of erotic footage, apparently shot in Mexican whorehouses, that so offended his sponsors that they let the American authorities destroy it. They were also very upset by his bundles of sketches, which one sponsor called 'plain smut'. One of them was apparently 'a parody of Christian paintings showing Jesus and the two thieves banging on crosses; the penis of Jesus is elongated into a hose, and one of the thieves has the end in his mouth'. All that is apparently left of the crucifix conceit and the delightful connotations it has (the identification of religious mysticism with sexual feeling?) is Eisenstein's filmed recreation of a Mexican Passion ritual included among the unedited material. Something the customs officials never did get their hands on is a wonderful snapshot of Eisenstein and a phallic cactus he mounted one day while strolling through the Mexican desert. [...]

Hero Worship

Parker Tyler states, in his treatment of Eisenstein in *Screening the Sexes*, that 'hero worship is a natural part of the homosexual aesthetic myth'.

Whether this can be accepted as a general principle or not, it's certainly clear that it was part of Eisenstein's own personal homosexual myth. All of his male characters are erotically idealized heroes of great immediacy and appeal — particularly the working-class figures that both history and personal conviction dictated as protagonists in his films.

Tyler describes Eisenstein as 'having a great eye for human beauty, and more especially for male beauty'. One can only concur, looking at the knights from *Alexander Nevsky* (1938) or the sailors in *Battleship Potemkin* (1925). But it is more than a simple question of an eye for male beauty. The Marxist worldview that motivated his films provided a natural channel of expression for this sexual aesthetic. The physical beauty of the male proletarian hero arose from a unique confluence of erotic sensibility and political belief. [...]

— Thomas Waugh, 'A Fag-Spotters Guide to Eisenstein', *The Body Politic*, no. 35 [July—August 1977] supplement 15—17, republished in *The Fruit Machine: Twenty Years of Writing on Queer Cinema* [Duke University Press, Durham, North Carolina, 2000]

Andy Warhol and Pat Hackett 'POPism: The Warhol Sixties' (1980)

[...] My mind kept going back to what De had just told me about that exhibition that Jasper had made for himself in his own loft. De was such good friends with both Jasper and Bob that I figured he could probably tell me something I'd been wanting to know for a long time: why didn't they like me? Every time I saw them, they cut me dead. So when the waiter brought the brandy, I finally popped the question, and De said, 'Okay, Andy, if you really want to hear it straight, I'll lay it out for you. You're too swish, and that upsets them'.

I was embarrassed, but De didn't stop. I'm sure he saw that my feelings were hurt, but I'd asked him a question and he was going to let me have the whole answer 'First, the post-Abstract Expressionist sensibility is, of course, a homosexual one, but these two guys wear three-button suits — they were in the army or navy or something! Second, you make them nervous because you *collect* paintings, and traditionally artists don't buy the work of other artists, it just isn't done. And third,' De concluded, 'you're a

commercial artist, which really bugs them because when *they* do commercial art – windows and other jobs I find them – they do it just to survive.' They won't even use their real names. Whereas *you've* won *prizes!* You're *famous* for it!'

It was perfectly true, what De said. I was well known as a commercial artist. I got a real kick out of seeing my name listed under 'Fashion' in a novelty book called *A Thousand New York Names* and *Where to Drop Them*. But if you wanted to be considered a 'serious' artist, you weren't supposed to have anything to do with commercial art. De was the only person I knew then who could see past those old social distinctions to the art itself.

What De had just told me hurt a lot. When I'd asked him, 'Why don't they like me?' I'd naturally hoped to get off easier than this. When you ask a question like that, you always hope the person will convince you that you're just paranoid. I didn't know what to say. Finally I just said something stupid: 'I know plenty of painters who are more swish than me'. And De said, 'Yes, Andy, there are others who are more swish – and less talented – and still others who are less swish and just as talented, but the *major painters* try to look straight; you play up the swish – it's like an armor with you'.

There was nothing I could say to that. It was all too true. So I decided I just wasn't going to care, because those were all things that I didn't want to change anyway, that I didn't think I *should* want to change. There was nothing wrong with being a commercial artist and there was nothing wrong with collecting art that you admired. Other people could change their attitudes, but not me – I knew I was right. And as for the 'swish' thing, I'd always had a lot of fun with that – just watching the expressions on people's faces. You'd have to have seen the way all the Abstract Expressionist painters carried themselves and the kinds of images they cultivated, to understand how shocked people were to see a painter coming on swish. I certainly wasn't a butch kind of guy by nature, but I must admit, I went out of my way to play up the other extreme.

The world of the Abstract Expressionists was very macho. The painters who used to hang around the Cedar bar on University Place were all hard-driving, two-fisted types who'd grab each other say things like 'I'll knock your fucking teeth out' and 'I'll steal your girl'. In a way, Jackson Pollock had to die the way he did, crashing his car up, and even Barnett Newman, who was so elegant, always in a suit and monocle, was tough enough to get into politics when he made a kind of symbolic run for mayor of New

York in the thirties. The toughness was part of a tradition, it went with their agonized, anguished art. They were always exploding and having fist fights about their work and their love lives. This went on all through the fifties when I was just new in town, doing whatever jobs I could get in advertising and spending my nights at home drawing to meet deadlines, or going out with a few friends. [...]

– Andy Warhol and Pat Hackett,
POPism: The Warhol Sixties
[Harcourt Inc., 1980] 14–16

Derek Jarman
'Diary, July 1989' (1989)

[...] I was just eighteen years old in 1960, so if a decade belongs to youth, the sixties were mine. I missed National Service by a few months; even now I can hear the sigh of relief; a whole generation of pretty boys forgot square bashing, and beat a trail to Carnaby Street. Art was my passion. The Slade still a centre – its yearly dance the only place where you could let you hair down, dance with your hands on another boy's arse, open his flies and slip your hand in, and rock the place. Art was very heterosexual, beards and billiards at the pub. Rauschenberg, Johns, Hockney and Warhol were to change that.

Gay? Well we were still queer, with nowhere to go, just two or three unlicensed bars that held a hundred at the most; coffee bars with dance floors where you were forbidden to touch: 'Now lads please, you know the rules'. So you sipped lukewarm Nescafé in a Duralex glass cup and stared and stared.

Victim on release and some years to legislation. Fucking was fucking once you were in bed in the 'privacy of your home'. Drinking clubs like the Rockingham for the Quentin Crisps; the Rockingham! – the name was enough to put you off; our clubs were La Deuce, the Gigolo and the Hustler, the A & B – Arts and Battledress – a memory of the war, a mere fifteen years ago.

David Hockney won the prize for Young Professionals at the London University Art Competition in '61, I was classed as an Amateur and took my £5.00 prize along with him.

We were the ones who swung, out and about at 4am – cruising. Sort of high class renters, though no-one got my arse for a dinner. A large cock was an advantage in this world. I thought myself dead butch. It was not until the end of the decade – shortly after the first meeting of the Gay Liberation Front at the London School of Economics –

that I turned over and got fucked – at the hot end of the Gigolo; no words will describe how exciting that was.

Clothes. Carnaby Street was cheap and egalitarian, art school clothes at Pauline Fordham's Palisades were on the way. My friend Ossie Clark who swung London, and lost a collar or two to the sound of the Doors, founded the King's Road. Meanwhile David's friend, Mo, painted the large blue skies and swimming pools in the background while David held the foreground with charm and a toothpick. 'Blondes have more fun'. David was constant, unlike Rudolph, who danced right off the stage of the Opera House, down King's Road in the small hours 'till he turned a trick. Patrick Proctor gave up and redecorated 'Moroccan'.

Where's the party?

I fucked with my first man in the basement of 64 Priory Road, Kilburn. A student hanger-on, bystander.

David and Patrick seemed so rich, rich and old, though we were only separated by a few years. Peter said we were there to protect them from the confetti of purple hearts at La Deuce – social shields. We ate upstairs at the Casserole and after 11:00 dived into the scrum in the basement of the Gigolo, whose owner had nearly a dozen large Francis Bacons on the third floor which you might be invited to admire.

Finding sexual partners was difficult and they were often transitory – hardly bothered to take their pants down before buttoning up. And the police might raid, send the prettiest ones in as *agents provocateurs*. They had hard-ons, but didn't come. Just arrested you.

Where's the party?

It might be Tony Richardson's whole metallic rooms echoed to the cry of a pet toucan; the Guinesses, where we talked to David Niven and rolled joints in a corner; or Isabel Aberconway's where we behaved and admired the Picassos, gingerly accepting grapes dipped in chocolate at tea time.

Snobbism in large helpings sunk Patrick's leather boys and Joe Orton's; their place taken by the Buckles and Snowdons in increasingly transitory watercolour. David painted lurid Western art collectors and opera directors sitting on Breuer chairs.

A private view? Where's the private view?

– Derek Jarman, 'Diary, July 1989',
Modern Nature [Vintage, 1991]
113–15

Merril Mushroom
'How the butch does it: 1959' (1992)

I. The butch combs her hair

The butch combs her hair. She combs it at home in private. This is the functional combing. She stands in front of the mirror. Holding the comb between her thumb and first two fingers, she slaps the flat of it against her other palm, then places the comb down on the edge of the sink.

She leans forward and peers at her reflection, flicks her first three fingers through the front of her hair, pulls a curl down over her forehead. She tilts her head sideways and looks at her reflection from beneath lowered eyelids. The butch is sultry. The butch is arrogant. The butch is tough. She picks up the bottle of Vitalis and pours a generous amount into her palm, rubs her hands together, and strokes the lotion through her hair, rubbing carefully to be sure that each strand is well coated, yet not greasy. Then she turns on the water and wets her hair with her hands. Now she is ready to begin.

The butch lifts the comb from the side of the sink. She stretches both her arms forward, then bends her elbows. Now! One-two-three-four, she strokes the comb carefully through one side of her hair, following the path of teeth with the flat fingers of her other hand, barely touching herself as she smoothes. The pattern of hair wings back above her ears, back, back, all the way to the middle of her head. Then, five-six, the sides are lifted on the comb to fall in a wave over the top.

Okay, one-two-three-four, comb the other side in the same manner, five-six, over the top. Now back to the first side again, going straight up to the top this time, seven-eight-nine-ten, then the other side in the same pattern. The butch pats her hair as she combs it, pressing it gently into place. She admires her reflection, tilting her heard this way and that. Then she lifts the comb to vertical, places the edge of the teeth carefully at the top of the middle of the back of her head, and draws it precisely down the center, pushing the ends of her hair into the furrow, creating a longitudinal cleft above her neck — a perfect duck's ass.

Now the butch concentrates on the top of her hair. She uses the comb expertly to settle the waves into a pompadour. When she is finally satisfied with the effect, she pulls the teeth of the comb carefully down through the center and over her forehead, then uses her fingers to push, pull and tease the front into one very casual-looking lock that curls over her brow.

The butch makes eyes at her reflection. She is ready to go out. She is satisfied with her appearance.

The butch combs her hair

The butch combs her hair. She combs it in public. This is the 'show' combing, done primarily for effect. The butch shows off. She draws the comb from her pocket smoothly, holding it between the thumb and index finger of the dominant hand. She stretches both arms out forward, then crooks her elbows, ready to begin.

The butch spreads her legs, balancing her weight on the balls of her feet. She holds the comb ready to do her hair, the fingers of her other hand extended, ready to smooth stray ends if necessary. She leans over to the side, bending away from the side she will be combing, tilting her head toward the comb. Her elbows jut until they are almost horizontal. She squints, concentrates, and then she lowers the comb. She will not comb her hair just yet — there is something more she wishes to do to show off.

With the first two fingers of the hand that does not hold the comb, the butch pulls a cigarette out of the pack that is either in her breast pocket or rolled up into the sleeve of her t-shirt. She places the white cylinder between her teeth, closes her lips around it, and rolls her head back just a little. She pulls out her Zippo, flicks the flame on and ready to the end of the cigarette in one expert motion, inhales deeply, then snaps the Zippo closed with her thumb, palms the lighter, and curls the index finger of that same hand around the cigarette, withdrawing it from her mouth. Still holding the cigarette, she slips the lighter into her hip pocket, pushing it down with her thumb, then grasps the cigarette firmly between the tips of her thumb and index finger. She places it back between her lips, then swiftly combs her hair, four strokes on each side, then two, then the top. Skilfully, seemingly carelessly, the butch fingers her pompadour and casual curl into place. Then, with a flourish, using her comb followed by the fingertips of her other hand, she creases the duck's ass down the middle of her back.

All this time, smoke from the cigarette in her mouth has been curling up into her face. Although she squinted her eyes, she did so only in concentration on her task. At no time did she close her eyes against the smoke, nor did she cough or gasp for breath. The butch is tough, stoic. Only at the completion of the combing does she remove the cigarette from between her lips, and she does not draw in a deep breath immediately thereafter.

Now the butch returns her comb to its pocket. She does not reach up

to check on her hair, to make sure that all is as it should be. She trusts that she looks wonderful, that her hair is impeccably in place, perfectly styled. She is satisfied with her performance. [...]

— Merril Mushroom, 'How the Butch does it: 1959', from Joan Nestle ed., *The Persistent Desire: A Femme-Butch Reader* [Alyson Publications, Boston, 1992] 133—5

Ann Gibson
'Lesbian Identity and the Politics of Representation in Betty Parson's Gallery' (1994)

Abstraction is rarely approached in terms of gender, in fact, it is usually considered to have escaped such constraints. And certainly it has seldom been analyzed in a lesbian perspective. It is a striking fact, however, that just before mid-century in New York, a type of art characterized as heterosexual and male - Abstract Expressionism — and recognized as the major abstraction in its time, appeared to emanate from a gallery run by a lesbian — Betty Parsons. Parsons also showed art that was not 'Abstract Expressionist' a fact that indicated to some critics and even some of her artists that her standards of quality weren't strong or consistent enough. I would like to argue that both her advocacy of the art that became Abstract Expressionism and of art that did not issued from her belief that *difference* superseded 'quality'. Or put another way, for her, difference — stubbornly defended, even pursued past the point of practicality — was the quality she valued most highly. [...]

Now, difference, whether it is between realism and abstraction or loving someone of the same or other sex, is not intrinsically oppositional or hierarchical. What makes difference into opposition are often acts based on a desire to make one object, mode, or person superior to another. If power is developed when one group of people direct the actions of another group, it is necessary to specify how one group differs from the other so that the group in power can define itself. In the case of sexual difference this has meant drawing on distinctions that form the web of relations that have empowered some sexualities and disempowered others. In the case of realism and abstraction it has taken the form of arguments about how art best represents experience. To do as Parsons did — to favour what was

different for its own sake, was to short-circuit power plays based on preferences that calling something 'different' facilitated.

When the National Gallery opened its new East Wing in 1978, the critic John Canady noted that 10 out of the 23 artists represented had been given their first one-man shows in Betty Parsons's gallery. In addition to Pollock and Gottlieb there were Mark Rothko, Clyfford Still, Barnett Newman, Hans Hofmann, Ad Reinhardt, Richard Pousette-Dart, Joseph Cornell and Bradley Walter Tomlin. [...][1]

By the end of the third quarter of the twentieth century, it seemed as if Betty Parsons had launched Abstract Expressionism single-handedly.[2] But if Abstract Expressionism as it has been presented until recently was an all-male, all-white, heterosexual movement, it needs to be said that Parsons also gave one-person shows to a number of artists who did not fit those parameters and have yet to achieve the renown of many of those named above. As noted above, some were women. Of these at least one, Sonia Sekula, was a lesbian. Parsons also showed men who, although not out in today's sense, were understood by their closer friends in the art community to be devoted to their male partners; these included Alphonoso Ossorio and Leon Polk Smith. She showed Forrest Bess, too, whose visionary mysticism including gay, scatological and (eventually) transsexual images and themes [...] displayed form and references in some ways more extreme than the subjective biomorphism of much Abstract Expressionism. [...]

As noted above, Abstract Expressionism has been characterized as a notably male and ostensibly, at least, heterosexual male affair. Rudi Blesh's description of these artists in his book, *Modern Art USA, Men, Rebellion, Conquest, 1900–1956* reads now [...] as a parody. But it was not intended that way, nor initially received as anything but high praise:

> They will be long remembered as a remarkably rugged lot, with minds as well muscled as their bodies (*Time* calls Pollock 'The Champ'). They are built like athletes, and some of them, like Pollock and De Kooning, paint like athletes. If pictures could explode, theirs would, so grimly by the force of their wills have they compressed their dual muscularity onto the canvas [...] If any group can ever force our museums and collectors to accept American modernism, this is surely the bunch to do it'. [...][3]

In the thirties and forties it was generally assumed that women without

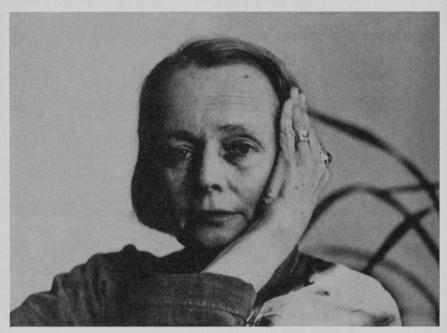

Betty Parsons, New York, c.1965

husbands and children were neurotic and unfulfilled, even though they themselves may have thought they were having a fine life. [...]

The conviction that women could be psychologically healthy only if they were wives and mothers pervaded the arts as it had other fields, establishing a polarity between the focussed, unified potential of the artistic male psyche and what was constructed as the necessarily fragmented female artist, split between the demands of home and professional life. [...]

Recognizing the male valence of the atmosphere of Abstract Expressionism, it seemed to Gertrude Barrer — a heterosexual women, with children, whose abstract expressionism has yet to find its place in the history of that era — that being a gay *man* was not a disadvantage for an artist, but that being a woman, straight or lesbian, was. A number of closeted gays were in positions of power, she recalled, and gay men could pass as straight when necessary.[...] Although some might take issue with the idea that being gay and male was no problem in the arts, perceptions of insufficiency were particularly easily activated in the case of sexually active lesbian women. Sonia Sekula, for instance, showed paintings and drawings that were both abstract and expressionist with Parsons from 1948 through 1957. Although her work was well-received, she was seen as unfortunate, partly because she was psychologically unstable, but partly because of her sexuality.

In an era where properly feminine women were supposed to subject themselves to masculine needs, there was, however, also an upside to

lesbian identity. If gay men were belittled as 'less than' heterosexual men and therefore comic or neurotic in a binary sexual system that constructed gay males as feminine, lesbian women were 'more than' heterosexual women — that is, more like men. Men in dresses were funny; women in pants were real artists. 'The lesbian world was much quieter then', according to Alphonso Ossorio, 'although everyone knew it was there. It was chic to be a lesbian. Priscilla Park, the head of *Vogue* was a dyke. The art world was riddled with rich young queens'.[4] As poet and painter Elise Asher observed of lesbianism in the forties, 'compared to other women, lesbians had force and aggression when they go together — since women had to insist more, this was an advantage. Lesbians were living for themselves. They didn't need that male affection'. [...][5]

If lesbian sexuality's most valuable political potential is its refusal to let male power determine female desire, then one of its most notable loci at mid-century was Betty Parsons's gallery. Parsons's 'giants' as she called them — Rothko and Newman particularly — were eager to guide her in her exhibition and sales policies. As early as 1949 some of her more prominent artists (Newman, Still, Pollock, Rothko) urged her to abandon most of her other artists to concentrate *their* (the Giants) version of abstraction. In 1951, led by Barnett Newman, these men gave her an ultimatum; get rid of the other artists or we will leave.[6]

'I was present at that extraordinary meeting,' recalled Alphonso Ossorio.

Where seven powerhouse artists were thinking of leaving Betty [...] They presented their ultimatum: Either you cut down on the frequency of shows and give us some sort of assurance — a contract of some kind — or else we'll just have to leave you. Betty said, 'Sorry, I have to follow my own lights — no'.[7]

Lee Hall, Parsons's biographer, recounted a somewhat different version of this meeting, attended by Pollock, Rothko, Newman and Still in early 1951. 'We will make you the most important dealer in the world', Parsons recalled Newman's telling her. 'But that wasn't my way' Parsons said. 'I need a larger garden'.[8] Parsons's relations with her artists were multifaceted. 'Betty promoted the men more actively than she did the women,' reflected Jeanne Miles, an artist whose painting is best known for its contemplative geometry. 'Betty's being a lesbian didn't mean that she was pushing women's work. She thought like a man, in a way. She liked having women around. But she was not going to break her head against the wall for women artists. Men were in a position to do a lot for themselves'. [...][9] Parsons's obvious enjoyment of her artists and her simultaneous refusal to permit them to determine her gallery's direction provides an example of a woman who refused to let masculine insistence fashion her desires or determine her program. Parsons supported her gallery not only by her artists' sales, but also through the financial assistance of a network of women friends.[10] A painter herself, Parsons resented the implication that the men's work was so important that the other artists she showed should be discarded.[11]

Some of the artists whose representation by her gallery Parsons had no intention of disturbing included Hedda Sterne, Sonia Sekula, Maud Morgan, Adaline Kent, Buffie Johnson, Jeanne Miles, Perle Fine, Anne Ryan, Sari Dienes, Day Schnabel, and Ethel Schwabacher. As the reputation of her gallery grew, Parsons was increasingly discreet about the fact that women held the central place in her affections and indeed, provided her most valuable business connections. Worried that she would be identified as a lesbian, she told Hall, 'You see, they hate you if you are different; everyone hates you and they will destroy you. I had seen enough of that. I didn't want to be destroyed'.[12] But neither did she have any intention of caving in.

Betty Parsons's own sexuality was not exactly a secret. She had affairs and liaisons, with both men and women after an early and short-lived marriage. But her most passionate and lasting relationships were with women.

Although at various periods in her life, urged by friends such as Dorothy Oehlrichs, she considered marriage, she could not bring herself to sacrifice her independence and what she described in her diary as *Strange wild wishes never quite the same. Desires no mortal man can name*....[13]

The result was that although most of Parsons's artists and her closest friends knew about the women she loved, this legendary art dealer did not permit her sexuality to become a part of her public persona, the Parsons she presented to visitors to her gallery. In effect, she 'passed' as a heterosexual.[14] What part may her sexuality, in whatever degree closeted, have played in the way she chose the artists she so successfully showed?

It is worth noting that the stylistic variation that Parsons cultivated in her gallery appeared also within the production of some of her individual artists; not only Sterne but also Sekula, who wrote to Parsons in 1957, 'I paint each hour differently, no line to pursue no special stroke to be recognized by, [...] it is still me though it contains over a 1000 different ways.'[15] In the light of Parsons's personal and business decisions, the refusal to grant one stylistic mode hierarchy over another begins to appear as something of principle. Never one to lock herself into something as fixed as a principle, however, she later said simply of her decision to reject 'The Giants' offer: I always liked variety.[16]

Notes

[1] John Canaday, *The New York Times*, Nov. 1, 1978.

[2] Peggy Guggenheim gave one-person shows to Jackson Pollock in 1943, to Hans Hoffman in 1944, to Mark Rothko in 1945, Clyfford Still in 1946, and Richard Pousette-Dart in 1947. Melvin Paul Lader, 'Peggy Guggenheim's Art of This Century: The Surrealist Milieu and the American Avant-Garde, 1942—1947,' Ph. D. diss, University of Delaware, 1981, 395—441.

[3] Rudi Blesh, *Modern Art USA, Men, Rebellion, Conquest, 1900—1956* (New York: Aflfred A. Knopf, 1956), 291. Blesh's book grew out of a study of modern art for a television project commissioned by the Museum of Modern Art.

[4] Alphonso Ossorio, conversation with the author, 5 October 1990, Wainscott, New York.

[5] Elise Asher, interview with the author, 18 June 1988, New York.

[6] Hall, *Betty Parsons*, 94 — 95, 101—103.

[7] Alphonso Ossorio, quoted in Jeffrey Potter, To a Violent Grave (New York: O. P. Putnam's Sons, 1985): 146—47.

[8] Hall, Betty Parsons, 101—102. For a third version of this meeting see Steven Naifeh and Gregory Smith, Jackson Pollock (New York: Clarkson N. Potter, Inc. 1989), 677—678.

[9] Jeanne Miles, interview with the author, New York, 6 August 1988.

[10] Hall, *Betty Parsons*, 80, 91, 92, 103, 116, 138.

[11] Hall, *Betty Parsons*, 102. She was also saddened by their refusal to accept her as an artist. Lee Hall, 'Betty Parsons, Artist,' in pamphlet, 'Betty Parsons, Paintings, Sculpture, Works on Paper,' East Hampton: Pollock-Krasner House and Study Center, Southampton: Fine Arts Gallery, Southampton Campus, Long Island University, and the Benton Gallery, May—July 1992.

[12] Lee Hall, *Betty Parsons*, 53.

[13] Betty Parsons, quoted in Lee Hall, *Betty Parsons*, 53.

[14] Parsons's stance in regard to the way she presented her own sexuality is similar to that for which Teresa de Lauretis approvingly cited Carolyn Allen's discussion of Djuna Barnes: the author of Nightwood refused to be identified as a lesbian, De Lauretis suggested, because to submit to the homophobic understanding of lesbianism was to refuse what de Lauretis discusses as sexual (in) difference: that is, defining feminine sexuality in terms of male needs — by attributing the characteristics of male sexuality (i.e. the possibility of separating sexuality and procreation) to the male and denying them to the female, Western European society has made all sexuality male, i.e. indifferent. 'Sexual Indifference and Lesbian Representation,' in *Performing Feminisms*, ed. Sue Ellen Case (Baltimore: The Johns Hopkins University Press, 1990), 19—23.

[15] Sonia Sekula, letter to Betty Parsons 24 November 1957, the Betty Parsons Papers, Archives of American Art, Smithsonian Institution, Washington, DC, as Roger Perret noted, this was typical of Sonia's attitude earlier, too, as a quotation from an article in 1946 indicated: 'I change consciously from day to day, according to the daily new sphere that surrounds me. Its flux changes continuously.' Sekula in 'An Artist Speaks: Sonia Sekula,' by Cicely Aikman, The League (the publication of the Art Students Leaguee), Winter 1945—46, p.2. Roger Perret, 'Auf Bedeutungsjagd,

auf Bedeurungsflucht. Die Wort
und Farbkunatlerin Sonja Sekula.'
Affenschaukel 16 (1992): 14–15.

[16] Hall, Betty Parsons, 86, 92, 102, 108.

— Ann Gibson, 'Lesbian Identity and
The Politics of Representation in
Betty Parson's Gallery', *Gay and
Lesbian Studies in Art History*
[Hayworth Press, New York, 1994]
245–270

Jonathan Weinberg
'"Boy Crazy":
Carl Van Vechten's Queer
Collection' (1994)

Carl Van Vechten's art — his novels,
like *Nigger Heaven* and *The Tattooed
Countess*, and his photographs and
music criticism — was eclipsed by his
pursuit of what might be called the
extracurricular activities of modernism:
knowing the right people, having the
right things, above all being seen
at the right places at the right time.
In the late-teens and twenties he
made an occupation out of going to
parties and speakeasies [...where] he
gathered material for his novels, was
introduced to many of the celebrities
that would become the subject of
his photography, and spotted new
talent... Van Vechten was particularly
instrumental in establishing Gertrude
Stein's career. And of course Van
Vechten was a leading white publicist
for the Harlem Renaissance. His
collection of letters, manuscripts,
newspaper clippings, theatre posters
and playbills documenting Harlem
in the twenties and thirties was given
to Yale University to become the
cornerstone of the James Weldon
Johnson Memorial Collection of Negro
Arts and Letters. This collection
has been called Van Vechten's
real legacy, 'not the novels.'[1] Indeed,
in 1930, only four years after the
publication of his phenomenally
successful novel *Nigger Heaven*,
Van Vechten gave up writing fiction
entirely and started taking photographs.

Collecting and its corollary,
cataloguing, were in some sense part
of all of Van Vechten's production.
He was notorious for including
descriptive lists in his novels. Van
Vechten has the hero of his *Peter
Whiffle* declare that 'life is made up
of a collection of objects, and the
mere citation of them is sufficient to
give the reader a sense of form and
color, atmosphere and *style* [...]'[2]
Photography more than writing
was a way for Van Vechten to make
permanent his compilation of the
famous. He spoke of his practice of
photographing celebrities not as a

creative act but as collecting people.[3]
His most famous images are those of
prominent African-Americans, pictures
of people like Langston Hughes or
Joe Lewis [...] But he also seemed
intent on making a complete record of
homosexual artists, ranging from Cecil
Beaton to Tennessee Williams [...]

It is significant that Van Vechten
chose to begin his autobiographical
sketches, *Sacred and Profane Memories*
with a description of his mother's
tin trunk.

'In *our* box my mother preserved
old letters, the rarest old letters,
written to honor various family
celebrations, old pictures, specifically
daguerreotypes [...]'[4]

His mother helped the young Van
Vechten with his own collecting:

'[...] she brought boxes of letters,
which my father had written before
and during the Civil War, down from
the garrett [...] Observing me, my
father [...] demanded that the letters
be burned and burned they were while
my mother wept softly [...] some of
them were love letters, and I should
have liked to know how my father
made love to my mother.'

[...] For Van Vechten the ultimate
collection is not just a conglomeration
of objects but a bringing together
of images and texts rich with
experiences and desires so powerful
they draw forth the wrath of the
father and the tears of the mother.

It is precisely such a collection
that Van Vechten put together some
time in the mid-1950's when he was
an old man. Van Vechten left Yale
some twenty-odd scrapbooks of
photographs and newspaper clippings.
These scrapbooks are essentially
homemade [gay] sex books [...] Van
Vechten's taste in erotica runs from
the relatively conventional (numerous
beefcake shots and snapshots of
men in uniform) to the racy (pictures
of beautiful boys performing fellatio
and anal intercourse...) He highlights
particular talents — images of men
sucking their own penises. And he
includes the bizarre — photographs
in which a boy pretends to hammer a
dildo into a friend's anus [...] Private
erotica occupy the same album with
numerous articles and photographs
clipped from magazines and newspapers
that were made for a general public.
There are several pictures of local
sports heroes. For example, alongside
a picture of a handsome tennis player,
with blond curls and a tight polo shirt
are the captions 'Some Like Action
But Others Watch', and 'THE BEST
MAN FOR THE JOB! Man who leads
a double life ...' while he pastes above
another photo of a smiling varsity
team member the words 'Cute Trick'.
He loves sport photos in which
male athletes are brought into close
proximity of lovers: two wrestlers
are locked into a tight embrace
('Close to the End') or a Russian

racer kissing a competitor ('L'amour,
l'amour, l'amour') [...]

Van Vechten pasted together a
history of gay life from the thirties
to the fifties, what has come to
be known as the pre-Stonewall gay
liberation period [...] This practice
of cutting up newspaper articles and
reassembling them was a return to
one of Van Vechten's first jobs when as
a young man at a Chicago newspaper
he was asked to clip articles of rival
dailies and provide his editor with
composite article.[5] But where the
young man innocently participated in a
process that standardized information
so that the *Chicago American* would
have essentially the same news as its
competitors, the old man knowingly
cut and pasted to produce difference.
He found homosexuality where
homosexuality had been suppressed —
the crime reports — and he found
homosexuality where it was not
supposed to be — the tennis court
or the wrestling mat. If it were not
implicit in a photograph he provided
a caption that made it clear [...]

George Chauncey [...] noted the
way that gay men used terms like
'Mary' to refer to each other.[6] This
appropriation of the enemy's worst
insult as a positive signifier is part
of the operating mode of Van Vechten's
scrapbooks [...] Words like 'queer' and
'queen' are snatched from headlines
and used in unintended ways to find
homosexuality everywhere. For example,
below an image of three men on a
sofa in the midst of anal intercourse
are the words 'Tots Atop Queen' and
'INTERIOR DECORATION', punning on
the stereotype of interior decorating
being a gay profession. In the
scrapbooks the dominant culture's
language, the stuff of its crime
reports and of its advertising copy,
is made to speak sexual transgression.

Even exalted works of art are not
immune from this process. Van Vechten
pasted in several postcards of famous
paintings, for example Correggio's
Abduction of Ganymede, adding the
caption 'Manly Memorial Chase'. Van
Vechten treats Correggio precisely
the same way he treated the
pornographic photos [...] Van Vechten's
own photography is not immune from
this levelling effect. A particularly
aesthetic shot of a male nude — his
knees forward and his head and arms
flown back — in a rapturous dance on
the beach, is captioned 'Putting the
bite on 'OVERHEAD!' [...]

Van Vechten, by putting his own
[art] photographs into the scrapbook
negates the typical pornographer's
pose of anonymity [...] Van Vechten's
revels in the surreptitious pleasures
suggested by the cutout newspaper
messages — even giving us a sense
of the often anonymous contact of
strangers that was such an essential
aspect of much gay sexual interchanges
in the fifties — while at the same time

he did not seem to give a damn if the book fell into the wrong hands […]

Certainly the pornographic scrapbook was not an invention of the gay subculture of the fifties. But just as Van Vechten's collection of memorabilia of the Harlem Renaissance is marked by its extraordinary range and self-conscious sense of the importance of what is being remembered, my suspicion is that Van Vechten's scrapbooks are special for their encyclopaedic and historical quality […]

[What fun to] imagine Van Vechten and his friends at private parties laughing over the jokes of the book but what is perhaps more extraordinary about them is that they were intended to survive. They were not destroyed when he died in the way that so many letters, photographs, dairies, erotica that might reveal the homosexuality of its owners has been and continues to be, by embarrassed relatives. In a sense the scrapbooks have at last found their intended audience […] One of the pages even addresses the scrapbooks' future home: 'Yale May Not Think So, But It'll Be Just Jolly' or as another page says, the purpose is 'Educating the Half-Educated' so that 'You Will Lead a More Colorful Life'. In this sense Van Vechten's work of collecting has not stopped […] Van Vechten will continue to collect those of us who want to know how gay people expressed their forbidden desires and created spaces of freedom in the period before so-called gay liberation.

Notes

For a discussion of the question of race and homoeroticism in Van Vechten's work please see the original essay as well as James Smalls, *The Homoerotic Photography of Carl Van Vechten: Public Face, Private Thoughts* (Philadelphia, PA: Temple University Press, 2006).

1 Darryl Pinckney, 'The Honorary Negro,' *The New York Review of Books*, August 18, 1988, 35.

2 Carl Van Vechten, *Peter Whiffle, His Life and Works* (New York: Alfred A. Knopf, 1921), 49.

3 Carl Van Vechten, Columbia Oral History project.

4 Carl Van Vechten, 'The Tin Trunk,' *Sacred and Profane Memories* (New York: Alfred A. Knopf, 1932) 1.

5 Bruce Kellner, *Carl Van Vechten and the Irreverent Decades* (Norman, University of Oklahoma Press, 1968) 29.

6 George Chauncey, Jr. 'Christian Brotherhood or Sexual Perversion? Homosexual Identities and the

Construction of Sexual Boundaries in the World War One Era,' *Journal of Social History* 19 (Winter 1985): 189—211.

— Jonathan Weinberg, '"Boy Crazy": Carl Van Vechten's Queer Collection', *The Yale Journal of Criticism*, vol. 7, no. 2, [John Hopkins University Press, 1994] 25—49

Jonathan David Katz
'Committing the Perfect Crime: Sexuality, Assemblage and the Postmodern Turn in American Art' (2008)

Epilogue

Forty-four years ago, in his catalogue essay for Rauschenberg's first museum exhibition, the curator Alan Soloman had this to say about meaning in Rauschenberg's works:

'It is not true that the combines are intended to be anagrammatic statements of ideas….which we are expected to puzzle out and which will reveal their meanings to us if we succeed in fitting the pieces properly. There are not secret messages in Rauschenberg, no program of social or political discontent transmitted in code, no hidden rhetorical commentary...no private symbolism available only to the initiate.'1

That was in 1963. Exactly forty years later, in his 2003 Rauschenberg book *Random Order*, Branden Joseph sounded almost exactly the same note, albeit more up to date, now bolstered through the ventriloquized voice of Rosalind Krauss:

'The status of Rauschenberg's work as high art has brought forth increasingly intense attempts to read it through the most traditional paradigms of signification, including that of iconography. Such readings have recently gained in prominence as the artists' work has come to be seen as expressing coded messages about his sexual orientation. Although, as Rosalind Krauss has observed, 'the convicted iconographer is almost impossible to dissuade', nearly three decades of such analyses…. have yielded only partial and unsatisfactory results.'2

In the four decades between those two texts, much has changed, but much, as the quotations reveal, has not. Both denounce the prospect of traditionally conceived meanings encoded or otherwise secreted in Rauschenberg's work. As Joseph understands it, 'Rauschenberg pursued forms of aesthetic signification and spectatorial reception that challenge traditional signifying means'.3 'Yes, of course he did. But we have failed to put this new approach to meaning in its historical context, failed to ask about the resonance between such a renewed attention to the problem of meaning and the advent of the cold war, perhaps American's most heavily policed cultural moment'.4 Instead of analyzing how queer authorship came to be nervously frontloaded with an array of doubts, dis-simulations, and anxieties at the height of the Red Scare, McCarthyism, and the House Un-American Activities Committee, the last forty years of Rauschenberg–Johns scholarship have instead witnessed a near-continuous critical reengagement with the terms of a proposition figures like Cage, Rauschenberg, and Johns first promoted in the middle of the last century. When generally disputatious scholars cooperatively circle the wagons against a spectre dubbed 'traditional signifying means', it is clear how powerfully critical intelligence has become allied, and stayed allied, with one postmodern critical project — in large measure because it ventriloquizes a foreclosure of any discussion of same-sex sexuality through recourse to the artists themselves.5

The native opposition in Rauschenberg–Johns scholarship between a putatively postmodernist denigration of intentionallity on the one hand and what gets called iconography on the other is itself a highly instrumentalized distinction. Joseph's dismissal of, in his words, iconography's new 'prominence as the artist's work has come to be seen as expressing coded messages about his sexual orientation' alludes to what is at stake here and why. The new homophobia no longer flatly denies, as it once did, the same-sex relationships among Johns, Rauschenberg, Twombly, Cage, Cunningham, and so many others in their circle. Instead, it denies that biographical fact any critical purchase, casting it aside as a relic of what Joseph dismisses as 'the most traditional paradigms of signification'. But, as I have shown, it was precisely John's and Rauschenberg's sexuality that informed their development of a critique of traditional forms of meaning-making. In short, the postmodern turn in American art had authors; these authors had relationships with one another; these relationships not only informed their

thinking about audience and meaning-making in a context of grave constraint, but moreover are written on the surfaces of their work — not only as iconography but as a far less codified but no less intentional pressure on the process of signification as well.

It is, at best, an unwarranted assumption to extrapolate from the position that because an audience cannot reconstruct an artist's meanings, the artist therefore intended none. To articulate an audience-centred art does not require eliminating the prospect of authorial intention. A fully audience-centred art open to the free play of signification can in fact happily coexist with quite specific and traditional authorial meanings; the author's meanings do not have to be the audience's, but that doesn't entail that authors not have meanings of their own. In short, works that 'challenge traditional signifying means' may also — partially and discontinuously — signify in traditional ways, which is to say intentionally, expressively, not least when extant social codes necessitate differentiated forms of address for different audiences in the context of illicit desire. In short, there are multiple audiences for the work of Johns and Rauschenberg — a general audience, an audience among a circle of friends, and audiences of each other. These different levels of audience at various points in the work engage different reading strategies. It is no denigration of postmodernist practice to insist also and at the same time that works are utterly decentred from the perspective of a general audience and often do have particular meanings for their makers, or for friends of their makers. In ordinary discourse, we readily accept that couples maintain private codes and meanings; why is it so hard to accept that in art-work? Indeed, Johns and Rauschenberg's breakthrough toward a critical stance of anti-authoriality was, as I have argued, itself a deliberate authorial strategy, an alluring invitation proffered to deflect attention away from other, more personal meanings. As code makers know, there is nothing as effective as a superfluity of signification to camouflage the generation and receipt of particular messages. To historicize postmodernism — to explore the conditions of its genesis — underscores the rootedness of these insights in a particular cold-war cultural matrix. Now, over a half-century later, such a historicization of postmodernism is well overdue.

Notes

1 Alan R. Solomon, *Robert Rauschenberg*, exh. cat. (New York: Jewish Museum, 1963), n. p.

2 Joseph, II. See also Richard Meyer's review of Joseph's book, 'Two on One: Richard Meyer on Robert Rauschenberg,' *Artforum* 42, no. 6 (February 2004): 25–26.

3 Joseph, II.

4 Moira Roth first modelled this contextual approach in 1977.

5 Perhaps the most significant analysis of this moment in all its complexity remains Amelia Jones's landmark *Postmodernism and the En-Gendering of Marcel Duchamp* (New York: Cambridge University Press, 1994).

— Jonathan David Katz, 'Committing the Perfect Crime: Sexuality, Assemblage and the Postmodern Turn in American Art. Epilogue', *Art Journal*, vol. 67 [2008], 52–3

E –
Into the Streets
(1965–79)

This section documents the rise of urban gay culture as a lifestyle organized around the pleasures and expanded possibilities of sexual life. While gay male art and publications of the 1970s often embraced hardcore sex and the codes, costumes and fitness regimes that signalled one's devotion to it, lesbian separatists of the same moment were far more explicitly political in their critique of patriarchal culture, including the masculinism and misogyny of many gay men. As the 1970s progressed, both lesbian and gay male cultures reached new levels of visibility and cultural inventiveness. They did so, however, with increasing autonomy from — and occasional antipathy towards — one another.

Clark P. Polak
'The Story Behind Physique Photography' (1965)

[...] Interest in visual sexual stimulation is a peculiarly masculine trait as women almost never achieve the same kind of arousal from photographs or artistic representations. Lesbians, for instance, are no more concerned with the Playboy fold out than straight women are with *TM* [Tomorrow's Man]. In those instances where particular men are not overly stimulated in this manner, they are at least appreciative.

Postmaster Tackled

Physiques could not always be sold as freely as they are today. This status is of recent vintage and not until H. (for Herman) Lynn Womack, the albino chieftain of the Guild Press, tackled JFK appointed Postmaster General J. (for James) Edward Day in 1961 did the world become safe with physical publications.

Predictably, Womack lost in the lower courts and spent six months in jail and 18 months in a mental hospital for his trouble, but he pushed the case to the Supreme Court, which held:

> 'These portrayals of the male nude cannot fairly be regarded as more objectionable than many portrayals of the female nude that society tolerates. Of course not every portrayal of male or female nudity is obscene'.

The court was quick to find, as we have found here, that the material was: 'dismally unpleasant, uncouth, and tawdry', but this, happily, was insufficient argument to declare it legally obscene.

In rendering this decision the Supreme Court was unable to regard Womack's motives as anything other than 'sordid' nor the gay public as more than 'unfortunate', but this case stands as one of the two most important homosexual court victories and as a testament to Womack's courage.

Over Masculinization

Not all publications on the market featuring semi-clad torsos of attractive young men are overtly directed at homosexuals, and so-called muscle books (*Mr. America*, *Iron Man*) have great popularity among weight lift enthusiasts. It is suspected that a significant portion of these persons would, however, fall into Kinsey's elusive 13% of all males who are erotically attracted to other men but who never express their interest sexually. Partially as a reaction to the increased blatancy of the physiques, the muscle books have become highly conservative of late.

Strong editorial policy precludes inclusion of shots of rear nudes or posing strap views. Sexually provocative photos are conspicuously absent, lending an almost sterile air. [...]

Money

The average model receives from $5 to $100 depending on what was described to us as 'skill'. Many insist they enter the field for the few dollars involved: 'That is what I told myself', remembers an ex-star turned photographer.

'It was a heady experience seeing my pictures plastered where ever I went, but I still told myself I was doing it for the money.

'Now that I have a stable of young bucks and my personal posing days are over, I realise the money was the least of it'.

Gay or Straight?

Not all models are gay or even available, but the majority have some experience. In this they are but little different from the 37% of males generally who have at last one homosexual experience to the point of orgasm during their life-times.

Robert **DURANTON**, Plus Bel Athlète de France 48-49
(Lire dans ce numéro les commentaires et tous les résultats du Concours)

Cover of the November 1949 issue of *La Culture Physique*

Whether the photographers have the models sexually or not is as much a matter of circumstances as it is in all of life. Womack has grumbled: 'People begin physique photography as it is an easy way to get trade', but this does not seem to be a necessary rule. More realistically, Neil Edwards holds that confusing 'personal involvement' with what can most productively be a professional relationship is an almost certain way to alienate a valuable model.

The Top

[...] Some top models have gained immense followings and have used modeling as a stepping stone.

[...] Bob Hover and Jim Stryker are everywhere to be seen in male fashion advertising (Hover is one of the highest paid models in the world and Stryker recently presented in a 20 page *Gentlemen*'s *Quarterly* spread); Glenn Bishop, another of the most popular stars, now practices chiropractic in Michigan.

Besides the obvious exceptions, models are from lower socio-economic levels. Men from this stratum are not only more readily available, but are taken to be more masculine. In our society, intellectuality and sophistication have feminine associations that mitigate against pure physical attractiveness.

'Dirty' vs. 'Clean'

To ask that all physique photographers have genius and all models Grecian builds is as unreasonable are being willing to accept total lack of form, composition, and technique. Cleanliness in matters sexual has little relationship to the subject depicted for there is nothing inherently 'dirty' about sexually stimulating photographs of two persons enjoying sodomy, fellatio mutual masturbation or any other act.

Currently distributed pictures of tumescent boys and men are not 'dirty' because of the tumescence, but because of the apparent view that this delightful state is the *only* point of importance. In operating, as we do, from the position that sexual stimulation is a valuable force, we ask not that it be channeled into what the hard core puritans might term 'productive' endeavors, but that it be treated as worthwhile and not as semi-clandestine and shameful.

Obviously, if given a choice between non-sexual art and non artistic sex, only a unique few would elect the former. But crude photographic technique is not vital for sexual arousal.

Future's Meaning

Regardless of temporary local set backs, the future will see wider and wider circulation of all sexual publications in line with the current trend. Even today there are few towns in which at least one physique book is not available and a surprising number of rural and metropolitan areas feature nudist magazines.

This spreading distribution assumes importance well beyond the value of the visual and masturbatory benefits to the reader: the free sale and display of literature designed for homosexual pleasure serves to improve the well-being of the community through the promotion of happier citizens in addition to heralding the emergence of less repressive societal attitudes, affecting both heterosexuals and homosexuals.

— Clark P. Polak, 'The Story Behind Physique Photography', *Drum*, vol. 5, no. 8 [October 1965] 11–15

Valerie Solanas
'S.C.U.M. Manifesto' (1967)

Life in this society being, at best, an utter bore and no aspect of society being at all relevant to women, there remains to civic-minded, responsible, thrill-seeking females only to overthrow the government, eliminate the money system, institute complete automation and destroy the male sex.

It is now technically feasible to reproduce without the aid of males (or, for that matter, females) and to produce only females. We must begin immediately to do so. Retaining the male has not even the dubious purpose of reproduction. The male is a biological accident: the Y (male) gene is an incomplete X (female) gene, that is, it has an incomplete set of chromosomes. In other words, the male is an incomplete female, a walking abortion, aborted at the gene stage. To be male is to be deficient, emotionally limited; maleness is a deficiency disease and males are emotional cripples.

The male is completely egocentric, trapped inside himself, incapable of empathizing or identifying with others, or love, friendship, affection or tenderness. He is a completely isolated unit, incapable of rapport with anyone. His responses are entirely visceral, not cerebral; his intelligence is a mere tool in the services of his drives and needs; he is incapable of mental passion, mental interaction; he can't relate to anything other than his own physical sensations. He is a half-dead, unresponsive lump, incapable of giving or receiving pleasure or happiness; consequently, he is at best an utter bore, an inoffensive blob, since only those capable of absorption in others can be charming. He is trapped in a twilight zone halfway between humans and apes, and is far worse off than the apes because, unlike the apes, he is capable of a large array of negative feelings — hate, jealousy, contempt, disgust, guilt, shame, doubt — and moreover, he is *aware* of what he is and what he isn't.

Although completely physical, the male is unfit even for stud service. Even assuming mechanical proficiency, which few men have, he is, first of all, incapable of zestfully, lustfully, tearing off a piece, but instead is eaten up with guilt, shame, fear and insecurity, feelings rooted in male nature, which the most enlightened training can only minimize; second, the physical feeling he attains is next to nothing; and third, he is not empathizing with his partner, but is obsessed with how he's doing, turning in an A performance, doing a good plumbing job. To call a man an animal is to flatter him: he's a machine, a walking dildo. It's often said that men use women. Use them for what? Surely not pleasure.

Eaten up with guilt, shame, fears and insecurities and obtaining, if he's lucky, a barely perceptible physical feeling, the male is, nonetheless, obsesses with screwing; he'll swim through a river of snot, wade nostril-deep through a mile of vomit, if he thinks there'll be a friendly pussy awaiting him. He'll screw a woman he despises, any snaggle-toothed hag, and furthermore, pay for the opportunity. Why? Relieving physical tension isn't the answer, as masturbation suffices for that. It's not ego satisfaction; that doesn't explain screwing corpses and babies.

Completely egocentric, unable to relate, empathize or identify, and filled with a vast, pervasive, diffuse sexuality, the male is psychically passive. He hates his passivity, so he projects it onto women, defines the male as active, then sets out to prove that he is ('prove that he is a Man'). His main means of attempting to prove it is screwing (Big Man with a Big Dick tearing off a Big Piece). Since he's attempting to prove an error, he must 'prove' it again and again. Screwing then, is a desperate compulsive, attempt to prove he's not passive, not a woman; but he is passive and *does* want to be a woman.

Being an incomplete female, the male spends his life attempting to complete himself, to become female. He attempts to do this by constantly seeking out, fraternizing with and trying to live through and fuse with the female, and by claiming as his own all female characteristics — emotional strength and independence, forcefulness, dynamism, decisiveness, coolness, objectivity, assertiveness, courage, integrity, vitality, intensity, depth of character, grooviness, etc. — and projecting onto women all male traits — vanity, frivolity, triviality,

weakness etc. It should be said,
though, that the male has one glaring
area of superiority over the female —
public relations. (He has done a
brilliant job of convincing millions of
women that men are women and women
are men). The male claim that females
find fulfilment through motherhood and
sexuality reflects what males think
they'd find fulfilling if they were female.

Women, in other words, don't have
penis envy; men have pussy envy.
When the male accepts this passivity,
defines himself as a woman (males as
well as females think men are women
and women are men), and becomes
a transvestite he loses his desire to
screw (or to do anything else, for
that matter; he fulfils himself as a drag
queen) and gets his dick chopped off.
He then achieves a continuous diffuse
sexual feeling from 'being a woman'.
Screwing is, for a man, a defense
against his desire to be female.[…]

'Great Art' and 'Culture':
The male 'artist' attempts to solve his
dilemma of not being able to live, of
not being female, by constructing a
highly artificial world in which the male
is heroicized, that is, displays female
traits, and the female is reduced
to highly limited, insipid subordinate
roles. That is, to being male.

The male 'artistic' aim being,
not to communicate (having nothing
inside him he has nothing to say), but
to disguise his animalism, he resorts
to symbolism and obscurity ('deep'
stuff). The vast majority of people,
particularly the 'educated' ones,
lacking faith in their own judgment,
humble, respectful of authority
('Daddy knows best'), are easily
conned into believing that obscurity,
evasiveness, incomprehensibility,
indirectness, ambiguity and boredom
are marks of depth and brilliance.

'Great Art' proves that men
are superior to women, that men are
women, being labelled 'Great Art',
almost all of which, as the anti-
feminists are fond of reminding us, was
created by men. We know that 'Great
Art' is great because male authorities
have told us so, and we can't claim
otherwise, as only those with exquisite
sensitivities far superior to ours can
perceive and appreciate the slop
they appreciate.

Appreciating is the sole diversion
of the 'cultivated'; passive and
incompetent, lacking imagination and wit,
they must try to make do with that;
unable to create their own diversions,
to create a little world of their own,
to affect in the smallest way their
environments, they must accept what's
given; unable to create or relate,
they spectate. Absorbing 'culture'
is a desperate, frantic attempt to
groove in an ungroovy world, to escape
the horror of a sterile, mindless,
existence. 'Culture' provides a sop to
the egos of the incompetent, a means
of rationalizing passive spectating;

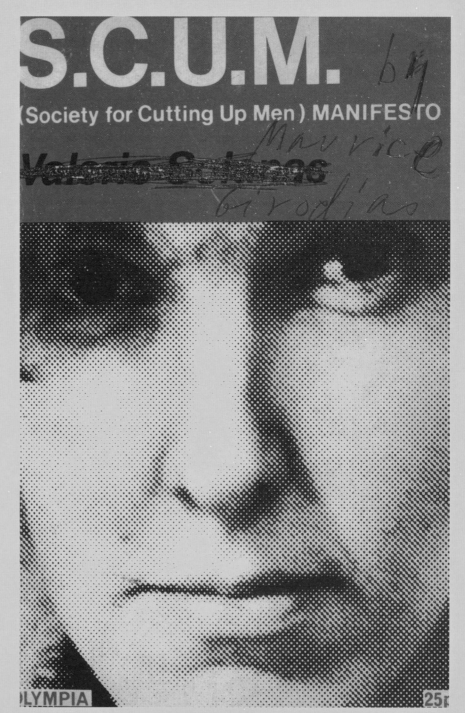

Valerie Solanas's defaced cover of her *S.C.U.M. Manifesto*, 1967

they can pride themselves on their
ability to appreciate the 'finer'
things, to see a jewel where this is
only a turd (they want to be admired
for admiring). Lacking faith in their
ability to change anything, resigned
to the status quo, they have to
see beauty in turds because, so far
as they can see, turds are all they'll
ever have.

The veneration of 'Art' and
'Culture' — besides leading many women
into boring, passive activity that
distracts from more important and
rewarding activities, from cultivating

active abilities, leads to the constant
intrusion on our sensibilities of
pompous dissertations on the deep
beauty of this and that turn. This
allows the 'artist' to be setup as one
possessing superior feelings,
perceptions, insights and judgments,
thereby undermining the faith of
insecure women in the value and validity
of their own feelings, perceptions,
insights and judgments.

The male, having a very limited
range of feelings, and consequently,
very limited perceptions, insights and
judgments, needs the 'artist' to guide

him, to tell him what life is all about. But the male 'artist' being totally sexual, unable to relate to anything beyond his own physical sensations, having nothing to express beyond the insight that for the male life is meaningless and absurd, cannot be an artist. How can he who is not capable of life tell us what life is all about? A 'male artist' is a contradiction in terms. A degenerate can only produce degenerate 'art'. The true artist is every self-confident, healthy female, and in a female society the only Art, the only Culture, will be conceited, kooky, funky, females grooving on each other and on everything else in the universe.[…]

— Valerie Solanas, *S.C.U.M. Manifesto* [self-published, 1967] [Olympia Press, New York, 1968]

Lucian K. Truscott IV
'Gay Power Comes to Sheridan Square' (1969)

Sheridan Square this weekend looked like something from a William Burroughs novel as the sudden spectre of 'gay power' erected its brazen head and spat out a fairy tale the likes of which the area has never seen.

The forces of faggotry, spurred by a Friday night raid on one of the city's largest, most popular, and longest lived gay bars, the Stone-wall Inn, rallied Saturday night in an unprecedented protest against the raid and continued Sunday night to assert presence, possibility, and pride until the early hours of Monday morning. 'I'm a faggot, and I'm proud of it! 'Gay power!' 'I like boys!' — these and many other slogans were heard all three nights as the show of force by the city's finery met the force of the city's finest. The result was a kind of liberation, as the gay brigade emerged from the bars, back rooms, and bedrooms of the Village and became street people.

It began as a small raid — only two patrolmen, two detectives, and two policewomen were involved. But as the patrons trapped inside were released one by one, a crowd started to gather on the street. It was initially a festive gathering, composed mostly of Stonewall boys who were waiting around for friends still inside. Cheers went up as favourites emerged from the door, striking a pose and swishing by the detective with a 'Hello there, fella'. Wrists were limp and hair was primped. The stars were in their element.

Suddenly a paddywagon arrived and the mood of the crowd changed. Three of the more blatant queens — in full drag — were loaded inside, along

with the bartender and doorman, to a chorus of catcalls and boos from the crowd. A cry went up to push the paddywagon over, but it drove away before anything could happen. The next person to come out was a dyke, and she put up a struggle. At that moment, the scene became explosive. Limp wrists were forgotten. Beer cans and bottles were heaved at the windows, and a rain of coins descended on the cops. At the height of the action, a bearded figure was plucked from the crowd and dragged inside. It was Dave Van Ronk, who had come from the Lion's Head to see what was going on. He was charged with throwing an object at the police.

Almost by signal the crowd erupted into cobblestone and bottle heaving. The trashcan I was standing on was nearly yanked out from under me as a kid tried to grab it for use in the window smashing melee. From nowhere came an uprooted parking meter — used as a battering ram on the Stonewall door. I heard several cries of 'Let's get some gas', and a blaze soon appeared in the window of the Stonewall. As the wood barrier behind the glass was beaten open, the cops inside turned a firehose on the crowd. By the time the fags were able to regroup, several carloads of police reinforcements had arrived and the streets were cleared.

A visit to the 6th Precinct revealed that 13 people had been arrested on charges that ranged from Van Ronk's felonious assault of a police officer to the owners' illegal sale and storage of alcoholic beverages without a license. Two police officers had been injured in the battle with the crowd. By the time the last cop was off the street Saturday morning, a sign was going up announcing that the Stonewall would reopen that night. It did.

Protest set the tone for 'gay power' activities on Saturday. The afternoon was spent boarding up the windows of the Stonewall and chalking them with signs of the new revolution: 'We are Open', 'There is all college boys and girls in here', 'Support Gay Power — C'mon in, girls'. Among the slogans were two carefully clipped and bordered copies of the *Daily News* story about the previous night's events, which was anything but kind to the gay cause. But the real action was in the street. Friday night's crowd had returned, led by a group of gay cheerleaders. 'We are the Stonewall girls', they chanted. 'We wear our hair in curls. We have no underwear. We show our pubic hairs!' The scene was a command-performance for queers. If Friday had been pick-up night, Saturday was date night. Hand-holding, kissing, and posing accented each of the cheers with a homosexual liberation that had appeared only fleetingly on the street before. Radio news announcements

about the previous night's 'gay power' chaos had brought half of Fire Island's Cherry Grove running back to see what they had left behind. The generation gap existed even here. Older boys had strained looks on their faces and talked in concerned whispers as they watched the up-and-coming generation take being gay and flaunt it.

As the chants on the street rose in frequency and volume, the crowd grew restless. 'Let's go down the street and see what's happening, girls', someone yelled. And down the street went the crowd, smack into the Tactical Patrol Force. Formed in a line, the TPF swept the crowd back to the corner of Waverly Place where they stopped.

A stagnant situation there brought on some gay tomfoolery in the form of a chorus line facing the helmeted and club-carrying cops. Just as the line got into a full kick routine, the TPF advanced again and cleared the crowd of screaming gay powerites down Christopher to Seventh Avenue. The cops amused themselves by breaking up small groups of people, till the crowd finally dispersed around 3.30 am.

Sunday was a time for watching and rapping. Gone were the 'gay power' chants of Saturday, but not the new and open brand of exhibitionism. Steps, curbs, and the park provided props for what amounted to the Sunday fag follies as returning stars from the previous night's performances stopped by to close the show for the weekend.

Around 1 a.m. a non-helmeted version of the TPF made a sweep of the area. They put a damper on posing and primping, and as the last buses were leaving Jerseyward, the crowd grew thin. Allen Ginsberg and Taylor Mead walked by to see what was happening and were filled in by some of the gay activists. 'Gay power! Isn't that great!' Allen said. He expressed a desire to visit the Stonewall — 'You know, I've never been in there' — and ambled on down the street, flashing peace signs and helloing the TPF. It was a kind of joy to see him on the street, with his laughter and quiet commentary on consciousness, 'gay power' as a new movement, and the implications of what had happened. I followed him into the Stonewall, where rock music blared from speakers around a room that might have come right from a Hollywood set of a gay bar. He was immediately bouncing and dancing whenever he moved.

Ginsberg left, and I walked east with him. Along the way, he described how things used to be. 'You know, the guys there were so beautiful — they've lost that wounded look that fags all had 10 years ago'. It was the first time I had heard this crowd described as beautiful.

We reached Cooper Square, and as Ginsberg turned to head to-ward home, he waved and yelled, 'Defend the fairies!' and bounced on across the square. He is probably working on a manifesto for the movement right now. Watch out. The liberation is under way.

— Lucian K. Truscott IV, 'Gay Power Comes to Sheridan Square', *Village Voice* [3 July 1969]

Radicalesbians 'The Woman Identified Woman' (1970)

What is a lesbian? A lesbian is the rage of all women condensed to the point of explosion. She is the woman who, often beginning at an extremely early age, acts in accordance with her inner compulsion to be a more complete and freer human being than her society — perhaps then, but certainly later — cares to allow her. These needs and actions, over a period of years, bring her into painful conflict with people, situations, the accepted ways of thinking, feeling and behaving, until she is in a state of continual war with everything around her, and usually with her self. She may not be fully conscious of the political implications of what for her began as personal necessity, but on some level she has not been able to accept the limitations and oppression laid on her by the most basic role of her society — the female role. The turmoil she experiences tends to induce guilt proportional to the degree to which she feels she is not meeting social expectations, and/or eventually drives her to question and analyze what the rest of her society more or less accepts. She is forced to evolve her own life pattern, often living much of her life alone, learning usually much earlier than her 'straight' (heterosexual) sisters about the essential aloneness of life (which the myth of marriage obscures) and about the reality of illusions. To the extent that she cannot expel the heavy socialization that goes with being female, she can never truly find peace with herself. For she is caught somewhere between accepting society's view of her — in which case she cannot accept herself — and coming to understand what this sexist society has done to her and why it is functional and necessary for it to do so. Those of us who work that through find ourselves on the other side of a tortuous journey through a night that may have been decades long. The perspective gained from that journey, the liberation of self, the inner peace, the real love of self

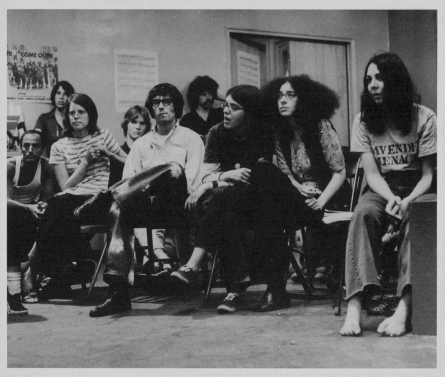

Ellen Shumsky, Gay Liberation Front Meeting, Washington Square Methodist Church, 1970. Front row: Pete Wilson, Fran Winant, Flavia Rando, Judy Rieff

and of all women, is something to be shared with all women — because we are all women.

It should first be understood that lesbianism, like male homosexuality, is a category of behavior possible only in a sexist society characterized by rigid sex roles and dominated by male supremacy. Those sex roles dehumanize women by defining us as a supportive/serving caste in relation to the master caste of men, and emotionally cripple men by demanding that they be alienated from their own bodies and emotions in order to perform their economic/political/ military functions effectively. Homosexuality is a by-product of a particular way of setting up roles (or approved patterns of behavior) on the basis of sex: as such it is an inauthentic (not consonant with 'reality') category. In a society in which men do not oppress women, and sexual expression is allowed to follow feelings, the categories of homosexuality and heterosexuality would disappear.

But lesbianism is also different from male homosexuality, and serves a different function in the society. 'Dyke' is a different kind of put-down from 'faggot', although both imply you are not playing your socially assigned sex role […] are not therefore a 'real woman' or a 'real man'. The grudging admiration felt for the tomboy, and the queasiness felt around a sissy boy point to the same thing: the contempt in which women — or those who play a female role — are held.

And the investment in keeping women in that contemptuous role is very great. Lesbian is a word, the label, the condition that holds women in line. When a woman hears this word tossed her way, she knows she is stepping out of line. She knows that she has crossed the terrible boundary of her sex role. She recoils, she protests, she reshapes her actions to gain approval. Lesbian is a label invented by the Man to throw at any woman who dares to be his equal, who dares to challenge his prerogatives (including that of all women as part of the exchange medium among men), who dares to assert the primacy of her own needs. To have the label applied to people active in women's liberation is just the most recent instance of a long history: older women will recall that not so long ago, any woman who was successful, independent, not orienting her whole life about a man, would hear this word. For in this sexist society, for a woman to be independent means she can't be a woman — she must be a dyke. That in itself should tell us where women are at. It says as clearly as can be said: women and person are contradictory terms. For a lesbian is not considered a 'real woman'. And yet, in popular thinking, there is really only one essential difference between a lesbian and other women: that of sexual orientation — which is to say, when you strip off all the packaging, you must finally realize that the essence of being a 'woman' is to get fucked by men.

[…] We are authentic, legitimate, real to the extent that we are the property of some man whose name we bear. To be a woman who belongs to no man is to be invisible, pathetic, inauthentic, unreal. He confirms his image of us — of what we have to be in order to be acceptable by him — but not our real selves; he confirms our womanhood — as he defines it, in relation to him — but cannot confirm our personhood, our own selves as absolutes. As long as we are dependent on the male culture for this definition, for this approval, we cannot be free.

The consequence of internalizing this role is an enormous reservoir of self-hate. This is not to say the self-hate is recognized or accepted as such; indeed most women would deny it. It may be experienced as discomfort with her role, as feeling empty, as numbness, as restlessness, as a paralyzing anxiety at the center. Alternatively, it may be expressed in shrill defensiveness of the glory and destiny of her role. But it does exist, often beneath the edge of her consciousness, poisoning her existence, keeping her alienated from herself, her own needs, and rendering her a stranger to other women. They try to escape by identifying with the oppressor, living through him, gaining status and identity from his ego, his power, his accomplishments. And by not identifying with other 'empty vessels' like themselves. Women resist relating on all levels to other women who will reflect their own oppression, their own secondary status, their own self-hate. For to confront another woman is finally to confront one's self — the self we have gone to such lengths to avoid. And in that mirror we know we cannot really respect and love that which we have been made to be.

As the source of self-hate and the lack of real self are rooted in our male-given identity, we must create a new sense of self. As long as we cling to the idea of 'being a woman', we will sense some conflict with that incipient self, that sense of I, that sense of a whole person. It is very difficult to realize and accept that being 'feminine' and being a whole person are irreconcilable. Only women can give to each other a new sense of self. That identity we have to develop with reference to ourselves, and not in relation to men. This consciousness is the revolutionary force from which all else will follow, for ours is an organic revolution. For this we must be available and supportive to one another, give our commitment and our love, give the emotional support necessary to sustain this movement. Our energies must flow toward our sisters, not backward toward our oppressors. As long as woman's liberation tries to free women without facing the basic heterosexual structure that binds us

in one-to-one relationship with our oppressors, tremendous energies will continue to flow into trying to straighten up each particular relationship with a man, into finding how to get better sex, how to turn his head around — into trying to make the 'new man' out of him, in the delusion that this will allow us to be the 'new woman'. This obviously splits our energies and commitments, leaving us unable to be committed to the construction of the new patterns which will liberate us.

It is the primacy of women's relation to women, of women creating a new consciousness of and with each other, which is at the heart of women's liberation, and the basis for the cultural revolution. Together we must find, reinforce, and validate our authentic selves. As we do this, we confirm in each other that struggling, incipient sense of pride and strength, the divisive barriers begin to melt, we feel this growing solidarity with our sisters. We see ourselves as prime, find our centers inside of ourselves. We find receding the sense of alienation, of being cut off, of being behind a locked window, of being unable to get out what we know is inside. We feel a real-ness, feel at last we are coinciding with ourselves. With that real self, with that consciousness, we begin a revolution to end the imposition of all coercive identifications, and to achieve maximum autonomy in human expression.

— Radicalesbians, 'The Woman Identified Woman', self-published manifesto distributed during the Lavender Menace protest at the Second Congress to Unite Women on 1 May 1970 in New York, reprinted in Rosalyn Baxandall and Linda Gordon, eds, *Dear Sisters: Dispatches from the Women's Liberation Movement* [Basic Books, New York, 2000]

Martha Shelley
'Gay Is Good' (1970)

Look out, straights. Here comes the Gay Liberation Front, springing up like warts all over the bland face of Amerika, causing shudders of indigestion in the delicately balanced bowels of the movement. Here comes the gays, marching with six-foot banners to Washington and embarrassing the liberals, […] staining the good names of the War Resister's League and Women's Liberation by refusing to pass for straight anymore.

We've got chapters in New York, San Francisco, San Jose, Los Angeles, Minneapolis, Philadelphia, Wisconsin, Detroit and I hear maybe even in Dallas. We're gonna make our own revolution

because we're sick of revolutionary posters which depict straight he-man types and earth mothers, with guns and babies. We're sick of the Panthers lumping us together with the capitalists in their term of universal contempt — 'faggot'.

And I am personally sick of liberals who say they don't care who sleeps with whom, it's what you do outside the bed that counts. That is what homosexuals have been trying to get straights to understand for years. Well, it's too late for liberalism. Because what I do outside of bed may have nothing to do with what I do inside — but my consciousness is branded, is permeated with homosexuality. For years I have been branded with your label for me. The result is that when I am among gays or in bed with another woman, I am a person, not a lesbian. When I am observable to the straight world, I become gay. You are my litmus paper.

We want something more now, something more than the tolerance you never gave us. But to understand that, you must understand who we are.

We are the extrusions of your unconscious mind — your worst fears made flesh. From the beautiful boys at Cherry Grove to the aging queens in the uptown bars, the taxi-driving dykes to the lesbian fashion models, the hookers (male and female) on 42nd Street, the leather lovers…and the very ordinary very un-lurid gays… we are the sort of people everyone was taught to despise, and now we are shaking off the chains of self-hatred and marching on your citadels of repression.

Liberalism isn't good enough for us. And we are just beginning to discover it. Your friendly smile of acceptance — from the safe position of heterosexuality — isn't enough. As long as you cherish that secret belief that you are a little bit better because you sleep with the opposite sex, you are still asleep in your cradle and we will be the nightmare that awakens you.

We are women and men who, from the time of our earliest memories, have been in revolt against the sex-role structure and nuclear family structure. The roles we have played amongst ourselves, the self-deceit, the compromises and the subterfuges — these have never totally obscured the fact that we exist outside the traditional structure — and our existence threatens it. […]

And you straights — look down the street, at the person whose sex is not readily apparent. Are you uneasy? Or are you made more uneasy by the stereotype gay, the flaming faggot or diesel dyke? Or most uneasy by the friend you thought was straight — and isn't? We want you to be uneasy, be a little less comfortable in your

straight roles. And to make you uneasy, we behave outrageously — even though we pay a heavy price for it — and our outrageous behavior comes out of our rage.

But what is strange to you is natural to us. Let me illustrate. The Gay Liberation Front (GLF) 'liberates' a gay bar for the evening. We come in. The people already there are seated quietly at the bar. Two or three couples are dancing. It's a down place. And the GLF takes over. Men dance with men, women with women, men with women, everyone in circles. No roles. You ever see that at a straight party? Not men with men — this is particularly verboten. No, and you're not likely to, while the gays in the movement are still passing for straight in order to keep up the good names of their organizations or to keep up the pretence that they are acceptable — and to have to get out of the organization they worked so hard for. [...]

Once I dressed up for an American Civil Liberties Union benefit. I wore a black lace dress, heels, elaborate hairdo and make up. And felt like — a drag queen. Not like a woman — I am a woman every day of my life — but like the ultimate in artifice, a woman posing as a drag queen.

The roles are beginning to wear thin. The makeup is cracking. The roles — breadwinner, little wife, screaming fag, bulldyke, James Bond — are the cardboard characters we are always trying to fit into, as if being human and spontaneous were so horrible that we each have to pick on a character out of a third-rate novel and try to cut ourselves down to its size. [...]

And now I will tell you what we want, we radical homosexuals: not for you to tolerate us, or to accept us, but to understand us. And this you can do only by becoming one of us. We want to reach the homosexuals entombed in you, to liberate our brothers and sisters, locked in the prisons of your skulls. [...]

We will never go straight until you go gay. As long as you divide yourselves, we will be divided by you — separated by a mirror trick of your mind. We will no longer allow you to drop us — or the homosexuals in yourselves — into the reject bin; labelled sick, childish or perverted. And because we will not wait, your awakening may be a rude and bloody one. It's your choice. You will never be rid of us, because we reproduce ourselves out of your bodies — and out of your minds. We are one of you.

— Martha Shelley, 'Gay is Good',
 Rat [24 February 1970], reprinted
 in Karla Jay and Allen Young, eds,
 *Out of the Closets: Voices of
 Gay Liberation* [Jove, New York,
 1972] 391–4

FHAR (Front Homosexuel d'Action Révolutionnaire) 'Unsigned manifestos' (1971)

To Those Who Believe Themselves To Be 'Normal'

You don't think of yourselves as oppressors. You fuck like everyone else, it's not your fault if some people are sick and some people are criminals. It won't make any difference, you say, if you're tolerant. Your society — because if you fuck like everyone else, it's certainly your society — has treated us like a plague upon the state, the object of scorn for real men, the focus of terror for mothers of families. The words that serve to represent us are your worst insults.

Have you ever thought about what we feel when you use these words, one after the other: 'bastard, scum, faggot, pederast'? When you say to a girl: 'dirty dyke'?

You protect your sons and daughters from our presence as if we carried the plague.

You are individually responsible for the horrible deformations you have caused us to endure by reproving us for our desire.

You who want revolution have wanted to impose upon us your repression. You fought for the blacks, and you called up the cops to go fuck themselves — as if that were the worst possible insult.

You, lovers of the proletariat, have encouraged with all your might the image of the virile worker. You have said that the revolution will be the act of working men, rough, loud, hefty, and broad shouldered.

Do you know what it is for a young worker to be a homosexual in hiding? You who believe in the formative virtues of the factory, do you know what the comrades in a workshop make a faggot endure?

We know, because we know each other, and only we can know.

We are, like women, the mat of morality upon which you can wipe your conscience.

We say here that we've had it. You will no longer bash our faces in because we will defend ourselves. We will hunt down the racism you direct against us even into language you use.

We say more. We will not be content with defending ourselves. We will attack.

We aren't against 'normal people', but against normal society. You ask, 'What can we do for you?' You can't do anything for us as long as you remain representatives of normal society, as long as you refuse to see all the secret desires that you have repressed.

You can't do anything for us as long as you don't do anything for yourselves.

April 1971

To those who are like us:

You haven't dared to say it. Perhaps you haven't dared to say it to yourself.

A few months ago we were like you.

Our Front (Front Homosexuel d'Action Révolutionnaire) will be what you, and we, make it. We want to destroy the family and this society because they have always oppressed us. For us, homosexuality isn't a way to bring down society. It is, first, our situation, and society forces us to combat it.

We don't make distinctions amongst ourselves. We know that male and female homosexuals experience different oppressions. The men are traitors to male society, the women are also oppressed as women.

Male homosexuals benefit, as men, from privileges that women don't have. But female homosexuality is perhaps less scandalous for men, who have used it as entertainment.

There are contradictions amongst us, and we have to say them.

We want to know how an alliance with the MLF (Women's Liberation Movement) can be possible without submitting to heterosexual ideology.

In order to know this, we need you.

Repression exists at every level. We have been brainwashed by heterosexual propaganda since childhood. The goal of the propaganda is to eradicate our sexuality and to reintegrate us into the bosom of the sacrosanct family, cradle for cannon fodder and the surplus value of capitalism and Stalinist socialism.

We continue to live our repression daily, risking surveillance, prison, banishment, insults, bashing, mocking smiles, pitying stares. We lay claim to our status as a plague until imperialism is completely destroyed.

Down with the money hungry society of hetero-cops!

Down with the narrow sexuality of the procreative family!

Up with roles, active and passive!

Stop hugging the walls!

Here's to self defense groups that oppose by force the sexual racism of the hetero-cops!

Here's to a homosexual front that will have for its goal the destruction of normal fascist sexuality.

April 1971

— FHAR manifestos (unsigned),
first published in *Tout!*,
journal of the group Vive La
Revolution! [23 April 1971],
reprinted in *FHAR: Report
Against Normality* [Editions
Champ Libre, Paris, 1971] trans.
Catherine Lord

An episode of the Ménie Grégoire radio programme (1971)

Ménie Grégoire: This is Ménie Grégoire.
Hello to all of you out there. Here
you can hear a very noisy Salle Pleyel
filled to the brim. [...] But before I
hand over to the people who for lots
of different reasons are familiar with
this issue, I am going to try and sum
up what I've been told over the last
three years, and what I've tried
to make of it. [...] I think people have
told me three things. First of all,
I was told that it's an accident, we're
not born like that, it's unexpected
and contrary to belief they must have
become like that. But we don't know
how. People say that it's because
they relate badly to the world, often
represented by the parents. Second,
I have been told that every human being
between twelve and fourteen years
old can make mistakes, they always
have to go through a stage where
they haven't made up their mind yet,
where they are a bit lost, and it can
happen to anyone. The third thing
people say is that the notion of guilt,
which is very important in this case,
comes from society. [...] And this is
why I am going to ask a question, just
like I've been asked it. It's not funny
at all, and in the end it's something
very important that could happen to
any family, and to each and every one
of our children. [...]

(*The discussion begins with
several interventions.*)

The psychoanalyst: In most cases
it can be said that homosexuality is an
accident and that normally it resolves
itself. (*agitation in the room*)

Ménie Grégoire: Yes. In other words,
there are cases where it is
irreversible, even if it happens really
early on? (*commotion in the room*)

(*After further discussion, including
comments from the Frères Jacques,
Ménie Grégoire takes back the floor
from a very excited room.*)

Ménie Grégoire: Imagine that
homosexuality becomes a social model.
Well I just don't know but very quickly
we would stop reproducing! Here we
are touching on something: there are

laws of nature. After, all homosexuality
is nothing less than a negation of life,
or the laws of life. I think we can say
this without offending anybody. Over
to the audience! [...] After all it's
not something good to be homosexual.
You blame the families for making people
gay, and I follow you totally on this —
I think that the families are in on
the game. [...] Listen, I want to say
something before coming back to you.
I want us to ask ourselves a question.
[...] Can homosexuality be accepted as
a model for society? Really, I want us
to go this far. I say: no, it's not a
model, I am ready to be respectful
and understanding but I wouldn't go
as far to say that it's a social model.
[...] Mr. Baudry, who we haven't heard
yet, from the journal *Arcadie*.

(*audience cries out*)

Baudry: Above all I would like to say
that [*he turns to the audience*] ladies
and gentlemen all around you, among
you in your families, among your
colleagues at work, in your village,
everywhere there are homophiles
that you don't know of. It could be
the chief constable, or your parish
vicar, your brother. (*noise in the
room*) Exactly!

Ménie Grégoire: (*shouting into the
microphone*) Oh la la! Look, I'm ... I'm
sorry for the noise in the room that's
stopping us from carrying on. You can
see just how passionate the debate
is, but we can still bravely go on, if
you can. [...] Earlier on you mentioned
a religious problem. After all I would
like Father Guinchat to give us his ...
to answer ... What do you do when
someone comes to you and says 'I'm
homosexual'? What do you say to them?
Do you try and reassure them as well?

The priest: I am a bit embarrassed
to have to answer this question. As a
priest, well, I'm part of a church,
and I try to be faithful to a God who
has given a certain way of life, that
is not imposed, but to belong to the
house, well, after all, you should
follow the right path. And then there
are the concrete facts. I completely
agree with everything that has been
said concerning the suffering that
occurs in certain situations. So, there
too, I welcome in lots of homosexuals,
my peers as well, who come to talk
about their suffering, and we can't be
untouched by this form of suffering.

(*A voice speaks out.*)

Anne-Marie Fauret: Stop speaking
about your suffering...

Ménie Grégoire: (*Getting her
breath back*) Listen up, here now,
something extraordinary is happening,
the crowd has invaded the stage and
the homosexuals ...

(*Someone shouts into the microphone.*)

Peter Hahn: Liberty! Liberty!

Ménie Grégoire: There are homosexuals
of all sorts, men and women ...

(*Someone else shouts.*)

Voice: We demand freedom for you and
for us!

A second voice: Fight! Fight!

(*The sound is cut, the show goes
back to the studio, and the
jingle starts.*)

— Transcript of a live broadcast
of the Ménie Grégoire radio
programme on RTL [10 March 1971],
reprinted in Frédéric Martel,
La Longue Marche des Gays
[Gallimard, Paris, 2002] 105–6,
trans. Alice Hertzog Fraser

Anonymous 'Italian Gay Libletter' (1972)

We are a minority and therefore
have revolutionary potential. But
it is evident that this potential will
burst forth only if brought into the
light of day; it won't do to keep it
buried.

What are we asking of you?
To come out!

What do we propose? A gay activism.

What do we want? To reject
integration into the society.

— Not to tolerate intolerance.
— Not to tolerate tolerance.
— To live our homosexuality fully,
not giving a damn for the niceties
of bourgeois society or the
narrow-mindedness of the left.
— To have the right to do whatever
we want with our own bodies.
— To tear down the bourgeois myth
of the sacrilegiousness of the
asshole, a myth especially
developed among the proletariat.
— To abolish such terms as 'fag' and
'queer', sissy and fairy.
— To eliminate the classifications
and distinctions passive and
active, above and below, cylinder
and piston.
— Not to have to produce goods
(children) or be consumers (wives).

To make revolution you have to have
one or more antagonists; if they don't
exist, you have to create them. Here
is a list which can be added to easily:

MOTHER: Cries when she learns
we're homosexual.

FATHER: Wants to disown us.

BROTHERS AND SISTERS: Are afraid of catching it.

AUNTS: Believe themselves to be the direct cause by means of alternating hereditary cycles.

HUMOR: We are one of its most sparkling subjects.

HOMOSEXUALS: Those who camouflage themselves and don't come out.

HETEROSEXUALS: Those who believe themselves to be the sexual norm.

SEX: In its least liberated, i.e., bars, urinals, saunas, pools, parks.

TOLERANT SOCIETY: Accuses the other half of intolerance and then says we are sick.

PSYCHIATRY: Says we are 'curable' and therefore sick.

MARX: Ignores the question of sex.

MARXISTS: Say homosexuality is a decadent bourgeois disease.

THE PROLETARIAT: Creators of the myth of the masculine, virile man. In the style of Marlon Brando in *On the Waterfront*.

MARXISM — LENINISM: Ignores us because Marx ignored us.

HITLER: Eliminated us in concentration camps.

MAO: Eliminated ten thousand of us in the Night of the Long Knives. (But this might be a capitalist tale).

CASTRO: Castrates us.

THE GREATS: Shakespeare, Michelangelo, Leonardo, Caesar, Alexander, etc., etc., whom we present with pride as magnificent examples: They too! They too!

— Italian Gay Libletter, *Fuori* ('Come Out') [Turin, 1972], reprinted in Len Richmond and Gary Noguera eds, *The Gay Liberation Book*, [Ramparts, San Francisco, 1973] 154–155

Mary Phoebe Bailey
'Pratt: A Four-Syllable Word Meaning Nothing' (1972)

[…] Since the final class of the semester was to be held in the evening, Adele had asked me to accompany her. It is a fast-disappearing security,

but in certain parts of the city two persons are still somewhat safer than one. […] Poor Adele tries so hard to look tough on the streets but the best she can manage is 'baby butch'. She looks like a twelve-year-old boy and they are getting to be about as safe on this city's streets as women. Adele speaks as though her mouth is full of cotton candy and somewhat resembles a vanilla pudding in drag. That's how effective she is. In other words, she had the misfortune to have been born with a body male instinct wants to tear limb from limb. […]

Adele had been one of the students who brought art work. She told me later that the actual text of the assignment had been, 'Do anything you want and tell how it relates to Sociology'. In other words — do anything you want. Adele had brought two of her paintings of women. One was of two women without clothes and the other was of two women playing violins together. Everyone was making sort of nowhere comments about them because the connection between Adele's project was as vague and nonspecific as everyone else's. The Ravi Shankar chick took it upon herself to liven up the discussion. She had been scooting her chair over next to the not-even-an-index-card boy so she could flirt with him by means of entangling her legs in the rungs of his chair. He was not responding to her advances very well. 'Why do your paintings *exclude* men?' she asked Adele. Seems the girl had noticed in earlier instances in the semester Adele was apt to take the feminist view. She was taking this opportunity to point out to Adele the great defect in that philosophy. This argument put her in the amusing position of defending the existence of men who, like the one she was flirting with, were doing their best to deny her existence and wishing she would bug off if not disappear. Poor girl, making sure to include men at every turn while they were equally busy trying to exclude her. Poor girl, with her giggling artsy-craftsy-funky affectations and contrivances. You see, she was not the sort of girl men generally treat with very much attention or respect, mainly because she wasn't very pretty. It is a singularly idiotic habit in certain ugly women to always be the first to jump up in defense of men. What do they think they are going to get out of it? Human kindness? Romance? What?

I must interject here that no one in the class including the Ravi Shankar girl seemed to catch on to the slightly blatant sapphic overtones of Adele's paintings, although everyone seemed aware of the feminist ones. It is always to me a slightly shocking quality in even very sophisticated, very hip, very

young New Yorkers that they seem to be perfectly oblivious to anything less obvious than Liberace.

Adele made a placating remark to the chick's question saying, 'The paintings don't exclude men. They just show how it could be if women are together. I like to see women together sometimes'. The Ravi Shankar girl pushed the discussion until the phrase 'Women's Liberation' finally escaped Adele's mouth. At that, a boy in the class completely flew out of his mind. He turned around and started swearing at Adele. 'I have had my belly full of that lib crap. I got my wife out of that crock of shit'. He went on to say he and his wife were living in a commune full of beautiful people and she was pregnant and doing natural childbirth and so forth and she was going to breast feed and so on. He ended with an inarticulate chain of abuse directed at Adele.

[…] I was trying to keep quiet because I knew from past experience the folly of plunging into such an argument under the circumstances. I knew it would have to be Adele and me against twenty others. You have to be very, very good to answer twenty simultaneous attackers in a debate. Just knowing that makes even quick-tongued women stutter with the glut of their anger. I too was nearly incoherent. The argument continued. First, I said to the chick, 'What's wrong with excluding men?' Then she answered saying 'How insensitive and inhuman and unliberal that would be'. I said, 'Well, for example, if men were excluded or obliterated we wouldn't have had to have been afraid to come here tonight'. At that nine people jumped on me on my right and I looked and they were all male because the class was mostly male and the rest of the girls were not the type to speak up except for the Ravi Shankar girl who was really ruining her image even further by doing just that. You know, men don't even like women who argue intelligently *against* women's lib. One guy was yelling something, the old thing about 'You have to have men for sex. And procreation! What about that huh, huh, what about that!' I said that I highly recommended test tube babies once the vast supply of homeless and abused children runs out. They all made a great groaning sound and said that was the sickest thing they had ever heard — that the natural way, the organic way was the truth and the light. I said the artificial way was the way. The boys all called me a fascist and they cited *Brave New World*, saying that was the future of feminist infidels. […] I said as I was reading *Brave New World* I was having a hard time identifying with how bad things were supposed to be in the novel because I kept thinking how great it would be to be a woman living in such a universe. 'Anyway', I finally said to

effemináte

VERB. 1. TO STRUGGLE TO BECOME UNMANLY. 2. TO OPPOSE THE MASCULINE HIERARCHY AN IDEOLOGY OF FASCISM. THE DOMINATION OF ONE PERSON OVER ANOTHER OF ONE SEX RACE CLASS OVER ANOTHER. 3. TO BECOME NON-COMPETITIVE. 4. TO SHARE 5. TO RAISE CHILDREN 6. TO BE VULNERABLE 7. TO BE ABLE TO CRY FOR AND WITH SOMEONE ELSE. 8. NOT TO TELL WOMEN WHAT THEY SHOULD DO ABOUT THEIR MOVEMENT. 9. NOT TO OPPOSE THE STRENGTH. ANGER AND POWER OF WOMEN. 10. NOT TO BE DIVISIVE OF THE LOVE WOMEN HAVE FOR EACH OTHER. 11. NOT TO BECOME PASSIVE OR PARALYZED IN OUR STRUGGLE TO CHANGE. 12. TO FIGHT AGAINST OUR OPPRESSION AS FAGGOTS IN MILITANT WAYS.

Steven F. Dansky, 'Effeminate', *Double-F: A Magazine of Effeminism* [Effeminist, 1972]

them all, 'I don't need men for anything, not even sex'. They made some more disparaging groans. One of them went so far as to say, 'Oh come on you really want a penis, you've got to, every woman does'. 'Nope, I am a Lesbian, don't have the slightest use for one – and for that matter most straight women don't either'. No sooner were those magic words out of my mouth than while I was turned to the nine or so men who were attaching me on my right a boy who was lounging against the wall on my left suddenly spoke up: 'Have you ever had a *Relationship*?' Very concerned for me as it were.

I jerked my head around to him and said, '*No*' and jerked just as quickly back to answer the others still yelling questions and remarks to me on my right. [...]

I got it. That was how he did it. How he made me lose. 'Have you ever had a Relationship?' he had asked and I had said '*No*' instead of asking first. 'Just what do you mean boy. Are you trying to ask me if I ever had a penis in my vagina. In other words do you want to know if I have ever been fucked?' (As in fucked over and fucked up, as in knocked over and knocked up). Anyway he had won somehow. It doesn't do any good

to think up good retorts afterward. So that's what it is with the heterosexual: stick a penis in a vagina and by George you've got yourself a relationship. He said so himself. He admitted something. [...]

— Mary Phoebe Bailey, 'Pratt: A Four-Syllable Word Meaning Nothing', *The Ladder* [1972], reprinted in Barbara Grier and Coletta Reid, eds, *The Lavender Herring: Lesbian Essays from The Ladder* [Dianna Press, Baltimore, 1976] 270–8

Jill Johnston
'Their Inappropriate Manhood' (1972)

Last week as I said I strayed from completing some report on the emergence of revolutionary effeminism which I think is important for women to perceive and for men to join. The effeminists unlike their brothers of gay liberation are not expecting women to participate in any of their meetings or marches or city hall protests. I don't think they're into

meetings or marches or protests although they were protesting the christopher street gay liberation march this year handing out leaflets of kenneth pitchford's 88 reasons for refusing to march among them that gay liberation is a sexist plot between gay and straight men to keep women and faggots in their places and that the only time he went to a dance at the GAA firehouse the light show included stag movies one of which showed a nude woman being raped by a nude man and that all the new gay syndicate wants to do is to climb up with straight men on the backs of women as in ancient Greece and that the gay male leaders of gay liberation have written for screw and gay and two of them are also in fact partowners with the main man straight sadmasculinist al goldstein who allowed screw to carry advertisements for films showing the rape by their fathers of girls not yet 10 years old and that the men of gay liberation make the playing of roles in the sexual act the central question of their lives using gutter phrases butch and femme to classify and objectify them when any faggot knows that the focal reality of his life is the bitter lack of any tenderness in men gay or straight, any gentleness, any

willingness to cooperate rather than complete, any sincere consideration or concern for others, rather than the same monotonously repeated self-preoccupation with ripping off another orgasm from 'our' despised and nameless faggot bodies and that marching is boring anyway are a few of the 88 reasons. I think what the effeminists are doing primarily is consciousness raising in small groups and developing an effeminist analysis which acknowledges sexism as the root cause of all oppression. Such an analysis from men has been long forthcoming. The gay books to date excepting that by dennis altman have been an accounting of actions by gay militants and the politics of the movement and personal statements about coming out and new studies and interpretations of homosexual oppression. In other words books and essays dealing only in gay consciousness which without being completed by a feminist consciousness remains just as straight in its apologetic demand to be approved and accepted by straight sexist society. Gay liberation has defined itself as an oppressed minority rather than as a movement for revolutionary social change. Gay liberation from the start was associated with every left cause in the identification with other oppressed minorities. In common with the left gay liberation identified the enemy as the white ruling class, with the emphasis on the white ruling class male. The effeminists have correctly located the enemy within themselves. I can't say the enemy isn't within me too, I mean it's a world-wide problem, the difference between me and the man being one of birth and from there of consciousness. I could sit across from pitchford for an hour or so to discuss these things and know that he agrees he's my enemy for we were all brought up that way. Thus there isn't much to say except ideology and to wonder what that would mean in any organizational sense and I don't think much. Nor do they.

The best they can do is say as does pitchford that it should not be their purpose as revolutionary effeminists to get feminists to regard them as certifiable non-male-supremacists — a typically masculinist notion and quite impossible anyway and in so saying acknowledging their task which is to eliminate themselves. These are potentially the men whose coming Valerie Solanas predicted when she summarily and casually provided men with their mission in life as the men's auxiliary to S.C.U.M — "those men who are working to eliminate themselves... faggots who by their shimmering, flaming example, encourage other men to de-man themselves..." A fine point to consider is that the rhetorical vision of effeminists includes eliminating

the manhood from themselves rather than themselves. Valerie was very advanced. I don't know how it's possible to be walking around as things are as a man and eliminate yourself as a man but one thing can be done and that is to comprehend the necessity of it. There are apparently a few practical things that can be done too. These things could be called taking on the burden of reparations for other men. The project that seems to most interest pitchford is faggot child care centres. He says he tends to bond with other men who like to take care of babies which is in his self interest since he has a three year old kid whom he looks after 50 per cent to slightly less than 50 per cent of the time and occasionally slightly more. He says they're convinced faggots will never be free until women are free and that that they've discovered that their task is to rejoice in their condemned qualities of effeminacy and to support defend and promote effeminism in all men everywhere by all means necessary.[...]

Here's an essay by steven dansky called God, Freud, Daddy And Us Faggots in a publication called faggotry in which dansky (an early gay male polemicist) says that many faggots have left the gay liberation movement because even the most radical and militant factions have made a one-sided attack against sexism. He goes on faggots have left gay liberation because they have seen male supremacy as the root from which all other oppressions branch...'We will not have our freedom on the backs of women...We are what is feared most: effeminists...Men who are struggling to become unmanly, men who oppose the hierarchy and ideology of a masculine fascism that requires the domination of one person by another, of one sex, race, or class by another. We will become gentle but strong faggots who will fight their oppression in militant ways, faggots who are vulnerable to each other, able to cry, but not passive or paralyzed in our struggle to change.' End-quote. I guess a lot of people might want to know why revolutionary effeminists call themselves faggots. It was over this word that I first heard from pitchford. He wrote to me june 12 he was surprised that I had recently addressed two of my columns to a man and that the man was identified as a faggot. These were two columns written as letters to vince aleti who had referred to a column of his in a rock magazine as a faggot column and somehow I knew because of his reference and others or probably more likely just by what's in the air that the word like dyke had acquired some positive currency and I used it that way without knowing there was a movement which is what pitchford was writing

to inform me about. He said they had split from the whole gay movement some time ago because of its outrageous anti-womanism and its sexism in general and he criticized the exclusive use of GAA spokesmen in the voice who among other things apparently use their names to hard sell sadomasochistic porn movies that degrade women and faggots and such and he included his journal called the flaming faggots. [...] So the enemy has known all along the danger in strong women and gentle men, has known that both present the same threat to masculine domination. That is why we have decided to embrace faggot as our one word description, complete with a piece of our buried history unearthed, and accept it positively as a tool to cut through our last ties to 'passing' — those of us who were in the privileged position of having such an option. [...]

These faggot militants have assimilated feminist literature and are somehow welding it to their own history as faggots for an effeminist analysis which should if it's completely consistent whatever that is or at least honest emerge in its actions at the service of women in the Solanas spirit of self elimination and the reinstitution of the female principle. [...]

— Jill Johnston, 'Their Inappropriate Manhood', *Village Voice* [6 July 1972], reprinted in *Admission Accomplished: The Lesbian Nation Years (1970–75)* [Serpents Tail, London, 1998] 119–27

Andrew Hodges and David Hutter 'With Downcast Gays: Aspects of Homosexual Self-Oppression' (1974)

Flaunting Ourselves

The phrase 'coming out', as used by gay people, has three meanings: to acknowledge one's homosexuality to oneself; to reveal oneself as homosexual to other gay people; and lastly, to declare one's homosexuality to everyone and anyone.

Homosexuals are unlike any other oppressed group in that their identity is almost always invisible to others. They can even conceal their homosexuality from *themselves*, for such is the disgust attached to the word 'homosexual' that many people who have need of homosexual experience never acknowledge it, and sometimes even those who quite frequently seek out such experience manage to convince themselves that they are not really 'one of them'.

Behind so much that has been expressed in the gay movement lies the awareness that there exist these people who are so oppressed that they have not come out in the first sense of 'admitting' their gay feelings even to themselves. Many are married with children and throughout their lives have been totally denied any sexual pleasure. They raise no protest at their deprivation, for they cannot admit that it exists, and they can never be reached by openly gay people, for it is openness they fear. There are happy exceptions, for the establishment of gay counselling organisations such as *Icebreakers* or *Friend* has enabled many such people to break a lifetime's silence – men of middle age who say that they have never knowingly talked to a homosexual but that they always think of other men while fucking their wives; women who realise after their children have grown up that they have really always wanted to love another woman. There are a number of organisations trying to end the isolation of such people, but self-oppression so profound is unlikely to be ended by a few telephone conversations or by the arguments of this booklet. This essay is *only* about those who identify themselves as gay among gay people, but do not come out in the outside world.

Under plain cover

If asked, closet gays often say that, although they 'don't shout about it on every street corner', their friends know and their parents 'must have realised by now', but 'they've never asked me about it, so I haven't brought the subject up'. Pressed further, they add that they 'don't see the point of telling people at work,' as 'what I do in bed is my own business, and anyway I might lose my job'. Some gay people go to considerable lengths to fake up a heterosexual image, devising tales of suitably remote fiancées, passing appreciative or disparaging remarks on women (or men), and laughing heartily at the usual stream of jokes about homosexuals.

Actually these stratagems are unnecessary, because unless there is reason to believe otherwise, it is always taken for granted that people are heterosexual. Deception need not be a positive act; one can deceive by default. At work, camp jokes will not demonstrate that one is gay; they will be accepted just as jokes, and one kiss at the Christmas party will be sufficient to wipe out a whole year's subtle hints and innuendoes.

The fear of putting a job at risk is often deliberately exaggerated by those who need a convincing excuse for secrecy. If they really wanted to come out and were prevented only by the threat of economic deprivation, they would be bitterly

angry about discrimination rather than, as is usual, passively accepting it as inevitable. Most homosexuals would suffer little loss in purely material terms by coming out. It is the loss of a protective shell which is the real barrier.

Gays expose the fact that they are merely looking for excuses for remaining in the closet when they plead their purely voluntary activities as reasons for secrecy. Apparently we are expected to see their hobbies as some inescapable, unchangeable aspect of their lives. When they say that if they came out they could not continue with their Church or youth work, one can only question the value of commitments which involve supporting organisations apparently so homophobic. It would be truer to say that their self-hatred lies so deep that they leap at any chance to hide their real nature. [...]

Self-oppression or self-interest?

Passing as heterosexual is by no means a private matter, for one self-oppressive deceit generates a thousand others. Friends and lovers are all included by being told what they may say on the telephone and how to behave in the street. The selfishness of those with privileged positions to defend seeps through the whole gay community, and the demoralising message is absorbed by the great number of ordinary gays who have no privileges whatever to protect.

Homosexuals who have access to the media and refuse to come out allow those who condemn or pity us to dominate the stage. When the reactionary Cyril Osborne was attempting to defeat the 1967 homosexual law reform bill, he rested much argument on the belief that the House of Commons had no homosexual members. Gay M.P.s who remained silent allowed all his stupid assertions to stand.

It is not that people of status should come out in order to make a propaganda point about how important or talented gay people are. It is simply that gays in the public view are ideally placed to give society a truthful view of its homosexual component.

Privileged closet gays are traitors to the gay cause, but as yet they are never referred to as such. We so lack any sense of common identity that the notion of treachery is scarcely formed. It is almost as if our bitter oppression were merely an elaborate game of pretence, the winners being those who perpetrate the cleverest frauds. [...]

– Andrew Hodges and David Hutter, *With Downcast Gays: Aspects of Homosexual Self-Oppression* [Pomegranate Press, London, 1974; Pink Triangle Press, Toronto, 1977] 15–19

Louise Fishman
'How I do It: Cautionary Advice from a Lesbian Painter' (1977)

[...] The following comments, advice, and information about my work process are addressed to lesbians who have made a decision to be painters.

LOOKING

[...] It is important not to judge our own responses to paintings as inappropriate. Any place we deny the validity of our thoughts or activities is a place that will weaken our relationship to our art.

Try not to cut whole bodies of work out of your vision unless you've looked at them and studied them thoroughly: don't stop looking at El Greco because he's not Jewish, or Chardin because he's not an abstract painter or Matisse because he's not a lesbian. By all means look at Agnes Martin and Georgia O'Keefe and Eva Hesse. But don't forget Cézanne, Manet and Giotto. If good painting is what you want to do, then good painting is what you must look at. Take what you want and leave the dreck.

DOING

My experience has been that I need to go through ritual events before my mind is clear and focussed enough to work. It involves an hour or two, or sometimes a day or two; of sweeping the floor, talking on the phone (not to anyone who could be too distracting or disruptive), keeping a journal, writing a letter, sending off bills, doing some sort of exercise or meditation, sitting quietly and reading or drawing. At certain times music has been very distracting.

[...] My experience is that leisure is important to work – so if I only have a little time to work, I try to compress some ritual loosening up into that time. Without the ritual I sabotage myself. It's important that these activities take place in the studio.

After I've gone through this process, I try to take the painting by surprise. I begin as if accidentally (although all the while I have been sneaking glances at the work). Anything in my vision can be as distracting as noise or an emotional interruption.

Some people say you must have no thoughts about other people or other things while you are working. I often have a rush of imaginary conversations with people, ideas that fill the room. But I don't stop working. They allow me to unhinge my unconscious. I don't look for those conversations, but I let them happen.

As I get excited about an image forming, I am often also engaged in what seems to be a totally separate thought.

Once I've started working, the important thing is to keep myself in the studio despite the fact that I invent lots of reasons why I must leave at that precise moment. When I've set up a day for painting, there is no pressing activity anywhere, unless I construct it on the spot.

Sometimes, leaving the studio has to happen. It's never too clear until later whether I'm coping or copping out. As I'm about to leave the studio, I'm often more able to work than before. The brain gives up hugging itself into nonmovement and I am free to work again for a while. This is often the time when I do my best work. But there are times when that little joy that happens in working disappears for weeks. And I am suffering, making what seems like endlessly boring, ugly, uninspired forms. I can't draw worth shit. Everything has become awkward. I feel like I've made a terrible mistake being a painter. And this goes on for weeks and week. The only thing that gets me through is a lot of complaining to a friend or my lover. I need them to encourage me into believing that I really am a painter and my troubles are temporary. [...]

This is the most important time to stay with the work.

Then there's a short time when something changes, a painting or an idea evolves and there is a little relief in the air. The work is not necessarily better than what came before it, but it represents the end of that particular struggle.

At the end of a work day, I usually leave my studio abruptly. I can't seem to even clean my brushes. I sometimes forget to turn off the lights. If I've left a painting that I am particularly excited about, I know to expect that by the next day I am often terribly disappointed by what had seemed pure genius. I often return to find a finished painting not at all finished, or a group of paintings I liked the day before suddenly repulsive to me, superficial, eclectic, simplistic.

I've learned that a quick look can be very damaging. You often see very little of a painting in a quick look, although sometimes you can find fresh clarity about a work. More often that not, I am simply cutting off myself and several day's work, denying the seriousness of that work and those thoughts.

I can be a much worse audience than anyone I can imagine. I often switch roles on myself without being aware of it. I suddenly have become a person who stepped into my studio from the street, who despises the work because she knows nothing about it and couldn't care less — a subtle bit of self-mutilation.

The lion-headed Barbara Urselin, born in 1641 in Augsburg, from Aldrovandus' *Opera Omnia Monstrum Historia*, 1668.

Collaborative poster for *Lesbian Art and Artists* issue of *Heresies*, 1975

It's hard to paint, and it can be impossible if you don't recognize your own trickery. Handling your unconscious with firm but caring hands, fully conscious about your work process, is absolutely necessary.

INTEGRITY

I want us to develop a sense of our strength through the integrity of work, to trust the search for honest imagery through a dialogue with the materials and through a work process devoid of shortcuts. We've got to be ready to destroy anything that comes up in our painting which is less than what finally has a degree of clarity which we as artists using our most critical thinking can recognize.

I want to caution against the dangers of purposefully and consciously setting out to make lesbian or feminist imagery or any other imagery which does not emerge honestly from the rigors of work. The chief danger as I see it lies in losing direct touch with the art, risking an involvement with a potentially superficial concern. This is not to say that the question of feminist or lesbian imagery is not a legitimate concern but rather to caution against its forced use.

We can't allow anything unworthy to distract us from working as intensely as possible. Distraction can be in the form of pressures about imagery, methods of working or process, anything that is characterized as the 'right way' or the 'only way'. Or it can be in the form of people who are disruptive to our work, our sanity, our clarity, our ability to believe in ourselves.

Get the creeps out of your head and out of your studio.

We must be willing to trust our own impulses about that the source of our work is — and where to go with it. It takes long periods of time, perhaps

years, to understand which habits are constructive, to discover what an honest source of inspiration is and to trust that source of inspiration. […]

— Louise Fishman, 'How I Do It: Cautionary Advice from a Lesbian Painter', *Heresies: Lesbian Art and Artists*, no. 3 [Fall 1977] 74—7

James M. Saslow 'Closets in the Museum: Homophobia and Art History' (1979)

Perched on a rocky bluff at the edge of downtown, the stately colonnades of the Philadelphia Museum are surrounded by high stone walls, elaborate fountains, and cascading staircases. This overpowering monumentality could be looked upon as symbolizing either of two ideas: the dignity of art's function, or the power of the institution itself. One glance at the surrounding landscape makes clear which connection is intended. […]

Over the last several years, I have been investigating our gay heritage in the visual arts, and find that it is richer than many of us are yet aware of. I have also found that the powerful complex of institutions that are the custodians of our artistic heritage — museums, galleries, universities — tends to overlook or suppress the historical evidence of gay artists and gay themes. I will attempt here a brief overview of the art world's present attitudes toward homosexuality and homoerotic art, and of some progress that has been made toward breaking the hold of tradition on our past…

The art world has declared gay people and their emotions 'obscene' — from the Latin *obscaenus*, literally 'offstage.' As one element of society's existing structure, the art world has good reason to curtail the subversive power of gay images. To allow visual expression of gay themes would have two effects: it would show that the existing order is incomplete, thus illegitimate; and it might lead to a threatening sense of solidarity among those who share a sense of beauty in the same 'forbidden' images. Tennessee Williams eloquently evoked this power of images in his poem 'The Dangerous Painters':

I told him about the galleries upstairs, the gilt and velour insulation of dangerous painters. I said, if they let these plunging creations remain where they sprung from easels, in rooms accessible to the subjects of them…
They would be stored fuel for a massive indignation.

The fingers of misshapen bodies would point them out, and there would always be the goat-like cry of 'Brother!'

The cry of 'Brother!' is worse than the shouting of 'Fire!', contains more danger.

For centuries now it has been struck out of our language.

A surprising number of our 'dangerous' gay brothers — and sisters — are represented on museum walls. Often, however, their art 'sneaks through' because it is barely recognized as such …

'Gay art' includes several different aspects. First, gay artists and gay subject matter are separate, though related, issues. Second, within gay subjects it is necessary to consider the twin categories of male and female eroticism.

When confronted with the first issue — secrecy regarding artists who were themselves gay — museum staffs could argue that it's not the museum's role to explicate the private lives of artists. This argument might hold true, unless that life has some relevance to the meaning of the work. Unfortunately, it is precisely that relevance which the art world is unwilling to perceive.

If a heterosexual male artist paints a portrait of his wife or mistress, that relationship is usually evident from the title of the wall plaque, (which) calls our attention to a potential layer of meaning. Yet in 1975 Francis Bacon, a highly respect painter from Britain, exhibited several dramatic canvases depicting the death of his lover of many years, George Dyer; New York's Metropolitan Museum coyly identified Dyer as a 'close friend and model'. […]

Naturally, we want to learn about past gay artists and take pride in their achievements. More important than these 'guessing games', however, is exposing the gay content of works of art. In this sphere the uncomfortable curator has a distinct advantage: interpretation of the past often requires information that was commonplace to original viewers but is now unfamiliar. Neo-classic subjects of the late eighteenth centuries, for example, are particularly rich in gay imagery. But Benjamin West's 'Death of Hyacinthus,' which portrays the stricken boy expiring in the arms of Apollo, would probably strike an unknowing observer as a sort of 1770's Red Cross poster. To appreciate the real pathos of the scene, you have to know that the two men were lovers — a bit of mythology not likely to have come out in grade school. […]

Intimacy between women has }been permitted in Western art more frequently than male eroticism, for several reasons. As in much contemporary pornography, the close

physical contact between women in Ingres' Turkish bath scenes, Degas' prints of brothels, or Courbet's 'Sleep' titillates straight men….In the enthusiasm of revisionism, we must be careful not to impute to every depiction of women a conscious attempt to portray lesbianism. Nevertheless, we today are more sensitized to the broad range of possible meanings inherent in a portrayal of women alone together. […]

Despite a general rise in the social consciousness of museums over the last decade and a half, increased visibility for gay artists and subjects will probably come first through the exhibits of individual contemporary artists who happen to be gay and feel comfortable about letting that be known. We must, therefore, touch on the role of the commercial art gallery; fortunately, the news in this sphere is somewhat encouraging.

The gallery world, like the museum world, is notoriously gay: for familiar reasons, it too used to be discreetly closeted. A few gays artists, like Paul Cadmus in New York and David Hockney in England, have been able to show somewhat erotic works for the last thirty years, but these artists are a tiny minority. However, the first stimulus a commercial venture responds to is money. As gay people, primarily men, begin to constitute a visible market, with its own channels of publicity, galleries have begun to react favourably. New York artist John Button recalls how his gallery panicked when he proposed a show of male nudes; management was won over when every work on display sold out on opening day. Gallery owners now tend to be glad to see me coming to review a show for *The Advocate*; some owners even seek out the gay clientele. […]

On the other hand, a group of lesbian artists met with so much hostility from established New York outlets that in 1976 they formed their own collective to provide exhibit space. This attitude, too, has some economic stimulus; lesbians are perceived to be a small market and, like women as a class, to have less expendable income.

For truly significant signals of a 'push' for new information and interpretations in art, we must look to the academic community. The history of art is primarily preserved, researched, and disseminated in the university. In the very recent past, a few cracks have appeared in the formerly monolithic silence of the academic world on gay matters. It is at least possible to indicate on a graduate school application that you are gay — as I did — and not be summarily rejected. Most of today's academics (however), lacking exposure to a coherent philosophy of sexual politics, are unprepared to grasp the

importance of gay art or its broader ramifications. When I informed an adviser, now nearing retirement, that I wanted to write a psychological study of images of women in the work of Sandro Botticelli (whose life contains more than a hint of homosexuality), he looked bemusedly startled, then shrugged that he couldn't see 'any reason why you *can't* do it.'

Even where an artist's sexuality was clearly known to his or her contemporaries, and relevant to the work, this is information usually discreetly ignored in lectures and publications.

The most infamous example if the Italian Renaissance artists Giovanni Bazzi, whose sexual proclivities earned him the nickname *Il Sodoma*, 'because he always mixed and lived with beardless boys,' as the chronicler Giorgio Vasari recounts. Bazzi is listed in encyclopaedias under 'Sodoma,' but mention is seldom made of the origin of his sobriquet, or of what connection this knowledge might have to his work. His portrayal of baby Jesus fingering an arrow proffered by an androgynous nude Saint Sebastian takes on new overtones if we recall Vasari's report that 'most of the young men of Siena followed Sodoma'. [...]

Few male professors have been willing to broach homoeroticism in the classroom for fear of bringing suspicion on their own heads. As much victims as perpetrators of current stereotypes, they suffer from the ancient spectre of effeminacy that haunts men engaged with 'the arts.'

In part because of homophobic stereotypes, art history is, in fact, dominated by women students [which] has helped it become a pioneering field in feminist scholarship; the impact of the women's movement has provided the beginnings of a similar openness to gay scholarship, for two reasons.

At the most basic level, serious research into creative women was bound to turn up a percentage who loved other women. The clearest case is the legendary 'Paris in the Twenties,' where the artistic community included, besides Stein and Toklas, the American painter Romaine Brooks, who painted portraits of her lover, author Natalie Clifford Barney[...] On a more philosophical level, issues raised by feminist art historians have begun to 'clear the ground' for a more sympathetic understanding of concepts important to developing a theoretical justification for gay art. Prominent critics like Linda Nochlin and Lucy Lippard bring to their analyses a concern for gender roles and androgyny as well as a psychological and sociological understanding of oppression, both of which clearly overlap with gay concerns.[...]

Such openness is to be lauded, but is still a novelty in 'official' circles. Within the gay community itself,

however, the Gay Academic Union has consistently provided a forum for gay-related research and its annual conferences. Topics have ranged from Michael Lynch's research on [the painter Marsden] Hartley, to silent films by Eisenstein and Genet, and the visual imagery in contemporary gay publications.

Art historians rely on scholarly publications to disseminate new findings such as these. Here again, while an occasional article surfaces dealing with topics like homoerotic imagery in Caravaggio, the number does not yet seem commensurate with the potential material. Fortunately, magazines, unlike museums, are already within the gay community's own capabilities. A number of respected publications such as *Gay Sunshine* and *The Body Politic* already devote space to scholarship and criticism in art.

In summation, we have seen that museums are storehouses — and, like most storehouses, are full of closets. But what is shut up in the basements of great classical temples [...] is the visible record of human consciousness. Part of that consciousness has been gay. And, contrary to what most of us have been led to believe, that consciousness has found innumerable, sometimes truly beautiful ways to break through to artistic expression. But access to these expressions is still effectively denied to us — indeed, to the entire culture. [...]

One need only look at the crazy-quilt of restrictions on 'obscenity' to see that our society, too, acknowledges and fears the power of art to encourage non-conforming thoughts and behaviour. For art is also the first and ideal weapon of those groups who seek to establish *new* cosmologies that will legitimize that group's values. From Eugéne Delacroix's 1830 'Liberty Leading the People' to the explicit illustrations for *Fag Rag* magazine's 'Cocksucking as an Act of Revolution,' art has served as midwife to new social values. Once visualized, ideas and images which were formerly only the property of a few scattered minds can be shared, can serve as the basis for a more complete imagining of share consciousness.

Art is a battleground in the struggle for self-determination — for gay people even more than for others, because we are not born into our own culture. We discover its relevance only later in life, and it is then we desperately need models and images that are too seldom available.

By continuing to ferret out these images...that prove gay people are a continuous presence in human culture, art historians will be adding to the 'stored fuel' needed to establish gay people as an intrinsic and beautiful part of the larger universe.

Tennessee Williams, in 'The Dangerous Painters,' phrased the same thought more poetically: 'Revolutions only need good dreamers.'

— James M. Saslow, 'Closets In The Museum', Karla Jay and Allen Young, eds, *Lavender Culture* [Harcourt Brace Jovanovitch, New York, 1979] 215–27

Monique Wittig
'One Is Not Born
A Woman' (1980)

[...] However, now, race, exactly like sex, is taken as an 'immediate given', a 'sensible' given, 'physical features', belonging to a natural order. But what we believe to be a physical and direct perception is only a sophisticated and mythic construction, an 'imaginary formation'[1] which reinterprets physical features (in themselves as neutral as any others but marked by the social system) through the network of relationships in which they are perceived. (They are seen as black, therefore they are *black*; they are seen as *women*, therefore, they *are* women. But before being *seen* that way, they first had to be *made* that way). Lesbians should always remember and acknowledge how 'unnatural', compelling, totally oppressive, and destructive being 'woman' was for us in the old days before the women's liberation movement. It was a political constraint, and those who resisted it were accused of not being 'real' women. But then we were proud of it since in the accusation there was already something like a shadow of victory: the avowal by the oppressor that 'woman' is not something that goes without saying, since to be one, one has to be a 'real' one. We were at the same time accused of wanting to be men. Today this double accusation has been taken up again with enthusiasm in the context of the women's liberation movement by some feminists and also, alas, by some lesbians whose political goal seems somehow to be becoming more and more 'feminine'. To refuse to be a woman, however, does not mean that one has to become a man. Besides, if we take as an example the perfect 'butch', the classic example which provokes the most horror, whom Proust would have called a woman / man, how is her alienation different from that of someone who wants to become a woman? Tweedledum and Tweedledee. At least for a woman, wanting to become a man proves that she has escaped her initial programming. But even if she would like to, with all her strength, she cannot become a man. For becoming

a man would demand from a woman not only a man's external appearance but his consciousness as well, that is, the consciousness of one who disposes by right of at least two 'natural' slaves during his life span. This is impossible, and one feature of lesbian oppression consists precisely of making women out of each for us, since women belong to men. Thus a lesbian *has* to be something else, a not-woman, a not-man, a product of society, not a product of nature, for there is no nature in society.

The refusal to become (or to remain) heterosexual always meant to refuse to become a man or a woman, consciously or not. For a lesbian this goes further than the refusal of the *role* 'woman'. It is the refusal of the economic, ideological and political power of a man. This, we lesbians, and nonlesbians as well, knew before the beginning of the lesbian and feminist movement. However, as Andrea Dworkin emphasizes, many lesbians recently 'have increasingly tried to transform the very ideology that has enslaved us into a dynamic, religious, psychologically compelling celebration of female biological potential'[2]. Thus, some avenues of the feminist and lesbian movement lead us back to the myth of woman which was created by men especially for us, and with it we sink back into a natural group. Having stood up to fight for a sexless society[3], we now find ourselves entrapped in the familiar deadlock of 'woman is wonderful'. Simone de Beauvoir underlined particularly the false consciousness which consists of selecting among the features of the myth (that women are different from men) those which look good and using them as a definition for women. What the concept 'woman is wonderful' accomplishes is that it retains for defining women the best features (best according to whom?) which oppression has granted us, and it does not radically question the categories 'man' and 'woman' which are political categories and not natural givens. It puts us in a position of fighting within the class 'women' not as the other classes do, for the disappearance of our class, but for the defense of 'woman' and its reinforcement. It leads us to develop with complacency 'new' theories about our specificity: thus, we call our passivity 'nonviolence', when the main and emergent point for us is to fight our passivity (our fear, rather, a justified one). The ambiguity of the term 'feminist' sums up the whole situation. What does 'feminist' mean? Feminist is formed with the word 'femme', 'woman', and means: someone who fights for women. For many of us it means someone who fights for women as a class and for the disappearance of this class. For many others it means someone who fights

for woman and her defense — for the myth, then, and its reinforcement. Buy what was the word 'feminist' chosen if it retains the least ambiguity? We chose to call ourselves 'feminists' ten year ago, not in order to support or reinforce the myth of woman, nor to identify ourselves with the oppressor's definition of us, but rather to affirm that our movement had a history and to emphasize the political link with the old feminist movement. […]

Thus it is our historical task, and only ours, to define what we call oppression in materialist terms, to make it evident that women are a class, which is to say that the category 'woman' as well as the category 'man' are political and economic categories and not external ones. Our fight aims to suppress men as a class, not through a genocidal, but a political struggle. Once the class 'men' disappears, 'woman' as a class will disappear as well, for there are no slaves without masters. Our first task, it seems, is to always thoroughly dissociate 'women' (the class within which we fight) and 'woman'. The myth. For 'woman' does not exist for us: it is only an imaginary formation, while 'women' is the product of a social relationship. We felt this strongly when everywhere we refused to be called a '*women's liberation movement*'. Furthermore, we have to destroy the myth inside and outside ourselves. 'Woman' is not each one of us, but the political and ideological formation which negates 'women' (the product of a relation to exploitation). 'Woman' is there to confuse us, to hide the reality 'women'. […] But to become a class we do not have to suppress our individual selves, and since no individual can be reduced to her / his oppression we are also confronted with the historical necessity of constituting ourselves as the individual subjects of our history as well. I believe this is the reason why all these attempts at 'new' definitions of woman are blossoming now. What is at stake (and of course not only for women) is an individual definition as well as a class definition. For once one has acknowledged oppression, one needs to know and experience the fact that one can constitute oneself as a subject (as opposed to an object of oppression), that one can become *someone* in spite of oppression, that one has one's own identity. There is no possible fight for someone deprived of an identity, no internal motivation for fighting, since, although I can fight only with others, first I fight for myself. […]

It is we who historically undertake the task of defining the individual subject in materialist terms. This certainly seems to be an impossibility since materialism and subjectivity

have always been mutually exclusive. Nevertheless, and rather than despairing of ever understanding, we most recognize the *need* to reach subjectivity in the abandonment by many of us to the myth 'woman' (the myth of woman being only a snare that holds us up). This real necessity for everyone to exist as an individual, as well as a member of a class, is perhaps the first condition for the accomplishment of a revolution, without which there can be no real fight of transformation. But the opposite is also true: without class and class consciousness there are no real subjects, only alienated individuals. For women to answer the question of the individual subject in materialist terms is first to show, as the lesbians and feminists did, that supposedly 'subjective,' 'individual,' 'private' problems are in fact social problems, class problems; that sexuality is not for women an individual and subjective expression, but a social institution of violence. But once we have shown that all so-called personal problems are in fact class problems, we will still be left with the question of the subject of each singular woman — not the myth, but each one of us. At this point, let us say that a new personal and subjective definition for all humankind can only be found beyond the categories of sex (woman and man) and that the advent of individual subjects demands first destroying the categories of sex, ending the use of them, and rejecting all sciences which still use these categories as their fundamentals (practically all social sciences).

To destroy 'woman' does not mean that we aim, short of physical destruction, to destroy lesbianism simultaneously with the categories of sex, because lesbianism provides for the moment the only social form in which we can live freely. Lesbian is the only concept I know of which is beyond the categories of sex (woman and man), because the designated subject (lesbian) is *not* a woman, either economically, or politically, or ideologically. For what makes a woman is a specific social relation to a man, a relation that we have previously called 'servitude'[4], a relation which implies personal and physical obligation as well as economic obligation ('forced residence,'[5] domestic corvée, conjugal duties, unlimited production of children etc) a relation which lesbians escape by refusing to become or to stay heterosexual. We are escapees from our class in the same way as the American runaway slaves were when escaping slavery and becoming free. For us this is an absolute necessity; our survival demands that we contribute all our strength to the destruction of the class of women within which men appropriate women.

This can be accomplished only by the destruction of heterosexuality as a social system which is based on the oppression of women by men and which produces the doctrine of the difference between the sexes to justify this oppression.

Notes

[1] Colette Guillaumin, 'race et Nature: Systeme des marques, idee de groupe naturel et rapports sociaux,' Pluriel, no. II (1977). Translated as 'Race and Nature: The System of Marks, the idea of a Natural Group and Social Relationships,' *Feminist Issues* 8 no. 2 (Fall 1988)

[2] Andrea Dworkin, 'Biological Superiority: The World's Most Dangerous and Deadly Idea,' *Heresies* 6:46.

[3] Atkinson, p.6: 'If feminism has any logic at all, it must be working for a sexless society.'

[4] In an article published in *L'Idiot International* (mai 1970), whose original title was 'Pour un movement de liberation des femmes' ('For a Women's Liberation Movement').

[5] Christiane Rochefort, *Les stances á Sophie* (Paris: Grasset, 1963).

— Monique Wittig, 'On ne naît pas femme', *Questions féministes* [1980], published in English as 'One Is Not Born A Woman', *The Straight Mind and Other Essays* [Beacon, Boston, 1992], 11–20, 101–3

Tee Corinne
'Imagining Sex Into
Reality' (1994)

[…] Imagine 1974. Imagine pictures of lesbian sexuality in that year or books about it. The only pictures were in porno magazines and scattered among a very few, difficult-to-locate art books. Imagine me, 30 years old, wanting those images and words and looking for ways to make them real.

I worked as a volunteer at the San Francisco Sex Information Switchboard one afternoon each week. Four of us at a time worked three hour shifts — noon to three or three to six. We answered questions about sexuality from around the country, around the world. The training was intense, dealing with factual, behavioural, and emotional issues. Our goal was to respond nonjudgmentally to discussions of the whole range of sexual behaviours.

Initially I volunteered because I wanted to see sex education movies,

an integral part of the training. I wanted to learn as much as possible about sexual images in order to have a baseline for art which I longed to make, even before I could imagine exactly what it would look like.

The Switchboard offered more than just a three hour stint on the phones. We were a community, a large support group interested in talking about and affirming sexuality. Official and unofficial Switchboard parties drew people of diverse sexual persuasions. We talked about sex a lot and often fantasized about books and media we wanted to produce. […]

Photos by a man at an art show early in 1975 showed two women making love. Someone said the women and the photographer were all lovers. Someone

else suggested that if a woman had taken the photos the images would look different. The subjects, who were present at the reception, agreed to have women photograph them.

A few nights later, at a birthday party for a friend, someone asked for other women willing to be photographed making love. The photos would be used as the basis of drawings for a lesbian sex manual, the first lesbian sex manual.

The person asking was artist Victoria Hammond. I suggested we use my large, carpeted, sparsely furnished living room. Of the nine women participating in the photo session a few days later, one identified as heterosexual, the others were evenly divided between bisexual and lesbian.

Tee Corinne, poster for the journal *Sinister Wisdom*, 1977

We photographed all day. It was the first time I had ever worked with actual lovemaking. I had made drawings from photographs of wrestlers and lovers. To say that I was excited would be an understatement. The women's bodies were beautiful, forming and reforming patterns in relation to one another, pairs and triads, touching, moving, sometimes coming, laughing. As the day progressed we worked our way through fear and self-consciousness to an expansive openness. We were moving in uncharted territory. [...]

When *Loving Women* — the book for which the images were made — was published, some lesbians complained that it never should have been written. 'Let women find out how to make love to another woman by doing it,' they said. Others knew that something very special was happening, was starting to happen.

I was, at this time, completing a book of drawings of women's genitals tentatively titled *The Cunt Coloring Book*. Most of the women who modelled for me worked at the Sex Information Switchboard. These were women who understood how important labia images were for validation and healing.

The first time I asked a woman to model I rehearsed the words I was going to say for weeks, if not months. I don't know what I was so afraid of: that she would turn me down? That I would feel embarrassed?

She said yes. We set a date and time. My apartment was warm as she undressed and positioned herself on the bed. I finished the first drawing and knew that I needed to deal with my internal censors who were getting between me and what I was seeing.

Mentally I reviewed and put aside all the negative things I had ever heard about genitals and about looking. I encouraged the artist in me to find a way to move forward, take and stay in control. Voices in my head shrieked, 'What are you doing? I can't believe you're doing this! What's the matter with you anyway? Pervert.' I had to confront the part of me that was freaking out about what I was doing.

I moved additional lights into position, breathed deeply, focussed internally on what I wanted, what I needed to do. I made a second drawing. The difference was dramatic. The forms were clear and the delineation sure. [...]

By the end of 1975 *The Cunt Coloring Book* was in women's bookstores and was selling well despite recurring complaints about the title. Within a few years *I am My Lover* would be published, using sixteen of my color images of labia. Others were used in educational books and college texts, or hung in galleries in women's bars. I looked, always, for ways to make the imagery available to a wider public and for ways

to frame it, intellectually, so that the pictures would not be too frightening for comprehension. [...]

— Tee Corinne, 'Imagining Sex Into Reality', *Courting Pleasure, A Collection* [Banned Books, Austin, Texas 1994], 119—24

Laura Cottingham 'Sexual Politics: Judy Chicago's 'Dinner Party' In Feminist Art History' (1996)

[...] If the thirty-nine women invited to Judy Chicago's *Dinner Party* were to come, some, such as Natalie Barney and Sappho, would arrive as self-identified lesbians; others such as Emily Dickinson, Virginia Woolf, and Georgia O'Keeffe, would arrive surrounded by a lesbian aura; and others might be silently lesbian. All would participate in a lesbian gesture as they proceeded to eat from the vulvar plates. Just as lesbianism functions as a process involving various physical, sexual, and social instances of women coming into being (as lesbians), this dinner party metaphor locates lesbian and feminist practices within a shared continuum of coming into being. Lillian Faderman has suggested a continuity between pre-twentieth-century romantic friendships among women and contemporary lesbianism.[1] Borrowing from Faderman and altering her suggestion of continuity, I would like to situate 1970's and contemporary feminist practices within a lesbian continuum. My paradigm assumes that lesbianism occupies neither the deviant biological-psychological category established in academic thought during the nineteenth century nor the exclusively sexual category implied by most contemporary usages. Rather, this paradigm assumes that lesbianism is coextensive with all feminist practice as a nonstatic nomenclature that encompasses women's various efforts toward self-definition and escape from male emotional, economic, sexual, and cultural hegemony.

Most, if not all, of the art produced in America within the loose boundaries defining the feminist art movement and its legacy could, like *The Dinner Party*, be read in relationship to a lesbian perspective. A lesbian perspective is, after all, a 'woman's perspective,' that of, in the terminology of 1970's feminist discourse, a 'woman-identified woman.' But many of the artists who participated in the movement would not want to be associated with lesbianism (that their fear is also hypocrisy is something many can't see), and many

lesbians are uncomfortable when this aspect of their lives is brought forward. How, then, can lesbianism and feminism be discussed while respecting individual women but without perpetuating the marginalization of lesbianism? How can the very idea of 'woman' be freed from its implicit silencing of lesbians?

To begin with, it would be so much easier and so much more productive to think, write, and converse about the relationship between lesbianism and feminism within art and culture if the word *lesbian* itself didn't, on its own, without the addition of qualifiers, flip people out. As Marilyn Frye has so eloquently understated it: 'The connection between lesbianism and feminism has made many women nervous.'[2] Of course, the relationship between lesbianism and feminism is many different relationships. It is a historical association that began in the nineteenth century during the emergence of the first wave of feminism. It is a political connection based in the ideal of, and the political struggle for, women's autonomy. It is a cycle of enablance, whereby feminist consciousness can produce lesbian experience. The complicated contiguity between lesbians and feminists, between lesbianism and feminism — which can be charted along social, emotional, and political lines as well as according to a taxonomy of sexual practice — is also frequently found configured into an explicitly hostile equation: women who are potential or actual feminists have often been accused of lesbianism.[3]

Lesbian is a word that can still stop discussion, raise eyebrows, trigger snickers, suggest sensationalism, and terminate or preclude employment. It's also a term the American television and print media, especially the supermarket tabloids, have recklessly and eagerly thrown at Nicole Brown, Hillary Clinton, Anita Hill, Roxanne Pulitzer, Vanessa Williams, and other women who are consciously or obliquely associated with feminism (even if they are not women who have ever chosen *feminist* as a self-appellation) because they possess a degree of personal and political autonomy that is considered unusual *for a woman*. Both *lesbian* and *feminist* are words that circulate around women whose actions, attitudes, and beliefs indicate that they might not fully believe in either the idea or practice of subordinating themselves to men. Charges or assertions of lesbianism can stir up emotions almost as readily as accusations of witchcraft once did in Salem Village, and the primary target is the same.[4]

Although the term perhaps provokes less anxiety now than it did before the women's liberation movement encouraged lesbians to organize communities and assert ourselves as a political entity (and identity), lesbian

is still a word that few people in the United States can write or say with any neutrality. Lesbian and its colloquial synonym, dyke, are seldom spoken or heard as purely descriptive enunciations; rather, both words are routinely inflected with threat, fear, uncertainty, taboo, marginality, exoticism, pornographic implications, apology, and confusion. Especially when spoken, *lesbian* is seldom allowed simply to be, to signify on its own terms, to mean what it could potentially, neutrally describe: a woman who is emotionally and sexually intimate with women (and not men) or a woman who is not economically or socially dependent on men. *Lesbian* (and I refer to actual lesbianism, not its simulacrum as practiced by women for the voyeuristic pleasure of men) cannot be allowed to mean only, or simply, this, because this is something that women who live in a male supremacist society, such as that of the United States, are still not permitted only, or simply, to be.

Lesbianism is a much noisier word than feminism. In dominant discourse lesbian is frequently used as a signifier for far out, freaky, or everything but the kitchen sink. Take this published comment from one straight, white, male curator to another 'You're projecting a curatorial policy that now would have to take into account everything from Latvian artists to lesbian artists, I assume.'[5] Here *lesbian* is emptied of all cognitive content, used simply for its alliteration with *Latvian*. If accepted as more then empty rhetoric, the equation between Latvian and lesbian artists, many of who are, like the two white, male curators in discussion, living and working in New York City and not, like the alleged Latvian artists, at a great geographical and cultural distance. This gratuitous comment (and the acquiescent response of the other participant in the discussion) makes it safe to assume that neither of these individuals has any familiarity with or interest in either Latvian *or* lesbian cultures.

One should consider what a privilege ignorance is among the otherwise educated or, rather, consider how impossible it would be for anyone to function in the American art community without an extensive knowledge of the ways and histories of the white male, while the white, male educator, artist,

curator, and critic can so easily continue in happy, hermetic ignorance of the rest of us (and use us as empty, flashy signifiers in conversation and in curating). This inequity is, of course, a basis of the multicultural argument; similar sentiments have been expressed by activists and scholars on behalf of all those who are excluded from the white, male paradigm. Lesbian life and scholarship do not, however, fit easily into the theoretical framework established for progressive considerations of race and gender. Lesbianism, unlike race or gender, is not a static component of one's individual history.

Because of the confusion that surrounds the word *lesbian*, misunderstanding and theft suffocate us. Many lesbians still cannot say *lesbian* or, as they would say, just prefer not to. Our community and its history are shrouded in a silence that many feel is their only guarantee of economic, social and emotional survival. Heterosexual domination insists that lesbians remain invisible and lesbians, as well as nonlesbians, usually comply. As Adrienne Rich has written, this cycle of silence is self-perpetuating: 'Whatever is unnamed, undepicted in images, whatever is omitted from biography, censored in collections of letters, whatever is misnamed as something else, made difficult-to-come-by, whatever is buried in the memory by the collapse of meaning under inadequate or lying language — this will become, not merely unspoken, but unspeakable.[6]

We who have been unnamed, misnamed, and denamed cannot magically reclaim ourselves; only human actions can do that. This historical change has already begun...slowly. A reclamation of lesbianism emerged with the second wave of feminism in the late 1960's and early 1970's; the word, idea, and life of the lesbian in the United States, and the West generally, have not been the same since. So that when I use the word lesbian, I call forth a meaning that has been produced for me through the words and ideas of Mary Daly, Christine Delphy, Marilyn Frye, Jill Johnston, Audre Lorde, Kate Millett, Adrienne Rich, Monique Wittig, and other lesbian feminist thinkers. When I use the word *lesbian*, I also assume its contiguity with Sappho and with her poem fragments. When I see the ellipses between her words and

stanzas marking what has been lost, I think of the importance of preserving lesbian culture. I hear the word *lesbian* echoing in the letters and thoughts of Virginia Woolf, Vita Sackville-West, and the rest of the women of Bloomsbury and the Paris expatriate set, even though they seldom said *lesbian* and preferred the word *sapphist*. And, despite her well-known verbosity, Gertrude Stein never said the word at all. [...]

Notes

[1] Lillian Faderman, *Surpassing the Love of Men* (New York: William Morrow, 1981)

[2] Marilyn Frye, 'Wilful Virgin; or, Do You Have to Be a Lesbian to Be a Feminist?' first published in *Off Our Backs*, August—September 1990; reprinted in Wilful Virgin: Essays in Feminism, 1976—1992 (Freedom, Calif: Crossing Press, 1992), 124—37.

[3] For an insightful discussion of lesbianism as it functions and dysfunctions in the practice of women's studies, see ibid.

[4] The categorical similarities between modern-era lesbianism and Christian-era witches have been suggested and explored by some lesbian feminists; see especially Mary Daly, *Gyn.Ecology: The Metaethics of Radical Feminism* (Boston: Beacon Press, 1978).

[5] A question asked by independent curator Bruce Ferguson to Museum of Modern Art curator Robert Stott; as published in *Artforum* 33 (October 1994): 78. The condescension and absurdity of Ferguson's pseudo-sweeping question appear to be lost on Storr, whose immediate response is: 'I think that's a good definition of what people ought to be doing.'

[6] Adrienne Rich, *Sinister Wisdom*, no. 6, cited by Arlene Raven in *At Home*, exh. cat. (Long Beach, Calif; Long Beach Museum of Art, 1983), 20.

— Laura Cottingham, *Sexual Politics: Judy Chicago's 'Dinner Party' in Feminist Art History* [Armand Hammer Museum of Art, University of California, Los Angeles, 1996] 210—13

F —
Sex Wars
(1980 – 94)

The AIDS crisis occasioned heated debates about the representation and alleged 'promotion' of homosexuality. Artists and writers in ACT UP (the AIDS Coalition to Unleash Power) developed impassioned arguments about the genocidal effects of homophobia. They urged the public to recognize AIDS as a social, political and medical disaster of massive proportions rather than as a matter of (somebody else's) personal loss, individual tragedy or abject suffering. The need for positive, accurate images of the populations affected by AIDS rapidly became a priority, as did arguing for documentary strategies and activism as aesthetic practices.

John Perrault
'Gay Art' (1980)

Recently you have been writing a great deal about gay art and gay issues. When you wrote about the Marsden Hartley retrospective at the Whitney Museum, you emphasized the newly published information that Hartley was homosexual.[1] You also contributed a piece to a Soho News supplement called Is there Gay Culture?[2] and you devoted a fair amount of space to the recent lesbian show at the Hibbs Gallery.[3]

The subject just keeps coming up. It also came up when I was interviewed by the *Artworkers News*.[4] But let's not exaggerate. I write a great deal and I talk a great deal and I have written and talked about a lot of other things.

Nevertheless, currently you seem particularly concerned about this.

Yes. First of all, I was very moved by the Marsden Hartley information because he really suffered. He was a great pioneer of American modernist art and of abstraction. His 'German military' paintings are very advanced, but during and after the First World War the U.S. was going through an isolationist, nationalist period, and the paintings were misinterpreted as being pro-war and pro-German. It nearly wrecked Hartley's career, but what they were really about was his German lover who died in the war. No one really knew that until recently. And then later on, a similar thing happened. *Fisherman's Last Supper* is one of Hartley's most famous paintings. Its subject is a Nova Scotian family after a death of two sons at sea. Hartley also painted one of the sons, Alty Mason, separately. The painting is called *Adelard the Drowned, Master of the Phantom*. In the painting Alty wears a flower behind his ear, as was apparently his custom. What we didn't know before reading Barbara Haskell's excellent catalogue biography[5] is that Hartley was in love with Alty. With Alty's family's permission, they were going to set up house nearby. This changes and enriches the meaning of the paintings. It made me wonder how many other artworks are misinterpreted because of censored biographies.[6] We need all the information we can get. In contemporary art we have a handicap, too; again this information is off limits.

Does this mean you are going to specialize in gay art form now on?

No, of course not. I have many interests. However, I am gay and I am an art critic. One should attempt to integrate aspects of one's own life. And whenever I can I do what I call

first person criticism.[7] Furthermore, I think we're entering another phase of gay liberation. First there was the subculture phase, then there was the gay pride / gay rights phase. That battle is still not over.[8] But now I sense a third phase, a vanguard, a reaching out to the world.

Aren't you being idealistic, particularly at a time when there appears to be such a strong turn to the right in America?

Of course I'm being idealistic. We already know what life is (suffering) and what art is (commerce). It's time to start thinking about what life and art might be. And yes, the right-wing drift is very dangerous, which is why we have to stand up and be counted and encourage others to do so before it's too late.

So what is gay art?

It is too soon to tell. This is a probe, a beginning. Only recently have some gay artists begun to feel free to express their experience in art in a conscious way. There has been homosexual art before, in our own culture and in others. But in modern times, if it has found expression, it has mostly been in code.

You just used the term 'homosexual art.' I am confused, is there a difference between homosexual art and gay art?

I am proposing one. Homosexuality is a depressingly 'scientific' term. As a matter of fact it wasn't used until the late 1860's. It is a term coined by our oppressors. Gay is what most of us call ourselves. Gay means liberation and pride. I like to think that someone who is gay is no longer 'homosexual.' No longer limited to a pseudoscientific category that is reductive and that narrows sexuality. Gay art is by gay artists who are trying to be open and free.[9]

Is gay art then any art done by a gay artist?

Perhaps. But that's only a beginning, once again. It is much more complicated. I don't think the only difference between gay people and heterosexuals is that we prefer to have sex with and tend to fall in love with members of our own sex. We may have different perceptions of our bodies and those of other people. Can anyone tell if a male nude was painted by a woman, a heterosexual man or a gay man? Can there be gay abstract art? I find these questions fascinating; but we don't have enough information to answer them.

Does sexuality really influence art?

My premise is that the art almost always reflects who the artist is, sometimes in small ways, sometimes with overwhelming force. If this is true, then a *homosexual* artist (ie an artist suffering under severe social restrictions) will reflect the oppression in his or her art, whereas a *gay* artist might express his or her

liberation. Because of the taboo we've lost a great deal of art energy and human information that could help everyone. Hiding and coding take a great dealt of energy.

Some might say it is the coding process that turns expression into art. Hasn't art profited by the process of sublimation?

The concept of sublimation is a justification for repression. If suffering and repression are the main forces behind art, then maybe we had better forget art. I prefer to think of celebration as the major force behind art, though of course there are others. Art has been many things and has been used in many ways. We must be visionary. Sexuality falls on a continuum. Male and female are not necessarily opposite. It is a both / and situation. Sexuality is plural. I think eros is at the center of art. If this is so, then we can't separate sexuality from art. Art works are expressions of love for others and for the world, even those angry works of art that assault prevailing shams and pretenses.

And yet you hint that there is such a thing as specifically gay art?

It may be just a stage, but it is one that I want to investigate. There are enormous critical problems; already there exist several possible definitions of gay art as it is or as it will be. One idea is that it is art done by gay artists on gay subjects for other gay people Although this may be a necessary first step, I find it separatist and far too accepting of the ghetto. Lesbian artists appear to be moving beyond the separatist stage and are attempting a form of public address. What I object to is that when some gay males say gay art if only for gay people, they mean gay men and they mean gay erotic art. I have nothing against erotic art, but most of it is single-purpose art (ie sexual excitement) and most of it is no more than illustration. Erotic art is simply not ambitious enough.

So your gay art is made by gay artists but addresses the general public?

That's a beginning. Artists willing to be publicly identified as gay are political, and I am all for that. But gay art must go beyond this, and use its content in a public context. It must do this because the insights, information and expression that gay artists might bring to the world are needed for general liberation from sex-role stereotypes.[10]

But aren't you forgetting that the art world is as homophobic as any other world?

It is amazing that the art world has been so little affected by gay liberation.

And yet the art world has a reputation for being so bohemian, so liberal.

And silent. At least when it comes to gay topics. The art world is an example of repressive tolerance. Everyone is 'accepting' as long as you keep quiet and don't ask embarrassing questions. I've heard people outside the art world claim that it is controlled by gay people, which is ridiculous.

Can you give me an example of this kind of claim?

I announced in the *Soho News* that I was working on an article about gay art and planning an exhibition, and would welcome slides from gay artists who were willing to be so identified. It is an offer that still holds. Curiously enough I was asked: wouldn't some artists claim to be gay just to get into my exhibition? People seem to be totally unaware of the stigma attached to being gay. I am afraid you are right. The art world has not welcomed gay liberation.

Why is this?

I have several theories that may help to explain. The first is that art has always had a bad name in American society. Art is what women and sissies do. Hence the macho image of many male artists. My second theory has to do with the dominance of formalism. Art is art; life is life. The personal and the biographical are to be excluded from both the making of art and its interpretation. It can be argued that formalism was necessary to make amends for the sloppy biographical criticism that previously held sway. There is no doubt that formalism has helped us see certain internal aspects of art more vividly and more meaningfully. However, one cannot avoid the fact that formalism makes art less threatening to the status quo: it de-eroticizes and depoliticizes art. But since the early '70's — thanks to feminist artists, minority artists, and now lesbian[11] and maybe gay male artists — art is slowly but surely being re-eroticized and repoliticized. The art world has to catch up. Representational art is again possible. Narrative art is possible. Personal art everywhere, and the personal sometimes is political, which is why it has been repressed. But there is also an economic reason.

Isn't it enough that in the past year you have announced you are gay? I suppose you are now going to declare you are a Marxist-Leninist?

No. As it happens I am not a Marxist-Leninist, nor have I ever pretended to be. Although I believe it is productive for people to work together toward common goals, I am not even sure I am a traditional socialist. It's only that economics is a part of life. Most artists hope to make a living from their art, and some of them actually do. I suspect that many established artists haven't come out because they are afraid it would hurt sales. But whatever else it may do, true gay liberation does not support the status quo. It works towards being non-separatist, anti-ghetto, anti-racist, and pro-feminist.

So gay art — particularly your ideal gay art — will have a difficult time of it in the art world. It seems hopeless. What will happen?

The art world will have to change.

John Perreault is senior art critic of the *Soho News*.

[1] John Perreault, 'Marsden, We Hartley Knew Ye,' *Soho News*, 12 March, 1980.

[2] John Perreault, 'Not Yet,' in the supplement *Is There Gay Culture?* Doug Ireland and Jeff Weinstein, eds. *Soho News*, 25 June, 1980.

[3] John Perreault, 'Lesbian Lessons,' *Soho News*, 10 September, 1980.

[4] John Perreault, *Artworkers News*, April 1980.

[5] Barbara Haskell, *Marsden Hartley*, (New York: Whitney Museum of American Art and Yew York University Press 1980)

[6] Emily Farnham's *Charles Demuth: Behind a Laughing Mask* (University of Oklahoma Press, 1971) revealed the homosexuality of another important American modernist, but with appalling bigotry: 'A flower blossom — fresh, perfect, beautiful beyond compare — has the most sublime spiritual meanings. Yet, although Demuth understood this fact better than most, since he passionately loved flowers. In his art the beauty of the blossoms and his perverted sex life merged.' (p.4).

[7] John Perreault, 'First Person Criticisms,' *Art Criticisms*, Vol. 1 No.2 1979.

[8] For a documentary look at the past I recommend Jonathan Katz' Gay *American History* (New York: Cromwell Press, 1976; Avon Press, 1978). Present struggles can be followed in the newsprint pages of *Gay Community News* (Boston) and *the Body Politic* (Toronto). The latter in particular is articulate and progressive.

[9] In this regard Michel Foucault's *The History of Sexuality* (New York, Vintage, 1980) is instructive. Foucault seems to argue that naming and categorization are methods of control. I agree. He, however, does not seem to realize that renaming can be an aspect of liberation. The power of the word can be positive as well as negative. The use of the terms 'black' and 'Afro-American' represents a positive change. So does the term 'gay.

[10] Mario Mieli, in his provocative and definitely 'third phase' book, *Homosexuality and Liberation: A Gay Critique* ((London: Gay Men's Press 1980) uses the term 'trans-sexual which is too easily confused with transsexual. Polysexual is too Freudian. Pansexual seems an improvement, but suggests licentiousness. We need a new word.

[11] Here I should mention and recommend the pioneering 'Lesbian Art and Artists' issue of *Heresies*, No. 3 1977. I also wish to clarify that although lesbians and gay men have many interests and problems in common, I am writing mainly from the perspective of gay man and do not presume to speak for lesbians.

— John Perrault, 'Gay Art' ('I'm asking — Does It Exist? What Is It? Whom Is It For?'), *Artform*, no. 19 [1980] 74—5

Mark Thompson 'Portfolio: Robert Mapplethorpe' (1980)

He comes across like a satyr in black leather. Lean. Taut. With a look some have called shrewdly appraising. Perhaps it's just the look of an appetite hungry for imagery.

New York photographer Robert Mapplethorpe has established an international reputation not only for his sensitive portraits of flowers and faces, but also for his unflinching documentation of gay sadomasochistic ritual. Timing — as in knowing the exact moment to click the shutter — is essential in establishing a successful career within the rarefied strata of the professional art world today. It is a scene where style and not substance often seems the criterion of taste.

But the imagination of the aesthete and the eye of the public were equally caught by Mapplethorpe's bold, almost casual, pictures of the S/M underground. In the often mundane and overly familiar world of photography, with its insatiable need and microscopic ability to record every visual surface, Mapplethorpe provoked his audiences with an act of startling difference — he had photographed something new. These unsettling images have insured his celebrity; only an ever-evolving sensibility continues to insure his self-professed desire to photograph what is truly personal to him. Mapplethorpe has a diffident — sometimes shyly charming — nevertheless streetwise edge about him. He is, indeed, shrewd in his assessment of the qualities necessary for survival in a fickle artists marketplace. But like the satyr, he is bound not to take any of it too seriously. And not surprisingly, he has been criticized as mercurial, even philistine, in his attitudes about

his art — his work dismissed as slick images calculated for the hard sell.

His photographs have been compared to the commercial fashionability of Richard Avedon's work, to the voyeuristic peeks offered by Diane Arbus. But unlike Avedon, he admits that he has never been a good fashion photographer. 'I've always been interested in the personality of the model,' he explains. 'That's problematic because in merchandising they want clothes to show and not the model.'

Perhaps he is closer to Arbus, who once admitted, 'I always thought of photography as a naughty thing to do — that was one of my favourite things about it. And when I first did it I felt very perverse.' But he feels a kinship to Arbus' view only in the human extremes they have both revealed.

'Where we differ….' Mapplethorpe begins, but stops with a sigh. He's in San Francisco to oversee a recent show of his work at the Lawson de Celle Gallery and still hasn't settled in from a successful afternoon of photographing a man he just met. 'I probably took a great photograph today,' he grins. Black men, in particular, are a current fascination for him — 'One reason is the way they read sculpturally, very close to bronzes' — and that interest has provided the title and the theme for his show here, 'Blacks and Whites.'

'Occasionally,' he resumes, 'I'll take a picture that's Diane Arbus-like. Her pictures are very powerful, but I find them a little depressing. I suppose people have found the sex pictures I've done to be depressing too, but the people in them come out looking their best. Arbus has captured people in a place that is unattractive. I try to place people attractively. They still look like people I'd like to meet.'

How does he approach a subject? Does he try to evoke a mood or attitude, or does he lay claim to objectivity — merely recording what is there? 'For me, it's about relating directly to the person I'm photographing. More time is spent in conversation then in the actual taking of the photograph. It's a sort of coming together. I rarely take a photograph of a person I don't know well.'

Mapplethorpe's first camera was a Polaroid which he used to take pictures of himself. He was studying painting and sculpture at the time and living with rock poet Patti Smith. Their seven-year relationship was a well-documented, much discussed affair. 'Patti's a genius,' he says. 'I can't take a bad photograph of her. There's always magic happening.'

Magic, perhaps best described here as submission to susceptibility — the allowance for naivete — is a necessary requirement for Mapplethorpe's life and work. It is a

quality about his nature not always grasped; an innocence seemingly in contradiction to the images he has selected to capture. His pictures project a confident, classic, often elegant control. To this he attributes a formal understanding of technique and art history. But underlying the erudition of his method remains a compulsion he finds, in contrast, difficult to explain.

'Anyone who is creative and doesn't create, I think, becomes neurotic or nervous. Sometimes it's just a self-applied guilt in order to accomplish something. I can go through periods where I don't take pictures and don't care to take pictures. I would still prefer to experience life without a camera because it's more exciting.'

Unlike many photographers who confess to perceiving the world through their lenses, Mapplethorpe is most comfortable with 'just experiencing' and then later perhaps trying to photograph it. 'It's like the work I've done with sexuality,' he says. 'I would prefer a sexual experience to photographing one. The camera gets in the way, although I have always made an effort to use it.'

'For instance, I think I was one of the first to really approach sexuality with an eye for lighting and composition and all the other considerations relative to a work of art. I recorded it from the inside. I was talking with a friend recently about filmmakers, and she said they see everything secondhand; they're voyeurs, people who don't experience the experience, who view life from the outside. I resent that.'

Mapplethorpe started to photograph his series of S/M images about four years ago. 'I was in a position then when I was relating strongly to that form of sexuality,' he explains. 'I felt I could get something out of that experience into photography that no one else had done before. It was a new territory without any rules, so it was exciting for me. I trace back down to the time when I was 16 and walking down 42nd Street and seeing male pornography for the first time and being able to get it. I was in art school at that moment and was aware I was getting an exciting feeling from being able to get it. But it was a feeling much stronger than just sexuality.'

Most established galleries refused to exhibit the images resulting from his explorations. They were eventually shown in alternative gallery spaces on both coasts — such as in a 1978 San Francisco show titled 'Censored' curated by art dealer Edward de Celle at 80 Langston Street — and sometimes in conjunction with another exhibit of his more traditional and socially palatable work. The shows created a controversial interest in

his work and helped serve as the genesis for what some critics in the gay press are now referring to as 'The Robert Mapplethorpe/Mine Shaft School of Photography.'

'I'm not as involved with extreme forms of sexuality as I once way,' says Mapplethorpe. 'What I discovered during that period, however, is that I could get off on almost anything. They weren't things that I fantasized about previously. I didn't know they existed until I came across them. But again, I didn't feel like a voyeur. I felt I was directly *there*.

'People get blocked about what pleasure is. It can be incredibly sensual to, say, piss into someone's mouth. It can be incredibly sensual to receive it. It's all about reaching a certain mental place that's very sophisticated. It's almost impossible to talk about in clear terms.

'I don't think anyone understands sexuality. What's it about? It's about an unknown, which is why it's so exciting. During sex you forget about time, you forget about everything. I was amazed to discover how much energy there was in that type of sexuality. It's like when I took the picture of a man this afternoon. When I looked at him through the lens it was like magic to me. But I understand that it won't necessarily be that for anyone else.

'I don't understand the way my pictures are. It's all about the relationship I have with the subject that's unique to me. Taking a picture and sexuality are parallels. They're both unknowns. And that's what excites me most in life — the unknown.'

— Mark Thompson, 'Portfolio: Robert Mapplethorpe', *The Advocate* [24 July 1980], 21—2

Gayle Rubin
'Concepts for a Radical Politics of Sex' (1982)

The social relations of sexuality have always been as political as the social relations of class, race, gender, and ethnicity. However, at certain periods of time, in certain societies, the organization of sexual behavior is more actively contested, and in arenas more visible and centrally located. Since 1977, in the United States and in much of the western capitalist world, sexuality has become the locus of intense, focused, and bitter political struggle. A generation of political activists, veterans of the 1960's and 1970's, have been taken by surprise by attempts to reimpose tighter standards of sexual morality.

There has been a lack of conceptual tools with which to record,

analyze, and position the events of the many discrete battles in the new sex wars. Many radicals have assumed that the body of feminist theory contained the necessary concepts. But feminist analysis was developed to describe and criticize oppression based on gender. While sexual experience is affected by the social relations of gender, sexuality is nevertheless not the same thing as gender. Just as gender oppression cannot be conceptualized by way of an understanding of gender relations, no matter how complete.

We need to develop an analytical apparatus specifically engineered to see, describe, and criticize sexual oppression. This workshop will propose some elements of a radical political theory of sex. The agenda for building such a body of thought about sexuality would include the following items: (1) It is essential to learn, albeit critically, the existing body of knowledge about sexuality. Sexological work contains useful empirical information, as well as material from which some of the structures of erotic oppression can be inferred. (2) It is important to get rid of the idea of sex as an asocial or transhistorical biological entity. (3) The persistence of the western (and especially Anglo-American) idea of sex as a destructive force needs to be explored. (4) The idea that there is a single kind of 'good' sex that is 'best' for everyone needs to be criticized. (5) Above all, we need to understand that there is systematic and serious mistreatment of people based on sexual behavior. Oppression generated out of sexuality is just as real, unjust, and barbarous as are the oppressions of class, race, gender and ethnicity.

— Gayle Rubin, 'Concepts for a Radical Politics of Sex', *Diary of a Conference on Sexuality* [Barnard College, 1982]

Anonymous for German AIDS=Hilfe, Safer Sex Comic 4, detail, 1984

The Advisory Committee of the People with AIDS 'The Denver Principle to Empower People With AIDS' (1983)

We condemn attempts to label us as 'victims,' a term which implies defeat, and we are only occasionally 'patients,' a term which implies passivity, helplessness, and dependence upon the care of others. We are 'People with AIDS.

Recommendation for all People

1. Support us in our struggle against those who would fire us from our jobs, evict us from our homes, refuse to touch us or separate us from our loved ones, our community or our peers, since available evidence does not support the view that AIDS can be spread by casual, social contact.

2. Not scapegoat people with AIDS, blame us for the epidemic or generalize about our lifestyles.

Recommendations for People with AIDS

1. Form caucuses to choose their own representatives, to deal with the media, to choose their own agenda and to plan their own strategies.

2. Be involved at every level of decision-making and specifically serve on the boards of directors of provider organizations.

3. Be included in all AIDS forums with equal credibility as other participants, to share their own experiences and knowledge.

4. Substitute low-risk sexual behaviors for those which could endanger themselves or their partners; we feel people with AIDS have an ethical responsibility to inform their potential sexual partners of their health status.

Rights of People with AIDS

1. To as full and satisfying sexual and emotional lives as anyone else.

2. To quality medical treatment and quality social service provision without discrimination of any form including sexual orientation, gender, diagnosis, economic status or race.

3. To full explanations of all medical procedures and risks, to choose or refuse their treatment modalities, to refuse to participate in research without jeopardizing their treatment and to make informed decisions about their lives.

4. To privacy, to confidentiality of medical records, to human respect and to choose who their significant others are.

5. To die — and to LIVE — in dignity.

— The Advisory Committee of the People with AIDS, 'The Denver Principle to Empower People With AIDS' [self-published, 1983], reprinted in *Major Problems in the History of American Sexuality: Documents and Essays* [Houghton Mifflin, ed. Kathy Peiss [New York, 2001], 451–2

G. B. Jones and Bruce LaBruce 'J.D.s Manifesto' (1985)

Sex. The Final frontier.

This is the voyage of *J.D.s*, its continuing mission: to seek out and destroy outdated ideas about sex.
What are you? Gay or something? What do you think Sid and Johnny were doing before Nancy? And, like, haven't you ever heard of the Buzzcocks? And what were you doing when Dee Dee Ramone was giving head on 42nd Street? And Phranc was in Nervous Gender? OK, now it's the Nip Drivers — 'Quentin Crisp'; Mighty Sphincter — 'Fag Bar'; Victims Family — 'Homophobia'. This is the *J.D.'s* Top Ten today. Get with it.
When you're reading *Maximum RocknRoll*, everything is question authority — question rules applied to music, ecology, politics, the mosh pit…but what about sex? If you're fighting against how the majority tells you to act, then how can you act like the majority when it comes to sex-type stuff? The biggest way schools, parents, the church, and other institutions control youth is by telling them who they have to love and fuck. How you have to act according to the rules of being a girl or boy. Who says girls can't be butch? Who says boys can't be fags?

J.D.s is the homocore movement.

'See how the other half lives and fucks. Recommended for hets.'
— review of *J.D.s* in *Scut* Magazine.

J.D.s is a softcore zine for hardcore kids. All you punks who have ever been called a fag or a dyke — you know what we're talking about. Our themes so far have been tattooing,

G. B. Jones, *I Am a Fascist Pig #3*, 1985

motorcycles, and movies, and upcoming issues include skateboarding and homocore bands. We actively solicit stuff from our readers (photos, commix, drawings etc) and we'll publish any of the true-to-life sex adventures of a fag or duke punk sent to us. We promise. *J.D.s* is also looking for more groups who want to be interviewed, so write us now, 'cause we're getting ready to release a cassette for sale: 'J.D.s Homocore Hits'. Our new issue is 42 pages of 'pure pornography' and it's three bucks. No dough, no go. (US). We are the New Lavender Panthers. Don't be gay, write today.

— G. B. Jones and Bruce LaBruce, 'J.D.s Manifesto', *J.D.s*, no. I [1985].

Kobena Mercer and Isaac Julien 'True Confessions' (1986)

[…] In recent years questions of pleasure and desire have been in the foreground of debates around photography and the politics of representation. In many ways this reflects the political priority given to the issue of pornography in debates led by the women's movement and the gay movement. From our point of view one of the most notable features of this political activity around sexual representation is the marked absence of race from the agenda of concerns — it is as if white people had 'colorized' this agenda in

contemporary cultural politics for themselves alone. While some feminists have begun to take on issues of race and racism in the women's movement, white gay men retain a deafening silence on race. Maybe this is not surprising, given the relative apathy and depoliticized culture of the mainstream gay 'scene.'

On the other hand there is a bitter irony in this absence of political awareness of race in the gay male community, especially when we consider recent trends in gay subcultural 'style.' After the clone look in which gay men adopted very 'straight' signifiers of masculinity — mustache, short cropped hair, work clothes — in order to challenge stereotypes of limp-wristed 'poofs', there developed a stylistic flirtation with s/m imagery, leather gear, quasi-military uniforms and skinhead styles. Politically, these elements project highly ambivalent meanings and messages, but it seemed that the racist and fascist connotations of these new 'macho' styles escape gay consciousness as those who embrace the 'threatening' symbolism of the tough-guy look were really only interested in the eroticization of masculinity.

[...] Our starting point is *ambivalence* as *we want to look, but don't always find the images we want to see.* As black men we are implicated in the same landscape of stereotypes which is dominated and organized around the needs, demands and desires of white males. Blacks 'fit' into this terrain by being confined to a narrow repertoire of 'types' — the supersexual stud and sexual 'savage' on one hand, or the delicate, fragile and exotic 'oriental' on the other. These are the lenses through which black men become visible in the urban gay subculture. The repetition of these stereotypes in gay pornography betrays the circulation of 'colonial fantasy,' that is a rigid set of racial roles and identities which rehearse scenarios of desire in a way which traces the cultural legacies of slavery, empire and imperialism. This circuit for the structuring of fantasy in sexual representation is still in existence. The *Spartacus* guidebook for gay tourists comments that boys can be bought for a packer of cigarettes in the Philippines.

Against this backdrop, Robert Mapplethorpe's glossy images in *Black Males* are doubly interesting as the stereotypical conventions of racial representation in pornography are appropriated and abstracted into the discourse of 'art photography.' In pictures such as *Man in Polyester Suit*, the dialectics of white fear and fascination underpinning colonial fantasy are reinscribed by the exaggerated centrality of the black man's 'monstrous' phallus. The black subject is objectified into Otherness as the size of the penis signifies a threat to the secure identity of the white male ego and the position of power which whiteness entails in colonial discourse. Yet, the threatening phobic object is 'contained' — after all this is only a photograph on a two-dimensional plane; thus the white male viewer is returned to his safe place of identification and mastery but at the same time has been able to indulge in that commonplace fixation with black male sexuality as something 'dangerous,' something Other.[1] As Fanon argued in *Black Skin, White Masks*, the myths about the violent, aggressive and 'animalistic' nature of black sexuality were fabricated and fictioned by the all-powerful white master to allay his fears and anxieties as well as provide a means to justify the brutalization of the colonized and any vestiges of guilt. Mapplethorpe's carefully constructed images are interesting, then, because, by reiterating the terms of colonial fantasy, the pictures service the expectations of white desire: but what do they say to our needs and wants?

Here we return to that feeling of ambivalence because while we can recognize the oppressive dimension of the fantasies staged in such sexual representation, we are fascinated, we still want to look, even if we cannot find the images we want to see. What is at issue is that the same signs can be read to produce different meanings. Although images of black men in gay porn generally reproduce the syntax of common-sense racism, the inscribed, intended or preferred meanings of those images are not fixed. They can at times be prized apart into alternative readings when different experiences are brought to bear on their interpretation. Colonial fantasy attempts to 'fix' the position of the black subject into a space that mirrors the object of white desires; but black readers may appropriate pleasures by reading against the grain, overturning signs of 'Otherness' into signifiers of identity. In seeing images of other black gay men there is an affirmation of our sexual identity.

This touches on some of the qualitative differences between gay and straight pornography: because 'homosexuality' is not the norm, when images of other men, coded as gay, are received from the public sphere there is something of a validation of gay identity. For isolated gays, porn can be an important means of saying 'other gays exist.' Moreover, pornographic conventions sometimes slip, encouraging alternative readings. One major pornographic code is to show single models in solo frames, enabling the imaginary construction of one-to-one fantasy; but sometimes, when models pose in couples or groups, other connotation — friendships, solidarities, collective identity — can come to the surface. The ambivalent mixture of feelings in our response to porn is of a piece with the contradictions black gays live through on the 'scene.' While very few actually conform to the stereotypes, in the social networks of the gay sub-cultures and the circumscribed spaces of its erotic encounters, some black gay men appear to accept and even play up to the assumptions and expectations which govern the circulation of stereotypes. Some of the myths about black sexuality are maintained not by the unwanted imposition of force from 'above,' but by the very people who are in a sense 'dominated' by them. Moreover, this subtle dialect between representation and social interaction is at work in the broader heterosexual context as well — to explore this dimension, and its implications for cultural politics, we pursue Michel Foucault's idea that sexuality constitutes a privileged 'regime of truth' in our societies.[2] From this perspective we may uncover issues around the construction of black masculinities in and through different forms of representation. [...]

Notes

[1] The concept of 'colonial fantasy' is developed by Homi Bhabha, 'The Other Question — The Stereotype and Colonial Discourse,' *screen* 24 (November 1983). See also Homi Bhabha's introduction 'Remembering Fanon' in the reprint of *Black Skin, White Masks* (London: Pluto Press, 1986).

[2] See Michel Foucault, *The History of Sexuality, Volume I* (London: Allen Lane, 1978); on 'regimes of truth,' see Michael Foucault, *Power/Knowledge: Selected Interviews and Other Writings 1972–1977*, ed. Colin Gordon (Brighton, England: Harvester, 1980).

— Kobena Mercer and Isaac Julien, 'True Confessions', *Ten 8*, no. 22 [Summer 1986], reprinted in *The Film Art of Isaac Julien*, [Centre for Curatorial Studies, Bard College, Annandale-on-Hudson, 2000]

Gregg Bordowitz
'Picture of Coalition' (1987)

As a twenty-three-year-old faggot, I get no affirmation from my culture. I see issues that affect my life — the issues raised by AIDS — being considered in ways that will probably end my life. For this reason I think that if there is to be a movement that will shift the discussion of AIDS away from the moralizing, punitive attitude

that has characterized this country's policy, it will be built out of an emergent popular culture, one that affirms the lives of those affected. It will be a counterculture that will grow out of a broad-based mobilization to end the global epidemic.

There are already moves to contain this growing activism. Threats of mass mandatory HIV antibody testing and quarantine are written in banner headlines. Certain individuals and groups have already been subject to such assaults — within those institutions where surveillance is most easily enforced. This is not even to mention the discrimination people living with AIDS (PLWA's) have faced in all aspects of social life. The first targets of repression are, as always, the most disenfranchised. Thus, New York City's health commissioner Stephen Joseph has recently called for consideration of 'mandatory AIDS testing [sic] for prostitutes and sex and drug offenders, as well as a heavy crackdown on all forms of prostitution.'[1]

What purpose will enforced testing serve? Test results will establish much more than the extent to which a population has been exposed to a virus. Their purpose is to identify an entire social group on the basis of the presence of antibodies. A whole new class of people will be designated as seropositives. The limits of the AIDS community will be established.

What is really being tested? The limits of control that can be exerted over our bodies. The limits of constraint that can be placed on our actions.

We are being tested. The Reagan Administration spends funds for costly, inefficient testing programs instead of for medical research, preventative education, and health care. This misuse of our tax dollars and neglect for our real needs tests the limits of our tolerance. It tests the limits of our will to fight back.

We in the communities affected by this epidemic will not stand for further intrusion into our already disempowered lives. Through direct action we will wrest control of the public discussion of AIDS. Through direct action we will make known the demands of the sick. Through direct action we will establish a national health care policy in the interest of people living with AIDS.

Drastic measures are being adopted. Activists are taking to the streets, making demands on their elected officials. Activists are providing alternative health care, educating their communities, researching alternative treatment. Activists are producing alternative media.

When circumstances require that drastic measures be adopted, independent media activists assume a central role. This role is twofold: to assist other activists in clarifying their positions and goals and to represent those positions and goals to the world. Adopting the agenda of AIDS activists, media activists make armed propaganda.

Video activists are everywhere met with the same challenges. We must call into question the established structures of the media. We must create new ways to make and distribute media. We must work toward participatory forms of representation that incorporate people into the communication process.

In the AIDS crisis, all of this must be done in order to facilitate moves toward the treatment and cure of AIDS and ARC, the distribution of preventive education materials, and the protection of civil rights. Video activists must clarify situations, render relations, picture possibilities for the emerging AIDS movement.

In the spring of 1987 the Testing the Limits Collective, comprised of lesbians, gays, and straights, formed to document emerging forms of activism arising out of people's responses to government inaction in the global AIDS epidemic. The founding members of the collective, Sandra Elgar, Robyn Hutt, Hilery Joy Kipnis, David Meieran, and myself, are all activists who view our documentary work as organizing work. The productive capacity and efficacy of the collective's project depends on establishing and maintaining links with pro-test-oriented groups and support organizations in the communities affected by AIDS.

Most of the members of the collective are participating members of ACT UP (AIDS Coalition to Unleash Power), 'a diverse, nonpartisan group united in anger and committed to direct action to end the global AIDS epidemic.' ACT UP's first action was staged on Wall Street in March 1987 to protest the unavailability of promising drug treatments and the announcement by Borroughs-Wellcome that they would charge each patient up to $13,000 per year for AZT. Immediately following the action, at which seventeen people were arrested, the Food and Drug Administration announced plans to cut two years off the drug approval process. Media attention began to focus on drug treatment issues, and film of ACT UP's Wall Street demonstration became stock footage in subsequent reporting.

After this initial demonstration, ACT UP grew to be a core group of over 200 people. [...]

Through participation in ACT UP at every level of its process, the Testing the Limits Collective has been able to document [a series of actions] resulting in material that was, in effect, produced by the entire membership of ACT UP. As a member of both the video collective and the activist organization, it was important to me to be able to integrate my participation into a single practice. Thus, within ACT UP, I insisted that my work as a documentarian be recognized as itself a form of activism. Such recognition is hard-won. Activist groups generally consider only the dominant media, to which they have a fundamentally contradictory relationship: seeing it as the enemy and at the same time seeking legitimation from it. Discussions of the media are often bogged down in such petty issues as how to write a good press release or how to get the organization two minutes' coverage on local news broadcasts. An activist group that expends too much of its energy on the presentation of its image before the dominant media only gives the impression that it is more interested in publicity than in achieving its goals through direct action.

Within ACT UP, Testing the Limits had to earn its support. We were initially regarded as hobbyists, just as we are by the mainstream media: we cannot get press passes and the network musclemen physically cast us aside because we don't have broadcast-level equipment. One of our tasks was therefore to educate the group about the importance of alternative media. We had to introduce and reintroduce ourselves as independent documentarians within the group. We arranged screenings to show people what we were doing. We had constantly to announce our intentions and explain our activities. [...]

The agenda of this project compels the video activist to organize the screening and distribution of material. People must be able to see themselves making history. People living with AIDS must be able to see themselves not as victims, but as self-empowered activists. In view of this agenda, distribution plans have to be fundamentally pragmatic: Generate as much material as possible. Show this material in as many forms and as many places as possible. Utilize every possible resource. Work by any means necessary. [...]

Imagine a screening. In a local community center a consumer VCR deck and a TV set sit on a table. Representatives from the various communities affected by AIDS sit in front of the TV. They watch a video composed of interviews with each of them. They see themselves pictured in relation to one another as they sit next to one another.

Consider this screening. It presents both means and ends for the video AIDS activist. The AIDS movement, like other radical movements, creates itself as it attempts to represent itself. Video puts into play the means of recognizing one's place within the movement in relation to that of others in the movement. Video has the potential to render the concerted

efforts — as yet unimagined — between groups. The most significant challenge to the movement is coalition building, because the AIDS epidemic has engendered a community of people who cannot afford not to recognize themselves as a community and to act as one.

The AIDS epidemic has caused us to change our behavior. It has shaped our social relations as it has changed our views of ourselves. This became apparent to me recently, after coming out to my family. I realized that I had come out as a member of two disenfranchised groups. I am a member of the gay community and a member of the AIDS community. Furthermore, I am a gay member of the AIDS community, a community that some would establish by force, for no other end but containment, toward no other end but repression, with no other end but our deaths — a community that must, instead, establish *itself* in the face of this containment and repression. We must proudly identify ourselves as a coalition.

Picture a coalition of people refusing to be victims.

Picture a coalition of people distributing condoms and clean works.

Picture a coalition of people having safe sex and shooting up with clean works.

Picture a coalition of people staging die-ins in front of City Hall or the White House until massive funds for AIDS are released.

Picture a coalition of people getting arrested for blocking traffic during rush hour as they stand in the middle of Times Square kissing one another.

Picture a coalition of people occupying abandoned buildings, demanding that they be made into hospices for people living with AIDS.

Picture a coalition of people chanting 'Money for AIDS, not for war' as they surround and quarantine the Pentagon.

The government and the medical establishment denounce as 'immoral' the people who get sick and the people they hope will get sick. They worry about themselves, their children, and the 'innocent victims.' They predict the kinds of people who get AIDS, the numbers of people infected, the numbers of deaths that will occur. But they are doing next to nothing to cure the sick and prevent the spread of AIDS.

People are asking, 'If they won't do anything now, when will they?' 'If they won't do anything for those who are sick now, for whom will they?'

Getting no answers, people are mobilizing.

Getting no answers, a movement is emerging.

Picture a coalition of people who *will* end this epidemic.

Notes

[1] Ronald Sullivan, 'AIDS Test is Weighted in Sex Cases,' *New York Times*, November 21, 1987, p.B30.

— Gregg Bordowitz, 'Picture a Coalition', *October*, no. 43 [1987] 183–96

Simon Watney
'Taking Liberties: An Introduction' (1989)

[…] Section 28 states that:

1. A local authority shall not:

(a) intentionally promote homosexuality or publish material with the intention of promoting homosexuality;

(b) promote the teaching in any maintained school of the acceptability of homosexuality as a pretended family relationship.

2. Nothing in subsection (1) above shall be taken to prohibit the doing of anything for the purpose of treating or preventing the spread of disease.

In order to understand the extraordinarily complex and difficult situation in which community-based AIDS educators find themselves, it is necessary to unpick some of the ideological threads that hold together this powerful and now legally binding view of the world. There are four key concepts which are closely locked together here: homosexuality, the family, teaching and disease. Stepping back a little from the actual wording of the legislation we can see that there is a central distinction between 'pretended' and, by implication, 'real' families. The law aims to prevent lesbian or gay relationships from being represented as if they are 'real' family relationships. Furthermore, it is implied that any family with open lesbian or gay members is somehow 'unreal'. Stepping back still further we can see that homosexuality is identified as a threat, to the extent that its 'promotion' could undermine 'real' families, either by actively

seducing heterosexuals into homosexuality, or more simply by challenging the absolute supremacy of marriage as the only legitimate institution validating adult sexual relationships. From this point of view, lesbian and gay relationships are not only illegitimate, they are 'unreal'.

Section 28 is, of course, obliged to acknowledge that homosexuality exists, but can only explain its existence in terms of a crude conspiracy theory which regards lesbians and gay men as sinister predatory seducers, eagerly 'promoting' our perversions to the young and 'innocent'. It thus speaks from a long tradition of legal moralism, dedicated to the protection of the supposedly 'vulnerable'.[1] Significantly, there is no attempt to legislate against specific sexual acts. On the contrary, Section 28 tacitly recognizes that the two decades prior to the emergence of HIV have been characterized by what Jeffrey Weeks has described as: 'a decisive move away from the morality of 'acts' which had dominated sexual theorizing for hundreds of years and in the direction of a new relational perspective which takes into account context and meaning.'[2] It is the field of lesbian and gay *culture* that exaction 28 targets, where our personal and collective identities and political confidence are formed and validated. As the Prime Minister insisted at the 1987 Tory Party conference: 'Children who need to be taught to respect traditional moral values are being taught that they have an inalienable right to be gay.'[3] A year later she returned to the same them: 'Children need to be taught traditional moral values and to understand our religious heritage. We cannot leave them to discover for themselves what is right and wrong.'[4] Indeed, the Prime Minister was 'the driving force' behind Section 28, according to senior Government sources.[5]

Section 28 only makes sense according to a picture of human social and sexual relations in which everyone is basically heterosexual, save for a few inexplicable perverts, whose aim is to corrupt young people and seduce them into what is fondly described as 'the gay lifestyle.' One of the most decisive ways in which public AIDS commentary has changed the ideological field of British society is to be found in the widespread use of the notion of 'the heterosexual community', in response to descriptions of how different communities of gay men and lesbians have responded to the epidemic. This new ideological unity is evidently primarily *defensive*. Hence the endless appeals to 'tradition' and 'heritage', which serve to replace those social institutions that have been widely sacrificed in the name of 'self-sufficiency' and

cost-cutting. Besides, Mrs Thatcher explicitly rejects the very idea of 'the social'. As far as she is concerned: 'we've been through a period where too many people have been given to understand that if they have a problem, it's the government's job to cope with it. 'I have a problem, I'll get a grant.' 'I'm homeless, the government must house me.' They're casting their problem on society. And, you know, there is no such thing as society. There are individual men and women, and there are families. And no government can do anything except through people, and people must look to themselves first...A nation of free people will only continue to be great if family life continues and the structure of that nation is a family one.'[6]

It is this dream-like fantasy of a nation which only exists as individuals in closed family units, supervised by government, that Thatcherism both draws on and wishes to impose with the full force of law. In this respect AIDS has played a central role in the ideological assault on all social values rooted in collectivities which are incompatible with this type of individualist absolutism. Michel Foucault and others have argued persuasively that modern forms of government authority depend increasingly on structures of political consent which involve strong personal identifications with institutions that are not necessarily recognized as 'political'. Thus governments may assume power in the name of 'the family' or 'the nation' or 'traditional values', even and especially when these are presented as highly vulnerable and in need of 'strong' action in order to protect them. Such abstract, ideological entities are presented as if they were natural phenomena, prior to and independent of the workings of state power. It is Foucault's contention that such categories, and the personal identities by which they are fleshed out and inhabited, are in fact indispensible mechanisms of state power itself, which he describes as the practice of 'governmentality'.[7] Of course, few people ever stop to consider why it is that they consent to state power and authority, except in moments of crisis. AIDS has been used to represent just such a crisis, pulling individuals round to identify *with* the government, in the name of 'public health' and its protection. At the same time those who have actually been directly affected by AIDS are excluded from consideration as part of 'the public' or 'public health'. Hence gay men in particular have suddenly found themselves not only politically unrepresented, but unable to discover any public institutions willing to acknowledge their only too real lived experience, including the routine denial of what are usually taken as fundamental social rights in the West –

access to life insurance, mortgages, adequate social security, employment rights, and in many cases basic health care provision. After all, what is the place of gay men in relation to a National Health Service which has since its inception represented 'the nation' and its health in exclusively heterosexual terms? How at this of all times are we to trust doctors who can write to their own professional journals asking if it is too much to hope for that homosexuality should be outlawed and that at least some sensible precautions should be taken to prevent the spread of AIDS to millions, even if those now relatively few victims of the disease need to suffer some deprivations to this end.[8] 'I view homosexuals with the kind of vague loathing that I view terrorists.'[9]

Eight years into the epidemic, the British government has still not spent a single penny on directly communicating support, sympathy or information to the social constituency that makes up more than 80 per cent of people with AIDS in the United Kingdom. We will only begin to understand this all but incredible state of affairs in relation to the specific forms of governmentality in modern Britain, and the obsessive mobilization of the *ideological* entities of family and nation. It goes without saying that most people with HIV infection and disease are officially regarded as if they are not members of families at all, a denial of reality fully backed up in law by the language of Section 28. This is largely a consequence of the historical institution of parliamentary democracy, which is by its nature deeply insensitive to the complex demographic make-up of the actual population of the UK. Parliament claims to stand for a pre-given 'national interest' which assumes the existence of a unified homogeneous country, whilst at the same time: 'it pre-empts all basic arguments about what the nation and its interests are and should be,' as Raymond Williams has pointed out.[10] [...]

Notes

[1] see Simon Watney, *Policing Desire: Pornography, AIDS and the Media*, London 1987, chapter 4.

[2] Jeffrey Weeks, *Sexuality*, London 1986, p.81

[3] 'Thatcher mocks right to be gay,' *Capital Gay* no. 314, 16 October 1987

[4] 'Thatcher claims Wesley as ally,' *The Guardian*, Thursday 26 May 1988, p.2

[5] Nicholas de Jongh, 'Thatcher pushed to keep Clause 28', *The Guardian*, Friday 8 April 1988, p.1

[6] Douglas Keay, 'AIDS, Education and the Year 2000', *Woman's Own*, 31 October 1987, p.10

[7] Michel Foucault, 'On Governmentality', *Ideology & Consciousness* no. 6 1979.

[8] Dr Joan M. Woodley, 'AIDS concern misplaced', *General Practitioner*, 6 March 1987, p.16.

[9] Dr T Russell, 'Gay acts are immoral', *General Practitioner*, 18 March 1988, p.18 (I would like to thank Dr Simon Mansfield for drawing my attention to this and the previous reference).

[10] Raymond Williams, 'Democracy and Parliament', *Marxism Today*, June 1982, p.17.

– Simon Watney, 'Taking Liberties: An Introduction', *Taking Liberties: AIDS and Cultural Politics*, eds. Simon Watney and Erica Carter [Serpent's Tail, London, 1989], 22–55

David Wojnarowicz 'Postcards from America: X Rays from Hell' (1989)

[...] My Friend across the table says, 'The other three of my four friends are dead and I'm afraid that I won't see this friend again.' My eyes settle on a six-inch-tall rubber model of Frankenstein from the Universal Pictures Troup gift shop. TM 1931: his hands are enormous and my head fills up with replaceable body parts; with seeing the guy in the hospital; seeing myself and my friend across the table in line for replaceable body parts; my wandering eyes aren't staving off the anxiety of his words; behind his words, so I say, 'You know... he can still rally back...maybe...I mean people do come back from the edge of death...'

'Well,' he says, 'he lost thirty pounds in a few weeks...'

A boxed cassette of someone's interview with me in which I talk about diagnosis and how it simply underlined what I knew existed anyway. Not just the disease but the sense of death in the American landscape. How when I was out west this summer standing in the mountains of a small city in New Mexico I got a sudden and intense feeling of rage looking at those postcard-perfect slopes and clouds. For all I knew I was the only person for miles and all alone and I didn't trust that fucking mountain's serenity. I mean it was just bullshit. I couldn't buy the con of nature's beauty; all I could see was death. The rest of my life is being unwound and seen through a frame of death. And my anger is more about this culture's refusal to

deal with mortality. My rage is really about the fact that WHEN I WAS TOLD I'D CONTRACTED THIS VIRUS IT DIDN'T TAKE ME LONG TO REALIZE THAT I'D CONTRACTED A DISEASED SOCIETY AS WELL.

On the table is today's newspaper with a picture of cardinal O'Connor saying he'd like to take part in operation rescue's blocking of abortion clinics but his lawyers are advising against it. This fat cannibal from that house of walking swastikas up on fifth avenue should lose his church tax-exempt status and pay taxes retroactively for the last couple of centuries. Shut down our clinics and we will shut down your 'church.' I believe in the death penalty for people in positions of power who commit crimes against humanity — ie. fascism. This creep in black shirts has kept safer-sex information off the local television stations and mass transit spaces for the last eight years of the AIDS epidemic thereby helping thousands and thousands to their unnecessary deaths. [...]

I scratch my head at the hysteria surrounding the actions of the repulsive senator from zombieland who has been trying to dismantle the NEA for supporting the work of Andres Serrano and Robert Mapplethorpe. Although the anger sparked within the art community is certainly justified and will hopefully grow stronger, the actions by Helms and D'Amato only follow standards that have been formed and implemented by the 'arts' community itself. The major museums in New York, not to mention museums around the country, are just as guilty of this kind of selective cultural support and denial. It is a standard practice to make invisible any kind of sexual imaging other than white straight male erotic fantasies. Sex in America long ago slid into a small set of generic symbols; mention the world 'sex' and the general public appears to only imagine a couple of heterosexual positions on a bed — there are actual laws in parts of this country forbidding anything else even between consenting adults. So people have found it necessary to define their sexuality in images, in photographs and drawings and movies in order to not disappear. Collectors have for the most part failed to support work that defines a particular person's sexuality, except for a few examples such as Mapplethorpe, and thus have perpetuated the invisibility of the myriad possibilities of sexual activity. The collectors' influence on what the museum shows continues this process secretly with behind-the-scenes manipulations of curators and money. Jesse Helms, at the very least, makes public his attacks on freedom the collectors and museums responsible for censorship make

theirs at elegant private parties or from the confines of their self-created closets.

It doesn't stop at images — in a recent review of a novel in the *new york times book review*, a reviewer took outrage at the novelist's descriptions of promiscuity, saying, 'In this age of AIDS, the writer should show more restraint...' Not only do we have to contend with bonehead newscasters and conservative members of the medical profession telling us to 'just say no' to sexuality itself rather than talk about safer sex possibilities, but we have people from the thought police spilling out from the ranks with admonitions that we shouldn't *think* anything other than monogamous or safer sex. I'm beginning to believe that one of the last frontiers left for radical gesture is the imagination. At least in my ungoverned imagination I can fuck somebody without a rubber, or I can, in the privacy of my own skull, douse Helms with a bucket of gasoline and set his putrid ass on fire or throw congressman William Dannemeyer off the empire state building. These fantasies give me distance from my outrage for a few seconds. They give me momentary comfort. Sexuality defined in images give me comfort in a hostile world. They give me strength. I have always loved my anonymity and therein lies a contradiction because I also find comfort in seeing representations of my private experiences in the public environment. They need not be representations of my experiences — they can be the experiences of and by others that merely come close to my own or else disrupt the generic representations that have come to be the norm in the various medias outside my door. I find that when I witness diverse representations of 'Reality' on a gallery wall or in a book or a movie or in the spoken word or performance, that the larger the range of representations, the more I feel there is room in the environment for my existence, that not the entire environment is hostile.

To make the *private* into something *public* is an action that has terrific repercussions in the preinvented world. The government has the job of maintaining the day-to-day illusion of the ONE-TRIBE NATION. Each public disclosure of a private reality becomes something of a magnet that can attract others with a similar frame of reference; thus each public disclosure of a fragment of private reality serves as a dismantling tool against the illusion of ONE-TRIBE NATION; it lifts the curtains for a brief peek and reveals the probable existence of literally millions of tribes. The term 'general public' disintegrates. What happens next is the possibility of an X-ray of civilization,

an examination of its foundations. To turn our private grief for the loss of friends, family, lovers and strangers into something public would serve as another powerful dismantling too. It would dispel the notion that this virus has a sexual orientation or a moral code. It would nullify the belief that the government and medical community has done very much to ease the spread or advancement of this disease.

One of the first steps in making the private grief public is the ritual of memorials. I have loved the way memorials take the absence of a human being and make them somehow physical with the use of sound. I have attended a number of memorials in the last five years and at the last one I attended I found myself suddenly experiencing something akin to rage. I realized halfway through the event that I had witnessed a good number of the same people participating in other previous memorials. What made me angry was realizing that the memorial had little reverberation outside the room it was held in. A tv commercial for handiwipes had a higher impact on the society at large. I got up and left because I didn't think I could control my urge to scream.

There is a tendency for people affected by this epidemic to police each other or prescribe what the most important gestures would be for dealing with this experience of loss. I resent that. At the same time, I worry that friends will slowly become professional pallbearers, waiting for each death, of their lovers, friends and neighbors, and polishing their funeral speeches; perfecting their rituals of death rather than a relatively simple ritual of life such as screaming in the streets. I worry because of the urgency of the situation, because of seeing death coming in from the edges of abstraction where those with the luxury of time have cast it. I imagine what it would be like if friends had a demonstration each time a lover or a friend or a stranger died of AIDS. I imagine what it would be like if, each time a lover, friend or a friend or a stranger died of this disease, their friends, lovers or neighbors would take the dead body and drive with it in a car a hundred miles an hour to Washington D.C. and blast through the gates of the White House and come to a screeching halt before the entrance and dump their lifeless form on the front steps. It would be comforting to see those friends, neighbors, lover and strangers mark time and place and history in such a public way.

But, bottom line, this is my own feeling of urgency and need; bottom line, emotionally, even a tiny charcoal scratching done as a gesture to mark a person's response to this epidemic

means whole worlds to me if it is hung in public; bottom line, each and every gesture carries a reverberation that is meaningful in its diversity; bottom line, we have to find our own forms of gesture and communication. You can never depend on the mass media to reflect us or our needs or our states of mind; bottom line, with enough gestures we can deafen the satellites and lift the curtains surrounding the control room.

– David Wojnarowicz, 'Postcards From America: X Rays from Hell', *Witnesses: Against our Vanishing* [Artists Space, New York, 1989], reprinted in *Close to the Knives: A Memoir of Disintegration* [Vintage, New York, 1991], 111–23

Douglas Crimp
'A Day Without Gertrude' (1990)

In the introduction to AIDS: *Cultural Analysis / Cultural Activism*, I wrote that 'my intention was to show…that there was a critical, theoretical, activist alternative to the personal, elegiac expressions that appeared to dominate the art-world response to AIDS. What seemed to me essential was a vastly expanded view of culture in relation to crisis.' I took some flak for that statement, because it was interpreted as saying that personal expressions of loss are unacceptable, that only activist responses are legitimate. That was not what I meant, and for several reasons. The first is, as I tried to make clear in writing an essay about the activist hostility to mourning, that I think our sense of personal loss must be honored absolutely. And if this includes artistic expressions of mourning, then they are to be honored, too. The second is that I think it is dangerous to essentialize activism, to presume to know in advance what constitutes activism and what does not.

Having said that, I think what I wrote in 1987 is still true of the art world generally. Even though a certain amount of attention has recently been paid to activist practices, that attention is limited – limited mostly to the collective Gran Fury, which the art world seems to have designated as the AIDS activist cultural group that can represent activist practice tout court. But what I'd like to recall, and to speak about briefly, is the second sentence of my original statement: 'What seemed to me essential was a vastly expanded view of culture in relation to crisis.' It isn't merely a question of the accommodation of certain aesthetic practices by the institutions of art –

a videotape by DIVA TV shown here, a performance by Gang there. Rather it is crucial that art institutions recognize that representation is not restricted to discrete symbolic gestures, events, or works, but rather that everything they do functions as representation. It is not a matter of occasionally allowing a political representation of the AIDS crisis; rather, institutions constantly make political representations, directly or indirectly, of the crisis.

'A Day Without Art' is an example of what I mean. A Day Without Art is itself a vast representation and it can be read as such. A Day Without Art has become somewhat more complex in this, its second year, taking on a more activist cast than it did last year – by providing education, raising money for service organizations, providing forums for discussions of AIDS activism and spaces for exhibitions of AIDS activist art. But it still signifies mostly in two ways: first, by showing that the art world has borne heavy losses to the epidemic that it wishes to mourn, and second, by being willing to set aside *one day* to draw attention to the devastation, if not always to the political mendacity that bears much of the blame for this devastation. It still seems necessary to interpret this sense of loss as a privileged one, that is, that the loss of artists' lives is somehow greater than the loss of other lives. This is what I mean by the fact that A Day Without Art is itself a representation, and in this sense, a regrettable one.

But more important, what A Day Without Art represents, in its very name, is that the art world is willing in various ways to participate in the struggle against AIDS for *one day* each year. If art institutions were to recognize what I called a vastly expanded view of culture in relation to crisis, it seems obvious that they would consider 354 more days a year during which they might act as if they knew a crisis existed. If, for example, an art museum is willing to display AIDS information on A Day Without Art, why not display that information every day of the year?

Here's another way of posing this question: Last year, the Metropolitan Museum's participation in A Day Without Art involved removing for the day Picasso's famous portrait of Gertrude Stein, a gesture that seemed particularly obscure to many people. If we were to ask the museum to remove that picture until the end of the AIDS crisis, what do you suppose their response would be? Something, I suppose, on the order of 'What purpose would such deprivation serve?' And our answer would have to be: 'The same purpose as removing it for one day, only with a permanence more commensurate with the losses that we are actually experiencing.'

My real problem with the Met's gesture, which is being repeated this year without paintings, is that it is meaningless, or if not meaningless, then meaningful only in ways that art institutions understand representation generally – that is, as hermetic, necessary to interpret.

I'll make a stab at interpreting the Met's gesture from last year's Day Without Art: It is meant to signify lesbian invisibility – not just lesbian invisibility generally, but the invisibility of lesbians in the AIDS epidemic. And my suggestion for how the Met might make their representation more meaningful is that they replace Picasso's portrait of Gertrude Stein with a text about the refusal of the Centers for Disease Control to include lesbian transmission in its epidemiology, and to explain further that this refusal regarding lesbians might stand symbolically for the CDC's wider refusal to include the diseases that HIV-infected women get among the disease that determine the definition of AIDS. In other worlds, what I would ask of art institutions is that they consider the concrete representational politics of AIDS. For the CDC, too, is involved in representational practices, in this case representational practices that systematically undercount the number of women with AIDS in the United States.

ACT UP will demonstrate at the CDC this week to try to force them to change their epidemiology to include women. ACT UP, too, fighting a war of representation. ACT UP's understanding of representation is the understanding I had in mind when I said that we needed a vastly expanded view of culture in relation to crisis. And I still think the art world needs to pay heed to this expanded view.

– Douglas Crimp, 'A Day Without Gertrude', presented at the panel discussion 'Art, Activism, and AIDS: Into the Second Decade' [in conjunction with 'A Day Without Art' at Soho Photo Gallery, New York, 30 November 1990], reprinted in *Melancholia and Moralism: Essays on AIDS and Queer Politics* [MIT, Cambridge, 2002]

Holly Hughes and Richard Elovich
'Homophobia at the N.E.A.' (1990)

John Frohnmayer, chairman of the National Endowment for the Arts, has taken the unprecedented step of overturning four solo performance

art fellowships that had been strongly recommended for funding by their peer panel.

The artists whose fellowships were denied – Karen Finley, John Fleck, Holly Hughes and Tim Miller – all create works that deal with the politics of sexuality. Three are highly visible gays.

The overturning of these grants represented Mr Frohnmayer's and President Bush's attempt to appease the homophobic, misogynist and racist agenda of Senator Jesse Helms and company.

Mr Frohnmayer apparently believes he an make sacrificial lambs out of gay artists and that no one will care, that no one will speak up for us. Unfortunately, he may be right.

Where was the outcry when the word 'homoerotic' was included in the list of restrictions attached to National Endowment for the Arts funding contracts by Congress? No other group was so blatantly and prejudicially targeted.

There was no outcry. For there to be one, the gay and lesbian community would have to speak up with an informed voice. Nobody else will do so on the community's behalf.

Even well-intentioned arts organizations leading the anti-censorship battle are reluctant to speak up for us. They are afraid of turning off Middle America by embracing these artists' unapologetic effort to make their sexual orientation visible

And because we gay artists, particularly lesbian artists, are so invisible, our problems are invisible as well so we must demand visibility, or the issue will be lost. This is a First Amendment issue that affects all Americans.

The overturning of the N.E.A. grants must be understood in the context of the Government's continued indifference to the AIDS crisis and inaction toward it – and the 128 percent increase in reported gay-bashing incidents in New York City this year. The homophobes in the Government don't think we're being killed off at a fast enough rate.

The gay and lesbian community must embrace the endowment de-funding issue, because there is no direct action group in the cluster of arts organizations to do this work with us.

We two writer don't claim to represent the gay community, or even all lesbian performance artists who live on St Marks Place. But the right wing sees us – and artists like us – this way. In attacking the lesbian poets Audre Lorde, Minnie Bruce Pratt, Chrystos in Jesse Helm's direct-mail campaigns and defunding the four performance artists, the right is trying to black list all gays. The right wants to force all of us back into

the closet, where it hopes we will suffocate and die in silence.

Gays and lesbians need to direct their outrage at Jesse Helms and anyone else who would cater to his agenda – and that means Congress, the President, Mr Frohnmayer and fundamentalists.

The gay and lesbian community knows from its experience in the AIDS crisis that lobbying – letters, postcards, telegrams to Congress – is not enough. Jesse Helms must be confronted through demonstrations in Washington.

Gay men and lesbians must confront the nation's arts institutions – from the galleries to the theaters, from the downtown alternative spaces to the mainstream museums – and demand that they publicly support these blacklisted artists, that they increase their presentations of open lesbian and gay artists, that they condemn Mr Frohnmayer's actions and demand their reversal. To do anything less would be complicity.

The gay and lesbian community has insisted again and again that homophobia be specifically addressed when dealing with the endowment crisis. Such support must come primarily from the gay and lesbian community. The community must get behind the various anti-censorship organizations and insist that they openly include the homophobia issue in their efforts.

– Holly Hughes and Richard Elovich, 'Homophobia at the N.E.A.', *The New York Times* [28 July 1990], reprinted in *Art Matters: How the Culture Wars Changed America* [New York University Press, 1999], 233–39

Deborah Bright
'Dream Girls' (1991)

The impulse for a lesbian photo*monteur* (*menteur*) to paste (not suture, please) her constructed butch-girl self-image into conventional heterosexual narrative stills from old Hollywood movies requires no elaborate explanations. For a long time, I resisted doing such obvious 'one-liners' because my training as a fine art photographer had taught me to make only work that was indirect, densely layered, elliptical and metaphorical. On the other hand, I felt hobbled by various (and competing) tendencies among feminist film and photo theorists whose demands for analytical rigour on questions of gender and power I shared, yet in whose writings (and works) I found little that evoked my own experience as a lesbian.

Even as I submitted myself to the tutelage of strict mistresses such as Mary Ann Doane and Jacqueline Rose,

I found myself envying the unabashed funkiness of contributors to lesbian porn rags like *On Our Backs*, *Bad Attitude* and *Outrageous Women* who brandished their strap-ons and wooed their lace-clad 'bottoms' with gusto, derisive of righteous feminist mafias. The montages, then, were conceived and made in the spirit of the latter – to construct 'scenes' and summon into material from these old fantasies for my own pleasure. But it is with a nod to my intellectual 'tops' and the serious context of this book that I attempt a brief archaeology of what preceded this work. I am also indebted to the work and example of Jo Spence, who showed me the importance of allowing myself to play, remember and reconstruct my social and psychic selves before the camera.

Though I represent my adult self in these altered stills, the fantasies are from my childhood and adolescence. I grew up in the white, white collar professional suburbs of Washing, DC, during the 1950's and 1960's, in a devoutly Christian family that very much resembled the conservative, Republican post-war ideal of the time. Because the values of my milieu were socially privileged (even divinely sanctioned, it seemed) and because I had little contact with those of different origins and beliefs, I had no perspective on their severity, intolerance and reductiveness until I left home at 18. Even then I spent another decade of unresolved passions for women, followed by a stint of heterosexual marriage, before I found the means to come out, both physically and socially.

But thinking back over those years of childhood and adolescence, I recognize many signposts along the way that matched those of many of my lesbian friends: my intense attachments to particular girlfriends; a pugnacious contempt for things 'feminine'; the embrace of a tomboy identity (named 'Jack'); and the idealization of older women who were intelligent, autonomous and spirited. None of these predilections particularly troubled my mother, who convinced herself (more than me) that I would outgrow them and that my desires would 'naturally' turn to boys. The power of parental suggestion is great when there are few visible alternatives. In the world of my adolescence, 'spinsters' were seen only as heterosexual women whose status was not chosen but given by unfortunate circumstances.

But it was clearly my adolescent fantasy life that kept me going when I lacked any knowledge of the realizing of homoerotic desire, a fantasy life led by images from my immediate environment. I didn't seek these from illicit or underground sources – they were the banal fare of everyday experience, the kinds of shows and

Page from Diane DiMassa's zine *Hothead Paisan: Homicidal Lesbian Terrorist*, 1991

novels most of my schoolmates also saw and read, the magazines that lined the coffee-tables of many middle-class suburban living rooms.

My fantasy materials were highly particularized to my race and social class. I day-dreamed my narrow culture in the language of its signifiers, turned out to perfection in the cinematic narratives of MGM, Paramount and Warner Brothers. But subject-identification in the movies is a slippery thing, more complicated than most heterosexual feminist film theorists have acknowledged to date. So I'm going to try here to analyze the kinds of erotically satisfying subject-positions I achieved for myself in certain films in the 1950's and 1960's, positions that I might retrospectively call 'lesbian' without essentialising that relation in any way.

In classic Hollywood romance, reading a contradictory 'lesbianised' subject-position usually demands resisting the film narrative's resolution, which often culminates in the monogamous union of the hero and heroine. My resistant reading was often (though not always) triggered by a compelling erotic attraction to the heroine.[1] After informally polling a sample of lesbian friends of my general age-group who shared a similar socialization in the pre-Stonewall USA, I found that female stars who attracted a dedicated following among us included Katherine Hepburn, Lauren Bacall, Greta Garbo, Marlene Dietrich, Maureen O'Hara, Barbara Stanwyck, Doris Day, Ann Southern, Julie Andrews, Vanessa Redgrave and Audrey Hepburn. Cinematic traits

these stars shared in their films from the 1940's to the mid-1960's included supple, athletic bodies, in tailored suits, strong facial features, dominant rather than subordinate body language, displays of superior intelligence and wit, and (by definition) roles that challenged conventional feminine stereotypes.[2] These transgressions of the norms of femininity were often 'punished' or regulated by the monogamous, heterosexual logic of the film narrative, but that did not matter much. For reception is driven by desire and what many young, middle-class proto-dykes 'saw' in these films in the early 1960's were concrete (if attenuated) suggestions of erotic possibilities that they could not name and that their own lived experience did not provide.

It seemed easy enough to fragment the narrative that evoked this desire and incorporate the desirable parts into a coherent day-dream where the heroines' 'potential/potency' as homoerotic partners could be more fully and safely realised. These fantasy scenarios were of course far removed from the original narrative context of the film. Simon Watney has written of this kind of 'aggregation of sexual fantasy' around objects 'legitimated' by heterosexual culture for other purposes: the classic Hollywood Western as a staple scenario of gay male pornography, for example.[3] It is also testimony to the vitality and fluidity of desire that it so easily appropriates whatever channels are available to it, and certainly without requiring the kind of elaborate psychic calesthenics that some film theorists

assign to any female spectator who possesses a desiring look.[4]

My pleasure in these montages is with the power relations among the characters they depict; with the sabotage of the heterosexual Hollywood set-up by a supplementary or substitute character of ambiguous gender who upsets the heterosexual economy of the scene. The montages undermine the function of the love triangle in the heterosexual narrative. For example, the lesbian 'driver' in Katherine Hepburn's car makes Spencer Tracy's kiss benign and impotent — little more than a grandfatherly peck on the check which Hepburn indulges. In the altered still from *The Sound of Music*, Christopher Plummer's character is apprehensive and protective of his 'property' in the presence of a potent (and equal) rival for her attention. Before its alteration, the dinner scene from *A Touch of Class* showed Glenda Jackson staring fixedly off-screen as George Segal held forth over his wine. I gave Jackson something more interesting to look at, leaving Segal firmly locked out of the visual loop. Other stills feature more conventional pairings (a lesbian inserted in place of the male partner as seducer/playmate), while several montages explore the eroticism of a drag identity. These are my fantasy postcards from childhood, sent with love.

'Lesbianised', these film stills raise a different set of expectations about the action that took place and resolution of these stories. Their subversiveness is related to their time in history, a time when gender

roles and sexuality in Hollywood cinema were strictly regulated by the Hays Code.[5] Before the 1970's, industry censors screened films for overt signs of homosexuality: 'fruity' men and 'dykey' women. Because they concentrated on flamboyant behaviours constructed by bigoted stereotypes censors overlooked films with less explicitly coded signifiers of homoerotic bonding. [...] But because post-1960's films allow a new (if not altogether satisfying) visual explicitness, they don't offer me the same emotional charge or sense of discovery / trespass that I found in those earlier film images where my desire shaped the content to my own needs. In short, my film-still fantasies are constructed by (even as they deconstruct) the eroticized taboo and invisibility that were a part of their original context.

Finally, I should make some reference to the tactics of appropriation, pastiche and charade in postmodernist practice, particularly in the work of Cindy Sherman, Sherrie Levine and Barbara Kruger. Following Brecht's admonition that the structure of a representation be laid bare, revealed rather than mystified, postmodern appropriationists made their borrowings blatant and used the 'already-given' of their imagery to thwart conventional pleasures of fantasy and seamlessness. Like many feminist theorists of the 1970's and 1980's, they saw women's politicized appropriations of given signifying systems as a useful and sophisticated weapon against our invisibility (as well as a well-aimed blow at modernism's idealist aesthetics). Even if women could not stand outside masculine symbolic discourse, according to these theorists, they could use its gaps, contradictions and elisions to represent their own (feminine) identities and experience. Levine's rephotographing and repainting of canonical masterworks by male artists, Kruger's utilization of gender-specified modes of address in her public signage and Sherman's apeing of a generic repertoire of stereotyped women's roles in high art, film noir, advertising, television soaps and other mass media sources were forceful, economical critiques of how the male-dominated sexual economy was reproduced at all levels of the culture industry.

While my strategy of photographer-as-performer in Dream Girls might recall Cindy Sherman's Film Stills of a decade ago, I have a different agenda which reflects the differing historical experiences of heterosexual women and lesbians. Sherman constructs images of femininity in her Film Stills, each frame producing a coherent 'cinematic' illusion channeled by our expectations of the familiar 'type' she represents for us. [...]

Sherman's Film Stills are grounded in heterosexual definitions of femininity, which are largely male-defined and regulated. She brilliantly exposes the constructed nature of our culture's 'essences' of femininity (a condition that can only exist in relation to an equally imputed essence of 'masculinity'), but she does not challenge the universality of heterosexuality as a governing discourse. But heterosexuality and its discontents are problems most lesbians do not have.

As the title Dream Girls suggests, my work is about fantasy. The lesbian subject roams from still to still, movie to movie, disrupting the narrative and altering it to suit her purposes, just as I did when I first watched those films. This lesbian subject is herself constructed: a partial, fragmented representation of someone who may or may not correspond to the historical Deborah Bright who dreamt her into being. But what matters is that she's having a good time and that she's doing it with Julie, Vanessa, Glenda and Kate. To the lesbian friends who've seen them, these Dream Girls have provoked a whoop of recognition and pleasure and that is satisfaction enough.

Notes

[1] My identification always incorporated elements of both conventional gender roles: I fantasized pursuing, courting and making love with the heroine, while at the same time, I also fantasized being (like) her.

[2] The impulse to search for any apparent continuity between such cinema-inspired fantasies and the lives of the actors who played them is quickly discouraged. In the case of Katherine Hepburn, gay film historian Vito Russo recounts her horror at the very thought of homosexuality, flatly refusing to believe that such people existed. In later years, she has been a vocal opponent of homosexuality, linking it with other 'social ills' of society.' Vito Russo, The Celluloid Closet (New York: Harper and Row, 1987), p.116.

[3] Simon Watney, Policing Desire (London: Comedia Publishing Group, 1986; 1987), p.73. Watney introduces this point to argue that such wholesale appropriations from the banal image-banks of everyday experience put to naught efforts by anti-porn interests to designate certain genres as inherently 'pornographic'.

[4] For example, Constance Penley quotes Mary Ann Doane's account of 'the convoluted means' by which a woman might assume a centred position of spectatorship in 'women's films' like Rebecca: 'I am looking, as a

man would, for a woman'; or else, 'I submit myself, as if I were a man who thought he was a woman, to a woman who thinks she is a man'. Constance Penley, Feminism and Film Theory (London and New York: Routledge, 1988), p.16.

[5] The Hays Code, or Motion Picture Production Code, was formulated by the industry under the leadership of Will Hays, Hoosier Presbyterian elder and head of the Motion Picture Products and Distributors of America. It was designed to protect the industry from outside censorship in the 1930's and remained in effect until the late 1960's. After some daring experimentation with gender roles in films of the 1920's early 1930's, religious and civic pressure groups had demanded reform, particularly the banning of homoeroticism and 'deviant' sexuality on screen. Hays also inserted morals clauses into actors' contracts and kept a list of 'those deemed unsafe' because of their personal lives.' See Vito Russo, op.cit., pp.31, 45

– Deborah Bright, 'Dream Girls', Stolen Glances: Lesbians Take Photographs, eds. Tessa Boffin and Jean Fraser [Pandora Press, London, 1991] 151–4

Jan Zita Grover
'Framing the Questions: Positive Imaging and Scarcity in Lesbian Photographs' (1991)

[...] We must learn to look at representations both for what they forget and what they remember; photographic absences ('forgetting') are equally as meaningful as photographic presences ('remembering'). Thought about in this way, ordinary photographs – advertisements, say, for beauty products – are equally important for what they 'forget' (class, colour, sickness, old age, poverty) as for what they 'remember' (youth, health, wealth, Anglo-Saxon appearance and social power).

'Romantic comedies' are significant not only for what they 'remember' (the social and economic primacy of the heterosexual couple) but for what they 'forget' (the possibility of same-sex couples, social collectives, the single person).

In the same way, countercultural or sub-cultural positive images propose a complex 'forgetting' of present realities – a resistance to, say, the painful realities of war, powerlessness or poverty – and 'remembering' of possible alternatives: peace, security and affluence.

Thus it is naïve — or very cynical — to dismiss positive images as merely sentimental or old-fashioned. To do so is to treat them as if they proposed no arguments, embodied no aspirations, reflected no ongoing struggles.

I know this is true of the first widely circulated lesbian images, which were formally conventional portraits of lesbian couples that attested to the wish for, willed the existence of, enduring couplehood. In the early 1980's I looked at many lesbians' photographs of their communities constructed according to these terms and I always found them affecting at this level of yearning of desire. Conventional portraits set up their subjects as socially respectable individuals, as a socially respectable unit, in a custom stretching back to at least the fifteenth century in Northern Europe. The lovingly crafted portraits made by so many lesbian photographers in the 1970's and 1980's attested to the growing wish for legitimation, the longing for recognition, of individuals and couples in our communities. These images of single women and couples surrounded by their cats, dogs, plants and furniture embodied the desire to stay time, to make things as perfect as one wished they could be. These photographs frequently involved a second coming-out for their subjects, for they formalised their identity as lesbian and attested to their desire to maintain the social identity embodied in the photograph — whether as a couple, homeowner, biker, what-have-you.

What these photographs did not very often subjunctively embody was a sense of lesbians as people for whom their sexual relationships to other women were determinants of identity both within and outside their primary communities. The entire topic of identity politics is far too complex to go into here, I'll remark only that the dominant strategy in North America[1] was to downplay the sexual component in the lesbian community and instead emphasise its spiritual or emotional basis (Adrienne Rich's 'the lesbian in all of us'). There are historic reasons for this particular emphasis — for example, the homophobia of heterosexual women within the women's movement, the wish to see women defined for once in terms other than sexual — that find their traces in the almost rigorously asexual lesbian portraits of the period before 1986. But what these photographs managed to 'forget' — that sexual desire is what drives a great deal of lesbian identity — resurfaced (one is tempted to say, with a vengeance, as in: the return of the repressed) in the second half of the 1980s.

The form in which subjunctive discourses shifted was the sudden explosion of sexually explicit lesbian imagery. This is not to say that such images were not being made before the mid-1980's; among the lesbian photographers whom I interviewed while writing 'Dykes in Context' (1984–6), many mentioned that tucked away amid their negatives they had some pretty hot stuff. When I asked why they hadn't exhibited or published that work, all of them told me that they didn't think their communities 'were ready' to see it. The institutions through which their images circulated were, they thought, unable to accept sexually explicit lesbian photographs. And this has unhappily proved to be the case: with few exceptions, erotic/porn lesbian photographs have been circulated through a wholly different set of channels than earlier and more 'respectable' photographs were shown. Objectification — lesbian feminist for 'concentrating-on-body-parts-at-the-expense-of-the-whole-woman' — and other displacements away from desire function to police the boundaries of respectable lesbianism. Thus publications like Off Our Backs in the USA and Spare Rib in Britain keep a kind of faith that is increasingly irrelevant to large numbers of lesbians, most particularly those who came of age after about 1978.

Increasingly, young lesbians are rejecting even the label lesbian; they are queer, they'll have us know and queer transcends older categories of sexual and political identity. Older defectors are also donning silicon dicks, reliving the bad old days before the women's movement in masquerade — re-enacting butch/femme identities, the perils and pleasures of sexual/social pariahism. It is an invigorating time to be alive. And the photographs that explore these mutable, fantastic possibilities seem to me infinitely exciting. They are an augmentation to the existing visual arguments about what lesbians are and can be, just as Nicaraguans' photographs of laughing children and well-fed peasants are. No one has the right to censure these evocations of what is yet to be — lesbian sexuality as present, hot and inclusive.[2] These images, so frequently scorned as pornographic or obscene, are much more complicated than such dismissals suggest. They are before anything else idealising: they attempt to fix desire as iconically as formal portraits fix identity. Where scarcity existed, they propose plenitude: tattooed women, non-thin women, women of colour, physically disabled women, butch women, femme women. And this, I would argue, can only advance everyone's agendas — from the delighted inventors of lesbian porn to the women who cancel subscriptions to OUTLOOK and threaten in print to burn On Our Backs.

THE PROBLEM OF SCARCITY

What are the usual effects of any form of scarcity? People hoard; people attribute immense value and power to whatever commodity has become or is designated as scarce. For example, diamonds are not actually scarce gemstones; it is the artificial scarcity created by the De Beers cartel that gives them their enormous metaphoric and material value.

In a similar way, subcultures that are consistently un-represented[3] deal out of a scarcity of images that does not accurately reflect either their sense of current realities or their aspirations for future ones. I can think of no other explanation for the extraordinary passion — most of it, unfortunately, splenetic and censorious — that meets any but the blandest representations of lesbians or, for that matter, gay men, blacks and other socially marginalised people.

So few representations, so many expectations: how can any image possibly satisfy the yearning that it is born into? If a sexually explicit lesbian image depicts desire in the terms of a soft-focus greeting card, a significant portion of those among whom it circulates deride its sentimentality and sexual evasion: they want something to reflect their reality. If another photograph fixes desire through signs of otherness — for example, leather and sex roles — it will be decried by women who associate desire with romantic merging. [...]

In the case of a woefully under-, un- or mis-represented subculture, however, behaviour of even one member — or one representation — carries a far greater significance, a much heavier burden. Here, there are few or no examples to provide counter-arguments for the centrality of this particular identity or behaviour. As a result, subcultures are more likely to actively police members' behaviour and representations than are dominant cultures. When was the last time you heard a lesbian (or black woman) described as 'a disgrace to her community'?

When was the last time you heard a white person described as 'a credit to his/her race'?

[...] But the current debates around lesbian porn, lesbian sexual and social representation may well become moot before long. A new generation of women whose primary sexual commitment is to members of their own sex is already rejecting the terms in which the debates have historically been couched.

Notes

[1] With the exception of Quebec, where French feminist theory held sway during the 1970's and early 1980's in

a way that it would not in Anglophone Canada and the USA until later.

[2] I don't know if this apocryphal tale is common in Britain as it is in the USA, but it is nonetheless telling: 'If you put a penny in a jar for each time a lesbian couple has sex in the first year of their relationship and then withdraw a penny for each time they have sex in subsequent years together, you will never get to the bottom of the pennies.' QED.

[3] I am indebted to Douglas Crimp for this particularly pithy phrasing of the problem.

— Jan Zita Grover, 'Framing the Questions: Positive Imaging and Scarcity in Lesbian Photographs', *Stole Glances: Lesbians Take Photographs*, eds. Tessa Boffin and Jean Fraser [Pandora Press, London, 1991] 184—90

Yvonne Rainer
'A Woman Who...' (1991)

These musings began to take shape over a year ago in a lecture called 'Narrative in the (Dis)Service of Identity: Fragments toward a performed lecture dealing with menopause, race, gender and other uneasy bedfellows in the cinematic sheets. Or: How do you begin to think of yourself as white when you've finally gotten used to thinking of yourself as an 'a-woman?'

I subsequently — a deceptively simple way to say it is: I subsequently became a lesbian, and accordingly revised both paper and title. Let me quote the revised title and beginning of the revised paper: 'Narrative in the (Dis)Service of Identity: Fragments toward a performed lecture dealing with, menopause, race, gender and other uneasy bedfellows in the cinematic sheets, Or: How do you begin to think of yourself as a lesbian — and white — when you had just about gotten used to the idea of being an "a-woman?"

'A young, white, artist-activist in New York City named Gregg Bordowitz begins a lecture on AIDS and safe sex with the words: 'I am gay; I am HIV-antibody positive; I like having sex with men.'

'Bordowitz inspires me to lay it — or something not quite like it — on the line: I am a white, menopausal lesbian, and, after many years of celibacy following decades of a heterosexual identity, I am once again — to borrow a phrase from the medical professionals — sexually active. You may well ask what prompts (what some might call) these embarrassing confessions, or why my

sexual preference or sexual activity is anyone's business. Who wants to know? Not any of you, certainly, or, if you do, I feel under no obligation to reward such prurient curiosity. And why should I even mention the words 'white' and 'menopausal' in one breath as though they might in some way be equivalent, when in fact they denote contradictory relations to social privilege, and it is blatantly obvious that I am middle-aged Caucasian? And if it is not so obvious that I am a lesbian (notwithstanding the short hair and lack of make up that in some quarters might signify 'butch'), why is it necessary to state my sexual status so baldly?

'If you know anything at all about gay culture in the United States, you can conclude quite correctly from the foregoing that I am a novice at all this, an *arriviste*, newly "come out," not from the closet, however, but from the sanctuary of heterosexuality, that hallowed site legitimated and regulated by the institutions of patriarchy, not the least of which is the family. Upon learning about my newly launched romantic attachment, a member of my family responded "It's wonderful that you're with someone, but you don't have to call yourself a lesbian." An entire history of disavowal, repression, and persecution is contained in that simple declaration. "You don't have to call yourself a lesbian."

'So what does it mean to "call yourself a lesbian" for the first time at the age of fifty-six? Outside of the usual requests on passport and bank account applications for age, gender, race, and citizenship, I never had to "call" myself anything but dancer, choreographer, filmmaker, or teacher. I can even remember a time when I didn't question the benefits I enjoyed from being young, white, and middle-class, or the disadvantages that accrued from being female. As recently as six months ago I could describe myself as engaged in struggle with the reductive nomenclature that defines desires, ie. *heterosexual*, *homosexual*, *bisexual*, believing that by mixing up the terms that position us so implacably as dominant or marginal, privileged or unprivileged, protected or endangered, I could somehow invent a new position for myself, something along the lines of a *lapsed heterosexual* or *political lesbian*, or even a utopian *a-woman*, the last derived from Monique Wittig's declaration in her 1978 essay, 'The Straight Mind,' that "Lesbians are not women." If lesbians are not women, I persuaded myself, then I too could renounce the culture-debased designation, *woman*. *A-woman* was the alternative I came up with. *A-womanly*. *A-womanliness*.

'But then, the first time I kissed my female lover on the street, I knew

I was into a whole new ball game and that my previous wordplay had been a charade keeping me from acknowledging that — however dormant my sexual drive had been — I had been living in the safe house of heterosexuality, under the illusion that I was benefiting from all the security and legitimation that such habitation could offer, and not realizing that it is a protection system that does not service everyone equally, especially women. One of the spoken house rules is that after a certain age women have to move out; you're on your own. Many of us try to pass as young in order to prolong our residency. But the day of reckoning inevitably comes.

'Following from my new sexual status, to "call myself" a lesbian is not only a statement of sexual preference, it is a way of pointing to where I — and others like me, for the same, also different, reasons — live: outside the safe house, on the edge, in the social margin. As a lesbian and aging woman, I reside in this margin. In contrast, as a Caucasian and successful artist, I reside in what Audre Lorde has called the *mythical norm*, that place in the United States usually reserved for those who are "white, thin, male, young, heterosexual, Christian, and financially secure." As you see, I am still about forty percent safe.'

In this context, if I'm going to distill out my lesbianism from those other markers of social status that comprise a heterogeneous identity, including lapsed heterosexual, political lesbian and a-woman, it might be worthwhile to start from scratch and ask, 'What is a lesbian?' If calling myself a 'political lesbian' was an attempt to declare solidarity, it was also an effort to challenge the notion of a fixed and closed sexual category. However, once my sexual life had undergone change, I was more than willing to embrace the category, come what may, to indicate my sexual preference. I welcomed and carefully noted every opportunity for formally or casually declaring my new sexual status. 'Oh yes, my girlfriend lives near there,' or 'I'll either be here or at my girlfriend's house: here's the number.' Or 'Now that I'm a lesbian....,' and so on. I've already noted the family response. Most people congratulated me on my newfound felicity, but I was amazed to learn that in some quarters lesbians would, like my family members but for different reasons, be reluctant to accord me *lesbian* status. You may be sleeping with a woman, but you're not a lesbian.

Hey! What is this? A club or something? I eat pussy just like you. Just 'cause you've been doing it longer does that make you more of a lezzy than me? Well, evidently. Unlike the term *gay man*, the word *lesbian* —

at least to some who identify as such — carries more than a sexual meaning. A man comes out, and no one questions his credentials as gay. If you're out and a man and have sex with men, then you're gay. But a woman doesn't necessarily become a lesbian by changing the gender of her sleeping companion. In those quarters you have to earn your stripes, have been on the barricades, taken shit, and certainly you must have foresworn men as sexual partners.

OK, OK. I'm not the pushy type. I'm perfectly happy with my neologisms for the time being, anyway. And I have a strong survival sense: while trying to get into the club I didn't burn my bridges; I didn't give up my identity of a-woman, lapsed heterosexual, and political lesbian. So next year I'll simply reapply. After all, my résumé does contain some impressive data — I marched in the Gay Pride Parade before ever applying for admission to the club, and some of my best friends are lesbians. As for pussy-eating, you'll have to take my word for it.

Yes, I mean to be a bit silly here; forgive me if I strike the wrong note. One thing I find unsettling is that in the gay and lesbian public sphere I am being paid attention to as a lesbian *before* doing any work that identifies me as one. It's not that I wish to preserve privacy, far from it, but as a former member of the dominant sexual category I can still see it as odd that the gender of the person one has sex with is a determining factor in public recognition. This, of course, is a view that a gay person can afford to sustain only in the best of all possible visions of a world. In the world we know, where same-sex preference is a signal for exclusion, ridicule, persecution and neglect from individuals and institutions that don't have to name their sexual bias, only point to ours, our relegation to weirdo-freak-queer marginality if we do name ourselves still demands that we exceed the bounds of polite address and scream our name. Fundamentalism and essentialism aside, I therefore call myself a lesbian, present myself as a lesbian, and represent myself as a lesbian. This is not to say that it is the last word in my self-definition. 'Lesbian' defines not only a sexual identity but also the social 'calling', or resistance, made necessary by present societal inequities. I must keep in mind that 'white' and 'aging woman,' as markers of both social privilege and social stigma, form other parts of this identity and that my status as aging lesbian, however stigmatized in daily life, is not equivalent to the experience of people of color. [...]

— Yvonne Rainer, 'A Woman Who...', lecture for the Lookout Lesbian and Gay Television Festival at Downtown Community Television, New York [13 October 1991] first published in *Queer Looks: Perspectives on Lesbian and Gay Film and Video*, eds. Martha Gever, John Greyson and Prathiba Parmar [Routledge, New York, 1993], reprinted in *Working Round the L-Word* [John Hopkins University Press, Baltimore, 1999] 110–13

Whitney Davis
'Founding the Closet: Sexuality and the Creation of Art History' (1992)

In 1992, it might appear that calls for censorship of the arts have become increasingly common. The recent efforts of authorities in Cincinnati to police Dennis Barrie's exhibition of Robert Mapplethorpe's photographs sparked a controversy that was intense in its own right and also came to stand for the larger problems facing artists, art historians, art curators, art archivists, and art librarians today. We have, of course, won some important battles. To take one notorious example, Senator Jesse Helms's proposed amendments to congressional appropriations bills would have changed the accepted way in which the National Endowment for the Arts disburses grants to artists through peer review processes standard throughout the scientific and academic world — but they were beaten back.[1]

In a war, as another recent experience has shown, it is very easy to represent the other side according to convenient stereotype and to overlook the extent of one's own hypocrisy, opportunism, or responsibility for the very situation one claims to oppose. Art scholarship is no exception. Today it finds itself fighting intervention or censorship from the outside, at the same time as it has experienced and practiced various forms of internal censorship dating from the 1750s or 1760s, when modern techniques of collecting art objects, exhibiting and cataloguing them, acquiring and storing information about them, and analysing them were formalized in what we now call art history. I have no intention of arguing here that art history's contemporary efforts to combat censorship and ensure wide access to art and the knowledge about it are totally vitiated by its own long-standing implication in techniques of policing art and art historical knowledge. (No doubt, however, there is some truth in the old saw about the mote in your brother's eye.) Instead, in this brief essay I want to notice something more complex in the particular case of art history's relationship with homosexual artists, collectors, critics, and scholars, among whom Robert Mapplethorpe must be counted. Since its beginning in the 1760s, the scholarly study of art has involved a displacement of questions of sexuality, especially homosexuality. This displacement has so profoundly affected the very methods, theories, and resources of art history that art history, over 200 years later, is not in the best position to do the job in contexts like the Cincinnati struggle. Crudely, in Cincinnati, art history was forced to lie when it should have been speaking the truth. [...]

In the fall of 1991, I cotaught a course on 'Greek Civilization in the Classical Period' as part of a regular eight-course introductory sequence dealing with 'Patterns in European Thought and Culture,' qualifying as a college-wide 'distribution requirement' in the arts and sciences. A course of this kind risks becoming a celebration of the masterworks of Western philosophy, art, and literature, especially if it adopts the sort of 'Great Books' curriculum seemingly favoured by Lynne Cheney, the chairperson of the National Endowment for the Humanities, when she calls for teaching the enduring values of Western culture through study of its great spiritual and artistic expressions[2] — a study supposedly to tell today's multi-ethnic and perhaps socially disruptive student population what brings Americans together as people with a common heritage. In other words, one cannot teach a course on ancient Greece today without landing right in the middle of the most divisive contemporary debates about national and cultural identity.

In this extremely charged context, I was determined to give two lectures — out of the eight assigned to me — on the homosocial or homosexual structure of elite male social life in classical Athens, in particular as this way of life was represented in the popular medium of vase painting. A substantial number of Greek painted vases depict scenes of homosocial relationships and homosexual courtship or sexual activity and were actually made as love gifts to be passed between men. They were related to an equally important series of vases that represent the specific roles for women in classical Greek society, in which a woman is either a gracious, dignified, but sequestered housekeeper or an amusing, pathetic whore. Rather than his wife, it was a late adolescent boy whom a mature man in Athens treated as a moral equal, albeit younger and more passive than he. According to the system, the mature man who courted an

adolescent boy had once been such a boy himself, courted by his own suitors. Thus, in the broadest terms, the homosocial and homosexual liaison functioned as a means of passing on male knowledge and status in the community of voting citizens, which was, of course, exclusively male as well. A Greek man rose up in this system by exchanging the youth's passive homosexual role, which was not supposed to provide bodily pleasure but was an accepted ritual of apprenticeship in wisdom, for the man's adult, active homosexual role, which was supposed to provide him pleasure, challenge, and relaxation and correlated with his full status as a man of affairs, of real economic, political, and sexual power. Greek vase paintings represent aspects of this complex sociocultural system in finely nuanced detail.

I had three reasons to present this material. First, it is obvious that the homosocial or homosexual culture of Greece, in its broad sense, was central to the fashioning of Greek literature, art, philosophy, and the rest. This fact has been evident for as long as classical scholarship and archaeology have existed, although, as we will see, with major qualifications. Second, I was interested in having my students challenge the rather sanitized, if not downright inaccurate, accounts propounded by various proponents of 'our Western heritage.' Lynne Cheney wants students to study Socrates; and why not? I thought. Socrates was surrounded with pretty boys; the dialogues, as narrated by Plato and others, are partly just fancy versions of the intellectual cultivation, the ostentation, contest, and romance, and the idealization of the merely sexual into the broadly ethical that characterized Greek male courtships. Certainly most of the standard textbooks of the history of art do not address the issue, despite the great importance that studies of gender and sexuality have come to have in art history generally and the obvious presence of an erotically meaningful representation of the male body in classical art. And third, I have been an 'out' gay teacher for a number of years; I know that students come to some of my classes to learn about things they will not hear mentioned elsewhere.

My reasons for deciding what I wanted and needed to teach were good and my motivation was strong. But pulling the two lectures together — I only had three hours in all — to do barest justice to the material was nearly impossible. When I turned to it, I discovered that our slide collection had only a few reproductions of vase paintings which had any direct bearing on my topic. The gap in our slide library was not to be blamed on its curator but

rather on my forerunners in the faculty of my department. Although they were art historians actively teaching ancient art, apparently they saw no need, or, more likely, did not have the resources, to deal with this, one of the three or four most focal aspects of the whole story.

No problem, I thought; it would be easy enough to have slides made. [...] But the elementary job of collecting the images turned out to be no small chore. One might think that a teacher could go over to the art library, pluck a monograph or two from the shelves, hike them over to the studio, and have some slides shot. In fact, however, there is only one monograph in English on homosexuality in Greek art (Dover's pioneering *Greek Homosexuality*) and only a small handful of monographs, such as Keul's *Reign of the Phallus*, which, in the

course of more wide-ranging studies, cover the topic in any detail.[3] Although the subject is addressed in other places, they are not accessible through the subject headings for Greek art or for homosexuality in the Library of Congress or Dewey classification systems. ('Sodomy,' 'pederasty,' and similar headings will sometimes reveal other sources, depending on the library's holdings.) One might have some luck with other possibilities. For example, pursuing the many disparate, and often rather out-of-the-way, books classified under the subject heading 'erotic art' will ultimately yield such useful essays as Otto Brendel's conceptualization of different types of ancient erotic art, where the topic at hand is briefly considered;[4] but the issue of homosocial and homosexual meanings in Greek art should not really be

The Lesbian Avengers, *Dyke Manifesto*, 1993

reduced to a question of merely sexual or even more broadly erotic representation, at least as that has traditionally been defined by Western collectors and historians. Just as one would not think to limit an inquiry into the way women have been conceived in Western art — as objects of representation and as subjects making and observing representations — to erotic or pornographic images of women, so one cannot limit the study of Greek homosocial masculinity to ancient sexual images of men. [...]

There is no doubt that Dover's book changed the data base and, just as important, our access to it, practically overnight; all subsequent writers owe a tremendous debt to it. But by the standards of scholarly publication within art history, *Greek Homosexuality* (not written primarily as a work of visual reference or an art historical analysis) rates a 'B' at best. The photos are small and cropped and frequently do not show all the images on a vase but only the ones Dover selected according to his own criteria. [...] One really should go back to the original publications Dover worked from, themselves very partial, or to museum collections, where it is often possible to run into further trouble (the sequestering of erotic vases in some kind of 'X' collection was once a common practice, and even now, when such objects are displayed, the euphemistic labelling can be highly misleading). In the end, having limited time and resources at my disposal, I compromised and worked up my slide lectures from Dover's pictures, knowing all along that subsequent classical scholarship had already come up with different, sometimes more encompassing or subtle accounts of the materials. I venture to say that something like this is the absolutely standard experience for any scholar teaching, or just touching on, lesbian and gay art history in the modern West or on the history of same-sex sexuality in the visual arts in other cultures.

It would be easy to see this general phenomenon as the obvious, inevitable result of systematic long-standing homophobia in the academy and of myriad outside disincentives that have kept comprehensive projects for collecting resources from ever getting off the ground. [...] But the irony is that there has really been very little need for outsiders to shove art history back into the closet, as it were, whenever it threatens to 'come out', because art history already is *in* the closet. Indeed, at a fundamental level, art history was invented and its resources collected, exhibited, and interpreted *as* a closet, that is, as art historians' practical and to some extent necessary way of avoiding painful social conflicts and wrenching

personal questions by transposing the direct subjective expression of same-sex erotics into substitutes formalized by the disciplinary discourse of art history into a vast, but peculiarly sterile and arid, framework of supposedly objective interests. Same-sex sexuality and history precisely fails to be one of the objective interests of art historians, informing their collecting, research, and writing about people in the past, precisely because its *subjective* reality, for them, is continually being denied. Again, speaking out of personal experience, this displacement leads to the curious unreality of supposedly objective scholarship in art history, the weird feeling I had in college, graduate school, and still today of being surrounded by lesbian and gay artists, scholars, librarians, and students with basically zero explicit engagement with the fact. Evidently art history still functions as a successful closet. Exactly why, I am not fully sure, for it is impossible to know all the details of the many ways in which lesbian and gay students or scholars have chosen, or been forced, to shape their sexual and professional identities. The general situation, moreover, is rapidly changing, so that in a few years I hope my experience will be dated; but features of its *historical* emergence can be partially identified. To the extent that art history today is a product of its own history, how could it not be, considering its dependence on great collections, libraries, archives, and photograph or slide collections founded many years ago? The earliest stages in the development of art history are worth recalling.

Although there are important roots for modern art history in the archaeology and antiquarianism of the Renaissance, for my purposes the main episode to consider is the crafting of what is generally accepted as the first true history of art, Winckelmann's *History of Ancient Art*, first published in Dresden in 1764.[5] Winckelmann is an enigmatic figure. Serious study of his achievement is hampered by the very closeting of essential resources I have already identified. Intimate letters detailing his erotic interests and sexual escapades, for example, still remain partly untranslated. Winckelmann's same-sex erotics were recognized by his acutest commentator, Goethe, to motivate much of his conceptual labor;[6] but what those erotics actually involved remains uncertain, although we have at least one possibly reliable document in Casanova's report of discovering Winckelmann relaxing with one of the young Roman castrati he favoured, as well as Winckelmann's own testimonies to his infatuations with noble German boys he was hired to tutor or guide. [...]

It is safe to suppose that Winckelmann, both socially and personally defined as a sodomite interested in sexual activity with others of his own sex, participated in the sodomitical subculture of his day, a subculture that revolved, like some 20th-century urban homosexual subcultures, around certain cafes, theatres, and drinking establishments, as well as open-air strolling in various quarters of the city and suburbs. It is entirely relevant to remember that one of Winckelmann's chief employments as papal antiquarian was to guide British, German, and other northern gentlemen on their tour through the ruins of Rome, an activity that by the late 18th century already clearly signified, at least for many participants, the availability of sex with local working boys, liaisons that tended to be frustrated or proscribed in the Anglo-German states. That Winckelmann's apartment in Rome was graced with a bust of a faun, which he published and described in his treatise, was not, then, merely a manifestation of his antiquarian scholarship in the questions of Greco-Roman art history. It also was fully consistent with, and probably functioned partly as, his self-definition and representation in the contemporary subculture to which he belonged. [...]

Winckelmann's *History* has to be read carefully to identify his strange separation between the known meaning of ancient Greek sculptures, revolving partly around the sexualized cult of masculinity noted earlier, and the history of Greek style. Essentially, Winckelmann focused his attention, and that of the entire tradition of art history which inherits its twinned methods of 'formalism' and 'historicism' from him, on the *form* of Greek art and on the facts of technique, use, and the like, going all the way back to such factors as climate, which he deemed to be relevant to explaining form historically. But major aspects of the art's *content*, its frequent depiction of or allusion to the social practices of ancient Greek masculinity, homosociality, and homosexuality, were not usually acknowledged. When meaning absolutely *had* to be addressed in the formal or historical analysis, Winckelmann employed an elaborate euphemism. For him, Greek art is formally about and historically depends on 'freedom,' although the freedom to be or to do exactly what is left somewhat undefined. [...]

At points, Winckelmann's understanding of the freedom of Greek art does shine forth, but always in code. For example, the naturalistic beauty of a Greek statue came, for Winckelmann, from the Greek sculptors' close observation of inherently beautiful boys naked in the gymnasium. But exactly why the boys are inherently beautiful is not represented

as a personal attitude of the historian-observer, which it must be; instead, it is said to result from the favourable Greek climate and social context of training men for war, factors which must somehow determine particular forms of beauty or of art. In general, throughout Winckelmann's writing on the history of art, as opposed, in some cases, to his more philosophical meditations on questions of aesthetics, such objective historicist explanation overrides the subjective aesthetic, political-sexual response that motivated it in the first place.

An alert reading can catch Winckelmann's contradictions in his systematic transposition of subjective personal erotics and politics into objectivizing formalist and historicist analysis. One striking contradiction creeps in almost as if he could not help it. According to the explicit standards of Winckelmann's analysis, the Hellenistic hermaphrodites, let alone the Roman portraits of Hadrian's young lover Antinous, were contemporary with the total decline of general freedom in Greece and thus could not embody the essence of Greek art. But Winckelmann nonetheless cites them as great Classical works: which just goes to show that the real denotation of freedom, for Winckelmann, is not, or not only, in civic politics at all but rather in species of social-sexual license possible in a monarchic or imperial society as much as in a democratic one. [...] What archaic Greece supposedly lacked, of course, was political freedom; but if Winckelmann is willing to admit the unfree, if Hellenized, art of Hadrianic Rome or Justinian's Ravenna as producing great classicism, on what grounds can he exclude the 6th-century *kouroi*, the remarkable but frequently unnaturalistic standing statues of naked youths? [...]

A reader of Winckelmann's book can be forgiven for not being able to work out these tangles even though they have interested historians today; the general point is that the *History of Ancient Art* largely manages the erotic — the wish for and memory of what is subjectively witnessed as beautiful and desirable in sexual, political, and ethical terms — almost entirely off stage.

'Off stage', that is, from the point of view of the reader. From the point of view of Winckelmann, however, it is possible that he was having things both ways. Exploring his sexual and ethical attractions, actively filling them out with images, information, and a social and historical reality, both through and in the very doing of his research, he finally transposes them all into another narrative for others. [...] Art history is a *discipline*, as has been pointed out many times; but what it disciplines are not the

facts of art history, or only secondarily the facts of art history. What it primarily and inaugurally disciplines is itself.

We can readily fault Jesse Helms for trying to censor art and its exhibition, publication, and discussion, for the external intervention in the disciplines of art history, curatorship, or archiving. But I do not blame art historians for the internal closeting I have been indicating here. Winckelmann's complex personal and textual self-discipline is not exactly the same thing as social censorship, especially if it is undertaken, as might have been or still be the case, to avoid or survive an external, imposed censorship or suppression. And I do not just mean to refer to the historical suppression of homoeroticism, pederasty, and sodomy or, latterly, of homosexuality. The repressions requiring the self-discipline or self-censorship of art history include much broader, more diffuse attempts to contain human variety and its multiple ways of immediately engaging the world. At what might be the most general level of all, art history has consistently sited visual meaning in the fully abstract, derealized domains of optics and of signs and the salient historical context of this meaning in the domain of articulated, rationally managed disputes about ideas in institutional policies and in wider social affairs. Optics, signs, and historical contexts so defined are, of course, objectively describable using one or another of the many scientific, or, more properly, scientistic, techniques of art theory, semiology, or sociology; but in each case, to carry out the objective analysis, one must be transported, or transposed, out of the actual bodily and mental realities involved, namely, for optics, looking; for signs, sense; and for social context, subjectivity. And as the examples of Winckelmann and Mapplethorpe show, this transposition is not a full translation of the erotically interesting into the objectively known; certain realities drop out.

One of the ironies of Dennis Barrie's trial in Cincinnati, for me, was the argument, successful, it turned out, of the curators and scholars. In reviewing the transcripts, one finds that Barrie's defenders said very little about the content or meaning of Mapplethorpe's 'X' pictures, about B&D and the leather world, rubber, or water sports, and Mapplethorpe's intriguing, problematic images as particular historical versions of the affective or aesthetic realities of those worlds.[7] Their argument was, as it were, *falsely* affective and aesthetic: they went on about the striking compositions, superb lighting, and general formal beauty of the photos, and about Mapplethorpe's historical place in the

development of modern photography. The jury, of course, was reassured to hear this voice from the closet, for it actually implied that the images are more closeted, less disruptive, than they really are — art, not representation, beauty, not freedom. In this particular case, the closet did the job against censorship without needing to put into evidence anything other than tried-and-true aesthetic and art historical banalities it could parade in hundreds of other situations as well. But one wonders how long this device is going to work before outsiders see it for the deflection and euphemism the historians already know it to be.

Notes

[1] After this paper was delivered, the situation changed for the worse. Reports have circulated that the peer review process has been compromised, prompting the president of the College Art Association, Larry Silver, to complain to the acting chairperson of the National Endowment for the Arts (see the CAA *Newsletter*, May 1992). As is widely known, the previous chairperson, John Frohnmayer, was forced out of his job when the administration caved in to pressure from the far-right wing of the Republican party.

[2] See Lynne Cheney, *Humanities in America: A Report to the President, the Congress, and the American People* (Washington, D.C.: National Endowment for the Humanities, 1988); see also Lynne Cheney, et al, *50 Hours: A Core Curriculum for College Students* (Washington, D.C.: National Endowment for the Humanities, 1989).

[3] Kenneth Dover, *Greek Homosexuality* (Cambridge, Mass: Harvard University Press, 1978); Keuls, *The Reign of Phallus*.

[4] Otto Brendel, 'The Scope and Temperament of Erotic Art in the Greco-Roman World', in *Studies in Erotic Art*, eds. Theodore Bowie and C. V. Christenson (New York: Basic Books, 1970), 3–69.

[5] The only English translation, by G. H. Lodge (4 vols, Boston: Little, Brown, 1880), is unsatisfactory in several respects; a new rendition is long overdue.

[6] J.W. von Goethe, *Winckelmann und sein Jahrhundert in Briefen und Aufsatzen*, ed. H. Holtzhauer (Leipzig: Seeman Verlag, 1969). Although there have been numerous subtle studies of Winckelmann's art historical writing and aesthetic theory, only a handful have attempted to integrate them with an account of his sexuality.

[7] It is well worth reading these transcripts in comparison with Goethe's reflections on the life, work, ethics, and eroticism, of Winckelmann (see above, note 6). In both cases, although the commentators know something about the reality of the artist's or the writer's interests, they do not directly name them. Actually, to be fair, Goethe was more honest than some of Mapplethorpe's defenders.

— Whitney Davis, 'Founding the Closet: Sexuality and the Creation of Art History', *Art Documentation* [Art Libraries Society of North America, 1992] 171–75

Robert Blanchon '[never realized]: 4 opportunistic infections for public viewing and consumption' (1993)

There are four major iconographic representations of people with HIV — evidence that the campaign to place a face on 'AIDS' (personalizing a plague) — is short of worthwhile and probably dangerous.

First, and most common, is the portrait of a decaying, bedridden, presumably queer white man in his 30s or 40s. This rendering, although incongruent with efforts to illustrate how a super smart, gene mimicking virus affects all demographics, remains real and popular. It's a problematic portrayal for two reasons. On one hand, it fuels those using this plague for ideological and political power, like the plethora of family value groups sprouting out across the nation on the graves of dead queers. On the other hand, it is still a significant rendering for those who are queer, of all ethnicity and genders, who, while watching each other die, have been screaming about the kindness of HIV not to discriminate. [...]

Second is the overplayed and subsequently confused victim. Embodied in personalities like the late Kimberly Bergelis and African-American children whose parents are junkies (and considered the weakest fiber in the great fabric of this nation), the victim identity came into existence when heterosexuals contracted HIV during the initial years of the plague, unsuccessfully blurring the lines between queers and regular folks. Whether a blood transfusion, an infected parent, or a pathologically psychotic dentist, these early victims were presented with innocence and pity. Simply put, those exposed to HIV via sex or drug works are responsible for their own destruction. [...]

THE WORLD IS GETTING EMPTY OF EVERYONE I KNOW ONE BY ONE IN EVERY DIRECTION THEY ARE LEAVING THIS WORLD FOR SOME PEOPLE EVERYONE THEY KNOW HAS DIED

JOHN GIORNO for VISUAL AIDS • NEW YORK • DAY WITHOUT ART • 1993
Funded in part by the Lannan Foundation and the Andy Warhol Foundation for the Visual Arts Inc. © 1993 John Giorno

John Giorno for *Visual AIDS / Day Without Art*, 1993

The third identity is the celebrity. Some are dead — Liberace, Rock Hudson, and supermodel Gia. Some are living — Magic Johnson. Either way, the HIV community, as diverse as it may be, invested in famous people with the disease to raise Society's consciousness — to ring a bell loudly and wake up those in the deep sleep of plague denial. Here the problem is the interpretation. It's not denial. It's rejection — something one doesn't wake up from involuntarily. Like all attempts to personalize the plague, the Magic Johnsons of the world are unlikely to change the destination of those sick for reasons of simple economic exclusion and social expulsion. No one related to Rock Hudson when he was a drop-dead handsome heterosexual celebrity because no one relates to movie stars. [...]

Fourth, the last and most complicated representation of

someone living with HIV, is the lunatic or deviant. Not easy to define since this person is part queer, part drug user, part sex-worker, and mostly anti-American, among other attributes. This person is the victim of society's collective avoidance of anyone down and out, or different. Down because the kindness of America is a charade, and out by either personal choice or the exclusion of others. The truth about sex-workers being more likely to use a condom than most college students has little impact on the contagious carrier image they must endure. Of course, being queer, a woman, drug-user or anything but white is a slap in the face of the now-defunct American dream. Rejected and ignored, those carrying this amazingly intelligent, top-notch virus may feel inclined to disregard ethically enlightened behaviour:

I have HIV running throughout every gene in my body and I still enjoy sex. I host a deadly virus that has confused even the brightest of minds in bio-medical research and I still use drugs and have sex. I have children. I question your motives and politics. I infect others out of the despair you created. I have HIV and you ignored me. This is a problem. I can kill you.

For over a decade, people with or affected by HIV have devoted a great deal of time to personalizing this plague and the language surrounding its subscription yet never actually describing the disease physically. This may prove to be a grave mistake and waste of time. We now have access to images of all kinds of people with HIV. With good intentions, activists, artists, writers, and community leaders have presented the faces of everyone with HIV to our society in a variety of cultural venues. The results have been less than anticipated. After all these years, if you didn't care enough by now, you never will.

With these thoughts in mind, I am overwhelmed with a desire to depersonalize HIV and offer physical proof of the plague that will not fall prey to the embedded biases of our world.

I once conceived a public art project for New York City as a means to end the cyclical madness I've described. Certainly most have seen the graphic portrayal of HIV at work, or two-dimensional posters calling people to action. One can even find graphically pleasing, desk-top produced billboards on safe sex. There are not, however, popular pictures I can recall that illustrate, without exploiting people sick, what HIV is and what it can do.

Since this plague is a disease comprised of symptoms, this project, entitled *4 opportunistic infections for public viewing and consumption*, consists of sculptural vessels where infections are hosted by those with minimized immune systems. The vessels are an attempt to replace the four representations we have with a new visual vocabulary that accurately depicts what we physically have, had, or may have. In sharp contrast to the two-dimensional stickers and posters found in urban environments, this project aims to elevate the physiological aspects of HIV to a level of reality that represents the pain, loss, and massive suffering caused by this plague.

Initially, the project required the production of 40,000 stark white, actual size, plastic multiples of four inner parts of the body: 10,000 brains, 10,000 spines, 10,000 lung chambers, and 10,000 tongues

resting on jaw bones. Distribution, romantic at best, never realized at worst, required giving one body part multiple to one person sick, accompanied by an invitation with a date and time to throw the casting out one's window. Like rain, the falling body parts would shower the streets with the reality of this disease. If you weren't hit over the head, or throwing one yourself, you might find a lung chamber on your doorstep. Picking up the lung, one would find engraved text reading: 'This lung represents one of 40,000 New Yorkers under consideration for PCP, a deadly pneumonia related to HIV, as well as a variety of other infections. The brain, tongue, and spine had different engravings listing possible host infections.

4 opportunistic infections replaces the faces with universal anatomy, insisting that HIV be viewed outside of cultural, personal, and political identity. After years of substantial proof that this virgin cyberspace virus attacks everybody, the physiological portrait is the only one that won't submit to discrimination. Furthermore, these representations are capable of transcending the inequities of us and them, sick and healthy, good-looking and not-so-good-looking, negative and positive, by presenting imagery with which all can relate.

There will be another 20 or more thousand new cases of HIV illness in New York City over the next two years. It is believed that somewhere between 500,000 and 1,000,000 are infected. Since it's simply a matter of quantity, these numbers, however dumbfounding they may appear, pose no threat to the project's implementation.

The deterrent is the inevitable passage of time.

— Robert Blanchon, *[never realized:] 4 opportunistic infections for public viewing and consumption* [1993], self-published [1996], reprinted in *Robert Blanchon*, eds. Tania Duvergne and Amy Sadao [Visual AIDS, New York, 2003] 109—115

Liz Kotz
'Erotics of the Image' (1994)

[…] What would it mean to consider lesbian visual production as not necessarily anchored in a notion of the authentic lesbian subject, the authentic female body? What would that look like? And would such choices really doom lesbian artists to complete cultural invisibility? Perhaps we should also consider what

covert prescriptions may lurk behind certain liberationist claims for lesbian visibility. Is sexual and bodily representation in lesbian art really so direct and unproblematic? And must all 'lesbian art' now be about the body, and the female body at that?

I want to consider what counts as 'lesbian' in the visual field, through looking at work that involves a kind of libidinal displacement — one that the conceptual artist Lutz Bacher has termed 'the erotics of the surrogate image.' At times, this surrogacy may take the form of imaging male bodies — male bodies that sometimes, I will argue, function as substitutes or stand-ins for the female. We may be all too familiar with representations of the female body that, ultimately, speak male longing, anxiety and desire, but we are less used to the reverse: a male body that speaks female fears and desires, particularly lesbian ones. Yet such is the case in Monica Majoli's series of gay male S/M scenes, painted in 1990 and 1991.

These small canvases — the originals are about 12" × 12" — look like Renaissance devotional paintings. Majoli tells us that they were made in dialogue with a gay male friend: he told her stories, which she then translated into highly-orchestrated tableaux.[1] These canvases could be seen as a rather morbid project of subcultural documentation: lesbian artist recording gay male friend's sexual adventures, presumably in the past tense. And in their darkness and melancholy, they are indeed works which are in some sense 'about' AIDS, about disappearing gay lives and gay ways of life. So we can read them as memorials: painting, as many have noted, often carries the task of mourning.[2]

But seeing them only as memorials effectively erases Majoli, the lesbian artist, and her desires. What is her relation to these men? In a recent article in *Art Issues*, the LA-based writer Susan Kandel has suggested that by masking her lesbian identity under the guise of the gay male figure, Majoli performs a kind of inauthenticity. Kandel suggests: 'Majoli's glowing images take an unexpected turn. They proclaim *eros* as transcendence, but evince little joy. They are dark, tightly wound, strangely suffocating. Perhaps this is because the paintings also camouflage Majoli's own lesbian desires. This she mimes in a masculine mode.[3]

Kandel goes on to suggest the dangers of such miming: the loss of identity, the collapse of the body into its surroundings. And clearly there is a way in which a lesbian artist appearing to image gay male desire does risk a certain loss of identity — a particularly acute risk given the lure of being taken up in the circuits of gay male art collecting and

exhibiting. Doesn't this just repeat the position of the woman exchanged between two men — a new kind of heterosexuality re-enacted among the literally homosexual?

Yet is that what is really going on here? Look at the bodies: many of the male figures are oddly feminized; some have curiously soft torsos, suggesting feminine contours. If Michelangelo painted his female figures simply by rendering men with breasts, Majoli seems almost to do the reverse. Tight, obsessive, and technically masterful, the small canvases evoke a sense of forbidden obsessions, and a world in which the painter herself is completely absent. But is she? Majoli has stated that the stories resonated with her because 'what these men were doing was how I had sometimes felt with women, that sense of erotic torture, of suffocation.' Besides offering psychic substitutes for her own lived sense of masochism, the men also represented figures of *desire* for Majoli — 'working on the paintings was a way to work out my feelings about men, about the male body — as well as a locus of *identification*: 'I am that man in the bathtub. He is me.'

What would Majoli's lesbian sex paintings look like? The example Kandel prefers, of two women on a bed, acting out fellatio with a dildo, is one option. Yet this image doesn't quite work for me — it seems too literal, too direct in its presentation of lesbian sex. Where I find Majoli's lesbian desires most powerfully imaged is in her series of body fragment self-portraits: luminous erotic paintings where the sexual merges, as it so often does, with narcissism. The image of a scratched and bleeding wrist, the first of the series, came to Majoli accidentally after a cat scratch. The painting probes the ambiguity of the marks: are they sexual wounds, stigmata, the results of a half-hearted suicide attempt? In each image, there is a nagging sense of abjection alongside the beauty.

Perhaps wary of highly romanticized representations of lesbian desire, Majoli works through the fragment — a structure of fetishism, to be sure, but one that can also register as violence or dismemberment. Yet what is 'sex' here becomes more enigmatic, rather than localized in certain acts, certain parts of the body, a clearly depicted narrative or scene, it seems diffused along the body. In other paintings, the images of skin are so close up they become abstract: through them Majoli explores the ambiguity of bodily representations, the indeterminacy of meanings, the projections of the viewer.

Majoli's use of the male body as surrogate is echoed in a series of recent projects by another Los Angeles-based artist, Amy Adler.

Adler's photographs use appropriated images, but she submits them to an intermediary stage as drawings, introducing a highly personalized third term between photographic 'original' and 'copy'. In *After Sherrie Levine* (1994), Adler presents a large charcoal drawing of one of Levine's *Untitled (After Edward Weston)* photographs. The image (originally of Weston's son Neil) is of a young male torso shot from the chest down; Adler subsequently photographed the drawing, producing a series of small (8 x 10) prints. There's something uncanny about the doubled-back nature of this process: making a drawing derived from a photograph, and then photographing it. Something muffled and disguised, which speaks, indirectly, about the suppressed erotics of the image: a nubile young body posed for our pleasure, a transaction between father and son, artist and viewer, original and copy.

Adler's own 'copy' is congruously distanced, displaced, and very, very intimate. By physically handling, touching, meticulously drawing the boy's body, she puts herself in a more proximate relation to him. Is she the nubile young figure, the object of potentially incestuous desire? Or the onlooker, masking lust under the alibi of Art? *After Sherrie Levine* hinges on photography's capacity to distance these positions and make them slippery, reversible. Yet the return to drawing re-emphasizes the image's sexual side, desublimating an erotics that has been persistently repressed in critical readings of Levin's work. This relation between the artist and her borrowed image, Levine has insisted, is not merely a critique of male authorship, but a displaced erotics that must be mediated through a third term: 'My work is so much about desire and its triangular nature. Desire is always mediated through someone else's desire.'[4] [...]

Catherine Opie's work presents a different project, one that also uses photography to get at some of the destabilizing vicissitudes of sex and gender. Last year Opie exhibited her series 'Being and Having' in New York: 24 color portraits of young women dressed up as male street toughs, engaged in a sometimes convincing, sometimes utterly arthritical, form of cross-gender drag. Subsequently, she turned to other, perhaps more serious forms of sexual self-fashioning. Women she knew, long-time friends from the leather community in San Francisco, were taking hormones and turning into 'men', choosing to live in the world as men whether or not they had actually undergone surgery — most hadn't. The artist wasn't sure how she felt about this: is it an escape from oppression or a betrayal when lesbians 'become' men?

She wanted to honor her friendships and her community, yet also explore this ambivalent terrain.

A series of portraits ensued, mostly taken in the San Francisco gay and leather communities. What is intriguing and unsettling about the images is that they don't tell you exactly what you're seeing. In both *Mike and Sky* (1993), there is nothing to announce that these are pictures of lesbians taking male hormones; there is a suggested swelling of the shirt, but nothing more. So the viewer is left in a certain ambiguity, one which gets lost in the speedy 'rush to the signified' that animates many critical readings — making the photographs 'about' female transsexuals, S/M, the leather community etc. Where such unease or ambiguity is diminished, as in the portraits of tattooed and pierced subjects and subcultural celebrities, the pictures become more pedestrian; without the capacity to disturb and unsettle, they verge closer to fashion photography, albeit in a subcultural vein.

Two images of the most recent work strike me as most challenging, most difficult. One is a self-portrait called *Cutting* (1993): a happy domestic scene, two stick-figure girls holding hands in front of a house, a scene cut by a friend into the artist's back. It is not an easy image to look at, but one can relate to the inseparability of pain and longing, transcendent pleasure and presence, it embodies: this is writing on the body in its most literal sense. [...]

What provisional generalizations could we make about these artists' quite heterogeneous work — and perhaps that of some other lesbian artists as well? It's very engaged with sexuality, but often in a distanced form, no longer localized in gender or specific sexual identities: it's sex as diffused along the body and the skin, for instance, or as read across other scenes — heterosexual or gay male. It's aggressive, sometimes violent, and unwilling to anchor these images within the terms of an explicitly-articulated 'critique'; there's no text, no artist's statement, and a refusal to read and hence 'frame' these images for the viewer. And in addition, it's work engaging with the repressed, sensual side of artmaking, whether taking up painting as the ultimate 'bad object', or leaving aside activist traditions of photo-text to turn to sumptuous formalist photography. It's also work that's very invested in male lineages of art.

Linking these projects, however disparate, is the refusal of a set of framing strategies that predominated in much 1980s feminist art. Re-emphasizing the indeterminacy of the image — where the viewer doesn't know exactly what she or he is seeing, or what it means —

seems key to reopening the circuits of libidinal investment in and around the image. Of course, critics might argue that by abandoning the kind of contestatory voice that implicitly addresses the straight male viewer, and by paradoxically adopting the male body as psychic substitute and problematic site of desire, these artists disguise and disperse their own lesbian subjectivities. Yet in so doing, their work refuses a kind of containment and reduction; there's always something a little seamy, twisted or abject to remove them from a more direct, celebratory project of mainstream identity politics. If lesbian desire in this work is mostly subliminal, it is not unreadable. [...]

Notes

1 Discussion with the artist, June, 1991, and subsequent.

2 As Yves-Alain Bois has suggested, the real object of painting's mourning may be the passing of its own historical possibility, see his 'Painting: the Task of Mourning,' in Painting as Model, [Cambridge, NUT Press, 1990].

3 Susan Kandel, 'Of Mimicry and Woman,' Art Issues, January/February, 1994, p23.

4 See Jeanne Siegel's interview with Levine, 'After Sherrie Levine,' published in Arts Magazine, June, 1985, reprinted in Art Talk: The Early 80s, ed. Jeanne Sigel [New York: Da Copo Press, 1988], 248.

— Liz Kotz, 'Erotics of the Image', Artpapers, vol. 18, no. 6 [November—December 1994] 16—20

Juan Vicente Aliaga 'A Land of Silence: Political, Cultural and Artistic Responses to AIDS in Spain' (1997)

[...] Not until 1987 were practical measures taken to encourage gay men to stop seeing AIDS as an anti-homosexual phenomenon and to regard it as a serious, but preventable, risk. Contributing factors to the slowness of this move include: the scant consciousness of a gay identity among Spanish homosexuals; the dispersal of any gay activism that did exist throughout multiple regions and nationalities; an overall lack of activist coordination; the wear and tear of personality clashes; the

eagerness of some gay leaders to land the starring role; and the counterproductive creation of rival factions in the gay community. Linked to this is the false sense of complete freedom, accompanied by political apathy, of so many gay men, who felt immune from harm within the security of the gay commercial scene.

Thus did the celebrated 'tolerance' of Spanish society have paradoxically damaging results. Tolerance is not the same as accepting the full facts of gayness. Tolerance can in fact exacerbate gay invisibility, under the guise of protecting privacy. In countries like the US and Great Britain where anti-gay laws have been more explicit and, at times, brutal, gays and lesbians have fought hard to defend their visibility and identities. In relation to AIDS, tolerance masquerades as acceptance. The renowned poet, Jaime Gil de Biedma, whose homosexuality was known by his relatives, as well as by readers who could read between the lines, kept his AIDS condition silent right up until his death in 1990. According to the writer Ana Maria Moix, 'Perhaps he did not make it public because his mother, for whom he had an enormous amount of affection and respect, was still alive. But I believe that he was simply ashamed of disease, not because it was AIDS. He would have done the same had it been cancer. I remember him saying, "I really go to the dogs when I'm sick, I don't want to see anyone or anyone to see me."'1

The apparent inability of drug addicts to organize politically or socially, along with the disillusionment of the heterosexual population, added to this political paralysis. There had been a deafening silence around AIDS for many years, and from silence springs lethal consequences. Fearful of abuse and stigma, homosexuals seemed intent on fleeing reality. For many people, contracting HIV meant chaos and confusion, in which their very lives and lifestyles were suspect.

The first Anti-AIDS Citizens' Committees emerged in 1984. Despite their misguided activities in the early 1980's, we should not ignore their efforts. Made up of gays, lesbians and heterosexuals, the Anti-AIDS Citizens' Committees were legally recognized in 1986, and were to initiate a series of campaigns with the message that AIDS is of concern to everyone, a similar message to those found in advertisements from the Ministry of Health.

Trailing initiatives from other Western countries, the Ministry of Health conceived its first prevention campaign in 1987. Brief TV 'spots' showed little dolls and grotesque puppets which, jumping around and emitting infantile sounds, explained what caused AIDs, and what did not:

the play on words between the name of the syndrome (SIDA) and the two syllables uttered with little shrieks — Si da (it strikes), No da (it doesn't strike) — bordered on the ridiculous. The next institutional campaigns emphasized the general implications of the disease. Up until 1 December 1995 only one campaign provoked an outcry. This was an ad which promoted the use of the condom with the endearing double imperative, 'Póntelo, pónselo' (Put it on yourself, put it on him). In the foreground was a rolled condom underneath an array of sexually transmitted diseases including gonorrhoea, condylomas, and AIDS. The Episcopal Confederation reacted violently, demanding legal action, arguing that the promotion of latex encouraged sexual contact.

As I have already noted, not a single governmental campaign has ever targeted injecting drug users. The small-scale, under-funded campaigns of the Basque authorities directed at injecting drug users only underline the paucity of prevention efforts nationwide.

Overall, the Ministry of Health's campaigns have been scant on explanations, pusillanimous with direct language, and directed at a general population which is, by implication, heterosexual. Within this context we must ask, what representations of AIDS has Spain generated since the 1980's? Until 1985, when the anthropologist Alberto Cardin announced that he was HIV-positive, the silence about AIDS was practically absolute among the Spanish intelligentsia. Cardin, one of Spain's very few openly gay theoreticians, published two texts. The first bore the ominous title, SIDA: Maldición biblica o enfermedad letal? (AIDS: Biblical curse or lethal disease?, 1985); the second was entitled Enfoques alternatives (AIDS: Alternative Views, 1991). In the prologue to the second book, having attacked the supposed expertise of the medical profession, Cardin addresses homosexuals, for whom the transition from a cult of the body as an instrument of pure pleasure, to a new conception of a body in pain and in need of care could be problematic.[2] Aside from Cardin, who was relatively neglected during his lifetime, the impoverished bibliography on AIDS in Spain is shocking. A 1990 article by Vicente Molina Foix documented the large literature generated by AIDS in the Anglo-Saxon and French worlds, and the limited literary response to the epidemic in Spanish. What are the reasons for this critical vacuum? The fragile status and tradition of the Spanish essay? The perception of AIDS as an individual problem? The fear of associating oneself with such a loaded subject?

Pepe Espaliu, an artist from Córdoba, broke the silence once more

with his *Carrying Project*. In 1992 the artist was carried through the streets of San Sebastián and Madrid by successive pairs of supports who linked hands beneath him.[3] The transportation of the AIDS-stricken artist became a metaphor for solidarity with the sick, clearly showing that human contact with an AIDS suffered was not synonymous with danger. Making the symbolic gesture of showing his sores, just as Joseph Beuys had done in *Zeige deine Wunde* (Show Your Sores, 1976), Espaliu highlighted the social dimension of art, fleeing the formalist self-absorption which informs so much contemporary culture. In Madrid his route traversed Parliament and the Reina Sofia Museum, figuratively linking politics with aesthetics.

The success of Espaliu's work can be seen in the many variations of the carrying that were subsequently orchestrated by people outside the art world. For example, carrying performed by groups of people with AIDS in Barcelona circled the city's male 'model prison' where so many people with AIDS were incarcerated. In conjunction with a performance in Pamplona, Espaliu manufactured pieces of iron, inspired by the discovery of photographs of sedan chairs which had been used by members of the eighteenth-century Spanish nobility. Espaliu's sedan chairs were at once funeral urn, sealed boxes, protective armour, and psychic shelter. They convey the paradoxical lives of people with AIDS. Forced into hiding from fear of attack and discrimination, the crudeness of the sick body may have offered a *via meditation* through which to consider, free of theatricality, carnivalesque, and mock repentance, the foundations of human relations, and even a more serene vision of existence. The power of Espaliu's late works lies in its reconciliation of the pleasures of extreme sado-masochistic sexuality with the knowledge that such *jouissance* may lead to danger and harm. His holistic conception of the body, life and death, show a debt to the Sufi poet,

Yalal al-Din Rumi (1207–1273).[4] In Spanish art taking AIDS as its theme, there is a before and after Espaliu. The Carrying Society, a group created in San Sebastián, spurred on by Josu Sarasua and especially by Jorge González, continued the spirit of Espaliu's projects until recently. One of their most successful projects involved tape-recording the testimonies of people living with AIDS. *Como una antorcha* (Like a Torch, 1995) privileged the voices of people with AIDS and the ears that hear them. The installation revolved around a circle of chairs in which the viewer felt drawn to sit. On one of the chairs was seated a loud speaker, emitting, without interruption, the different testimonies of people with AIDS. A naked bulb hanging above the circle of chairs projected a torch-like light. This was an emotionally-charged offering of the privacy of the sick to a public audience. The disembodied voices made the emotional impact of those testimonies particularly acute. [...]

Blatant sexual imagery figures in a number of art works focused on AIDS. Pepe Espaliu was insistent about the sexual content of his work. An untitled collage/drawing on paper of 1993 combined with an erect penis, a hand bearing evidence of ejaculation, and a scrotum pierced by nails. A metal ring adorns the penis's head. In the lower half of the picture is an inverted flower with thorns. This piece fuses the pleasures and pains of gay sado-masochistic sex with the safety of masturbation. What does the flower represent? Suffering? Torment? Beauty?

Spanish art which takes AIDS as its theme is as dispersed and scattered as the political and social responses to AIDS itself have been. The huge impact of Espaliu's *Carrying Project* is remembered and mourned. Occasionally, an individual initiative re-ignites consciousness of the magnitude of AIDS: Pepe Miralles, an HIV-negative artists who has been working on the subject of AIDS for five years, organized an exhibition in Jávea, Alicante, called *Pensar la SIDA* (Thinking

on AIDS) in 1996. But no institution, art centre, or museum has dedicated space to artistic responses to AIDS. Curators, directors, magazine editors and artists alike continue to be suspicious of an art that combines aesthetics with social commitment. The AIDS crisis is in danger of being engulfed once more in silence.

Notes

[1] *Panorama* 278, 21 September 1992.

[2] Following Baudrillard, Paul Julian Smith strings together a hypothetical interpretation of the visualization of AIDS in Spain which departs from the concept of fatality. See 'Fatal Strategies: The Representation of AIDS in the Spanish State', *Vision Machines, Cinema, Literature and Sexuality in Spain and Cuba, 1983–1993*, [London, Verso, 1996], 101–27.

[3] The first 'carrying' was performed on 26 September 1992 in San Sebastián; the second in Madrid on 1 December of the same year.

[4] Rumi's thought pervades Espaliu's final installation, *El nido*, The nest. Here we also find remnants of Duchamp and of the dances of the dervishes. *El nido* is a reflection on the bodily dispossession produced by AIDS. For just as birds pluck their own feathers in order to make nests for their young, so the AIDS patient sees the body erode at the same time that they surrender to themselves in the act of solidarity, struggle and love. See the catalogue, *Sonsbeek 93*, eds. Jan Brand, Cateligne de Muynck, and Valerie Smith, Ghent, Snoeck Ducaju & Zoon, 1993, pp. 114–18, 130, 238–53.

— Juan Vicente Aliaga, 'A Land of Silence: Political, cultural and artistic responses to AIDS in Spain', trans. Vincent Martin, *Acting on AIDS: Sex, Drugs and Politics*, eds. Joshua Oppenheimer and Helena Reckitt [Serpent's Tail, London, 1997], 394–407

G —
Queer Worlds
(1995–present)

Since the founding of the activist group Queer Nation in 1990 and, around the same time, the introduction of the term 'queer theory' into academic discourse, 'queer' has been reclaimed by gay men, lesbians, bisexuals, transgender people and other sexual minorities as a defiant means of self-description. To call oneself 'queer' is to confront but also to defy the violent uses to which that word has been put in the past. 'Queer' suggests a thoroughgoing critique of gay and lesbian normalization and of the 'positive' images of homosexual dignity, patriotism and community that accompany it. On the other hand, given the rise of global capitalism and its quest for new consumers and commodities, 'queer' also runs the risk of being recuperated as little more than a lifestyle brand or a niche market. The documents collected here reflect the unsettled questions and contradictions of queer world-making.

Nayland Blake
'Curating in a Different Light' (1995)

[...] Thus when Larry Rinder approached me about this exhibition, I reacted to the idea with a low level of interest if not outright hostility. [...] I only became interested after Larry and I had a discussion of some of the things that we might do differently. Over the course of several conversations, we developed several requirements the show would have to fulfil in order to be a genuine step forward.

First, it would have to be multigenerational. For almost fifteen years, museums have been unable or unwilling to bring together the work of successive generations of artists. Instead, artists are continually grouped within their own generation, leading to the continual reinforcement of whatever critical discourse has surrounded that period. We are thus encouraged to believe that we already know the truth about a particular group of artists, and that nothing more remains to be said. Artists themselves do not impose such neat distinctions on their influences. I know I don't.

Second, the show should have both queer and straight artists in it. In the same way that artists are not simply responding to the works of people the same age, they are not only looking at works by those who share their sexual preference. Indeed, much of what queer artists are doing these days is questioning the value of identity politics.

In light of that concern, my third requirement was that the exhibition should not have the words gay, lesbian, or queer in its title. The title is the doorway through which the viewer enters the exhibition. If we essentialize the work of these artists in the title, we limit the views' chances of being able to find new information and connections among the works. The artists would be once again ghettoized. [...]

Finally, I hoped to make the show responsive to the ways in which artists operate in the world, as distinct from the way curators or art historians might imagine them operating. This exhibition began, like many others, in response to a type of energy and activity around a community of artists. What, then, is it like for artists to be around that energy, that excitement? What are artists doing? In working on this show, I have thought about those times when being in the world as an artists has meant the most to me; those times when I could feel a presence, a looming joy in the works around me. The early '90's were such time in the queer community in San Francisco; notions that had been circulating began to come together in new constellations. The world seemed full of fresh messages, truths perhaps addressed to us alone, but connecting us to other initiates. These group epiphanies are the calls we respond to when we make work. [...]

The works in this exhibition form a new map [...] of a queer practice in the visual arts over the past thirty years. It is, like our journey, incomplete and personal. This very process of mapping, or remapping, is one of the most important components of the particular practice we are trying to document. Many of the artists included in this show have been involved either individually or in groups, with the project of creating and discovering queer territory. These mappings have either proceeded across the physical terrain of cities, the ideological space of the art world, or across history. In many ways, this process has been the same for other marginalized groups, and the ability of artists today to queer the reading of various signs owes much to the previous efforts of those groups. Those on the outside have to struggle to find their face in the distorting mirror of mainstream discourse. This struggle has a deeper meaning for queers since they do not have recourse to the usual alternative repositories of meaning: religious, ethnic or familial heritages.

Queer people are the only minority whose culture is not transmitted within the family. Indeed, the assertion of one's queer identity often is made as a form of contradiction to familial identity. Thus, for queer people, all of the words that serve as touchstones for cultural identification – family, home, people, neighbourhood, heritage – must be recognized as constructions for and by the individual members of that community. The extremely provisional nature of queer culture is the thing that makes its transmission so fragile. However, this very fragility has encouraged people to seek retroactively its contours to a degree not often found in other groups. Queer people must literally construct the houses they will be born into, and adopt their own parents. The idea that identity and culture are nonorganic constructs is also one of the most important characteristics of postmodernism. It should be noted that many of the theoreticians of the postmodern – the generation of critics and philosophers that came of age in the '60's – were gay and lesbian. In certain ways, the discourse of the postmodern is the queer experience rewritten to describe the experience of the whole world.

From the margins, queers have picked those things that could work for them and recoded them, rewritten their meanings, opening up the possibility of viral reinsertion into the body of general discourse. Denied images of themselves, they have changed the captions on others' family photos. Left without cultural vehicles, they have hijacked somebody else's. They have been forced to trespass and poach. To be queer is to cobble together identity, to fashion provisional tactics at will, to pollute and deflate all discourses. Historically, this activity has been a possibility for either the upper class, whose privilege is utilized to exercise in power, or for the lower class, whose reworkings of high culture have often served as a form of social resistance. At various times queer practice has been associated with both the upper and lower class positions. Because queers do not share a set of physical characteristics, we have also had to have greater recourse to semiotic means to express our tribal affiliations. We resort to dress codes, colors, earrings, references to tell-tale culture interest, whether Judy or Joan Jett. In histories and biographies we scan for words like 'companion' and 'spinster'. Or we read the obituaries looking for men who die before their fifties of a lingering illness.

Queers are a minority because of what we do, not what we are. As such, we continue to pose a dilemma for a society that can only believe in equality if it is linked to biology. What used to be true only of queer culture though, has now become true of all culture. All artists today are confronted with a culture that is no longer unified or even divided into the convenient binary of high and low. Postmodern culture is an ever-mutating system of signs and meanings. Value is fluid. Artists have developed a number of strategies for negotiating this circumstance – strategies that bear a marked resemblance to those employed by queers in relation to the heterosexual world. How then do those strategies differ for queer artists? [...]

The first rumblings of what we could call a queer practice began to be heard in places where there was already no chance of real acceptance, where queers had nothing to lose: independent film and theatre. Made far afield from the attention and financial clout of the culture industries, and playing to minuscule audiences of like-minded outsiders, the films, plays and spectacles of Kenneth Anger, Jack Smith, Ronald Tavel and Charles Ludlum conjured a new world of glamour and terror out of the city's rubbish. As desperate leaps of faith, these down-at-heel extravaganzas pointed the way for a series of new challenges to the cultural mainsteam.

One of the first of these was Fluxus, founded in the late '50s by a loose confederation of artists, composers and poets in an attempt to dissolve the boundaries of the art world. By exploding form, confusing authorship, relying on the multiple rather than the unique, Fluxus answered Duchamp's call with a questioning of the very formulation of art movements. While drawing inspiration from many of the twentieth century's avant-gardes, Fluxus always managed to elude easy definition. It was an aggregation of individuals, a 'movement' that could barely be charted, and that by some accounts has not yet ended. If the Cage group attempted to take Duchamp's practice as a lesson on the individual level, Fluxus used it as the blue print for collective experiment. Ultimately, many of the artists around Cage moved through the mainstream art world without difficulty, their formal innovations finally posing little problem for the art world. By contrast, much of Fluxus remains unassimilated. Fluxus also spawned a host of corollary movements — performance and conceptual art, mail art, and body art — that have continued to thrive on the margins of the commercial art world and have acted as a conduit for Fluxus' spirit over the past thirty years.

It is important to see Fluxus also as another one of the many discourses of freedom that flowered throughout Europe and the United States in the late '50s and early '60s. It was very much part of the nascent counterculture, an event like many others that combined a pointed questioning of received knowledge with a giddy celebration of unexpected possibilities. Against a centralized art world bound to the notion of a historic progression of unique masters and their great works, Fluxus deployed a blizzard of incidental objects, bottles, scrawled notes, tiny books, stamps, squeaks and stumbles that refused to play the part of masterpieces. In Fluxus, people were demonstrating their exuberance in overturning boundaries between disciplines (painting, sculpture, music, sports, theater dance), identities (composer performer and audience) and values (uniqueness, authenticity, permanence). It acted in some ways as the universal solvent of artistic hierarchy, and its economics of generosity and democracy was and still is a challenge to the closed economy of the mainstream art world.

While Fluxus could posit many types of freedoms, it still retained many of the blind spots of the culture it tried to revolutionize. The most important one of these was that of gender. While many women produced and participated in Fluxus works, their place within the Fluxus culture was often the same as that of women throughout the art world — wife, muse, or objectified body. In this, as in many other things, Fluxus was product of its time. Women were beginning to find that much of the counterculture of the '60's could not or would not listen to them or provide opportunities for them to exercise agency. The civil right, black power and student movements of the later '60's — all attempts to make real the rhetorics of freedom that had energized the early part of the decade — provided much of the blue-print for the women's liberation movement. In the art world, this has come to be known as the women's art movement. [...]

For many of the women involved in transforming the structure of their practice in those years, the experience of making community has been as important as that of making art. Their efforts were designed not only to showcase the works of individual artists, but also to call a community into being. This community transformed many of the collective, anticapitalist strains in '60's culture into much of what we now call the nonprofit art world. [...]

One of the major achievements of the women's art movement, and one of particular importance to us here, was the invention and promulgation of a gendered reading of form. The argument that certain formal choices within works reflected the gender of the work's maker allowed for the first substantive discussions of the differences in men's and women's approaches to abstraction. It also made possible a gendered critique of the assumptions of a (supposedly) universal and neutral modernist abstraction. Like many aesthetic theories, this critique eventually became a way of setting up and policing borders rather than a way of talking about and understanding the practice of artists. Unfortunately, it also became in some cases an instrument with which to exclude artists whose work was somehow not female enough; using an essentializing approach as a way of trying to sort out the 'true' practitioners from the false. The women's art movement also sparked an enormous project of historical research. Women artists began to sift though art history to resurrect the vanished voices of their forebears. They began to question the way that value had been bestowed on the artists of the past and labored to construct institutions that would allow them to take control of the way that their own work would be valued. Artists began to take on the roles of curator, critic, and historian. Their efforts have provided the model for every outside practice since. [...]

By the mid '70's, much of the momentum of social liberation movements of the '60's had been lost or derailed into increasingly limited lifestyle choices. Popular culture embraced escapist nostalgias instead of engaging with social issues. The '50's became a sign of lost innocence, the last time America felt good about itself. The '70's also saw the maturation of the Stonewall generation into gay male ghetto clones. Gay liberation was replaced by gay power, often imagined in terms of economic self-determination and institution building. Gay men and lesbians both began to operate businesses, open their own bars, establish neighbourhoods. To some extent this form of community-building reflected a continuing commitment to creating a separate space of tolerance and diversity, but often it reflected an aspiration to join in with the class assumptions and blind commercialism of the straight world.

The decade's strongest attack on those assumptions came in the form of punk. Punk can perhaps best be characterized as a pair of mutually reinforcing explosions of musical activity based initially in New York and London in the late '70's. It drew its name from a prisoner's slang term for faggot. Punk is rarely talked about as a queer movement, but much of its history and many of its poses and strategies are tied to queerness. In New York, the punk scene traced its roots back through glam rock to the Velvet Underground and Andy Warhol's Factory. In London punk was dreamed up by a group of ex-art students as an attempt to recapture the social upheaval of the 1968 Paris student revolts through the construction of self-contradictory consumer artefacts. [...]

More importantly, punk was the beginning of a critique of the stultifying cultural quietism that followed the flirtation with progressive social change in the '60s. Punk overturned the notion that everything was alright by demonstrating that there were needs that consumerism hadn't filled. It fragmented consumer culture and expanded the pieces into obscene horror shows. While much of punk's imagery was sexual, it deployed that imagery to demonstrate the impossibility of any redemption through sex. In punk the body assumed presence only through a demonstration of its extreme alienation. Punk parodied capitalism's annexation of romance and sexual desire to commodity fetishism by portraying sex itself only through fetishism. It turned the private language of fetish wear into street style. Punk refashioned the street into a place of excitement, danger, and longing. It also created an

enormous groundswell of cultural producers, thousands and thousands of people who found in punk the permission to wrench culture into their own meaning. Many punk graphics, band posters, record sleeves, and 'zines communicate the sense that new codes and new possibilities are shining out from the fragments of shattered signs. Punk was negation turned into a raucous noise of refusal. Like Fluxus, punk is a movement of fragments, a deliberate lack of mastery, of abjection. Like queers, punks are on the bottom of the cultural transaction, but punk rewrote the terms so that the bottom becomes the escape point, an escape into fury and blankness that demolishes the top.

Punk spread its message through flyers, records and self-published magazines. The networks of 'zine distribution that grew up as a result of punk have had a crucial impact on the formation of new queer culture. The magazine has always occupied a vital place in the lives of gay men and lesbians. In the '50s, magazines were the medium of gay and lesbian culture to people outside of urban centers, magazines such as the *Ladder*, the *Mattachine Newsletter*, and *Physique Art Pictorial*. Queer 'zines are inheritors of this tradition, as well as that of artist-published magazines like *File* that were outgrowths of the international mail art movement. They have served as forums for sexual debate, as well as a way of identifying like-minded people outside the gay and lesbian mainstream.

Punk was not the only attempt to produce and distribute alternative music in the '70's. Part of the explosion of women's culture at the time was the women's music movement. Women's music became one of the most successful lesbian cultural expressions, generating not only a new roster of lesbian stars, but also providing through concerts and festivals new possibilities for women to meet each other and forge communities. Both punk and the women's music movement were attempts to confront social problems via culture strategies. Yet, while their forms might be similar, their underlying ideologies were obviously vastly different. While punk was profoundly anti-humanist, women's music was strongly informed by the humanist ideals of social activism (an attitude shared by many women in the visual arts at the time). While strongly critiquing patriarchy, many of the women involved had a positive attitude towards libertarian notions of self-determination and social dignity. The artists involved were attempting to redeem culture by positing the positive, unifying potential of a culture made by and for

women. The belief in essentialism allowed women to create the most visible lesbian culture in the history of the United States. That culture came under attack, however, by a younger generation of women who were highly sceptical of both essentialism and humanism. [...]

[In the 1980s], the AIDS epidemic became the catalyst for the first viable social protest movement since the feminist heyday of the mid '70's. For a generation of gay men who had previously indulged themselves in assimilationist fantasies, it provided the undeniable evidence of American's profound homophobia. Many became activists for the first time; many of them became artists. In combating the hatred and disdain of straight society, these new activists drew on the techniques of the movements that had come before them. The response also varied greatly from place to place. In New York, artists and activists countered gay invisibility by forging a new street art of arresting immediacy. Once again the streets teemed with new information, on t-shirts, posters and stickers. The city was remapped as an infected zone. Artists began producing works for the gallery context that explored the loss they experienced. Their elegiac works had profound implications for queer artists. Specifically for gay men, they marked the first time that there was recognized gay content that was not simply representations of gay male desire. Ironically, gay artists were exploring issues of mortality at precisely the time that the rest of the art world was abandoning personal content in favour of highly theoretical discussions of simulation and spectacle. The art world was recognizing gay artists' right to speak on a crucial issue. But there was little interest in hearing about anything else. AIDS had provided the wedge, however, and increasing numbers of artists insisted on being heard. Many younger artists explored explicit identifications as queer only after a period of social activism. The experience of opening up a place for queer identity on the street then provided the model for doing so in the context of the gallery. The traditional model of cultural progress posits that ideas surface first in avant-garde elites, and are then dispersed into the general culture. In the case of this new queer content, the model was reversed. [...]

— Nayland Blake, 'Curating in a Different Light', *In a Different Light: Visual Culture, Sexual Identity, Queer Practice*, eds. Nayland Blake, Lawrence Rinder and Amy Scholder [City Lights Books, San Francisco, 1995], 9–29

Carrie Moyer
'Not an Incest
Survivor' (1995)

The search for and production of lesbian artifacts has occupied me for most of my life. By the time I discovered I was a lesbian child and began making art, the Stonewall Riots and the women's movement had already happened. Although I have been painting for years and making overt lesbian activist propaganda since 1989, my paintings were primarily abstract until about three years ago. At that time a public debate [was underway] about the existence of a 'gay gene', a newly discovered biological explanation for homosexuality. It seemed like a step backwards for society to become so obsessed with the origins of homosexuality, instead of just accepting it. At the same time that researchers were insisting on a biological basis for homosexuality, vehement debates over gay content in public school education revealed society's refusal to acknowledge that gay people were ever children at all. In response, I began making paintings that imagined the various determinist theories of how I came to my lesbian girlhood: born that way; raised by an overly attentive mother; recruited by a butch teacher, adult, friend; or simply an early rebellion at the price we pay for being born female.

Paintings such as *Heather Has Two Mommies*, *The Pussy Eater*, *The Gay Gene*, and *Pat the Bunny* are about girls who know what they want, GIRLS WHO WANT THEIR MOMMIES. I'm making paintings about girlhood homosexuality, tracking the source of my 'problem' to an imagined collusion between mommy and me. These little man-haters are having sex with each other, eating menstruating pussies, preying on Mother, castrating their Daddies and generally acting up.

My intention is to up-end the cherished belief that children are inherently heterosexual. Yet when straight people see my pictures, they immediately ask if I am a victim of incest. Observing that I am 'nothing like my work,' they proceed to see it as form of cathartic autobiography. *Maybe someday you won't be so angry and won't need to make victim art anymore.* This frequent (mis) interpretation, the one that points to an incested past, mainlines directly into the expectation that women will make confessional art. The inability to conceive of childhood homosexuality leaves a void that must be filled in by the imagination — molestation by an adult becomes the only possible reading.

I'm finding out that certain content is so jarring that all conventions as

to how painting functions and is understood are abandoned. Some of the most sophisticated viewers (especially straight feminist artists) look at my current work and see a fact, instead of the fiction that painting is generally taken to be. Paul McCarthy, Mike Kelley and other male artists who use similar, over-the-top strategies are never called upon to reveal their motivations, much less biographical triggers. Apparently when men use shocking images to depict family dysfunction or subterranean desires, they are addressing universal feelings shared by all. However when I deploy camp, sarcasm and comparable absurdist tactics, I am 'working through something,' using art as therapy to exorcise demons. The incest reading completely ignores my protagonist: the knowing, rapacious little lesbian who gets what she wants when she wants it.

— Carrie Moyer, *Not An Incest Survivor*, artist's statement [1995, revised 2011]

RG
'What is Riot Grrrl?' (1997)

RIOT Grrrl is an underground, non-commercial womyn's support / action group here to open people's eyes and promote womyn in society. Riot Grrrl is not a bunch of angry man-hating lesbians wanting to take over the world. Let me explain:

1. We ARE angry! We are pissed off how we as grrrls (females) are treated in society. We are angry that patriarchy rules our lives from birth to death. We are angry that the media continues to promote and condone the abuse and rape of womyn. Womyn are seen as the lesser gender: the one to be dominated, owned, ruled. We are angry that more people don't stand up and tell patriarchy: 'FUCK OFF AND LET ME BE!'

2. We do not hate men. We promote grrrl love. That's one reason the meetings are womyn only. We want a pro-female community of support. The act of loving yourself as you were created (female) has been devalued. We promote loving yourself as you are. We meet with guys once a month to keep communication flowing.

3. We are not a lesbian group. We have grrrls who are lesbian, bi and straight. We don't care what sexual orientation you are. You are a grrrl. We all bleed the same, we have the same struggles. Together we can make it.

4. We DO want to take over the world.

PAD POWER — LET THE BLOOD FLOW!

What Does RG Do:

We discuss topics relevant to womyn and how to deal with them; we volunteer with the NOW escorts at the reproductive health clinic and ACT UP to educate people about HIV; we come together, create our own positive space and building strong female friendships; and we create our own zine, *Mons of Venus*, a collection of our feelings and opinions.

We can do anything else you want… this is your group. You can do as much or as little as you want. Our group ranges in age from fifteen to twenty-nine but all ages are welcome. All womyn are welcome, regardless of age, ethnicity, religion, political thought, shoe size…Variety adds spice to life!

— RG, 'What is Riot Grrrl?' *Mons of Venus* [1997], republished in *A Girl's Guide To Taking Over The World: Writing From The Girl Zine Revolution*, eds. Karen Green and Tristan Taormino [Saint Martin's Press, New York, 1997] 185

Beatriz Preciado
'L.' (1998)

Because 'there won't be a true political revolution until all women are lesbians'.
— Jill Johnston

Where does L. live?

L. has grown up in the father's home. She's grown up inside the mother. Home is the place where the father has set up the gender-simulation business. The sex-gender system is the technology that allows the father's business, name and family line to be perpetuated. Not knowing quite how, the business is stronger than they are. They are only their own machinery; like the machine, they are banned from knowing or desiring anything beyond the production with which they repeat themselves.

L. is the accident of that system, the unlikely failure of gender that risks the name of the father. Yet in every technology, error, even if it's the exception to the rule, is unavoidable. Gender accidents confirm that gender is a technology. The heterosexual matrix is a limited technology that can't work without causing ongoing accidents. L. and her anti-discipline have grown up under the alert shelter of the violence of the father's order. Tactically speaking, L. has read the rule of polemos

written on the back of the romantic machinery. Little by little she has sharpened the knife with which the father sacrifices the animal, until she has created a *Labrys*.

At home, the mother knows how to divide spaces: birth, periods, wedding… probably death. Day and night, the sun and the moon. That's what Mom knows about, of the little death, and of the big Death. Mom tastes of death. She knows how to dress catastrophes: she's familiar with derailment, crash, shipwreck, collision, the calculation that falls short, error, breakdown, failure, depression. Mother knows about the death politics that makes her stay at home: thanatopolitics.

Until she accidentally finds out about the fallibility of gender, Little L. also plays a differential role in a system that reeks of death: the space of heterosexuality. Monique Wittig was the first feminist to make out the eternal return of the same, the compulsion towards repetition, the difficulty in speaking of L. without destroying with every word her sense and her phenomenon. Mom's heterosexuality is a political regime, a system of domination that legitimizes the oppression of women under men's dominance. Nature is heterosexuality. It's women's natural fate to produce and reproduce without a rest, to be the object of humiliation, mutilation, physical and psychological abuse. Submission, marriage and public and domestic service are the fate written on her body: her genes, hormones, and empty and full uterus are the grammar used by this language of domination. The ideal of romantic love is the order by which that fate is structured as desire. To think of the refusal to reproduce the normality of this desire as a perversion is to practice concealment; it is, in a way, to work for the gender company.

But L. exits that cave made by the media, where her mother has made a home: she goes over to the pregnancy waiting room, to the birthing hall, the rearing kitchen, and all the way to the bottom of the spiral staircase of menstruations and miscarriages. L. doesn't stop that movement that shakes her out of common sense, because she intuits that this is the only way she can avoid the 'ancient murder of the mother'. She would like to bring her mother back to life. She wishes her mother alive.

L. is afraid when she leaves home, she fears losing the intimate. Because what's intimate is kept inside. But, what can intimacy be when the interior is only a semblance of separation created by the patriarchal establishment? The shut, private, limited, constrained house. 'A woman is the home, all the better if her paw is broken'. This is what Mom knows about, of the little death and of the big Death.

L. looks up her family history in the archives of her city. The archives are silent. When they do speak, they say: syphilitic, alchemist, blasphemer, demented. What's happened to the traces of those who were like L.? Behind history's silence is the mothers' complicity in murdering L.'s forebears. L. feels that she is not from this city, that she, like Antigone, does not belong to the laws of the city that has silenced their names. L. does not belong. Because she is outside oikonomic exchange, the home exchange, and doesn't belong to anyone, and no one belongs to her. She feels she is not a human being.

L. does not have a place. She is from abroad. Abroad is the place for what's primitive. What's wild. What still hasn't been domesticated. What's raw before leaving life. L. is in the outside. She's been kicked out from heterosexual paradise, beyond which there is no memory. Outside, there is nothing. There are no things. Neither subject nor object. There is no *techne*, there is no episteme that can point the return to paradise. Only events.

L. has inherited a loss. A lost tradition. It's necessary to remember by making things up, to remember by imagining, to dig up the names of L.'s forebears with each new word. At this point she learns to read the coded symbols of a hidden tradition through the language of the city: *Archibollo*.

L. accepts the impossibility that makes her possible. L. searches for a place where she can define herself. Better yet, a place where, being empowered, she won't need to define herself anymore. A place pre and post definition. L., the unpossessed, the dispossessed, inhabits without having space. She does not own a home. Owning is not something that defines her. Owning in the oekonomical exchange means having a penis, having a son, that's what Freud says, he who defined with exactitude the terms of this sexual consumption. L. abandons the space where man owns and mother is possessed: home. She doesn't have a body nor fixed sex. L. doesn't have a vagina. She is no sheath. She is not a pod, nor a shell. She doesn't have a home or possession. Or identity or difference. And this is how she builds, with those like her, a heterotopia that does not fix sex. That does not make oppression into something natural. A space that inverts / invests. An inverted / invested space. Inversion / investment through loss. [*The Spanish word inversión can be read to mean both inversion and investment.*]

Look carefully: behind every space there is an outside where L. walks.

Listen carefully: behind every text there is an erased line that refers to L.

Track down carefully: behind every space that's dominated by a network of disciplines, there's a vanishing point where the outside begins, a landscape of events.

— Beatriz Preciado, 'L', *Non Grata*, no. 3 [LSD Collective, 1998]

Catherine Lord
'The Anthropologist's Shadow: The Closet, the Warehouse, the Lesbian as Artifact' (2000)

In 1994, Millie Wilson and I spent a great deal of time in Santa Fe, New Mexico, looking for lesbians. Most of the time we did this across from the Inn of the Anasazi at the state photo archives. It tends to be either way too hot or way too cold in Santa Fe. Whichever, it was easier to look indoors. We had been invited to New Mexico to produce a project on lesbians, or as lesbians — the finer theoretical distinctions between these performance was and would remain bureaucratically unexplored — by an organization called Site Santa Fe. [...]

When we were developing a proposal the logic was, as far as I can reconstruct it, that if we had to spend a lot of time on the road, we might as well not spend most of it with straight people. I suppose we turned ourselves into *faux* anthropologists, as we ironically described ourselves and as the curators later made official, both as an escape from our straight work worlds and in protest against a genre that Hal Foster has called 'pseudo-ethnographic reports in art that are sometimes disguised as travelogues for the world art market.'[1] If the request was to produce a project about lesbians specific to a geographical region, the challenge was to truck the dirt into the museum in a way that would perhaps reduce the ethnographic gaze to a squint. Our proposal to Site Santa Fe, then, written with lesbian tongue well inside lesbian cheek, was to go to New Mexico, find fifty to one hundred individuals who 'lived outside the institutions of heterosexuality,' and borrow from them an object of personal significance, entirely of their choosing, that they had not themselves made.[2] These we proposed to install in the Museum of Fine Arts, along with a text written by the lenders addressing the significance of each object. [...]

The lenders to *Something Borrowed*, as the project came to be called, almost all from Northern New Mexico, ranged in age from seventeen to eighty-three. They included Anglos, Hispanics, members of various indigenous nations, and African Americans. Their occupations were various: a good sprinkling of artists, writers, students, and professors, a few anthropologists and school teaches, as well as a psychologist, a lawyer, a fireman, a waiter, a chiropractor, a *currandera*, a builder, a rancher, a judge, a janitor, an electrician, a singer, a baker, a community organizer, a clerk, a manufacturer of sex toys, an ex-prostitute, and an ex-cop. The idea, however, was neither to 'out' the lenders nor to interpellate them to visibility under the culturally specific label 'lesbian.' Nothing in the framing devices of the installation, therefore, said 'lesbian.' Nothing in the loan requirements dictated that a lender be publicly identified by her full name, her legal name, her place of residence, or her occupation. Nothing in the loan requirements obligated the lender to be 'a lesbian,' or even a woman. Indeed, *Something Borrowed* netted a few practicing heterosexuals who didn't mind associating with lesbians, as well as two men, one straight and one gay, who lent an object in memory of women who had lived in long relationships with women but who they insisted would never have described themselves as lesbians. It also included objects lent by women of various ages who found the label repellent, irrelevant, or simply less central than other adjectives. I hope that we invented a structure of visibility that allowed the category 'lesbian' to dominate while at the same time undermining the predictable essentializing reactions by fogging exactly that visibility, instead foregrounding revelations that had nothing to do with sexuality or intimacy, encouraging the use of codes, making spaces for silences, allowing the name withheld to function as both shield and provocation.

If this structure was a means to withhold the object of the ethnographic gaze by selectively obscuring the legibility of an essentializing category, it was countered by displaying the borrowed objects in a way that would titillate with the promise of exactly such a reading, a reading made inevitable by the site in which we were working. In New Mexico, a state where anthropology and its effects are ubiquitous, anything on a shelf with a label reads as a sign of culture, a material trace, probably stolen, of a group already declared to be other. (The fifty thousand tourists who visited the Museum of Fine Arts that summer did so on the same ticket that admitted them to the anthropological museum up the hill.) An eight-foot wall of objects on plexiglass shelves, arranged in a grid was a strategic tease, anthropology conceived so that it could not help but fail, so that any disciplinary hopes for order would

be buried under material specificity. There was no conceptual rationale whatsoever for the arrangement of the objects, besides the formal commitment to create a nonhierarchal visual field and putting anything really expensive out of reach.

There were, as one would expect, objects that more or less clearly signalled a lesbian identity: the 1927 Victory edition of *The Well of Loneliness*, lent by a retired and still closeted school teacher; a motorcycle helmet with a pink triangle, lent by a nineties dyke, and a motorcycle helmet with a women's symbol, lent by a seventies lesbian; two brown-skinned Barbies having at it, lent by a young Chicana-about-town; a certificate of marriage from the Metropolitan Community Church, lent by a recovering alcoholic; a coming-out journal; a blank journal, a gift from the lender's first lesbian lover, a gift in turn received from her mother; and the world's first functional and reasonably priced dildo harness, made by two young entrepreneurs.

There were objects explicable as 'lesbian' only in terms of the lender's story: one of the rings exchanged by two thirteen-year old girls, who remained lovers for five years; the basket in which a prostitute used to keep her condoms; a tassel that marked the moment of a lawyer's graduation as well as her return to the closet; the worn clothes with which a mother had washed the backs of her daughter and her daughter's lover, signalling her reluctant acceptance of the relationship by offering them the same gesture of sensual intimacy that had been a ritual in her relationship to her husband; the plastic bucket used to haul water by the dykes on a separatist-back-to-the-land collective; the kente cloth doll two middle-aged professionals gave to their recently adopted African American son; a videotape of the *Sound of Music* with Julie Andrews on the cover; the vanity license plate that two New York stockbrokers put on the RV in which, having cashed in their options, they fled the rat race; the coffee pot used by the photographer Laura Gilpin and her 'companion' Betty Forster on their camping trips in the 1930's around the Navajo reservation, the place where they could be most themselves; a hand-made card given in 1975 to the homecoming queen at the University of New Mexico, the only such queen in history to arrive at her festivities in a dykely three-piece suit; the pink plastic lunch box carried by a house painter to her jobs with all-male crews; a scrapbook page that memorialized the lender's mother, who ran Santa Fe's only gay bar for twenty years and on her deathbed had the pleasure of having her daughter come out to her; the Othello sheath

knife acquired by a young tomboy; the jacket patches worn by the Sirens, Albuquerque's lesbian bikers; a glove used by the Baby Ruths in their softball games in the hot desert sun; and a spinster's ring on a rubber monster woman, lent by an eminent folklorist.

There were tributes of all kinds to love and family and death: Aunty Nelly's cup and saucer, from the daughter of a family that talked things out over coffee; the gardening gloves, one of his and one of hers, used by one artists' parents; the wool comb made in the 1970's by an uncle who went to Vietnam and didn't come back the same; the lures used by a grandfather who taught the lender to fish in silence and killed himself one Valentine's Day; the seamstress's tool used by a musician's mother to pull the buttons through denim fabric in the jeans factory in El Paso where she worked for thirty-five years; a sliver of bone in a silver Navajo box, saved by one student from her mother's cremated remains; the music box to which a couple in Oklahoma used to dance, a gift to them from their children, who saved pennies to buy this luxury; a notebook of songs loaned by a cowboy, part of a collection he inherited from a woman who had seen him through his childhood in the ranch country south of Santa Fe by teaching him to play the banjo and whom he hesitated to disrespect by naming her a lesbian; the tourist guide produced by a woman who passed as a man, lent by her companion of twenty years, a toy given by a grandmother; and a drawing of a cat lent by a woman who still mourned the child who had made it. [...]

And finally, there were fables, riddles, and admonitions: the pair of dykes lent by an electrician who had the daily pleasure of cutting wire with a pun; the joke glasses lent by a teenager who didn't want to go below the surface; the photograph of a woman in a bouffant hairdo amid a sea of uniformed mean, lent by a woman who had been the only female graduate in the 1964 class of the Albuquerque Police Academy; and, lent anonymously, by an anthropologist, an empty shelf 'to stand for the manifest but elusive range of invisible and unnamed women who live together or alone, among all classes, everywhere in New Mexico.'

It was a queer place, this wall informed by the closet, or more accurately, this wall that performed and formed the closet, which is of course hardly ever a closet, in the conventional sense of an architectural receptacle for those kinds of private property intended for rotating display, but rather a bedroom, a studio, a garage, a trailer, a kitchen, a bar, an office, a classroom, a casita, a cabin, a hogan, or a file cabinet,

a drawer, an *armorio*, a locker, a wallet, a tool chest, a basket, or just an old cardboard box. To imagine that these assorted doors and lids and flaps could or would possibly open out one piece of queer territory called lesbian, one coherent community, one culture, was to catch oneself sweating to invent a fiction both reductive and redundant, or so I still hope. It is also to suggest the delicate, often treacherous, negotiations around issues of visibility that hounded the project. The price of visibility is high for queers and other deviants, since it provides both the solace of community and the curse of pathology. We neither want to pay that price, at least in full, or ask our collaborator to do so. At least we wanted to haggle. We were trading in paradox. We had gathered a collection of artefacts from a finite set of individuals who could not be accommodated under the label our presence as lesbians, especially a brace of domesticated lesbians, was supposed to authenticate. Verifiably lesbian in part because we were coupled, able to find the members of our tribe because we performed coupledom by flaunting it as both bait and camouflage, our role in the site-specific recuperation of identity politics was to reveal insider information, to serve as native informants, to solicit and to certify a singular culture to which we were said to belong, to which we had to belong in order to have a nationality eligible to the terms of the exhibition. In other words, the artists needed strategies that would at least postpone their capture as ethnographic objects. In this sense, the wall was a collaborative performance between two rogue anthropologists[3] — and a motley band of natives who at the least wanted to represent themselves and at the most didn't want someone else's culture to manifest itself as a by-product of their pleasure. [...]

Footnotes

[1] Hal Foster, 'The Artists as Ethnographer,' in *The Return of the Real* (Cambridge: MIT Press, 1996), 186. Foster's essay, a provocative, often scathing, critique of 'ethnographer envy' among artists, generally fails to imagine the possibility of the artists as trained inside, or an insider capable or using paradox and making double-edged comment.

[2] We did not want to privilege the access of artists, as skilled object producers, to the museum, and we did not want to curate a lesbian art show. Though the decision was undemocratic, and doubtless unresponsive to part of the 'very specific regional context' we had been asked to address —

that is, the number of lesbian artists unrecognized by the New Mexico mainstream — if I had to do it all over again, I'd make the same decision.

3 Foster, 'Artists as ethnographer,' 182, uses this term dismissively — 'rogue investigations of anthropology, like queer critiques of psychoanalysis, possess vanguard status: it is along these lines that the critical edge is felt to cut most incisively.' Personally, I find the connection between these two social formations of the named tantalizing: both typically structure escapes from the nuclear family into another field altogether.

— Catherine Lord,
 'The Anthropologist's Shadow:
 The Closet, the Warehouse, the
 Lesbian as Artifact', *Space, Site,*
 Intervention: Situating Installation
 Art, ed. Erika Suderburg
 [University of Minnesota Press,
 Minneapolis, 2000] 297—316

Richard Meyer
'At Home In Marginal
Domains' (2000)

Here it becomes evident that
the hallmark of the new type
of researcher is not the eye
for the 'all encompassing
whole' nor the eye for the
comprehensive 'context,' …
but rather the capacity to be
at home in marginal domains.
— Walter Benjamin,
'The Rigorous Study of Art'[1]

I have always been at home in marginal domains or, rather, in the movement from marginal domains to mainstream ones and back again. A gay sex club I know in New York City is located around the corner from the headquarters of the College Art Association (CAA), the leading professional organization for art historians in this country. Whenever I walk past either the CAA or the sex club, I think, at least for a moment, of the 'other' institution. There is something peculiar and pleasurable in this juxtaposition, this secret association between the space of academic art history and that of queer sex culture.

I sometimes think of the proximity between the CAA and the club as a metaphor for the relation between art history and gay and lesbian studies, a metaphor for the ways in which each field might unexpectedly pierce the other's terrain. How, in other words, might the art historian's attention to visual images inflect the critical study of homosexuality and how,

conversely, might a scholarly focus on homosexuality shift the concerns and commitments of art history?

When Walter Benjamin wrote 'The Rigorous Study of Art' in 1933, he was almost certainly not thinking of homosexuality as one of the 'marginal domains' to which the 'new type' of art-historical researcher should attend. Yet Benjamin did have in mind various forms of visual production (e.g. architectural drawings and stage designs) that had been marginalized within the field of art history. And he was arguing for a scholarly method that would include 'an esteem for the insignificant' — an esteem for anonymous works and overlooked details, for the obscure and for the non-canonical.[2] In what follows, I focus on a single work of art that has heretofore remained invisible within academic art history. That many scholars might dismiss this work as unworthy of art historical study accounts for no small part of my interest in, and esteem for it.

In 1964, when *Life* magazine published an article on 'Homosexuality in America' ('A secret world grows open and bolder. Society is forced to look at it — and try to understand it.'), the lead photograph for the story, spanning two pages, was an interior shot of the Tool Box, one of the first gay motorcycle bars in San Francisco. The picture featured about a dozen patrons of the bar, almost all of whom wear black leather biker jackets, sometimes accessorized with silver-studded leather caps or black sunglasses. Several of the men hold bottles of beer — no mixed drinks or cocktail glasses here. A mural on the far wall of the bar portrays a long row of men in black jackets against an unmodulated white backdrop. This mural was painted the previous year by Chuck Arnett, a San Francisco artist who was also a bartender at the Tool Box.

In 1971, in the midst of the gay liberation movement, the Tool Box closed. In 1975, the building that housed the bar was demolished. For a time after the razing of the bar, a single wall of the original structure was left standing, the wall on which Arnett's mural was painted. A 1975 picture by local photographer (and occasional Tool Box patron) Michael Kelley shows the mural, still marvelously intact, alongside an expanse of concrete blocks and collapsed metal beams, a tableau of rubble, rocks, and architectural debris. Arnett's mural, intended for the interior of a gay bar, has unwittingly become a public work of art no less visible to passing motorists and pedestrians than, say, the Harrison Street sign behind

the detritus-strewn lot on which the bar once stood. It is as though the process of architectural demolition and reconstruction has itself paused before Arnett's mural, in hesitation or in momentary refusal to tear down the picture.

I am admittedly a latecomer to the story of the Tool Box mural. By the time I saw Michael Kelley's photograph in 1998, a number of other queer scholars — Gayle Rubin, Martin Meeker, Willie Walker, Jack Fritscher — had already excavated the history of the Tool Box and its mural. I do not regret my belatedness, however, because the prior work of these writers has forged an ongoing dialogue on queer history, one in which Arnett's mural, *Life*'s article, and Kelley's photograph also participate.

According to Fritscher, the appearance of the Tool Box photograph in *Life* magazine marked a crucial moment — a kind of collective coming to consciousness — for gay viewers in 1964: 'Thousands of queers in small towns who thought they were the only faggots in the world … suddenly saw, compliments of *Life*, that there was an alternative homomasculine style.'[3] Meeker has similarly argued that *Life*'s coverage of the 'gay world of San Francisco' had the effect of advertising the city and the available resources to many an isolated homosexual; and in many cases the advertisement was alluring enough to encourage them to want to move to the city.'[4] That the photograph would have galvanized gay readers to move to San Francisco is not without a certain irony, given that *Life*'s 1964 article insistently framed homosexuality as pathetic and disgraceful. Listen, for example, to the magazine's description of the patrons of the Tool Box:

These brawny young men
in their leather caps, jackets,
and pants are practicing
homosexuals, men who turn to
other men for affection. They
are part of what they call the
'gay world,' which is actually a
sad and often sordid world. (TK)

The anonymous writer of this passage aims to undo any sense of the 'gay world' as a pleasurable space of alterity by insisting that such a world must be 'sad and often sordid.' In a similar rhetorical maneuver later in 'Homosexuality in America,' the apparent butchness of the men at the Tool Box is revealed as just so much foppish premeditation: 'The efforts of these homosexuals to appear manly is obsessive — in the rakish angle of the caps, in the thumbs boldly

hooked in belts.'[5] While these men may look like bikers and tough guys, they are, *Life* assures its readership, just a group of nelly homosexuals whose manliness must be choreographed down to the last thumb gesture.

Long after the initial moment of its publication, *Life*'s picture of the Tool Box continued to circulate among gay audiences. According to Rubin,

> The photograph of the mural, the mural itself, and even copies of the mural became venerated relics of the leather community. One large blowup of the photograph was made for a later bar called the No Name. After the No Name closed, the blowup, glued to a large piece of framed masonite, was eventually housed in the Catacombs. On the back of the masonite, Chuck Arnett made an outline of the men in the foreground, and identified them by name and astrological sign.[6]

In a pictorial relay between dominant culture and gay subculture, *Life*'s photograph of Arnett's mural is displayed at another San Francisco gay bar and then at the Catacombs, a sex club in the Mission district. The name of bar at which the photographic blowup was first shown — the 'No Name' — alludes to the significance of anonymity within the gay world, to the necessity, but also to the pleasure, of withholding identity ('no names please').

Kelley's photograph of the Tool Box mural amidst the rubble of Fourth and Harrison Streets extends and enriches the mural's status as a "venerated relic." As seen here, the Tool Box lot looks something like the site of an archaeological dig from which an important historical artifact has been excavated. The mural's material persistence — its survival in the face of seemingly imminent destruction — seems to have fueled the symbolic power of the work for later audiences. Writing in 1991, Jack Fritscher describes the mural's public visibility in especially dramatic terms:

> The Tool Box, long deserted, was torn down by the city for urban renewal. Somehow, though, the wrecker's ball failed to knock down the stone wall with Arnett's mural of urban aboriginal men in leather made famous by *Life*. [...]
>
> For two years, at the corner of Fourth and Harrison, drivers coming down off the ramp from the freeway were greeted by Arnett's somber dark shadows, those Lascaux cave drawings of Neanderthal, primal, kick-ass leathermen.[7]

Like Rubin, Fritscher casts the Tool Box mural as a precious relic of the gay leather scene. By likening the painting to the cave drawings at Lascaux, Fritscher means to underscore the phantasmatic appeal of the men pictured by Arnett. The fact that two of the men in the mural wear ties and button-down shirts goes unmentioned by Fritscher, who prefers to see the figures in the painting as 'primal,' 'aboriginal,' and 'Neanderthal.' For Fritscher, the mural marks not simply the prior existence of the Tool Box bar, but also an imagined history of homoerotic manliness stretching back to a distant, even prehistoric, past.

A final aspect of the Tool Box story that merits discussion in this context is the visitation of leathermen to the site of the demolished bar. According to Rubin, 'when the building that housed the Tool Box was torn down for redevelopment [...] old patrons came by to get bricks to keep as mementos.'[8] Rubin's account of bar patrons returning to the (now razed) Tool Box to claim material remnants of the bar might be taken as a metaphor for the practice of writing gay and lesbian history, a practice that requires the historian to retrieve bits (or bricks) of a past that can never be fully reconstructed or recovered. 'One of the problems in tracing the history of homosexuality,' writes the art historian Jonathan Weinberg, 'is that it is a history that was never meant to be written.'[9] In order to trace — or to write — such a history, we must be willing to look in places (and at pictures) that are not 'properly' situated within the domain of conventional scholarly practice. The theatre scholar David Román has argued that writing the history of queer culture means rethinking what counts as historical 'evidence' and 'documentation.' As Román sees it, some of the most salient traces of queer experience are embedded 'in oral history, cultural memory, social ritual, communal folklore, and local performance — media that do not rely on print culture for their preservation. Because this archive often exists outside of official culture, it is frequently undervalued or even derided.'[10] Román proposes that we attend more closely to queer legacies of performance and community-based art, to the ephemera and everyday life of gay and lesbian subjects.

The context in which I initially encountered the story of the Tool Box summons the sort of archival practice that Román has in mind. I first saw Michael Kelley's photograph of the Tool Box in a 1998 exhibition entitled, 'Queer and Kinky Danger: Art of San Francisco's Leather/SM/Kink Worlds,' at the Gay and Lesbian Historical Society of Northern California.[11] The exhibition, organized by the archivist Willie Walker, drew together some 200

visual and material objects — from matchbook covers to psychedelic paintings — produced by and for San Francisco's queer sex culture from the 1930s to the 1990s. The exhibition included prints, drawings, photographs, paintings, and sculptures that once decorated the walls of local bars, clubs, and bathhouses, as well as posters, buttons, greeting cards, matchbooks, t-shirts, and banners created for gay and lesbian clubs, parades, parties, contests, auctions, and orgies. Handcrafted or otherwise noteworthy examples of fetish gear and S/M paraphernalia — a purple and black flogger with oak-tanned tails and monster knots on the handle, for example — were also featured in the exhibition.

As is no doubt clear from my brief sketch of the show's contents, 'Queer and Kinky Danger' lavished curatorial attention on objects that would never be granted display within traditional art galleries or historical societies. One vitrine, for example, showcased the enamel pins and metal buttons that marked membership in various gay motorcycle clubs of the 1960s, along with motorcycle caps and other leather paraphernalia. Near this vitrine stood the plaster replica of Michelangelo's *David* in boots, leather cap, and biker jacket that once graced Fe-Be's, an early San Francisco leather bar. No small part of the historical appeal of such objects is that they were never intended to bear historical meaning in the first place. Works such as the *David* from Fe-Be's or the mural from the Tool Box were created to adorn the interiors of gay bars, not to be preserved in an archive or presented in an exhibition at a historical society. And yet, it is the unlikely introduction of these objects into archives, libraries, and historical societies that allows them to be seen — and studied — in the present. In some cases, the material modesty of the objects at issue — a set of matchbooks from the Tool Box, for example, one of which features George Washington ('father of our country') as a leatherman — retroactively imbues them with historical value and particularity. As Román suggests, studying the queer past means retooling the practices of scholarly writing and interpretation. In our case, it means rethinking the methods of art historical analysis and description in the face of an object as tiny, yet as unforgettable, as a matchbook portrait of George Washington as a leather daddy.

Notes

[1] Walter Benjamin, 'The Rigorous Study of Art: On the First Volume of *Kunstwissenshaftliche Forschungen*,' [1933], translated by Thomas Y. Levin, *October* 47 (Winter 1988): 90.

2 Benjamin, 'The Rigorous Study of Art,' 86.

3 Jack Fritscher, 'Chuck Arnett: His Life/Our Times,' in Mark Thompson, ed., *Leatherfolk: Radical Sex, People, Politics, and Practice.* Boston: Alyson Publications, 1991: 107.

4 Martin Meeker, 'The Gay *Life*: The Mattachine Society, The Mass Media, and the Creation of Gay Migrant Networks, 1963–1966:' 44. Chapter 4 of Meeker's as-yet-untitled dissertation on gay and lesbian migration to San Francisco.

5 Paul Welch, 'The Gay World Takes to the City Streets,' Part I of 'Homosexuality in America,' *Life*, June 26, 1964: 70.

6 Gayle S. Rubin, 'The Valley of the Kings: Leathermen in San Francisco, 1960–1990,' Ph.D. dissertation, Department of Anthropology, University of Michigan: 159.

7 Fritscher: 117–118.

8 Gayle S. Rubin, 'The Miracle Mile: South of Market and Gay Male Leather, 1962–1997,' in James Brook, Chris Carlsson, and Nancy J. Peters, eds., *Reclaiming San Francisco: History, Politics, Culture.* San Francisco: City Lights Books, 1998: 257–258.

9 Jonathan Weinberg, 'Speaking for Vice: Homosexuality in the Art of Charles Demuth, Marsden Hartley, and the Early American Avant-Garde,' Ph.D. dissertation, Harvard University, 1990: 14. Weinberg subsequently revised his dissertation and published it as *Speaking for Vice: Homosexuality in the Art of Charles Demuth, Marsden Hartley, and the First American Avant-Garde.* New Haven and London: Yale University Press, 1993.

10 David Román, 'Visa Denied,' in Joseph A. Boone et al, eds., *Queer Frontiers: Millenial Geographies, Genders, and Generations.* Madison and London: University of Wisconsin Press, 2000: 351.

11 Now the Gay, Lesbian, Bisexual, Transgender Historical Society, San Francisco

— Richard Meyer, 'At Home in Marginal Domains', *Documents*, no. 18 [2000], 19–32

AA Bronson
'Untitled (on Felix Partz)' (2002)

I made the photograph of Felix, which you seen on the preceding pages, a few hours after his death. He is arranged to receive visitors, and his favourite objects are gathered about him: his television remote control, his tape-recorder and his cigarettes. Felix suffered from extreme wasting, and at the time of his death his eyes could not be closed: there was not enough flesh left on the bone.

Felix and Jorge and I lived and worked together from 1969 until 1994. This communal life ended when Jorge died of AIDS on February 3 1994. Felix followed shortly after, on June 5, 1994.

These bodies are our houses. We live in them as temporary tenants for a few years, for this short lifetime. We inhabit physical structures which mimic our physical form: windows to see, temperature controls, waste disposal systems. We gather these houses in towns and cities. By day we live in these cities as if they were permanent, relatively unchanging, while at night we inhabit the continuous flux of the dream world without questioning its fluidity.

But in fact both are dream worlds, both equally fluid: we might wake up at any time from one and find ourselves in the other.

Felix and Jorge and I lived and worked together for twenty-five years: during that time we became one organism, one group mind, one nervous system; one set of habits, mannerisms and preferences. We presented ourselves as a 'group' called General Idea and we pictured ourselves in doctored photographs as the ultimate artwork of our own design: we transformed our borrowed bodies into props, significations manipulated to create an image, a reality. We chose to inhabit the world of mass media and advertising. We made of ourselves the artists we wanted to be.

Since Jorge and Felix died, I have been struggling to find the limits of my own body as an independent organism, as a being outside of General Idea. Over the last five years I have found myself, much like a stroke victim, learning again the limits of my nervous system, how to function without my extended body (no longer three heads, twelve limbs), how to create possibilities from my reduced physicality.

I have had to place Jorge and Felix and General Idea at a distance. This has been difficult, like escaping from my own skin.

Dear Felix, by the act of exhibiting this image in this exhibition, I declare that we are no longer of one mind, one body. I return you to General Idea's world of mass media, there to function without me.

We need to remember that the diseased, the disabled and, yes, even the dead walk among us. They are part of our community, our history, our continuity. They are our co-inhabitants in this dream city.

— AA Bronson, 'Untitled (on Felix Partz)', *Mirror Mirror*, published to accompany the exhibition of the same title at the MIT List Visual Arts Centre [MIT Press, Cambridge, 2002], 46

Wayne Koestenbaum
'Fag Limbo' (2004)

I live in 'fag limbo,' a useful term borrowed from artist Hernan Bas, who also employs the phrase 'nouveau sissies.' My subject today is a sensibility that I will irresponsibility call *fag* limbo, as it if were a neighborhood, a parking garage, a clothing boutique, a housing project, an asylum, or a treasured corner of anyone's mental library, with a drooled-over copy of Ludwig Wittgenstein's *Tractatus Logico-Philosophicus* alphabetized next to a cum-stained hardcover of David Wojnarowicz's *Memories That Smell Like Gasoline*. Fag limbo has always existed. In each generation, it takes new, vital forms.

Young skinny-armed art guys around town don't strive to muscle-build and don't announce a sexual orientation. It's gauche to ask. Only narrow-minded critics bother to delimit, to classify. I have no wish to reinstate defunct sexual categories. I am simply responding to a homework assignment. No one has sorted, tagged, or priced the heirlooms of identity politics, at sexuality's estate sale, where the prime items are disidentification, vagueness, and hovering.

Listen. A year or two ago, I wanted to make an experimental Super-8 nudie, *Why I Am Not A Painter*, based on the Frank O'Hara poem, which advertises his desire to hang around attractive straight men who might sleep with him if he flatters their art. Simultaneously my nudie was to be a brief remake of *Taylor Mead's Ass*, Warhol's 1964 masterpiece. My screenplay, simple, required a three-minute close-up of a young male artist's butt. Any young male artist. Didn't matter how cute.

I interviewed two artists for the role. The first demurred. He thought I was intending to make a porn flick. He said, 'I don't want to be in a film whose only purpose is to get guys hard.' We were drinking café con leche.

The second artist made things complicated by talking about concept. All I wanted was intergenerational nude artmaking, documents that would posthumously stage a truce between O'Hara and Warhol through my

post-Warholian gaze at a post-post-Warholian artist's ass, via 8 mm film, a pre-Warholian technology.

So I stopped talking to young artists about my nudie, and I hired a hustler instead. Two hundred dollars. He came to my apartment, took off his clothes. I filmed him with my Elmo. Through my south-facing apartment window, Chelsea afternoon light spread its bamboo fingers over his hairy butt cheeks, caught forever on black-and-white Kodak Tri-X Reversal 7278 film. (I always keep a spare cartridge in the fridge, in case a good ass pays a spontaneous house call.) The guy was a theater student at the New School. Physically he fit the role, but I'd wanted an artist, not a hustler, for my intergenerational allegory, my Pygmalion/Galatea film treatment of 'Why I Am Not A Painter.'

Anti-masculinist strategies – feyness, embroidery, craft, dithering, laziness, industriousness, sleeping-in, hibernation, softness, sibilance, reflection, fandom, shyness, brazenness, star-fucking – characterize fag limbo. The artists I am thinking about include _____, _____, _____, _____, and _____. And there are others. Please don't pin down the artists. Mentioning an artist as part of a 'school' is a form of hostile outing, whether or not the artist approves the appellation.

I googled the artists to figure out whether they were gay and came up with, in some cases, specific info, in most cases nothing.

Let's say that being cornered and not knowing how to defend one is this art's sine qua non.

Isolation tank and what you make of your isolation are the umbilici of this art.

Getting suicidally depressed and then suddenly feeling opulent gives this art its *je ne sais quoi*.

Not doing too good a job allows this art its accurate haruspication of 2004's innards.

Wallpaper and cum and mylar and floor stickers and werewolves and snot and flat asses are a few of this art's incidentals.

Yoko Ono and Peter Max and Kurt Schwitters and Boy Scouts have met this art.

This art cares more for music than for Marx, and it understands the beauty of *do it yourself*. Nothing wrong with hiring an assistant, if you can afford it! But let's remember the virtue of handmade *dasein*.

Don't forget that *fag* means *fatigue*.

I got into a conversation about gender with some young artists. I said that laptop computers – as visual items – contained gender codes. I also said that paintings speak gender, whether the paintings like it or not. (The young artists disagreed. Gender is passé.) I mentioned Rothko. Rothko is gendered, right? Smart young

people sometimes use 'right?' as rhetorical interrogative. I'm acquiring this habit.

Satiation, or the experience of being historically belated, can produce envious indigestion, or it can (if the artist pursues fag limbo's Zen route) catalyze lightheartedness, an anti-erudite unencumberedness, and a refusal to 'reference' in a gimmicky way. Fag limbo means taking the present moment just as it is, without the prophylaxis of peppiness (*I'm cheerful and allusive and past-oriented!*) but also without a hamfisted competitiveness. Fag limbo allows the artists, and the speculator, to pursue neighborhoods other than career, that overvisited cemetery. To embrace limbo (*you can't pin me down*) and to embrace fagginess (*my Weltanschauung is flitty*), permit outsiderness without the doldrums and loneliness of actually being an outside artist. Fag limbo interprets a former moment's addiction to the A-list as a spiritual disease, and proposes that *flunking out of art* does not preclude virtuoso strategies. You need not renounce saturation, cornucopia, richness, skill, intensity, or texture, just because you've decided to opt out of art's regular curriculum.

I'm not interested in art that wants to be successful, or that imagines a brilliant career for itself. You're welcome to work hard, or to goof off, or to dream, secretly, of bigness, but don't wear that wish on your art's sleeve. Subscribing to unsuccess's tenets, I therefore value passive-aggressive art, which is sometimes a fag limbo strategy: pretending passivity, pretending not to fight for one's place at the table, this art may meanwhile house rebarbative aggressions. [...]

One place to end is dream – how a culture and a psyche create floor shows. The oneiric items may be off today's menu, and yet whatever Yayoi Kusama meant when she filmed dot-making in the 1960's in Central Park (or so I recall) involved resuscitating dream-ideation, giving it mouth-to-mouth. If figurative or decorative elements reenter art under the aegis of *wish* or *fancy* ('I dreamt those shapes,' 'I wanted those colors,' 'I like to knit'), then art takes a salutary turn toward whimsicality as authoritarianism's antidote. I need eleven hours of sleep a night. We lack the time for a lengthy detour to Gaston Bachelard's *The Poetics of Space*, which would help us understand the crucial place that dreamwork occupies in any aesthetic utilizations of the spatial If we did not believe in space, then we could not have rooms. Without rooms, we would lack backrooms.

Dream, 12 November 2003: I French-kissed Hillary Clinton, a small woman, vulnerable, pretty, beleaguered. Was I

kissing her in order to get close to Bill, or was I kissing her for the pleasure of the act itself, and for love of Hillary? How venal was my conduct? How noble? She reminded me of a foreign-language bookstore, but also of a toy piano: she made tiny yet hard gamelan noises.

Writing about art exists, but it is a conceptual impossibility, because art has no outside: there is no space *outside* art. Writing that pretends to stand *outside* art, looking in, also necessarily dwells *inside* art. This essay has no wish to occupy a position of superior vantage, looking down at art; nor does this essay desire to occupy a position of inferior vantage, looking up to art. Nor does this essay propose a relation of equal footing, a mutual, interactive gaze between art and writing. This essay asserts that it has been swallowed by art; this essay is delighted to have been digested by art. The alimentary limbo in which this essay resides, inside art's canal, is a pleasantly claustrophobic space. Limbo is writing's always internal address within art's body; limbo is the post office box at which art's letters, written in this very type-face, always punctually arrive. Let me say it again, because I am slow today, and afraid of being misinterpreted: this essay is not *about* art. This essay, bad or good or in between, is *inside* art – not because art is an honorific to be selectively bestowed, but because art is the easiest, most available, most promiscuous category, the catchall for every enacted wish, every short-circuited fantasy. Art is not a difficult achievement. It is where we already live, and it is how we identify that, indeed we live.

– Wayne Koestenbaum, 'Fag Limbo', *Whitney Biennial 2004* [Whitney Museum of American Art, New York, 2004], 118–121

Judith Butler
'Transgender and the Spirit of Revolt' (2006)

Let me pause for a moment and recapitulate the argument so far: I am first of all trying to understand the significance of asserting an identification in language and, in particular, through a mode of address that may or may not have an existing addressee. In this sense, the assertion of identification has what we might call an apostrophic character as a mode of address. Secondly, the public assertion of cross-gendered identification seeks to break through a public interdiction on cross-gendered existence, one that

communicates a pathologizing gender norm, and that the angry and defiant mode of address is one way of making use of that pain or operationalizing that pain for other effects. Thirdly, whereas we tend to think about identifications as interior, psychological phenomenon, and norms as culturally imposed by an 'outside' world, we make an error in this regard, failing to recognize that norms not only work to make possible our emergence as subjects, but also articulate the internal topography of the psyche.

If we begin to think about cross-gendered identification, we find, I think, that we are caught up in a vacillation between sociological and psychological discourses. Invariably, we try to speak about *a girl* who finds that she identifies as a boy, for instance, and when we use this mode of description, a mode that seems both very ordinary and inevitable, we posit a sociological girl who finds herself engaged by a psychic identification that fails to conform to the psychological expectations generated by the sociological position. But does our grammar also hold the *sociological* girl separate from the *psychic* identification, and so assume the necessity of that discordance? At what point can we talk about a cross-gendered identification necessitating a shift in the way in which the sociological facts are named? Of course, the one way that happens is *that* someone asks to be addressed as boy, at which point a petition is made to change the sociological description. In fact, there are two acts taking place: the first is one of self-naming, but the second is a form of address, an address to a 'you' who is asked to now refer to this one as a boy. At this point, we can no longer speak about the identification as an exclusively psychic reality, as something that is accomplished internally, and that takes place apart from a sociological identity or a sociological scene of interlocution. On the contrary, the identification takes form as speech and as address and within a context in which being recognized in language constitutes some part of the social reality at issue here. It is within this context of addressing another with the request to be called by a different name, to be referred to pronomially through another set of terms, that we see both (a) a bid to remake social reality by altering the terms of recognition by which it is constituted and (b) a bid to the other to assist in that remaking. 'Call me a boy' can be put this way: 'live in the world in which I am recognizable as a boy: recognize me, and rework the norms of recognition by which my reality stands a chance of being constituted'. Note that we are not exactly talking about bringing

an internal psychological reality into an explicit social reality. If the identification remains inarticulate, if it has not yet taken on the form of an address, it may well operate precisely as a silence, or as a potential. So at the moment when the question is formed, or the demand is made: please refer to me from now on as John or Eric or Shawn, this a moment in which a certain fear and shame is transformed into an explicit bid or petition for recognition.

This is, then, not the transformation of a psychic phenomenon into a social one, but rather a shift in one way of living out a socially mediated and informed psychic reality to another, equally socially mediated and informed psychic reality. The psyche is thus not only formed through cultural norms that exceed and precede us, that work their way into each of us as externalities without which we cannot live. The psyche also takes form, and changes form, in *the context of an address* that makes use of the terms by which recognition is conferred to reconstitute the social reality of persons.

So what I'm trying to move toward here is an imagining of cross-gendered identification not as the affiliation to the gender that once was, but rather as a 'fantastic bid for relationality.' And I'm doing this over and against a model that would either immediately read it as repudiation or as a narcissistic solution that is in the end arelational. It may be that the boy who will not play those games with swords and fantastic wars, prefers his ribbons and his dresses, finds in what is called 'femininity' a way of articulating a set of orientations, desires, modes of appearing for another, modes of appealing to another. And it may be that the shame associated with that cross-gendered behavior is itself the cause of his withdrawal from relationality, if there is withdrawal. In these cases, we are dealing with a sociological boy who may well be negotiating his most basic relational needs through conventions of femininity. But we are also dealing with a crisis in the very notion of the sociological boy: that 'boy' is constituted not only by *how* he is addressed and perceived, but also by *the conventions* that are brought to bear on the ways he addresses himself and is addressed by others. Similarly, the putatively sociological girl who wants mainly or exclusively to play war games, to wield the sword, even save the damsel in distress, is finding something in a cultural norm of masculinity that facilitates some kind of expression, that constitutes a basic emotional vocabulary for the gendered self that she is. In my view, then, it is not that she is a sociological girl with a psychic identification that acts in dissonance

with received sociological notions or norms of girlness. She is also, through language, gesture, and the signifying dimension of bodily practice, introducing a crisis into the sociological category of the girl, demonstrating that we can't just refer unproblematically to her sociological construction as if that were over and done and settled for all time. If the social reality of gender is constituted, in part, through practices of naming — self-naming and being named by others — as well as by the conventions that orchestrate the social performance of gender, then it would seem that the sociological referent can no longer inaugurate and secure our explanation of what is happening here. It is the settled character of the sociological referent that is brought into crisis by the dissonance at work in this and other such occasions.

Is 'the boy' an inner feeling or a mode of social presentation? If it is an inner feeling, then is it not yet formed by cultural norms? Does it become 'cultural' or 'social' only through its exteriorization? The 'I' who would reflect upon itself and endeavor to come to terms with gender categories in the course of that reflection, is already constituted by cultural norms which, it turns out, are at once outside and inside — this is not only their status, but also their power. Or perhaps better put, cultural norms *negotiate* the question of the boundary between inside and outside. And since the boundary of the ego is invariably a bodily ego, as Freud suggests in *The Ego and the Id*, it would seem to me that gender is to be found neither as inside nor outside of a boundary understood to separate the two; rather, gender is to be found as a problem of the boundary that is sometimes set and sometimes lost between the two. [...]

If I turn toward Freud at this moment, it is not to come up with a diagnosis. Rather, it is to try and understand the relationship between raging and sorrow, a link that is, for most of us, not easy to understand under the best conditions. When I was addressed in that angry way, it was clear that the speaker did not think that I was there, did not think that I wanted to hear what she had to say, did not know that I had traveled that day precisely in order to hear the poems. When I came up to her to say how much I enjoyed the lucidity and rage in her poem, she thanked me, but did not know my face. For her, Judith Butler was without a face. So when I told her my name, she looked at first shocked. It led me to reflect on the way that a presumed absence conditions that rageful poem. The presumption is that queer theory is not listening to trans discourse, that queer theory is somewhere else, absent,

that it has not listened, will not listen, will not be present, will continue in its academic way, won't enter the street, the public slam poetry event. So who is assumed to be rejecting whom? And where might we find sorrow or loss in this picture, in this scene of address, an address to no one, to everyone, to anyone?

In my view, melancholia is most interesting not as a feature of an individual psyche, but as a cultural consequence of prohibited mourning. During the early years of the AIDS crisis in the U.S., it was clear that certain lives could not be named, and certain deaths could not be openly mourned because certain forms of intimate association and love were considered too shameful to admit into the public sphere. Indeed, the public sphere was in part produced by the prohibition on mourning the loss of lives that did not count as lives, the loss of loves that did not count as loves. A related form of melancholia suffuses the media coverage of the wars in Iraq and Afghanistan, since the ban on photographing caskets, dead Iraqis, and dead U.S. soldiers has worked in a pervasively cultural way to de-realize and disavow the loss of lives that occurs daily. This proscription on mourning is a way of circumscribing the domain of recognizable humans — structured by racial and gendered norms — legitimate attachments — structured by heterosexual marriage norms and implicit bans on miscegenation, to name a few. I want to suggest that this refusal to identify a life as living in accord with certain norms implies directly that the loss of that life will be no loss: it is simply the transfer from one mode of social death to a literalized version of the same.

So if I seem to situate gendered pain in the matrix of melancholy, I am not attempting to psychologize individuals, but to show how melancholia is orchestrated at a cultural and political level to distinguish between lives and loves that are recognizable and, so, subject to open and public mourning, and those that are not. In what sense, then, does transgender enter into this matrix of the unequal distribution of grievability?

[…] Freud's description makes melancholia seem to be a relation between one person and another, but I want to suggest that what can be lost is precisely a sense of place or possibility as a person. If for Freud the melancholic remains unconsciously attached or totally devoted to a lost object, then can we re-describe this situation of attachment that permits of a reading that is not centered on the subject and its interior drama in this way? For instance, are there

attachments without which there is no recognizable self, and are these attachments orchestrated by prevailing norms of recognizability? How does melancholia work as a cultural phenomenon as a consequence? If the work of the norm de-realizes a life, then that life is in some sense lost, lost before being lost, and this sense of loss is precisely what cannot be recognized. The reason, of course, it cannot be recognized, is that it is now defined as the unrecognizable, and so the life that has no place or standing as a life is precisely lost without any open mourning. The same mechanism that precludes the possibility of the life being recognized and regarded as sustainable precludes as well the possibility of the life being mourned. If the social norms that work this derealization become part of the self through an identificatory practice, then it follows that only be breaking one's loyalty to one's own derealization does some future emerge: and this has to be a loud and angry process. Only if it is gone through, does it become possible to form new subjects who might have sustainable prospects for living.

If, then, under pervasively transphobic conditions, what is repeatedly lost for transgendered peoples, and is repeatedly trying to be secured is a place, a name, a site of recognizability, then transgender desire, if we can speak this way, is bound up with the possibility of addressing and being addressed; the loss of place, the desire for place, is what emerges in that vexed scene of address in which the 'you' seems not to offer recognition, in which there is a plaint, a fuck you, an anger that can be directed outwards or inwards, or both at once when the 'you' to whom the address is directed seems not to exist or not to listen or not to offer any form of recognition. In either case, we are in the presence of an 'I' who is struggling to be heard, and who would triumph over what would silence that speaking in order, simply, to live. Perhaps this can be a point of departure for thinking about violence against transgendered people and suicide rates among queer and transgendered youth.

Can we understand such scenes of address as part of a non-solidaristic trend within sexual politics? And can we also consider that when we speak psychologically about modes of identification, we are already speaking about modes of address — even modes of withholding within address, in which case the names we call ourselves function less to refer than to facilitate a certain appeal, and a certain relationship to another. Identifications are not private property or internal realities exclusively,

but practices of address, and in this sense bound up with the scenes in which there is always the questions: *who is listening, who is there?* Importantly, the melancholic brings his or her plaint into the public, suggesting that the deficit is precisely there, in *the public world* in which no one is there to hear, no one to petition, no one who can redress and redeem the loss. When the melancholic is not indicting him or herself, she indicts the world, in 'a spirit of revolt.'

Finally, then, what conclusions do we draw? First, it seems to me that there are non-solidaristic modes of coalition for which I have been arguing for some time, and we can see here, in this discussion, how fractious debates among feminists, queer theorists, trans activists, are important ways of delineating social forms of violence and aggressive forms of politics. As much as recent sexual politics has embraced the pro-marriage agenda, it is important to keep alive an equally important, if not more important goal: the opposition to modes of gender violence that include the legal and psychiatric regulation of gender norms. In this respect, the discussion of cross-gendered identification is meant to counter those various social and psychiatric authorities that seek to exploit the concept for the purposes of pathologization. At stake is no less than a reconfigured world, one which contests the strict distinctions between inner and outer life, and which suggests that the pain that is suffered through pathologization is also the resource from which angry poems are crafted, ones that take public form, and that demand a new public capacity to hear.

— Judith Butler, 'Transgender and the Spirit of Revolt', originally published in *The Eighth Square* [Museum Ludwig, Cologne, 2006], this exceprt taken from a revised version [2011].

Julia Bryan-Wilson 'Repetition and Difference: LTTR' (2006)

'It is our promiscuity that will save us,' AIDS activist and art theorist Douglas Crimp asserted in 1987, a time often marked by the brutal vilification of gay sex, when a devastating health crisis was portrayed in the media as punishment for pleasure. Crimp defied this moralism by arguing that gay men's sexual flexibility might help them adapt to safer sex strategies. While the AIDS crisis continues, albeit cushioned for some by the effects of life-extending drugs, it is

nevertheless difficulty to render Crimp's claim intelligible today. The value of promiscuity considered literally, as Crimp did, seems impossible to imagine given the profound conservatism of much of the contemporary gay and lesbian movement. (The terms of public discourse have changed, clearly, when debates focus on the participation of gays in the institutions of marriage and the military.) Gay couples have perhaps become more tolerated in US society, but other queer practices and community formations have arguably become more limited. Given the

current, narrow visions of queerness, there are still lessons to be learned from Crimp's promotion of openness and diverse encounters.

An embrace of a kind of promiscuity, then, has driven the New York-based collective LTTR from the outset. LTTR is a shifting acronym: it started in 2001 as 'Lesbians to the Rescue' — a superhero slogan if there ever was one — and has since stood for phrases ranging from 'Lacan Teaches to Repeat' to 'Let's Take the Role.' Just as the words behind its initials are variable, so too are its membership and output. Founded by

Ginger Brooks Takahashi and K8 Hardy, LTTR has been joined by Emily Roysdon and Ulrike Müller; all four have ongoing individual practices as artists, videomakers, writers, and/ or performers, and they frequently participate in other artistic and activist projects. (Lanke Tattersall was also an editor for the fourth issue). While LTTR began as a collectively edited and produced journal, the group now also organizes screenings, exhibitions, performances, read-ins and workshops. The original phrase 'Lesbians to the Rescue suggests that someone, or something,

Cover of *LTTR* no. I, featuring a photograph from Emily Roysdon's series *Untitled (David Wojnarowicz Project) (2001–07)*, 2002

needs to be saved (the phrases is missing only an exclamation point to drive home is campy urgency) — and it is clear from the excited, even libidinal ethos of its projects that LTTR sees this redemption as rooted in desire.

In a political climate tinged by anger, defeatism, and the persistent shaming of unruly forms of queerness, LTTR's objective is a generosity based in exuberance. It is, in other words, with a purposeful critical promiscuity that LTTR puts itself forward. As Samuel R. Delaney explains in *Times Square Red, Times Square Blue* (1999), a hybrid memoir/theoretical investigation of the effects of gentrification on gay public sex in New York, it is the small exchanges of good will, modeled for him in the practices of casual sex, that make life 'rewarding, productive and pleasant.' The group's open calls for submission and the multiple audiences of its live events exhibit its willingness to engage those with whom it might not otherwise come into contact. Promiscuity, whether sexual or — in the case of LTTR as an organization — curatorial, generates all-important moments of unexpected connection.

Takashi writes in an editorial for the first issue of LTTR's journal that the project was generated out of eager curiosity, a way 'to share our big love for the homos.' Here, the term 'homo' is used in its loosest sense — LTTR explicitly refuses strict self-definitions — and this expanded meaning is quickly discerned in the journal's make-up: LTTR's critical promiscuity emphasizes bringing different bodies together across race, gender, and generation. Likewise, the contents of the journals do not conform easily to categories, and often blur the lines between art, criticism, and fiction. In the four issues produced to date (each produced in a limited edition of one thousand copies and distributed mostly in independent bookstores), contributors have included emerging artists, transgender activists, punk musicians, and established scholars. Authors have ranged from Eileen Myles to Lisa Charbonneau, Anna Bloom to Matt Wolf; and artists from Mary McAlister and Zara Zandieh to Gloria Maximo and Lynne Chan. To get a concrete sense of the publication's wide-ranging forms of production, consider the second issue (called 'Listen Translate Translate Record'), which included a CD with audio tracks by Sarah Shapiro, Wikkid, and Boyfriend, as well as an altered tampon by Fereshteh Toosi, a poster by Silka Sanchez, 'mood charts' by Leah Gilliam, poetry by Mary DeNardo, an essay by Craig Willse, and a small, stand-alone exam book, complete with a reproduced sticky note and

scrawled notes to the instructor, by Astria Suparak. With every issue, LTTR draw on the resources of friends and colleagues, sharing the labor according to skills and energies; as much as the journal stems from do-it-yourself impulses, it is always a finely wrought object.

Emblematic of its mission, the cover of the first issue features a photo (part of a larger series by Roysdon) of a masturbating Roysdon wearing a strap-on dildo and a facemask of David Wojnarowic — underlining an affective fag/dyke connection. This gesture across gender and generation provocatively suggest that LTTR's inevitable engagements with the past are hardly straightforward, and can be irreverent, joyfully perverted, or achingly intense. The group has numerous queer art/activist precedents, including the AIDS/HIV graphic-making collective Gran Fury, as well as feminist legacies such as the West-East Bag (conceived by Judy Chicago, Lucy Lippard and Miriam Schapiro in 1971 as 'an international information liaison network of women artists') and *Heresies* (formed in 1976 as an independent feminist, art, and politics publication). In fact, LTTR often explicitly references previous feminist practice, as in the title of the journal's fourth issue: 'Do you wish to direct me?', a provocative question appropriated from Lynda Benglis's pioneering video *Now* (1973). Benglis, in an autoerotic meditation on the possibilities of the then-emerging video technology, asks this query to her own on-screen image. LTTR answers her questions, dialogically, in its editorial statement, noting that 'sometimes when you call, what you get back is both an echo and a response,' and the playful commands hinted at by Benglis are taken up by the works in the issue itself, such as Liz Collins's red knit glove that directs the hand into unexpected configurations. But with its 'genderqueer' focus — instead of calling itself a strictly lesbian project, LTTR instead invokes another kind of queer/trans sociality — LTTR has an identity-defying attitude that is markedly different from separatist's moments in radical feminist art production. For example, consider the Lesbian Art Project, formed in Los Angeles in 1977 by Terry Wolverton, Arlene Raven and others. That group similarly curated exhibitions, made small publications, and programmed events, but defined itself as exclusively by and for lesbians.

LTTR's refusal of such a fixed subjectivity is not an example of what has been termed 'post identity,' implying progress beyond or transcendent of all categories, but is instead a vision of a more permeable, unbounded sense of possible

identification. The term 'queer' was reclaimed in the 1980's to signal solidarity between gay men and lesbians (even as the word came off as erasure to some dykes), and the shifting nature of the 'lesbian' in LTTR suggests a continuing search for new terminology to help us negotiate increasingly complex relationships to sex and self. LTTR thus underscores the insufficiency of the term 'identity politics' without dismissing the politics of identity.

In fact, the political resonance of LTT may be discerned best in its sprawling live events, multiform publications, and curatorial endeavors, as they reach out to a somewhat improvised network of artists, activists, and theorists that could be called a community at a moment when it is increasingly difficult to speak with any precision about what was once called the public sphere. The recent upswing in institutional interest in collaborative production may merely suggest the artistic trend *du jour* (witness the weather reports issued around this year's Whitney Biennial), but underlying this resurgence in collaboration is a deeper anxiety about shared social space today, whether virtual, ideological, or physical. Against this culture backdrop, LTTR has programmed a vibrant range of public events at numerous non-profit art spaces around New York, including the Kitchen and Printed Matter. In summer 2004, it hosted Explosion LTTR at Art in General: a month-long series of events and exhibits featuring, among other things, a talk by Gregg Bordowitz; the Toronto-based troupe Free Dance Lessons grooving with random passerby in Chinatown; music by Lesbians on Ecstasy; and a transgender legal workshop.

For the Explosion, LTTR also played matchmaker by pairing artists — most of whom did not previously know each other or each other's work — to collaborate for one day in the Art in General storefront window. One such collaboration between Leidy Churchman and Luis Jacob extended the vibe of promiscuity by installing a beige sofa in the window and inviting people to use it as a rendezvous site (*Make-Out Make-Out Make-Out Couch*, 2004). Some pairs, like Matt Keegan and Xylor Jane, whose mutual interest in pattern led to an installation featuring concentric square spirals in yellow and orange tape, have since occasionally worked together again. As the event progressed over several weeks, remnants of previous collaborations remained in the storefront, and artists responded in part to those traces, creating a palimpset-like layering. This was made most explicit by Courtney Daily and Klara Liden, who created exact

replicas of the art in the gallery space. These all-white ghost copies then spilled out over and across the street, extending the space of the gallery into the city. For example, one of the Keegan/Jane spirals was redone on the wall opposite the storefront, and it remained as a trace of this experiment for months after the residency ended. In each of these endeavors, LTTR rallies people together with ardent enthusiasm.

Enthusiasm like this, of course, is perilous, and almost always draws fire: detachment is often more critically prized. As Jacobs, one of the Explosion LTTR collaborators explains, 'To ask strangers to collaborate is risky; it's an experiment that could have collapsed. What's amazing is how well it worked.' LTTR's willingness to take such chances with their editorial choices has led to contradictory criticism. Some see its projects as hodge-podge or ragged (ie. too inclusive), while others think its process is not open enough (ie. too exclusive). Despite — or even because of — the sometimes scrappy nature of its enterprise, LTTR presents itself as a vital alternative, and not only to the art market's high gloss. It also represents a different face of queer aesthetic production, one uninterested in a consumerist 'queer eye' that knows exactly which scented candle to buy. 'Practice More Failure' was the name of the third journal, and it is a knowing one, as it highlights LTTR's emphasis on 'process and practice over product' — potential criticisms, collapses, and all.

LTTR's search for promiscuity — and all the risk and rewards that term implies — continues to motor its projects. In September 2005, LTTR hosted a release party in Chelsea for the fourth issue of the journal, featuring DJs and street performances. It was a strikingly intergenerational, heterogeneous scene, as hipsters young and old joined in the celebration, participating in interactive installations and dancing on the piers. Maybe it was merely a crowd of artists and musicians and self-declared freaks, but it was also a community — a fragile, restless one that is constantly expanding and reconstituting Feminist theorist and English professor Lauren Berlant has recently proposed that negativity and depression could be politically necessary responses to the disenfranchised character of our contemporary moment. Yet during an era of real despair, with an administration hateful of all types of difference, we also need these localized moments of pleasure and unsecured possibility, moments motored not only by passion but also a willingness to fail.

— Julia Bryan-Wilson, 'Repetition and Difference: LTTR', *Artforum* [Summer 2006]

Jack Pierson
'The Name of this show is not GAY ART NOW' (2006)

Look, I'm really sorry about how late you're all receiving this announcement. I've curated this summer group show for Paul Kasmin Gallery which opens June 8th at 293 Tenth Avenue. There is an opening from 6—8pm, and you should come, it'll be fun. The name of this show is not Gay Art Now. It seems to me the notion of Gay Art is somewhat passé and this show is an ode to its passing. It includes work by over fifty artists, not all of whom are gay, identified as gay, and not all of whom are living. The name of this show is not Gay Art Now. Maybe the link being made is about sensibility, maybe it's about society. — Jack Pierson, curator.

— Jack Pierson, 'The Name of this show is not GAY ART NOW', press release [Paul Kasmin Gallery, 2006]

Elisabeth Lebovici
'Paperback Writers' (2007)

[...] HOW TO DO THINGS WITH WORDS is a famous work of analytical philosophy. Its author, John Langshaw Austin, a White's Professor of Moral Philosophy at Oxford, was primarily interested in ordinary language. He trusted everyday words rather than philosophical concepts, deeming the former more subtle in their differences when it comes to redefining language. Unlike the Aristotelian conception of language, whose primary object is to describe the world as it is, to Austin, language is action. 'By saying, or in saying something, we are doing something.' The two opposing parties of truth or falsity, linked to the correlation between the statement and what it describes, are thus cast aside by Austin in the performative utterances he invented. 'The name (performative) is derived, of course, from 'perform', the usual very with the noun 'action.' Austin considered what he called the *performativity of language acts* by asking himself in what way one could say it is 'possible to do things with words.' The problem of performativity is thus immediately linked to the problem of transitivity. What does it mean for a word to not just name, but also perform something; in particular, to perform what it names? The triple dimension of the term — a speech act, an action, and the performing of that action all at the same time — has been debated and criticized by numerous philosophers, in particular Jaques Derrida.

In her work, Dana Wyse quotes from what she has read. These book sculptures, these shelves where a segment of her *how-to* book collection is placed, are not all that it is about.

It is also about her medicine cabinet. The pills that Dana Wyse has floated on the market since 1996 — notably in those ambiguous and ever-proliferating sites that are museum shops — are, in effect, wrapped and placed both 'in use' (the principle of their distribution) and 'out of use' (the principle of their non-consumption) by plastic bags topped with a cardboard label. Each of these labels bears an image and a performative utterance destined for its audience-recipients. So many actions to be performed.

ACCEPT THE FACT THAT YOU'RE AGING

BE A BEST-SELLING WRITER

BE A GOOD FATHER

BE BLACK

BE BLONDE

BE INCREDIBLY CREATIVE

BE PROUD OF YOUR HOMOSEXUAL SON

BE STRAIGHT

BELIEVE IN GOD

CATCH A FISH EACH AND EVERY TIME

CLONE YOUR BESTFRIEND'S GIRLFRIEND

CONVERT TO JUDAISM INSTANTLY

ENJOY ANAL SEX

ENJOY SPENDING TIME WITH YOUR MOTHER

GUARANTEE THE HETEROSEXUALITY OF YOUR CHILD

HAVE A PERFECT FAMILY

INSTANT AFRO

INSTANT ORGASM PILLS

LOOK AND FEEL CANADIAN INSTANTLY

NEVER HAVE YOUR PERIOD AGAIN

RAISE A PILOT

GUARANTEED SUICIDE PILLS

UNDERSTAND CONTEMPORARY ART

Here, we find ourselves quite far from the famous list of 107 action verbs which, in 1967—68, Richard Serra inscribed in a program of sculptural gestures that go against the resistance of materials; a list of verbs that seem suspended in the grammatical space between the infinitive, with no fallout, so to speak: 'to roll, to pleat, to fold, to tidy, to curve, to shorten, to turn, to twist, [...] to splash, to knot, to spread, to pour, to shake.' For Dana Wyse does not place her progam in the realm of 'to do' (or, at least, not solely, for the utterances in her work can also be heard autobiographically, but then why make them for potential clients?), but rather in the 'to make (someone) do', an action that inscribes itself inside the spectator's body. A body of words. That is, she invites us to abandon the raw, almost brutal, representation of the artist's action upon matter as creation. Her matter is the social body and, in a Foucauldien perspective, she designates the words that submit a person to a power which gives them the force to act — or react — if we consider the legendary power of reaction of pharmaceuticals. This power does not only repress; it makes (you) exist.

In each of her proposals, Dana Wyse's language contains a fear and a promise experienced simultaneously on two levels: a body level, and a language level. By using the infinitive or the imperative, her utterances are careful not to reveal the gender either of the subjects of the discourse (unlike the French language, which distinguishes them) or of the men or women who she is addressing. Proposals that would usually be considered absurd, or which cancel each other out (What does it mean to be a good father when you're addressing a woman? Can one be blond and have an Afro haircut? Can an orgasm be instant?), are taken out of judgement, outside of operations that decide and entrench to form a universal queer. Dana Wyse introduces a confusion that sabotages the heterosexual model of the difference between the sexes generally at play when thinking sexuality and, more broadly speaking, all binary models of difference used to represent human actions. The art of action has become an art of redistribution.

That these formulas encase pills — medication that is supposed to have an effect, to operate a chemical 'reaction' — is certainly not intended to destroy this displacement, but to condition it. Better still, to defer it. Here, we return to the quality unique to a work of art: its 'delay'. In Kafka's short story *Before the Law*, 'the one who waits for the law, sits before the door of the law, attributes a certain force to the law for which one waits. The anticipation of an authoritative disclosure of meaning is the means by which that authority is attributed and installed: the anticipation conjures its object.'

HOW I WROTE CERTAIN OF MY BOOKS

'The work is given to us divided just before the end by a statement that undertakes to explain how ...*This How I Wrote Certain of My Books*, which came to light after everything else was written, bears a strange relationship to the work whose mechanism it reveals by covering it in an autobiographical narrative at once hasty, modest, and meticulous,' writes Michel Foucault.

He is writing about Raymond Roussel, the author of *Impressions of Africa* (1911) and *Locus Solus* (1914) who, shortly before he died, held an ultimate mirror up to his work to reveal its mechanism. Far from revealing anything, *How I wrote Certain of My Books*, intended for posthumous publication in 1993, 'transforms what is revealed into an enigma.' The '*How-I*' with which Raymond Roussel heads his final work is meant to explain, yet spreads great doubts: 'By giving a 'solution', he turns each word into a possible trap, which is the same as a real trap, since the mere possibility of a false bottom opens — for those who listen — a space of infinite uncertainty. This does not question the existence of the key process nor Roussel's meticulous listing of facts, but in retrospect it does give his revelation a disquieting quality.'

The same applies to Dana Wyse's library, which offers not the secret of her artistic mechanism, but rather, its enigma.

— Elisabeth Lebovici, 'Paperback Writers', *Dana Wyse: How to Turn Your Addiction to Prescription Drugs into a Successful Art Career*, eds. M. Hunt and E. Lebovici [Editions du Regard, Paris, 2007], 154—160

Eileen Myles
'Play Paws' (2007)

I kind of acted like a gross guy with Sadie's new video. Trotted it around like the new girl in tow. So of course I even did watch it in bed with the new girl and (how guy of me is this?) she's so much smarter than I am. She used a lot of field recordings, said Paige quietly. Field recordings? What's that?

By the time I got back to California I was having dinner with Susan and Darwin and Taylor, friends of mine who happen to be a nuclear family. I figured they would have a whole other perspective on Sadie. Stupidly, I told them I was writing about her video, so anything you say might wind up in my piece. That was real brilliant of me. They promptly shut up.

There' a lot of sex — gay sex — in *Play Pause*. I keep wanting to call it *Play Paws*. Because it's fun. If you look at all of Sadie's work in a great rush you begin to see that her earliest videos are like comic books. Or circus. The bold kid titles for each little video: pure cartoon. The scribbled ransom-note dialogue is like cartoon bubbles, but torn instead of drawn and stuck on the inside of her film. Cough, I mean video.

Anyhow I'm watching *Play Pause* with my family and prior to this viewing I had been entirely approving of how Sadie scattered moments not so much of pussy-eating or fucking but of *about to* (pussy-eat or fuck) throughout her video. I've been kind of obsessed for a few years now with this thing Robert Smithson liked, an idea which *he* lifted from an anthropologist, Anton Ehrenweig, that cultures can generally be divided into two types — ones with a buried god, and ones with a strewn one. I'm thinking about sex here in place of god, and in the case of Sadie thinking that though there are artists who might actually bury their sexual content in their work (like a dog buries a bone), other artists let the sex be strewn throughout their productions. Of course all in vastly different proportions. The thing about gay content is that it's so often strewn instead of buried because you know if it's buried then you wind up in a don't ask don't tell kind of situation. It's the straight way of being gay, pretty much, and of course, what's implied by that approach is a whole lot of invisible power, ie. I think that only the implicitly powerful can readily bury their sex or their gods and not feel somewhat erased themselves as a result.

Lesbian content always pretty much has to be visible; that's how it goes. But Sadie's distribution of the item seemed to me to be on the order of like lesbian ripple or chip. A lesbian ice-cream *flavor* pretty much, rather than you know head-on lesbian shit and so on.

But when I watched it with my family, well.

It was just kind of still. These are hip people but I know everyone was thinking is it okay for me to be watching this with my kid, my parents, my friend. That quiet thought was cycling through the room. I went ha-rumph. *My friend* (I meant Paige) described these as field recordings. That's interesting, said Darwin who is a scientist. For *us* pretty much anything done outside of the laboratory is in the field. Which is the

world. And then I think well this work of Sadie's, this extremely I think allegorical cartoon of this phenomenal moment we are all living in, is a fairly scientific work. Though geeky play science. Also like Smithson! Certainly Sadie rides her bide around Chicago or wherever, this generic depressed fertile Midwestern city, and obviously for some of that time she's travelling around with a tape recorder like Alan Lomax. Getting a folk recording of the world. How it was. Sadie tells me that she started with the sex, which is so funny. She drew it first. I thought it was strewn, erupting every once in a while like a huffy little volcano. But when I watched it with my friends I was actually closer to the truth — of the piece. Sadie built a world around the real and imagined sex — the inside of the world that we know. She constructed a tiny town. But sex is the train. The game. The reason. Everyone has sex, even if they don't. She pointed out to me that it was kind generic sex. Afterwards or before. The sex is actually never happening. People are exposed, ready or else spent. And so she was thinking that that makes the sex a little more universal perhaps. She didn't use that word, but I think she meant user-friendly. It's like the sex pushed *Play Pause* like the sex was kind of god. And God says, Hey honey I'm going to go out and get some cigarettes, maybe something for us to drink, but you know since there aren't any stores or other people or bars, I'm going to have to make them so it might take a little while. So I think this is a video generated by an act of love about to happen. And the skies came first too. Those strange shifting metal sculpture skies. I think about sitting on a plane in one of those wonderful composed moods you get flying. I look up and what do you call it, the fin of the plane, had a raccoon. Look there's a raccoon out there, I said to no one into my little microphone probably in a poem. Sadie has some people having sex on the fin. No this is not subtle, this is a couple actually fucking. Let me look again. In one of Sadie's earlier films the entire screen gets filled by fish. Just swimming around in the water. It was perfect. Films are wishful, aren't they. It's just a wish floating around. A gay teen decides to stay home from school and make her own world. I told Sadie about how the most famous people I knew in New York, Allen Ginsberg and Andy Warhol, always went around with a camera. I'm looking at you buddy. That's what's going on here. Everyone was staring at Sadie when she was a kid. Trying to figure out what sex she was. So she just went and made her own fameful representation. Initially she kind of joined the staring people and her

camera was staring at her but then it started moving around, and slowly she began to replace herself. I notice in her films that when her face is talking there's no mouth on the screen. So to me the film was all mouth. Like the missing mouth was the film's moons. Its ring. And later she made masks. And a pencil drawing, a line. Soon the world was drawings on walls, signs on stores, and stores that were closed, just signs. That's a real depressed city. Ads selling things that weren't there. Remember when the world became an ad for the web. Around 1998 I think. It was great but it was hard to know anymore which world came first. Then eventually Sadie was gone. In her work. No Sadie to be found. But wasn't Sadie always a *mask*.

I drove my truck to the beach last week. I'm in San Diego. The beach is everywhere here. I sat in my truck with my computer on my lap and I pushed the button (well the picture of a button on the screen) and I watched *Play Pause* surrounded by the gleaming ocean with streams of late afternoon light jumping around on it. A film is an ocean, right. This is real, and this is real. The setting was perfect. Balanced. Some people think the world stopped a few years ago. Certainly that world that we know is gone. It seems to me that when I look at all of Sadie's work she's always taking something away to make everything else move. Someone said that this video is sad. And it is. Listen to the music at the beginning while the train rattles by in our eyes. And then there was sex and she put the world back and probably we can have everything when we're ready. If we know what to push.

— Eileen Myles, 'Play Paws', *Sadie Benning: Suspended Animation* [Wexner Center for the Arts, Columbus, 2007], reprinted in *The Importance of Being Iceland* [Semiotext(e), New York, and MIT Press, Cambridge, 2009]

Emily Roysdon
'Ecstatic Resistance' (2009)

Ecstatic Resistance is a project, practice, partial philosophy and set of strategies. It develops the positionality of the impossible alongside a call to re-articulate the imaginary. Ecstatic Resistance is about the limits of representation and legibility — the limits of the intelligible, and strategies that undermine hegemonic oppositions. It wants to talk about pleasure in the domain of resistance — sexualizing modern structures in order to centralize instability and plasticity in life, living, and the self.

It is about waiting, and the temporality of change. Ecstatic Resistance wants to think about all that is unthinkable and unspeakable in the Eurocentric, phallocentric world order.

The project is inspired by several years of witnessing and participating in projects that re-imagine what political protest looks like. And what it feels like. With one foot in the queer and feminist archives, and another in my lived experience of collectivity,[1] I first began to use the phrase as a way to think through all the reverberations and implications of the work I saw around me — work I was both invested in and identified with. Ecstatic Resistance became the form of my engagement, as both provocation and inspiration, challenge and context.

As an artist, it is very important to me to engage my peers practices and to think publicly about the terms and contexts of aesthetic production; to develop concepts and experiences from the social and aesthetic fields in which I have had the privilege to situate my life. I was moved to articulate the connections I saw developing and to make explicit a vocabulary with which these artists and their works could make an impact on multiple disciplines. I also believe it crucial to situate these works within a genealogy of activity to assert the trans-historical-ness of the subjects, events, and strategies that are expounded here. Ecstatic Resistance is a thread of historical action that if seized upon has great potential to dismantle and restructure the cultural imaginary.

My project here is to write the echoes of ecstatic resistance, a vocabulary with which we can begin a conversation and hope that the related theses set the stage for future actions and articulations. In teasing out the ambitions and potential of the diverse works that inspired this project, I climbed my way through questions of occupation, universality, the unconscious, truth, technology, risk, ethics, and more. Eventually I centralized my understanding and my desire around a few keys terms: impossible, imaginary, pleasure, plasticity, strategy, communicability; connecting these ideas to talk about the image of resistance.

Ecstatic Resistance expresses a determination to undo the limits of what is possible to be.

'I am looking for the body, my body, which exists outside its patriarchal definitions. Of course that is not possible. But who is any longer interested in the possible?'
— Kathy Acker[2]

Ecstatic Resistance develops a positionality of the impossible as a

viable and creative subjectivity that inverts the vernacular of power. By exposing past impossibilities, the actor of history is thus revealed as the outcast of the contemporary. Ecstatic Resistance works to change this by celebrating the impossible as lived experience and the place from which our best will come.

Alongside the vitalization of the impossible life, Ecstatic Resistance asserts the impossible as a model for the political. Politics is a system of that which is forbidden and cannot be done. When politics is framed as 'reason and progress' it disguises the primacy of oppression. Changing the perspective of politics away from a positivity and pointing to its limitations and selective applications, reorganizes the hierarchy of political actors. The impossible always arrives.

"It is always the first time. / The written, the imagined, / the confrontation with reality. / Must imagination shun reality, / or do the two love each other? / Can they become allies? / Do they change when they meet? / Do they swap roles? / It's always the first time."
— Lady Windermere in Johanna d'Arc of Mongolia, Ulrike Ottinger [3]

Ecstatic Resistance postulates the necessity of a new imaginary. The potential of this new imaginary is to move forward from a place that is unrestricted by patriarchal rationality and historical oppositions that serve only the man who is a man and looks like a man and wants to be a man.

Great feminist thinkers [4] have long written the desire to unbound sexual difference in the imaginary, to overthrow the rule which creates the world in which 'the woman is a defective man'. A world in which the idea of a *different* body is unspeakable within a system of meaning and recognition. Within this limited frame people have continuously composed their bodies in opposition — living, moving, struggling and improvising meaning. The persistence of these multi-valiant subjectivities has produced many things over time, but it is no longer possible to move forward without amending the imaginary harbored in our bodies and the language that comes forth from there. In order to develop this new imaginary we must be willing to disrupt our knowledge of self, and to risk unrecognizability.

This new imaginary is the recently returned phantom left hand of the impossible. It is our body map changing and reconnecting our idea of self to that which was considered impossible — to feel things that can't be seen, to believe in a body outside the limits of the intelligible.

"Health consists in having the same diseases as one's neighbors."
— Quentin Crisp [5]

Ecstatic Resistance asserts the centrality of plasticity — profoundly acknowledging the ability of brain, body, and culture to reorganize itself. Plasticity is the subterranean quake to the caked shell of modernity. It's the cross-dressing, cell splitting, boundary shifting, apology giving, friend making mirror. Getting ready for an evening when the plasticity principle pushes up on the pleasure principle and says 'Think again. Think again. Your mind has changed as quickly as the clock. The world is not pleasure, pain, and gratification, we breathe struggle, improvisation and collaboration.'

'Writing is precisely the very possibility of change, the space that can serve as a springboard for subversive thought, the precursory movement of a transformation of social and cultural structures.'
— Helene Cixous [6]

Ecstatic Resistance fundamentally alters the image and process of the political by developing strategies that bypass and subvert entrenched theoretical constructions that set the limits of the intelligible. Ecstatic strategies unearth the potential to find new ways of being in the world.

Working to renegotiate the vernacular of power and resistance, the limits of representation become scenes of improvisation in which the process of consolidation and the fallacy of transparency give way to the lived experience of contradiction and simultaneity.

Implicit is a critique of representation; explicit is the demand to recognize these strategies as significant contributions to the field of aesthetics and social change.

'It wasn't a question of communication or something to be understood, but it was a question of changing our minds abut the fact of being alive.'
— John Cage [7]

Ecstatic Resistance emphasizes 'the telling' as a key relational model between the unspeakable and communicability. Communicability is defined by the laws of legitimacy — what is possible to say. The unspeakable exists outside of articulation, law, the imaginary and even alterity. 'The telling' theoretically triangulates these terms in the form of an encounter. Significant is the formulation of speaking as a desire, a desire to share, to articulate an experience

to an / other. The telling springs forth from desire, the tension between pleasure and need forge a route to bridge the encounter. Assisted by affect, the situation becomes improvisational — 'I must find a way': to say what I mean, to share what I've seen.

'The telling' occupies a space between reportage and the creative function of self-narrativizing. The act of sharing inaugurates the potential of one experience to accumulate and become a formative moment of transformation.

Ecstatic Resistance is an inquiry into the temporality of change. Time, the time of transformation, the duration and physicality of the experience of change. And drama — the arc of history. The temporality of the ecstatic opens a non-linear experience in which connections are made at break neck pace and a moment later time appears to stop us in the dynamism of one challenging thought.

This disorganization of time is against the force of realism. It is a personal allowance that once incorporated proliferates the production of alternatives and builds new perspectives from the ruins. Excesses of experience become the fragments for the future.

Ecstatic Resistance wonders about waiting — the dynamic between action and recognition, movement and the symbolic.

Notes

[1] I worked for six years in the collective LTTR, producing an independent feminist art journal and events.

[2] Kathy Acker: Seeing Gender, in: *Critical Quarterly*, Vol. 37, Winter 1995, p.84 (found in Ulrike Müller essay, No Land Ho. Kathy Acker's Literature of the Body, springerin, volume IX, issue 1/03, Vienna, 2003)

[3] *Ulrike Ottinger*, Image Archive, Verlag für moderne Kunst Nürnberg, 2005, p.11

[4] Notably Helene Cixous and Luce Irigaray

[5] Quentin Crisp, *The Naked Civil Servant*, 1975, transcribed from film

[6] Hélène Cixous, "The Laugh of the Medusa," trans. Keith Cohen and Paula Cohen, *Signs* I, no. 4 (1976): 875—93

[7] John Cage, transcribed from radio interview, WNYC August 27, 2007, www.wnyc.org/music/johncage.html

— Emily Roysdon, 'Ecstatic Resitance' pamphlet for the exhibition of the same name at Grand Arts, Kansas City, Missouri (2009)

Billy Miller
'The Towers of Cum & Horndogs of Yore' (2011)

Up until 9/11 (a fatal event that The Man used as an excuse to implement sweeping anti-homo measures), EVERY public restroom, secluded park area, roadside stop, et al., since the beginning of time, was a potential or actual orgy room.

I stumbled upon several hot spots for public sex within my first few days in New York City back in the late-'70s, and then discovered even more when I started living here full-time in the mid-'80s. There is not enough room here to outline even a fraction of what existed until The End but one such spot was most definitely The World TRADE Center.

Stop #1 on a sex tour of the WTC would be the men's room on the lower level near the entrance to the PATH trains-where you could find rows of guys jerking off 24/7 since the day it opened 'til the day it blew up. There was every combination of guys there: from workmen, delivery boys, shop workers, executives, tourists, random dads, and well...you name it. Lunch hour was typically out of control and the cops would periodically try to bust it up by standing around for a while with their walkie-talkies turned up loud for effect, or they'd knock a nightstick on the stalls and bark something like 'OK ladies, time to break it up.' But then the minute they'd leave, the boys would be back at it. Besides the wanking at the urinals, there'd be hanky-panky going on in the stalls. One guy would stand on a toilet seat so his legs would be out of view, while another would blow or even screw his partner(s). That, or the doors would open and close as random dudes flashed boners. Some guys went there specifically for this kind of action but many would simply wander in and get caught up in the heat of the moment.

For the more in the know there were other, more private, restrooms on other floors...sometimes you'd need a key and sometimes not. Sometimes you could get access via a horny employee and other times you'd just catch the door opening as someone was exiting. In those tearooms, there'd often be more leisurely fucking and sucking going on-sometimes with multiple participants. There were also private unused offices and then one time, I followed a workman through a series of back hallways to a storage room and got busy with him there (although he was mainly into black guys with huge dicks and only settled for me on a couple occasions as a last resort I guess). In all cases, in every area of the complex of buildings, it'd be a mix of white-collar and blue-collar guys of every race, class, and ethnicity.

The best place by far though was the underground stairway and stairwells leading up from the underground parking lot. Basically, nobody took those stairs except horndogs who used it as a secluded sex spot; everybody else took the elevator — which was faster, cleaner, and more convenient. The thing about that stairwell that made it so popular was that cops never patrolled it and you could hear someone coming from several floors above or below. And THE best area of all was on the ground level because the door only opened from the inside out, so if you did hear someone coming, you'd just duck out onto the busy street and get lost in the crowd of pedestrians. Because of that feature, that part of the stairway was literally covered in decades of cum. There were also years' worth of raunchy graffiti where guys would write stuff like 'Meet me here on Tuesday to get fucked by my 10".' etc. Used condoms were strewn everywhere and obviously the workmen and anyone else who happened to see that area could have figured out what was going on there and how often(!) Shit, a retarded squirrel could have seen that in about a half second. I have no idea how it got there, but I swear I once saw a thin plastic mattress tucked under the stairs, presumably for fucking. Anyways, I could go on and on, and that was just one of many, many places I knew about in the Manhattan, Brooklyn, Queens, Staten Island, and the Jersey City metro area.

This is prolly enough type here for your thing but back in the day I met a very experienced guy who marked up my subway map with various hot spots around the city and told me what time of the day or night was best for each location. It'd be one of the men's rooms in the subway early in the morning (yes, they had restrooms in the subway!), Borough Hall an hour after that (where you'd see Hasidic boys and men jerking off), WTC to catch the rush at lunch hour, Washington Square Park a bit later, and so on.

Anyways, it all ended everywhere in every part of the country over a decade ago and is regrettably ancient history now. But I know for a fact that there was dick sucking and butt fucking going on there the day the planes hit those buildings. I have talked to at least one guy who was THERE, and narrowly escaped. And since it was always going on, well...'nuff said.

— Billy Miller, 'The Towers of Cum & Horndogs of Yore', originally published under the name Aiken Forrett, *Petite Mort: Recollections of a Queer Public* [Forever & Today, New York, 2011]

Wu Tsang
'Untitled (Whitney Biennial catalogue essay)' (2012)

There is a bar called the Silver Platter in the MacArthur Park neighborhood of Los Angeles that has been a safe space for a group of immigrant transgender women — to earn a living, create community, and to form a chosen family — for decades. Or at least, that's the story I wanted to tell. I came to know the Silver Platter through Wildness, a performance-party that I co-organized at the bar from 2008–10 with my friends Asma Maroof, Daniel Pineda, and Ashland Mines. In deciding to make a film about my experiences there, I was torn between my desire to 'give voice' to an under represented movement (critical trans resistance) and the problems of representation itself—the burden of speaking on behalf of experiences that were not entirely my own. These negotiations were held in the balance by the daily challenges of doing the Wildness party, which strove to be a fun, entertaining, and critical space that was respectful and engaging of its site, and willfully not a site for any one group of people or form of creativity. I felt I needed to reach beyond the visual art audience, but still I wondered: who was I really making this film for, and why? The project became as much about the process (from within which I still write) as the product, a realization that led me to make my private artistic decisions public in the form of a blog called CLASS. Central to all this was an unresolved question. I'd set out to make a film about a safe space, but what did that mean? What is a 'safe space,' and can it ever be said to really exist?

According to the nonprofit GLBTQ organization Equality Network, the average lifespan of transgender people worldwide is twenty-three. Known causes of early death are suicide, murder, homelessness, criminalization, imprisonment, poverty, risky behavior — i.e., all the stuff that makes for the expected dramatic trans narrative. But there is also a more insidious violence: the violence wielded by the seemingly banal and neutral agencies of state administration — the DMV, parole officers, homeless shelters, criminal courts, the U.S. Immigration and Customs Enforcement, and departments of housing, unemployment, social security, and welfare, to name a few. Critical trans political resistance tries to expose how these entities systematically exclude and collude against gender variant people, as well as poor people, immigrants, people with disabilities, and people of color.

This kind of violence doesn't kill us outright; it shortens our lives through consistent exposure to violence, humiliation, and deprivation. Living in Los Angeles today, in a social climate that is demonstrably and increasingly hostile to immigrants (as evidenced by the passage of SB 1070, H.R. 4437, and other anti-immigration laws), it is hard to imagine a more intense time and place to be poor and trans and undocumented. Without a doubt, the Silver Platter is a refuge, a place where we can live a kind of life made almost impossible by contemporary conditions of oppression. It's a space not only where trans people 'get by'; it's a place where we can party and make art, have friendships and drama – and really live life. But is it a 'safe space'? I once asked Gonzalo Ramirez, the seventy-two-year-old owner of the Silver Platter, if he thought of the bar as such. His response was very matter of fact: 'Yes, we have security guards every day.' I struggled to communicate what I meant by 'safe.' I knew the bar had been around since the early 1960s, and I was digging for Stonewall-era stories. Did the place ever get shut down? Were there raids by the cops? Queens pumping their fists in the air? It turns out the bar has been gay on this block for forty-eight years, virtually without trouble. 'Simply put, the city does not bother us at all,' said Gonzalo. Except for people sometimes driving by and throwing eggs or insults, the Silver Platter has remained in peaceful coexistence with its surroundings. I remember being a little confused by this first interview because it didn't fit with my idea of queer liberation. But I felt such a strong connection to the energy and to the scene that I was compelled to keep trying to put the pieces together. With the help of many participants, friends, and a documentary crew over a two-year period, we filmed more than thirty interviews and 150 hours of life at the bar. I thought that I'd already come to know the place inside and out, but the story of Silver Platter that emerged was far more singular, radical, and complex than I could ever imagine. Many voices tell the story. The Silver Platter was founded in 1963 by Rogelio Ramirez (Roy for short). He was a handsome, charismatic guy, and wherever he opened shop, the gays would flock together. He had several bars around town, but this one remained the longest. Birthdays, dancing, fucking in the alleys; the guys with the tejano boots and leather jackets – the place was alive. It was packed by 6 p.m., full of people parading in and out. There was just a dance floor and a jukebox (no DJ); besides a few coats of paint, it looks exactly the same today. Roy was there every night – hosting, match-making, dancing across the room and offering people soup to cure their hangovers. At the end of the night, he would holler, 'You fucking queers, you get outta here right now and go suck dick in MacArthur Park. It's time to leave, bitches!' He worked a straight job during the day and ran the bar late into the night, sometimes until 4 or 5 a.m., inviting folks back to his apartment to make a morning of it. Everyone knew and adored him; all the bartenders were his boyfriends.

He looked out for his little brother Gonzalo when times were tough: 'Don't worry about being out of a job. Here's some money for your rent and to stock up your fridge. And next week we'll see what we can do.' Everyone seems to remember those early years as happy and prosperous. Then came the 1980s. Even as many of the regular crowd got sick and died, people were too scared to speak openly about AIDS. 'We just kept them company and went to all their the funerals –,' Gonzalo said. Roy died of AIDS in 1991, and he left the bar to two of his younger siblings, Gonzalo and Gloria, who were both gay. He said to Gonzalo: 'Continue everything exactly as it is, as normal as possible. And to the person that helps you, or is good to you, if later on you want to pass it on to them, well then, so be it.' That person turned out to be Gonzalo's long-time partner and best friend Koky Corral, who's been bartending there for over twenty-two years. Gonzalo said, 'Now he is the owner of half of it. I already put it in a will. I'm prepared for everything.' To this decree, Koky admitted, 'Well, I feel some pressure…. His brother passed this place down to him, and now he's giving it to me, and to keep this place running on track, to keep moving forward…. We will do it as long as we can, God willing.' Gonzalo's other brother, Julio, and his wife, Nora, also feel a deep, special attachment to this place. Nora recalls being seventeen the first time she went to the bar in the late 1970s, and she was instantly captivated by the women – the *vestidas* – the ones who 'dressed up.' There weren't many in those days, because Roy didn't allow it. 'If you want to come in, come as a man. You can dress up outside in the streets,' he used to say. But Gonzalo and Gloria were more open and accepting of the newer generations, and things started to change after they took over. First came one, then two, then three, four, and now it's everyone. 'The transformation has been substantial,' says Nora. 'They put on a dress, and they never want to take it off.' Nicol, the doorwoman, confides that these little changes happen all the time: 'Many people who come here realize it's ok to come dressed as a woman, and there are some people who have always had that fantasy…. The next day they go buy themselves a wig, and there you go.' In recent decades the Silver Platter has become a beacon for trans youth migrating from Mexico and all over Central America: Guatemala, Honduras, El Salvador. The weekend belongs to them, *las chicas*, and their stories intertwine. 'It feels almost just like the place where I came from,' says Viki. 'I've been coming here since I arrived seven months ago,' says Griselda. It was the first place Yasenia came when she arrived from Guatemala "exactly five years ago." 'When they arrive they are struggling,' Nora says. 'They work in restaurants, as hairdressers, cleaning – El Pollo Loco, McDonalds – various jobs,' says Gonzalo. 'We have to show them the way,' says another patron, Rosario. 'For example, if they want to get into prostitution, then they need to protect themselves, watch out for this or that. Let's look for a job instead, that even if it's low paying, then you're doing something decent and will get ahead.' Like most everywhere else in Los Angeles (and in the country, for that matter), MacArthur Park is not safe at night if you're visibly trans. Morales, the director of the weekend drag show, says, 'If I go out wearing my blond wigs trying to dominate outside, someone will walk by and they're going to break my mouth. But if I leave the bar normal and get into my car and go home, nothing is going to happen." Nicol, who lives full-time as a woman, has a different experience:

'Even if we dress regularly, bad things happen to us.' And, she adds, those outside prejudices still have a way of seeping into the bar: 'To this day, whenever someone comes in here calling themselves "straight," they are always either violent or rude.' Such problems aren't confined to so-called outsiders. Regulars at the Silver Platter split off into cliques, factions; there's cattiness, back-stabbing, and, on occasion, an all-out fight. 'Maybe because of what they have had to live through back in their countries, I feel that maybe that's the reason that they come here with that violence,' says Rosario. 'I think they no longer do it from a place of malice, but from instinct. They're constantly on the lookout to see who's giving them the wrong eye.' There's plenty of alienation and loneliness at the Silver Platter, too. Venus, who's been coming for thirty years, says, 'I've always sat in this corner. This is my favorite spot. So these girls now come to a scene that they believe is theirs…. When they find me here, they start to make a mob in front of me, and I'm mortified by that. They don't greet me, they start waving their hair.' Yasenia says knowingly, 'You're ok as long as you

don't have any problems with anyone else.' I wondered if 'community' was just another form of coexistence, the simple fact of occupying space together. Yet it's hard to deny the magical, magnetic quality the Silver Platter exerts. People come back again and again, and they often become regulars over a long period of time. After twenty years, Betty says, 'I won't ever leave, God willing.' When Nora closes her eyes and pictures the outside of the bar, she sees the people who have died, lingering around this spot. It's as if they want to stay, even after they're gone. So is the Silver Platter a refuge from a crazy, hateful world out there? Sometimes it definitely feels like it to me. On Fridays, I can never find parking nearby, so I have to run, teetering in too-tall heels or after too many drinks, until I make it safe inside. Its warmth is something I had never known before. But I also bring to it my own experiences: I am trans/feminine, yes, and a second-generation immigrant, and like many of the women at the Silver Platter, I have been running my whole life from an emotionally unsafe home. But I also have a college education, and as an artist I'm part of a socially mobile class; I myself may not have a lot of money, for example, but I recognize that I have tremendous access to wealth and resources through a network of artist friends and associates. I wrestled again with what 'safe space' means. It seemed the definition could be slippery and shift depending on class and privilege. What is a safety net, and who has one?

— Wu Tsang, untitled essay, *Whitney Biennial 2012*, eds. Elisabeth Sussman and Jay Sanders, eds. [Whitney Museum of American Art, New York, 2012]

Artists' Biographies

BERNICE ABBOTT [b.1898, Springfield, Ohio, USA; d.1991, Blanchard, Maine, USA] documented the landscape of New York. Training her camera on the city's diverse residents and its changing architecture, her work became a study in urban design. Abbott began her photographic career as a darkroom assistant to Man Ray in Paris, with whom she later exhibited at the Salon de l'Escalier, Paris. She is credited with saving the work of Eugène Atget by purchasing his archive and tirelessly promoting his work.

AMY ADLER [b.1966, New York] lives in Los Angeles. Her paintings examine notions of authorship by exploring the relationships between artist, subject and viewer. Solo exhibitions include 'Director' at the Museum of Contemporary Art in San Diego [2006] and 'Amy Adler Photographs Leonardo DiCaprio' at the Hammer Museum of Art in Los Angeles [2002].

GÖSTA ADRIAN-NILSSON [b.1884, Lund, Sweden; d.1965, Stockholm] belonged to the early modernist school and was influenced by Fernand Léger. The undisguised homoeroticism of his work interfered with his critical success during his lifetime. His work is included in the collections of the Ateneum Art Museum in Helsinki and the Moderna Museet in Stockholm.

LAURA AGUILAR [b.1959, San Gabriel, California, USA] lives in Los Angeles and uses black and white photography and video to make work about her identity and status as a lesbian Hispanic-American. Her work has been included in 'Shifting Terrains' at Zone Gallery in Newcastle, England [1997] and 'Sexual Politics: Judy Chicago's *Dinner Party* in Feminist Art History' at the Hammer Museum of Art in Los Angeles [1996].

DAVID ALTMEJD [b.1974, Montreal] lives in Montreal and London. His sculptures and installations incorporate elements of fantasy and the grotesque, and use decay in order to suggest the possibility of growth. His exhibitions include the 2008 Liverpool Biennial, the Canadian Pavilion at the 2007 Venice Biennale, and the 2004 Whitney Biennial in New York.

STEPHEN ANDREWS [b.1956, Sarnia, Canada] uses mediated materials, including obituaries and images disseminated on the internet or television, to comment on the transmission of information and memory. His subject matter, including war crimes and AIDS-related deaths, calls into question objective truth and dehumanizing behavior. His work has been featured in solo exhibitions at the Power Plant in Toronto [2007] and the Cue Art Foundation in New York [2004].

PATRICK ANGUS [b.1953, North Hollywood, California, USA; d.1992, Los Angeles] is considered an important contributor to American social realism. His paintings and drawings reveal the goings-on of the 1980s-era New York gay underground and hint at the loneliness of urban life. The Leslie-Lohman Gay Art Foundation in New York organized the exhibition 'Slave to the Rhythm: Patrick Angus and the Gay 80s' [2004] as a tribute to the artist.

CHUCK ARNETT [b.Charles Arnett, 1928, Bogalusa, Louisiana, USA; d.1988] became known for murals that he painted in gay bars in San Francisco and New York. His best-known work is a 1963 painting at the Tool Box in San Francisco, one of the first leather S/M bars. A photograph of this painting later appeared in a *Life* magazine article that proclaimed San Francisco to be America's 'gay capital'. Arnett's first retrospective, 'Lautrec in Leather: Chuck Arnett and the San Francisco Scene', was organized by the Gay, Lesbian, Bisexual, Transgender Historical Society in San Francisco [2008].

ASCO was a performance art collective active from 1972 to 1987 in East Los Angeles. Taking its name from the Spanish word for nausea, its core members were Harry Gamboa Jr, Gronk, Willie Herrón and Patssi Valdez. Through multimedia and performance work, the group lambasted not only high art and cinema but also the nationalism of the Chicano arts movement.

ASSUME VIVID ASTRO FOCUS [AVAF] is an art collective comprising Brazilian-born artist Eli Sudbrack, French-born Christophe Hamaide-Pierson and a shifting cast of collaborators, working in a variety of media, creating wallpaper designs, music videos, large-scale installations, T-shirts, and floor stickers. In 2005 AVAF enlisted the artists Anna Sew Hoy, Giles Round and Paloma Mentirosa to create *HOMO CRAP #1*, an immersive installation at the Museum of Contemporary Art in Los Angeles.

CHARLES ATLAS [b.1958, Saint Louis] lives and works in New York City. His work includes performance, installation, film and video. He began his career as the filmmaker-in-residence for Merce Cunningham Dance Company [1978–83]. He went on to help forge the genre of media-dance, the practice of choreographing works specifically for the camera. He has collaborated with Marina Abramovic, Leigh Bowery, Michael Clark and Yvonne Rainer, among many others. His work has been shown internationally at institutions including the Whitney Museum of American Art, New York; Centre Georges Pompidou, Paris; and Stedelijk Museum, Amsterdam.

ALICE AUSTEN [b.1866, New York; d.1952, New York] was one of the first American women to be recognized as a photographer and to work outside the confines of a studio. Born to a life of privilege in Staten Island, she documented both family life in the Gilded Age and the circumstances of immigrants and workers in Manhattan, while her photographs of her circle of independent female friends include many signifiers of the 'new woman'. In 1899 Austen met Gertrude Tate, who would become her lifelong companion. Both women died in poverty. Austen gained some recognition for her photographs before her death when some were published in Oliver Jensen's book *The Revolt of Women* [1951].

RICHARD FAYERWEATH BABCOCK [b.1887, Denmark, Iowa, USA; d.1954, Evanston, Illinois, USA] was an American illustrator known for his military recruiting posters. He was associated with the Art Students League and the Works Progress Administration. His work has been exhibited at the Art Institute of Chicago.

FRANCIS BACON [b.1909, Dublin; d.1992, Madrid] captured the anxieties of the modern condition, emphasizing images of sexuality, violence and isolation. The individuals in his Surrealist-influenced paintings often possess animal-like qualities. He represented Britain at the Venice Biennale [1954], and important retrospectives of his work have been presented by several major museums, including the Musée National d'Art Moderne in Paris [1996] and Tate Modern in London [2008].

LÉON BAKST [b.1866, Grodno, Russia; d.1924, Paris] was a Russian portrait painter and revolutionary costume and

set designer for theatre productions and ballets. With the artist Sergei Diaghilev, Bakst founded the Ballets Russes and the periodical *World of Art*. Later in his career he taught in a Saint Petersburg school at which Marc Chagall was a student.

ALVIN BALTROP [b.1948, New York; d.2004, New York] cruised the area around the Hudson River piers in Manhattan and photographed the landscape, sex and crime that unfolded there in the 1970s. Group exhibitions include 'Darkside: Photographic Desire and Sexuality Photographed' at Fotomuseum Winterthur [2008] and 'Homomuseum' at Exit Art in New York [2005].

JUDIE BAMBER [b.1961, Detroit] lives in Los Angeles. Drawing and painting from photographic sources, she blurs the boundary between mark-making and the mechanically reproduced image. Her work encompasses a range of cultural and autobiographical content, including female genitalia, seductive seascapes and photographs of her father. Exhibitions include 'Judie Bamber: Further Horizons' at Pomona College Museum of Art in Claremont, California [2005].

DJUNA BARNES [b.1892, Cornwall-on-Hudson, New York, USA; d.1982, New York] was a key figure in New York's Greenwich Village bohemian life in the 1910s, as well as a mainstay of the Paris expatriate lesbian scene in the 1920s and 1930s. Barnes played an important role in the development of modernist writing with lesbian themes. Her books include *The Book of Repulsive Women* [1915]; *Ladies Almanack*, published under the pseudonym 'A Lady of Fashion' [1928]; *Ryder* [1928], dedicated to her longtime companion, Thelma Wood; and *Nightwood* [1936]. Barnes's writing was often stunningly bawdy in its representations of lesbian sex. The US Postal Service refused to ship *Ryder*, and T. S. Eliot himself excised parts of *Nightwood*.

RICHMOND BARTHÉ [b.1901, Bay St Louis, Mississippi, USA; d.1989, Pasadena, California, USA] was educated at the Art Institute of Chicago and relocated to New York, where he became affiliated with artists of the Harlem Renaissance. His sculptural works often depicted African-American figures and explored racial politics, religion and sexuality.

CRAWFORD BARTON [b.1943, Georgia, USA; d.1993, San Francisco] documented gay culture in San Francisco in the 1960s and 1970s. His work was featured in the exhibition 'New Photography' at the city's M. H. de Young Memorial Museum [1974] and in periodicals such as *The Advocate* and the *Bay Area*

Reporter. A book of his photographs, *Beautiful Men*, was published in 1976.

AUBREY BEARDSLEY [b.1872, Brighton, England; d.1898, Menton, France] was an illustrator and author known for his homoerotic line drawings. He illustrated Oscar Wilde's play *Salomé* and a privately printed edition of Aristophanes' *Lysistrata*. Beardsley also served as art editor for art and literature quarterlies such as *The Yellow Book* and *The Savoy*.

CECIL BEATON [b.1904, Hampstead, England; d.1980, Broadchalke, England] immersed himself in the worlds of high society, fashion and theatre as a stage and costume designer and fashion photographer. His penchant for unusual poses and props is considered an early manifestation of camp. His photographs appeared in *Vanity Fair*, *Vogue* and *Harper's Bazaar*, and he became the Royal Family's official portraitist.

ALISON BECHDEL [b.1960, Lock Haven, Pennsylvania, USA] is a cartoonist best known for her comic-strip *Dykes to Watch Out For*. First published as a one-off cartoon by *Womannews* in 1983, the strip was picked up by other outlets and acquired a regular cast of characters. Bechdel later produced a short-lived strip titled *Servants to the Cause* for *The Advocate*, as well as the graphic memoir *Fun Home: A Family Tragicomic* [2006].

SADIE BENNING [b.1973, Madison, Wisconsin, USA] began making videos on a Pixelvision camera when she was fifteen years old, using diaristic text and imagery to convey the complexities of adolescence. Her more recent work has moved into animation, film and painting. Benning's solo exhibitions include 'Sadie Benning: Suspended Animation' at the Wexner Center for the Arts in Columbus [2007] and 'Play Pause' at the Power Plant in Toronto [2008].

RUTH BERNHARD [b.1905, Berlin; d.2006, San Francisco] created photographs ranging from studio-based still lifes to complex nudes and commercial portraits. A colleague of Minor White, Edward Weston and Imogen Cunningham, she produced work for over seven decades. Her photographic career and her often-speculated-about love life is the subject of Margaretta K. Mitchell's biography *Ruth Bernhard: Between Art and Life* [2000].

FORREST BESS [b.1911, Bay City, Texas, USA; d.1977, Bay City] believed that his artistic imagery formed a blueprint for an ideal human state. He attempted to advance his medical and psychological theories, which sought immortality via pseudo-hermaphroditic alteration. His relatively small body of paintings was periodically exhibited at Betty Parsons Gallery, New York.

DANA BISHOP-ROOT [b.1981] lives and works in Bradrock, Pennsylvania. She is an artist and designer interested in public space, sustainability and community engagement. She is a member of the arts-based community organization Transformazium. Originally based in New York City, the group relocated to Bradrock, Pennsylvania to deconstruct a parish house they acquired after it had been abandoned. She participated in The People's Biennial in Haverford, Pennsylvania in 2012.

ROBIN BLACK [b.1975] is a photographer based in Los Angeles, who has published in magazines such as *Butt*, *Color*, *Dossier*, and *Blend*. She is the editor and founder of *The New Tough* zine. She has shown at the Ronald Feldman Gallery, New York [2012] as well as Los Angeles Contemporary Exhibitions [2012].

NAYLAND BLAKE [b.1960, New York] is an artist, writer and curator who lives in New York. His sculptural installations and performances use playful and subversive tactics to address the complexities of identity, health and relationships. With Lawrence Rinder, Blake curated the pivotal exhibition 'A Different Light' at the Berkeley Art Museum in 1995. Solo exhibitions include 'Some Kind of Love: Performance Video 1989–2002' at the University of Maryland's Center for Art and Visual Culture in Baltimore [2003 and tour] and 'Three photographs, three mirrors, a sculpture and a sign' at Gallery Paul Anglim in San Francisco [2007].

ROBERT BLANCHON [b.1965, Boston, USA; d.1999, Chicago] employed a variety of media and conceptual strategies to plumb tropes and concerns of gay life in the 1990s. His materials included hankies, sympathy cards, stains, tattoos and references to plagues. Solo exhibitions have included White Columns in New York [1995] and Artists Space in New York [1994].

ROSS BLECKNER [b.1949, New York] lives in New York and Sagaponack, Long Island. Bleckner's paintings, though formally shifting over the course of his career, express his continued interest in light and mortality. Often using abstraction or organic forms, he creates works that are seductive and hypnotic. His first solo museum exhibition was organized by the San Francisco Museum of Modern Art [1988]. His work has since been the subject of numerous solo exhibitions, including a mid-career retrospective organized by the Solomon R. Guggenheim Museum in New York [1995].

GIOVANNI BOLDINI [b.1841, Ferrara, Italy; d.1931, Paris] was an internationally recognized portrait painter who settled in Paris in 1871.

He was nominated commissioner of the Italian section of the Paris Exposition [1889].

ROSA BONHEUR [b.1822, Bordeaux; d.1899, Thomery, France] painted landscapes and animals in the realist tradition. Her most famous painting is the monumental *Le Marché aux Chevaux* [Horse Fair, 1855], almost 5 metres in width. Bonheur sought a police permit to wear men's clothing, nominally to better perform her work, and, after debuting in the Paris Salon of 1841, her artistic career often eclipsed her male counterparts. She was the first woman to be awarded the Légion d'Honneur [1894].

ANDREA BOWERS [b.1965, Wilmington, Ohio, USA] lives in Los Angeles. Her work reflects both her aesthetic and political concerns. Her drawings and videos often centre around the idea of bearing witness to history and civil disobedience in the context of political activism. Solo exhibitions include 'The Weight of Relevance' at Secession in Vienna [2007] and 'Nothing is Neutral' at REDCAT in Los Angeles [2006].

LEIGH BOWERY [b.1961, Melbourne; d.1994, London] moved to London in 1980, where he appeared in extraordinary costumes and makeup in the fashion and underground clubbing scenes. In 1993 he formed the rock band Minty, and he performed his notorious 'birth' piece with Nicola Bowery at numerous venues and events including the 'Fête Worse Than Death' at Hoxton Square in London [1994]. A posthumous exhibition was held at Tanya Bonakdar Gallery in New York [1995].

MARK BRADFORD [b.1961, Los Angeles] lives in Los Angeles, CA. He primarily works at the intersection of collage and painting, framing scavenged materials through discourses of abstraction. His large-scale works frequently explore underground economies, migration, public space and political activism. His works have been included in exhibitions such as the São Paulo Biennial [2006]; the Whitney Biennial [2006] and 'inSite: Art Practices in the Public Domain' [2005]. He received the Joan Mitchell Foundation Award in 2002, the Louis Comfort Tiffany Award in 2003, the Bucksbaum Award in 2006, and a MacArthur Fellowship in 2009.

JOE BRAINARD [b.1942, Salem, Arkansas, USA; d.1994, New York] created assemblages, designed theatre sets, appropriated the comic book form for his drawings and paintings, and collaborated with New York School poets. His published memoir, *I Remember*, is a vivid account of his own working process and his circle of friends and collaborators, and his life has been documented in a biography [2004] and a documentary film [2012]. Retrospectives of his work have been organized by Tibor de Nagy Gallery in New York [1997] and the Berkeley Art Museum [2002 and tour].

BRASSAÏ [Gyula Halász, b.1899, Brassó, Hungary (now Romania); d.1984, Beaulieu-sur-Mer, France] moved to Paris in 1924, where he learned photography. His nocturnal images were compiled in *Paris de Nuit* [1933], a book that helped launch his career. During the 1920s and 1930s he photographed the Paris demi-monde, recording prostitutes, transvestites, homosexuals, pimps, johns and madams, as well as bars and masked balls. Exhibitions include retrospectives at the Museum of Modern Art in New York [1968] and the Centre Pompidou in Paris [2000 and tour].

KAROLINA BREGULA [b.1979, Katowice, Poland] is a Warsaw-based artist, videographer, film director and photographer. She has shown widely in Eastern Europe as well as in Germany and the United States. Bregula moved to Sweden in 1999 to study photography at Folkuniversitet in Stockholm and worked in 2002 as the official photographer of the rock festival Popaganda. She has since returned to Poland and dedicates much of her art and film work to fighting various forms of intolerance.

DEBORAH BRIGHT [b.1950, Washington, DC] lives in Boston. Her groundbreaking anthology of images and writings on photography and sexuality, *The Passionate Camera: Photography and Bodies of Desire*, was published in 1988. Bright is professor of photography and art history at the Rhode Island School of Design. Her photographs have been included in 'Only Skin Deep: Changing Visions of the American Self' at the International Center of Photography in New York [2003] and 'Photography and the Feminine' at Senac University's Photography Gallery in São Paulo [2006].

AA BRONSON [Michael Tims, b. 1946, Vancouver, Washington, USA] lives in New York. In 1969, with Jorge Zontal and Felix Partz, Bronson founded General Idea. The group remained active until 1994, when Zontal and Partz died of AIDS. Much of Bronson's solo work deals with trauma, loss and death. He has had solo exhibitions at Secession in Vienna [2000] and at the Power Plant in Toronto [2003]. He has also been active as a curator, writer and publisher, and from 2004 to 2010 he was Executive Director of Printed Matter in New York.

KAUCYILA BROOKE [b.1952, Oregon City, Oregon, USA] lives in Los Angeles. Using photographs and text, she produces narratives that address sexuality, as well as the enculturation of nature and the naturalization of culture. She teaches in the photography programme at the California Institute of the Arts. Her solo exhibitions include Kunstverein Springhornhof at Neuenkirchen, Germany [2005], Platform in Berlin [2004], Michael Dawson Gallery in Los Angeles [2001 and 2005] and Art Resources Transfer in New York [2001 and 1999].

ROMAINE BROOKS [Beatrice Romaine Goddard, b.1874, Rome; d.1970, Nice] specialized in portraiture, rendering her friends and lovers in shades of grey, which she used in protest against the prevailing Victorian aesthetic. Briefly married, she enjoyed flings with figures such as Gabriele d'Annunzio and Ida Rubenstein. Brooks is known for her depictions of figures in the lesbian Paris of the 1920s, including her own lovers. She had a fifty-year relationship with poet and novelist Natalie Clifford Barney [1876–1972]. Brooks's solo exhibitions include Galeries Durand-Ruel in Paris [1910], Galerie Jean Charpentier in Paris [1925] and 'Amazons in the Drawing Room: The Art of Romaine Brooks' at the National Museum of Women in the Arts in Washington, DC [2000].

TOM BURR [b.1963, New Haven, Connecticut, USA] lives in New York. His work in sculpture, installation, drawing and photography addresses architecture and public space and their tangential psychological and social affects. Solo exhibitions include 'Black and Blue' at Galerie Almine Rech in Paris [2008], 'Tom Burr: Extrospective: Works 1994–2006' at Musée Cantonal des Beaux Arts in Lausanne [2006] and 'Moods' at Secession in Vienna [2007].

JOHN BUTTON [b.1929, San Francisco; d.1982, New York] and MARIO DUBSKY [b.1939, London; d.1985] were commissioned in 1971 by the Gay Activists Alliance [GAA] to paint a mural at the New York Firehouse, the organization's headquarters. Public images with gay themes, such as their mural, became more prevalent following the 1969 Stonewall Rebellion.

HELENA CABELLO [b.1963, Paris] and ANA CARCELLER [b.1964, Madrid] live and work in Madrid as Cabello / Carceller, an artistic partnership initiated around 1994. Their combined education includes stints at Complutense University and Autonoma University, Madrid, as well as studies in new genres at the San Francisco Art Institute.

CATHY CADE [b.1942, Hawaii] is an author, publisher and photographer based in Oakland, California. She is a longtime activist who participated in the civil rights, gay liberation and

women's liberation movements, and her photographs are intricately linked to her work for social justice. She is the author of *A Lesbian Photo Album: The Lives of Seven Lesbian Feminists* [1987].

PAUL CADMUS [b.1904, New York; d.1999, Weston, Connecticut, USA] was a figurative painter who came to national attention as a result of the US Navy's confiscation of his 1934 painting *The Fleet's In!*. Though his work of the late 1940s and 1950s was somewhat eclipsed by the rise of Abstract Expressionism, he enjoyed a loyal collecting base [including Cole Porter, Lincoln Kirstein and, later, Malcolm Forbes] throughout his long career. In the 1970s, he was reclaimed by the gay press as a pioneering figure whose homoerotic art had cleared the way for Tom of Finland and Robert Mapplethorpe, among many others. Cadmus continued to make art, including numerous nude sketches of his lover Jon Andersson, until his death a few days shy of his ninety-fifth birthday.

MIKE CAFFEE worked as a graphic designer for many San Francisco gay businesses and publications. He produced art for *Vector Magazine* and designed the logo for Febe's bar by modifying Michelangelo's 'David' into a 1960s gay biker.

CLAUDE CAHUN [b.Lucy Schwob, 1894, Nantes, France; d.1954, Jersey, Channel Islands] made almost all of her work in collaboration with her partner, and stepsister, Marcel Moore [b. Suzanne Malherbe, 1892; d.1972].The couple worked together to produce books [*Vues et visions*, 1919] as well as an extended series of performative, staged portraits that are complex manifestations of a shared subjectivity. Both were involved, for a time, with avant-garde theatrical troupes, Moore as a set designer and Cahun, occasionally, as an actor. Cahun translated Havelock Ellis' writings about sexuality into French in 1929. Exhibitions include 'Claude Cahun: Photographe: 1894–1954' at the Musée d'Art Moderne de la Ville de Paris [1995] and a retrospective at Institut Valencià d'Art Modern in Spain [2001–02].

JEROME CAJA [b.1958, Cleveland; d.1995] painted as a way to celebrate sexuality and meditate on loss. His used nail polish, glitter, lipstick, ashes, bones, fast-food wrappers and rags to create scenes of pageantry, religious rites and other spectacles of mystery. Posthumous exhibitions include Gallery Paule Anglim in San Francisco [2007], 'Made in California' at the Los Angeles Country Museum of Art [2000] and 'In a Different Light' at the Berkeley Art Museum [1996].

TAMMY RAE CARLAND [b.1965, Portland, Maine, USA] is a San-Francisco-based artist who works primarily with photography and experimental video. She was the creator of the zine *I [Heart] Amy Carter* and co-founder and owner, from 1997–2005, of Mr Lady Records, an independent record label and video art distribution company dedicated to the production and distribution of queer and feminist materials. Solo exhibitions of her visual art include 'An Archive of Feelings' at Silverman Gallery in San Francisco [2008] and 'Beds and Letters' at Spring Street Gallery in New York [2002].

FLÁVIO DE CARVALHO [b.1899, Brazil; d. 1973] trained as an architect and channelled his interests in psychoanalysis, sociology and anthropology into an eclectic mix of artistic pursuits. Via writing, architectural proposals, performances, mail art, fashion and media interventions, he merged art and life in ways that enriched São Paulo culture and challenged the definitions of art.

HEATHER CASSILS [b.Toronto, 1975], based in Los Angeles, incorporates elements of film, video, performance and photography in her work. From 2000–08 she was a member of the Los Angeles-based performance collective Toxic Titties. Cassils often uses her body as a medium for endurance pieces that interrogate the relationship between the physical and cultural constructions of gendered physique. Her work has been included in exhibitions such as 'Speculative Technologies, Modify', the Hammer Museum, Los Angeles [2002]; 'A Certain Tendency in Representation', Thomas Dane Gallery, London [2005]; 'Have We Met Before?', Ronald Feldman Gallery, New York City [2012] and 'Los Angeles Goes Live: Exploring a Social History of Performance Art in Southern California', Los Angeles Contemporary Exhibitions, [2012].

GAYE CHAN [b.1957, Hong Kong], a conceptual artist, and NANDITA SHARMA [b.1964, Bhopal, India], an activist scholar, collaborated to plant papaya seedlings on public land near their house in Kailua, Hawaii in 2003. While growing and sharing food, the gesture simultaneously problematized the concept of 'public' space and the laws governing its use.

MARK I. CHESTER [b.1950, Milwaukee] lives in San Francisco. In 1979 he began to photograph San Francisco's radical gay sex underground, a practice that he still continues. His work raises questions about health, death, pleasure and ecstasy, and how to negotiate desire with its consequences. His book, *Diary of a Thought Criminal*, was self-published in 1995.

PHYLLIS CHRISTOPHER [b.1963, Buffalo] is a San Francisco-based photographer of lesbian communities and the butch, femme, kink, glamour, rebellion, art and erotica found therein. Her work has been published in books and periodicals such as *Quim, On Our Backs, Cupido* and *Photo Sex: Fine Art Sexual Photography Comes of Age*.

JEAN COCTEAU [b.1889, Maisons-Laffitte, France; d.1963, Milly-la-Forêt, France] was a leading figure in French avant-garde film and theatre in the first half of the twentieth century, as well as a poet, essayist, actor and visual artist. His best-known works include the play *Les enfants terribles* [1929] and the films *Le Sang d'un Poète* [The Blood of a Poet, 1930], *La Belle et la Bête* [Beauty and the Beast, 1946] and *Orphée* [Orpheus, 1949]. In the 1940s Cocteau cast his handsome lover Jean Marais in several films that would help catapult the younger man into French cinematic stardom.

LIZ COLLINS [b.1968, Alexandria, Virginia, USA; lives in New York] is an internationally recognized artist and designer known for innovative apparel, textiles and installations. She is also a founder of KNITTING NATION, a collaborative performance and site-specific installation group/project. Exhibitions featuring her work include 'Radical Lace and Subversive Knitting' at the Museum of Arts and Design in New York [2007] and 'SAFE: Design Lab' at the Knoxville Museum of Art [2005].

MOLLY MALONE COOK [b.1925, San Francisco; d.2005, Provincetown, Massachusetts, USA] was a photographer, gallerist, literary agent and bookseller. In early 1950s Provincetown she opened the East Coast's first gallery dedicated to photography, where she presented the work of such figures as Edward Steichen, Berenice Abbott and Eugene Atget. Her own photographs included portraits of political and artistic luminaries, including her then lover, the playwright Lorraine Hansberry. After Hansberry's death, Cook went on to establish her own literary agency, representing her partner, the poet Mary Oliver, among other clients.

HONEY LEE COTTRELL [b.1946, Astoria, Oregon, USA] has photographed her friends, lovers and herself since 1968. Exhibitions include 848 Community Space in San Francisco, The Gay and Lesbian History Society of Northern California, and Name Gallery in Chicago. Her images have also appeared in such publications as *On Our Backs*.

PATRICIA CRONIN [b.1963, Beverly, Massachusetts, USA] lives in New York, where she manipulates gendered art historical forms, such as watercolour

and marble statuary, to address contemporary issues of sexuality, gender, power and class. Solo exhibitions include 'An American in Rome' at the American Academy in Rome [2007] and 'Memorial to a Marriage' at Grand Arts in Kansas City [2002].

BÉATRICE CUSSOL [b.1970, Toulouse, France] lives in Paris. Her watercolours present bodies, full of excesses and limits, acting out queer and surreal scenarios. Solo exhibitions include Envoy Gallery in New York [2007], and group exhibitions include 'Global Feminisms' at the Brooklyn Museum of Art [2007].

HENRI DE TOULOUSE-LAUTREC [b.1864, Albi, France; d.1901, Malromé, France] was a post-Impressionist painter and illustrator who depicted the Parisian nightlife of cafés, bars and brothels. His life and art have been the subject of numerous publications and international museum exhibitions.

DIANA DAVIES [b.1938] began her career as a musician in the early 1960s, and became a noted photographer of fellow musicians and gay and lesbian activists. Davies's photographs have been published in *The New York Times*, *The Washington Post*, *The Boston Globe*, *Life*, *Time*, *Newsweek*, *The Journal of Women in Music* and *The Village Voice* and collected by the Smithsonian Institution, Howard University and the Swarthmore College Peace Library.

JUAN DAVILA [b.1946, Santiago, Chile] lives in Melbourne. He studied law before going to art school in Chile and is an advocate for art that tackles social and political issues in an international context. His paintings critique the Australian political system, capitalism, the structures of the art world, and sexuality. They have been included in the Sydney Biennial [1982 and 1984], the São Paulo Biennial [1998] and Documenta 12 [2007].

F. HOLLAND DAY [b.1864, Norwood, Massachusetts, USA; d.1933, Norwood] was a photographer and publisher who advocated for photography as fine art. His platinum prints often referenced classical antiquity and featured nude figures. His later work involved elaborately staged scenes, including a re-enactment of the crucifixion in which Day portrayed Jesus. Solo exhibitions include a retrospective at the Boston Museum of Fine Arts [2000], and group exhibitions include 'Photography and the Self: The Legacy of F. Holland Day' at the Whitney Museum of American Art in New York [2007].

BEAUFORD DELANEY [b.1901, Knoxville, Tennessee, USA; d.1979, Paris] lived in New York in the 1930s and 1940s and reacted to the simultaneous grimness of the Depression and excitement of the Harlem Renaissance. In 1953 he relocated to Paris, where he developed a style of Abstract Expressionism and befriended James Baldwin and Henry Miller. Exhibitions include a retrospective at the Studio Museum in Harlem in New York [1978] and 'Beauford Delaney: From Tennessee to Paris' at Philippe Briet Gallery in New York [1988].

CHARLES DEMUTH [b.1883, Lancaster, Pennsylvania, USA; d.1935, Lancaster] developed a style of painting known as Precisionism. He was celebrated primarily for his exacting watercolours, the subjects of which ranged from figures to botany to industrial landscapes, and his visual work was often influenced by his literary interests. Exhibitions include 'Chimneys and Towers: Charles Demuth's Late Paintings of Lancaster' at the Amon Carter Museum of Art in Fort Worth, Texas [2007 and tour].

DIANE DIMASSA [b.1959] lives in Westport, Connecticut, USA, and creates graphic novels and comics featuring the character Hothead Paisan, a 'lesbian terrorist' who takes the law into her own hands to act out her revenge fantasies against a heterosexist, patriarchal culture. DiMassa also illustrated Kathy Acker's *Pussycat Fever* [1995] and Kate Bornstein's *My Gender Workbook* [1998].

OTTO DIX [b.1891, Untermhaus, Germany; d.1969, Singen, Germany] was profoundly affected by his service in the German Army during the First World War. His subsequent prints and paintings depict the harsh realities of Weimar society, National Socialism and war. Along with George Grosz and Max Beckmann, Dix became one of the most important artists of the Neue Sachlichkeit [New Objectivity] movement. Exhibitions include the Fundación Juan Marc in Madrid [2006] and 'Otto Dix und die Kunst des Porträts' at Kunstmuseum Stuttgart [2007—08].

CIRILO DOMINE [b.1969, Pagasinan, Philippines] lives in Tokyo. Domine received his BA from the University of California, Los Angeles, and his MFA from the University of California, Irvine. Exhibitions include 'MAMA-SAN' at Glendale College Art Gallery in California [2009], 'Humor Us' at Barnsdall Municipal Art Gallery in Los Angeles [2007] and 'EPIC: Visualizing Heroes Within' at SOMA Arts Cultural Center in San Francisco, CA [2009]. He currently lives in Tokyo.

ALEX DONIS [b.1964, Chicago] lives in Los Angeles. His paintings and drawings imagine enemies communing with one another. His work was featured in 'Pas de Deux' at Sherry Frumkin Gallery in Los Angeles [2006], Watts Tower Art Center in Los Angeles [2001] and 'My Cathedral' at Galeria de la Raza in San Francisco [1997].

HILDA DOOLITTLE [HD] [b.1886, Bethlehem, Pennsylvania, USA; d. 1961, Zurich] was a poet and novelist. She attended the University of Pennsylvania, where she met Ezra Pound and William Carlos Williams, and later became a leader of the Imagist movement. Her writing, much of which was published posthumously, includes *The Gift* [1982] and *Tribute to Freud* [1956] and is characterized by an economy of language and the influence of classical mythology.

INES DOUJAK [b.1959, Klagenfurt, Austria] lives in Vienna. In her installations and photographs, Doujak presents scenes that allow us to examine norms and their effects. She has often focused on the ways in which sexism and heteronormativity structure desire, language, family and economy. Exhibitions include Secession in Vienna [2002] 'Dirty Old Women' at the Salzburger Kunstverein in Salzburg [2005] and Documenta 12 [2007].

JOHN DUGDALE [b.1960 Connecticut, USA] lives in New York and Ulster County, New York. Working in a state of near-blindness after an AIDS-related stroke, Dugdale uses historical photographic processes, such as cyanotype and albumen prints, to create his portraits, figure studies and still lifes. Exhibitions include 'In the Twilight of Memory' at Holden Luntz Gallery in Palm Beach [2006] and 'The Poetics of Vision' at the Houston Center of Photography [1996].

LUKAS DUWENHÖGGER [b.1956, Munich] lives in Istanbul. His architectonic painting installations draw upon literary and art historical references, depicting intimate social interactions in order to create a tableaux of gay life. Exhibitions include 'Prinzenbad' at Kunstverein Hamburg [2004], 'Next to Kin' at Galerie Daniel Buchholz in Cologne [2006] and Documenta 12 [2007].

THOMAS EAKINS [b.1844, Philadelphia; d.1916, Philadelphia] was known for his work as a figurative painter and photographer. He apprenticed in Paris with Jean-Léon Gérôme, and returned to America in 1870. He became Director of the Pennsylvania Academy of Fine Arts, from which he was dismissed in 1886 for removing a loincloth from a male model in a class that included female students. Solo exhibitions include a retrospective exhibition at the Whitney Museum of American Art in New York [1970] and 'Thomas Eakins: American Realist' at the Philadelphia Museum of Art [2001 and tour].

NICOLE EISENMAN [b.1965, Verdun, France] lives in New York and takes cues from classical art, comic books, television and pornography to create witty and subversive work that is often loaded with gender metaphors and cultural critique. Solo exhibitions include 'A Show Born of Fear' at Susanne Vielmetter Los Angeles Projects [2007] and 'Progress: Real and Imagined' at Leo Koenig, Inc. in New York [2006].

SERGEI EISENSTEIN [b.1898, Riga, Latvia; d.1948, Moscow] influenced cinema with his innovative use of montage, particularly in his film *Battleship Potemkin* [1925]. Both in his films and his theoretical writings, he promoted the notion of montage as the centre of cinema. Juxtaposition and 'collision' of shots, he proclaimed, were essential for directing emotion, creating metaphors and advancing political ideas.

ELMGREEN & DRAGSET [Michael Elmgreen, b.1961, Copenhagen; Ingar Dragset, b.1969, Trondheim, Norway] live in Berlin and began their collaboration in 1995. Since then they have created a wide range of installations, performances and environmental works. They reorganize or alter architectural and social spaces to draw attention to desire, perception and control in relation to the built landscape. Exhibitions include the Danish and Nordic pavilions at the Venice Biennale [2009], 'Home is the Place you Left' at the Trondheim Kunstmuseum in Norway [2008] and the Bawag Foundation in Vienna [2005].

PEPE ESPALIÚ [b.1956, Cordoba, Spain; d.1993] lived in Madrid and Cordoba. He was first known for his paintings and writings for the Seville-based art magazine *Figura*. His later work in performance and sculpture was informed by his experience of AIDS. He was included in 'Rites of Passage' at the Tate Gallery in London [1995]. Solo exhibitions include Brooke Alexander, New York [1989].

ROTIMI FANI-KAYODE [b.1955, Lagos; d.1989, London] created work that engaged issues of diaspora, spiritual identity and sexuality. He was educated and lived in Nigeria, the United States and London. He co-founded Autograph, the British association of black photographers, and collaborated with Alex Hirst on the publication *Black Male / White Male* [1988]. His photographs have been shown at the Solomon R. Guggenheim Museum in New York [1996] and the Venice Biennale [2003].

FIERCE PUSSY was an art collective, active from 1991–95, whose core members included Pam Brandt, Nancy Brooks Brody, Joy Episalla, Alison Froling, Zoe Leonard, Suzanne Wright and Carrie Yamaoka. Together the queer women who collaborated as fierce pussy created public art and performed direct action to advance lesbian visibility in New York, utilizing low-tech, low-budget means to bring their message to the streets in response to the political urgency of those years.

SPENCER FINCH [b.1962, New Haven, Connecticut, USA] works in a wide range of mediums, including light, glass, electronics, video and watercolour, to address notions of visual perception and memory. Solo exhibitions include 'What Time Is It on the Sun?' at the Massachusetts Museum of Contemporary Art in North Adams [2007] and 'As if the sea should part' at the Queensland Gallery of Modern Art in Brisbane [2009]. His work has also been included in the Venice Biennale [2009].

HAL FISCHER [b.1951] worked as a photographer and critic throughout the 1970s. He published in journals such as *Artforum* and *Artweek*, and his photographs were widely exhibited throughout the United States, though he remains best known as the author of *Gay Semiotics* [1977]. Fischer is now an independent consultant for the non-profit sector in San Francisco.

LOUISE FISHMAN [b.1939, Philadelphia] lives in New York. Trained as an abstract painter at the Pennsylvania Academy of Fine Arts and the University of Illinois. In late-1960s New York she became involved in the feminist art movement and gay liberation, turning to practices that reflected women's traditional tasks, such as cutting, tearing, wrapping and stitching, before returning to abstract painting in the late 1970s. Her work has been included in 'WACK! Art and the Feminist Revolution' at the Museum of Contemporary Art in Los Angeles [2007 and tour] and 'Significant Form: The Persistence of Abstraction' at the Pushkin State Museum of Fine Arts in Moscow [2008].

JANET FLANNER [b.1892, Indianapolis; d.1978, New York] departed the United States for Paris in 1921 with her lover Solita Solano, with whom she maintained a lifelong relationship. In 1925, under the pen name Genet, she became the Paris correspondent for *The New Yorker*, a position that she held for the next fifty years. Her column, 'Letter from Paris', not only provided trenchant commentary about the politics and culture of the period but also regularly included news of goings-on in gay Paris.

MARTHA FLEMING [b.1958, Toronto] and LYNNE LAPOINTE [b.1957, Montreal] have produced site-specific projects, often enveloping and responding to entire architectural structures. A ferry terminal in Manhattan, a library in Madrid and a vaudeville theatre in Montreal are among the many sites for their ephemeral installations. The exhibition 'Studiolo: Martha Fleming & Lyne Lapointe' at the Musée d´Art Contemporain de Montréal [1998] introduced a wide audience to their collaborative work.

CHARLES HENRI FORD [b.1913, Brookhaven, Mississippi, USA; d.2002, New York] edited the Surrealist magazine *View* in the 1940s. His creative production ranged from novels and poetry to photography, painting and collage. His novel *The Young and Evil* [1933], co-authored with Parker Tyler, was a candid portrait of queer life. His visual art exhibitions include 'Thirty Images from Italy' at the Institute of Contemporary Arts in London [1955].

EVE FOWLER [b.1964, Philadelphia] lives in Los Angeles, where she makes photographic portraits that explore issues of questionable and fluid identity. Exhibitions include 'Small Things Fail, Great Things Endure' at New Langton Arts in San Francisco [2008] and 'The Way That We Rhyme: Women, Art & Politics' at the Yerba Buena Center for the Arts in San Francisco [2008].

JARED FRENCH [b.1905, Ossining, New York, USA; d.1988, Rome] was a magic-realist painter who employed the painstaking medium of egg tempera to create mystical, often erotically charged compositions. A lover of Paul Cadmus in the 1930s, and a lifelong friend thereafter, French married the painter Margaret Hoening in 1937. Throughout the late 1930s and 1940s Cadmus and the Frenches worked together as an informal photographic collective called PaJaMa [for Paul, Jared and Margaret]. PaJaMa photographs document the summers the three artists shared on Fire Island and the various men [including George Platt Lynes, Truman Capote and George Tooker] with whom they socialized.

GENERAL IDEA, an art collective consisting of Felix Partz, Jorge Zontal and AA Bronson, was formed in Toronto in 1969. Inhabiting and subverting forms of popular and media culture, including beauty pageants, boutiques, television talk shows, trade fair pavilions and mass media, their work was often presented in unconventional formats such as postcards, prints, posters, wallpaper, balloons, crests and badges. From 1987 through 1994 they addressed the AIDS crisis, with work that included some seventy-five temporary public-art projects. Solo exhibitions include the retrospective 'General Idea Editions: 1967–1995' at the Centro Andaluz de

Arte Contemporáneo in Seville [2007 and tour] and 'One Day of AZT / One Year of AZT' at the Museum of Modern Art in New York [1996].

ANDREA GEYER [b.1971, Freiburg, Germany] lives in works in New York City. She works primarily in photography and video, through which she often incorporates text, sculpture and installation. Her work investigates imperialism, history and historiography, war, landscape and narrative. In 2007 she collaborated on 'Nine Scripts from a Nation at War' with David Thorne, Kayta Sanger, Ashley Hunt, a commission for Documenta 12, which has since travelled to the Museum of Modern Art, New York City, 2012. Her work has been shown internationally at institutions such as the Whitney Museum of American Art, New York City; Central House of Artist, Moscow, Russia; and Museum of Modern Art, Vienna, Austria.

ALLEN GINSBERG [b.1926, Newark, New Jersey, USA; d.1997, New York] attacked conformity and materialism in his poetry. His best-known poem, 'Howl' [1956], marked the beginning of the Beat literary movement and sparked an obscenity trial in San Francisco the year after its publication. A friend and probable lover of Jack Kerouac and William Burroughs, Ginsberg used his celebrity to promote the writers in his circle and to speak out on political issues. In 1974, with Anne Waldman, he founded the Jack Kerouac School of Disembodied Poetics at the Naropa Institute in Boulder, Colorado. Ginsberg's life partner was Peter Orlovsky.

GLUCK [Hannah Gluckstein, b.1895, England; d.1978] trained at the St John's Wood School of Art. She patented the 'Gluck Frame' to show her work in a way that became an integral part of the architecture of the rooms in which they hung. Her best-known paintings are of stylized floral arrangements inspired by the creations of an early lover. A retrospective exhibition was held at the Fine Arts Society in London [1978].

ROBERT GOBER [b.1954, Wallingford, Connecticut, USA] lives in New York and creates psychologically charged installations and sculptures. Informed by Surrealism, Minimalism and Conceptual art, he presents familiar objects in unfamiliar and disconcerting ways to activate themes of sexuality, religion, memory and politics. Exhibitions include a retrospective at the Schaulager in Basel [2007] and 'Robert Gober: Sculpture + Drawing' at the Walker Art Center in Minneapolis [1999 and tour]. He represented the USA at the 49th Venice Biennale [2001].

DAVID GOLDBLATT [b.1930, Randfontein, South Africa] lives in Johannesburg. Since 1948 he has photographed South African people and landscapes, creating extended documentaries that address apartheid, environmental damage, dislocated workers, and cemeteries that are evidence of the impact of HIV and AIDS. Exhibitions include Museu Serralves in Porto [2008], Galerie Paul Andriesse in Amsterdam [2008] and 'Intersections Intersected: The Photography of David Goldblatt' at the New Museum of Contemporary Art in New York [2009 and tour].

NAN GOLDIN [b.1953, Washington, DC] lives in New York and London. Her diaristic photographs of New York's downtown New Wave scene in the 1970s and 1980s document amorous and abusive couples, drug addiction, AIDS-related illness and the homes and clubs where she and her 'extended family' spent time. Her numerous solo exhibitions include the mid-career retrospective 'I'll Be Your Mirror' at the Whitney Museum of American Art in New York [1996] and 'Devil's Playground', a travelling retrospective organized by the Centre Georges Pompidou in Paris and Whitechapel Art Gallery in London [2001]. Goldin was the recipient of the 2007 Hasselblad Award.

DANIEL GOLDSTEIN [b.1950, Mount Vernon, New York, USA] lives in San Francisco. He is especially known for the Icarian series, which reused the leather coverings of workout machines from a San Francisco gym. The elegiac sculptures became meditations on AIDS, fetish, bodies and public space. His woodblock prints, collages and sculptures can be found in the permanent collections of museums including the Fine Arts Museums of San Francisco, the Art Institute of Chicago and the Brooklyn Museum of Art.

MARIA ELENA GONZÁLEZ [b.1957, Havana] lives in New York and Basel, Switzerland. Her sculptural works tackle the inaccuracies and inconsistencies of memory. She has received numerous prestigious awards, including grants from Anonymous Was A Woman, the Pollock-Krasner Foundation, the Tiffany Foundation and the Joan Mitchell Foundation. She has had solo exhibitions at El Museo del Barrio in New York [1996], The Project Gallery, New York [2006] and The Contemporary Museum, Honolulu, [2006].

FÉLIX GONZÁLEZ-TORRES [b.1957, Cuba; d.1996, Miami] is known for his minimal installations, photographs and conceptual sculptures using prosaic materials such as lightbulbs, clocks, candies and paper. Much of his work involves viewer interaction, which means that it changes with each exhibition, context or owner. In a subtle way, he reflected the sense of urgency, fear and passion about the severity of the AIDS crisis, the efficacy of politics, historical memory, love and loss. Retrospectives of his work have been organized by the Solomon R. Guggenheim Museum in New York [1995], the Sprengel Museum in Hannover [1997] and the Serpentine Gallery in London [2000].

AGNES NOYES GOODSIR [b.1865, Victoria, Australia; d.1939, Paris] was a portrait painter and part of the lesbian scene in Paris in the 1920s and 1930s. She often painted androgynous women or women wearing men's clothing. Exhibitions of her work include the Salon Nationale des Beaux Arts in Paris [1924] and the Fine Arts Gallery in Melbourne [1927].

GRAN FURY was an activist / artist collective that emerged from the ranks of ACT UP in 1987 to produce the installation 'Let the Record Show…' for the window of the New Museum in New York. Named after the brand of Plymouth car favoured by the New York police department the group was active until 1995. Serving as ACT UP's unofficial propaganda ministry Gran Fury created work that used commercial advertising strategies to disseminate political information and incite awareness about the AIDS epidemic and sexuality. Its members included Marlene McCarty, Mark Simpson, Donald Moffett, Tom Kalin and John Lindell.

DUNCAN GRANT [b.1885, Rothiemurchus, Scotland; d.1978, Aldermaston, Scotland] was the husband of painter Vanessa Bell, and the sometime lover of economist John Maynard Keynes and historian Lytton Strachey. A painter, fabric designer and ceramicist, the prolific artist was a member of the Bloomsbury Group; Charleston, the Sussex house that he shared with Bell became the group's country retreat and remains a testament to the couple's art and decorative style. Grant was one of the founders of the Omega Workshops [1913–19] a laboratory of radical and exuberant design ideas that challenged the 'stupidly serious' mainstream Edwardian aesthetic.

PAIGE GRATLAND [b. Ontario, Canada, 1978] explores issues of sexuality, celebrity and resistance in her visual art and music. Her work has been exhibited internationally and can be found at the National Gallery in Ottawa and Tate Modern in London. She is a member of the Blocks Recording Club, an artist-owned worker's cooperative based in Toronto.

NANCY GROSSMAN [b.1940, New York] uses industrial materials in unusual combinations to create sculptures that address the physicality and vulnerability of the body. She rose to

prominence in the 1960s and had five solo shows by the age of thirty. A retrospective was organized by the Hillwood Art Museum, Long Island [1990]. Recent solo shows include 'Nancy Grossman: Heads' at MoMA PS1 in New York [2011] and 'Nancy Grossman' at the Frances Young Tang Museum, Saratoga Springs, NY [2012 and tour].

GROUP MATERIAL was an art collective whose members included Julie Ault, Tim Rollins, Mundy McLaughlin, Doug Ashford and Félix González-Torres. The group was founded in New York in 1979 as a response to what members found to be the unsatisfactory ways that art was being taught, exhibited and distributed. By organizing temporary exhibitions and public interventions, they invited everyone to question the culture they took for granted. Active until 1995, their exhibitions included 'The People's Choice' at 244 East 13th St in New York [1980], 'AIDS Timeline' at the University of California, Berkeley [1989], and 'Americana', which was part of the Whitney Biennial in New York [1995].

SUNIL GUPTA [b.1953, New Delhi] lived and worked in Canada and the United Kingdom before returning to New Delhi in 2005. Gupta's photographs draw upon his experiences as an immigrant and as a gay man of colour. After his AIDS diagnosis in 1995, his work turned to the issues of living with HIV. His 1990 anthology *Ecstatic Antibodies: Resisting the AIDS Mythology* [1990], co-edited with Tessa Boffin, was a groundbreaking activist contribution. Exhibitions include Bombay Art Gallery in Mumbai [2009], 'Looking for Langston [with Issac Julien]' at Metro Pictures in New York [2006] and 'Make Art/ Stop AIDS' at UCLA Fowler Museum in Los Angeles [2008].

HARMONY HAMMOND [b.1944, Chicago] is an artist, writer and curator who lives in Galisteo, New Mexico. She was founding member of AIR, the Manhattan-based feminist art collective initiated in 1972, as well as, in 1977, the feminist journal *Heresies*. In 1978, Hammond curated the first American exhibition of lesbian art, 'A Lesbian Show', at 122 Greene St, New York. Hammond's large-scale work in painting and sculpture, generally abstract, addresses issues of the female body, class and labour. She is the author of *Lesbian Art in America: A Contemporary History*, and her work has been featured in solo exhibitions at Center for Contemporary Arts in Santa Fe [2005] and Site Santa Fe [2002].

KEITH HARING [b.1958, Reading, Pennsylvania, USA; d.1990, New York] had a brief but intense career that spanned the 1980s. His early painted murals and chalk drawings in the New York subway led to public works created in cities throughout the USA and Europe, advertising campaigns, high-profile collaborations with other artists, and the opening of his own store, the Pop Shop. His thickly outlined and energy-emanating figures enacted scenes of birth, death, love and sex. He participated in international survey exhibitions such as Documenta 7 [1982], the São Paulo Biennial [1983] and the Whitney Biennial [1983], and his work has been the subject of numerous retrospectives since his death in 1990.

CHARLES 'TEENIE' HARRIS [b.1908, Pittsburgh; d.1998, Pittsburgh], photographically chronicled minority communities in Pittsburgh for the *Pittsburgh Courier*, one of the oldest black newspapers in the USA. The Carnegie Museum of Art created the Teenie Harris Archive Project in 2005 and opened a major touring retrospective in 2011.

LYLE ASHTON HARRIS [b.1965, New York] lives in New York. His photographs question fictions of race, gender and sexuality. He was included in 'Black Male: Representations of Masculinity in Contemporary Art' at the Whitney Museum of American Art in New York [1994]. Solo shows include 'Self/Portrait' at the Studio Museum in Harlem [2011].

MARSDEN HARTLEY [b.1877, Lewiston, Maine, USA; d.1943, Ellsworth, Maine] studied art in Cleveland but moved to New York in his twenties. There he became affiliated with Alfred Stieglitz's Gallery 291, where he had his first exhibition in 1909. His early works were mostly abstract, but he later returned to representational techniques. Settling in Maine in the 1930s, he produced 'memory portraits' of Nova Scotia seamen and landscapes of the Maine shoreline. Exhibitions include 'Marsden Hartley and the West: The Search for an American Modernism' at the Amon Carter Museum of Art in Forth Worth [2008] and 'Marsden Hartley: American Modern' at the Joslyn Art Museum in Omaha [2000].

RICHARD HAWKINS [b.1961, Mexia, Texas, USA] lives in Los Angeles. His work in collage, sculpture and painting often explores desire, the relationship between popular culture and transnational histories, and the body. He combines history and fantasy in projects such as his 2006—09 collage series *Urbis Paganus*, a queered art historical account of Roman sculpture. His work has been the subject of the retrospectives 'Of Two Minds, Simultaneously' at de Appel in Amsterdam [2007] and 'The Third Mind' at the Art Institute of Chicago [2010].

SHARON HAYES [b.1970, Baltimore] lives in New York, where she engages in an art practice that moves between video, performance and installation. She investigates the relations of history, politics and space to the process of individual and collective subject formation. Solo exhibitions include 'In the Near Future', Warsaw Museum of Art, Poland [2008] and 'I march in the parade of liberty, but as long as I love you I'm not free', at the New Museum in New York [2007], and the Whitney Museum [2012].

FRANK 'TICO' HERRERA [b.1941, Beckley, West Virginia, USA] is a West Virginia-based photographer who teaches at Shepherd College and the Corcoran School of Art. He has received both a Guggenheim Fellowship and a grant from the National Endowment for the Arts.

JUAN HIDALGO [b.1927, Las Palmas, Gran Canaria, Spain] is an experimental musician who was the first Spanish composer to participate in the Darmstadt festivals and, in 1964, was one of the founders of Madrid's Fluxus-related Zaj group. Hidalgo is also a prolific performance and visual artist, whose work extends to postal art, photography and object-making. He lives in the Canary Islands.

DAVID HOCKNEY [b.1937, Bradford, England], arguably the best-known British artist of his generation, lives in Los Angeles and Bridlington, East Yorkshire. He achieved international attention in the 1960s for paintings and prints that playfully referenced popular culture while retaining a strong sense of colour, geometry and composition. After relocating to California in 1964, he incorporated images of young men (often naked), swimming pools and sun-drenched landscapes. Hockney is also known for his photocollages, which are comprised of dozens of Polaroids and commercially processed 35mm prints. His numerous solo exhibitions include the Royal Academy of Art in London [2011], Nottingham Contemporary [2009] and the Los Angeles County Museum of Art [2006 and tour].

TIMOTHY HORN [b.1964, Melbourne] lives in New Mexico. His sculpture removes jewellery from the territory of the body to recast it as monumental sculpture. Horn's work was featured in solo exhibitions including '(in)discrete objects, Sub-Urban Series' at the Knoxville Museum of Art [2006] and 'Bitter/Suite' at the de Young Museum in San Francisco [2008].

JONATHAN HOROWITZ [b.1966, New York] lives in New York State. He often uses iconic imagery and media, such as the American flag,

the cross and the television, in a way that deflates them so that viewers can reconsider their value and meaning. Solo exhibitions include 'And / Or' at MoMA PSI in New York [2009], 'Apocalypto Now' at the Museum Ludwig in Cologne [2009] and 'Time, Life, People' at the Kunsthalle St Gallen, Switzerland [2001].

PETER HUJAR [b.1934, Trenton, New Jersey, USA; d.1987, New York] was a fixture in New York underground circles in the 1970s and 1980s. Using black and white photography, he documented New York's architecture, nightlife, notable artists, intellectuals and anonymous residents. Attention to his work has grown steadily since his death in 1987, and he has been the subject of major retrospectives at PSI in New York [2006] and the Institute for Contemporary Art in London [2007–08].

DOUG ISCHAR [b.1948, Honolulu] lives in Chicago and produces installations, videos and photographs around issues of male intimacy, psychological and social loss, and private fantasies coinciding with public space. His documentary photographic work from the 1980s focused on Chicago's Belmont Rocks gay beach and the San Francisco S/M leather scene at the height of the AIDS crisis.

EUGÈNE JANSSON [b.1862, Stockholm; d.1915, Stockholm] was a painter little-known outside of Sweden during his lifetime. His early paintings focused on nocturnal Stockholm landscapes. He later turned his attention to the figure, enlisting models from the Swedish Navy, whom he painted nude or semi-nude while training with weights or performing other athletic activities.

JEB [Joan E. Biren, b.1944, Washington, DC] has documented the lives of lesbian, gay, bisexual and transgender individuals for more than thirty years. JEB's films include *No Secret Anymore: The Times of Del Martin and Phyllis Lyon; Removing the Barriers*, which was used to train healthcare providers to improve service to lesbian clients; and *Solidarity, Not Charity*, on relief efforts in New Orleans following Hurricane Katrina. *For Love and For Life and A Simple Matter of Justice* documented the 1987 and 1993 gay rights marches on Washington. In 1997, George Washington University mounted the retrospective 'Queerly Visible: 1971–1991', a retrospective that later toured the nation.

JESS [Burgess Collins, b.1923, Long Beach, California, USA; d.2004, San Francisco] turned to art after a disillusioning career in the military, during which he worked as a chemist for the Manhattan Project. Many of his paintings and collages have themes drawn from chemistry and the occult. He had a long-term relationship, creative and romantic, with the poet Robert Duncan [1919–88], author of the landmark essay 'The Homosexual in Society', with whom he lived in San Francisco after the early 1950s. The retrospective 'Jess: A Grand Collage, 1951–1993', toured the USA in 1993–94 and was accompanied by a catalogue of the same name.

JASPER JOHNS [b.1930, Augusta, Georgia, USA] lives in Sharon, Connecticut. He rose to prominence after his first exhibition at the Leo Castelli Gallery in 1958, becoming one of the most significant figures in American Pop art. Johns is known for his use of imagery of targets, flags, maps and other familiar two-dimensional subjects. His working process combines experimentation with intense deliberation and obsessive craft. Solo exhibitions include a retrospective at the Museum of Modern Art in New York [1996–97] and 'Jasper Johns: An Allegory of Painting, 1955–1965' at the National Gallery of Art in Washington, DC [2007].

RAY JOHNSON [b.1927, Detroit; d.1995, Sag Harbor, New York, USA] was a member of American Abstract Artists from 1949 to 1952, exhibiting alongside such painters as Ad Reinhardt. In the mid-1950s, after meeting Robert Rauschenberg and Cy Twombly, Johnson began making collages from newspaper and magazine images. In the mid 1960s he pioneered mail art, founding the New York Correspondance [sic] School. Solo exhibitions include a retrospective at the Museum of Modern Art in New York [1999]. He is the subject of the award-winning documentary *How to Draw a Bunny* [2003].

FRANCES BENJAMIN JOHNSTON [b.1864, Grafton, West Virginia, USA; d.1952, New Orleans, USA] was an American photographer and photojournalist. She opened a studio in Washington, DC, where she photographed political luminaries and artists. She was the official White House photographer through five successive administrations. Her later work focused on her interest in architecture.

G.B. JONES [b.1965, Bowmanville, Ontario, Canada] lives and works in Toronto, Canada. She is a visual artist, performer, filmmaker, musician, writer and publisher of zines. She is known as an innovator in the queercore movement in the visual and performing arts. She collaborated with Bruce LaBruce on the queer-punk zine *JD's* (short for juvenile delinquents) which ran from 1985 to 1991 and spawned movie nights, compilation cassette tapes and the spin-off zine *Double Bill*. Jones also makes super-8 films, including *The Lollipop Generation* [2008], which she worked on for thirteen years. She has shown her work internationally in exhibitions including 'Explosion LTTR: Practice More Failure', Art In General, New York City [2004]; 'Smell it!' In Kunsthalle Exnergasse, Vienna [2009]; and 'This Will Have Been: Art, Love and Politics in the 1980s' at the Museum of Contemporary Art Chicago [2012].

MATHEW JONES [b.1961, Melbourne] lives in London. His paintings, photographs and installations address obsession, sexuality and desire alongside fate and the passage of time. His work has been featured at the Museum of Contemporary Art in Sydney [2002], Toronto Photographers Workshop [1995] and the Institute for Modern Art in Brisbane [1991].

MICHEL JOURNIAC [b.1935, Paris; d.1995, Paris] studied theology as a trained priest but left the church when he could no longer reconcile his homosexuality with Catholic doctrine. He became a painter and then, in the late 1960s, a pivotal force in French body art. Exhibitions include the Musée d'Art Moderne et Contemporain de Strasbourg [2004] and the Centre Pompidou in Paris [2008].

ISSAC JULIEN [b.1960, London] lives in London. He is a filmmaker, videomaker and installation artist known for his meditations on popular mythology, race, sexuality, history and diaspora. Julien was a founder of the Black Audio Film Collective (active 1982–98) and the Sankofa Film Collective, founded in 1983. He curated the exhibition 'Derek Jarman: Brutal Beauty' at the Serpentine Gallery in London [2008], and his work has been featured in solo shows at the Centre Pompidou in Paris [2005], the Museum of Contemporary Art in Miami [2005] and the Kerstner Gesellschaft in Hanover [2006].

DEBORAH KASS [b.1952, San Antonio, Texas, USA] lives in New York. In her work, much of which incorporates text, she deals with the intersection of the self, popular culture, contemporary art and art history. Solo exhibitions include the Andy Warhol Museum in Pittsburgh [2012] and the Kemper Museum of Contemporary Art in Kansas City [1996]

BHUPEN KHAKHAR [b.1934, Bombay; d.2003, Baroda, India] made work that combined his concerns regarding sexuality and gender identity with an interest in Indian mythology. His figurative paintings were included in 'Horn Please. Narratives in Contemporary Indian Art' at

Kunstmuseum Bern [2007] and 'Pictorial Glimpses' at the National Gallery of Modern Art in Mumbai [2006].

EDWARD KIENHOLZ [b.1927, Fairfield, Washington, USA; d.1994, Hope, Idaho, USA] was a sculptor and assemblage artist who created life-size environments. He moved to Los Angeles in 1953 and, four years later, opened the Ferus Gallery with Walter Hopps and Beat poet Bob Alexander. Incorporating detritus and found objects, Kienholz' installations addressed controversial issues ranging from illegal abortion to the war in Vietnam to the institutionalization of the mentally ill. Exhibitions include 'Kienholz: A Retrospective' at the Whitney Museum of American Art in New York [1996 and tour].

SHIGEYUKI KIHARA [b.1975, Upolu, Samoa] lives in Auckland, New Zealand. A Samoan-born multimedia and performance artist, Kihara uses photography to explore themes of Pacific culture, identity, colonialism, indigenous spirituality, stereotypes, gender roles and consumerism. Exhibitions include 'Living Photographs' at the Metropolitan Museum of Art in New York [2008–09]. She is the winner of the Creative New Zealand Emerging Pacific Artist Award [2003].

KISS AND TELL was a Vancouver-based performance and art collective whose work addressed lesbian sexuality. The group is best known for the photographic exhibition 'Drawing the Line', which responded to debates in the 1990s in the feminist community around acceptable sexual practices, morality and pornography. The group — Susan Stewart, Persimmon Blackbridge and Lizard Jones — also produced the collaborative book Her Tongue on My Theory: Images, Essays and Fantasies [1994].

JOCHEN KLEIN [b.1967, Giengen, Germany; d.1997, Munich] painted impressionistic landscapes featuring young men and women in various states of daydreaming and awareness. Exhibitions include a retrospective at the Pinakothek der Moderne in Munich [2008].

INS A KROMMINGA [b.1970, Emden, Germany] is an intersex activist who's visual work traces gender classification systems, notions of othering and the abject. Exhibitions include 'sh(OUT)' at the Gallery of Modern Art in Glasgow [2009], 'Just Different' at the Cobra Museum in Amsterdam [2008] and 'Normal Love' at Studio I Bethanien in Berlin [2007].

JOHN KOCH [b.1909, Toledo, Ohio, USA; d. 1978, New York] chronicled intimacy and relationships in his realist paintings. Populated with

musicians, socialites, models, intellectuals, lovers and friends, his paintings reflected changing social attitudes, spaces and events in New York, and defied the prevalent abstract style of the time. His painting Siesta [1962] appeared on the cover of Time magazine in 1964 to accompany the article 'Sex in the United States: Mores and Morality'. A retrospective of his paintings was organized by the New-York Historical Society [2001–02].

ELISAR VON KUPFFER [b.1872, Tallinn, Estonia; d.1942, Minusio, Switzerland] used the pseudonym Elisarion for much of his writing and visual art. After studying in Russia and Germany, he established himself as a painter and muralist in Switzerland, where he lived with his partner, the philosopher and historian Eduard von Mayer. His publications include Lieblingminne und Freundesliebe in der Weltliteratur [1900], an anthology of homoerotic literature created as a protest against the imprisonment of Oscar Wilde in England.

KAY TOBIN LAHUSEN [b.1930, Cincinnati] lives in Kennett Square, Pennsylvania. With her life partner, writer Barbara Gittings, she helped to found the New York chapter of the Daughters of Bilitis. She is considered the first photojournalist to document the gay rights movement. Her photographs have appeared in The Ladder and A Lesbian Review, among other publications.

THOMAS LANIGAN-SCHMIDT [b.1948, Elizabeth, New Jersey, USA] was raised in a religious immigrant community, and his work explores the relationship between religious devotion and sexual freedom. Employing materials such as artificial flowers, foil, glitter and beads, his collages are nods to kitsch, glamour and Baroque excess. His work was included in 'The American Century: Art & Culture 1900–2000' at the Whitney Museum of American Art in New York [1999].

GREER LANKTON [Greg Lankton, b.1958, Flint, Michigan; d.1996, Chicago, USA] created life-like dolls and figures that have been compared to the Surrealist works of Hans Bellmer. Lankton, who had sexual reassignment surgery at the age of twenty-one, focussed on the malleable aspects of gender, sexuality, distress and glamour. Exhibitions include the Whitney Biennial in New York [1995] and the Venice Biennale [1995]. Her final show, 'It's All About Me, Not You', has become a permanent installation at the Mattress Factory in Pittsburgh.

MARIE LAURENCIN [b.1883, Paris; d.1956, Paris] was a Cubist painter who explored themes and representations of femininity in her

visual work. She also produced stage designs and illustrated books, such as Lewis Caroll's Alice's Adventures in Wonderland. Her work and archives are housed in the Musée Marie Laurencin in Nagano Prefecture, Japan.

NIKKI S. LEE [b.1970, South Korea] lives in New York and investigates questions of identity through the vernacular use of photography. She is known primarily for her Projects, which consist of snapshots of her posing with and attempting to pass as a member of various ethnic groups and subcultures. Solo exhibitions include the Gesellschaft für Aktuelle Kunst in Bremen [2007], the Kemper Museum of Contemporary Art in Kansas City [2005] and the Cleveland Museum of Art [2003].

CARY LEIBOWITZ / CANDYASS [b.1963, New York] lives in New York. His artwork addresses ideas of self-doubt and cultural assimilation, paying particular attention to issues surrounding Jewish and queer identity. Exhibitions include 'In a Different Light' at the Berkeley Art Museum [1996] and 'Bad Girls' at the New Museum for Contemporary Art in New York [1994].

ZOE LEONARD [b.1961, Liberty, New York, USA] lives in New York. During the course of her artistic career, she has examined natural and cultural structures, such as museums, neighbourhoods, trees and fences, in order to point out their connections and contradictions, as well as what we take for granted. In the early 1990s she was a member of the collective fierce pussy. Solo exhibitions include Pinakothek der Moderne in Munich [2009], Hispanic Society of America in New York [2009] and the Centre National de la Photographie in Paris [1998].

LEONE AND MACDONALD [Hillary Leone, b.1962, Miami; and Jennifer MacDonald, b.1958, New York] made art together from 1988 to 1998. The duo produced installations, drawings, sculptures and videos that examined issues such as AIDS, abuse, identity, and censorship. Exhibitions include 'Such as We: Leone & Macdonald, Ten Years of Collaboration' at the North Dakota Museum of Art in Grand Forks [1999 and tour] and 'Stung by Splendor' at the Cooper Union in New York [1997].

JOSÉ LEONILSON [b.1957, Ceará, Brazil; d.1993, São Paulo] created sculptures, paintings, drawings and embroidery. From 1984 on, his work was increasingly autobiographical and incorporated organic forms, language and sewing. Solo exhibitions include 'Leonilson: São tantas as verdades' at Galeria de Arte do SESI in São Paulo [1995] and 'Projects 53' at the

Museum of Modern Art in New York [1996]. The Leonilson Project, initiated by the artist's family and friends, archives and promotes scholarship of his work.

NINA LEVITT [b.1955, Toronto] lives in Toronto. Her photography, installation and video works examine the representation of women in popular culture and often rely on the recovery and manipulation of existing images. Exhibitions include 'The Uncanny: Experiments in Cyborg Culture' at the Vancouver Art Gallery [2003] and 'Little Breeze' at the Doris McCarthy Gallery at University of Toronto Scarborough [2004].

ANNIE LIEBOVITZ [b.1949, Waterbury, Connecticut, USA] is a noted portrait photographer who has worked for magazines including Rolling Stone and Vanity Fair, and has been commissioned to photograph major advertising campaigns. She had a long-term relationship with the writer and cultural critic Susan Sontag and documented Sontag's battles with cancer. A retrospective of her work originated at the Brooklyn Museum of Art [2007].

GLENN LIGON [b.1960, New York] lives in New York and works in multiple media that explore race, sexuality, identity, representation and language. He is perhaps best known for a series of paintings and drawings begun in the early 1990s, for which he selects fragments of text — from works of literature by authors such as James Baldwin, Zora Neale Hurston and Walt Whitman, or from other sources — and stencils them onto sheets of paper or canvas. The Whitney Museum of American Art in New York organized a major mid-career survey exhibition [2011 and tour].

KALUP LINZY [b.1977, Clermont, Florida, USA] appropriates the soap opera format for his video-based work, in which he creates dramatic storylines and portrays most of the characters himself. The campy behavior of the characters and the campy quality of the soap format allow the artist to reveal more complicated issues of race, gender and sexuality via humour. Solo exhibitions include LAXART in Los Angeles [2006] and PS1 in New York [2006]. Linzy was named a 2007–08 Guggenheim Fellow.

ALMA LOPEZ [b.1966, Los Mochis, Sinaloa, Mexico] is an artist and activist who lives in Los Angeles. Via paintings, photographs, public murals and videos, she addresses issues of representation and social justice, and deconstructs and refigures cultural icons. She co-founded the Los Angeles organizations LA Coyotas, Tongues and Homegirl Productions.

FEDERICO GARCÍA LORCA [b.1898, Fuente Vaqueros, Spain; d.1936, Spain] is remembered as one of the most important Spanish poets of the twentieth century. He was also a painter, composer and key member of the avant-garde group Generation of '27. His work addresses themes of love, pride, passion and violent death. His play, El Público, remained unpublished until the 1970s because of its gay themes. He was murdered by members of Franco's militia in 1936, probably in part because of his homosexuality.

LOVETT AND CODAGNONE [John Lovett, b.1962, USA; and Alessandro Codagnone b.1967, Italy] have worked together since 1995. Their video works, performances and photography projects combine elements of gay S/M with literary and cinematic references that point to lust, endurance and power dynamics. Their work has been shown at Museo Nazionale del Cinema in Turin [2007], Participant Inc. in New York [2007] and Museum Ludwig in Cologne [2006]. They live in New York.

LSD [Jose Belbel, Maria Diaz Merlo, Azucena Vieites, Estibaliz Sadaba, Liliana Couso Dominguez, Katuxa Guede Garcia, Floy Krouchi Zafarrano, Fefa Vila Nunez, Virginia Villaplana Ruiz, Marisa Maza, Arantza Gaztanaga, Itziar Okari, Beatriz Preciado, and Pilar Vazquez] was an activist collective that was active in Madrid from 1993–98. The group's multidisciplinary project facilitated sociopolitical debate, artistic creativity, sociability, and visibility for lesbians.

LTTR is a feminist, genderqueer artist collective founded in New York in 2001 by Ginger Brooks Takahashi, K8 Hardy and Emily Roysdon. Between 2002 and 2006, LTTR produced five issues of an eponymous independent art journal, with the titles Lesbians to the Rescue, Listen Translate Translate Record, Practice More Failure, Do You Wish to Direct me?, and Positively Nasty. Their exhibitions, events and performances are a continuing practice.

ATTILA RICHARD LUKACS [b.1962, Alberta, Canada] lives in Vancouver. Lukacs is known predominantly for his paintings of male skinheads and American military cadets from the early 1990s. These brutal works were influenced by Caravaggio and David, as well as painters and illustrators from India and the Middle East. Exhibitions include 'Lily of the Valley', Banff Centre, Alberta [2008] and Documenta 9 [1992].

MARIETTE LYDIS [Marietta Ronsperger, b. 1894, Vienna; d.1970, Buenos Aires, Argentina), lived in Paris and Argentina. Briefly married, she fled the Nazi invasion of Paris for rural England with her lover, Erica Marx. Her erotic drawings illustrated luxury editions of works by Charles Baudelaire, Colette and Pierre Louys.

GEORGE PLATT LYNES [b.1907, East Orange, New Jersey, USA; d.1955, New York] began photographing his circle of artist friends in Paris and New York. The attention he garnered eventually led to fashion shoots for major magazines and department stores. In the 1930s, he began to work with the Kinsey Institute, which now holds the largest collection of his male nudes.

PHYLLIS LYON [b.1924, Tulsa, Oklahoma, USA] and DEL MARTIN [b.1921, San Francisco; d.2008, San Francisco] were activists who, after fifty years together, married in San Francisco in June of 2008. In 1955 they founded the Daughters of Bilitis, the first major lesbian organization in the USA. Both served as editor of the organization's newsletter, The Ladder. The couple is the subject of Joan E. Biren's documentary No Secret Anymore: The Times of Del Martin and Phyllis Lyon [2003].

MONICA MAJOLI [b.1963, Los Angeles] lives in Los Angeles. Her figurative paintings engage issues of identity, intimacy and mortality. By depicting people engaging in physical or sexual acts, Majoli addresses the quest for emotional closeness and connection. Her work was featured in the Whitney Biennial [2006] and 'Eden's Edge: Fifteen LA Artists', Museum of Contemporary Art, Los Angeles [2007].

JEANNE MAMMEN [b.1890, Berlin; d.1976, Berlin] emerged as an artist and illustrator during Germany's Weimar period. Her style was antithetical to the harsh realism of the period. She sympathetically represented residents of Berlin, paying special attention to changing social roles for women and newly visible lesbians.

MAN RAY [b. Emmanuel Radnitzky, 1890, Philadelphia; d.1976, Paris] contributed to the Dada and Surrealist movements. He work includes painting, film, sculpture and collage, but he is best known for his experiments in photography. Along with Katherine Dreier and Marcel Duchamp, Ray created the Société Anonyme. His autobiography, Self-Portrait [1963], was republished in 1999 and solo exhibitions include the Metropolitan Museum of Art, New York [1973] and 'Man Ray: Photography and Its Double', Centre Georges Pompidou, Paris [1998 and tour].

ROBERT MAPPLETHORPE [b.1946, Queens, New York; d.1989, New York] During the 1970s and early 1980s, Mapplethorpe produced severely elegant photographs of flowers, celebrities and socialites alongside equally stylized pictures of gay sadomasochism and naked black men. Mapplethorpe's work — and very name — became inextricably linked to the 'culture wars' over homoeroticism and federal funding to the arts when a museum retrospective of his work, The Perfect Moment, was cancelled by the Corcoran Gallery of Art under pressure from religious and political conservatives in 1989. When the exhibition opened at the Contemporary Art Center in Cincinnati the following year, both the museum and its director, Dennis Barrie, were indicted on charges of obscenity and child pornography. Though both Barrie and the CAC were acquitted, the trial marked the first time an American art museum faced criminal charges for presenting an exhibition to the public.

CEDAR MARIE [b.1963, Minneapolis] lives in Milwaukee. Marie combines hand-crafted objects with mass-produced commodities to create installations and sculptural narratives that reference physicality and the emotional signification of materials. Marie teaches at the Milwaukee Institute of Art and Design, where she recently curated the exhibition 'This is My Land' [2008].

VIRGIL MARTI [b.1962, St Louis, Missouri, USA] lives in Philadelphia. His hybrid environments and sculptures create a dialogue between the Baroque, science fiction, and psychedelia, pushing ideas of the decorative to an extreme. Solo exhibitions include Hirshhorn Museum, Washington DC [2007], 'I Repeat Myself', Memphis College of Art, Memphis [2005], 'The Flowers of Romance', Institute of Contemporary Art, Philadelphia [2003], and the Whitney Biennial, Whitney Museum of American Art, New York [2004].

GABRIEL MARTINEZ [b.1967, Miami] is a Cuban-American, Philadelphia-based artist who works across a range of media including photography, installation, performance and video. His work often focuses on questions of sexuality, the male gaze, and memorialization. Exhibitions include 'Out, Loud, & Proud', William Way Community Center, Philadelphia [2007], 'The Studio Visit', Exit Art, New York [2006], and 'HOMOMUSEUM', Exit Art, New York [2005].

MARLENE MCCARTY [b.1957, Lexington, Kentucky, USA] lives in New York. She explores sociopolitical issues as an artist and commercial designer. She was a member of the AIDS activist collective Gran Fury in the 1980s. In 1989, along with Donald Moffett, she founded Bureau, a multidisciplinary design studio dedicated to producing art, film titles, and brand identities. Solo exhibitions of her artwork include 'Young Americans Part 2', Neue Kunsthalle St Gallen, Switzerland [2004], and 'CANDY.CRY.STINKER.HUG. (some drawings concerning absorption, reflection, inversion, and progression)', Sikkema Jenkins & Co., New York, [2008].

FRED MCDARRAH [b.1926, New York; d.2007, New York] was a photographer for the Village Voice. He also documented Beat Generation artists and the New York art scene of the late 1950s. Many of his photographs were published as book-length compilations, among them The Beat Scene [1960], New York, N.Y. [1964] and, in collaboration with his wife, Beat Generation: Glory Days in Greenwich Village [1996].

MCDERMOTT & MCGOUGH [David McDermott, b.1952, Hollywood, California, USA; and Peter McGough b.1958, Syracuse, New York, USA] began collaborating in the 1980s and became known for living, dressing and making art as if they were Victorian dandies. Their work continues to question contemporary society and contemporary events by recalling and referencing imagery from previous historical periods. Solo exhibitions include 'Please Don't Stop Loving Me!', Galerie Jérôme de Noirmont, Paris [2007], and 'An Experience of Amusing Chemistry: Photographs 1990—1890', Irish Museum of Modern Art, Dublin [2008].

ANN MEREDITH [b.Hot Springs, Arkansas, USA] photographed and recorded the oral histories of women who were HIV-positive or had AIDS in San Francisco. She initiated the project in 1987 to shed light on an underrepresented aspect of the AIDS epidemic. The exhibition, 'Until That Last Breath: Women With AIDS', was presented at the New Museum of Contemporary Art, New York [1989]. Meredith has tackled other social issues in her work, including breast cancer, gay marriage, women in the military, and injustices faced by women internationally. Other exhibitions include 'The Global Face of AIDS', Brooklyn Museum, NY [1994] and 'Don't Call Me Honey: Photographs of Women and Their Work', City Hall, San Francisco [2002].

DUANE MICHALS [b.1932, McKeesport, Pennsylvania, USA] lives in New York, and is known for photo-sequences that combine image and text. Employing the technique of double and triple exposure to depict individuals in what appear to be dream-like or surreal scenes, Michals incorporates hand-written narratives, text fragments, or painted images on the final prints. The Museum of Modern Art, New York, hosted Michals's first solo exhibition [1970]. More recently, he has had one-person shows at the Odakyu Museum, Tokyo [1999], and at the International Center of Photography, New York [2005].

KATE MILLETT [b.1934, St Paul, Minnesota, USA] lives in New York. A feminist writer and activist, she is best known for her book Sexual Politics [1970]. Sexual Politics motivated many women to engage in the second-wave feminist movement and propelled Millett's notoriety. She is also the author of The Prostitution Papers [1973], Flying [1974] and Loony-Bin Trip [1990]. She founded the Women's Art Colony Farm in Poughkeepsie, New York, as a residency and workshop space for artists.

BOB MIZER [b.1922, Hailey, Idaho, USA; d.1992, Los Angeles] created an underground industry of photographs, films, and publications featuring homoerotic content. He set up the Athletic Model Guild as an agency to photograph would-be film stars in Hollywood after WWII. The mail-order publication Physique Pictorial developed out of the nude and semi-nude images he made in his studio.

DONALD MOFFETT [b.1955, Texas, USA] lives in New York. He was a founding member of the AIDS activist collective Gran Fury. In his personal work, Moffett often combines traditional painting techniques with sculptural and video elements, while ruminating on death, desire, power and scandal. He collaborated with Marlene McCarty in Bureau, the design studio that they co-founded. Recent solo exhibitions include 'Impeach' and 'Hippie Shit', Marianne Boesky Gallery, New York [2006, 2005], 'Paintings from a Hole', Anthony Meier Fine Arts, San Francisco [2004], and 'Donald Moffett: What Barbara Jordan Wore', Museum of Contemporary Art, Chicago [2002].

PIERRE MOLINIER [b.1900, Agen, France; d.1976, Bordeaux] his photographic work, depicts an autoerotic relationship with his own body, usually costumed and made up as a woman. Molinier was included in 'Transformer: Aspekete der Travestie', Kunstmuseum, Lucerne [1973]. Solo exhibitions include l'EtoileScellée (André Breton's Surrealist gallery), Paris [1956], and a retrospective at the Musée National d'Art Moderne, Centre Georges Pompidou, Paris [1979].

KENT MONKMAN [b.1965, Winnipeg, Canada] lives in Toronto. He draws inspiration from the histories depicted in nineteenth century art,

colonial portrayals of Aboriginal peoples, and cinematic genres such as classic Hollywood Westerns. Using these conventions he constructs new stories that take previously missing narratives and perspectives into account and explores stereotypes of masculinity and queer culture. Exhibitions include 'Kent Monkman: The Triumph of Mischief', Art Gallery of Hamilton [2007 and tour], and Walter Phillips Gallery, Banff Centre, Canada [2005].

FRANK MOORE [b.1953, New York; d.2002, New York] was profoundly affected by the AIDS crisis and the losses that he experienced as a result. Health, science, ecology and sexuality merged in his figurative, colourful paintings. His work was featured in the Whitney Biennial, Whitney Museum of American Art, New York [1995].

YASUMASA MORIMURA [b.1951, Osaka] lives in Osaka. Using photography, overpainting and computer imaging Morimura makes self-portraits in which he deconstructs categories of race, gender, age and culture, undermining both European art history and American popular culture by positioning his own costumed body as an element in the image. Solo exhibitions include 'Yasumasa Morimura: My Life Through A Looking-Glass', Reflex New Art Gallery, Amsterdam [2007]; 'Yasumasa Morimura: Reflections', John Michael Kohler Arts Center, Sheboygan, WI. [2007] and the group exhibition 'Rrose is a Rrose is a Rrose', Solomon R. Guggenheim Museum, New York [1998].

MARK MORRISROE [b.1959, Malden, Massachusetts, USA; d.1989, Jersey City, New Jersey, USA] is known for his performance, photography and active involvement in the formation of the Boston and New York punk scenes. His photographs were often portraits of himself or friends rendered through experimental exposure and printing techniques, sometimes incorporating handwritten text. His photographs have been included in group shows such 'Split Vision' (curated by Robert Mapplethorpe in 1985) and 'Witnesses: Against Our Vanishing' (curated by Nan Goldin in 1989). After his death, Morrisroe was the centre of the survey exhibition 'Boston School' at the Institute of Contemporary Art, Boston 1995.

NICHOLAS MOUFARREGE [b.1948, Alexandria, Egypt; d.1985, Bronx, New York] was an artist, critic and curator. His visual work, consisting of paint and thread on needlepoint canvases, involved appropriated and juxtaposed motifs from high and low

art and Eastern and Western cultures. Solo exhibitions include Gabrielle Bryers Gallery, New York [1983] and Fun Gallery, New York [1985].

CARRIE MOYER [b.1960, Detroit] lives in New York and is one half of the public art project Dyke Action Machine! [DAM!]. She is a painter who mixes the graphic influences of rock and pop posters and political and social movements with modernist painting gestures. Exhibitions include 'That Was Then This Is Now' at PSI New York [2008] and 'Sister Resister' at Diverseworks, Houston [2004].

BILLY NAME [Billy Linich, b.1940, Poughkeepsie, New York, USA] is a photographer, filmmaker, and archivist of the Warhol era. His images of Edie Sedgwick, Lou Reed, Nico, and the cast of characters at Andy Warhol's Factory, are iconic Pop-era images. His work was featured in 'Ten Years After: The Warhol Factory', Audart, New York [1997], and in the book All Tomorrow's Parties: Billy Name's Photographs of Andy Warhol's Factory [1997].

ADI NES [b.1966, Kiryat Gat, Israel] lives in Tel Aviv. His work subverts stereotypes of Israeli masculinity by staging photographs that feature vulnerable male figures, often with art historical, religious, and homoerotic suggestions. Solo exhibitions include 'Bibilical Stories', Wexner Center for the Arts, Columbus [2008], 'Adi Nes: Photographs', Tel Aviv Museum of Art, Tel Aviv [2003 and tour], and the group exhibition 'Between Memory & History: From the Epic to the Everyday', Museum of Contemporary Canadian Art, Toronto [2008–09].

DANIEL NICOLETTA [b.1954, New York] lives in San Francisco and has been documenting the gay, lesbian, bisexual, and transgender communities since 1975. He was hired by Harvey Milk to work at Castro Camera and later worked on Milk's campaigns for city supervisor. Nicoletta's work has been featured in books including Gay by the Bay [1996] and The Mayor of Castro Street [1988] and films including The Times of Harvey Milk [1984] and Sex Is [1993]. His work is in the Berg Collection at the New York Public Library, the James C. Hormel Gay and Lesbian Center at the San Francisco Public Library and the Schwules Museum, Berlin.

NICHOLAS NIXON [b.1947, Detroit] is known for his portraiture and documentary photography projects including 'The Brown Sisters' and 'People with AIDS'. Solo exhibitions include the Museum of Modern Art [1976], the Art Institute of Chicago [1985] and the Sprengel Museum in Hannover, Germany [1994].

RICHARD BRUCE NUGENT [b.1906, Washington, DC; d.1987, Hoboken, New Jersey, USA] was a painter and writer who lived at the centr of the Harlem Renaissance. A protégé of Alain Locke, Nugent was one of the few African-American writers of the time to indicate his same-sex desire in print. In 2002 Duke University Press released Gay Rebel of the Harlem Renaissance: Selections from the Work of Richard Bruce Nugent, which included examples of his writing and artwork.

HÉLIO OITICICA [b.1937, Rio de Janeiro; d.1980, Rio de Janeiro] was a painter, sculptor and performance artist. He was a key member of the Neo-Concretist movement, and his work ranged from abstract compositions to environmental installations. The retinal and physical experience of colour became a major focus of his work. Exhibitions include 'Hélio Oiticica: The Body of Colour', Museum of Fine Arts, Houston [2006 and tour] and 'Hélio Oiticica', Witte de With, Rotterdam [1992].

HENRIK OLESEN [b.1967, Esbjerg, Denmark] lives in Berlin. His works range from posters, fliers, text, collages and found-object sculptures, to spatial interventions. His wide-ranging investigations into structures of power, systems of knowledge and social rules often focus on the criminalization and persecution of homosexuality and the unacknowledged expressions of same-sex desire in Western art history. Recent works include a series of portraits of the British mathematician Alan Turing and a site specific work for the 'Projects: 94' series at MOMA [2011].

CATHERINE OPIE [b.1961, Sandusky, Ohio, USA] lives in Los Angeles, where she teaches at UCLA. She has investigated aspects of community in her photographic work, making portraits of LGBT. individuals, surfers, and most recently high-school football players. She has also focused on how identities are shaped by our surrounding architecture. Solo exhibitions include 'Catherine Opie: American Photographer', Guggenheim Museum, New York [2008], and 'In and Around Home', Aldrich Museum, Ridgefield, CT [2006 and tour].

JEAN-MICHEL OTHONIEL [b.1964, Saint-Etienne, France] lives in Paris. His sculptural work and installations often feature glass and allude to sensuality, the body, dreams, celebrations and myths of the American West. Solo shows include 'Secret Americana', Sikkema, Jenkins & Co., New York [2008], 'L'Edredon Cellulique', Musée du Feutre, Mouzon, France [2008], and 'Crystal Palace', Fondation Cartier, Paris [2003].

ULRIKE OTTINGER [b.1942, Konstanz, Germany] lives in Berlin. In addition to being a photographer, theatre director and set designer, she has produced a series of pivotal feminist and lesbian films: *Madame X* [1977], *Freak Orlando* [1981], *Dorian Grey in the Mirror of the Yellow Press* [1984], and *Johanna d'Arc of Mongolia* [1989].

THOMAS PAINTER [b.1905, New York; d.1978] participated in the homophile movement as a community sex researcher. Beginning in the 1930s, and in association with the Kinsey Institute, he researched, interviewed and photographed hundreds of gay men from coast to coast. Painter devoted particular attention to the culture of male prostitution while also documenting the homosexual bars, parties and drag shows, as well as the possibilities afforded by attendance at the ballet, theatre and concerts.

BETTY PARSONS [b.1900, New York; d.1982, New York] opened the Betty Parsons Gallery in 1946 and directed it until her death. In the years after World War II, she identified, promoted, and nurtured a generation of American artists, with a special interest in abstract expressionism. Parsons herself was a painter and her work is held in the collection of the National Museum of Women in the Arts, Washington, DC and the Smithsonian Museum of American Art, Washington, DC.

CHI PENG [b.1981 Yantai, China] fuses reality and fiction in his digitally-generated photographs. He uses and multiplies his own image, often with a backdrop of imagined Chinese cityscapes, to address consumerism, urban architecture and social stigmas. He was featured in a solo exhibition at He Xiangning Art Museum, Shenzhen, China [2009] and the group exhibitions Guangzhou Photo Biennial [2009] and the International Triennale of Contemporary Art, Prague [2008].

VALENTINE PENROSE [b.1898 Valentine Boué, Mont-de-Marsan, France; d.1978, England] was a surrealist writer and collagist who married the English painter Roland Penrose in 1925. The couple helped to introduce surrealism to England, and were friends with Max Ernst and Joan Miró. Penrose left her husband in 1936 to go to an ashram in Indian with Alice Rahon. In 1962, she published the novel *The Bloody Countess: The Atrocities of Erzsebet Bathory*. Penrose remained in relative obscurity even during her association with noted surrealists.

SHEILA PEPE [b.1959, Morristown, New Jersey, USA] lives in New York and creates site-specific installations shaped from ready-made materials such as shoelaces, yarn, gigantic rubber bands, and nautical line. Exhibitions include 'Sheila Pepe: Red Hook at Bedford Terrace', Smith College Art Museum, Northampton, MA [2008], 'Sheila Pepe: Mind the Gap', University Gallery, University of Massachusetts, Amherst [2005], and 'Greater New York', MOMA PS1, New York [2000].

DANICA PHELPS [b.1971, New York] lives in New York. She chronicles her personal life with an extensive system of lists and charts, accompanied by diagrams of coloured stripes. Solo exhibitions include 'Stripe Factory', Sister, Los Angeles [2008], and Zach Feuer, New York [2008].

PABLO PICASSO [b.1881, Málaga, Spain; d.1973, Mougins, France] co-founded the Cubist movement and is one of the most recognized figures in twentieth-century art. His paintings, drawings and sculptures represent a fluctuating range of artistic styles. Settling in Paris for many years, Picasso surrounded himself with other visual artists and writers, many of whom became subjects in his work. Solo exhibitions include Museum of Modern Art, NY [1939], Musée des Arts Décoratifs, Paris [1955]. The Museu Picasso, Barcelona; Musée Picasso, Paris; and the Museo Picasso, Málaga, are all dedicated to showcasing his life and work.

PIERRE ET GILLES is Pierre Commoy [b.1949, La Roche-sur-Yon, France] and Gilles Blanchard [b.1953, Le Havre, France]. Since 1976, they have produced highly stylized portraits and self-portraits by building their own sets, creating costumes, and retouching the finished prints. Their work often features images from popular culture, gay culture and religion. Exhibitions include 'Pierre et Gilles: double je 1976–2007', Galerie Jérôme de Noirmont, Paris [2007], and Museum of Contemporary Art, Shanghai [2005].

JACK PIERSON [b.1960, Plymouth, Massachusetts, USA] lives in Joshua Tree, California and New York. His photographs, drawings, text pieces and installations reflect an undercurrent of emotional experiences bound up in loss, love and lust, and draw upon our response to memory, nostalgia and cultural symbolism. Recent exhibitions include the group show 'Stripped Bare', C/O, Berlin [2007], and a solo exhibition at the Irish Museum of Modern Art, Dublin [2008].

GEORGE PLANK [b.1883, Pennsylvania, USA; d.1965, Sussex, England], self-taught artist and illustrator, moved to London in 1914, where he circulated among fellow artists, actors, and writers. He contributed several witty cover designs to *Vogue* magazine as well as numerous illustrations for books (including those by his friend E. F. Benson), stationery, posters for the Red Cross, as well as stage sets and costumes for the theatre and ballet.

JILL POSENER [b.1953, London] lives in Berkeley, California. She was a founder and partner of the publishing company 'Picture This'. She was the first female member of Britain's gay professional theatre company 'Gay Sweatshop,' and wrote the company's first lesbian play in 1974. From 1988–89, she was the photo editor for the feminist pro-sex publication *On Our Backs*. Her books of political graffiti photographs include *Louder Than Words* and *Spray It Loud*.

ERNESTO PUJOL [b.1957, Havana] lives in New York. A former monk, Pujol produces photographs, installations and performances that address individual and collective memory, spirituality, ecological issues, war and mourning. Solo exhibitions include 'Memorial Gestures', Chicago Cultural Center, Chicago [2007], 'Becoming the Land', Salina Art Center, Kansas [2003], and group exhibitions including 'Rewind... Rewind...', Instituto de Cultura Puertorriqueña, San Juan, Puerto Rico [2005].

MONTE PUNSHON [Ethel May Punshon, b.1882, Ballarat, Australia; d.1989] was known in the 1980s as the oldest living lesbian. She was a member of the Australian Women's Army Service during WWII and worked in Japan at the Tatura internment camp. Her autobiography, *Monte-San: The Times Between, Life Lies Hidden*, was published in 1987.

ROBERT RAUSCHENBERG [b.1925, Port Arthur, Texas, USA; d.2008, Captiva Island, Florida, USA] studied in Paris [1948–49] and at Black Mountain College in North Carolina [1948–52], where he met composer John Cage, choreographer Merce Cunningham and artist Cy Twombly. Their shared ideas led him to explore 'the gap between art and life' in his combines of the mid-1950s as well as in his collaborations with performance and dance companies. At the start of his career Rauschenberg worked with his one-time partner Jasper Johns as a window dresser for Manhattan stores under the name of Matson Jones. In 1963 Rauschenberg was awarded the Grand Prize for painting at the Venice Biennale. His work has been collected by many of the world's largest museums, and the Guggenheim Museum in New York organized a major touring retrospective in 1997.

CHARLES RAY [b.1953, Chicago] lives in Los Angeles. In early work he introduced his body into sculptural installations, forcing the monumentalism of the Minimalist tradition back to human scale. Subsequent series include mannequins in which the figure is enlarged, reduced or replicated. His work was included in the Whitney Biennial, New York [1993]. Major solo shows include the Newport Harbor Art Museum [1990], and the Rooseum Center for Contemporary Art, Malmo [1990 and tour].

HUNTER REYNOLDS [b.1959] is a visual artist and AIDS activist. He was a founding member of ACT UP and ART-Positive. He has performed extensively in his Patina du Prey *Memorial Dress*, and has created mixed-media work that is often a tribute to deceased friends. Exhibitions include 'Patina du Prey's Memorial Dress: 1993–2007', Artists Space, New York [2007], and a retrospective at Mary Goldman Gallery, Los Angeles [2006].

LARRY RIVERS [Yitzok Loiza Grossberg, b.1923, New York; d.2002, Southampton, New York, USA]. After changing his name when working as a jazz saxophonist at the age of 17, Rivers studied music at The Julliard School, New York, and initiated what would become a lifelong friendship with Miles Davis. At around the same time, he took up painting and gradually shifted his creative energies and professional ambitions from jazz to visual art. Rivers incorporated figurative elements, popular images, stencilling, and photography into his art. Openly bisexual, Rivers addressed various forms of eroticism, desire and embodiment in his paintings. Solo exhibitions include a retrospective at the Corcoran Gallery of Art, Washington, DC [2002].

IRARE SABASU helped found NAPS, the first black lesbian performing arts group, along with Ntozake Shange, Aida Mansuer and Sapphire.

JOHN SINGER SARGENT [b.1856, Florence; d.1925, London] studied in Paris under Emile Auguste Carolus-Duran, and regularly exhibited portraits at the Paris Salon. His facility for referencing the masters in a contemporary manner resulted in a steady stream of commissioned portraits, and led many to consider him the most successful portrait painter of his generation. Solo exhibitions include a retrospective at the Whitney Museum of American Art, New York [1986], and Museum of Fine Arts, Boston, [1999 and tour].

COLLIER SCHORR [b.1963, New York] works in New York and Germany. Best known for her portraits of adolescent men and women, Schorr's pictures often blend photographic realism with elements of fiction and youthful fantasy. Her work was featured in the 2002 Whitney Biennial and the 2003 International Center for Photography Triennial, New York.

GEORGE SEGAL [b.1924, New York; d.2000, New Brunswick, New Jersey, USA]. Segal began making life-size figures with plaster over burlap and wire in 1958, and casting from live models in 1961. Segal often set his figures in urban locations such as diners, buses or street corners. His figures often demonstrate minimal colour and detail, adding to the ghostly, melancholic nature of his work. Solo Exhibitions include 'George Segal: Street Scenes', Madison Museum of Contemporary Art [2008] and travelling, and a retrospective at The Jewish Museum, New York [1998].

SONJA SEKULA [b.1918, Lucerne, Switzerland; d.1963, Zurich] moved with her family to New York when she was a teenager. Sekula was an abstract expressionist painter who showed at the Betty Parsons Gallery in the 1940s and 50s. The confident marks of her paintings contrasted with her own mental instability; she was frequently institutionalized and eventually committed suicide. In 1996 a retrospective of her work was organized by the Swiss Institute, New York.

YINKA SHONIBARE MBE [b.1962, London] moved to Lagos when he was three years old, and at age sixteen he to returned London, where he still lives. His work interrogates colonialism and post-colonialism within the current context of globalization through painting, sculpture, photography, film and performance. His works have been included in major international exhibitions, including Documenta 10 [2002]. After receiving the Most Excellent Order of the British Empire in 2004, he officially added the title to his professional name. In 2008, he was the subject of a major mid-career survey at the Museum of Contemporary Art in Sydney, which toured to the Brooklyn Museum [2009] and the Museum of African Art at the Smithsonian Institution, Washington, DC [2009].

ELLEN SHUMSKY [b.1951, Brooklyn, New York, USA] is an artist and psychoanalyst. She was a founding member of Gay Liberation Front and Radicalesbians, and photographically documented the gay, lesbian, and feminist movements of the early 1970s. Exhibitions include 'Women and Signs', Djuna Books, New York [1972], 'Becoming Visible: The Legacy of Stonewall', New York Public Library [1994], and 'Portraits of Transformation: 1967-1973', LGBT Center, New York [2009]. A book of her photographs, *Portrait of a Decade: 1968—1978*, was published in 2009.

SILENCE=DEATH PROJECT, a group of six gay activists in New York who collaborated in 1986 on the design and public distribution of a wheat-pasted protest poster. The poster featured an iconic pink triangle and the slogan 'SILENCE=DEATH' floating against a black monochrome backdrop. Though it predated the formation of ACT UP in 1987, the SILENCE=DEATH graphic (variously reproduced as button, T-shirt, crack-and-peel sticker, even a neon sign) would become closely associated with the passionate activism of street protests of ACT UP. Though anonymous at the time, the SILENCE=DEATH Project included Avram Finklestein, Oliver Smith and Chris Lione.

JEANNIE SIMMS [b.1967, Boston] lives in Boston and New York. She uses stories, texts and biographies from real and fictional individuals to explore the interconnections between subjectivity, language, environment and representation. Her works have screened at the International Film Festival, Rotterdam [2006], Courtisane Video and New Media Festival, Belgium [2006], and the ICA, London [2002].

ALLISON SMITH [b.1972, Manassas, Virginia, USA] works in New York. Her diverse artistic practice engages in an investigation of the cultural phenomenon of historical reenactment and the role of craft in the construction of national identity. She uses historical references to produce sculptural installations and live art events that allude to contemporary social conflicts around issues of gender, art and war. Exhibitions include 'Grow Your Own', Palais de Tokyo, Paris [2007], and 'Greater New York 2005', MOMA PS1, New York [2005].

JACK SMITH [b.1932 Columbus, Ohio, USA; d.1989, New York] was a filmmaker, photographer, performer and artist. After moving to New York in 1953, he met the filmmaker Ken Jacobs, whose *Blonde Cobra* [1959] is a portrait of Smith. Smith's *Flaming Creatures* [1962], with its transvestite orgy, immediately became a cult classic and was the subject of an obscenity trial in 1964. Warhol met Smith in 1963; they shared a star, the performer Mario Montez. Retrospectives have been organized by PS1, New York [1997], Reina Sofía, Madrid [2008] and the Institute of Contemporary Arts, London [2011].

LEE SNIDER [b.1939] is a New York-based photographer who specializes in travel photography and American history.

ANNIE M. SPRINKLE [Ellen
F. Steinberg, b.1954, Philadelphia] is
a multi-media artist who has toured
one-woman theatre performances
about her life since 1989. She was
a formative figure of the sex-
positive feminist movement in the
1980s, and her work has long
championed sex education and equal
rights. She is the author of *Post
Porn Modernist* [1998] and *Hard
Core From the Heart: The Pleasures,
Profits and Politics of Sex in
Performance* [2001]. She collaborates
with Elizabeth M. Stephens on the
'Love Art Laboratory'.

ANITA STECKEL [b.1930, New York;
d.2012, New York]. A veteran feminist
artist, Steckel addressed sexual
politics through a combination of
painting, drawing, collage and
photomontage. In 1973, she founded
the 'Fight Censorship' group of women
artists working with sexually explicit
imagery. The group included, Louise
Bourgeois, Martha Edelheit, Joan
Semmel and Hannah Wilke.

A. L. STEINER [b.1967, Miami] uses
photography, video, installation,
performance and curatorial work to
question sexuality, feminism, androgyny
and ecological concerns. Steiner,
who collaborates with numerous visual
and performing artists, is a member
of the collectives Chicks on Speed
and W.A.G.E., as well as the co-curator
of Ridykeulous. The collaboration,
'C.L.U.E.', with robbinschilds,
was on view at the New Museum,
New York [2008].

ELIZABETH M. STEPHENS [b.1960,
Montgomery, West Virginia, USA] is an
interdisciplinary artist, activist and
educator who has explored themes
of sexuality, gender, queerness
and feminism through art for over
twenty years. Her current project,
'SexEcology', addresses environmental
degradation, environmental healing,
and pleasure. She is also involved
in an on-going collaboration with her
partner, Annie Sprinkle, called the
'Love Art Laboratory'.

FLORINE STETTHEIMER [b.1871,
Rochester, New York, USA; d.1944,
New York] was a painter, designer
and poet. She gained recognition
for the sets and costumes she
devised for 'Four Saints in
Three Acts', an opera by Virgil
Thompson with a libretto by Gertrude
Stein. Posthumous retrospectives
include the Museum of Modern
Art, New York [1946], and the Whitney
Museum of American Art, New
York [1995].

HAROLD STEVENSON [b.1929,
Idabel, Oklahoma, USA], a Pop artist
and occasional actor in Warhol films,
Stevenson created *The New Adam*,

a monumental male nude, for a 1963
exhibition at the Guggenheim Museum
titled 'Six Painters and an Object.'
When curator Lawrence Alloway saw
the painting, he rejected it from
the exhibition on the grounds that its
size and subject matter would
'detract' from the work of the other
artists in the show (including Warhol,
Johns and Rauschenberg). After
spending several decades rolled up in
storage, *The New Adam* was exhibited
by the Mitchell Algus gallery in
1992 and by the Andy Warhol Museum
in 1998. The Guggenheim Museum
acquired the work for its permanent
collection 2005, thereby reclaiming
the homoerotic nude it had long
ago rejected.

GEORGE STOLL [b.1954, Baltimore]
recreates everyday objects such as
sponges, Tupperware and paper towels,
out of sculptural and painted materials.
Interested in the relationship of
high art to consumer culture, his
trompe l'oeil works create links between
Pop art, Minimalism and monochromatic
painting, and reconsider domestic
materials that are often taken for
granted. Exhibitions include 'I Won't
Grow Up', Cheim and Read, NY [2008]
and 'Here's the Thing', Katonah
Museum of Art, Katonah, NY [2008].

MARY ELLEN STROM [b.1955, Butte,
Montana, USA] makes work in the form
of video installations, single channel
videos, performance and public art
projects. Her work is project based
and is most often temporal. Strom's
single channel videos and installations
have been presented at the Museum
of Contemporary Art, Los Angeles,
the Museum of Modern Art, New York,
and the Wexner Center for the Arts,
Columbus. Her collaborative work
with Ann Carlson was featured in
'Carlson/Strom: New Performance',
DeCordova Museum and Sculpture
Park, Lincoln, MA [2009].

GINGER BROOKS TAKAHASHI [b.1977
Huntington, West Virginia, USA] is a
visual artist and musician living and
working in Brooklyn, NY. Her work
uses social practice to investigate
new forms of building and sustaining
community. She is an editor and
co-founder of the queer feminist
journal and artist collective LTTR
and co-founder of Mobilivre
Bookmobile, a traveling exhibit of zines
and artists books. She has exhibited
work at Documenta 12, Kassel,
Germany [2007]; Serpentine Gallery,
London [2009]; Textile Museum,
Toronto, Canada [2009]; and the New
Museum, New York [2009]. She is also
an original member of the queer
techno pop group MEN.

DR. BERNARD TALMEY [b.1862;
d.1926] was a gynaecologist who
practised in New York. He was

the author of *Woman* [1904] and
*Love: A Treatise on the Science of
Sex-Attraction* [1919].

PAVEL TCHELITCHEW [b.1898,
Moscow; d.1957, Rome] was a painter,
stage-designer, and partner
of Charles Henri Ford. He is known
for his surrealist works that are full
of ambiguity and figures in states
of metamorphoses. He contributed
illustrations for the Surrealist
magazine *View*, and exhibited work at the
Museum of Modern Art, New York [1930].

MASAMI TERAOKA [b.1936, Onomichi,
Japan] lives in Hawaii. His early
work critiqued the traditions of both
Japanese and European art and often
involved imagery of cultures colliding.
In the 1980s, Teraoka turned his
attention to AIDS as a subject, moving
his ukiyo-e influenced paintings
into a more sombre, political realm.
Exhibitions include Asia Pacific Triennial
of Contemporary Art, Queensland
Art Gallery, Australia [2006], and
'The Holy Terrors', a travelling career
survey originating at the Honolulu
Academy of Arts, Hawaii [2009].

PAUL THEK [b.1933, Brooklyn; d.1988
New York] worked in painting, sculpture
and performance, and was one of
the early innovators of installation
environments. He became known in
the early 1960s for his 'meat pieces',
sculptures resembling decomposing
flesh and body parts placed in Plexiglas
boxes that referenced minimalist
sculpture. In 1967, he left New York
City for Europe, where he travelled
and exhibited extensively, developing
his style of ephemeral and collaborative
site-specific environments. He
returned to New York in 1976, where
he experienced little commercial
recognition but continued his work
in painting and sculpture. 'Paul Thek:
Diver, A Retrospective,' originated
at the Whitney Museum of American Art,
New York in 2010, and then travelled
throughout the USA.

MICKALENE THOMAS [b.1971, Camden,
New Jersey, USA] lives in New York.
Her work, permeated by an interest
in the 1970s, is full of self-assured,
glamorous women. Thomas received
a MFA from Yale University in 2002.
Recent solo exhibitions include Susanne
Vielmetter Los Angeles Projects
[2007], and the Indianapolis Museum
of Contemporary Art [2007].

THUKRAL AND TAGRA [Jiten Thukral,
b.1976, New Delhi; Sumir Tagra, b.1979,
New Delhi] live and work in New Delhi.
They work collaboratively in a variety
of media including painting, sculpture,
installation, video, music and graphic
design. Their work responds to the
contemporary politics of India, and
raises awareness of global concerns
such as HIV/AIDS. Recent exhibitions

include Art Basel 38, Basel [2007], Gallery Nature Morte, New Delhi, [2007], and Teatro Armani, Milan, [2006].

WOLFGANG TILLMANS [b.1968, Remscheid, Germany] lives in Berlin and London. Since the mid-1980s, he has developed a distinctive style of image-making that embraces a broad range of subjects from portraiture to still life and landscape, as well as exploring photography's material and abstract potential. He varies the sizes and presentation of his photographs based on the specific exhibition venue, making formal, symbolic and ephemeral connections between seemingly disparate works. Solo exhibitions include PS1, New York [2006], Hamburger Bahnhof, Berlin [2008], Serpentine Gallery, London [2010] and Kunsthalle Zürich [2012]. In 2000 he was awarded the the Turner Prize.

TOM OF FINLAND [Touko Laaksonen, b.1920, Kaarina, Finland; d.1991, Helsinki] produced drawings and illustrations of hyper-masculine figures with hyperbolic features. His heavily-muscled men, often in uniform or leather, engaged in sexual escapades and helped shape gay fantasies for nearly four decades. His illustrations appeared in *Physique Pictorial*, and he was the subject of F. Valentine Hooven III's 1993 biography *Tom of Finland: His Life and Times*. Today his work is in the collections of major museums, including the San Francisco Museum of Modern Art.

BORIS TORRES [b.1976, Ecuador] creates paintings and drawings about sexuality, domesticity, character and pride. His series 'Positive Paintings' features self-identified HIV-positive men and women. Recent exhibitions include 'Sex in the City', DUMBO Arts Center, NY [2007], 'No More Drama: The Saga Continues', The Center for the Book Arts, NY [2006], and the solo project 'Boris Torres: Recent Paintings', The Center, NY [2009].

WU TSANG [b.1982, Worcester, Massachusetts, USA] lives and works in Los Angeles. He is a performance artist, and his work uses video, installation and community organizing to explore the intersections between social spaces, embodiment and transgender. His 2012 film *WILDNESS* presents a portrait of the Silver Platter, a bar in Los Angeles that has provided a home for Latin / LGBT immigrant communities since 1963. His work was the subject of a solo exhibition 'Re:New / Re:Play', New Museum, New York [2011] and has been featured in such group exhibitions as 'Our Bodies Our Selves', Montehermoso Cultural Center, Vitoria-Gasteiz, Spain [2008], the California Biennial, Orange County Museum of Art, Newport Beach [2010] and the Whitney Biennial [2012].

YANNIS TSAROUCHIS [b.1910, Piraeus, Greece; d.1989, Athens] helped define and portray Greek identity. Combining techniques of Impressionism with elements of Hellenistic sculpture, he filled canvases with images of vulnerable men and strong women. Today, the Yannis Tsarouchis Museum operates out of the artist's former home in an Athenian suburb.

NICOLA TYSON [b.1960, London] lives in New York. She was the co-proprietor of the gallery Trial Balloon, a three year experiment in presenting feminist and lesbian work that launched in New York in the early 1990s. Tyson attempts to strike a balance between figurative and abstract elements in her paintings and drawings in order to examine identity, gender and sexuality. Forms appear as androgynous mutations of familiar objects and body parts. Solo exhibitions include Sadie Coles HQ, London [2008], and Kunsthalle Zurich [1998].

JAMES VAN DER ZEE [b.1886, Lenox, Massachusetts, USA; d.1983, Washington, DC] lived in Harlem, New York, where he opened his own photography studio. Fighting against stereotypical portrayals of Harlem as a ghetto, his portraits chronicled the Harlem Renaissance and an emergent black middle class. He often retouched his negatives to stress the glamour and pride of his sitters. His work was the subject of a retrospective at the National Portrait Gallery, Washington, DC [1993] and his photographs of funerals are compiled in *The Harlem Book of the Dead* [1978].

CARL VAN VECHTEN [b.1880, Cedar Rapids, Iowa, USA; d.1964, New York] took an avid interest in the Harlem Renaissance, and befriended, photographed and wrote about many African-American artists. As the literary executor of Gertrude Stein, he helped bring many of her unpublished writings into print. He is the author of *Peter Whiffle: His Life and Works* [1922], *The Blind Bow-Boy* [1923], and *Music After the Great War* [1915]. As the literary executor of Gertrude Stein, he helped bring many of her unpublished writings into print. Exhibitions include 'Extravagant Crowd: Carl Van Vechten's Portraits of Women', Beinecke Rare Book and Manuscript Library, Yale University, New Haven [2003].

FRANCESCO VEZZOLI [b.1971 Brescia, Italy] lives in Milan. His works in film and performance make heady reference to the power of celebrity culture and concomitant depictions of decadent lifestyles, and include collaborations with the director Roman Polanski, actors Helen Mirren, Natalie Portman and Michelle Williams and the pop star Lady Gaga. Recent exhibitions include 'Francesco Vezzoli: Scarilegio' at Gagogsian Gallery in New York

[2011], 'Marlene Redux: A True Hollywood Story (Part One)' at Tate Modern in London [2006] and 'Francesco Vezzoli – Triologia della morte', Fondazione Prada, Milan [2005].

DANH VO [b.1975, Vietnam] lives in Berlin. He explores the porous divide between public and private, sometimes focusing on traces of Vietnam in the overlooked details of larger historical events. His work takes ideas of appropriation and ownership to an extreme, and it has involved marrying and divorcing several people, curating shows with well known artists in his parents' house, collaborating on projects without declaring his co-authorship, and stealing ideas from his boyfriend. Solo exhibitions include Stedelijk Museum, Amsterdam [2008], Kunsthalle Basel [2009] and Kunsthaus Bregenz [2012].

DEL VOLCANO [DELLA GRACE] [Debra Dianne Wood, b.1957, California, USA], an intersexed individual, is a 'gender abolitionist' who amplifies hermaphroditic traces to address the performance of gender. Publications include *Sex Works* [2005], *Sublime Mutations* [2000], *The Drag King Book* [1999], *Love Bites* [1991], and *Femmes Of Power: Exploding Queer Femininities* (with Ulrika Dahl) [2008].

BARON WILHELM VON GLOEDEN [b.1856, Mecklenburg, Germany; d.1931, Taormina, Italy] Born into Prussian nobility, von Gloeden (whose official title was Baron of the Court of the Hohenzollerns) studied antiquity, aesthetics, and painting before being diagnosed with tuberculosis at the age of 20. Advised by doctors to live in a warmer climate, von Gloeden settled in the Sicilian town of Taormina. Drawn to the town's young men and adolescent boys, Von Gloeden contrived to photograph them against Arcadian backdrops. Von Gloeden variously posed the young men individually and in groups, amongst columns and fountains, in togas and laurel crowns, and, quite frequently, altogether naked. Passed by hand and post through an international, if largely underground, network of discerning consumers (including Oscar Wilde and German industrialist Friedrich Krupp), the photographs helped establish Taormina as a tourist destination at the turn of the twentieth century.

ANDY WARHOL [Andrew Warhola, b.1928, Pittsburgh; d.1987, New York] worked as a commercial artist and illustrator before turning his creative efforts to his own avant-garde films, paintings and writing. He became the central figure in the Pop Art movement, attracting a following of collaborators, celebrities and hangers-on to his Factory. His work has been the subject of several major

retrospectives including the Museum of Modern Art, New York [1989] and the Metropolitan Museum, New York [2012], as well as the exhibition 'Andy Warhol: Other Voices, Other Rooms', Wexner Center for the Arts, Columbus [2008–09].

WEEGEE [b. Usher Fellig, 1899, Złoczów, Austria; d.1968, New York] Weegee's one-word professional moniker evoked both the Ouija board game and the squeegee used to remove excess ink from newspaper printing presses. A New York news photographer throughout the 1930s and early 40s, he seemed to appear wherever there was a breaking story, especially if it involved a grisly crime scene, deadly fire or nocturnal disaster. He was the first reporter in New York to secure a permit for a police-band radio, which may explain Weegee's success in arriving at crime scenes before other reporters and photographers. His first book of photographs, *Naked City*, was published in 1945 and became a surprise best-seller.

ALBERT WEISBERGER [b.1878, St Ingbert, Germany; d.1915, Fromelles, France] was a graphic artist and commercial designer. He taught at the Royal Bavarian Arts and Crafts Academy in Munich where he influenced artists such as John Heartfield.

MINOR WHITE [b.1908, Minneapolis; d.1976, Cambridge, Massachusetts, USA] photographed seemingly mundane objects and textures with the intention of triggering an emotional response in viewers. He also trained his camera on the male body — images that were not exhibited until after his death. With Ansel Adams, he co-founded the magazine Aperture, and later worked as a curator at George Eastman House.

KEHINDE WILEY [b.1977, Los Angeles] lives in New York. He has gained acclaim for his portraits that combine art historical and pop culture references to comment on the image and status of young African-American men in contemporary culture. Solo exhibitions include 'FOCUS: Kehinde Wiley', Modern Art Museum of Fort Worth [2008], 'New York States of Mind', Queens Museum of Art [2007], and 'Infinite Mobility', Columbus Museum of Art [2006].

FRED WILSON [b.1954, New York] examines and questions the biases and limitations of cultural institutions and how they shape our understanding of artistic value and historical truth. He received a MacArthur Foundation grant [1999] and represented the USA at the Biennial Cairo [1992] and

the Venice Biennale [2003]. His work was the subject of the retrospective 'Fred Wilson: Objects and Installations, 1979–2000', Center for Art and Visual Culture, University of Maryland, Baltimore [2001] and travelling.

DAVID WOJNAROWICZ [b.1954, Red Bank, New Jersey, USA; d.1992, New York] used his artwork and writing to express his outrage at the federal government's indifference to the AIDS epidemic. He also initiated successful litigation against conservative political action groups in the 1980s that misrepresented his art as pornography. Exhibitions include the Whitney Biennial, Whitney Museum of American Art [1987, 1991, and 1995], 'Witnesses: Against Our Vanishing', Artists Space, NY [1989], 'Fever: The Art of David Wojnarowicz', New Museum of Contemporary Art, NY [1999], and 'Rings of Saturn', Tate Modern, London [2006].

MARTIN WONG [b.1946, Portland, Oregon, USA; d.1999, San Francisco] was raised by his Chinese-American parents in San Francisco. His compositions chronicle survival in his drug-and-crime-besieged Lower East Side neighbourhood. In addition to his painting, Wong also experimented with poetry and prose, much of which he recorded on long paper scrolls. Solo exhibitions include: 'Martin Wong's Utopia', Chinese Historical Society of America Museum of Art, San Francisco [2004], and 'Sweet Oblivion: The Landscapes of Martin Wong', The New Museum, New York [1998].

TIM WOOD [b.1924], a retail salesman for the Sears department store, created a remarkable series of sexually explicit scrapbooks in the late 1950s and early 1960s. In the course of amassing an extensive collection of male physique photographs, nudes and 'action' shots, Wood visited gay beaches, cruising grounds and private parties in and around San Francisco, often accompanied by one or two friends who were amateur photographers.

VIRGINIA WOOLF [b.1882, London; d.1941, East Sussex, England] was a novelist, essayist, and member of the Bloomsbury Group. Her books include *Mrs. Dalloway* [1925] *To the Lighthouse* [1927], and *A Room of One's Own* [1929]. With her husband, Leonard Woolf, she founded the Hogarth Press. Woolf had a significant relationship with Vita Sackville-West throughout the 1920s, during which time she wrote *Orlando* [1928].

SUZANNE WRIGHT [b.1968, New London, Connecticut, USA] is a visual artist who lives in New York.

She has been involved in several collectives, including ACT UP, DIVA TV, and fierce pussy. Solo exhibitions include 'The Forest' at Monya Rowe, New York [2004] and group exhibitions at Los Angeles Contemporary Exhibitions [2007] and Participant, NY [2006].

DANA WYSE [b.1965, Vancouver] lives in Paris. She is the proprietor of Jesus Had a Sister Productions, which manufactures self-help books that purport to remedy all of society's ills. Exhibitions include 'L'Argent', FRAC-Ile-de-France, Paris [2008], 'In My Solitude', Aeroplastics Contemporary, Brussels [2007], 'Pretty World', Aeroplastics Contemporary, Brussels [2004], and 'Re-Play', La Périphérie, Malakoff, France [2003]. A monograph on her work [Paris: Editions du Regar], with an essay by Elisabeth Lebovici, was published in 2007

THE YES! ASSOCIATION was founded in 2005 by Malin Arnell, Johanna Gustavsson, Line S Karlström, Anna Linder and Fia-Stina Sandlund in connection with the exhibition 'Art Feminism — Strategies and Consequences in Sweden from the 1970s to the Present'. The collective defines themselves as a separatist association for art workers whose practices and activities are informed by feminism with an intersectional perspective. They work in Sweden, Germany and the United States, often through performances by Lee H. Jones.

KOHEI YOSHIYUKI [b.1946, Hiroshima Prefecture, Japan] documents people who gather in Tokyo's Shinjuku Park for clandestine nocturnal trysts. These flash-illuminated, snapshot-like images not only reveal the sexual exploits of their subjects, but also raise questions about privacy, surveillance and voyeurism. Solo exhibitions include 'The Park', Yossi Milo Gallery, New York [2007], and group exhibitions include 5th Berlin Biennial of Contemporary Art, Berlin [2008] and 5th Gwangju Biennale, Korea [2008].

NAHUM B. ZENIL [b.1947, Chicontepec, Mexico] reconciles issues of masculine and gay identity with the conservative and Catholic influence of his native Mexico. Inspired by realist and nineteenth century folk painting, Zenil paints full-body, theatrical self-portraits that hint at autobiographical events while raising larger social and political questions. His first USA museum exhibition was 'Nahum B. Zenil: Witness to the Self', Mexican Museum, San Francisco [1997].

Authors' Biographies

ALASTAIR [Baron Hans Henning Voight, b.1887, Karlsruhe, Germany; d.1969, Munich] was a dancer, mime, musician, artist, poet and translator. Best known for his drawings, his career was launched when John Lane published *Forty-Three Drawings by Alastair* in 1914. He illustrated the 1920 edition of Oscar Wilde's *The Sphinx* and the 1922 edition *Salome*.

JUAN VICENTE ALIAGA [b.1959] lives in València, Spain, where he is a member of the Fine Arts faculty at Polytecnic University of València. His research work is centred around feminist, gender and queer studies, with special attention to cultural, artistic and political representations of sexual diversity. Recent curatorial projects include 'Feminist Genealogies in Spanish Art: 1960–2010' (a collaboration with Patricia Mayayo) at MUSAC, León [2012–13]; 'Akram Zaatari, The Uneasy Subject' at MUSAC, León, and MUAC, Mexico City [2011–12]; and 'Claude Cahun' at Jeu de Paume, Paris, La Virreina, Barcelona, and the Art Institute Chicago [2011–12]. He is a correspondent for Artforum and has written numerous books, including *Akram Zaatari: The Uneasy Subject* [2011], *Orden fálico: Androcentrismo y violencia de género en las prácticas artísticas del siglo XX* [2007] and *Arte y cuestiones de género* [2004].

JAMES BALDWIN [b.1924, New York; d.1987, Saint-Paul de Vence, France] explored the complexities of racial and sexual identity and the political turbulence of the twentieth century in his novels, essays and plays. His prolific and diverse work includes *Giovanni's Room* [1956], *Tell Me How Long the Train's Been Gone* [1968], and *Notes of a Native Son* [1955].

DJUNA BARNES [b.1892, Cornwall-on-Hudson, New York, USA; d.1982, New York] played an important role in the development of modernist writing with lesbian themes. Her books include *Ladies Almanack* [1928], *The Book of Repulsive Women* [1915], and *Nightwood* [1936]. Many of these publications utilised personal, stream-of-consciousness narratives and often incorporated her own illustrations.

ANDRÉ BAUDRY [b.1922, Rethonde, France] led the French homophile movement from the 1950s into the 1980s, and advocated normalizing ideologies. He created a monthly periodical, *Arcadie*, which contained literary fiction, historical articles and scientific studies related to homosexuality.

LISA BEN [b.1921, San Francisco] was the pseudonym of Edith Eyde. Ben founded, edited, and was a chief writer for *Vice Versa*, the first American magazine directed at a lesbian readership. She was also an early member of the Daughters of Bilitis. She currently lives in Burbank, California.

THOMAS HART BENTON [b.1889, Neosho, Missouri, USA; d.1975, Kansas City, Missouri, USA] was a key member of the Regionalist art movement and is well known for his mural paintings that depict scenes of Midwestern life. He went on to teach at the Kansas City Art Institute, where Jackson Pollack was one of his students.

GREGG BORDOWITZ [b.1964, Brooklyn] is a writer, AIDS activist, and film- and videomaker. His work, including *Fast Trip, Long Drop* [1993] and *Habit* [2001], documents his personal experiences of testing positive and living with HIV within the context of a personal and global crisis. His writings are collected in *The AIDS Crisis is Ridiculous and Other Writings: 1986–2003*. He is currently on faculty in the Film Video and New Media department at the School of the Art Institute of Chicago.

BRASSAÏ [Gyula Halász, b.1899, Brassó, Hungary (now Romania); d.1984, Beaulie-sur-Mer, France] moved to Paris, and much of his artistic work involved his love of the city and desire to document it. He explored the distinctions between high and low culture in his images and writing, which he contributed to *Minotaure*, *Verve*, *Coronet*, *Picture Post*, and *Harper's Bazaar*, and which appeared in book form.

DEBORAH BRIGHT [b.1950, Washington, DC] lives in Boston. She is a photographer and author of *The Passionate Camera: photography and bodies of desire* [1988]. She has been a professor in the Photography and Art History Departments at the Rhode Island School of Design since 1989.

AA BRONSON [b. Michael Tims, 1946, Vancouver] lives in New York. Along with Jorge Zontal and Felix Partz, he founded the group General Idea in 1969. He has also been active as a curator, writer and publisher, and currently serves as the Executive Director of Printed Matter, New York. He has contributed essays for art magazines and catalogues, and his memoir, *Negative Thoughts*, was published in 2001.

JULIA BRYAN-WILSON [b.1973, Amarillo, Texas, USA] teaches in the Visual Studies programme at the University of California, Irvine. Her research focuses on the intersection of art and politics since the 1960s, taking up topics such as the visual culture of the nuclear age, the impact of AIDS on contemporary art, and the professionalization of institutional critique. A frequent contributor to *Artforum* and exhibitions catalogues, she has recently written about Sharon Hayes, Carrie Moyer and Sadie Benning.

JUDITH BUTLER [b.1956, Cleveland] is Professor of Comparative Literature and Rhetoric at the University of California, Berkeley, specializing in theories of gender difference and sexuality. Her books include *Gender Trouble* [1990], *Bodies that Matter* [1993], *Undoing Gender* [2004] and *Giving an Account of Oneself* [2009].

COLETTE [b. Sidonie-Gabrielle Colette, 1873, Yonne, France; d.1954, Paris] wrote nearly fifty novels in her lifetime, many of which focused on autobiographical themes of intimacy and struggle. Some of her notable works include *Le Pur et L'impur* [The Pure and Impure] [1932], and *Gigi* [1945].

TEE CORINNE [b. Linda Tee Cutchin, 1943, St Petersburg, Florida, USA; d.2006, Oregon, USA] began exhibiting and publishing art and writing in the mid-1960s. She was a co-facilitator of the Feminist Photography Ovulars [1979–81] and a co-founder of *The Blatant Image, A Magazine of Feminist Photography* [1981–83]. She is the author *Courting Pleasure: A Collection* [1994] and numerous artists' books and small edition publications.

LAURA COTTINGHAM [b.1963] writes about and recuperates feminist art. She is the author of *How many 'bad' feminists does it take to change a lightbulb?* [1994], *Lesbians are so chic … That We Are Not Really Lesbians At All* [1996], and *Seeing Through the Seventies: Essays on Feminism and Art* [1999]. She lives and works in New York.

THOMAS CRAVEN [b.1888, Salina, Kansas, USA; d.1969, Boston] was an anti-modernist art critic and art historian. He is the author of *Men of Art* [1931], *Modern Art: The Men, the Movements, the Meaning* [1934], and *Famous Artists and Their Models* [1949].

DOUGLAS CRIMP [b.1944, Couer d'Alene, Idaho, USA] is the Fanny Knapp Allen Professor of Art History at the University of Rochester. He began writing art criticism for *Art News* and *Art International* in the early 1970s, and continues to contribute to magazines including *Artforum* and *Art in America*. He is the author of *Melancholia and Moralism* [2002], *AIDS: Cultural Analysis / Cultural Activism* [1988].

JAMES CRUMP is a writer, director, and curator who focuses on twentieth century and contemporary art and photography. He is the director of the film 'Black White + Gray: A Portrait of Sam Wagstaff and Robert Mapplethorpe' [2007], and author of *George Platt Lynes: Photographs from the Kinsey Institute* [1993] and *F. Holland Day: Suffering the Ideal* [1995].

STEVEN F. DANSKY lives in New York and Las Vegas. He is a writer, activist, and photographer. He was one of the initial members of the Gay Liberation Front [GLF] in New York City, and in 1969 began working at the GLF newspaper *Come Out!*. He was a founding member of Effeminism, contributing to the infamous 'Effeminist Manifesto'. He is the author of two books on the HIV/AIDS pandemic, *Now Dare Everything: Tales of HIV-Related Psychotherapy* [1994] and *Nobody's Children: Orphans of the HIV Epidemic* [1997].

WHITNEY DAVIS [b.1958, London, Ontario, Canada] is Professor of History & Theory of Ancient & Modern Art at the University of California, Berkeley. He is the author of *Drawing the Dream of the Wolves: Homosexuality, Interpretation, and Freud's 'Wolf Man' Case* [1994] and co-editor of *Gay and Lesbian Studies in Art History* [1989].

LAURA L. DOAN [b.1951, San Diego] is the author of *The Lesbian Postmodern* [1994], and co-author of *Sexology Uncensored: The Documents of Sexual Science* [1998], and *Sapphic Modernities: Sexuality, Women, and English Culture* [2007].

ROBERT DUNCAN [b.1919, Oakland, California, USA; d.1988, San Francisco] was writer and student of H.D. He spent much of his life in San Francisco, and had a longtime partnership with the artist Jess. His essay 'The Homosexual in Society' is considered a pioneering treatise on gay life.

SIGMUND FREUD [b.1856, Freiburg, Moravia, Czech Republic; d. 1939, London] lived in Vienna and London. The father of psychoanalysis, he revolutionized medical treatment of the emotionally disturbed by his attention to the patient's spoken words. *The Standard Edition of the Complete Psychological Works of Sigmund Freud* was first published in English in 1963.

ANN EDEN GIBSON is Professor of Twentieth Century American and Contemporary Art at the University of Delaware. She is the author of *Abstract Expressionism: The Artist-Run Periodicals* [1990] and *Abstract Expressionism: Other Politics* [1997].

JASON GOLDMAN [b.1978, Santa Ana, California, USA] is an independent art historian whose work spans the history of photography, twentieth-century art and contemporary visual culture. His essay 'The Golden Age of Gay Porn: Nostalgia and the Photography of Wilhelm von Gloeden' was published in *GLQ: A Journal of Lesbian and Gay Studies*, vol. 12, no. 2 [2006].

JAN ZITA GROVER worked with people with AIDS for many years in San Francisco. Currently living in Minnesota, she writes about representation, the ravages of disease, and ecologically-ravished landscapes. She is the author of the essay 'Framing the Questions: Positive Imaging and Scarcity in Lesbian Photographs' [1989], and the book *North Enough: AIDS and Other Clear-Cuts* [1997].

ANDREW HODGES [b.1949, London] is a mathematician, author and early advocate for gay liberation, beginning with work he did in the 1970s. With David Hutter he co-authored *With Downcast Gays: Aspects of Homosexual Self-Oppression* [1974]. He is known for his contributions to twister theory in the field of physics. In 1992 he published *Alan Turning: The Enigma*.

DAVID HUTTER [b.1930, United Kingdom; d.1990] was a painter, editor, writer and activist. With Andrew Hodges he co-authored *With Downcast Gays: Aspects of Homosexual Self-Oppression* [1974]. His work is the subject of the book *Nudes and Flowers: 40 Watercolours by David Hutter* [2003], edited by Edward Lucie-Smith.

DEREK JARMAN [b.1942, Northwood, England; d.1994, London] was a filmmaker, writer and activist. He is the author of his autobiography *Dancing Ledge* [1984], two volumes of diaries *Modern Nature* [1991] and *Smiling In Slow Motion* [2000], and the defiant celebration of gay sexuality *At Your Own Risk* [1992].

JILL JOHNSTON [b.1929, London; d.2010, Hartford, Connecticut, USA] was a feminist author who wrote *Lesbian Nation: The Feminist Solution* [1973], *Admission Accomplished: the Lesbian Nation Years* (1970–75) [1998] and a critical biography of Jasper Johns [1996].

JONATHAN DAVID KATZ [b.1958, St Louis] is a significant contributor to the scholarly field of queer studies. He is founder of the Harvey Milk Institute and taught art history and gay and lesbian studies at several universities in the USA He is the author of the forthcoming book *Jasper Johns, Robert Rauschenberg and the Collective Closet: How Queer Artists Came to Dominate Cold War American Art* and involved with the exhibition 'Jess: Picturing Sexuality' [2000].

JONATHAN NED KATZ [b.1938] lives in New York City. He is an academic, activist, and a visual artist working in drawing and painting. A founding member of the Gay Academic Union in 1973, Katz also initiated OutHistory.org, an online resource about the history of sexuality that launched in 2008. He is the author of *The Invention of Heterosexuality* [1995].

WAYNE KOESTENBAUM [b.1958] is a cultural critic and poet who teaches English at the City University of New York. He is the author of *The Queen's Throat: Homosexuality, and the Mystery of Desire* [1993], *Cleavage: Essays on Sex, Stars, and Aesthetics* [2000], and *Andy Warhol* [2001].

TIRZA TRUE LATIMER [b.1950, New Orleans] has published work from a lesbian feminist perspective on a range of topics in the fields of visual culture, sexual culture, and criticism. She is co-editor, with Whitney Chadwick, of the anthology *The Modern Woman Revisited: Paris Between the Wars* [2003] and the author of *Women Together / Women Apart: Portraits of Lesbian Paris* [2005].

ELISABETH LEBOVICI [b.1953] is an art historian and art critic based in Paris. She was a cultural journalist for the daily newspaper *Libération* from 1991 until 2006, and has written extensively for exhibition catalogues and art periodicals. She is the co-author of a forthcoming book on the history of women artists in France.

CATHERINE LORD [b.1949, Roseau, Dominica] is professor of Studio Art and a core faculty member in the programme in Women's Studies at the University of California, Irvine. As a writer, artist and curator, she addresses issues of cultural politics, feminism, colonialism and queer

visualities. She is the author of *The Summer of Her Baldness: A Cancer Improvisation* [2004], and her essays have been included in the collections *The Contest of Meaning: Critical Histories of Photography* [1989], *Reframings: New American Feminist Photographies* [1996] and *The Passionate Camera: Photography and Bodies of Desire* [1998].

NORMAN MAILER [b.1923, Long Branch, New Jersey, USA; d.2007, New York] innovated the form of narrative nonfiction. He contributed essays and reviews for *The Village Voice*, *Esquire*, and *The New York Review of Books*. He is the author of the Pulitzer Prize winning book *The Executioner's Song* [1979], and *The Naked and the Dead* [1948].

KOBENA MERCER [b.1960, Ghana] is a writer and critic living in London. He is the editor of *Pop Art and Vernacular Cultures*, *Cosmopolitan Modernisms* [2007], and *Discrepant Abstraction* [2006], and author of *Welcome to the Jungle: New Positions in Black Cultural Studies* [1994]. He also contributes frequently to *Screen*, *Artforum*, and *Sight & Sound*.

RICHARD MEYER [b.1966, New Brunswick, New Jersey, USA] is associate professor of art history and director of The Contemporary Project at the University of Southern California. He is the author of *Outlaw Representation: Censorship and Homosexuality in Twentieth-Century American Art* [2002] and the editor, with David Román, of *Art Works I and II*, a two-part special issue of *GLQ; A Journal of Lesbian and Gay Studies*.

BILLY MILLER [b.1958, Detroit] lives in Jersey City, New Jersey. As an artist, writer, filmmaker, curator and independent publisher, he documents and exhibits artworks and cultural experiences that fall outside of the mainstream. His writing has appeared in magazines including *Index*, *Butt* and *Vice*, and he is the editor/publisher of a number of independent publications, including *When Johnny Comes Marching Home Again*, *No Milk Today* and the cult series *Straight To Hell* (*The Manhattan Review of Unnatural Acts*).

EILEEN MYLES [b.1949, Cambridge, Massachusetts, USA] teaches writing at the University of California, San Diego. She is the author of numerous books of poetry and fiction, including *Inferno* [2010], *Sorry, Tree* [2007], *Skies* [2001], *Cool for You* [2000], *Maxfield Parrish* [1995], *Not Me* [1991] and *Chelsea Girls* [1994]. She is a frequent contributor to *Book Forum*, *Art in America*, *The Village Voice* and *The Nation*.

JOHN PERREAULT [b. New York] is an art critic, curator and poet. He was the art critic for *The Village Voice* from 1966 to 1974 and was an art editor at *SoHo News* 1975–1983. His writings on art have also appeared in *Artforum*, *Art in America*, and in numerous anthologies.

CLARK P. POLAK [b.1937 Philadelphia; d.1980 Los Angeles] was an influential journalist and activist in the Philadelphia gay community during the 1960s. In 1963 he became president of the homophile organization Janus Society and he created, published and edited the Society's magazine, *Drum*.

LA FOREST POTTER was a doctor and early scholar of homosexuality. He wrote *Strange Loves: A Study in Sexual Abnormalities*.

BEATRIZ PRECIADO [b.1970, Borgos, Spain] lives in works in Paris. She is known for her contributions to philosophy and queer theory, which she often interrogates through experimental methodologies such as what she has called autopolitical fiction. Her publications include *Anti-Sexual Manifesto* [2002], *Testo Yankee* [2008] and *Pornotopia: Architecture and sexuality in Playboy during the Cold War* [2010], a finalist for the Anagrama Essay Prize.

YVONNE RAINER [b.1934, San Francisco] lives in Los Angeles. Her pioneering work as a dancer and choreographer with the Judson Dance Theater during the 1960s blurred the lines between dancers and non-dancers and incorporated unaccented movements and seemingly random, disconnected gestures. By the mid-1970s she had largely turned her attention to the medium of film, in which she has investigated themes such as terrorism, social exclusion and illness. Her 1996 feature *MURDER and murder* depicts the domestic life of a middle-aged lesbian couple, one of whom, like Rainer herself, had only recently come out.

EMILY ROYSDON [b.1977, Easton, Maryland, USA] lives in New York and Stockholm, Sweden. Her interdisciplinary practice encompasses performance, photography, installation, printmaking, video, collaboration, writing and curating. She is an editor and co-founder of the queer feminist journal and artist collective LTTR, and her work has shown internationally at venues including the Whitney Museum of American Art in New York, Museo Tamayo in Mexico City and the Power Plant in Toronto.

GAYLE RUBIN [b.1949] is a cultural anthropologist and theorist of sex and gender politics. Her writings about S/M, prostitution, pornography, and sexual subcultures include 'Thinking Sex: Notes for a Radical Theory of the Politics of Sexuality' [1984], and 'The Traffic in Women: Notes on the "Political Economy" of Sex' [1975].

JAMES SASLOW [b.1947] lives in New York City. He is a scholar of Italian Renaissance Art and Theater, known for his focus on representations of gender and sexuality. He was a founding member of City University of New York's Center for Gay and Lesbian Studies and of the College Association Art Association's Queer Caucus for Art. He is the author of numerous books including *Pictures and Passions: A History of Homosexuality in the Visual Arts* [2001].

MARTHA SHELLEY [b.1942] co-founded the Lavender Menace in 1970 and helped produce the lesbian manifesto 'The Woman-identified Woman'. She was also a member of the Daughters of Bilitis, and regularly contributed articles to *The Ladder*. Her noted writings include 'Notes of a Radical Lesbian', 'Gay is Good' and 'Lesbianism in the Women's Liberation Movement'.

JAMES THRALL SOBY [b.1906, Hartford, Connecticut, USA; d.1979, Connecticut] was an art historian and art collector deeply influenced by his visits to Paris, which began in 1926 when he abandoned his studies at Williams College. He built the collection at the Wadsworth Atheneum in Hartford from 1928–38, acquiring works by Ernst, Matisse, Miró and Picasso. In 1943 he began working for the Museum of Modern Art in New York. His books include *Contemporary Painters* [1948], *Ben Shan: His Graphic Art* [1963] and *Yves Tanguy* [1972].

VALERIE SOLANAS [b.1936, Ventnor City, New Jersey, USA; d.1988, San Francisco] denounced patriarchal culture and advocated for an all-female society. Best known for her attempt to assassinate Andy Warhol, she is the author of the self-published *SCUM Manifesto* [1969] and the play *Up Your Ass* [1965].

SUSAN SONTAG [b.1933, New York; d.2004, New York] wrote novels, stories and innovative essays covering a wide range of aesthetic, cultural and political issues. Her books include *AIDS and Its Metaphors* [1989], *Against Interpretation* [1966] and *Regarding the Pain of Others* [2004].

MARK THOMPSON [b. Monterey, California, USA] is an author, activist and photographer. A founding member of the Bay Area's Gay Students Coalition in 1973, he began writing at *The Advocate* in 1975 and contributed

to the publication for twenty years, culminating in editing the book *Long Road to Freedom: The Advocate History of the Gay and Lesbian Liberation Movement*. He is the author of a trilogy on gay spirituality [1987, 1994, 1999] and edited the anthology *Leatherfolk: Radical Sex, People, Politics and Practice* [1991].

LUCIAN K. TRUSCOTT [b.1947, Japan] graduated from West Point Academy in 1969 and lives in Franklin, Tennessee. His interest in journalism led to conflicts with the Army, beginning with an article he wrote for the *Village Voice* about rampant heroin abuse among troops. Truscott covered the Stonewall Riots in New York City in 1969. His 1979 novel *Dress Grey* was adapted by Gore Vidal as a miniseries for NBC in 1986.

SIMON WATNEY [b.1949, Leatherhead, England] is a cultural theorist, art historian and activist whose writings about HIV/AIDS have been particularly influential. He is the author of *Policing Desire: Pornography, AIDS, and the Media* [1987], *Practices of Freedom: Selected Writings on HIV/AIDS* [1994], and co-editor of *Taking Liberties: AIDS and Cultural Politics* [1989].

JONATHAN WEINBERG [b.1957, Passaic, New Jersey, USA] is a painter and art historian. He is the author of *Speaking for Vice: Homosexuality in the Art of Charles Demuth, Marsden Hartley, and the First American Avant-Garde* [1993], *Ambition and Love in Modern American* [2001], and *Male Desire: the Homoerotic in American Art* [2005].

RICHARD WHELAN [b.1946; d.2007] is the author of *Robert Capa: A Biography*, and was the consulting curator of the Robert and Cornell Capa Archives at the International Center for Photography, New York.

MINOR WHITE [b.1908, Minneapolis; d.1976, Cambridge, Massachusetts, USA] photographed seemingly mundane objects and textures with the intention of triggering an emotional response in viewers. He also trained his camera on the male body — images that were not exhibited until after his death. With Ansel Adams, he co-founded the magazine *Aperture*, and later worked as a curator at George Eastman House.

OSCAR WILDE [b.1854, Dublin; d.1900 Paris] was a novelist, poet and playwright, celebrated in London for his work, wit, personality and style. His writings include *The Picture of Dorian Gray* [1890] and *The Importance of Being Ernest* [1895]. Wilde prosecuted the Marquess of Queensberry, the father of his lover, Lord Alfred Douglas, for libel when Queensberry called him a sodomite. Wilde lost, and was himself then charged with gross indecency, convicted and sentenced to two years hard labour. In prison he wrote *De Profundis* [written in 1897, published in 1905], a mediation on his trial and the turmoil of his trial. His last work, *The Ballad of Reading Gaol* [1898], was a long poem about his prison life. He died destitute in Paris.

MONIQUE WITTIG [b.1935, Haut-Rhin, France; d.2003, Tucson, Arizona, USA] devoted her scholarly and activist energy to fighting gender and heterosexist oppression. She was a founder of the *Mouvement de Libération des Femmes* [Women's Liberation Movement] and the group *Gouines rouges* [Red Dykes], in France. She is the author of *Les Guérillères* [1969] and *The Straight Mind and Other Essays* [1992].

DAVID WOJNAROWICZ [b.1954, Red Bank, New Jersey, USA; d.1992, New York] used his artwork and writing to express his outrage about the AIDS crisis and the federal government's indifference and inaction. He is the author of *Close to the Knives: A Memoir of Disintegration* [1991], *Tongues of Flame* [1990], and *Memories That Smell Like Gasoline* [1992].

Index

Acknowledgements

AUTHORS' ACKNOWLEDGEMENTS

The book you hold in your hands is the result of a collaboration among many people in the US, the UK and beyond. We thank the artists and writers who contributed their work to *Art & Queer Culture*, and the many others who could not be included in this book. For time, expertise and generosity, we are are grateful to Juan Vicente Aliaga, Sue-Ellen Case, Susan Foster, Julia Bryan-Wilson, Jonathan David Katz, Jonathan Weinberg, Harmony Hammond, Erica Rand, Frank Wagner, Simon Watson, Elisabeth Lebovici, Catherine Gonnard, Peter Lloyd Lewis, Sunil Gupta, Alexander Gray, Marie-Jo Bonnet, Helen Molesworth, Nathalie Magnan and Henry Rogers. We are indebted to Jason Goldman and Kristine Thompson for their scholarly contributions, and to Marcelo Sousa and Katie Kerrigan for excellent research assistance. Craig Garrett, Hettie Judah and Emmanuelle Peri saw *Art & Queer Culture* through to completion at Phaidon Press, and we are deeply appreciative of their commitment to the project.

PUBLISHER'S ACKNOWLEDGEMENTS

We would like to thank all those who gave their kind permission to reproduce the listed material. Every effort has been made to secure all reprint permissions, and the editors and publisher apologize for any inadvertent errors or omissions. If notified, the publisher will endeavour to correct these at the earliest opportunity. We would also like to acknowledge the following organizations and individuals: 303 Gallery, New York; AFP/Getty Images; AKG-images; Alexander Ochs Galleries, Berlin/Beijing; The Alvin Baltrop Trust; Andersen's Contemporary, Copenhagen; Andrea Rosen, New York; Archives of American Art, Smithsonian Institution, Washington, DC; Art Resource, New York; Charles Atlas; Australian Lesbian & Gay Archives Inc.; Austrian Archives/CORBIS; Autograph ABP; Beinecke Rare Book and Manuscript Library, Yale University; Betty Parsons Foundation; Colby Bird; Bloomsbury Auctions; Daniel Boedeker, Hannover; Marik Boudreau; AA Bronson; Brooklyn Museum; Will Brown; Cabinet Gallery, London; Catharine Clark Gallery, San Francisco; Centro culturale e Museo Elisarion, Minusio; Charles Asprey Collection; Château-Musée Grimaldi, Cagnes-Sur-Mer; Cheim & Read, New York; Christopher Burke Studio; Clifton Benevento, New York; Sheldan C. Collins; Paula Court/The Kitchen Archives; Sean Coyle; CRG Gallery, New York;

Dalkey Archive Press; DC Moore Gallery, New York; Diana Davies; Dwight Hackett projects, Santa Fe; Elizabeth Dee, New York; Envoy Enterprises Inc; The Estate of Robert Blanchon/Visual AIDS; The Estate of Joe Brainard; The Estate of Ray Johnson, Courtesy Richard L. Feigen & Co; The Estate of Mark Morrisroe/Ringier Collection/Fotomuseum Winterthur; The Estate of Robert Rauschenberg/Licensed by VAGA, New York/Robert Rauschenberg Foundation; The Estate of Jack Smith/Gladstone Gallery, New York; The Estate of David Wojnarowicz/PPOW Gallery, New York; The Estate of Martin Wong/PPOW Gallery, New York; Kevin Fleming/CORBIS/©George and Helen Segal Foundation/VAGA, New York; Gagosian Gallery, New York; Galerie Andreas Huber, Vienna; Galerie Christophe Gaillard, Paris; Galerie Daniel Buchholz, Cologne; Galerie HILT, Basel; Galerie Isabella Bortolozzi, Berlin; Galerie Jérôme de Noirmont, Paris; Galerie Patricia Dorfmann, Paris; Galerie Zabriskie, Paris; Gallery Paule Anglim, San Francisco; Harry Gamboa Jr; Gasworks, London; Gavin Brown's enterprise, New York; Gay, Lesbian, Bisexual, Transgender Historical Society, San Francisco; Gearless/Peter Hjorth; Getty Images; Gigi Gatewood; Goodman Gallery, Johannesburg; Félix González-Torres © The Felix Gonzalez-Torres Foundation/courtesy of Andrea Rosen Gallery, New York; Inti Guerrero; Toni Hafkenscheid; Harmony Hammond ©VAGA, New York, and DACS, London; The Jess Collins Trust/The Poetry Collection/State University of New York at Buffalo; J. Paul Getty Museum, Los Angeles; Joan Prats Gallery, Barcelona; Mathew Jones; Kalli Rolfe Contemporary Art, Melbourne; Koninklijke Bibliotheek, the Hague; Knoedler & Company, New York; Kulturhistoriska Foreningen For Sodra Sverige Kulturen, Lund; Kunstsammlungen Chemnitz-Museum Gunzenhauser; Kunstverein Braunschweig; Leo Koenig Inc., New York; Alexander Liberman; Library of Congress; Luhring Augustine, New York; Lutz Heiber Collection, Hannover; Dick Makin; The Man Ray Trust/ARS-ADAGP; Marianne Boesky Gallery, New York; Mary-Anne Martin Fine Art, New York; Matthew Marks Gallery, New York; Olivier Martin-Gambier/FLC/DACS; Mary Boone Gallery, New York; Natalie Matutschovsky; Jean-François Mauboussin/RATP-DGC; Mercer Union, Toronto; Metropolitan Museum of Art, New York; Michael Buxton Contemporary Australian Art Collection; Michael Rosenfeld Gallery, New York; Minneapolis Institute of Arts; Minor White Archive, Princeton University Art Museum; Mortimer Rare

Book Room, Smith College Libraries; Peter Muscato; Museo Casa de los Tiros de Granada; The Museum of Modern Art, New York; National Gallery of Australia, Canberra; National Portrait Gallery, Smithsonian Institution, Washington, DC; Nationnalmuseum, Stockholm; Newark Museum; New York Public Library/Astor, Lenox and Tilden Foundations; Nimbus Film/Thomas Vinterberg; Fredrik Nilsen; Nora Eccles Harrison Museum of Art/The Marie Eccles Caine Foundation; Mary Oliver/The Sophia Smith Collection, Solomon R. Guggenheim Museum, New York; Bernard Olives; PPOW Gallery, New York; Pace Gallery, New York; Pace/MacGill Gallery, New York; Paolo Pellion; Paul Petro Contemporary Art, Toronto; Pavel Zoubok Gallery, New York; Pepe Cobo y cía, Madrid; Peres Projects, Berlin; Pinakothek der Moderne, Munich; Robert Plogman; Princeton University Art Museum; Projeto Hélio Oiticica; Andres Rameriz; Regen Projects, Los Angeles; Richard Telles Fine Art, Los Angeles; Rosenbach Museum & Library, Philadelphia; Saatchi Gallery, London; Scala, Florence; Schlesinger Library, Radcliffe Institute, Harvard University; School of Law, University of Missouri, Kansas City; Schwules Museum/Gay Museum Berlin, Sternweiler Collection; Sikkema Jenkins & Co., New York; Smithsonian American Art Museum, Washington, DC; Spanierman Gallery LLC, New York; Sperone Westwater Gallery, New York; State Tretyakov Gallery, Moscow; Staten Island Historical Society Collection; Stephen Friedman Gallery, London; Stevenson Gallery, Cape Town/Johannesburg; Eli Sudbrack; Susanne Vielmetter Los Angeles Projects; Taxter & Spengemann, New York; Tibor de Nagy Gallery, New York; Time & Life Pictures ©Getty images; Markus Tollhopf, Kassel; The Tom of Finland Foundation; Helene Toresdotter; Triangle Network; Douglas Blair Turnbaugh; Universitatsbibliothek Heidelberg; University of Maryland Libraries, Special Collections; University of Saskatchewan Library, Special Collections; Elmar Vestner; Victoria Miro Gallery, London; Fefa Vila; W. A. C. Bennett Library, Special Collections; Rich Wandel/Lesbian, Gay, Bisexual & Transgender Community Center, New York; Weegee ©Getty images; Josh White; Whitney Museum of American Art, New York; Ellen Page Wilson; Thomas H. Wirth; Yossi Milo Gallery, New York; Rob Zukowski/Lesbian, Gay, Bisexual & Transgender Community Center, New York; and those private collectors who wish to remain anonymous.